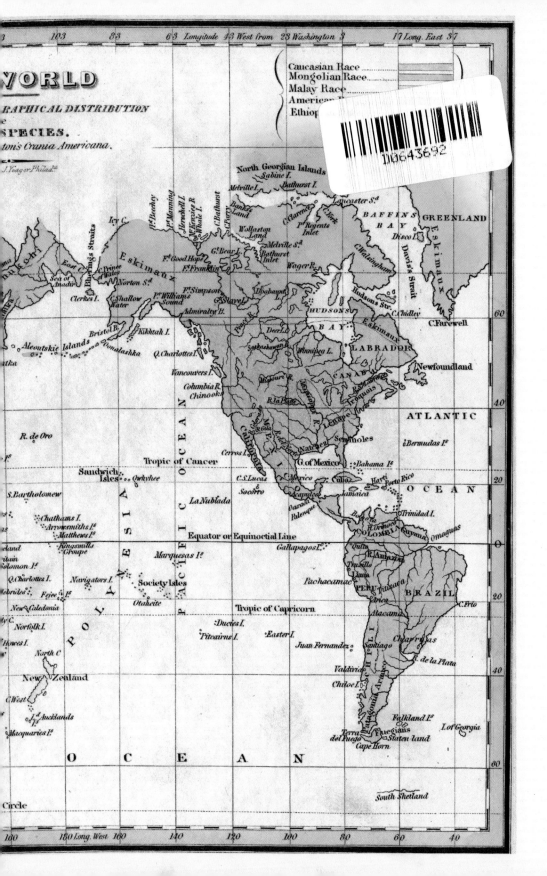

TYPECASTING

Tableau récapitulatif des formes sériées les plus caractéristiques
à signaler sur la fiche en tout état de cause

1. Bord sup.r plat.
2. Bord sup.r très grand
3. Bord post.r très grand
4. Bord post.r très grand
5. Lobe descendant
6. Lobe à golfe.
7. Lobe très petit
8. Lobe très grand
9. Antitragus horizontal
10. Antitragus à profil cave.
11. Antitragus versé en dehors
12. Conque traversée
13. Pli inférieur à coupe convexe
14. Pli inférieur à coupe cave
15. Pli sup.r nul
16. Pli sup.r accentué et très long

Clichés Dugast et Félix Geoffray

Bertillon's chart of criminal ears. COURTESY OF THE PREFECTURE DE POLICE, PARIS

TYPECASTING

On the Arts & Sciences
of Human Inequality

A History of Dominant Ideas

EWEN & EWEN

SEVEN STORIES PRESS

NEW YORK

A Seven Stories Press First Edition

Seven Stories Press
140 Watts Street
New York, NY 10013
http://www.sevenstories.com

In Canada:
Publishers Group Canada, 250A Carlton Street, Toronto, ON M5A 2L1

In the UK:
Turnaround Publisher Services Ltd., Unit 3, Olympia Trading Estate, Coburg Road, Wood Green, London N22 6TZ

In Australia:
Palgrave Macmillan, 627 Chapel Street, South Yarra VIC 3141

Library of Congress Cataloging-in-Publication Data

Ewen, Elizabeth.
 Typecasting : on the arts & sciences of human inequality / Ewen & Ewen.
 p. cm.
 Includes bibliographical references.
 ISBN-13: 978-1-58322-735-0 (hardcover : alk. paper)
 ISBN-10: 1-58322-735-0 (hardcover : alk. paper)
 1. Race. 2. Stereotype (Psychology) 3. Equality. I. Ewen, Stuart. II. Title.

HT609.E95 2006
305.8--dc22
2006012832

Frontispiece: Bertillon chart of criminal's ears. Prefecture de police, Paris.
Endsheets: from Samuel Morton, *Crania Americana* (1839).
Book design by Jon Gilbert

College professors may order examination copies of Seven Stories Press titles for a free six-month trial period. To order, visit www.sevenstories.com/textbook or fax on school letterhead to (212) 226-1411.

Printed in the USA

9 8 7 6 5 4 3 2 1

For our grandchildren,

Stella Wunder Ewen-Tanaka and Henry Cleveland Ewen,

who transcend all types

&

In memory of Stephen Jay Gould,

who transcended the limits of knowledge

Every way of seeing is also a way of not seeing.
—Helen Merrell Lynd

If we are ever to understand human behavior we must know as much about the eye that sees as about the object seen. . . . [T]he eye that sees is not a mere physical organ but a means of perception conditioned by the tradition in which its possessor has been reared.
—Ruth Benedict

The one duty we owe to history is to rewrite it.
—Oscar Wilde

How thinkest thou that I rule this people? . . . It is not by force. It is by terror. My empire is of the imagination.
—Ayesha, white Queen of the Lost City of Kor in Central Africa, in H. Rider Haggard's 1886 novel, *She*

CONTENTS

ACKNOWLEDGMENTS

While this book relied on a great deal of primary research, it could not have been written without the pathways of thought, research and imagination laid by a number of pioneering scholars and artists. Among these is the person to whom this book is, in part, dedicated, Stephen Jay Gould. His *The Mismeasure of Man* and the multivolume series, *Reflections in Natural History*, were powerful sources of inspiration from beginning to end. Though we take issue with some of his specific arguments, his vision was extraordinary. The writings of our teacher and friend, George L. Mosse, along with discussions we had before his death, were also of enormous value as we began to frame this book. Though very different, Eduardo Galeano's *Memory of Fire* trilogy had a profound influence on our approach to writing this book.

Others influential voices, who guided us along the way, include Richard D. Altick, Walter Benjamin, Edwin Black, Robert Bogdan, Donald Bogle, Sterling A. Brown, W. E. B. DuBois, George M. Frederickson, Henry Louis Gates, Jr., Mary Gibson, Sander Gilman, David Hockney, Matthew Frye Jacobson, David Levering Lewis, Walter Lippmann, Tommy Lee Lott, Stanley Nelson, Elaine Pagels, Kathy Peiss, Sandra S. Philips, Nicole Hahn Rafter, Ruth Richardson, Naomi Rosenblum, Londa Schiebinger, Allan Sekula, Philip Steadman, Madeleine Stern, Robert C. Toll, Immanuel Wallerstein, Carla Williams and Deborah Willis. Books by Daniel Pick, *Faces of Degeneration*, and Immanuel Wallerstein, *The Modern World System*, provided us with eloquent phrasing for the titles of Parts One and Three. These people, of course, are not alone. Our notes and bibliography provide additional names and sources. Without apology, we would also like to thank Google for putting an enormous number of indispensable resources at our fingertips.

In 2004 Justin Kazmark contacted us and volunteered to serve as our Research Assistant. Though we had never met him, initial discussions revealed a serious and intelligent person with a keen interest in history. Bringing him into this project was an excellent decision. He has been an invaluable ally in the making of this book. The generous advice of Paul Breines, Andrew Mattson, Rosalyn Baxandall, Gretel Smith Ewen, Steven Heller, Larry Sullivan, Dr. Yuri K. Chistov, Prof. Vladimir Ilyan, Richard Lan, Margaret Schotte, Eno Mezini and Seyla Martayan are also deeply appreciated. In

putting together images for this book, we received significant guidance and assistance from Barbara Mathe and Emily Lanzara, Archivists at the American Museum of Natural History; Deborah Willis, Professor of Photography at the Tisch School of the Arts at NYU; Frank Luca, Jacqueline Crucet, Cathy Leff and Kate Rawlinson of the Wolfsonian Museum in Miami Beach; and James Andrew Wagstaff and Jeremy McGraw of the New York Public Library.

Mira Felner, Kristin Muncheimer, Seanna Brown, Kathe Sandler, as well as Kathryn and Mick Hurbis-Cherrier were also helpful in identifying and/or securing important sources. Archie Bishop made critical contributions to the visual and conceptual tone of the book, and Alice Arnold helped him to reach his objectives. Andy Ewen produced original art for *Typecasting*.

For us, writing is inextricably linked to teaching. Presenting the material that follows and discussing it with students was one of the best ways to judge whether ideas and information were being clearly articulated. The feedback that resulted from teaching was a vital part of our creative process. In light of this, we are privileged to thank our students at Hunter College, the CUNY Graduate Center, and SUNY College at Old Westbury for their help.

In the years consumed by the writing of this book, conversations with friends and colleagues have been illuminating. Linda Gordon, Serafina Bathrick, Allen Hunter, Sheila Rowbotham, Julie Kaye Reich, Chuck Reich, Gail Pellett, Stephan Van Dam, Steve Resnick and Stephen Duncombe have been there for years and have been treasured critical advisors. Jeanne Saltsman, David Pavlosky, Chistopher Hobson, Ann Cohen, Robert Marino, Aubrey Bonnett, Amanda Frisken, Lois Stergiopoulos and Mary Jeys also played an important part in the carrying out of this work.

For most of the time spent writing this book, we had not looked for a publisher. While some publishers learned of the project and expressed interest, we enjoyed proceeding at our own pace, without external deadlines. Then we encountered the enthusiasm and commitment of people at Seven Stories Press, initially in the person of Greg Ruggiero. From our very first discussions, we were convinced that this was the place to go. The publisher Dan Simon and our excellent editor, Ria Julien, have been more than a pleasure to work with. They have understood the book from the first time they read a seventy-five percent completed manuscript. Since then they have patiently collaborated in bringing it to fruition. Dan, Ria and others at Seven Stories are avatars of responsible publishing at a time when this has become extremely rare.

The role of family in the course of creation is inestimable. Ideas, love and support provide an amazing foundation to build on. In this regard, we feel

blessed, and extend our thanks to our mothers, Frances Wunderlich and Scotty
Ewen. Scotty died unexpectedly in March 2006, six months prior to this book's XIII
publication, but in the weeks prior to her passing, her son, "the author," had been
reading the manuscript aloud to her each weekend. She was fascinated and
engaged by the parts of the story she heard, and was looking forward to more when
a catastrophic stroke took her from us.

Our fathers, Sol Ewen and Roger Wunderlich, were both interested in our sub-
ject and approach as we began work on this book. Their questions and ideas
informed our inquiry throughout. Sadly, both passed away in the years preced-
ing its completion, and were unable to enjoy the fruits of their influence.

Our children, Paul Ewen and Sam Travis Ewen have been, once again, our crit-
ical co-conspirators in the shaping of this enterprise. Their love and encourage-
ment has sustained our scholarly and creative work for decades.

Our grandchildren, Henry Cleveland Ewen and Stella Wunder Ewen-
Tanaka, and their mothers, Gretel Smith Ewen and Jaime Tanaka, have brought
joy to our lives and to our work. We also thank Phyllis Ewen, Andy Ewen,
Catherine Onsrud, Jim Campen, and Gale and Mike Flament for their unswerv-
ing interest and encouragement.

PREFACE

In 1956 Roget's International Thesaurus offered no synonyms for the noun "stereo-type" that mirrored the way we think of it today. All cognate words related to the print-ing trades: print, engraving, etching, steel plate, lithograph, type, linotype, font, and so forth. As a verb—to stereotype—it was associated with fixing, stabilizing, perpetuat-ing, and establishing, but was devoid of any social connotation. Only as an adjective—stereotyped—did synonyms move somewhat closer: trite, hackneyed, stock, set, banal, familiar, everyday, but still the contemporary usage of the word was not present.

Then, beginning in the 1960s, all of this changed. In the wake of the early civil rights movement, there was a growing awareness that racial discrimination was not simply about unequal social, economic, and political opportunities, but that the institutions of racism were upheld by a prevailing cultural milieu that portrayed black people as unfit for the responsibilities of citizenship; incapable of staying out of trouble; ignorant and uncultured; servile, scheming, or brutish.

Other social movements broadened people's consciousness of typecasting as a repressive social practice. The emergence of the women's liberation movement was inseparable from many women's understanding of the ways the mass media projected images of women that ignored all but their sexual and motherly functions. The term "sex object" entered the parlance of society in reaction to stereotypes that denied the full range of women's mental and physical capabilities. The war in Vietnam added to this new consciousness about stereotypes as many saw the ways that the dehumanization of an enemy is indivisible from the pursuit of conquest. Simultaneously, rampant stereotypes of homosexuality began to be looked at as a bulwark that served to dictate proper sex-ual practices.

In recent decades, a growing number of people have addressed the ways that deeply ingrained stereotypes shed negative light on a wide range of populations and commu-nities. For the most part, this work has addressed the portrayals of particular groups of people. Many scholars, writers, media makers, artists, and cultural institutions have explored the stereotyping of African Americans, women, Jews, Latinos, Asians, Amer-ican Indians, gays, immigrants, people with disabilities, and criminals and the poor, who are often conflated with one another.

This study has provided disturbing evidence of the ways that entrenched social injus-

tice is often transmitted through the perceptual corridors of "knowledge" and "culture." Yet such focused approaches have shed little light on the social forces and historical developments that have shaped modern habits of typecasting. The absence of an overarching history was the inspiration for this book. In our research and writing, which took place over a period of eight years, we looked to find connections that would help to illuminate the rise of modern stereotyping itself. The result appears in the pages that follow.

This is a critical history of dominant ideas. It explores the relationship between stereotyping as a persistent social, cultural, and mental practice and the rise of modern European and American societies. Rather than dwell on present-day instances of typecasting, the book is designed to provide a historical foundation that, hopefully, will make recent social trends somewhat more intelligible.

Our objective is to provide a vivid portrait of modern stereotyping as it was forged by the emergence of a global economy, colonialism, the matrix of urban life, and the rise of democratic and egalitarian movements and ideas. An ongoing issue of concern is the way that modern visual media—changing standards of visible evidence, and extensive networks of communication—have provided new languages and lubricants for propagating ideas of human inequality. In a progression of sections, the book also examines the ways that modern scientific, aesthetic, and religious cosmologies have turned the categorizing of human types from an ancient parochial practice into a globally instrumental expression of Western popular culture.

Most of all, this is a book about people, ideas, and deeds. Many of them contributed to an interpretation of the world that naturalized social hierarchies; subtly transmitting prevailing structures of power through the imposing filter of "human nature." At the same time, those who are naturalized into subordinate positions sometimes break the dominant visual and linguistic codes, piercing through the optic veil, breaching the customs of language, to proclaim and project a critical and oppositional point of view.

Given the breadth of our topic and the scope of the approach we have taken, we decided, very early on, that writing a comprehensive narrative history would be impossible. Instead of attempting to write a conventional history, we chose to devise another approach, to write a series of focused pieces that highlight significant moments and questions.

While the following vignettes are, for the most part, presented chronologically, each addresses particular historical developments and some of the central figures that played a part within them. Each segment explores a theme that

offers insight into a particular aspect of our overall subject. Many of the pieces traverse geographic and temporal boundaries, moving from place to place, time to time, bringing together events and ideas that converged to shape the taxonomies of human difference. While there is no all-inclusive narrative, nor could there be, our strategy in writing this book was to present a reader with a succession of stories that would, incrementally, build a deeper historical understanding of a vital, if often slippery, topic.

As we were writing this book, people repeatedly asked us how two people who have lived with each other for so many years could write a book together. Most assumed that the writing was broken up and that each of us took on responsibility for different sections. Nothing could be further from the truth. This book is product of an extended conversation that began in libraries and continued across a table with a laptop computer in the middle. Each sentence and paragraph was sculpted by this conversation, and no word went unturned.

Ewen & Ewen
New York City
April 2006

PART I

GENESIS: THE MODERN WORLD SYSTEM

1
DIDOT'S INVENTION

Stereotypes make sense of the big, complex, often transient world that confronts us. In the process they transform it. While the current meaning of stereotyping usually refers to the unthinking tendency to reduce individuals and cultures to one-dimensional, often slanderous, visual clichés, this practice has deep historical roots and is linked to the rise of the modern world.

Defining people according to simplistic categories, of course, dates back to antiquity. In myth, ritual, and drama, and in the ways that history was recounted, characters often appeared as easily identifiable types, embodiments of good and evil, virtue and trickery, innocence and cunning. In the contemporary world, however, where cultural meanings transcend customary borders, and where the standardization of images and information is commonplace, the problem of stereotyping has become particularly acute.

Within recent history, the media's capacity to spawn mass impressions instantaneously, has been a pivotal factor in the dissemination of stereotypes. In fact, the link between media and stereotype is found in the origin of the word itself. Coined in 1794 by the French printer Fermin Didot, "stereotype" was the name he gave to a novel printing process by which papier mâché molds were made from full pages of handset type. Like cookie cutters, these molds were then used to produce duplicate plates, cast in metal, permitting newspapers and books to be printed on several presses at the same time without the need to set individual pieces of type into forms for each printing press.[1]

Yet even among printers the contemporary implications of stereotyping were furtively in attendance. As far back as Gutenberg's development of movable-type printing, in the mid fifteenth century, the hard metal hand-cut die, or "punch," from which multiple pieces of type could be cloned, was referred to as the *patrix*, derived from the Latin for father, *pater*. The progenitor of type, then, was assigned a masculine role by a printing profession that was exclusively male. Stamped by the patrix, the molds that were used to mass-produce the pieces of type that bore their "father's" image, was called the *matrix*, from *mater* or mother. With Didot's innovation, handset type became the patrix, the molds they shaped became the matrix. Here, in the early jargon of printers, gender was used to communicate a hierarchy of importance in the evolution from original to copy.

Issues of power, and assumptions of social inequality, then, were joined to the term stereotype from its inception.[2] The invention of stereotype technology multiplied the variety of printed materials that could be produced, hastened the mass production of print and the growth of a mass readership. More than ever before, unprecedented numbers of people could now consume the same ideas and information simultaneously. Borrowing its prefix from the Greek *stereos*—meaning solid, hard, or fixed—the term stereotype, by the 1820s, was beginning to evolve into a metaphor, a common shorthand for "the idea of unchangeability, of monotonous regularity and formalisation."[3]

It was, however, the renowned American journalist Walter Lippmann who introduced the term stereotype into the social, cultural, and psychological vocabulary of contemporary life. The term had been used before, but never in quite the same way.

In *Public Opinion*, his classic 1922 study of "public mind" and the forces that shape popular consciousness, Lippmann presented "stereotypes" as axiomatic elements of human perception. In the modern world, he argued, their utility was essential. The complexity of modern existence, and the global reach of contemporary society, made it impossible for people to make sense of the world on the basis of firsthand knowledge.

> [T]he real environment is altogether too big, too complex, and too fleeting for direct acquaintance. We are not equipped to deal with so much subtlety, so much variety, so many permutations and combinations. And although we have to act in that environment, we have to reconstruct it on a simpler model before we can manage with it. To traverse the world men must have maps of the world.

Stereotypes, he contended, were those maps. Together they formed a "repertory of fixed impressions" that "we carry about in our heads," rigid mental templates that frame individual experience in an increasingly anonymous world.

For Lippmann, the stereotypes did not emanate from the individual. Instead, they were an inexorable by-product of the surrounding culture, a perceptual reflex that imposed itself between people's eyes and the world they believed they were seeing.

> For the most part we do not first see, and then define, we define first and then see. In the great blooming, buzzing confusion of the outer world we pick out what our culture has already defined for us, and we

tend to perceive that which we have picked out in the form stereotyped for us by our culture.

Through this fateful "mechanism," he maintained, "heroes are incarnated, devils are made."

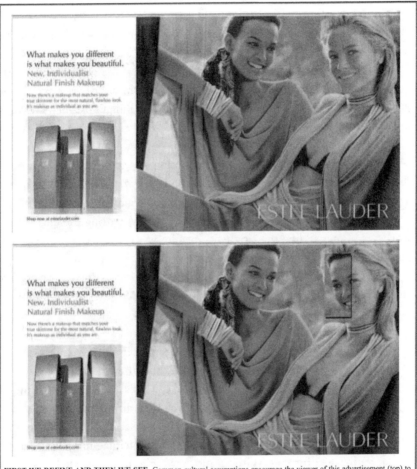

FIRST WE DEFINE AND THEN WE SEE. Common cultural assumptions encourage the viewer of this advertisement (top) to see these two women as essentially different. When the face of the black model is flipped horizontally and superimposed over the face of the white model (bottom), however, it becomes evident that socially inscribed racial distinctions defy common sense. Aside from variations in the hue of the skin, these two models could be identical twins, both conforming to a Nordic standard of beauty. Ideas of difference and inequality are simultaneously transmitted by the way the models are posed. While the white model confidently looks out to the desiring eyes of a prospective consumer, the black model's subordinate position is telegraphed by the palpable admiration she shows for her white counterpart, as seen in the original ad, above.

ARCHIE BISHOP

6

Lippmann's discovery was, without question, a reflection of its time. Prior to the modern era, most people had acquired their assumptions about the world from intimate surroundings, from a familiar and provincial sphere of experience. By the mid nineteenth century, however, the disorienting impersonality of urban industrial life was emerging as a widespread lament. Within the cacophony of this brave new world, the "screech, blare and color" of the modern media left a conspicuous imprint on the popular imagination. Mass circulation newspapers and magazines, photography, and vivid advertising billboards were ubiquitous, battling for public attention. An increasingly voyeuristic, physically disconnected dialog between people and the world at large was becoming the norm. The Age of Spectatorship was arriving.

By the turn of the twentieth century, movies were emerging as the quintessential modern medium. With flickering light, they were revealing an unprecedented capacity to speak, in silence, to the human psyche. The moving picture, wrote Harvard psychologist Hugo Münsterberg in 1916, "has furnished art with a means which far transcends the power of any theater stage." Movies, he observed, "can act as our imagination acts. . . . The photoplay obeys the laws of the mind rather than those of the outer world."4 Cecil B. DeMille, a prime mover of Hollywood filmmaking, concurred when he spoke of "the motion picture's ability to photograph thought."5 Mirroring the unconscious workings of mental life, the eloquence of film was capable of evoking a deep emotional response while bypassing the filter of critical reason.

This idea was not lost on Walter Lippmann. Underlying his reveries on stereotype was a profound appreciation for the power of Hollywood film.

> In the whole experience of the race there has been no aid to visualization comparable to the cinema. . . . [Movies] seem utterly real. They come, we imagine, directly to us without human meddling, and they are the most effortless food for the mind conceivable. Any description in words, or even any inert picture, requires an effort of memory before a picture exists in the mind. But on the screen the whole process of observing, describing, reporting, and then imagining, has been accomplished for you. Without more trouble than is needed to stay awake the result which your imagination is always aiming at is reeled off on the screen.6

Within this medium, the stereotyping process and the elaboration of formulas for making audiences identify with certain characters, and project their

deepest anxieties onto others, was being refined and standardized as never before. Unlike theatrical directors, who relied on the talents of trained actors, early moviemakers often selected "character actors" on the basis of pure physical

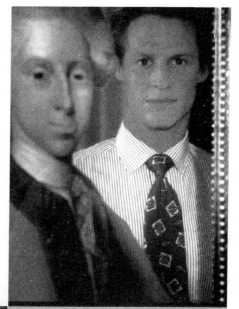

EVEN IN SILENCE, images can communicate a universe of meaning. In these two, taken from American magazine advertisements, the outlook of Western Civilization is laid bare, coldly stated in an eloquent if enigmatic instant.

The man in the looking glass (right) represents the decorum of the fine gentleman with whom he shares a frame. Positing a visual association between a man in a tie and one in an oil painting, these are the icons of reason, where culture and refinement reside.

The woman (below) represents the double bogey of animalistic inclinations. As a woman and as a dark-skinned person she is depicted as the wild repository of primitivism, assuming the blame for hypersexual danger, while the men at right are potential victims of her primitive allure. Like the dusky world that lurks beyond the boundaries of civilization, she must be tamed, lest her crafty passions destroy us.

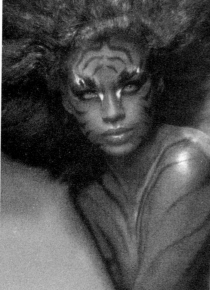

"We are told about the world before we see it. We imagine most things before we experience them. And these preconceptions, unless education has made us acutely aware, govern deeply the whole process of perception. They mark out certain objects as familiar or strange, emphasizing the difference, so that the slightly familiar is seen as very familiar, and the somewhat strange is sharply alien."

Walter Lippmann on the power of stereotypes

ARCHIE BISHOP

8

appearance, scouring the streets for easily identifiable social types. Münsterberg was among the first to describe the process.

> If the photoplay needs a brutal boxer in a mining camp, the producer will not . . . try to transform a clean, neat, professional actor into a vulgar brute, but he will sift the Bowery until he has found some creature who looks as if he came from that mining camp and who has at least the prize fighter's cauliflower ear. . . . If he needs the fat bartender with his smug smile, or the humble Jewish peddler, or the Italian organ grinder, he does not rely on wigs and paint; he finds them all ready-made on the East Side.[7]

By 1922, Hollywood typecasting had become a well-honed practice in American popular culture, and for Lippmann, Hollywood was a living laboratory, a paradigm within which the influence of simple images on public opinion could be analyzed and understood. "In popular representations," he explained, "the handles for identification are almost always marked. You know who the hero is at once. No work promises to be easily popular where the marking is not definite and the choice clear."[8]

For Lippmann, the example being set by the film industry offered a window into the more generalized processes of perception. In "The Great Society," as he labeled his contemporary world, stereotypes were the prevailing tools by which a media-driven culture explained, and made digestible, complicated and confusing social realities. Amid the chaos of the modern, nuance was an unaffordable luxury.

Educated by the teachings of psychoanalysis, Lippmann understood stereotype as something that resided, primarily, in the unconscious mind, apart from rational thought. This, he disclosed, was the secret of its power.

> Its hallmark is that it precedes the use of reason; is a form of perception, imposes a certain character on the data of our senses, before the data reach the intelligence. . . . There is nothing so obdurate to education or criticism as the stereotype. It stamps itself upon evidence in the very act of securing the evidence.[9]

These stereotypes provided people with narratives, stories that encouraged them, without reflection, to see certain things, certain people, in predetermined ways, regardless of countervailing evidence.

We are told about the world before we see it. We imagine most things before we experience them. And these preconceptions, unless education has made us acutely aware, govern deeply the whole process of perception. They mark out certain objects as familiar or strange, emphasizing the difference, so that the slightly familiar is seen as very familiar, and the somewhat strange is sharply alien.[10]

To Lippmann, the "pictures in our heads," indelibly inscribed, were an intractable part of a person's identity, they embodied "the core of our personal tradition." Stereotypes offered a habitual picture of reality, a line of defense against actual or perceived threats, protecting "our position in society."

> They are an ordered, more or less consistent picture of the world. . . .
> They may not be a complete picture . . . but they are a picture of a possible world to which we are adapted. In that world people and things have their well-known places, and do certain expected things. We feel at home there. We fit in. We are members. We know the way around. There we find the charm of the familiar, the normal, the dependable; its grooves and shapes are where we are accustomed to find them. . . . It fits as snugly as an old shoe.

When the "charm of the familiar" was imperiled, Lippmann noted, people will go to extremes to preserve and defend their version of things as they are. "No wonder," he wrote, "that any disturbance of the stereotypes seems like an attack on the foundations of the universe. It is an attack upon the foundations of our universe, and, where big things are at stake, we do not readily admit that there is any difference between our universe and the universe."[11]

With both hindsight and prescience, Lippmann had identified and named one of the most potent features of modernity. To be sure, the impulse to distinguish between the familiar and the alien is an ancient human trait. Modernity, however, had pumped up the volume. In a rapidly changing world, where firsthand experience was losing ground as a source of useful information, the media system was replacing customary networks, and rendering stereotypes into easily consumable, industrially generated substitutes for intimate knowledge. More and more, heroes would be celebrated, beauty would be venerated, enemies would be hunted down, wars would be fought all on the basis of such fragile, if marketable, preconceptions.

Writing in the aftermath of the First World War, Lippmann situated the rise

of stereotyping within "The Great Society," a world where global connections had become increasingly visible and localism seemed a remnant of an outmoded past. Yet stereotypes, as Lippmann defined them, were part and parcel of changes that had been altering the rhythms of existence, in many parts of the world, for centuries. "The Great Society" did not spring up overnight. It was the offspring of developments that had begun to take place, initially in Europe and then throughout the world, with the rise of merchant capitalism in the latter years of the Middle Ages.

THE COMPANY OF STRANGERS

The rise of modern stereotyping cannot be appreciated apart from sweeping changes that affected the dynamics of social, economic, and cultural life for people around the world. In different ways, and with uneven impacts, the flourishing of a "Modern World System," driven by exploration and mercantile trade, obliterated many of the customary boundaries that had previously separated people from one another. Aided by seaworthy ships and the rise of new communications technologies, beginning with the printing press in the mid fifteenth century, events taking place in Europe would significantly alter the physics of survival on a global level.

To be sure, not everyone was immediately affected. For most people, well into the eighteenth century, life continued to occur within a fairly narrow orbit of existence. People lived, worked, and died surrounded by familiar faces and a well-known terrain. Interactions with other people were, for the most part, limited to an accustomed circle of associates, defined by kinship, labor, and ritual, governed by local patterns of hierarchy. Historian Fernand Braudel describes a way of life in which the imperatives of small-scale agriculture still set the boundaries of possibility.

> The world between the fifteenth and eighteenth centuries consisted of one vast peasantry, where between 80% and 90% of people lived from the land and from nothing else. The rhythm, quality and deficiency of harvests ordered all material life.[1]

In the shadows of such conventions, however, crisis and change had already left their mark. Starting in the eleventh century, after centuries of dormancy following the fall of the Roman Empire, towns and cities were revived in Europe, marking "the beginning of the continent's rise to eminence."[2] This moment was marked by the beginning of the Christian Crusades against the Muslim world, commencing in 1096. Though ostensibly aimed at returning the Holy Lands to papal dominion, these military adventures carried goods from the East into European marketplaces, expanding the horizons of material life and desire. In this context, merchants and artisans built businesses producing and selling necessary and exotic goods to large landowners and to a small number of peasants who, beyond producing for themselves and paying trib-

utes to the landlord, were capable of generating a surplus. Exchanging merchandise for food, the dynamism of town life began to challenge the primacy of agriculture.

By the fifteenth century, the discovery of a "New World" in Africa, Asia, and the Americas, and of its desirable resources—gold, silver, precious gems,

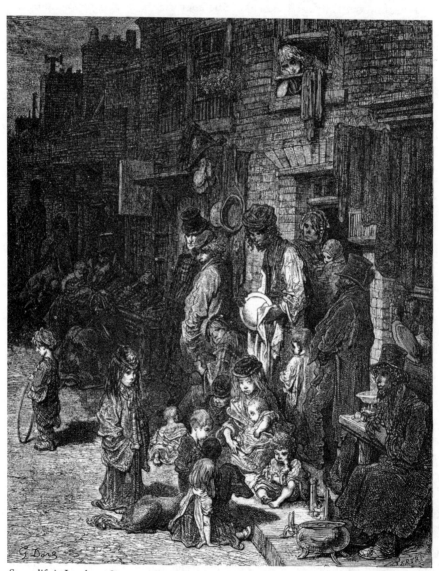

Street life in London, 1872. REPRINTED FROM GUSTAVE DORE'S *LONDON, A PILGRIMAGE* (1872)

silk, sugar, coffee, tea, spices, and tobacco—provoked the expansion of a commercial trade in luxury goods, feeding the insatiable appetites of a European aristocracy. With the growth of this trade, the merchant class, whose wealth was built on such exchanges, followed the social lead of aristocrats and emerged as a prime consumer of luxury items.3 To lubricate this expanding system of trade, money—of little significance in a localized agrarian economy—entered the lives of more and more people. The "Spirit of Capitalism," as Max Weber would call it, was taking hold.

Even in the countryside, this change could be seen. In Western Europe, by the fifteenth century, the traditional definition of agriculture was being destroyed. Driven by the force of a growing exchange economy, land that had been historically used to produce crops for local consumption was now being converted into pasture land. In these green pastures, sheep and cattle grazed, the sheep furnishing wool, the raw material of a nascent textile industry, the cattle supplying meat and a growing variety of dairy products. Instead of producing crops for local consumption, the owners of large estates and a growing number of small proprietors—yeoman farmers—were focusing their energies on the market.4

By the sixteenth century, sheep farming in England—also in Spain—led to "enclosure" movements, turning previously accessible common lands into fenced-in property. For peasants and others among the rural poor, these lands were vital lifelines for survival, supplying wood for housing and fuel and game for food. With the enclosures, and with deforestations to create pasture lands, many common folk were dispossessed of their rural roots, forced to seek a subsistence in swelling towns and cities. In France, as well, urban populations soared. The figures, in this regard, are eloquent.

Paris, at the beginning of the eleventh century, was a town of only 20,000 souls. By the beginning of the fifteenth, there were 275,000 Parisians. By the end of the seventeenth century, that number had nearly doubled. By the French Revolution, there were 600,000 inhabitants in Paris, and by the mid nineteenth century, 1,325,000.

The growth of London, Europe's other great mercantile hub, offers comparable evidence. At the start of the eleventh century, London's population was 25,000. Slower to grow than Paris, at least initially, London's population was still only 45,000 at the beginning of the fifteenth century. Enclosure, and the driving of peasants from the land, changed all that. By 1605, there were 224,000 people in London. By 1700, there were 550,000. At the end of the eighteenth century, London counted 861,000 inhabitants. By the mid nineteenth century, with England the ultimate world power, London was a metropolis of more than 2,300,000 people.5

A world of familiars was turning into a relic. People whose ancestors had spent generations anchored to specific locales were now on the move, traversing geography and, along the way, entering a new way of life. British historian Christopher Hill's description of seventeenth-century England reveals a land overflowing with migrating masses.

> Beneath the surface stability of rural England . . . was the seething mobility of forest squatters, itinerant craftsmen and building laborers, unemployed men and women seeking work, strolling players, minstrels and jugglers, peddlers and quack doctors, gypsies, vagabonds, tramps: congregated especially in London and the big cities.6

With this, cities were becoming a crazy quilt of strangers, people whose foreignness from each other was one of their most distinguishing characteristics. As they moved into cities, migrants from particular regions often practiced the same trade, creating a powerful and discernible link between particular ethnic identities and an increasingly complex division of labor that characterized urban life. A portrayal of Paris, written in 1788, offers a look at the ways that new arrivals from the provinces were turning the city into a landscape of observable difference.

> The people known as common laborers are almost all foreigners [a reference to people coming from different regions of France]. The Savoyards are decorators, floor polishers and sawyers: the Auvergnats . . . almost all water-carriers; the natives of Limousin are masons; the Lyonnaise are generally porters and chair-carriers; the Normans, stone cutters, pavers and pedlars, menders of crockery, rabbit-skin merchants; the Gascons, wigmakers or carabins [barbers' assistants]; the Lorrainers, travelling shoemakers or cobblers.7

With difference, and the social inequalities that marked urban poverty, came antagonism and prejudice. In London, as in other cities, a volatile mix of cultures bred "hostility to foreigners, or a militant type of chauvinism," asserts historian George Rudé. "'Foreigners' in this sense would include Scots and Irish as well as Frenchmen, Spaniards, Jews, and Roman Catholics."8

Colonialism, as well, was beginning to shape the complexion of urban populations. By the late eighteenth century, fifteen to twenty thousand people of

African descent were living in England, mostly in black enclaves in London. Contemporary engravings often present Africans as a representative element of the lower classes in that city. In the decades approaching the Revolution, the number of blacks living in Paris was between one and five thousand, an estimate based on the 765 extended families (*gens de couleur*) accounted for in police records.[9]

Interactions among strangers, however, were hardly limited to the cities of Western Europe. Developments that began in the West soon reverberated far beyond. One consequence resulted directly from the shift in land usage from arable crop production to pasturage. While the raising of sheep and cattle had provided a powerful stimulus for the development of a textile industry and was turning England and France into celebrated purveyors of meat and cheese, the impact on both countries' ability to feed their populations was disastrous. Raising herds was great for business but very inefficient as a way of generating enough calories for people to live on.[10] Amid an impending crisis, Western Europe began looking elsewhere for food.

In its quest for grain, an essential staple, the ascending mercantile states of the West looked to Eastern Europe. There, serfs—still bound to the land by ancient feudal custom—began raising crops not only for local consumption but also for

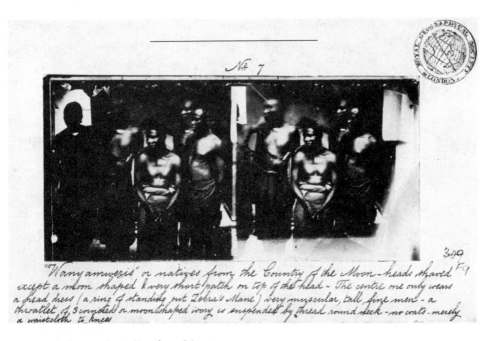

A slave auction in Zanzibar, 1862. FROM THE COLLECTION OF THE ROYAL GEOGRAPHIC SOCIETY

an emerging "capitalist world-economy."[11] Concurrently, relations between Western Europe and other parts of the world became entwined as never before. European colonies in the Americas, particularly in the Caribbean, became a pivotal element within a new world economic order. While many resources were mined or cultivated in the New World, sugar played a Promethean role in expansion of Europe's global dominance.

Alongside grain, sugar became a keystone in the European diet. Mobile masses needed to be fed cheaply, and sugar provided the answer, an efficient source of calories, a powerful stimulant, and a product whose seductive powers are evident to any young child. Once an unattainable luxury, used by aristocrats as a sign of their conspicuous ability to consume, cane sugar produced in Jamaica and other plantation-based colonies became a prodigiously profitable cash crop, the Golden Goose—wrote Eric Williams, former Prime Minister of Trinidad—upon which English capitalism would be built.[12]

As enclosure had required the migration of multitudes from the Western European countryside, the plantation system in the Caribbean and in North and South America was also constructed on the involuntary movements of people. The conquest of indigenous populations in these regions did not yield a productive or cooperative labor force and, in certain of the new colonies, the original inhabitants were entirely eradicated. The densely populated western coast of Africa soon became the source for a much needed labor supply. Beginning in the sixteenth century, millions of souls were drawn into an expanding web of empire, transported across the ocean, and bound into the modern system of plantation slavery to make money for European merchants and to feed a population that could no longer adequately feed itself.

Africans coerced into chattel slavery were not the only people that arrived in these new colonial outposts. Obviously, European landowners and colonial administrators were also there. In addition to these people, the surplus of Europe's rapidly growing population was dispensed into colonial regions as indentured servants, tenant and small independent farmers, skilled laborers, and entrepreneurial businessmen. As in the cities of Europe, this population explosion in the New World provoked unprecedented interactions among strangers from different places and different social experiences. On a global and local level, tangled connections between converging peoples and places were becoming part of the human routine.

If this new economic order was defined by an increasingly integrated world, it was a world in which "unequal development," to use Immanuel Wallerstein's term, was axiomatic. For Western Europe to triumph as a global center of com-

merce and industry, it was necessary for other regions of the world to be main-
tained in a subservient position, their economies stunted to serve the needs of 17
others. Even within Europe, for certain sectors to emerge as masters of the uni-
verse, it was necessary that others live in varying states of immiseration. For
"progress" to come into being, it was also seen as necessary for certain indigenous
populations to be subjugated or extinguished. Others were systematically dislo-
cated, enlisted into slavery, governed by the lash.

In the process, those Europeans who exercised social, economic, and military
dominance began to elaborate a language, an intricate system of human stereo-
types, in a practice predating Didot's coinage, that elevated and defended their
own position in relation to the strangers they now ruled. Along the way, similar
practices emerged to deal with the "foreigners" in their midst, those rural itin-
erants who had been forced into cities, as laborers and as paupers. In each case,
the ability to use words, images, scientific and religious theories to envelop the
conquered or the dispossessed in a cloak of moral, intellectual, and physical infe-
riority helped to make violent contacts and inveterate inequality justifiable. The
capacity to generate invidious comparisons was an indispensable privilege for
self-proclaimed civilizers whose practices might otherwise seem barbaric.

3
CREATED EQUAL

Throughout most of recorded history, lives have been lived within contexts shaped by entrenched social inequality. Divisions between rulers and the ruled, between haves and have-nots, between those who claim privilege as a God-given right and those for whom suffering is their inescapable lot permeate the archives of human events.

In Europe, during the period that witnessed the growth of towns and cities and the flowering of mercantile trade, the strict aristocratic and ecclesiastical hierarchy that had dominated feudalism for centuries continued to demarcate the boundaries of social and political power. Rights were still divine and exercised exclusively by a landowning nobility and by princes of the Roman Catholic Church. Common folk were expected to accept, without question, their inferior rank in a Great Chain of Being.

The Bible was the Word of God, the universal law, but its interpretation was kept in the hands of those privileged few who were sanctioned to read it. Biblical interpretation tended to uphold the immense social and political landholding power of the nobility and the Church. There was a vast chasm between the material abundance of the Church and aristocracy and the scarcity experienced by the peasantry, and this system was represented as the immutable order of things. According to the prevailing clerical reading of the Bible, social inequality was the way of God. Although feudal power was often held and defended by the sword, it was justified by the Word. The monopoly over the Word, over literacy, and over the ability to interpret what was read, was a fundamental aspect of rule.

In the feudal order, the ruling elite preached social order as the will of God. In deference and submission, they taught, lay salvation. Insubordination and sin paved the way to hell. This doctrine was upheld by a strict rule that forbade the translation of the Latin Bible into any language spoken and understood by ordinary people. This ban on "vernacular" literature was supported by severe sanctions. Those heretics who attempted to make the Word of God accessible to common people often suffered the punishment of death.

Town life, however, was not fully conducive to such restrictions. The growth of trade was invigorating sectors of society that, under the old order, had had little voice. An up-and-coming merchant class, gaining in wealth and economic influence, was stifled by the fossilized faiths of the feudal system. At the same time, the rural dispossessed became

increasingly hostile to landowners and the clergy and started to envision new creeds, new ways of life unfettered by their so-called superiors. These cosmic shifts in social temperament, which accelerated from the fifteenth century onward, signaled the inception of democratic imaginations.

As much as any other development, the development of movable-type printing in the mid fifteenth century gave wings to these newly rebellious ways of seeing. While the rudiments of printing technology dated back to the tenth century in China, the flowering of a mechanism for producing multiple, identical copies of printed texts took place in Germany, where a number of craftsmen were seeking to create such a device. In the 1440s, Johann Gutenberg, son of an eminent family of gold-coin makers, succeeded in developing a technique that gave birth to modern printing, and by the 1450s he had produced the first printed Latin Bibles, some on vellum, others on paper. While Gutenberg's objective was to supply Bibles to the Catholic clergy, his invention helped to set into motion events that would, very quickly, undermine the historic hegemony enjoyed by the Pope and the Catholic hierarchy.[1]

The printing press, an archetypal mass-production machine, could spread words, ideas, and information as never before. For people engaged in the new world of trade, it was an indispensable tool, providing the connective tissue of an ever-expanding market. As mercantile activities reached across continents and oceans, print generated standardized forms of information essential to the pursuit of business: contracts, patents, laws, measurements, and above all, notes of exchange. Simultaneously, for secular scholars and an increasingly literate middle-class public, the press enabled the interchange of ideas, scientific inquiry, philosophy, and social thought and popularized a belief in the power of these ideas to refute the traditional mysteries of Church doctrine. For these enterprising beneficiaries of economic development, the printing press was a defining symbol of their identity.

With the rise of print, more and more people became both readers and writers. Printed matter, written in commonly understood tongues, began to thrive. Already by 1500, in Europe, there were 20 million books in circulation and 1,100 print shops in 200 cities. Over the next two centuries, the availability of printed matter grew exponentially.[2] Beyond the practical authority of printed scientific facts and commercial information, beyond the secularization of knowledge, print emerged as a powerful weapon in the social struggle against feudal authority, a revolutionary instrument for promoting democratic ideals in the name of the people. In Western Europe and in the colonies, by

the seventeenth and eighteenth centuries, human rights and social equality were becoming watchwords of a modern epoch in formation.

The English Civil War of the 1640s, the American Revolution beginning in 1776, the French Revolution of 1789, and the Haitian Revolution of 1791-1804 were all galvanized by the explosion of democratic ideas. Bringing together the antimonarchist sentiments of merchants, artisans, independent farmers, unskilled laborers, and—in the case of Haiti—slaves, these revolutions were animated by a political rhetoric that threw customary notions of human inequality into question and affirmed the principle that the purpose of government is to protect the rights of the people.

> WE hold these Truths to be self-evident, that all Men are created equal, that they are endowed by their Creator with certain unalienable Rights, that among these are Life, Liberty and the Pursuit of Happiness.—That to secure these Rights, Governments are instituted among Men, deriving their just Powers from Consent of the Governed, that whenever any Form of Government becomes destructive of these Ends, it is the Right of People to alter or to abolish it.

Though penned by Thomas Jefferson, a Southern plantation owner, and interpreted primarily to serve the interests of free white men, such incendiary words hammered away at the edifice of inequality upon which traditional systems of power and politics had been built. When written, the Declaration did not universally apply its concepts of "Liberty" and "Equality." Invocations of the "People" did not include vast segments of humanity. Within the democratic revolutions of the seventeenth and eighteenth centuries, groups of people came together whose interests were often antagonistic. Though common folk actively participated in the overthrow of kings, many of those who spoke on behalf of "The Rights of Man" were oligarchs of the new world system, merchants, slave owners, and those who profited from the traffic in human chattels. Liberty, in their minds, was reserved for men of property, not for women, common laborers, or slaves.

This privileged interpretation of equality is painfully evident in Jefferson's notorious Notes on Virginia (1782), where the hallowed champion of democracy ruminated on the inherent deficiencies of "the blacks."

> I advance it, therefore, as a suspicion only, that the blacks, whether originally a distinct race, or made distinct by time and circumstances, are inferior to the whites in the endowments both of body and mind.

This "natural" difference, he ventured, meant that those of African descent were, most probably, unfit for the responsibilities of democracy. "This unfortunate difference of color, and perhaps of faculty, is a powerful obstacle to the emancipation of these people."

Though the sire of five mixed-race children with his late wife's half-sister, a slave named Sally Hemings, Jefferson virulently argued against the emancipation of blacks, warning that free blacks might pollute their former master's lineage. While Jefferson freed some of Sally Heming's children—among the few slaves he freed—either before his death or in his will, his fear of universal emancipation was both flagrant and sexually charged.

> Among the Romans emancipation required but one effort. The slave, when made free, might mix with, without staining the blood of his master. But with us a second is necessary, unknown to history. When freed, he is to be removed beyond the reach of mixture.[3]

In spite of Jefferson's attitudes, The Declaration of Independence was a time bomb. In the decades and centuries following 1776, these democratic faiths would be employed, again and again, in the name of those who remained socially, politically, and economically disenfranchised. Liberty and Equality would become the common property of antislavery and women's rights activists. They would be militant rallying cries in the struggle to organize labor. They forged the demands of the civil rights movement and fueled the aspirations of many twentieth-century anticolonial revolts. If, at first, these principles were intended for a narrowly conceived citizenry, they aroused utopian longings that reached far beyond.

In the late eighteenth century, however, democratic principles were part and parcel of a world in which new systems of inequality, functioning on a global level, were becoming increasingly virulent. To a large extent, the rise of modern stereotyping, the detailed elaboration of ostensibly scientific taxonomies of human difference, was a direct response to the inherent contradictions of a democratic age.

4
VISUAL TRUTH

It is, perhaps, not surprising that the categorizing of human types became an increasingly common activity within this modern cultural setting. Explorations had brought Europeans in touch with a diversity of peoples from around the world. Cities were amalgams of migrants coming from different regions, different experiences, and occupying different social classes. Within the budding taxonomical enterprise, Western eyes sought to make sense of this new situation in their own terms. Matters of human difference, real and imagined, began to wend their way into scientific lore. The facticity of images, an unfailing belief in the veracity of visible evidence, helped to make this possible.

In the contemporary world, we tend to think of art and science as occupying fundamentally different realms. Science is routinely portrayed as a dispassionate field of study, dedicated to uncovering the objective laws that govern the natural world. It uses a method that starts with educated guesses, testing these through experimentation, observation, and, then, arriving at findings; conventional wisdom teaches that the scientist is capable of ascertaining verifiable truths.

The artist, on the other hand, is often typecast as a passionate advocate of personal vision. In his or her creative works, the artist is understood to express a unique—often sublime—sensibility, a subjective way of seeing that derives from a particular outlook, sometimes pleasing, sometimes playful, sometimes shocking. Arranging materials and aesthetic elements, the artist is celebrated for portraying a world that transcends the limits and laws of detached observation.

This strict division between art and science, the demarcation separating aesthetic from objective truths, however, is a relatively recent development. In Europe, from the thirteenth century well into the nineteenth, art and science—particularly as they evolved as arenas of secular activity—often shared similar objectives, concerns, and assumptions. Drifting away from the spiritual preoccupations that consumed feudal dogma, both science and art became more and more fascinated with recording and comprehending the tangible characteristics of the physical world. With this gradual shift in focus, the material environment, in all of its detail, became an essential source of knowledge and inspiration.

In the feudal system, artistic creativity and scientific exploration, as we understand them, were prohibited. Knowledge of all kinds was strictly managed, and the ways of the universe were shrouded in a carefully constructed veil of mystery. Within these boundaries, the production of images tended to be controlled much like written words. Between the seventh and eleventh centuries, monasteries were the primary cultural centers of Europe, in large part governing the making and interpretation of images. In a world where creative labor was dedicated to maintaining the landed wealth of Church and nobility, countless artisans and skilled craftsmen worked anonymously under the rule of ecclesiastical power. Art, like the word, tended to uphold a sense of hierarchy as the absolute and eternal order of things.

In the iconographic portrayal of the cosmos, the style of depiction was strictly allegorical, infused with sanctity, and made no attempt to imitate the visual world as individuals would actually see it. Within these works, biblical figures and holy events occupied tableaus that stood apart, distant from the physics of common perception. Whatever truth was claimed by these pictures, it existed on a separate plane from the perspective of individual viewers. If anything, the importance of optical experience as a way of knowing was contradicted by the image. Its detachment from the mundane, in fact, was the essence of its power.[1]

With the rise of commercial centers, however, all of this worldview began to change. Merchants, artists, artisans, and scholars, loosened from the inflexible scrutiny of monastic control, began to articulate a more autonomous and worldly outlook. With the growth of trade, ideas began to travel along with goods. In many of the towns of Europe, a secular intelligentsia—armed with new scientific and technological discoveries—was beginning to shred the veil of mystery, replacing it with a belief in an observable and knowable world.

A key component in this newfound materialism was a mounting belief in the human eye as an instrument of inquiry, a powerful tool for gathering scientific knowledge. This credo, which took flight in Europe in the late thirteenth century, was significantly informed by the optical studies of a tenth-century Arab scholar known as Alhazen (Abu Ali al-Hasan Ibin al-Haytham, 965-1038). Alhazen, whose work was translated into Latin in 1270 as *Opticae thesaurus*, offered a battery of insights into the nature of vision, exploring the refraction of light, the sense of depth produced by binocular vision, and the ways that lenses and mirrors could enhance or alter visual perception. Most significant among Alhazen's discoveries was his explanation of vision itself, his argument that what people see flows from light that is reflected off external objects, traveling toward the viewer and into the eye. Implicit within this formulation was

the notion that seeing was an actual imprint of an objective world, that there was an inviolate relationship between human sight and truth.[2]

Against ecclesiastical doctrine, which maintained the innate fallibility of human cognition, such ideas set off an explosion of heretical thought and experimentation. In England, for example, Roger Bacon, a Franciscan scholar, built upon Alhazen's studies. Dissenting from the vow of the crusades, Bacon looked to Islamic science, not the Roman Church, for enlightenment knowledge. "All of my knowledge," he wrote, "has come to me from the Sages of the East."[3]

Following his penchant for observing nature in search of truth, he wrote treatises on optics and experimented with lenses to enhance and magnify the powers of the eye. With wonder, he wrote, "from an incredible distance we may read the smallest letters . . . the Sun, Moon, and stars may be made to descend hither in appearance."[4] In the face of such developments in secular philosophy and natural science, the Church reasserted "God's absolute power" (*potentia Dei absoluta*) with force, and Bacon was but one of a legion of thinkers who were imprisoned and/or excommunicated for their scholarly investigations. Nonetheless, an obsession with the gathering of visible evidence persisted, as did its suppression, on through Kepler and Galileo.

Parallel to this evolution, the visual arts were undergoing a corresponding revolution. Artistic works, mirroring the fixation of science, also sought to duplicate a sense of the real as gauged by the standard of the human eye. Though religious themes endured in painting, a number of developments signaled a growing trend toward worldliness. By the thirteenth and fourteenth centuries, for example, religious block prints and painted miniatures began to circulate in local markets. Once found, almost exclusively, on the walls of churches and other religious venues, art was becoming a piece of personal property, an acquisition to be bought, sold, and exchanged among individuals able to afford it. Though still dealing with sacred matters, the context of art was in the process of being secularized. So, too, was its point of view.

Al Hazen (Abu Ali al-Hasan ibn al-Haytham).
ANDY EWEN, 2006

26

By the mid fifteenth century, coinciding with the birth of movable-type printing, painters increasingly depicted settings in which depth and distance were definitive visual elements. Within this new style of painting, usually associated with the Renaissance, the eyes of an individual viewer became the central vantage point from which all representations of the world followed. In each picture, the unseen viewer was an active participant.

Roger Bacon. ARCHIE BISHOP, 2006

In the allegorical art of the Middle Ages, the size of figures within an image certified their importance within the cosmos, their place within an overarching hierarchy. Christ or the Madonna defied the terms of naturalism, dwarfing lesser figures: the saints, members of the clergy, the nobility. With the introduction of linear perspective in painting, a geometric exercise used to convey the illusion of depth on a flat surface, size now became an index of distance. Large figures were those standing closest to an imagined viewer. Smaller figures and objects were further away. At the horizon, a vanishing point stood for the outer limits of human sight. Adding to this materialist outlook, it became increasingly common for religious characters to be pictured wearing the fashions of the day, garments akin to those worn by the people who purchased the artwork.

This move toward a visual vernacular, which simulated the phenomenon of human sight, was very much in synch with the trajectory of science. Both were predicated on the veracity of optical data, and within this premodern social milieu, the arenas of art and science often converged. Technologies crossed boundaries much like sensibilities.

The camera obscura is a case in point. In pursuing his optical studies, Alhazen stood within a dark chamber with a small hole piercing one of its walls.[5] Within this unlit room, apparitions of the outside world were projected through the pinhole onto the opposing wall. This technical facsimile of the human eye provided Alhazen with a working model for studying the mechanics of sight.

With the flourishing of natural sciences in Europe, especially astronomy, the camera obscura became a widely used scientific tool. By the middle of the fifteenth century, it had emerged as a basic device for observing eclipses and other solar events. Soon, artists came to appreciate this new visual technology. In his notebooks, Leonardo da Vinci included an extensive treatise on linear perspective, visual geometry, and optics, and in it described an experiment by which he was able to view images from behind a translucent paper screen mounted in a dark chamber.

> [I]mages of illuminated objects penetrate into a very dark chamber by some small round hole. Then you will receive these images on a white paper placed within this dark room rather near to the hole, and you will see all the objects on the paper in their proper forms and colours, but much smaller; and they will be upside down. . . . These images, being transmitted from a place illuminated by the sun, will seem as if actually painted on this paper, which must be extremely thin and looked at from behind.[6]

With the introduction of lenses in the mid sixteenth century to replace the pinhole, the brightness and clarity of camera-obscura images improved significantly, augmenting its utility as an artistic and scientific tool. For the first time, argues the historian Philip Steadman, "it became a real practical proposition to use the apparatus for making drawings from life."[7] Moving beyond the mathematics of linear perspective, optically projected images offered a panoply of visual detail: the folds in patterned cloth, reflections off of rounded objects, the sensual complexities of vision.

Imaginary camera obscura. ANDY EWEN AND ARCHIE BISHOP, 2006

In 1558, Giambattista (also known as Giovanni Battista) della Porta published a multi-volume book entitled *Magia Naturalis* (Natural Magic). Della Porta was the founder of the Academy of Secrets (Academia dei Segreti) in Naples, which applied techniques learned from magic to influence the natural environment. Though the Academy of Secrets was silenced by the Inquisition, della Porta's *Natural Magic* remained extremely popular. Widely read and translated from Latin into a number of vernacular languages, in his book della Porta described an optically enhanced camera obscura that was capable of capturing detailed images of street life. If projections in early camera obscuras tended to be faint and imperfect, those fitted with a correctly ground convex lens offered pictures of people that were remarkable in their clarity. The body and face, the particulars of the countenance, were revealed for close study as never before: "If you put a small lenticular Crystal glass to the hole, you shall presently see all things clearer, the countenances of men walking, the colours, Garments, and all things as if you stood hard by."[8]

To della Porta, the camera obscura was not simply a tool for observation. If one carefully traced its projections, the device could also be used for producing pictures that were extraordinarily accurate, precise according to the prevailing standards of science.

Shortly, the camera obscura worked its way into manuals on art and architecture, instruction books that explained the practical science of drawing to artists and draftsman. One of these, written by the Venetian Daniele Barbaro in 1568, offered an eloquent exposition of how tracings on paper made with a camera obscura created a linear perspective that was true to life.

> Here you will see the forms on the paper as they are in reality, and the gradations, colours, shadows, movements, clouds, the ripples of water, the flight of birds, and everything else that can be seen. . . . Seeing, therefore, the outline of things on the paper, you can draw with a pencil all the perspective that appears there, and then shade and color it as nature displays it to you.[9]

By the seventeenth century, artists and scientists alike were regularly employing camera obscuras to create images that were, at once, aesthetically, mathematically, and perceptually realistic. Johannes Kepler, a reader of della Porta, added a multielement lens to the mechanism and made it portable.[10] Using his camera, this father of modern astronomy was able to produce, in his spare time, landscapes of high quality.[11]

The Dutch master Johannes Vermeer also used a camera obscura to create paintings that are admired for their beauty and their ability to capture the evanes- cent moments of human experience. Again, underwriting the close association between art and science, Philip Steadman has suggested that Vermeer's "optical consultant" was none other than his neighbor, Antoni van Leeuwenhoek, whose development of the microscope distinguished him as a major figure of seventeenth-century science.[12]

The capacity to produce apparently exact replicas of the physical world and to assemble archives of visual information, documenting all aspects of nature and social life, accelerated in the late seventeenth century and became a mania in the eighteenth. It became an idée fixe of Western art and science, a zealously pursued practice that helped to define the Enlightenment. During this time, scientific illustration flourished, encyclopedias were produced, and elaborate taxonomies, classifying and depicting all forms of life according to physical similarity or difference, emerged as emblematic artifacts of an Age of Reason.

5
CURIOSITY CABINETS

It is commonly, if erroneously, argued that "sensationalism" was a by-product of the late nineteenth century, when urban newspapers—in an attempt to amass vast reader-ships amid circulation wars—abandoned serious reporting and began appealing to the crude tastes of the masses. In 1910, E. A. Ross, a prominent American sociologist, lamented that sensationalism was an inevitable outcome of "giving the people what they want," an argument that continues to be made as an explanation or defense of the com-mercial media system. Packaging news for the "errand-boy and factory girl and raw immigrant," Ross wrote, required newspapers to forsake journalistic integrity and pro-duce something that was "spicy, amusing, emotional and chromatic."[1] Yet sensational-ism did not begin with "yellow journalism," and its devotees often included the most elite elements of society. The history of the "curiosity cabinet" is a case in point.

Some say that the practice began in the Middle Ages, when the medieval Church assembled relics of the saints, artifacts associated with Jesus and the Madonna, also ves-tiges of Hebrew forebears, to provide believers with tangible evidence, firsthand access to stories from the Old and New Testament. The Crusades, military incursions into the Holy Land, had brought a trove of sacrosanct souvenirs into Europe and people viewed them with a fervent sense of awe. In sealed cases, some ornately crafted, a panoply of sacred remnants could be found, including such items as "a drop of the Vir-gin's milk, a pot that figured at the miracle at Cana, a scrap of a martyr's shroud, nails or a fragment of wood from the true cross, a cameo with a portrait of the Queen of Sheba, a crystal goblet from King Solomon's temple, the girdle of St. Peter and the combs of Mary Magdalene."[2] Apostolic body parts were also on parade. "The arm of the Apostle James" and "part of the skeleton of John the Baptist" were among the human remains that offered believers a firsthand glimpse of biblical figures who previously had existed only in stories and paintings.

Alongside these religious objects, one might also find legendary and natural won-ders, also "brought back from distant lands by pilgrims and crusaders." Among these, "'wonderstones,' griffin's eggs, tortoise shells, unicorn's horns, antediluvian giants' bones and teeth," captured the imagination of European popular culture.[3]

As might be expected, most of these exhibits were installed in churches, part of a sacred environment designed to enhance both the spiritual and sensual experience of worship.

31

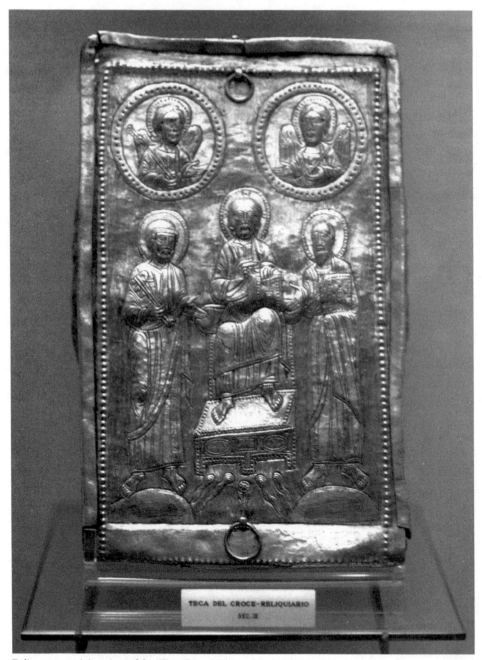

Reliquary containing piece of the "True Cross," Vatican Museum. PHOTO BY ARCHIE BISHOP, 2004

Devout Catholics also believed that these relics contained miraculous healing powers, both physical and spiritual, making their allure all the more powerful. To view these marvelous relics, parishioners were expected to make a special offering. Portable reliquaries, carried by itinerant monks, were also displayed to the curious in exchange for a modest donation. After touching a holy object, pilgrims could purchase commemorative metal badges that provided tangible proof of the experience.

Before the fourteenth century, relics were fairly accessible to people throughout Europe, and believers who had a chance to touch these relics believed that their curative powers would enter the body and work therapeutic magic. By the mid fourteenth century, however, firsthand access to reliquaries was becoming increasingly difficult. Pilgrimages were becoming mass events, at which thousands of believers thronged to view holy relics. Few could get close. Almost no one could touch them. By the fifteenth century, these events had grown to such a point that cathedrals were no longer able to handle the crowds and outdoor spectacles, performed from a stage, became more and more common.

In Aachen, Germany, for example, an every-seven-years pilgrimage to view "the swaddling clothes of the Christ-child, the loin cloth of the crucified Christ, the Virgin's robe and the cloth that held John the Baptist's severed head," drew an astounding number of people attending. At the 1432 pilgrimage, ten thousand people a day gathered over a period of two weeks to get a glimpse of the holy relics that were held up upon a wooden platform. For most people in the crowd, the healing magic of these items seemed too far away to have any effect. Whatever powers these relics emanated seemed to dissipate in the air.

Within such a context, where immediate access to the power of relics was no longer feasible, it was the science of optics that provided—in many people's minds—a solution. "Word spread," writes the historian John Man, "that a convex mirror, by capturing a wide angle view, would absorb the healing radiance of the holy relics." Metal badges, which had long been sold as mementos of pilgrimages, now were stamped with convex mirrors at the center, so that people could hold them high above their heads and absorb the magic from distant displays of holy objects. Johann Gutenberg, who is primarily remembered for his invention of movable-type printing, began his entrepreneurial career with an ill-fated scheme to mass produce convex mirrored badges for the 1439 Aachen pilgrimage.4 In a world where it was widely assumed that optical devices could capture and preserve the visible truths of the material world, a central technology of objective science was beginning to frame even the rituals of religious

mysticism. In time, science would replace religion as the primary collector and purveyor of miraculous objects.

By the mid seventeenth century, the collection and display of relics had migrated from their religious roots and now presented specimens associated with scientific learning and the expansion of global trade. This secularization of wonder began, to some extent, during the Renaissance, when aristocrats began to assemble the first museums of natural history. In an age of scientific discovery and commercial expeditions, familiarity with natural history, and with the myriad curiosities of a newly discovered world, was beginning to be seen as a sign of status among cultural elites.[5]

The rise of scientific reliquaries—or curiosity cabinets, as they were commonly known—was spurred on by the Royal Society of London for Improving Natural Knowledge, an organization founded in 1660 and incorporated two years later. While established by London's intellectual elite—early presidents included Samuel Pepys and Sir Isaac Newton—by the early eighteenth century, the Royal Society had attracted the interest of wider, less exclusive membership. The historian Richard Altick notes that "the society's membership, and the mixed character of its widely distributed correspondence had proved that no heavy erudition was necessary to share in the pleasures of scientific demonstration and speculation—that it was an intellectual game any amateur of some education, wealth and leisure could play." One of the primary enthusiasms of these gentleman naturalists, something that dovetailed with their acquisitive tastes, was the building of often extensive cabinets filled with items that, ensemble, validated the breadth of their scientific and worldly gaze. Altick continues: "Making cabinets of rarities and performing

A contemporary curiosity cabinet. THE EWEN LIBRARY

experiments with newly devised apparatus became as much a sign of a cultivated Londoner as attending the playhouse or gathering with wits at one of the modish coffee houses."[6]

Curiosity cabinets contained a random mix of items attesting to their owner's wealth and enlightenment. Among items routinely collected were seashells, mineral specimens, insects, stuffed exotic birds, animal skeletons, coins from the ancient world, and leather-bound volumes.[7] Paul Farber, a historian of science, reports that these collections were intimately connected to the expansion of European colonization.

> Domination of markets, natives and nature all went hand in hand. The greater presence of Europeans worldwide and the potential commercial value of many natural products stimulated systematic collecting on a hitherto unimaginable scale, creating opportunities for naturalists to explore exotic regions.

A growing trade in collectibles became a prominent feature of aristocratic and upper-middle-class life. The more exotic the specimen, the greater the price. Of particular interest to collectors were "South American parrots, Australian cockatoos, African orchids, Pacific nautilus shells, and brilliantly colored butterflies from Southeast Asia."[8] So widespread was the appetite for putting together impressive collections and exhibiting them in an interesting way that manuals were published directing amateur collectors on the proper aesthetic arrangement of their cabinets. Included in these manuals were detailed suggestions on how to construct elaborate dioramas for the display of their acquisitions. One French handbook, written by A. J. Desallier d'Argenville in 1780, offered the following instructions:

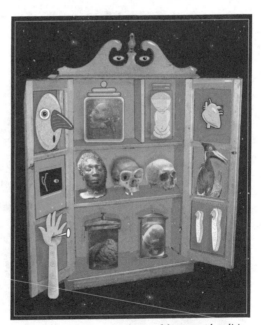

A cabinet of dreams and realities.
ANDY EWEN AND ARCHIE BISHOP, 2006

36

Those who have a considerable number of birds can display them in an enchanting manner by placing them on the branches of an artificial tree, which has been painted green and placed at the back of a grotto-like niche, with a small fountain, in which the water instead of from a spring comes from a pump or from a small lead cistern placed at roof level to receive rain water.9

Alongside animal, mineral, and plant exotica, collections also included bizarre arrays of human remains. At a time when the dissection of European bodies was widely seen as a sacrilege, except in the case of hanged murderers, where public dissection was meted out as postmortem punishment, the bones of non-European people were common items of display, either skulls or entire skeletons. Male and female brains and genitalia, preserved in jars of formaldehyde, were highly esteemed possessions, as were "abortives put up in pickle."10 These were the macabre spoils of imperial conquest, visible evidence of "human oddities" representing or, more likely, misrepresenting native peoples from around the world. If Enlightenment men took pride in their hunger for worldly knowledge, these gruesome specimens in their private museums revealed a dark side to their erudition, one rooted in the callous plunder of indigenous cultures that was an intrinsic part of Europe's rise to world dominance. Insofar as European examples were included in these cabinets, they came from despised and "degenerate" elements of the population: the brains of criminals, meticulously detailed casts of flayed bodies taken from the gallows, the skulls of suicides. (The Mütter Museum in Philadelphia still includes examples drawn from the nineteenth century.)

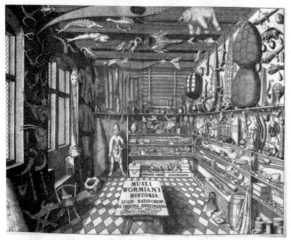

REPRINTED FROM *OLE WORM'S MUSEUM WORMIANUM [WORM'S MUSEUM, OR THE HISTORY OF VERY RARE THINGS, NATURAL AND ARTIFICIAL, DOMESTIC AND EXOTIC, WHICH ARE STORED IN THE AUTHOR'S HOUSE IN COPENHAGEN]*

To men of power, the promotion of global commerce went hand in hand with the acquisition of curiosity cabinets. Peter the Great of Russia, for example, journeyed to Holland in 1698 to gather knowledge about shipbuilding, commercial enterprise, and the promotion of industry. Twenty

years later, he returned to Holland to view private cabinets of natural history. There he encountered two appetizing collections that he immediately coveted. One was that of the Apothecary Seba, which included a vast variety of animal specimens and beautifully detailed scientific engravings. The second was the celebrated cabinet of the Dutch anatomist Frederick Ruysch. Beginning in the 1680s, Ruysch developed a secret technique for preserving lifelike human specimens in glass jars, his pieces culled from the bodies of criminals, vagrants, and stillborn infants. Applying a strong sense of aesthetics to his enterprise, Ruysch's curiosities were presented in elaborate tableaus. Stillborns were cradled in lace, and he even built small musical instruments out of preserved body parts. Purchasing Ruysch's enormous collection of two thousand specimens, along with the entire collection of the Apothecary Seba, Peter brought both collections to Russia where they became the cabinet of the Academy of Sciences in Petersburg, the Kunstkamera as it was known. Early in the morning, three times each week, Peter would visit his costly acquisitions, filled with the conceit that he was thus able to comprehend the ordering of nature.[11] Along with additional exhibits, the Kunstkamera (The Peter the Great Museum of Anthropology and Ethnography) still occupies its original building and is one of the most popular museums in this city of museums.

Peter also opened his cabinet to the Russian public, believing that its specimens would cure them of superstitious beliefs concerning nature and introduce them to the facts of modern European scientific knowledge. In creating the first large public natural history museum in Europe, according to the current director of the Kunstkamera, Dr. Yuri K. Chistov (whom we interviewed in St. Petersburg), Peter employed a curatorial strategy that was an ingenious fusion of science and entertainment.

While most of these collections were private, assembled for the enjoyment of their owners and a small orbit of wealthy acquaintances, a few others began to move into the public realm, eventually becoming the foundation for what would be large public institutions. In Don Saltero's coffee house in London, for example, items borrowed from the private cabinet of Sir Hans Sloane were displayed along the walls, creating the city's first public gallery of natural history wonders. While sipping their coffee and conversing, thousands of middle-class patrons, skilled craftsmen as well, got a glimpse of a world that existed beyond the boundaries of their everyday lives.[12]

Shortly, a more grandiose setting superseded the coffee house. The British Museum, established by an act of Parliament in 1753, began with the purchase of Sloane's Cabinet of Curiosities, only a small portion of which had been seen

by Don Saltero's customers. Sloane, a prominent English doctor and member of the Royal Society, had amassed a fortune in the slave trade.[13] From these brutal expeditions, and from purchases, he had built a collection of 79,575 objects, distinguished as the largest in England. It occupied nine enormous rooms in his manor house. The organization of his specimens was remarkably systematic, divided according to easily understood classifications, and was particularly suited for public display. Beginning with this bounty, the British Museum opened its doors in the palatial Montagu House—the former property of the Earl of Halifax—in 1759. It was, as specified by the act of incorporation, explicitly intended "not only for the inspection and entertainment of the learned and curious, but for the general use and benefit of the public." In an age that would soon give rise to democratic revolutions, the Board's fears that unruly lower-class visitors would overrun the museum meant that actual public access was initially made difficult. Over time, however, institutions such as the British Museum brought in increasingly broad audiences, and the expansion of natural history museums in the late eighteenth and nineteenth centuries offers an insight into the ways that the outlook of amateur private collectors, many engaged in colonial ventures, came to dominate narratives of natural history in the realm of popular culture.[14]

In France, the transformation of natural history into a public spectacle was a consequence of the French Revolution. In the decades leading up to the revolution, the Jardin du Roi, which opened as a botanical garden for the study of medicinal plants in 1635, was expanded to include the Cabinet du Roi, the natural history collection of the king. It was also a research center, a place where items gathered from French expeditions were housed, and where men of science delivered lectures outlining discoveries in anatomy, botany, and chemistry. When the French Revolution commenced in 1789, the properties of the king and other members of the aristocracy were seized. Among the revolutionaries there were advocates for the continuation of the research center's scientific mission, and in 1793 the Royal Garden, containing the Cabinet du Roi and other collections taken from the abandoned homes of aristocrats, was transformed into a public museum of natural history, the Muséum d'histoire naturelle. This collection, transfigured by the cauldron of democracy, made Paris an international hub for the public display and scientific study of natural history well into the nineteenth century.[15] In conjunction with this development, Paris also became a center for the study of comparative anatomy and for the dissection and display of bodies and body parts gathered from the lower classes and from around the globe.[16] Through its didactic exhibition of

human remains, the Muséum d'histoire naturelle emerged as one of the world's foremost institutions for transmitting ideas about the supposedly natural inequalities that differentiated people, the high from the low, according to social class and racial identification.

In the United States, by the late eighteenth century, curiosity cabinets also appeared, though they had a different pedigree from those of Europe. While European cabinets had begun as the private collections of elites, visible indications of their up-to-date scientific acumen, American collections were mostly entrepreneurial from the beginning, business enterprises combining high-minded claims of public enlightenment with the profitable and prurient display of sensational oddities. The celebrated portrait and landscape painter, Charles Wilson Peale, founded one of the first natural history museums in the United States. Peale's interest in collecting specimens from the natural world was simply an expression of the long-standing alliance between arts and sciences as unyielding allies in the quest to reveal and depict objective truths. Founded in 1786, the Philadelphia Peale Museum attracted large crowds to view exhibits that included albinos and other human curiosities, alongside spectacular animal specimens, one of the first prehistoric animal skeletons ever excavated, that of a huge mammoth unearthed in West Point, New York. While Peale is said to have been uneasy about the display of such startling items, they were the attractions that overshadowed endless cases of stuffed birds and lackluster artifacts.

A fascination with the strange, in large part, defined the American museum experience from the beginning. Given this attitude, it not surprising that the Peale Museum, which later opened branches in Baltimore and New York, along with the New American Museum, founded in New York in 1810 by the taxidermist John Scudder, were purchased by P. T. Barnum in the 1840s, providing the foundation for Barnum's American Museum.

In early American museums of natural history, many of the assembled items were similar to those found in Europe, but American museum shows also included living specimens, both animal and human. Reflecting the New World's wars against indigenous Indian populations and its economic reliance on the peculiar institution of slavery, many of the human exhibits, not surprisingly, were presented to demonstrate that Indians or Africans belonged to lower orders of humanity or to entirely different species from Europeans.[17]

Barnum took this interest in living oddities and totally blurred the distinction between natural science and popular entertainment. Attendance at Barnum's American Museum quickly surpassed that at the British Museum, attracting an estimated 41 million customers over its twenty-seven-year history. Key to its suc-

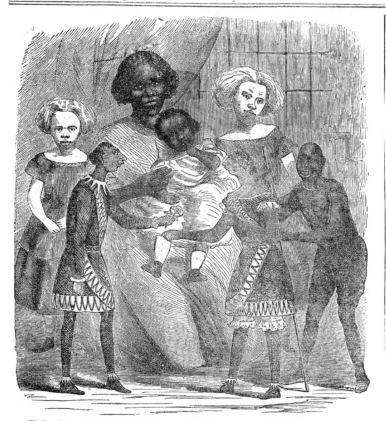

DECEMBER 15, 1860.] HARPER'S

Living Curiosities at Barnum's Museum.

Since Mr. P. T. BARNUM re-purchased the Museum last Spring, it has become more than ever a popular place of resort for Ladies, Children and Families, and the energies of this world-renowned "Prince of Showmen," seem to increase in a corresponding ratio with his patronage. Our artist has sketched the above from a host of other curiosities now on exhibition in the Museum at all hours, day and evening.

The two centre figures in the foreground of the above cut represent the celebrated AZTEC CHILDREN, found in one of the long lost cities of Central America. It will be observed that their cast of features, and very small heads, bear a striking resemblance to the sculpture found in those cities by Stephens and other travelers, which fact seems to indicate that the race of men to which they belong were the original type of these sculptures.

The figure on the right represents a creature, found in the wilds of Africa, and is supposed to be a mixture of the wild native African and the Orang Outang, a kind of Man-Monkey, but for want of a positive name is called "WHAT IS IT?" The two WHITE FIGURES represent two ALBINO GIRLS, and the black ones their black mother and sister. These Girls, though of black parentage, are a PURE WHITE, WITH WHITE WOOL AND PINK EYES, but with every other feature and characteristic of the real African. No one can look upon them without feeling the conviction that they are beyond all doubt WHITE NEGROES. All these extraordinary living wonders are on exhibition at

Barnum's American Museum,

in this city, where everything novel and curious is sure to be found. In addition to the above, the Museum presents a combination of wonders and curiosities, unequaled in any part of the world. The GRAND AQUARIA alone constitutes an attraction which well repays a visit. Here, in miniature Oceans, are to be found almost every variety of living Fish and other aquatic animals disporting in their native element, from a noble specimen of a living Seal, down to the tiny Stickleback, which builds its nest on the rocks and in the weeds. The HAPPY FAMILY, consists of beasts and birds of opposite natures, as Dogs, Cats, Rats, Hawks, Chickens, Pigeons, &c., &c., all living in peace and harmony, and the whole made amusing and interesting by a number of lively and playful Monkeys, which always keep spectators in capital humor by their inimitable sports. A monster den of mammoth Serpents, 30 in number, has just been added to the

850,000 Other Interesting Curiosities

contained in this wonderful Museum. How so much can be afforded for the low price of twenty-five cents admission is only explained by the fact that an average of nearly four thousand persons visit the Museum daily; on holidays the number of visitors frequently exceeds twenty thousand.

An advertisement for Barnum's American Museum. FROM THE COLLECTION OF THE LIBRARY OF CONGRESS

cess was the ability to spin fantastic yarns around its exhibits and its claim to offer American visitors an unprecedented view of "strange" beings from around the world. The indiscriminate mixing of ethnic oddities—"wild" American Indians, "The Last of the Ancient Aztecs of Mexico" (actually two microcephalic brothers from Central America), gypsies, a black mother with two albino children, and a mentally disabled African-American man displayed as a missing link named "What Is It?"—with traditional sideshow "Freaks of Nature" silently communicated the underlying argument that ethnicity, along with other marks of physical difference were appropriate subjects for either pity or derision.[18]

In Europe, by the early nineteenth century, the collection and display of living people from around the world was also becoming a popular feature in natural history museums. To some extent, as was the case with curiosity cabinets, the collecting of live human exhibits in Europe was rooted in the practices of the aristocracy, reaching back to early colonial times. From the end of the sixteenth century, it was not uncommon for wealthy families to "collect Africans as exotica, along with apes, camels, leopards and elephants." The possession of Africans by an aristocratic household was a conspicuous sign of affluence, as human collectibles were far more expensive than stuffed cockatoos. "Dukes paraded them as buglers and drummers in their militia, and noble families exchanged them as gifts, dressing them in gay uniforms to serve as butlers and maids, pages and coachmen."[19]

In the nineteenth century, displays of exotic people became a more and more frequent attraction in Europe's public museums and fairs. With this development, the meaning of these captives shifted. While aristocrats had used their human trophies as symbols of a sumptuous lifestyle, public exhibits were more often presented to popularize fashionable scientific arguments regarding the innate inferiority of the people being displayed. Once again, the flawed and biased logic of the curiosity cabinet was providing a base of "knowledge" upon which Europeans and Anglo-Americans would come to understand themselves in relation to the rest of the world.

Over the course of the nineteenth century, opportunities for Europeans and Americans to be "educated" by the skewed science of natural history grew exponentially. "By 1900," reports Paul Farber, "Germany had 150 natural history museums; Great Britain, 250; France, 300; and the United States, 250." Following the tentacles of empire, natural history museums also became fixtures in colonial cities. Established by Europeans as scientific justifications for their dominion, they could be found in Cape Town, Bombay, Calcutta, Montreal, Melbourne, Sao Paulo, and Buenos Aires.[20]

42

With the emergence of natural history as a popular fascination, a commerce in curios began to grow. Major cities of Europe and America contained shops dedicated to the sale of exotic items, brought from around the world by serious explorers, casual travelers, and enterprising sailors. For anyone to claim scientific expertise, it was only necessary to purchase a collection of curiosities, and for those who sought to explain and classify the varieties of humankind, the collection of bones and other human parts became an essential ingredient of their purported authority. As we shall see, those who spoke loudest about the contours of human inequality added weight to their arguments with extensive, well-publicized collections of human remains.

Alongside natural history, whose primary goal was to make distant worlds legible to urban audiences, corresponding sciences were taking hold that directed their gaze at human distinctions found within the urban environment itself. In the late eighteenth century, one of the most influential of these was the science of physiognomy.

PART II

TAXONOMIES OF HUMAN DIFFERENCE

PHYSIOGNOMY: THE SCIENCE OF FIRST IMPRESSIONS

Though often prejudicial, one of the enduring habits of street life is the quick once-over, a reflexive penchant for sizing up and drawing conclusions about unknown individuals who cross our path. The social make-up of the metropolis, its size and variety, almost requires us to make such unthinking mental judgements. So automatic are these instant evaluations of human appearances that it is hard to imagine that they might have provided the foundation for a systematic field of knowledge.

Yet, in 1775, a Protestant minister from Zürich, Johann Caspar Lavater (1741–1801), proclaimed the birth of a new method, amalgamating religion, science, and aesthetics, for evaluating human character on the basis of a detailed study of facial features. He called it physiognomy, borrowing the term from earlier explorations of human faces and their meanings.

JOHN CASPAR LAVATER.

Lavater. REPRINTED FROM JOHANN CASPER LAVATER'S *ESSAYS IN PHYSIOGNOMY*, VOLUME I, LONDON, 1810; FROM THE COLLECTION OF THE EWEN LIBRARY

Aristotle had written on the subject in *History of Animals and a Treatise on Physiognomy*.[1] Here, he drew correlations between the demeanors of people and animals, arguing that individuals who resemble a particular animal species tend to have a comparable disposition. Giambattista della Porta, whose work with the camera obscura made him acutely sensitive to facial and bodily detail, also wrote on human physiognomy in *De humana physiognomonia* (1586). Like Aristotle, della Porta grounded his analytical method on comparisons between men and "the lower animals."[2]

In the late eighteenth century, democratic notions were circulating throughout Europe and America. Responding to this threat, Lavater concocted an analytical system that reasserted human inequality as a God-given truth. This idea, reformulated in modern terms, was presented in a heavily illustrated multivolume tome called *Essays on Physiognomy*.[3] Following its initial publication, the work went through many editions and translations and established Lavater as one of the most celebrated

46

antidemocratic thinkers of his day. Among his admirers were the German writer Johann Wolfgang von Goethe, a close friend, and oddly, given his democratic leanings, William Blake, who provided illustrations for a subsequent edition in translation.

Zürich, Lavater's home, was a small city of 17,000 people, though it would soon become a major international financial center. Despite its size, Zürich was already a significant locus of learning and commerce, a cosmopolitan crossroads where people and ideas were in motion. As in other cities, encounters with strangers were an increasingly common aspect of life, and Lavater's physiognomic techniques offered a pragmatic approach for negotiating urban existence, for judging others at face value. His new science, such as it was, built on what he understood to be people's natural inclination to evaluate others on the basis of first impressions. "All men, in their intercourse with each other, form physiognomical decisions. . . . [M]ost men, in proportion as they have mingled with the world, derive some profit from their knowledge of mankind, even at first glance."4

DE HVM. PHYSIOGNOMONIA

Portrait of Della Porta on the cover of *De humana physiognomonia*, 1586.
COURTESY OF MARTAYAN LAN

Lavater's purpose was to refine this predilection, to improve the diagnostic power of such observations, to provide interpretive tools that would permit a trained physiognomist to evaluate "the correspondence between the external and internal man, the visible superficies and the invisible contents."5

As a minister in the first Swiss city to embrace the Protestant Reformation, Lavater revealed, through his work, the historical footprints of theological upheavals going back more than two hundred years. In the 1520s, under the spiritual leadership of Ulrich Zwingli, Zürich had become a staunch center of Reformation thought and action, outlawing the practice of the Catholic Mass in 1525, abolishing pilgrimages and processions, advocating marriage for clergymen, and closing monasteries.

By 1549, Zürich came under the influence of another Swiss theologian, John Calvin. Like Zwingli, Calvin abhorred the luxury and ostentation of Catholic ritual and posed, instead, a concept of religious devotion that was

built on the principle of pure, unadorned faith. Calvinism was founded on the doctrine of predestination, the conviction that—in the beginning of time—God decided who among humanity were "the elect," those chosen for salvation, and those who were not. There was no way that people could know, absolutely, if they were saved, and a life of faith was an anxious process of self-examination, a search for signs of favor in the eyes of God.

Yet, alongside faith, there was also a belief in the redemptive value of work and industry. Reflecting the social attitudes of its commercially engaged adherents, Calvinism began to construct an elaborate constellation of secular rules and regulations, behavioral prescriptions for moral discipline. While conduct, comportment, or physical appearance were not instruments by which salvation could be attained, Calvinists were expected to carry themselves in a way that suggested godliness. As Zürich flourished as a commercial center, these behavioral prescriptions became increasingly paramount. By the late eighteenth century, among many Calvinists, upright behavior in business and civic affairs, accentuated by a corresponding physical demeanor, had replaced apprehensive self-examination as the yardstick of piety.

Lavater's new physiognomic science was predicated on this evolution, on the growing prominence of worldly appearances as tangible indices of virtue. He justified this link with the story of Genesis, in which God created man in His own image. Yet, with the Fall from Grace and the expulsion from Eden, Lavater contended, only those who maintained a faith in God continued to exhibit the visual perfection of his likeness. Others, mired in sin and deceit, exhibited the signs of their degeneracy.

47

Pervert: "An image of the most brutal sensuality." REPRINTED FROM JOHANN CASPER LAVATER'S *ESSAYS IN PHYSIOGNOMY*, VOLUME I, LONDON, 1810; FROM THE COLLECTION OF THE EWEN LIBRARY

Miser: "The most sordid avarice." REPRINTED FROM JOHANN CASPER LAVATER'S *ESSAYS IN PHYSIOGNOMY*, VOLUME I, LONDON, 1810; FROM THE COLLECTION OF THE EWEN LIBRARY

48

Following the doctrine of predestination, which saw humankind divided, irrevocably, into sinners and saved, Lavater argued that a person's piety could be deciphered from the features of his or her face. Believing in an intimate connection between "corporeal and moral beauty," as well as between "corporeal and moral deformity," Lavater maintained that "The countenance is the

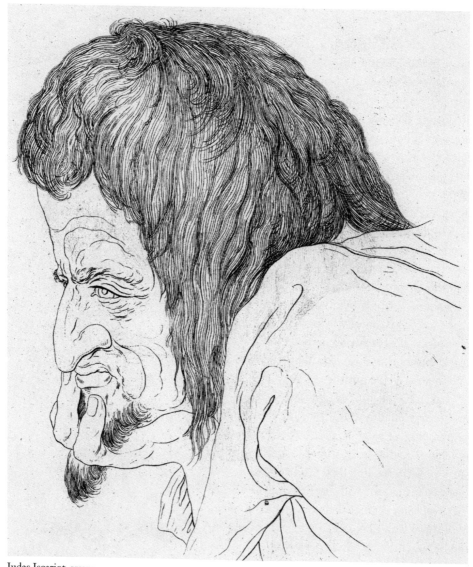

Judas Iscariot. REPRINTED FROM JOHANN CASPER LAVATER'S *ESSAYS IN PHYSIOGNOMY*, VOLUME I, LONDON, 1810; FROM THE COLLECTION OF THE EWEN LIBRARY

theatre on which the soul exhibits itself."[6] Beauty was the sign of a pious soul, ugliness the burden of the wicked.

Lavater was keenly aware that people were capable of dissembling, erecting appearances intended to create a mirage of moral integrity. In an urban environment, where deceptions were prevalent, Lavater warned that "first glance" verdicts could not be trusted for an accurate read of character.

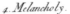

The Four Temperaments. REPRINTED FROM JOHANN CASPER LAVATER'S *ESSAYS IN PHYSIOGNOMY*, VOLUME I, LONDON, 1810; FROM THE COLLECTION OF THE EWEN LIBRARY

Men . . . make all possible efforts to appear wiser, better, and honester than, in reality, they are. They affect the behavior, the voice, the appearance of the most rigorous virtue. This is part of their art; they study to deceive, til they are able to remove every doubt, destroy every suspicion that is entertained of their worth.7

A trained physiognomist, however, would not be deceived by such artifice. A scientific understanding of elemental facial structures, Lavater maintained, would permit the educated eye to move in on certain unalterable features in order to locate absolute proof of a person's ethical merit or turpitude. Unaware of advancements in makeup and cosmetic surgery that would flourish in the twentieth century, Lavater enumerated those aspects of the human countenance that offered infallible evidence for physiognomic investigation.

What man, for example, . . . would be able to alter the confirmation of his bones, according to his pleasure? Can any man give himself instead of a flat, a bold and arched forehead; or a sharp indented forehead, when nature has given him one arched and round?

Who can change the colour and position of his eyebrows? Can any man bestow on himself thick, bushy eye-brows, when they are either thin or wholly deficient of hair?

Can any fashion the flat and short, into the well-proportioned and beautiful nose?

Who can make his thick lips thin, or his thin lips thick?

Who can change a round into a pointed, or a pointed into a round chin?

Who can alter the colour of his eyes, or give them, at his pleasure, more or less lustre?

Where is the art, where the dissimulation, that can make the blue eye brown, the gray one black?8

Assuming the permanent nature of certain key physical traits, Lavater presented the rules of a new science by which the right individual could become a physiognomist, who analyzed the content of character through a detailed examination of specific facial features. "[N]eglect no part of the countenance," he instructed, for "[e]ach trait contains the whole character of man as, in the smallest of the works of God, the character of Deity is contained. . . . Every minute part has the nature and character of the whole. Each speaks truth, the truth of the whole."

OF HUMAN LIBERTY, AND ITS LIMITS. 31 51

ADDITION H.

No. 1. With a face like this, no one will ever achieve a bold and hazardous enterprize: he will have domeſtic virtues, he will faithfully diſcharge the duties of his ſtation; but he is incapable of attaining any portion of the Warrior's valour, or the Poet's genius.

2. His forehead inclines too much backward, to admit of his having a ſufficient degree of firmneſs and conſtancy. In other reſpeᴄts, to conſider the whole together, the form of his face is not ordinary. He is leſs capable of obſerving for himſelf, than of judging with diſcernment concerning obſervations already made.

3. Has much more capacity and prudence than all the others, and 4. haſt the leaſt of theſe qualities. With difficulty will this laſt riſe above objeᴄts preſent and ſenſual.

If I were obliged to charaᴄterize them by a ſingle word, I would ſay of 1. He is timid; of 2. He has taſte; of 3. He is a prudent obſerver; of 4. He is ſenſual.

1. Can never attain the taſte which charaᴄterizes 2. nor he the prudence of 3. 4. Is equally incapable of acquiring the one or the other of theſe qualities.

REPRINTED FROM JOHANN CASPER LAVATER'S *ESSAYS IN PHYSIOGNOMY*, VOLUME II, LONDON, 1810; FROM THE COLLECTION OF THE EWEN LIBRARY

Beyond the eyes, he contended, certain facial elements stood out as ineluctable windows to the soul. The nose, a persistent fixation in the history of stereotyping, was Lavater's Rosetta Stone.

I hold the nose to be the foundation, or abutment, of the brain. Whoever is acquainted with the Gothic arch will perfectly understand what I mean by the abutment; for upon this the whole power of the arch of the forehead rests, and without it the mouth and cheeks would be oppressed by miserable ruins.

52

A beautiful nose will never be found accompanying an ugly coun-
tenance.... The following is requisite to the perfectly beautiful nose.

a. Its length should be equal the length of the forehead. b. At the top
should be a gentle indenting. c. Viewed in front, the back, dorsum,
spina nasi, should be broad. And nearly parallel, yet above the centra
something broader. d. The button or end of the nose, orbiculus, must
be neither hard nor fleshy; and its under outline must be remarkably def-
inite, well delineated, neither pointed nor very broad. e. The sides ...
seen in front, must be well defined, and the descending nostrils gently
shortened.... Such a nose is of more worth than a kingdom.

Teeth were also eloquent facial indicators. "Long teeth are certain signs of
weakness and pusillanimity. White, clean, well-arranged teeth, visible as soon
as the mouth opens, but not projecting, nor always entirely seen, I have never
met with in adults except in good, acute, honest, candid, faithful men." Chins,
too, were important indicators of character. "I am, from numerous experi-
ments, convinced that the projecting chin ever denotes something positive;
and the retreating something negative. The presence, or absence, of strength
in man, is often signified by the chin.9

Inheriting a tradition of visual truth that assumed that well-executed works
of art were accurate portrayals of their subject matter, Lavater, throughout his
book, illustrated his points on moral elevation or degeneracy by using engrav-
ings based on sculpture and paintings gleaned from the ages.

Referring to a portrait of Shakespeare, he wrote, "Who does not read the
clear, the capacious, the rapid mind; all conceiving, all embracing, that, with
equal swiftness and facility, imagines, creates, produces?"10

The face of indolence. REPRINTED FROM JOHANN
CASPER LAVATER'S *ESSAYS IN PHYSIOGNOMY*, VOLUME I, LON-
DON, 1810; FROM THE COLLECTION OF THE EWEN LIBRARY

In his commentary on a drawing of an
unidentified man, he injected, "Who does not
here read reason debased; stupidity almost
sunken to brutality? This eye, these wrinkles, of
a lowering forehead, this projecting mouth, the
whole position of the head, do they not all
denote manifest dullness and debility?"11

Reflecting on the face of Judas Iscariot as ren-
dered by the German painter Hans Holbein,
Lavater inquired with incredulity, "Who can
persuade himself that an apostle of Jesus Christ
ever had an aspect like this, or that the Saviour

could have called such a countenance to the apostleship? . . . Who could place con-
fidence in such a man?"[12]

Lavater continued his analysis of the face of Judas.

> Had we never been told that this is the portrait of Judas Iscariot after Hol-
> bein, had we never seen a face that wore the least resemblance to it, a
> primitive feeling would warn us at once to expect from it neither gen-
> erosity, nor tenderness, nor elevation of mind. The sordid Jew would
> excite our aversion, though we were able neither to compare him with
> any other nor to give him a name.[13]

Such historical exercises, which appear throughout *Essays in Physiognomy*,
served as object lessons for contemporary readers and would-be practitioners.
Inasmuch as physiognomic inquiries were time consuming and could not be com-
pleted on the spot, it was essential for specialists to learn how to fix their impres-
sions in memory, and translate these into usable notes and then into
mathematically precise drawings for later deliberation.

> First . . . describe the whole form and each particular feature in words,
> as if to a painter, who was to draw a picture of the person. . . . After this
> description, let this person sit, if it be practical. . . . Begin with his stature.
> Then give the proportions; first the apparent, as measured according to
> perpendicular and horizontal lines; proceed afterward to the forehead,
> nose, mouth, chin, and especially to the figure, colour, position, size,
> and depth of his eyes. . . . Draw the figure of the person, when he is
> absent, according to this description. . . . That this kind of exercise may
> become more perfect, a habit must be acquired of studying any counte-
> nance, so as to seize and deeply impress its most prominent features on
> the memory, in a few moments.

To insure mathematical accuracy, specific geometric drills were recommended
in the delineation of such portraits.

> Having observed the full face, I next examine the profile, perhaps by
> dividing it into two parts. I then define its perpendicular length, accord-
> ing to the three customary divisions and remark its perpendicular vari-
> ations: then the relative positions of these three parts, the forehead, the
> nose, the chin. This I can the easier do, if I imagine a right line passing

54

from the extreme point of the upper lip, immediately under the nose, to the point of the deepest part of the cavity under the forehead, by which this relative position, in all countenances, naturally divides itself into three principle sections; the perpendicular, the line projecting at the lower point, or the line projecting at the upper point. Without having such simple and determinate rules, it will never be possible for the imagination to retain the true form of the head, physiognomonically accurate.[14]

For rendering serviceable portraits, Lavater advocated specific tools and lighting conditions. "Oil paintings, when perfect, are the most useful to the physiognomist," he noted, but were too "expensive" a medium for ordinary use. Though inexpensive to create, drawings in black chalk were "useless," generating images so vague in detail that they were intrinsically "untrue and unnatural." Having investigated a wide variety of media, Lavater declared that "I have hitherto found nothing equal to the English black lead pencil,

retouched by Indian ink, to express the physiognomical character of the countenance, round, picturesque, powerful, and precise." In order to review the accuracy of a portrait once it had been drawn, Lavater recommended using "a camera obscura to compare the drawing to the true figure on the instrument."[15]

Given the underlying philosophy of Lavater's strange science, however, technique alone could not create a true physiognomist. According to a world view that equated specific standards of beauty with virtue, only the beautiful were in a position to identify the good. Only good-looking people were qualified to become physiognomists.

No one, therefore, ought to enter the sanctuary of physiognomy who

REPRINTED FROM JOHANN CASPER LAVATER'S *ESSAYS IN PHYSIOGNOMY*, VOLUME III, LONDON, 1810; FROM THE COLLECTION OF THE EWEN LIBRARY

has a debased mind, an ill-formed forehead, a blinking eye, or a distorted mouth.

No one whose person is not well formed can become a good physiognomist. The handsomest painters were the greatest painters. . . . The physiognomists of greatest symmetry are the best: as the most virtuous best can determine on virtue, and the just on justice, so can the most handsome countenances on the goodness, beauty, and noble traits of the human countenance; and, consequently, on its defects and ignoble prop-

414

FRAGMENT FIFTH.
ADDITION C.

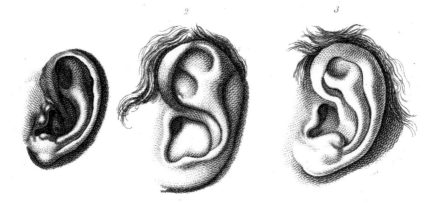

1. Seems made for a man capable of acquiring and tranfmitting knowledge; for a pedagogue, who mechanically collects a great number of fcientific articles.

2. Cannot be referred to any but a head exceffively weak. This form broad and fmooth; this want of rounding in the contours, may in truth fubfift with fuperior faculties, and particularly be frequently found in mufical ears; but when the whole is fo flat, fo coarfe, fo tenfe, it certainly excludes genius.

3. Has too much precifion to afcribe it to a blockhead, but, on the other hand, it is too round, and too maffy, to furnifh the indication of an extraordinary man.

REPRINTED FROM JOHANN CASPER LAVATER'S *ESSAYS IN PHYSIOGNOMY*, VOLUME III, LONDON, 1810; FROM THE COLLECTION OF THE EWEN LIBRARY

erties. The scarcity of human beauty is a certain reason why physiog-
nomy is so much decried and finds so many opponents.

Beyond physical beauty, the qualifications for a good physiognomist
included keen powers of observation, an anal compulsion for detail, and a will-
ingness to draw instantaneous, often invidious, conclusions about other peo-
ple, without hesitation.

> Whoever does not, at the first aspect of any man, feel a certain emo-
> tion of affection or dislike, attraction or repulsion, never can become
> a physiognomist.
> His first requisites, as has, in part, already been remarked, should
> be a body well proportioned and finely organized: accuracy of sensa-
> tion, capable of receiving the most minute outward impressions, and
> easily transmitting them faithfully to memory; or, as I ought rather to
> say, impressing them upon the imagination, and the fibres of the brain.
> His eye, in particular, must be excellent, clear, acute, rapid, and firm.
> Precision in observation is the very soul of physiognomy. The phys-
> iognomist must possess a most delicate, swift, certain, most extensive
> spirit of observation.[16]

Ostensibly a science that would enable a trained practitioner to evaluate the
moral worth of people encountered in everyday life, Lavater's cosmology also
contained within it the imprint of European empire, expressing the outlook of
a man whose universe had been shaped by the biases of colonialism. While much
of his book focused on individual traits and their interpretation, towards the
end of his treatise he opened up the subject of "National Physiognomy," a spe-
cific arena of his discipline that examined questions of racial character.

> That there is national physiognomy, as well as national character, is
> undeniable. . . . Compare a Negro and an Englishman, a native of Lap-
> land and an Italian, a Frenchman and an inhabitant of Terra del Fuego.
> Examine their forms, countenances, characters and minds. Their dif-
> ferences will be easily seen.[17]

While hard to fathom today, such biases were not antithetical to con-
temporary democratic thinking. Thomas Jefferson, whose Declaration of
Independence was published but one year after *Essays in Physiognomy*, was him-

self a devotee of such physiognomic generalizations as explanations of racial difference. Comparing whites and blacks, Jefferson wrote:

[T]he difference is fixed in nature, and is as real as if its seat and cause were better known to us. And is this difference of no importance? Is it not the foundation of a greater or less share of beauty in the two races? Are not the fine mixtures of red and white, the expressions of every passion by greater or less suffusions of color in the one, preferable to that eternal monotony, which reigns in the countenances, that immovable veil of black which covers the emotions of the other race? Add to these, flowing hair, a more elegant symmetry of form, their own judgement in favor of the whites, declared by their preference of them, as uniformly as is the preference of the Oran-utan for the black women over those of his own species. The circumstance of superior beauty, is thought worthy [of] attention in the propagation of our horses, dogs, and other domestic animals; why not in that of man?[18]

In the faces of individuals, Lavater argued, one uncovered more than their personal traits. The trained eye, he contended, could look beyond the individual and discern the general characteristics of the racial stock from which the individual came. Within particular features of an individual the traits of the group were simultaneously manifest. In the nineteenth century, methods for uncovering group identities within individuals became more and more elaborate—benefiting from instrumental uses of photography by criminologists, anthropologists and advocates of eugenics—but Lavater was among the first to propose the existence of such scientific linkages.

Describing a man in a turban, Lavater leveled his vitriol upon a people, judging them, from a single portrait, unqualified for learning, loving, or appreciating the benefits of civilization.

The conformation of the head, the overhanging of the forehead alone, decidedly speak stupidity, incapable of instruction; and not less so the position of the nose to the mouth, perfectly brutal, without affection or mental enjoyment: the eyes, chin, and beard, all correspond.[19]

While he was less disparaging of his European brethren, they, too, were classifiable according to physiognomic categories.

The French I am least able to characterize.—They have no traits so bold as the English, nor so minute as the Germans. I know them chiefly by their teeth and their laugh. The Italians I discover by the nose, small eyes, and projecting chin. The English by their foreheads and eyebrows. The Dutch by the rotundity of the head, and the weakness of the hair. The Germans, by the angles and wrinkles round the eyes, and in the cheeks. The Russians, by the snub nose, and their light-coloured, or black hair.[20]

For Lavater, the question of "national physiognomy" was pivotal. In an expanding world, where interactions between European and non-European societies were intensifying, the ability to draw a global map of physiognomic distinctions, a new hierarchy of inequality, had become an essential priority. Philosophers, businessmen, and men of contemplation alike must be educated in "the natural history of national physiognomy," he implored. It contained "profound, indestructible, and eternal" truths. To deny it, would be "equal to denying the light of the sun at noon day."

Read today, Lavater's work seems wildly opinionated. Though he claimed to be articulating a body of laws and principles, his subjective ramblings lack the aura of systematic thinking that one tends to associate with Enlightenment science. Nonetheless, Lavater's contribution helped to legitimize discriminatory evaluations of other people as an essential element in the emerging field of natural history and science. While many of those who inherited the physiognomic enterprise would criticize the imprecision of his work, Lavater's fixation on the conclusive moral significance of facial features—noses, brows, chins, eyes, ears, teeth, and the like—would mark popular and scientific understandings of human difference for centuries to follow. So, too, would his visual strategy of persuasion, which juxtaposed divergent portraits of humanity in order to communicate ideals of good and evil, intelligence and feeble-mindedness, civilization and savagery, beauty and ugliness.

HIERARCHIES OF HUMANITY

On July 11, 2002, the journal *Nature* published a report on the recent discovery of an early human male fossil, a partial skull unearthed by French paleontologists in Chad, in Central Africa. The story, heralding this event as "one of the most important fossil finds in the last 100 years," appeared on front pages around the world.[1]

Using the standard binomial naming procedure invented by a Swedish botanist named Carl von Linné (more generally known as Carolus Linnaeus, 1707–1778), the scientists labeled their specimen Sahelanthropus tchadensis but generally refer to him as Toumai, meaning "hope of life" in the Goran language. Declaring their find "the oldest and most primitive known member" of the human family, the French team predicted that the fossil would "illuminate the earliest chapter in human evolutionary history."[2] With a face and teeth that appear distinctly human and a small brain case like that of a chimpanzee, this nearly seven-million-year-old ancestor shattered basic assumptions about the lineage and development of the human species, previously estimated to be no more than four million years old. In an editorial appearing in the *New York Times* on July 12, the writer announced that, beyond his age, Toumai's appearance had thrown into question the widely held scientific belief that people had evolved, as a single species, along a neat "highway leading from the past to the present." Perhaps, the editorial suggested, present-day hominids are not the inheritors of a common line, but rather a diversified group, assembled out of several "closely related species."[3]

Man or ape? One species or many? Questions such as these, regarding the origins and diversity of humankind, were obsessive preoccupations of eighteenth-century European science. Encountering or, more often, relying on travelers' accounts of people with varying skin tones, hair textures, facial structures, and body types, Enlightenment scientists, philosophers, and dilettantes strained to construct intricate, well-ordered systems of classification in order to situate each particular variant within its "proper place" in the natural order of things. Within such systems, or taxonomies, organisms were assigned specific places, each in relation to all others, providing an ostensibly objective scientific map, a modern reconfiguration of the Great Chain of Being. This impulse animates the great contradiction within Enlightenment thinking. While radical democrats claimed nature and its laws as the bedrock upon which notions of human equality and "The Rights of Man" rested, others looked toward systematic scientific

60

schemas as a new refuge for upholding principles of hierarchy, as a rationale justifying the control of lesser beings by their superiors.

One common feature of eighteenth-century taxonomy was its dogmatic commitment to the idea that each life form occupied a distinctive place within an overall system, that each species embodied a specific ideal type and could be distinguished by a unique set of identifiable characteristics. There was little room for ambiguity. Each living thing conformed to a picture in the taxonomist's head, each had a singular and defining essence. Things that veered from these visible truths were viewed as aberrations, anomalies, nature's mistakes.

COURTESY OF LEE HERMAN

This conceit is at odds with much recent thinking about how to comprehend the nature of living things. Stephen Jay Gould, perhaps the most influential taxonomist of the twentieth century, argued that ideal-type organisms do not actually exist in nature. The borders separating one type from another, he maintained again and again, are, at best, blurry. "Nature," he wrote, "comes to us as continua, not as discrete objects with clear boundaries." Even within species, "variation is primary; essences are illusory."[4]

Gould's rejection of the eighteenth-century paradigm is not a minor quibble over the details of scientific classification. It is about the social values that shape the exercise of classification itself, speaking to questions of tolerance and justice, of who and what will be accepted within the bounds of normalcy. The debate, as he defined it, came down to essentialism, which he argued:

> establishes criteria for judgment and worth: individual objects that lie close to their essence are good; those that depart are bad, if not unreal. . . . Antiessentialist thinking forces us to view the world differently. We must accept shadings and continua as fundamental. . . .
>
> The taxonomic essentialist scoops up a handful of fossil snails in a single species, tries to abstract an essence, and rates his snails by their match to this average. The antiessentialist sees something entirely different in his hand—a range of irreducible variation defining the species, some variants more frequent than others, but all perfectly good snails.[5]

Gould's democratic approach, however, would have appalled Linnaeus, whose *Systema naturae* (System of Nature) still provides the foundation for modern biological nomenclature. In the first nine editions of the tome, beginning in 1735, Linnaeus cataloged and named 7,700 species of plant life. In the tenth edition of 1758, described by Gould as "the founding document of animal taxonomy," he applied his binomial system to more than 4,400 zoological varieties. Whether plant or animal, each species was defined by unambiguous and observable physical characteristics.

Despite its aura of certitude, classification is never a neutral act. Naming is a form of exercising power, and the ways that things are named often reflect the outlook of the namer. Linneaeus's binomial system belied his claims of scientific neutrality. In eighteenth-century Europe, though commerce and natural science had emerged as powerful arenas of authority and democratic reveries were becoming infectious, much of what went on in society still operated under the aegis and imprimatur of the crown. If Linnaeus's method created a tool for modern science, it still used the metaphor of monarchy as a way of framing the order of things. Plants and animals constituted two natural kingdoms (regna naturæ). Within these kingdoms, a hierarchy of classes, orders, genera, and species provided categories by which all life forms, plant and animal, were classified. In a world where many still saw hierarchy and inequality as natural, taxonomy provided a tangible ratification of this belief. Within the animal kingdom, for example, mammalia (mammals) occupied the highest level, followed by birds, amphibia, fish, insects, and vermin. Within the class of mammals, the genus primates held the highest ground, and among primates, it was Homo sapiens (humans) who stood dominant over Simia (apes and monkeys), followed by Lemur (lemurs) and then Vespertilio (bats), the last of these no longer considered primates. Every other class of animals was similarly divided into a hierarchical organization.[6]

Not only did monarchy supply a defining imagery for understanding nature, but the Linnaean system also validated prevailing inequalities of gender. Linnaeus's description of plants, discussed at length by the historian Londa Schiebinger, offers an instructive example. Plants, from the Middle Ages through the Renaissance, were mainly categorized in terms of their various medicinal applications. Herbalism, as a compendium of knowledge, emphasized these practical uses. By the eighteenth century, under the sway of Linnaeus and others, the "focus shifted from the medicinal virtues of plants to finding abstract methods of classification."[7]

In detailing the structural makeup of botanical specimens, gender and sexuality triumphed as the dominant allegory of plant life. Even though many plants

are hermaphroditic and do not conform to customary definitions of gender, Linnaeus emphatically described plants in terms of their male and female parts, with so-called dominant parts designated male, submissive parts female. So taken was he with patriarchal conventions of marriage, that he often described botanical features using the Greek terminology for husband and wife. Schiebinger adds that a scientific belief that plants, and animals as well, "reproduce within marital relations persisted into the nineteenth century."[8]

In Linnaeus's approach to the animal world, Schiebinger continues, dominant assumptions about human gender were also brought to bear. Most classes of vertebrates, for example, are named using descriptions applicable to all members of the group, regardless of sex. The class aves (or birds) was named for the power of flight, not limited to either sex. The class pisces (or fish) was also sexually indeterminate. In originating the term mammalia to describe the class to which humans belonged, however, Linnaeus selected the lactating breasts (mammary glands) of the female to serve as the diagnostic category of classification.

Given other patterns of vertebrate nomenclature, this choice may seem curious. But by creating the term mammalia, based on the female breast, Linnaeus defined the direct human connection to the animal world exclusively in terms of women. In a society that celebrated men as reasonable beings, apart from and above the bestiary, and viewed women as unreasonable and driven by instinct, perhaps it is not so strange that the burden of animality should have been so unequivocally linked with femaleness. Conversely, in naming the human species Homo sapiens, meaning "man of wisdom," Linnaeus opted to focus on that characteristic that purportedly separated men from the animal world.

While Linnaeus saw differences among the varieties of Homo sapiens, these differences were, for the most part, defined by culture and location. In the tenth edition of *Systema Naturae*, he named four principal varieties of Homo sapiens. These included Americanus, indigenous people of the Americas; Europæus, Europeans; Asiaticus, Asians; and Afer, people of Africa. Linnaeus specified distinctions separating these four groups in terms of color, temperament, and behavior, clearly holding a bias in favor of Europeans. If Europeans were "white, sanguine, [and] muscular," Asians were "pale-yellow, melancholy, [and] stiff." Africans were "black, phlegmatic, [and] relaxed."[9] Nonetheless, geographic orgin was the determining factor in defining these primary groups of Homo sapiens.[10]

The notion of subhuman species did work its way into Linnaeus's system with his inclusion of two fanciful creatures in his discussion of the genus Homo: an apelike missing link, named Homo troglodytes (Troglodytes), a figment that

endured in popular culture for some time, and Homo caudatus, an imaginary manlike creature with a tail. Both of these fabrications, it is thought, were based on the unreliable reports of travelers. Aside from these chimerical excursions, however, the invidious ranking of human types into a coherent system of greaters and lessers had not yet been fleshed out as a fixture of taxonomic thinking.

In describing the place of Homo sapiens within his overall system, Linneaus avoided biblical convention and did not trouble himself with recounting a story of creation. His goal was classification, and for the most part, geography offered a neat methodology for enumerating his four principal varieties of human beings. Yet, as Linnaeus worked, his *systema naturae* was being tinkered with.

Fourteen years after Linneaus began his study, Georges-Louis Lelerc, comte de Buffon, keeper of the Royal Garden (Jardin du Roi) in Paris, began publishing a massive illustrated history of nature, in which he altered the religious story of Creation, offering a more complex and secular naturalist interpretation of the earth and its history. Within his monumental *Histoire naturelle*, which eventually reached forty-four volumes, the history of the world moved from seven days to seven epochs, each lasting thousands of years.

Anticipating present-day descriptions of the earth and its development, Buffon's epochs were defined by the progressive cooling of the earth's surface. It was in the sixth epoch (mirroring the sixth day) that humans first appeared. According to his tale, climactic conditions in the area that now encompassed Catholic Europe, and particularly those regions known as Circassia and Georgia, in the foothills of the Caucasus, were ideal for the creation of the first, most perfect, humans.

The most temperate climate lies between the 40th and 50th degree of latitude, and it produces the most handsome and beautiful men. It is from this climate that the ideas of the genuine color of mankind, and of the various degrees of beauty ought to be derived.[11]

Troglodyte. LINNAEUS' DESCRIPTION BASED ON THIS ILLUSTRATION FROM JACOB BONDT IN HIS *HISTORIA NATURALIS ORIENTALIS*, 1658. COURTESY OF LEE HERMAN

64

If the climate of these regions was conducive to the development of the first and most beautiful of peoples, other climates, according to Buffon, contributed to a process of deterioration from the pristine original. Buffon's term for this was degeneration. The anthropologist and historian Miriam Claude Meijer explains that this term signified a regression from the pure and original state of the species.

> The term degeneration came from the Latin roots 'de' and 'genus', meaning 'from' and 'original stock' respectively. De-generation meant departure from the original form at creation, deviation from the pristine organic form through exposure to climactic extremes. The choice of words reflected the Christian tradition of an original perfection of nature which had been marred by human imperfection, i.e. the fall of man.[12]

Like much of Buffon's secularism, his story of degeneration mirrored biblical assumptions.

Buffon's idea of degeneration was climactically driven. As people ventured from the European cradle of creation, migrating to tropical and arctic climes, he argued, perfection gave way to decay. Africans and far-northern tribes, such as those from Lapland, as well as Asians and those who settled in the Americas were all counted among the degenerate.

But it was Johann Friedrich Blumenbach (1752–1840), a devoted student of Linnaeus, whose work would provide the most durable foundation for the fields of physical anthropology and natural history as they related to the classification of human types. A professor of medicine at the University of Göttingen and court physician to King George III of Great Britain, Blumenbach focused solely on the subject of human difference. First published in 1775, and revised in 1795, Blumenbach's masterwork, *Treatise on the Natural Variety of Mankind*, provided a scientific keystone for modern theories of racial inequality.

Building on Buffon's interpretation, Blumenbach added specificity and a now familiar lexicon to the narrative of origin and decline. Blumenbach was a bone collector, part of the growing brotherhood of bone collectors who, as Europeans, traversed the world, accumulated human crania, among other things, as evidence of their worldly sophistication. Blumenbach's collection of skulls was celebrated as one of the finest in the world, and people regularly sent him human trophies to add to his cabinets. In all, he amassed 245 skulls from around the globe. Amid these, one stood out. To Blumenbach she embod-

ied the pinnacle of human perfection, possessing a symmetry and beauty that was
simply and viscerally captivating.

The skull in question was that of a woman from the region of Georgia, in the
Caucasus, whom he named Feminae Georgianae.[13] From this single specimen,
Blumenbach wove a tale about the origins of humanity, its noble roots and its
subsequent decline. Echoing Buffon, he maintained that the Georgian woman
came from that place that was the
starting point of humanity, the loca-
tion where the species Homo sapiens
first appeared in its most pristine and
perfect form. He named this original
bloodline the Caucasian variety, a
term that continues to be used, usu-
ally without question. He explained:

I have taken the name of this vari-
ety from Mount Caucasus, both
because its neighborhood, and
especially its southern slope, pro-
duces the most beautiful race of
men, I mean the Georgian; and
because all physiological reasons
converge to this, that in that
region, if anywhere, it seems we
ought with the greatest probabil-
ity to place the autochthones [ori-
gins] of mankind.[14]

Feminae Georgianae, Blumenbach's muse for
the Caucasian type. REPRINTED FROM J. F. BLUMENBACH'S
ON THE NATURAL VARIETIES OF MANKIND, PLATE 4

To Blumenbach, the Caucasians
possessed "the most beautiful form of skull," a mark of their elevated status
among the peoples of the world. (It is ironic that in Russia, such an outlook is at
odds with commonly held biases regarding residents of the Caucasus. According
to a prominent Russian sociologist, Professor Vladimir Ilyan, whom we inter-
viewed in St. Petersburg, Russians have long viewed Caucasians as "gangsters
and thieves, similar to the way that Italians are routinely characterized in the
United States." Ilyan, himself a native of the Northern Caucasus, is well aware
of this prejudice from experience.) Presumably unaware of this invidious per-
spective, Blumenbach described his version of the Caucasian in flattering detail.

66

Colour white, cheeks rosy; hair brown or chestnut-coloured . . . face oval, straight, its parts moderately defined, forehead smooth, nose narrow, lightly hooked, mouth small. The primary teeth placed perpendicularly in each jaw; the lips . . . moderately open, the chin full and rounded. In general, that kind of appearance which, according to our opinion of symmetry, we consider most handsome and becoming.

Among the Caucasians, Blumenbach included the people of Europe (except for Europe's Jews, who were designated Oriental) along with people from the Middle East and North Africa. This inclusion of dark-skinned peoples within

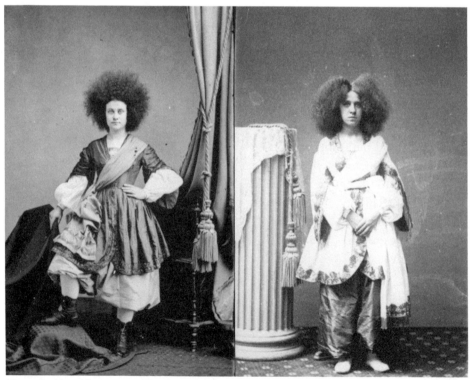

Blumenbach's racial science would endure, and its continuation was abetted by the showmanship of P. T. Barnum, who launched "Circassian Beauties" as a standard attraction in museums and midways of the nineteenth century. The "Star of the East." Zulumma Agra (left), Barnum's first example of the type, was supposedly rescued from a slave market in Constantinople. According to Barnum's puffery, she had been abducted from that region, which had produced the Caucasian race, and she was presented as the epitome of human beauty. Turkish sultans, according to myth, were behind the "white slave trade" that carried these unwilling but eminently desirable captives into their harems. To the right is another example displayed at Barnum's American Museum. PHOTOGRAPH OF ZALUMMA AGRA BY MATHEW BRADY FROM THE COLLECTION OF PICTUREHISTORY.COM

the Caucasian variety may seem curious, coming from a scientist who placed such a premium on whiteness. Perhaps the most compelling explanation for this inclusion is that for Europeans, the regions where these people lived encompassed areas widely understood to have been the cradle of civilization: places such as Egypt, Mesopotamia, and the Holy Land. By locating inhabitants of these regions neatly within the Caucasian variety, Blumenbach—and many subsequent racial scientists—were able to circumvent the possibility that any people, other than the type originating in Europe, could have been responsible for achieving significant social and cultural accomplishments.

This need to situate the founders of civilization within the Caucasian variety speaks to an essentialist mindset that insists on fitting people, and other life forms, into clear-cut and rigidly enforced categories. Had Blumenbach been able to anticipate Gould's notion that life exists on a continuum, that ideal types are abstractions that do not exist in nature, he would not have needed to place ancient civilization within the Caucasian camp. Without having done so, however, the very idea of rigidly divided racial categories would have made no sense, and the "truth" of racial categorization, and Europe's superiority, was a deeply embedded faith for men like Blumenbach.

Descending from the Caucasian ideal were four other racial groups, each seen as a degeneration from that ideal.

> All mankind . . . seems to me as it may be best . . . be divided into the five following varieties; which may be designated and distinguished from each other by the names Caucasian, Mongolian, Ethiopian, American, and Malay. I have allotted the first place to the Caucasian . . . which make me esteem it the primeval one. This diverges in both directions into two, most remote and very different from each other; on the one side, namely, into the Ethiopian, and on the other into the Mongolian. The remaining two occupy the intermediate position between that primeval one and these two extreme varieties; that is, the American between the Caucasian and Mongolian; the Malay between the same Caucasian and Ethiopian.[15]

Together, Blumenbach's taxonomy of the five human varieties could be visualized as a pyramid. At the top, characterized by their whiteness, stood the Caucasians, a vision of humanity as it was meant to be. At the base of the pyramid, each to one side, lay "two ultimate extremes" of degeneration, Mongolians (from Eastern Asia) and Ethiopians (dark-skinned Africans). The Malay (Polynesians and Melanesians of the Pacific; Australian aborigines) and Americans (Indians of the

New World) stood as intermediaries between the Caucasian ideal and its two utmost retrogressions. Throughout Blumenbach's work, color remained the most palpable index of decay, though facial structure was also discussed. According to Blumenbach's rendition of the Fall, all of these inferior varieties were created by a build-up of carbon in the skin, producing an "unnatural and diseased colour," the deleterious result of overexposure to the elements.[16] His unfounded assumption that white was the "primitive color of mankind" was based on the axiomatic belief that while it is "very easy for [white] . . . to degenerate into brown . . . [it is] very much more difficult for dark to become white, when the secretion and precipitation of this carbonaceous pigment has once deeply struck root."[17] Despite the fact that Blumenbach saw each of his five varieties as belonging to a common species, he had, at the same time, constructed a human hierarchy that elevated Caucasians to the highest level of creation, ranking all other types in terms of their innate pathology. This perspective would inform the trajectory and vocabulary of natural history and racial science into the late twentieth century.

Blumenbach, it must be added, was part of a scientific tradition still rooted in the synergy of art and science. His system of ranking was based, exclusively, on judgments about the relative beauty of the different types he surveyed. His criteria were essentially aesthetic. Issues of intellectual development or innate intelligence were not his primary concern, though they would certainly become central issues as the trail that he blazed became, in the nineteenth century and onward, a well-traveled highway.

Beginning in the Renaissance, European elites began to amass booty from global expeditions, creating curiosity cabinets in which a worldview was articulated through a strategic arrangement of natural artifacts. These cabinets, into the eighteenth century, were private collections through which the beneficiaries of Empire could inspect physical evidence of their power and position within an emerging world market.

It was men such as Linnaeus, Buffon, and Blumenbach, aided by the establishment of public museums of natural history, who took these private collections and transformed them into generally understood truths. While convex mirrors had taken the aura of religious relics and made them transportable, a growing taxonomic literature elevated the vanity of the curiosity cabinet to the rank of science.

CAMPER'S ANGLE

Blumenbach's aesthetic science was, to a large extent, the outcome of an idea that had been steeping in Europe since the time of Roger Bacon: the belief that material evidence, observed and interpreted by the eye's mind, provided an empirical footing for scientific knowledge and natural law. The notion that beauty is truth, and truth beauty, was unquestionably related to a marriage between artistic creativity and optical technology that originated in the late Middle Ages and took flight during the Renaissance. The belief that art encapsulated eternal truths, however, was not simply a product of this fusion of art and science. It was also related to a revitalized interest in the arts of antiquity and in the ideals of "classicism" initiated, in large part, by the papal court during the brief high Renaissance period of the late fifteenth and early sixteenth centuries.

In 1377, when the papacy returned to Rome after nearly seventy years in exile in Avignon, it reentered a city that had been destroyed by barbarian invasions and battles among local aristocrats. A search for ideals upon which a revived Roman Catholic Church could be built led a succession of popes toward the old Roman Empire, and the ancient civilization of Greece that had influenced it significantly, as archetypes to work from. The papacy saw Greek civilization, particularly in its works of art, as a beacon that could help to establish a new sense of order and grandeur. Many centuries earlier, the Roman Empire had gathered a trove of artworks from around the world and had also generated its own monumental statuary and architecture inspired by Greek culture. Beginning with Pope Alexander VI, elected in 1492, excavations were undertaken to bring these ancient treasures to light, to be placed in the Court of the Vatican. Among these rediscoveries was a statue that became known as the Apollo of the Belvedere—named for the Belvedere Courtyard in the Vatican where it stood—a marble Roman copy of a Greek bronze.[1]

In classical art, particularly in its rendition of the human form, the high Renaissance venerated a concept of beauty that was seen as timeless, an expression of "lasting, unchanging, incorruptible" truths that were, professedly, "eternally human." The art historian Arnold Hauser has convincingly argued that this notion of eternal beauty, rooted in the Aristotelian concept of *kalokathia* (nobility), was a fiction forwarded by ecclesiastical and secular elites in an attempt to elevate their own power into beauty and present their "influence and position as timeless, imperishable, and immutable." Within this

70

purview, says Hauser, "physical beauty and power become the valid expression of intellectual beauty and significance."[2]

Though the high Renaissance endured for only twenty years, the conceit that classical ideals of beauty embodied transcendent, universally applicable human values—though it fell out of favor for an extended period—proved to be remarkably durable. Nearly three hundred years after the unearthing of the Apollo, the cant of classicism reemerged as the bedrock upon which the new scholarly endeavors of art history and archaeology would be built. Not surprisingly, the founder of these nascent fields was a librarian who worked in the Vatican, cataloguing its large collection of Greek sculpture, the principal site of existing Greek and Roman statuary.[3]

His name was Johann Joachim Winckelmann (1717–1768). Hailing from Dresden, the capital of Saxony, Winckelmann converted to Catholicism in 1754 and moved to Rome the following year, where he would eventually be in the employ of the Vatican. There he began writing the first major works of art history, *Reflections on the Painting and Sculpture of the Greeks* (1755) and *The History of Ancient Art* (1764). By the time of his scandalous death at the age of fifty—

Winckelmann. REPRINTED FROM JOHANN CASPER LAVATER'S *ESSAYS IN PHYSIOGNOMY*, VOLUME II, LONDON, 1810; FROM THE COLLECTION OF THE EWEN LIBRARY

murdered in Trieste, while returning to Rome after being honored by the Habsburg court—Winckelmann was Europe's preeminent expert on ancient art. Translated from the original German into French and Italian by 1766, his *History of Ancient Art* was widely read and helped to promote and popularize the classical vision of beauty as the aesthetic paragon. In his wake, educated Europeans flocked to Italy to experience the artifacts of classical culture firsthand. People of wealth started building collections of Greek and Roman antiques, and adventurous art lovers participated in new excavations of ancient sites.[4] Among an enlightened middle class, even those unable to collect or excavate were instructed in the classical ideal through widely disseminated engravings and accounts.[5]

To Winckelmann, sculpture, far more than painting, served as the artistic standard of truth. Flat paintings, which offered only an illusion of depth, were, to his mind, but visual magic tricks. What is more, the sensual hedonism that he discerned in many eighteenth-century paintings he viewed as a debauched and debased perversion of beauty.[6]

Classical sculpture, on the other hand, offered an authentic rendition of

three-dimensionality, a physically scrupulous presentation of austere and simple aesthetic principles.7 In their sculpture, Winckelmann argued, the Greeks had articulated a strong and symmetrical vision of human beauty that exceeded the beauty one might encounter in everyday life, presenting, instead, a touchstone of aesthetic perfection and divinity.

Like Lavater, he believed that God represented "the highest beauty . . . and our idea of human beauty advances towards perfection in as it can be imagined in conformity of proportion, as it can be imagined in conformity and harmony with that highest existence." He continued: "This idea of beauty is like an essence extracted from matter by fire; it seeks to beget onto itself a creature formed after the likeness of the first rational being designed in the mind of the divinity."8

In order to depict this essence, he maintained, Greek statues were not patterned after single individuals but, rather, were careful and consummate constructions of ideal parts, each bodily detail modeled from a different person.

> This selection of the most beautiful parts and their harmonious union in one figure produced ideal beauty,—which is therefore no metaphysical abstraction; so that the ideal is not found in every part of the human figure taken separately, but can be ascribed to it only as a whole; for beauties as great as any of those which art has ever produced can be found singly in nature, but, in the entire figure, nature must yield the palm to art.9

To Winckelmann, it was the Apollo of the Belvedere that stood for the quintessence of the Greek ideal, the apotheosis of masculine magnificence. "The highest conception of ideal male beauty is especially expressed in the Apollo, in whom the strength of adult years is found united with the soft forms of the most beautiful spring-time of youth."10

Unlike our own society's ideal of highly articulated or "ripped" musculature, the Greek ideal was supple and smooth, honoring the body type of a leisured elite rather than that of a bulked-up laborer, as represented in the Apollo. "In the Apollo, an image of the most beautiful of the Gods, these muscles are smooth and, like molten glass blown into scarce visible waves, are more obvious to touch than to sight."11

This invitation to touch the Apollo, the better to fully appreciate his beauty, was but one expression of Winckelmann's distinctly homoerotic sensibility. Elsewhere, his Apollonian ideal was marked by a profound sexual ambiguity, a reverential admiration for the indeterminate boundaries of gender.

72

The attention which the Greek artists paid to the selection of the most beautiful parts from numberless beautiful persons did not remain limited to male and female youth alone, but their observation was directed also to the conformation of eunuchs, from whom boys of handsome shape were chosen. Those equivocal beauties, effected by the removal of the seminal vessels—in which the masculine characteristics approximated, in the superior delicacy of the limbs and in greater plumpness and roundness generally, to the softness of the female sex.[12]

Nineteenth-century souvenir photo of the Apollo of Belvedere. FROM THE COLLECTION OF THE EWEN LIBRARY

If Winckelmann's coronation of the classical ideal asserted that it embodied a transcendent and ethereal definition of beauty, the aesthetic guidelines he employed cannot be separated from the geopolitical position of Europe in the late eighteenth century, particularly in relation to its expanding colonial empires. Throughout his work, for example, there is a fixation on the inherent virtue of whiteness. "As white is the color which reflects the greatest number of rays of light, and consequently is the most easily perceived, a beautiful body will, accordingly be the more beautiful the whiter it is." While the Greeks, he offered, viewed "a brown complexion in beautiful boy" as a sign of courage, "those of fair complexion were called children of the Gods."

In Winckelmann, the divine harmony of the Greek ideal was posed vigorously against countenances found among those "nations which . . . have lost half of their likeness to the creator." Conspicuous among these fallen nations were Africans, Laplanders, and Asians.

The projecting, swollen mouth which the negro has, in common with the monkey of his land, is a superfluous growth, caused by the heat of the climate, just as among us the lips swell up from heat or a humid and harsh salt air, and in some men, indeed from violent anger. The small eyes of extreme northern and eastern nations make a part of the incompleteness of their growth, which is short and small.[13]

Winckelmann's rendition of beauty—white and male—dismissed the majority of humanity from its purview. It presented beauty as an exclusive property of 73 Europeans and, in so doing, shored up the colonialists' world view. Yet another part of its appeal to the European middle classes was its apparent affirmation of their antiaristocratic moral outlook. For a bourgeoisie that was becoming increasingly hostile to the excesses of monarchy and to the lavish aesthetic that surrounded aristocratic life, the stark clarity of the Greek ideal spoke for the values of a new democratic public. Though its aesthetic principles were biased and exclusionary, its influence on the neoclassical art that emerged amid the French Revolution, and on future revolutionary art forms, was unmistakable. It spoke to the disciplined ethic of a middle class that was coming into its own.

Winckelmann's impact on the emergence of art history and archaeology, as public fascinations and academic disciplines, was enormous. For many, his arguments about harmony and order continue to endure as aesthetic standards. In the Greek ideal that he celebrated, one might even see an early articulation of modernism, with its rejection of ornamentation and its focus on elementary forms and the balanced unity of the whole. Yet his ideas, and his worship of the Apollo of the Belvedere in particular, also worked their way into the history and development of racial science.

In this regard, one of the most influential disciples of Winckelmann was Petrus Camper (1722–1789), a Dutch surgeon, anatomist, and painter whose most significant undertaking was the development of detailed geometric rules for the visual portrayal of the different races of humanity. Camper, in many ways, was the embodiment of the nexus of art and science, prescribing links between "the science of anatomy" and "the arts of drawing" that assumed an identity of the two. "That an intimate connexion subsists between the different branches of the Arts and Sciences, by virtue of which the one elucidates or reflects a lustre upon the other, is a truth that has never been litigated."14

Petrus Camper. REPRINTED FROM *THE WORKS OF THE LATE PROFESSOR CAMPER ON THE CONNEXION BETWEEN THE SCIENCE OF ANATOMY AND THE ARTS OF DRAWING, PAINTING, STATUARY, ETC. ETC.*, LONDON, 1794; FROM THE COLLECTION OF THE EWEN LIBRARY

Camper was a man of many interests. Over his lifetime, he studied architecture, perspective, engraving, carpentry, welding, dyke maintenance, jurisprudence, and horticulture, among other things, but his primary contributions were in the fields of surgery, anatomy, and scientific illustration. Heavily influenced by Sir Isaac Newton's conviction

that "sensory experience was the only source of knowledge," he also looked to visual art as an indispensable tool for documenting observable truths.[15]

Graduating from the University of Leyden in 1746, Camper completed his Ph.D. and M.D. degrees, writing two theses, one on the anatomy of the eye, the other on the phenomenon of visual perception, approaching "the eye as an optical instrument, as a means of acquiring ideas through vision, and as a carrier of fallacies."[16] This fixation on optics placed him within a long lineage and, for Camper, moved him toward the visual analysis of measurable differences separating the races, particularly as they applied to facial structure.

Camper's systematic interest in human countenances commenced after he studied midwifery, when he began collecting fetuses of both black and white stillborn children for "his personal museum," noting that racial differences were already discernible in utero.[17] This area of inquiry may have been influenced by one of his teachers in midwifery, the Englishman William Smellie, who preached that "Nature herself has formed the human species into castes and ranks."

Later, while a professor of philosophy, anatomy and surgery at the University of Amsterdam, Camper encountered a variety of "foreign races," some on slave ships, in this hub of global commerce. There, he observed and drew a sampling of these dark strangers, some from life, others from the morgue, where he "performed judicial autopsies."[18]

Today the dissection of cadavers is seen as a customary aspect of medical training, and autopsies are routinely performed under a number of specified circumstances. In Camper's time, however, this was not the case. The dissection of the dead was generally seen as a profane act, a desecration of beings formed in the likeness of God. Insofar as human dissections were tolerated, only the bodies of the most reviled could be legally cut up.

In Great Britain, where Camper studied midwifery, the hanged remains of murderers had been the "sole legal source for corpses for dissection" since the reign of Henry VIII.[19] Due to this legal restriction, and the limited number of available corpses, anatomists and their students—increasingly hungry for knowledge of the human body—began to rely on "a black market in corpses" supplied by grave robbers, body snatchers, and other members of what was generally known as "the resurrection trade." Graveyards were routinely sacked and the general public viewed resurrectionists, and the anatomists whom they served, with a visceral hatred.

Ultimately, in the years 1827–1828, a case came to light that raised public revulsion to a fever pitch. Two men, William Burke and William Hare, decided that grave robbing required too much effort and began strangling poor people,

including a number of prostitutes, after getting them drunk. Once dead, their bodies, sixteen in all, came under the scalpel of Dr. Robert Knox, an eminent anatomist at the Edinburgh College of Surgeons. In the wake of a trial, in which he was convicted on the basis of evidence from his compatriot Hare and from Dr. Knox, Burke was hanged and then, as part of his punishment, dissected in front of a limited number of "ticket holders." After the main event, two thousand medical students were permitted to see the open cadaver and then, the next day, "between thirty and forty thousand members of the general public" were allowed to view the body.[20]

In 1831, in the wake of a second case of "Burking," the Anatomy Act was passed, providing a new legal source of bodies for dissection. Now, instead of murderers, those too poor to pay for their own funerals ended up on the slab. Ruth Richardson, who has written the definitive book on the relationship between dissection and the destitute, summarizes the Act with chilling clarity: "What had for generations been a feared and hated punishment for murder became one for poverty."[21] In France, as well, corpses were routinely harvested from among the poorest sectors of society.

In light of this situation, Camper's dissections, along with dissections by others who sought to codify the anatomy of human difference, must be seen as part of a practice that was reserved for the most despised and often powerless elements of society. Proper Europeans would not be subjected to such an indignity.

During Camper's years as a professor at the Academy in Groningen (1763–1773), his observations congealed into a grand, all-inclusive theory, energetically packaged for public consumption. Continuing to build what was becoming a considerable private museum of human and animal skulls, Camper began to "dissect blacks and orang-utans in public demonstrations" and then, in 1770, began publicizing the "facial line" (*linea facialis*) or "facial angle" formula that would make him famous.[22]

Traveling throughout Europe, Camper delivered lectures on the facial angle in major capitals, including an address in 1777 to the Royal Academy of Sciences in Paris. He also met with leading men of letters and was entertained by monarchs, including George III in England, Louis XVI in France, and Frederick the Great in Prussia.

The facial angle, the cause for his celebrity, was an ostensibly exact method for classifying different racial groups, founded on what he claimed to be unassailable empirical evidence. According to Camper, who invented special instruments to perform this procedure, an extended line connecting, in profile, the base of the brow with the upper lip, then juxtaposed with horizontal lines, produced a mea-

REPRINTED FROM *THE WORKS OF THE LATE PROFESSOR CAMPER ON THE CONNEXION BETWEEN THE SCIENCE OF ANATOMY AND THE ARTS OF DRAWING, PAINTING, STATUARY, ETC. ETC.*, LONDON, 1794; FROM THE COLLECTION OF THE EWEN LIBRARY

REPRINTED FROM *THE WORKS OF THE LATE PROFESSOR CAMPER ON THE CONNEXION BETWEEN THE SCIENCE OF ANATOMY AND THE ARTS OF DRAWING, PAINTING, STATUARY, ETC. ETC.*, LONDON, 1794; FROM THE COLLECTION OF THE EWEN LIBRARY

REPRINTED FROM *THE WORKS OF THE LATE PROFESSOR CAMPER ON THE CONNEXION BETWEEN THE SCIENCE OF ANATOMY AND THE ARTS OF DRAWING, PAINTING, STATUARY, ETC. ETC.*, LONDON, 1794; FROM THE COLLECTION OF THE EWEN LIBRARY

surable angle on the basis of which different kinds of people, as well as animals, could be predictably categorized. True to the spirit of his times, Camper began his investigation with those considered among the lowest ranks of humanity. His first human measurements used the skull of "a negroe" and one of a Calmuck, from an Asian Tartar people whom Camper deemed "the ugliest of all the inhabitants of the earth."[23] Alongside these two, Camper placed the skull of an ape.

> I observed that a line, drawn along the forehead and the upper lip, indi-
> cated this difference in national physiognomy; and also pointed out the
> degree of familiarity between a negroe and the ape. . . . This discovery
> formed the basis of my edifice.[24]

Having established what he saw as the lower end of the spectrum, Camper proceeded to examine European skulls and then applied his formula to Winckelmann's paradigm of splendor, the Apollo of the Belvedere. Scanning the spectrum of human diversity, he concluded that "the two extremities of the facial line are from 70 to 100 degrees, from the negroe to the Grecian antique."[25] The line attributed to "the negroe," the "Calmack," and the "Caffre," he reported, revealed a projecting lower jaw and a forehead that receded from above the nose, while the angle found on the Apollo revealed a forehead that projected forward, 10 degrees beyond the perpendicular. This was the range within which humanity fell, placing it in proximity to beasts at one end and to gods at the other. Europeans, whose "maximum and minimum of comeliness" fell between 100 and 80 degrees, came closest to the benchmark of the gods, though Camper admitted that it would be rare or impossible to find a living individual with the perfection of the Apollo.

Though his measurements of Africans were admittedly based on only a few skulls, he concluded that the average "negroe" had a facial angle in the neighborhood of 70 degrees. "However, the facial line must not sink much lower than five degrees; that is, to 65; as the countenance would too closely resemble that of an ape. Lower than seventy gives the features of an ape; still lower the resemblance of a dog."[26]

Like Blumenbach and other secular creationists, Camper assembled his skulls into a linear narrative, offering a visualization of the ostensible trajectory from lower life forms to the highest. In a cabinet in his museum, he created a parade of developmental evolution, allowing one skull in each category to stand for all.

> It is amusing to contemplate an arrangement of these, placed in a regu-
> lar succession: apes, orangs, negroes, the skull of a Hottentot, Madagas-

car, Celebese, Chinese, Moguller, Calmuck, and divers Europeans. It was in this manner that I arranged them upon a shelf in my cabinet, in order that these differences might become the more obvious.[27]

In order to carry this narrative to a greater public, Camper reported, he routinely illustrated his lectures with drawings comparing the "facial line of a European, of a Negro, of an ape, and of an ancient statue to the greatest pleasure and surprise of everyone. . . . All in all, the assembly was very satisfied with my lecture and amazed by my discovery."[28] His posthumously published *Treatise on the Natural Difference of Features in Persons of Different Countries and Periods of Life* also included detailed engravings of animal and human skulls and heads, shown in profile and in sequence, each with a matrix of appropriate lines to validate the geometry of difference.

Like Blumenbach and Lavater, Camper proposed a vision of human hierarchy that used Eurocentric aesthetic judgments as if they were empirical evidence. Such was the science of the time. What Camper contributed, however, was an apparatus of measurement, which replaced literary exposition with quantification. Now difference could be abstracted and simplified to a system of mathematically derived numbers, creating a phantom objectivity—in a world fascinated by the idea of mathematical precision—that conveyed its ideas through a generally accepted rhetoric of truth.

Along the way, Camper disposed of the imprecise issue of skin color as a pivotal element of diagnosis. Though color had figured significantly for Blumenbach and Winckelmann, Camper believed that it was an element not easily calculated, one that offered little information about the contours of grace. In sticking to the principle of measurement, Camper upheld the idea that human distinctions could be accurately gauged and numerically validated. Though some argued with the specifics of Camper's system, his introduction of measurement provided a methodological staple for future students of differentiation, providing a descriptive language that could easily assume a semblance of scientific objectivity.

Despite its apparent numerical exactitude, Camper's facial line drew criticisms from his physiognomic compatriots. Lavater, while he did not dispute the utility of Camper's angle, argued that physiognomic science could not be reduced to a single measurement and remained convinced that facial analysis required a more thorough gathering of physical data.[29]

Blumenbach was far less generous, accusing Camper of sloppy science and manipulation of evidence to serve his thesis. Within each of the different races,

he maintained, the facial line revealed a broad spectrum of difference. Using his own bone collection as evidence, he proclaimed that the angle that Camper attributed to Africans could be readily found among Europeans and, conversely, the supposedly European facial line could be found among Africans. The range of angles, he argued, ran the gamut of humanity and could not be divided along racial lines. At the end of the day, Blumenbach concluded, Camper's method was "arbitrary and uncertain," and even his placement of lines varied from specimen to specimen in order to produce a desired measurement.[30]

Yet, despite these objections, the apparent facticity that Camper's system generated was remarkably appealing to those intent on demonstrating human inequality. In France, the highly influential anatomist Georges Cuvier employed Camper's angle as a diagnostic tool for measuring relative intelligence among the races. Similarly, in the United States, Samuel George Morton used Camper's tools to document the innate inferiority and barbarism of the Indians of the Americas at a time when the extermination of these peoples was official government policy.

Moving from the specific to the general, the historian Londa Schiebinger has argued that Camper's angle and his application of measurement and measuring instruments to human heads, became "the central visual icon of all subsequent racism: a hierarchy of skulls passing progressively from lowliest ape and negro to loftiest Greek. As a primary instrument of racism in the nineteenth century, the facial line became the most frequent means of explaining the gradation of species."[31] Camper's angle, in the hands of scientists and casting directors, persisted, wittingly and not, well into the twentieth century.

9
TABLIER RASA

On Friday, August 9, 2002, in a solemn ceremony held upon a hilltop overlooking the green farmlands of Hankey, South Africa, Saartjie Baartman was laid to rest. A small crowd, about fifty mourners, watched respectfully as her coffin was lowered slowly into the ground. Her return to the earth, near the place where she was born, brought to a close the drama that had begun some 192 years before.

Saartjie's cruel odyssey commenced in 1810 at the Cape of Good Hope. The twenty-one-year-old daughter of a Khoisan shepherd, she had been brought there two years earlier to work as a servant for a family of Dutch farmers, who gave her the name Saartjie Baartman. With no written records of her birth, her original Khoisan name is unknown.

Saartjie's fortune took an ominous turn when an English doctor, Alexander Dunlop, arrived at the farm. Dunlop, who served as a ship's surgeon, "supplemented his income by exporting museum specimens from South Africa."[1] Cutting a deal with the farmers, Peter and Hendrick Cezar, Dunlop acquired a partial interest in the ownership of Saartjie. He then arranged for her to be brought to England, to be exhibited in Piccadilly as a living "curiosity" who, according to publicity, occupied a strange borderland between human and animal. Saartjie's participation in this scheme was exacted with the promise that she would eventually return home a rich woman.

In Piccadilly, the dehumanization of Saartjie Baartman moved forward. Promoted by her handlers as "The Hottentot Venus," her fame grew as hordes of Londoners flocked to gape at this supposedly hideous remnant. For Europeans, the use of the name Venus was a sardonic attempt at humor. The goddess Venus was widely regarded as the apotheosis of female beauty; Winckelmann had described her as "a rose which, after a lovely dawn, unfolds its leaves to the rising sun."[2] Conversely, Saartjie was exhibited as a degeneration from this ideal. She was presented as "the epitome of all that the civilized Englishman, happily, was not."[3]

Going back to the eighteenth century, Europeans had regarded the Khoisan, or the Hottentots and Bushmen as they were derisively called, as savages who were part human, part animal, occupying the lowest rung in the ladder of human development. In fact, the term *bushman* derived from *bosmanneken*, a Dutch translation of a Malay word for orangutan.[4] Certain physical characteristics—particularly those attributed to Khoisan women—were routinely cited by taxonomists and anatomists, including Lin-

naeus and Camper, as evidence of their primitive status. Part of the fascination with these women was their tendency toward a large accumulation of fatty tissue in the hips and buttocks, known by its medical term as steptopygia.5 In South Africa, such attitudes regarding the supposed primitive status of the Khoisan were also used to reinforce white supremacy. Routinely desecrating gravesites to gather bodies for "scientific" examination and public display, white curators often placed the bones of Khoisan people "alongside those of animals." Even now, more than 2,000 anonymous Khoisan skeletons remain in storage rooms in the museums and universities of South Africa.6

William Lawrence, an influential early-nineteenth-century English surgeon who wrote and lectured on physiology, zoology, and natural history, closely examined Saartjie's backside, offering comments on Hottentots in general, the Venus in particular:

> Hottentots have vast masses of fat accumulated on their buttocks . . . giving them the appearances of extraordinary and unnatural appendages. The vibration of these substances at every moment was very striking in the Hottentot Venus. They were quite soft to the feel.7

Along with skull shapes, Londa Schiebinger argues that the conformation of female breasts was also, in the late eighteenth century, a physiognomic feature cited to specify distinctions among the races and the supremacy of Europeans. Indeed, the English physician Charles White, in 1796, argued that the comeliness of European breasts embodied the essence of true female beauty.

> In what quarter of the globe shall we find the blush that overspreads the soft features of the beautiful women of Europe, that emblem of modesty, of delicate feelings, and of sense? . . . Where, except on the bosom of the European woman, two such plump and snowy white hemispheres, tipped with vermilion?8

Against this ideal, disgust with the breasts of non-European women was widely expressed by students of comparative anatomy. This is evident in William Lawrence's exposition on Hottentot breasts, in which he argued that, after childbirth, "the breasts become very loose and flaccid, so that they can turn them under or over their shoulder and suckle their infants on their backs."9 Such an unnatural shape, to European scientists, was one more indication of the Hottentot's deviation from the physiognomy of civilized people.

The greatest piece of the Hottentot legend, however, the physical trait that excited the most fascination, particularly among students of comparative anatomy, was her *tablier*, or apron. Not a garment, the tablier was comprised of Saartjie's elongated labia minora, the inner lips of her vagina. The actual length of these appendages remained a mystery to those Londoners who paid two shillings to view the Hottentot Venus, even to those who paid an extra fee to cop a feel of her buttocks. During her public display, in a meager gesture toward decency, this portion of her anatomy remained covered. But tales of the tablier circulated and this feature was cited as quintessential proof of her quasi-animal status.

This was science as entertainment in its most prurient form. Beyond her unfamiliar physiognomy, which audiences were willing to accept as confirmation of Saartjie's atavistic identity, the showmanship that surrounded her display in London and in the provinces was designed to emphasize Saartjie's supposedly bestial station. Near-naked, she was paraded on a platform and encouraged to speak no intelligible words, emitting only visceral grunts and clicks. A witness to these events offered the following description of the "Hottentot Venus" show: "The Hottentot was produced like a wild beast, and

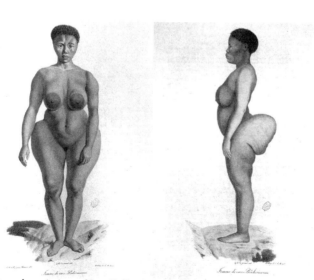

Watercolor paintings of Saartjie Baartman at the Muséum national d'Histoire naturelle, Paris, 1915. REPRINTED FROM ETIENNE GEOFFROY SAINT HILAIRE AND FRÉDÉRIC CUVIER'S HISTOIRE NATURELLE DES MAMMIFERÉS HELD AT BIBLIOTHÈQUE CENTRALE, MUSÉUM NATIONAL D'HISTOIRE NATURELLE (PARIS), COURTESY OF DEBORAH WILLIS AND CARLA WILLIAMS

ordered to move backwards and forwards and come out and go into her cage, more like a bear in a chain than a human being."[10]

So humiliating was the spectacle, such an assault on the character of all Africans, that the African Association, an antislavery group, brought suit against the degrading sideshow, demanding that it be ended. The suit requested that Saartjie be released from her captivity, given proper quarters while remaining in England, and returned to her home as soon as possible. In response, her handlers produced a written contract—of dubious authenticity—showing that Saartjie had willingly agreed to the terms of her public display, and the court rejected the African Association's petition.[11]

Though the show was permitted to go on, the court case led to widespread outrage over Saartjie's public exploitation. Antislavery sentiments in England were on the rise, and the exhibition of the Hottentot Venus was attracting negative publicity. In view of this, her keepers decided to export the show to France, where Saartjie was included among a menagerie of wild animals in Paris for fifteen months. Beginning, once more, as an oddity for public entertainment, Sarah Bartmann, as she was now known—having been baptized before leaving England—had landed in a city where the study of natural history was in full bloom. Even more than the Parisian crowds, scientists from the Muséum d'histoire naturelle in the Jardin du Roi viewed Sarah's arrival on French shores as an unprecedented opportunity to address a mystery that had plagued them for some time. Was the Hottentot a member of the human race? Or was she representative of a separate species, a "missing link" between humans and the animal kingdom? To pursue these questions in an appropriately serious environment, she was brought to the Jardin du Roi for closer examination.

There, over a period of three days in the spring of 1815, she was stripped totally bare except for a handkerchief over her genitals. In a forbidding hall in the museum, two nude portraits of her were painted. In addition, a delegation of "formally dressed" scientific gentlemen explored the details of her anatomy, though, due to her protestations, they reportedly caught only a quick and inconclusive glimpse of the renowned tablier.

Among the group of scientists examining Sarah Bartman was Georges Cuvier, Europe's leading naturalist. Cuvier was the father of paleontology, whose theories on comparative anatomy, and his approach to the reconstruction of fossils from partial remains, had significantly advanced the study of natural history. When Sarah was brought to the museum, the purpose of the examination was to situate the Hottentot in relation to the "lowliest race of

humans (the negro) and the highest type of ape (the orangutan); [also] to provide
the most complete possible description of the anomalies of her genitalia."[12]
Though this latter goal was not achieved at the time, Cuvier was an ideal person
to participate in such a perverse scientific investigation. His dismissive, if largely
ignorant, views on Africans' level of development were widely known and
accepted in Europe. In 1812, he had described Africans as too primitive, too dull-
witted to have created even a smidgen of worthwhile culture.

> The most degraded of the human races, the Negroes, whose shapes most
> closely approximate the brute animals and whose intelligence has not
> grown to the point of arriving at a regular government nor the least
> appearance of coordinated knowledge, has preserved no written records
> or traditions at all.[13]

So intent was his defamation of African people that—echoing Blumenbach's
designation of North Africans as Caucasians—he argued that Africans could not
possibly have created the ancient culture of Egypt. "No race of Negro," Cuvier
wrote, "produced that celebrated people who gave birth to the civilization of
ancient Egypt, and from whom the whole world has inherited the principles of
its laws, sciences, and perhaps also religion."[14]

Returning to her sideshow life after leaving the museum, the "Hottentot
Venus" died nine months later at the age of only twenty-six. As her final humil-
iation, Georges Cuvier was given the coveted assignment of dissecting her body
for the annals of science. What the live examination was unable to reveal would
be divulged by Sarah's postmortem. Cuvier clearly relished the job, for, in his
own words, "there is nothing more famous in natural history than the tablier."[15]

The dismantling of Sarah Bartman's body was particularized in a report filed
by Cuvier, first published in the *Mémoires du muséum d'histoire naturelle* in 1817,
and recirculated in later editions of his writings for years to come. Though today
a dismal instance of Enlightenment science at its worst, Cuvier's report was
intended as final proof of the Hottentot's zoologically primitive status. Examin-
ing her lifeless head, he wrote, "I have never seen a human skull more similar to
that of monkeys. Her stupidity was due to that cruel law which seems to have
condemned to eternal inferiority, those races with small compressed skulls."[16]
Discussing her buttocks, Cuvier likened them to the backsides of mandrill
baboons. Her breasts were maligned as well.[17] Calling to mind his examination
of Sarah while she was still alive, Cuvier wrote: "Her movements have something
brusque and capricious about them, which recall those of monkeys. She had,

above all, a way of pouting her lips, in the same manner as we have observed in orangutans."[18]

Most of these details, Cuvier noted, simply affirmed what Parisian observers, lay and scientific, already thought they knew. "Everyone," he wrote, "was able to see during her eighteen month stay in our capital, and to verify the enormous protrusion of her buttocks and the brutal appearance of her face."

The famous tablier, however, remained a puzzle waiting to be solved. As a cadaver, Sarah could no longer protect herself, and Cuvier approached her private parts with glee. He would reveal to the world what, until now, was only conjecture. Cuvier's report would now provide proof. Viewing Sarah's body as representative of all Khoisan women, he wrote:

> The labia minora, or inner lips of the ordinary female genitalia are greatly enlarged in Hottentot women, and may hang down three or four inches below the vagina when women stand, thus giving the impression of a separate and enveloping curtain of skin.

This abnormality, as he saw it, confirmed that the Hottentot were "most bestial" among humans, though he decided to include them within the species Homo sapiens. So fascinating to Cuvier were Sarah's genitalia that he removed them from her body and, when presenting his findings to a gathering at the Academy of Science, announced with a flourish, "I have the honor to present to the Academy the genital organs of this woman prepared in a manner that leaves no doubt about the nature of her tablier." With this, he dramatically unveiled the genitalia of Sarah Bartman, née Saartjie Baartman, pickled in formaldehyde.[19] Following this scientific debut, a bell jar containing Sarah's genitals, her skeleton, and a cast made of her body were put on public display at the Natural History Museum in Paris (later moved to the anthropological Musée de l'homme, remaining there well into the twentieth century). In a nod toward international cooperation, her skin was sent to England, where it was handed to a taxidermist, to be stuffed for public display. Londa Schiebinger writes that stereoscopic views of her body cast remained for sale at the Paris museum into the 1940s.[20]

Beyond cruelty, the story of the "Hottentot Venus," unveils another curious aspect of European thinking. Stephen Jay Gould, when he visited the Musée de l'homme in the 1980s, noted that Saartjie Baartman's genitalia were kept on a shelf alongside the genitals of "une négresse" and "une péruuvienne." Nearby, in other jars, stood the brains of "illustrious" European scientists, "all

white and all male." "I found," Gould reported, "no brains of women . . . nor any male genitalia."[21]

These equations of European masculinity with mind, sexuality and femaleness with primitivism, are ongoing refrains of Western culture. They shed light on a powerful ambivalence toward sexual life itself, a tendency to project this basic element of human experience onto "the other." In *Civilization and Its Discontents*, Sigmund Freud addressed this dichotomy and drew incisive links between sexual repression and colonial conquest. In "Western European civilization," he argued, sexuality is treated like a "suppressed" people who have been "subjected" to "exploitation." Like a conquered population, he wrote, sexuality is seen as a thing that must be vigilantly controlled lest civilization risk the dangers of "revolt."[22] Within Victorian culture, and its Continental counterparts, identifying the essence of non-European peoples through their primary and secondary sexual characteristics performed two functions at once. It denied them any claim to intelligence while, at the same time, it justified the need for "civilized" Europeans to exert their power over them.

With the rise of independence movements in Europe's former colonies and then in the postcolonial period, the display of the "Hottentot's" body parts began to lose its appeal. Rather than emphasizing Europe's superiority, it became evidence of the brutality with which Europe had methodically subjugated, and then defamed, many of the world's peoples. Unceremoniously, the body parts of Saartjie Baartman were removed from public view, secreted in the back rooms of the museum, though still available to scientists wishing to view the grisly trophies. Finally, after extended negotiations with French authorities, a postapartheid South Africa was able to reclaim the mutilated remains of its tragic daughter, attempting to restore a dignity that had been irreparably defiled.

Significantly, Saartjie Baartman was not the only person ripped from her roots to serve as a living representative of racial inferiority. If anything, she was the beginning of what would become a major industry. Throughout the nineteenth century and well into the twentieth, the exhibition of "primitive" types would become a mainstay of an expanding science-as-entertainment business. Group after group of "natives," some actual persons plucked from afar, some actors, would be paraded before European and American eyes, providing a visual argument on behalf of the inherent superiority of Western civilization.

London was an important center for this melding of science and popular culture. At the same time that Saartjie Baartman was being displayed there, a man named William Bullock opened the London Museum, or the Egyptian Hall as it was commonly known. This venue became known for its displays of

"primitive" human life. In 1822, Bullock displayed a group of Laplanders, inhabitants of Europe's far north, who were widely regarded as an inferior race. Later, a collection of "Wild Indians" from America appeared at the Egyptian Hall. Shortly thereafter, two "Bushmen" children were put on display, along with a group of monkeys. "The young Bushmen's routine," writes Richard Altick, "consisted of the very kind of tricks that monkeys were taught to perform."

These children were followed by a second troupe of Bushmen, assembled to invoke a vision of their brutish position in comparison with the status of those who paid to gawk. The *Times of London* reported on this exhibit on May 19, 1847:

> In appearance they are little above the monkey tribe, and scarcely better than the mere brutes of the field. They are continually crouching, warming themselves by the fire, chattering or growling, smoking, etc. They are sullen, silent, and savage—mere animals in propensity, and worse than animals in appearance. The exhibition is, however, one that will and ought to attract. The admirers of "pure nature" can confirm their speculations on unsophisticated man, and woman also, or repudiate them by a visit to these specimens.

The *Illustrated London News'* story on the Bushmen emphasized the extent to which the exhibit offered a palpable opportunity for the masses to see the chasm separating primitive Africans from cultivated Europeans. The Bushmen, the *News* reported, were a "fine subject for scientific investigation, as well as a scene for popular gratification, and rational curiosity."

> It was strange, too, in looking through one of the windows of the room into the busy street, to reflect that by a single turn of the head might be witnessed the two extremes of humanity—the lowest and highest of the race—the wandering savage, and the silken baron of civilization.[23]

These exhibits, orchestrated to underwrite ideas of human inequality, became a mainstay of popular, scientific entertainments in London, though they began to fade in the face of antislavery protestations as the century wore on.

In the United States, the legacy of slavery, along with ongoing wars against Native American peoples, provided a context that was ripe for orchestrated visions of "the primitive." One of the primary catalysts for this brand of

showmanship was a succession of world's fairs, commencing in 1876 with
Philadelphia's Centennial Exhibition. Alongside displays of American culture,
industry, and agriculture stood presentations of "native Americans and other
'exotic' people from around the world." In Philadelphia, the distinction
between science and the freak show became hazy, as evidenced in displays such
as "The Wild Men of Borneo," "The Wild Australian Children," and "The
Man-Eating Feegees."24

Less than twenty years later, Chicago's Columbian Exposition (1893), a
grandiose architectural showcase of American civilization, included a Midway
Plaisance, a long stretch of pay-for-view amusements. Some of these were quaint
reconstructions of small European villages. Far more evocative, however, were
exhibits constructed to illustrate convincing renditions of primitivism, situated,
not surprisingly, near tableaus that highlighted the sexual abandon of the Casbah.
The historian John Kasson writes:

> The Midway constituted a colossal sideshow . . . six hundred feet wide
> and a mile long. . . . Fairgoers threaded their way on foot or in hired
> chairs among a hurly-burly of exotic attractions: mosques and pagodas,
> Viennese streets and Turkish bazaars, South Sea island huts . . . and
> Indian tepees. Tourists gawked at the extraordinary panorama of the
> world's peoples: Egyptian swordsmen and jugglers, Dahomean drum-
> mers, Sudanese Sheiks, Javanese carpenters, Hungarian gypsies, Eski-
> mos, Chinese, Laplanders, Swedes, Syrians, Samoans, Sioux. . . . They
> pushed into the Streets of Cairo, the Algerian Village, and the Persian
> Palace of Eros to watch entranced as "Little Egypt," and her colleagues
> and competitors, performed the "Dance du ventre," popularly known
> as the hootchy-kootchy.25

Adding the imprimatur of science to these theatrics, the anthropologist
Franz Boas served as chief advisor for these ethnographic exhibits. Among his
responsibilities was the "Dahomey Village," housing "sixty-nine native war-
riors." These people from West Africa, who had recently been conquered by
the French, were presented as fierce savages, performing a war dance as the cen-
terpiece of each show. Robert Bogdan, the historian of freak shows, notes that
the "advertising banner for the exhibit pictured the Dahomans in ferocious poses
wearing grass skirts and carrying menacing spears." Like Saartjie Baartman,
many of the fair's human exhibits did not survive their public exposure. Unable
to endure in such circumstances, many died. Their preserved remains then

92

assumed another role, as specimens in a newly established Chicago museum, where Boas served as curator.

Not far from the fairgrounds, Buffalo Bill's Wild West Show provided live demonstrations of Indian attacks on a regular basis. A year after the Columbian Exposition opened, the Barnum and Bailey Circus included a "Great Ethnological Congress of Savage and Barbarous Tribes" in its menagerie, flanking more conventional human oddities.[26]

Despite frequent fatalities, the flow of human exhibits only continued. Robert Peary, in his explorations of the North Pole, had employed Inuit (Eskimos, as he called them) from Greenland, along with their dogsleds, to

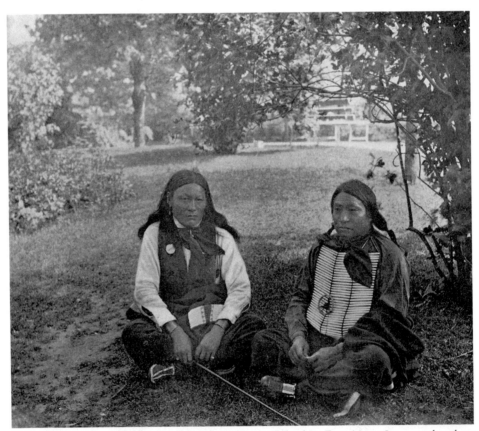

This portrait of two members of the "Sioux Nation" at the Columbian Exposition, 1893, was taken three years after the U.S. Army's massacre of American Indians at Wounded Knee, the final episode in the "Indian Wars." REPRINTED FROM J. W. BUEL'S *THE MAGIC CITY: A MASSIVE PORTFOLIO OF ORIGINAL PHOTOGRAPHIC VIEWS OF THE GREAT WORLD'S FAIR*, ST. LOUIS, 1894; FROM THE COLLECTION OF THE EWEN LIBRARY

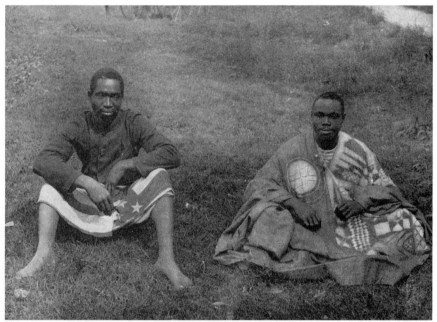

Two men described as "Dahomian Cannibals" at the Chicago World's Fair, 1893. J. W. Buel, who produced a portfolio of photographs of the fair noted, "Object lessons in intellectual advancement were afforded by the gathering here of representatives of many semi- and totally uncivilized races, brought from far away and benighted countries, peoples from hyperborean climes and from Equatorial regions, the extremes of heat and cold, where the savagery of original condition still prevails, among whom superstition controls and cruelty is custom." REPRINTED FROM J. W. BUEL'S *THE MAGIC CITY: A MASSIVE PORTFOLIO OF ORIGINAL PHOTOGRAPHIC VIEWS OF THE GREAT WORLD'S FAIR*, ST. LOUIS, 1894; FROM THE COLLECTION OF THE EWEN LIBRARY

hunt for meat to feed the expedition. They were paid "cheaply with trade goods brought from the United States." Despite what he described as their "trustworthy and hardy" contribution to his efforts, Peary condemned the Inuit as hopelessly uncivilized.

> I have often been asked: "Of what use are Eskimos to the world?" They are
> far too removed to be of any value for commercial enterprises; and, further
> more, they lack ambition. They have no literature; nor, properly speaking,
> any art. They value life only as does a fox, or a bear, purely by instinct.[27]

Despite his general condemnation of their characters, Peary believed that his Inuit recruits would be of interest in the United States, where the craze of natural history was at its peak. Accordingly, in 1897, he convinced four of his Inuit helpers, along with two of their children, to accompany him to New York. According to

94

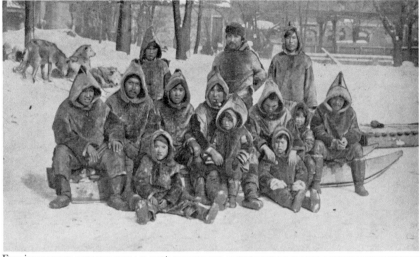

Esquimax group. REPRINTED FROM J. W. BUEL'S *THE MAGIC CITY: A MASSIVE PORTFOLIO OF ORIGINAL PHOTOGRAPHIC VIEWS OF THE GREAT WORLD'S FAIR*, ST. LOUIS, 1894; FROM THE COLLECTION OF THE EWEN LIBRARY

This "Moorish Odalisque" or harem girl from Algeria was presented as the sultan's favorite, "fresh from the Seraglio," the harem apartments of a palace. REPRINTED FROM J. W. BUEL'S *THE MAGIC CITY: A MASSIVE PORTFOLIO OF ORIGINAL PHOTOGRAPHIC VIEWS OF THE GREAT WORLD'S FAIR*, ST. LOUIS, 1894; FROM THE COLLECTION OF THE EWEN LIBRARY

Minik, one of the children, the group was promised a life of comfort and abundance. Peary, he recalled, "promised us nice warm homes in the sunshine land, and guns and knives and needles and many other things."[28]

With the encouragement of Boas, now assistant curator of New York's American Museum of Natural History, Peary deposited his wards at the museum, where they were to be studied and displayed as living primitives. He had sold Inuit bones to the museum in the past, but this time living flesh surrounded the bones. New York, evidently, was not conducive to the Inuit's health. Within months, four of them died of pneumonia, a fifth returned to Greenland, and the last, the child Minik, was—out of pity— taken into the home of a superintendent of the museum. The bones of the four dead Inuit, including Minik's father, Qisuk, became part of the museum's permanent collection. To assuage

Minik's grief over his father's death, while at the same time protecting its hold-
ings, the museum in 1898 staged a fake burial in which a log, which Minik
believed to be his father's bones, was solemnly laid to rest.[29] Meanwhile, his
father's actual skeleton lay in a display case beside the bones of the other Inuit who
had perished.

Years later, Minik returned to Greenland, reflecting on the
cruelty of the people who had turned him and his family into
a public scientific experiment. "Whites," he declared with
mocking bitterness, "are the civilized men who steal and
murder, and torture, and pray, and say 'Science.'"[30]

Among Anglo-Americans, such judgments fell on deaf
ears. At the St. Louis World's Fair of 1904, where anthro-
pology was a featured science, the display of primitives
continued. Again, Boas lent his prestige to the proceed-
ings. Among the exhibits, a defeated Geronimo, the once
proud Apache leader, was under armed guard, to be gaped
at by fairgoers. Geronimo, and other conquered Apaches,
stood adjacent to other anthropological acts, including an
exhibit of a hundred South African Zulus—who were
required to reenact battles with combined forces of whites
from the Boer War—and a group of pygmy Bushmen from
the Congo.[31]

One of the Bushmen was a twenty-three-year-old man
named Ota Benga. Captured by the Belgian colonial
Force publique following the massacre of many in his
encampment, he was forced into slavery in the village of
Baschilele. There he was discovered by an American
entrepreneur, Samuel Phillips Verner, who had traveled
to the Congo with a commission to bring back a group of
pygmies.

This "Soudanese Girl" was part
of a group on display at the
Columbian Exposition. J. W.
Buel, in his portfolio of fair
photos, wrote, "it would be a
very imaginary person who
could discover signs of beauty
in their faces or grace in their
movements." REPRINTED FROM J. W.
BUEL'S *THE MAGIC CITY: A MASSIVE PORTFO-
LIO OF ORIGINAL PHOTOGRAPHIC VIEWS OF
THE GREAT WORLD'S FAIR,* ST. LOUIS, 1894;
FROM THE COLLECTION OF THE EWEN
LIBRARY

Having gained notoriety in St. Louis, this little man,
his teeth filed to points, went on the road as a traveling
exhibit. Two years later, in 1906, Ota Benga arrived in
New York City, where he became an ethnographic dis-
play, once again at the Museum of Natural History, where
he was housed in an apartment. With Benga's manager,
Verner, in need of money, the director of the museum
proposed that the pygmy might be of greater interest to

A "Corean" (Korean) father and son on display in Chicago. REPRINTED FROM J. W. BUEL'S *THE MAGIC CITY: A MASSIVE PORTFOLIO OF ORIGINAL PHOTO-GRAPHIC VIEWS OF THE GREAT WORLD'S FAIR*, ST. LOUIS, 1894; FROM THE COLLECTION OF THE EWEN LIBRARY

the public if he were placed in the recently opened Bronx Zoological Gardens. Following this suggestion, Verner sold Ota Benga to the Bronx Zoo, whose directors gladly exhibited their purchase as a missing link. On September 9, 1906, the *New York Times* announced the new acquisition under the following headline: "BUSHMAN SHARES A CAGE WITH BRONX PARK APES."

He was an immediate sensation. For an Anglo-American population fearful of the massive influx of immigrants that was under way, and struggling to control a large free black population, the spectacle of a man living in the same cage with an orangutan offered tangible reassurance that the world was, in fact, inhabited by people of unequal worth. Indeed, Ota Benga was used to demonstrate that some groups occupied an enigmatic position in which the distinction between human and animal broke down. As the *Times* reported, "the pygmy was not much taller than the orangutan, and one had a good opportunity to study their points of resemblance. Their heads are much alike, and both grin in the same way when pleased."

Ota Benga remained at the zoo for scarcely a month. The spectacle brought widespread protests, and the twenty-three-year-old native of the Congo was then sent to live in an orphanage for black children. Despite the brevity of his sojourn in the Bronx, Ota Benga was part of a lasting tradition of public science exhibits that were used to validate the social and scientific marginalization of "lower" humans and, in some cases, to justify the elimination of these "inferior" beings.[32]

Yet it was not simply world's fairs and natural history museums that exploited exhibitions of the primitive. Competing for public attention with "scientific" displays in imposing settings, circuses, amusement parks, and so-called "dime museums" routinely included exotic people in their sideshow exhibits. Some were actual migrants from distant lands, others were dressed up to perform their assigned roles.

P. T. Barnum was an innovator in this direction. Adapting Blumenbach's racial taxonomy to the bombast of showmanship, his so-called primitives were exhibited along with a "Circassian Beauty," a young woman employed

to represent the summit of Caucasian perfection. Con-
forming to the tendency to equate female sexuality
with exoticism, official publicity announced that she
was acquired from a Turkish harem, a legendary site of
captivity for kidnapped Caucasian beauties, or "white
slaves," as they were often called. Insiders knew that
she was a woman from New York who had ventured
into the American Museum looking for work.33 By the
1880s, along with Wild Men of Borneo, Australian
Wild Men, and Fiji Cannibals, Circassian beauties
became a staple in sideshows around the country, offer-
ing a symbolic ideal of beauty against which so-called
primitives could be measured.

A girl from the "Streets of Cairo"
exhibit, Chicago, 1893. REPRINTED
FROM J. W. BUEL'S *THE MAGIC CITY: A MASSIVE
PORTFOLIO OF ORIGINAL PHOTOGRAPHIC VIEWS OF
THE GREAT WORLD'S FAIR*, ST. LOUIS, 1894; FROM
THE COLLECTION OF THE EWEN LIBRARY

Using Coney Island's Dreamland as his base, it was
a Missouri showman named Samuel Gumpertz who
transformed such human spectacles into a mass indus-
try. From 1905 into the late 1920s, he scoured the world for ethnographic odd-
ities, visiting Egypt, Java, Burma, Borneo, the Philippines, French Equitorial
Africa, Algeria, and many other locales. Importing nearly four thousand peo-
ple, he presented them at the famed seashore amusement park, leasing them as
well to "circuses, museums, and carnivals here and abroad."34 Barnum often
used imposters to represent people from around the world, but Gumpertz's
expeditions, like those of natural history museums, yielded bona fide human
booty.

> While P. T. Barnum foisted a local black man as the Wild Man of Bor-
> neo, Gumpertz went to Borneo and leased nineteen Wild Men from a
> tribal chieftain for a price of two hundred bags of salt. From Burma he
> brought women who had stretched their necks fourteen inches by grad-
> ually adding brass rings. A tribe of 125 Somali warriors, that he
> imported, fascinated the public by rubbing blue clay into self-inflicted
> wounds as an antidote to internal pain.35

By the 1920s, exhibits such as these brought "as many as thirty thousand
patrons a day" to Gumpertz's Dreamland Sideshow. Elsewhere, during a decade
when the Ku Klux Klan was in its prime and the lynching of blacks was still com-
mon, similar spectacles, emphasizing racial inequality, flourished. Alongside of this,
ironically at a moment when American women had recently acquired the rights

98

of citizenship, hypersexualized "Oriental" dancers, spiritual daughters of "Little Egypt," served as reminders of what was, for many men, a more enticing version of womanhood.

When it came to ethnographic exhibitions, the distinction between science and sensationalism had completely broken down. In 1933–1934, at Chicago's "Century of Progress" World's Fair, marvels of American industry were juxtaposed with a "Darkest Africa" exhibit, purporting to offer visible evidence of the stark distinction separating savagery from civilization. Promoted as an "educational display," the attraction featured near naked "Africans" (men in g-strings, women also topless) speaking a made-up gibberish, while an actor dressed as a Great White Hunter offered a narration of the cruelties these people were capable of. A few of the blacks working in "Darkest Africa" were, in fact, Africans, though they came from a community of expatriates living in New York City. The others, according to one of the showmen who organized the exhibit, "were recruited from Chicago pool halls."[36]

• • •

Ota Benga at the St. Louis Exposition, 1904.
FROM THE COLLECTION OF THE AMERICAN MUSEUM OF NATU-
RAL HISTORY

Today, a century after Ota Benga's arrival in New York, most natural history museums have worked to cleanse their public image. In a world that has, for the most part, been forced to acknowledge and accept ethnic diversity, many colonial trophies have been removed from public view. Some remain in storage, while others—like Saartjie Baartman—have been returned to their homelands for proper burial. Following decades of official refusal and an attempt to cover up the museum's complicity in their demise, in 1993, the bones of Qisuk and his three Inuit comrades were finally given back by the American Museum of Natural History for committal to their native soil in Greenland.[37] Similarly, in the year 2000, the Museu Darder d'historia natural in Spain relinquished a stuffed human being "dressed in feathers and skin," known as "El Negro," who had been part of the

museum's holdings since 1888. Stolen from his grave by two enterprising French taxidermists, he had been exhibited to ogling school children for over a century before being repatriated to Botswana.[38]

Similarly, as sensitivities to racism—as well as to disability—have evolved, the sideshow has largely disappeared as a feature of public entertainment. Yet, in great measure, visions of human inequality that were popularized by scientists and showmen in two overlapping arenas, continue to occupy a place in visual popular amusements, most specifically in the practice of typecasting that continues as a routine in film, television, advertising, computer games, and, perhaps of greatest concern, in the news of the day.

Minik, sole survivor of "Eskimos" brought to New York by Robert Peary for display at the American Museum of Natural History. FROM THE COLLECTION OF THE AMERICAN MUSEUM OF NATURAL HISTORY

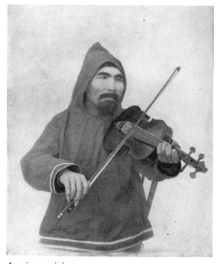

Arctic musician. REPRINTED FROM J. W. BUEL'S THE MAGIC CITY: A MASSIVE PORTFOLIO OF ORIGINAL PHOTOGRAPHIC VIEWS OF THE GREAT WORLD'S FAIR, ST. LOUIS, 1894; FROM THE COLLECTION OF THE EWEN LIBRARY

10
SPURZHEIM'S FUNERAL

On November 14, 1832, the *Boston Medical and Surgical Journal* carried out its "melancholy duty to record the death of a great and good man," Dr. Johann Gaspar Spurzheim. Regarded as one of the world's foremost experts on the "anatomy and physiology of the brain and nervous system," J. G. Spurzheim had arrived in the United States in September of the same year. Over the next two months, he delivered eighteen spellbinding lectures, continuing even after his health began to fail. Then, following a lecture in Boston, he died on a Saturday evening in November. Spurzheim's death, the *Journal* lamented, was nothing short of "a calamity to mankind."[1]

Spurzheim had come to the United States for the purpose of studying the heads and brains of "Indians and slaves" and visited a number of "medical schools and prisons" as well. Yet beyond these inquiries, he also earned a great deal of fame and money through his lectures, which caused a sensation. "Spurzheim's countenance beaming with superior intelligence," reported one attendee, "captivated his large audiences."[2]

Spurzheim's influence reached beyond the medical community. As a contemporaneous admirer observed, his lectures had drawn "the most eminent and the most humble—the fashionable and the learned, the gay and the grave, the aged and the young, the skeptic and the Christian."[3]

For many, his death came as a shock. Three thousand people marched to his funeral in Cambridge, which was led by Josiah Quincy, president of Harvard University. Ralph Waldo Emerson declared him "the world's greatest brain."[4] Following the funeral, his body—or, at least, most of it—was interred at Mount Auburn Cemetery.

In life, Spurzheim was no stranger to autopsies. Unlike the many who still viewed postmortems as desecrations of sacred remains, Spurzheim had spent years dissecting the brains of humans as well as many other life forms. Given this background, it is not surprising that Spurzheim's funeral was preceded by a "public autopsy" at the Harvard Medical School, performed by a team of thirteen eminent doctors.

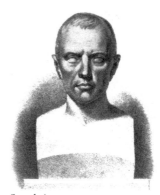

Spurzheim. REPRINTED FROM *JG SPURZHEIM: PHRENOLOGY IN CONNEXION WITH THE STUDY OF PHYSIOGNOMY*, 1833

Prior to the procedure, a body cast was made, and James Audubon, among other artists, prepared portraits of the great man in repose.5 Following this process, necessary incisions were made, with a particular emphasis on examining the brain of this widely heralded genius. The brain, itself, was declared "unusually large," weighing 57 ounces. After the examination of his brain and viscera was complete, his body was embalmed for burial, but his brain remained behind, to be preserved in alcohol and kept at the Harvard Medical School. A more appropriate memento of his visit to the United States J. G. Spurzheim could not have left behind.

Born on a farm near Trier, Germany, in 1776, Spurzheim achieved celebrity as the leading "missionary" of new science which, beginning in the first decade of the nineteenth century, began to stir a great deal of interest in Europe. The new science was known as phrenology. In truth, it was not Spurzheim who was the originator of this fascinating field of study. Phrenology was the invention of Spurzheim's teacher, Franz Joseph Gall.

After initially studying divinity and philosophy at the University of Trier, Spurzheim left his clerical aspirations behind and moved to Vienna in 1799. There he began to study medicine, supporting himself by serving as tutor for the children of a Viennese aristocrat. "Gall was the nobleman's physician and this is how Gall and Spurzheim first met in 1800."6

Spurzheim's senior by nearly twenty years, F. J. Gall was already an eminent doctor and anatomist. His cabinet of more than three hundred skulls, as well as casts made from skulls and brains, was among the largest in Europe. Yet Gall and the twenty-four-year-old Spurzheim had something in common. Both had begun their studies with theology. Both had deserted this pursuit for the study of medicine. An overlapping interest in religion and anatomy would leave a deep imprint on their legacy.

Spurzheim was immediately impressed by Gall's ideas and compelling personality, and he began attending the famed doctor's lectures on "cranioscopy." Soon he became Gall's assistant and, then, collaborator. As they joined forces, and as they gained a following, the term "cranioscopy" gave way to "phrenology." A study of the brain that saw it as broken up into twenty-seven different organs, phrenology assigned each organ its own particular function. Nineteen of these organs were common to humans and other animals. The remaining eight separated humans from the animal world.

Previously, the brain was little understood, and the human mind was seen as a metaphysical expression of the soul. Gall and Spurzheim's theory of

phrenology broke with that assumption. They argued that the mind, along with a range of other conceptual, emotional, and behavioral characteristics, was located in the brain. "The brain," Gall wrote, "is the organ of all faculties, of all tendencies, of all feelings."[7]

Both Gall and Spurzheim perceived themselves as carrying forward ideas first developed by Lavater in his *Essays on Physiognomy*. Like Lavater, they saw physiognomic analysis as a tool for deciphering an individual's moral worth. But, if Lavater saw the structure of the face as the primary text to be read, Gall and Spurzheim argued that facial dynamics were merely an expression of the true seat of character, the brain. "Skull palpitation," a detailed, hands-on assessment of a person's cranium, they believed, could provide an accurate map of the brain that lay within.

Phrenological examinations were predicated on assumptions about where different human faculties resided within the brain. These hypotheses were based on Gall's meticulous study of the heads and brains of people of differing characters and capabilities. He studied the cranial structures of men of proven talent and intelligence, also the heads of the insane and of criminals, including the brains of recently executed murderers. To provide himself with an adequate database, he also brought people from the streets into his home for systematic study.

> I collected in my house . . . quite a number of individuals following different occupations; such as coachmen, servants, etc. I obtained their confidence and disposed them to sincerity by giving them beer, wine and money and when they got favorably inclined; I got them to tell me of each other's good, bad and most striking characteristics. I ranged the quarrelsome on one side, and the peaceable on the other and examined carefully the heads of both. I found that in all the former the head, immediately behind and on a level with the top of the ears, was much broader than the latter.
>
> On another occasion I assembled separately those who were the most distinguished for their bravery and those most distinguished for their cowardice. I repeated my researches and found my first results confirmed. I, therefore, began to conjecture that the disposition to quarrel must really be the result of, a particular organ.[8]

Basing his original theory of cranioscopy on such explorations, Gall began to draw a comprehensive map of the human brain that provided the foundation upon which the study of phrenology would be built. Generally speaking, that portion of the brain that resides toward the front of the head, back to the tem-

104 ples and down behind the eyes, included the organs where intellectual, analytical, and rational faculties were found. The powers of language and observation, along with poetic, musical, and satirical abilities, occupied this region as well. Reflecting the implicit biases of Camper's facial angle, Gall and Spurzheim's cranioscopy deemed a high, broad, and large forehead a sign of formidable intellectual powers.

The top of the brain, situated closest to God, was the territory where moral and religious faculties were located. The area of the brain that surrounded the ear in front and behind was where personal propensities could be found: the love of property, ambition, and the desire for success, and—as we have seen—the combativeness or courage that leads one to violence. Secretive, destructive, and murderous tendencies were found here as well. The rear portion of the brain, reaching down toward the brain stem, was the headquarters for primal instincts: sexual and reproductive desire (termed "amativeness"), parental love, love of family and friends, and a sense of connection to the larger group. Development or lack of development in specific areas provided the phrenologist with keys for unlocking the overall character.9

Craniological examination commenced with a gross anatomical evaluation that, Gall and Spurzheim believed, could provide valuable prefatory information regarding a person's temperament. If the brain was divided into twenty-seven organs—thirty-five, after Spurzheim revised Gall's numbers—bodies fell into four general types, each indicating a particular constitution.

"The lymphatic . . . or phlegmatic temperament," Spurzheim explained, is marked "by a pale white skin, fair hair, roundness of form, and repletion of the cellular tissue. The flesh is soft, the vital actions are languid, the pulse is feeble; all indicates slowness and weakness in the vegetative, affective and intellectual functions.

"The sanguine temperament," he continued, "is proclaimed by a tolerable consistency of flesh, moderate plumpness of parts, light or chestnut hair, blue eyes, great activity of the arterial system, a strong, full, and frequent pulse, and an animated countenance. Persons thus constituted," he added, "are easily affected by external impressions, and possess greater energy than those of the former temperament.

"The bilious temperament," describing the third type, "is characterized by black hair, a dark, yellowish, or brown skin, black eyes, moderately full, but firm muscles, and harshly-expressed forms. Those endowed with this constitution have a strongly marked and decided expression of countenance; they manifest great general activity, and functional energy."

Last came the nervous temperament, characterized by "fine thin hair, delicate health, general emaciation, and smallness of the muscles, rapidity in the muscular actions, vivacity in the sensations. The nervous systems of individuals so constituted," Spurzheim concluded, "preponderates extremely, and they exhibit great nervous sensibility."[10]

These broad typologies were useful indicators, but they were merely expressions of that which was determined by the conformation of the brain. To decipher brain structure, a close measurement of cranial particulars was required. Spurzheim summarized the main points of this procedure.

> [The phrenologist] must . . . examine the head generally, in regard to size, and acquire ideas of what may be entitled small, middling, and large-size heads. After this he will consider the relative size of the various regions of the head, and the development of the individual parts of each region, that is to say, the length and breadth of the particular organs; finally he will ascertain the proportionate size of all organs to each other.[11]

While phrenological maps were infused with moral and religious values and could be employed to distinguish sinners from saints and good from evil, there was also something decidedly modern about Gall and Spurzheim's outlook. Paving the way for present-day understandings of brain function, they had an insight into the brain as a physical entity where different regions are devoted to the performance of particular tasks: conscious, unconscious, sensory, and autonomic.

This unvarnished materialism, despite the authors' retention of a largely religious vocabulary, landed Gall and Spurzheim in hot water. In Catholic Europe, their ideas were at odds with prevailing dogma and remained controversial. Their vision that a person's identity was situated in the nervous system contradicted the long-held notion that personhood was a spiritual state of being, capable of occupying or transcending the body, according to the vicissitudes of life and death.

Between 1800 and 1812, Gall reigned as the primary public spokesperson for cranioscopy, or phrenology, as it was more often called. He lectured widely to enthusiastic audiences. The notion that erstwhile mysteries of the soul could now be scientifically understood, applying rules of visible evidence, was enormously popular among an educated population that believed the laws of nature could be discerned through an informed process of observation and analysis. The power

of the Catholic Church, however, remained considerable, and authorities repeatedly banned lectures on phrenology. First, in 1801, Gall was accused of "materialism" and forbidden by the emperor to continue lecturing in Vienna. Following this ban, he took his show, along with Spurzheim, on the road, delivering lectures in Germany, Switzerland, Holland, and Denmark, all centers of Protestant thinking. As passions for his ideas grew, Gall's style of delivery became increasingly colorful. The science of phrenology was fast becoming an exercise in showmanship.[12]

This move toward theatrics upset numerous scientists, many of whom rejected phrenology as a speculative and unproven theory. The fanaticism that grew up around Gall's phrenological road show also alarmed them. More and more practitioners of phrenology, most without scientific training, were setting up shop, and official science began to decry Gall's theory as a catalyst for charlatanism.

Yet, scientific attacks on Gall also had a political dimension. When Gall and Spurzheim settled in Paris in 1807, one of Gall's first public acts was to perform a phrenological reading of Napoleon Bonaparte's head. In his chart of the Emperor's phrenological conformation, Gall committed a faux pas when he proclaimed that the circumference of the Emperor's head was somewhat smaller than might be expected of a great man. Napoleon was further offended that "Gall's interpretation of his skull missed some noble qualities he thought he had." Shortly after this well-publicized reading, Baron Georges Cuvier—the very same man who would later carve up Saartjie Baartman—was summoned to lead a committee from the scientific establishment to study phrenology's scientific legitimacy. The committee, formed by the prestigious Institute de France, issued a finding indicating that phrenology was neither scientific nor trustworthy. There are strong indications that this declaration was forged by pressure from Napoleon himself.[13] Rather than becoming defensive in the face of such denunciations, Gall seemed to bask in the publicity that came with attacks on his beliefs.[14] His lectures continued, and phrenology's popularity proliferated.

Between 1812 and 1813, trouble began to brew between Gall and his disciple Spurzheim. Gall's phrenology was based on anatomical examination. Its judgments were based on simple correlations between structure and character. Spurzheim suggested that phrenology had philosophical implications and could be employed as a tool for social improvement. While the details of this claim remain vague, Spurzheim argued that the organs of the brain, representing different human faculties, were inherently good. Raised in a wholesome climate,

a person would develop into a decent and honorable individual. When abused, however, these same faculties could lead one to a life of iniquity. This move toward a less deterministic perspective propelled a break between father and son. Spurzheim went off on his own as a new, even more potent missionary for phrenology, combining the certainty of science with the possibility of perfection. Spurzheim left France, where he and Gall had been living, and brought his revised theory to England, where he settled in March 1814. Beginning in the 1820s, he published his revised interpretation of phrenology in a number of books, including *The Anatomy of the Brain With a General View of the Nervous System* and *Phrenology in Connexion With The Study of Physiognomy*. In England, he also began to cleverly package phrenology for public consumption. One aspect of this effort was his publication of the now well-known image of a phrenological head, with sections of the cranium marked off to indicate the now thirty-five organs. Spurzheim's image became the basis for porcelain and plaster busts that were mass-produced throughout the nineteenth century and became prized possessions in Europe and the United States. Gall had published phrenological illustrations depicting subdivided skulls, but Spurzheim's more palatable use of a recognizable human head made the practice of phrenology more accessible to a nonscientific audience.[15]

In Britain, Spurzheim, along with his estranged mentor Gall, continued to be assailed by the medical-scientific establishment. In the pages of the esteemed *Edinburgh Review*, in 1815, John Gordon, an anatomist, pounced on the two for disregarding commonly accepted scientific knowledge. Spurzheim and Gall, he argued, have

> so impudent a contempt for the opinions and labours of others, are so utterly destitute of every qualification necessary for the conduct of a philosophical investigation . . . for there is nothing sufficiently certain in nature, which these gentlemen will not call in question, if it be hostile to their views. . . . The writings of Drs Gall and Spurzheim have not added one fact to the stock of our knowledge. . . . [Phrenology is] a piece of thorough quackery from beginning to end.[16]

As had been the case with Gall, Spurzheim was energized by such assaults. Having learned the arts of oratory from his teacher, he traveled throughout the British Isles, lecturing to scientific and lay audiences alike. Though Gall would live until 1828, Spurzheim soon surpassed him in popularity, becoming widely identified as the principal voice of phrenology.

In his lectures, he carried audiovisual technique to new heights. To refute Gordon's assertion that phrenology was scientifically unsound, Spurzheim began dissecting human brains as part of his live performances. Such sensational additions only multiplied his fame.

Given his writings and dramatic flair, Spurzheim's reputation was at its height by the time he reached the United States; he had become a legendary figure. His book, *Phrenology in Connexion With The Study of Physiognomy*, had just appeared in its first American edition and his audiences were primed. The writer Harriet Martineau, who witnessed the Spurzheim phenomenon firsthand, observed that, in response to his visit, vast numbers of Americans were becoming avid amateur cranioscopists. "When Spurzheim was in America, the great mass of society became phrenologists in a day, wherever he appeared . . . caps, wigs, were pulled off, and all tresses disheveled in the search after organization."[17]

11
CRANIA AMERICANA

When Dr. John Gordon published his condemnation of phrenology in the *Edinburgh Review*, dubbed "the literary gospel of Edinburgh," George Combe was a sympathetic reader. Neglected as a child, trained as a lawyer, obstinate in his opinions, and very much in need of attention, Combe had fashioned himself as a public critic of Spurzheim and Gall. With bravado, he poked fun at this erroneous science. When a weird opportunity knocked, however, he abruptly changed sides.[1]

The occasion of his epiphany was a fortuitous encounter with J. G. Spurzheim in Edinburgh. By chance, Spurzheim was carrying a human brain in a paper sack, and he invited the doubting Combe to participate with him in a dissection of the specimen.[2] Patiently pointing out the various organs of the brain, and the faculties and propensities associated with each, Spurzheim mesmerized the once skeptical Combe. Without any medical training whatsoever, Combe—now at this physical proximity to an actual human brain, embellished by Spurzheim's compelling narration—was turned from disbeliever into one of Britain's first and most zealous converts to the materialist faith of phrenology.

Shortly after their meeting, Combe began attending a series of Spurzheim's lectures and soon emerged as an avid student and advocate. John van Wyhe, a leading writer on the subject of phrenology, speculates that phrenological theory appealed to an insecure man, such as Combe, in part because of its ability to bestow a mantle of "superlative intellectual authority," while requiring only "minimal effort" in its acquisition.[3]

When Spurzheim left Edinburgh, returning to Paris in 1817, Combe remained in close touch with him and also began to publish his own writings on phrenology. By 1820, Combe founded the Edinburgh Phrenological Society, the first such organization anywhere. For middle-class men who hungered for the prestige that scientific dilettantism conferred, the organization proved to be a magnet. Many had heard Spurzheim lecture in their city. Spellbound and persuaded by his presentations, they welcomed the opportunity to become members of a learned society. Within six years, membership grew to more than 120, and Combe purchased "a hall" where large meetings could be held and where a growing curiosity cabinet of "casts and skulls" was on view.[4]

In 1828, Combe published a book entitled *The Constitution of Man Considered in Relation To External Objects*, which would become one of the most influential texts in this escalating field of phrenology, remaining in print for over three quarters of a century and

selling more than 350,000 copies by 1900. With the deaths of Gall in 1828 and Spurzheim in 1832, George Combe emerged as the most important messenger of phrenology, traveling and lecturing extensively in Great Britain, Germany, and the United States.

Yet Combe was not simply a mouthpiece for the teachings of his predecessors. He also added his own contribution, turning phrenology, by the 1840s, in a direction that brought it in increasingly close contact with the burgeoning disciplines of racial science. It is not that race was never considered by Gall or Spurzheim. Spurzheim, for example, took for granted the inferiority of black people, and in one of his books affirmed with certainty:

> However gifted with talents, the Negro would still, were it confided in, be proclaimed inferior to the almost idiotic European. . . . One Negro may be a good musician or a mathematician, but the whole race does not, on this account, excel in these talents.

Despite this bald reiteration of a widely held European conviction, however, neither Gall nor Spurzheim had focused on race as a central factor in their phrenological writings. Their venom, insofar as it was expressed, was predicated on what they saw as measurable structural determinants that could be unsavory even among the highest orders of society. Spurzheim's description of the Roman Emperor Caracalla offers an eloquent expression of an unwillingness to be impressed by the cloak of high office. Basing his phrenological analysis on an engraving of the Emperor's head, he wrote:

> Viewed according to phrenological principles, this is one of the most ignoble configurations of a head which it is possible to conceive. An individual thus constituted is the victim of his inferior appetites, and animal nature; he is one who will delight in destruction, and prefer violent measures to mildness and clemency; his desires can never be restrained by reason and benevolence; force alone will avail to keep him within bounds, and were he to succeed in throwing off the ties of civil laws, it would not be with a view to philanthropy, but to seize the supreme power, and to tyrannize over his fellow creatures. Born in the lower ranks of society, he would delight in vulgar and degrading amusements, and avoid the company of noble-minded and reasonable beings. He is unfit to excel in any art or science—the whole tendency of his mind is towards brutal pleasures.[5]

In Spurzheim, phrenological analysis was primarily a tool for determining the moral and intellectual character of individuals, wherever those individuals might be found. In Combe's hands, however, phrenological diagnosis was decisively linked with estimations predicated on race and national identity. According to a cranial conformation that, allegedly, was found only among Europeans, it was Europe alone that could claim the authorship of civilization.

> If we glance over the history of Europe, Asia, Africa and America, we shall find distinct and permanent features of character which strongly indicate natural differences in their mental constitutions, [I]n the inhabitants of Europe belonging to the Caucasian variety of mankind, have manifested in all ages a strong tendency towards moral and intellectual improvement. As far back as history reaches, we find society instituted, arts practiced and literature taking root, not only in intervals of tranquility, but amidst the plains of war.[6]

Even within Europe, according to Combe, there were disparities. Only certain nations had proved worthy in the cultivation of civilized life. Measurable "mental deficiencies," he argued, had compromised the histories of a number of European peoples: the French, the Russians, the Germans, and the Irish, for example. Cranial conformation, however, had been kind to the British and, on the Continent, the Swiss.

> Independence accompanied by civilization is the result of large aggregate size of brain with the intellectual organs well developed and the moral faculties cultivated. Independence, civilization and political freedom are the results of large aggregate size of brain, the moral and intellectual regions predominating in the majority of people aided by long cultivation. This combination characterizes the British, Anglo-Americans and the Swiss.

Considering this cranial mapping of Europe, the historian David de Guistino has insightfully observed that the "old national stereotypes which Englishmen enjoyed making of their Continental neighbors were thus absorbed into phrenology and given deeper meaning."[7]

If parts of Europe did not fare well within Combe's cosmology, his "cerebral determinism" (an expression coined by di Guistino) was far more severe in its regard for non-Europeans. Asians, Africans, and the indigenous people

of the Americas, he argued, were inherently incapable of civilization and self-rule.

The superior brainpower that Combe ascribed to the British became a physiological rationalization for the global empire that they ruled. The ability of a small island nation to preside over the world, for small numbers of men to dominate many, was the inevitable outcome, he believed, of unequal cranial development.

Basing his evaluations on phrenological analysis, Combe wrote: "When we turn our attention towards Asia, we perceive manners and institutions . . . far inferior to the European standard." Regarding Africa, Combe maintained that the "annals of the races who have inhabited that continent, with few exceptions, exhibit one unbroken scene of moral and intellectual desolation; and in a quarter of the globe embracing the greatest variety of soil and climate, no nation is at this day to be found whose institutions indicate even moderate civilization."[8]

Not everyone was won over by the charm of phrenology. Some whites protested these racial generalizations, rebutting Combe and his theories in print. In 1833, for example, the antislavery advocate Alexander Everett published a pamphlet in which he argued that there was no correlation between the cranial structure of Africans and either their brainpower or their potential. Calling phrenology a "miserable heresy," he dismissed the idea that because of their "physical conformation," Africans were "condemned . . . to vegetate forever in a state of hopeless barbarism." Responding to the libel against Africa, Everett, like others, cited Egyptian civilization as incontrovertible proof of black people's achievements. These black Egyptians, described by Herodotus, were the originators of Western civilization itself, he maintained. "So much for the supposed inferiority of the colored race, and their incapacity to make any progress in civilization and improvement," he scoffed.[9]

Combe, of course, disregarded such arguments and continued to argue for black inferiority. While they had been slowed down by their "moral and intellectual desolation," Africans—as evidenced by slavery—had cranially determined qualities that made them particularly suitable to serve masters. "The African," he wrote, "has been deprived of freedom and rendered property, because he is by nature a tame man, submissive, affectionate, intelligent and docile."[10]

Combe's harshest judgments by far were reserved for the Indians of the Americas, and they came at a time when they were of particular service to official United States government policy. Launched in the United States in the

1830s and 1840s, beginning with the presidency of Andrew Jackson, a period of intensified forced migration and annihilation of native people began as Anglo-America grabbed traditional Indian lands.

Known to the Indians as "Sharp Knife," Andrew Jackson "was one of the most quick-to-fight white men" to come out of the Tennessee frontier, and he made his name as an Indian fighter. As a commander of troops, notes Dee Brown, author of *Bury My Heart at Wounded Knee*, "Sharp Knife and his soldiers had slain thousands of Cherokees, Chickasaws, Choctaws, Creeks, and Seminoles" in a series of wars against the Indians of the Southeast. Despite the massacres, however, a significant number of survivors still "clung stubbornly to their tribal lands." When Jackson became president in 1829, his first speech to Congress urged legislators to enact a law removing all southern Indians to the territories west of the Mississippi River, opening 33 million acres for white settlement and for slavery. On May 28, 1830, the law was passed, followed by others supporting this policy.[11] During Jackson's presidency, and that of Martin Van Buren, "nearly all the Indians from territory east of the Mississippi" were expelled.[12] Subsequent presidents pursued the aggressive anti-Indian policy set off by Jackson, and Indian wars continued throughout much of the remaining century, always with the goal of assisting white settlement. As this orgy of human destruction commenced, Combe's assault against Indians' "natural" propensities provided scientific justification for these genocidal policies.

From the 1830s onward, Combe traveled widely in the United States. He wrote two books about his travels and delivered many lectures. In the process, he developed a strong affinity for Anglo-Americans and their goals of conquest. Along the way, he also converted a number of Americans to phrenology. One of these was Samuel George Morton, an upper-class medical doctor from Philadelphia.

Morton, like many of his ilk, was a bone collector. Beginning in the 1820s, he eventually amassed in his charnel house a collection that exceeded more than one thousand human skulls. His special interest lay in collecting specimens that would allow him to accurately rank the relative intelligence and moral worth of various human types. In 1839 he published a lavishly illustrated tome entitled *Crania Americana*, which focused on the skull formations of Indians from North and South

Samuel George Morton. reprinted from JOSIAH CLARK NOTT'S TYPES OF MANKIND, 1855. FROM THE COLLECTION OF THE EWEN LIBRARY

America in comparison with the other varieties of people, as defined in the 1770s by Blumenbach.

Morton, however, revised Blumenbach's hierarchy in two ways. Blumenbach's varieties were all related to one another, if only by a process of degeneration from the romanticized people who had emerged in the foothills of the Caucasus. Each variety represented a variant within the species Homo sapiens. In Morton, all sense of connectedness vanished. Breaking from Blumenbach's terminology, he pointed out to readers that "the word race is substituted for the word variety," accentuating the separation of humankind into distinct, mutually exclusive groups. Morton saw the races as discrete and unequal species, emanating from different bloodlines.[13]

"Chinook" skull. REPRINTED FROM SAMUEL MORTON'S, *CRANIA AMERICANA*, 1839

Second, Morton applied facial and cranial measurements to rank the intellectual power and civility of the races. Blumenbach, had used aesthetic criteria in order to designate the differences between human varieties and had placed the American "variety" in a mid-position between Caucasians and Mongols, the Malay variety between Caucasians and Ethiopians. Rejecting Blumenbach's aesthetic pyramid, Morton argued on behalf of a simple linear hierarchy, based on "measurements of the internal capacity of the skull," taken by filling cranial cavities with lead bird shot to calculate relative volume. Building on Camper, he also developed an apparatus, called the facial goniometer, for determining facial angles. According to his studies, the American race stood close to the bottom in terms of brain size and facial angle, only slightly above the Ethiopian race.

To circumvent the classical notion that ancient Egypt was a black African society, Morton argued that the accomplishments of Egypt were the work of people who shared the elevated racial qualifications of Europe. He began his analysis of Egypt by quoting Cuvier, who had written:

It is now clearly proven . . . that any race of Negroes, could not have produced the celebrated people who gave birth to the civilization of

ancient Egypt, and of whom we may say that the whole world has inherited its laws, sciences, and perhaps also religion. It is easy to prove that whatever may have been the hue of their skin, they belong to the same race as ourselves.

On the heels of such august authority, Morton continued:

Egyptians are part of the Caucasian race and never descended from black Africans who worked as servants to the Pharaohs, therefore the Caucasians gave birth to civilization. . . . It may justly be inquired, if science, art, and literature had their origin with a Negro tribe on the skirts of Africa, how does it happen that the stream of knowledge has never flowed into, but always out of that country? Again, it is now proved almost beyond controversy that Egypt and not Nubia, was the mother of the arts.

He made a similar argument about the wonders of the Aztec and Inca civilizations, explaining away these colossal Indian achievements by insisting that both peoples were, in fact, ancient Caucasians.[14]

In each case, Morton claimed that comparative cranial measurement provided the basis for his arguments. Beneath the allegedly objective surface of Morton's cold numerical measurements, however, laid a visceral revulsion, a palpable hatred of those he related to the lower orders. In *Crania Americana* his loathing for the Indians could not be contained.

"Dacota" skull. REPRINTED FROM SAMUEL MORTON'S, *CRANIA AMERICANA*, 1839

They are crafty, sensual, ungrateful, obstinate and unfeeling, and much of their affection for their children may be traced to purely selfish motives. They devour the most disgusting aliments uncooked and uncleaned, and seem to have no idea beyond providing for the present moment. . . . Their mental faculties, from infancy to old age, present a continued childhood. . . . In gluttony, selfishness and ingratitude, they are perhaps unequaled by any other nation of people.[15]

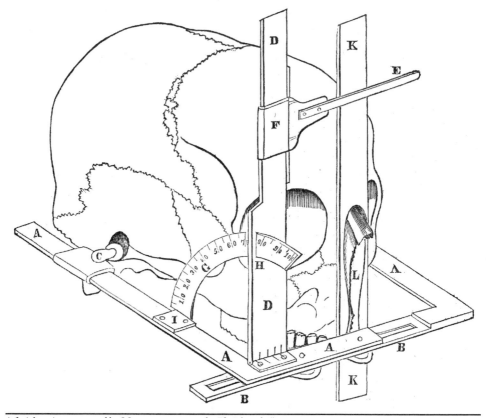

A facial goniometer, used by Morton to measure the "facial angle." REPRINTED FROM SAMUEL MORTON'S, *CRANIA AMERICANA*, 1839

Along with these deficiencies, Morton decreed that the Indians were also intrinsically brutal. "It is not to be denied, however, that Indians are unfeeling by nature and cruel by education. To spill the blood of an enemy, to torture him to death by slow degrees, is the supreme pleasure of the American savage."[16] There was no better justification of the eradication of a people than to define them as savages.

From the first pages of *Crania Americana*, George Combe's influence on Morton was evident. "I am free to acknowledge," he wrote, "that there is a singular harmony between the mental capacity of the Indian, and his cranial development as explained by Phrenology."[17]

Building on this link, and adding authority to his book, Morton asked

Combe to write the appendix. In this afterword, Combe upheld Morton's outlook and summarized phrenology's verdict on the Indians. "Many of the natives," he wrote, "remain at the present time the same miserable, wandering house-less and lawless savages as their ancestors were, when Columbus first set foot on their soil." This degraded condition, Combe claimed, was phrenologically determined and helped to explain why the annihilation of Indian tribes was—owing to their particular cranial conformation—unavoidable.

> Permanent subjection to a foreign yoke is a result of inferior aggregate development of brain, animal, moral, and intellectual, in the people subdued in proportion to the organs of combativeness, destructiveness, and self-esteem, that exists in tribes which prefer extermination to submission.[18]

Within this disquieting verdict and sentence, Combe voiced a common division that phrenologists saw among the "lesser" peoples who had been conquered by Europe. Some, such as Africans or "Hindoos" on the subcontinent of India, were suited for submission. Others were intrinsically resistant to submission.

Combe explained the "science" behind this line of demarcation. The Hindoo's "aggregate size of the whole brain" is, he maintained, "less than the aggregate size of the whole brain" of the English who conquered them. Yet, he continued,

> in them also the moral and intellectual regions of the brain are larger in proportion to the animal region, than the Carib [Taino, et al] or Iroquois Indians. The increased size in the moral and intellectual region in proportion the animal region gives docility, while the deficiency in aggregate size is accompanied by feebleness of character.

Carib and Iroquois brains, on the other hand, were defined by an inverted ratio of intellectual to animal faculties. Their "organs of self-esteem, firmness, combativeness and destructiveness," which were all defined as animal, were accentuated among these "aboriginal races," while the "moral and intellectual organs" were, according to Combe, atrophied. This combination, Combe argued, meant that they could never submit to European control. Unable to defend against the "superior strength" of the Europeans who have taken their lands, their only options, wrote Combe, were to be "exterminated or removed to distant lands."[19] Elsewhere in the world, interesting parallels existed. During the 1830s, for exam-

118

ple, English settlers in eastern South Africa, adopted the jargon of phrenology and made similar arguments to justify violent policies enacted against the Xhosa in that region.[20]

In the United States, phrenology as a popular fascination had begun with the charismatic showmanship of J. G. Spurzheim and his spectacular, if sudden,

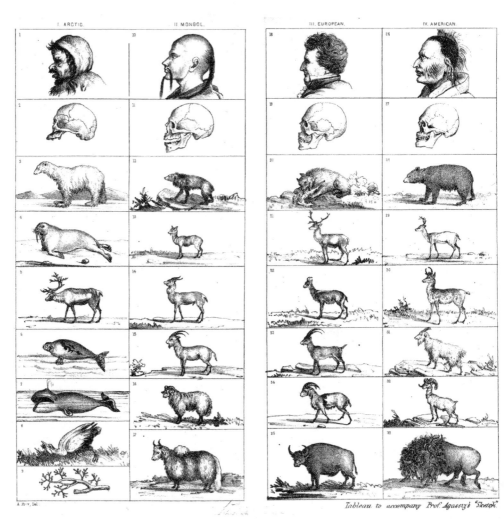

A follower of Morton, Louis Agassiz had this chart produced to argue that each race was a distinct species, likening them to the different species of animals that were found in each geographical region. REPRINTED FROM JOSIAH CLARK NOTT'S TYPES OF MANKIND, 1855; FROM THE COLLECTION OF THE EWEN LIBRARY

demise. As phrenology took root in the New World, it quickly adapted itself to the particular requirements of Anglo-Americans who were attempting to transform the wilderness into something they could manage and control. To a population attempting to exercise control over enslaved, unwilling, and rebellious populations, phrenology offered an explanation and a language that turned conquest into a scientifically determined inevitability. Combe put it this way: "The

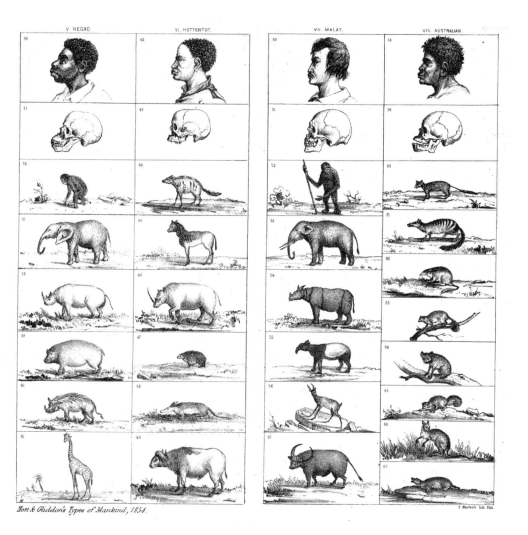

Nott & Gliddon's Types of Mankind, 1854.

propensities must be restrained and guided by some power, otherwise they will deviate into wild abuse."[21]

Morton paid considerable homage to phrenology, yet his work was far less intricate. If phrenology rested on an understanding of the brain as having a complex physiology, defined by highly specialized regions, or organs, Morton moved toward a single-measurement approach in his evaluation of the races. In this sense, his straightforward equation of intelligence to brain size signaled the emergence of the streamlined science of craniometry, far less time-consuming than phrenology, yet just as absolute in its judgments.

Beyond the ongoing influence of his writings on the inferiority of Indians, Morton was of considerable service to proslavery forces as well. In the 1840s and 1850s, his ideas became the inspiration for a new "American School of Ethnology" that argued "that the races of mankind had been separately created as distinct and unequal species."[22] In the decades leading up to the Civil War, it was Morton—aided by two disciples, George Gliddon and Dr. Joshua C. Nott—who became the foremost spokesman for the idea that Caucasians and Ethiopians had no species connection and that blacks, unlike whites, were inherently suited for the burdens of slavery. When Morton's position was endorsed by the famed Swiss naturalist, Louis Agassiz, craniometry had arrived as a cornerstone of anthropological science. Agassiz was the leading European disciple of Baron Cuvier and was appointed professor at Harvard in 1846. He also founded Harvard's Museum of Comparative Zoology and, according to Stephen Jay Gould, "did more to establish and enhance the prestige of American biology during the nineteenth century" than any other individual. For Morton, Agassiz's endorsement provided him with a commanding and lasting seal of approval. When Morton died in 1851, an obituary in Horace Greeley's *New York Tribune* declared, "probably no scientific man in America enjoyed a higher reputation among scholars around the world than Dr. Morton."[23]

Following Morton's death, his students Nott and Glidden joined with Prof. Agassiz to perpetuate their mentor's legacy. In 1854, they published *Types of Mankind: or Ethnological Researches Based Upon the Ancient Monuments, Paintings, Sculptures and Crania of Races and upon Their Natural, Geographical, Philological, and Biblical History*, a defense of slavery that contained a major essay by Agassiz, which included detailed racial maps and charts arguing for a polygenist understanding of human types. While monogenists saw Homo sapiens as a single species containing different, if unequal, varieties, polygenists, like Agassiz, defined the races as constituting separate species.[24]

In the United States the phrenological system of analysis continued to grow, but in Europe, Morton's craniometry, with Agassiz's backing, came to replace phrenology as the dominant scientific tool for gauging intelligence. In France—still the premiere milieu for the study of natural history—it was Paul Broca who took on Morton's approach and turned it into a scientific standard.

Broca, the founder of the Anthropological Society of Paris, revered Morton as a founding father of physical anthropology. Sharing Morton's conviction that the races represented separate and distinct species, he also believed that racial differences could be divined through brain measurement. His only revision of Morton's method was to move away, whenever possible, from the inexact measurement of brain volume, relying on the ostensibly more precise measure of weight. Nonetheless, Morton was his inspiration. "If Germany has had her Blumenbach, England her Prichard [author of *The Natural History of Man*, an influential volume on racial distinctions discussed in a subsequent section], America has had her Morton," Broca lamented in 1862, "French anthropology so far can boast no name of equal rank." Broca rose to the challenge, and within a few years he had emerged as "the world's greatest craniometrician."[25]

The weighing of brains became a European fixation, and for Broca, and others, it was the brain of Baron Cuvier that set the gold standard in this regard. Though Cuvier had died more than thirty years earlier, his celebrated intelligence, combined with an unusually heavy brain (weighing in at 1,830 grams or 64.59 ounces, according to postmortem records) was seen by craniometrists as proof positive that brain size and intelligence were intimately linked. Though not quite up to the standard set by Cuvier, Spurzheim's brain, at 57 ounces (1615.95 grams), had also been cited as an indication of genius.

Following Morton's invidious methodology, brain size was the defining index separating great from ordinary, superior from inferior, and male from female. The smaller brains attributed to women, children, and Africans were habitually employed as evidence of diminished, or, in the case of white male children, undeveloped intelligence. The minds of children, in fact, served as a common metaphor for describing the inferior mentality of women or of men among the "primitive" races. Amid this fixation on size, Broca offered his outlook on human disparity.

> In general, the brain is larger in mature adults than in the elderly, in men than in women, in eminent men than in men of mediocre talent, in superior races than inferior races. . . . Other things equal, there is a remarkable relationship between the development of intelligence and the volume of the brain.[26]

While Broca also placed some significance on facial angle, he saw the measurement of brains as the most important function of anthropology. More than anything else, he maintained, this practice could help to place the comparative worth of the different races on an objective foundation.

> The great importance of craniology has struck anthropologists with such force that many among us have neglected the other parts of our science in order to devote ourselves almost exclusively to the study of skulls. . . . In such data, we hope to find some information relevant to the intellectual value of the various human races.[27]

Subsequent studies have shown that variations in brain size cut across the diversity of humankind. When Broca came across an African or Asian brain diverging from these conclusions, he disregarded it, clinging to his predetermined conclusions in the face of evidence that would refute his ostensible scientific methods. When shown a chart disputing his evidence, he had this to say:

> [T]his does not destroy the value of small brain size as a mark of inferiority. The table shows that west African blacks have a cranial capacity about 100 cc less than that of European races. To this figure we may add the following: Caffirs, Nubians, Tasmanians, Hottentots, Australians. These examples are sufficient to prove that if the volume of the brain does not play a decisive role in the intellectual ranking of races, it nevertheless has a very real importance.[28]

When a small-sized brain was encountered among acclaimed Europeans, it was disregarded just as vigorously as a large-sized brain was among non-Europeans. The fact that J. F. Gall's brain had weighed in at a measly 1198 grams, or 42.3 ounces, was never used to question his eminence or intelligence. Neither was Walt Whitman's 1,282-gram (45.3 ounce) brain.

Ironically, when Broca died in 1880, his own brain weighed in at an unremarkable 1,484 grams (about 52 ounces), but given this discovery, his acolytes were unswayed. Craniometry—in spite of its apparent objectivity—was always a selective science.[29]

12
AN AMERICAN TALE

Born in 1809, Orson Squire Fowler grew up on a farm in Steuben County, New York. The eldest of three children, he had a brother, Lorenzo, and a sister named Charlotte. Though his parents farmed for a living, their interests reached beyond the soil. His mother had a strong love of literature and his father served as minister to a local congregation.

Growing up in a literate, if relatively poor, environment, Fowler went on to study at Amherst College, arriving there in 1829 with four dollars to his name. In the fall of 1832, touched by the enthusiasm that surrounded J. G. Spurzheim's lecture tour in America, Fowler developed a serious interest in phrenology. While some Amherst professors were impressed by the innovative theory of brain localization, Fowler's fascination with phrenology became the butt of jokes among many of his fellow students. One of these disdainful classmates was Henry Ward Beecher, the scion of a well-established American family, who would, in years to come, emerge as one of the nation's leading Protestant ministers.

Unperturbed by the mockery, Fowler viewed it as an opportunity to expound upon his newfound interest. When a student debate on the subject of phrenology was proposed, O. S. Fowler seized the occasion to speak on behalf of the pro position; Beecher chose to argue against. On the day of the debate, so persuasive was Fowler in his elucidation of the powers of phrenology, that Beecher was immediately converted and surrendered his position in the middle of the debate. After this remarkable turnabout took place, Fowler and his new friend Beecher went into business together, examining the heads of Amherst students, and others, for a fee of two cents per reading. Fowler's intuition regarding the commercial possibilities of phrenology would shape his activities, as well as those of his siblings, for the remainder of their lives.

When Fowler graduated from Amherst, he planned on studying for the ministry at Lane Seminary, where he had been accepted as a student. Before entering, however, events unfolded that altered the trajectory of his life. Disturbed by the ineptitude of a lecture on phrenology delivered by one of his friends, Fowler decided that he must take up the gauntlet to defend the reputation of his beloved science. This decision led to a new career. Inspired by his friend's failure, Fowler described the beginnings of what would become a phenomenally successful enterprise.

[My friend's ineptness] fired me with an ambition to try my hand at lecturing on phrenology. . . . One night I lay awake 'til broad daylight,' first thinking out whether I should make an attempt, which I fully resolved to do; next studying up my form of notices for my proposed handbill and advertisements; and finally studying our improvements in my chart in giving the definitions of the faculties. I spent nearly a week on it; bought paper, hired a printer, and got out a thousand copies [of his chart] along with my handbill; ordered a [phrenological] bust, and thirty-two dollars' worth of works on phrenology, opened my lectures, threw out my card, charged men twelve and a half cents for a phrenological chart marked, and ladies and children six and a quarter cents; cleared forty dollars.[1]

So successful was Fowler's carefully planned strategy for propagating phrenology that he began to earn a livelihood traveling from town to town, expounding on the subject and examining heads for a fee. For the price of a reading, each customer received a phrenological chart personally filled out by Fowler. With no scientific training or advanced degrees, he began to advertise himself as "Professor Fowler" and added his younger brother Lorenzo to the road show.

Working as a team, the brothers developed an earnest yet entertaining routine. First, standing in front of a large diagrammatic head, Lorenzo would methodically point out each organ of the brain, describing the particular faculty or propensity associated with it. After this introduction to the overall system, Professor Fowler would take over and in plain language, salted here and there with strange terminology, explain the marvelous possibilities of phrenology as the key to self-improvement. Once a person's cranial conformation had been documented, the Professor would explain, he or she could devote solemn effort to those faculties in need of enhancement. Following this presentation, which was free, the audience would line up eagerly, ready to pay for one of the brothers to perform an individual examination, and to take home a chart that would provide valuable personal direction for the future.

REPRINTED FROM O. S. AND L. N. FOWLER'S *THE NEW ILLUS-TRATED SELF-INSTRUCTOR*, 1868; FROM THE COLLECTION OF THE EWEN LIBRARY

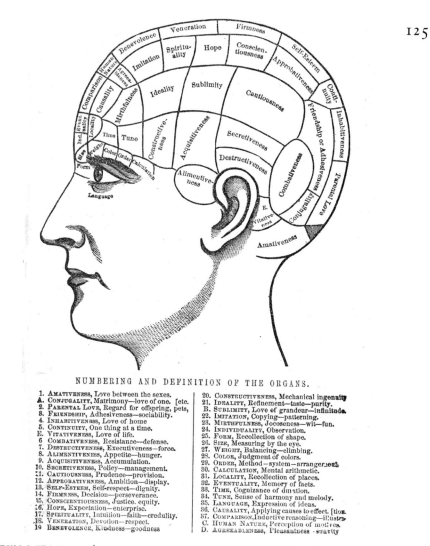

NUMBERING AND DEFINITION OF THE ORGANS.

1. AMATIVENESS, Love between the sexes.
A. CONJUGALITY, Matrimony—love of one. [etc.
2. PARENTAL LOVE, Regard for offspring, pets,
3. FRIENDSHIP, Adhesiveness—sociability.
4. INHABITIVENESS, Love of home.
5. CONTINUITY, One thing at a time.
E. VITATIVENESS, Love of life.
6. COMBATIVENESS, Resistance—defense.
7. DESTRUCTIVENESS, Executiveness—force.
8. ALIMENTIVENESS, Appetite—hunger.
9. ACQUISITIVENESS, Accumulation.
10. SECRETIVENESS, Policy—management.
11. CAUTIOUSNESS, Prudence—provision.
12. APPROBATIVENESS, Ambition—display.
13. SELF-ESTEEM, Self-respect—dignity.
14. FIRMNESS, Decision—perseverance.
15. CONSCIENTIOUSNESS, Justice. equity.
16. HOPE, Expectation—enterprise.
17. SPIRITUALITY, Intuition—faith—credulity.
18. VENERATION, Devotion—respect.
19 BENEVOLENCE, Kindness—goodness

20. CONSTRUCTIVENESS, Mechanical ingenuity
21. IDEALITY, Refinement—taste—purity.
B. SUBLIMITY, Love of grandeur—infinitude.
22. IMITATION, Copying—patterning.
23. MIRTHFULNESS, Jocoseness—wit—fun.
24. INDIVIDUALITY, Observation.
25. FORM, Recollection of shape.
26. SIZE, Measuring by the eye.
27. WEIGHT, Balancing—climbing.
28. COLOR, Judgment of colors.
29. ORDER, Method—system—arrangement.
30. CALCULATION, Mental arithmetic.
31. LOCALITY, Recollection of places.
32. EVENTUALITY, Memory of facts.
33. TIME, Cognizance of duration.
34. TUNE, Sense of harmony and melody.
35. LANGUAGE, Expression of ideas.
36. CAUSALITY, Applying causes to effect. [tion.
37. COMPARISON, Inductive reasoning—illustra
C. HUMAN NATURE, Perception of motives.
D. AGREEABLENESS, Pleasantness - suavity

REPRINTED FROM O. S. AND L. N. FOWLER'S *THE NEW ILLUSTRATED SELF-INSTRUCTOR*, 1868; FROM THE COLLECTION OF THE EWEN LIBRARY

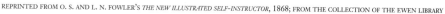

While the Fowlers—soon joined by sister Charlotte and her husband, a physician named Samuel Wells—would become, far and away, the most influential promoters of phrenology in America, they began as part of a wave of itinerant proselytizers. This was a society in which traveling lecturers, speaking on practical or inspirational subjects, were a major source of popular entertainment

For a Full Explanation of this Table, and the Marking of

CONDITIONS.	7 Very Large.	6 Large.	5 Full.	4 Average.	3 Moderate.	2 Small.	Cultivate.	Restrain.
Organic Quality......	PAGE 12	12	12	13	13	13	13	13
Health..............	17	17	18	18	18	18	18	18
Vital Temperament.	21	22	22	22	22	22	22	23
Breathing Power.....	24	24	25	25	25	25	25	
Circulatory Power....	26	26	26	26	26	26	26	26
Digestive Power.....	27	27	27	27	27	27	28	29
Motive Temperament.	30	31	31	32	32	32	33	33
Mental Temperament.	35	36	36	37	37	37	37	47
Activity........	44	45	45	45	45	45	45	46
Excitability...	46	46	46	46	46	47	47	47
Size of Brain, inches	40	40	41	41	41	41		
1 Amativeness........	76	76	77	77	78	78	78	79
A. Conjugality.........	80	80	80	80	80	80	80	81
2. Parental Love........	82	82	83	83	83	83	83	83
3. Friendship...........	84	84	85	85	85	85	86	86
4. Inhabitiveness.	86	86	87	87	87	87	87	87
5. Continuity	87	88	88	88	88	89	89	89
E. Vitativeness..........	91	91	91	91	91	91	92	92
6. Combativeness.......	92	93	93	94	94	94	94	94
7. Destructiveness	95	95	96	96	96	96	96	97
8. Alimentiveness.......	97	98	98	98	98	98	98	99
9. Acquisitiveness	100	101	101	101	102	102	102	103
10. Secretiveness........	103	103	104	104	104	105	105	105
11. Cautiousness.........	105	106	107	107	107	107	107	108
12. Approbativeness......	108	109	109	109	109	109	110	110
13. Self-Esteem..........	110	111	112	112	112	112	113	113
14. Firmness........	113	114	114	115	115	115	115	115

the Chart, the Reader is referred to Pages 7 and 8.

CONDITIONS.	7 Very Large.	6 Large.	5 Full.	4 Average.	3 Moderate.	2 Small.	Culti-vate.	Re-strain.
15. Conscientiousness....	PAGE 117	118	118	119	119	119	119	120
16. Hope...............	120	120	121	121	121	122	122	122
17. Spirituality.........	122	123	123	123	123	123	123	123
18. Veneration	124	125	125	125	125	125	126	126
19 Benevolence.........	127	127	127	127	128	128	128	128
20. Constructiveness.....	129	130	130	130	130	130	131	131
21. Ideality	131	132	132	132	132	133	133	133
B. Sublimity...........	133	133	134	134	134	134	134	134
22. Imitation...........	134	135	136	136	136	136	136	136
23. Mirthfulness	136	137	137	138	138	138	138	138
24. Individuality........	141	141	142	142	143	143	143	143
25. Form...............	144	144	144	144	144	144	144	144
26. Size	145	145	145	145	145	145	145	145
27. Weight.............	146	146	146	146	146	146	147	147
28. Color..............	147	147	147	147	148	148	148	148
29. Order	148	148	149	149	149	149	149	149
30. Calculation	149	150	150	150	150	150	150	150
31. Locality	151	151	151	151	151	151	151	152
32. Eventuality.........	153	153	153	154	154	154	154	154
33. Time...............	155	155	155	155	155	155	155	155
34. Tune	155	155	156	156	156	156	156	156
35. Language...........	157	157	158	158	158	158	158	159
36. Causality	161	161	161	161	161	162	162	162
37. Comparison.........	163	163	163	163	163	163	163	164
C. Human Nature... ...	164	164	164	164	164	165	165	165
D. Agreeableness........	165	165	165	165	166	166	166	166

During a reading at the Phrenological Museum, one of the Fowlers would fill out this chart included in *The Illustrated Self-Instructor*. REPRINTED FROM O. S. AND L. N. FOWLER'S *THE NEW ILLUSTRATED SELF-INSTRUCTOR*, 1868; FROM THE COLLECTION OF THE EWEN LIBRARY

128

and edification for Anglo-America. Amid the pandemonium of an emerging industrial culture, middle-class reform movements drew considerable interest among people whose sense of stability was in jeopardy. Religious and secular social movements were rife, bringing together a volatile mix of revivals, diet and dress reform, communitarian experiments, antislavery activities, and early women's rights politics. Each of these developments was propelled by oratorical eloquence and predicated on the possibility of bringing about a more perfect social and spiritual order.

In the 1830s and 1840s phrenology entered into the fray, becoming nothing less than a mass cultural phenomenon. Nearly every village, town, and city was touched by its promise, and wherever the subject was broached, it was received with enormous enthusiasm. At each event people willingly spent their money, and phrenological paraphernalia could be found in a multitude of homes. John Davies, a historian of the craze, has summarized it as "a combination of the Yankee missionary and Yankee peddler, dispensing hortatory zeal to whoever would listen, and useful wares to whoever would buy."[2]

Observing the money-making potential of this social obsession firsthand, O. S., Lorenzo, and Charlotte Fowler, along with Samuel Wells, took phrenology and transformed it into an enormously successful business. Wells, with considerable commercial acumen, took charge of business matters and oversaw a publishing company, Fowler and Wells, which published many books over the years, along with the *American Phrenological Journal*, a periodical that first appeared in 1838 and continued until 1911. Orson continued to lecture and also became the primary writer for the enterprise. Lorenzo—or L. N., as he was known—was a gifted head reader and took charge of examinations. Charlotte offered classes in phrenology for women.[3]

Abandoning the road, they made the decision to turn phrenology into a didactic tourist attraction, a museum and examination suite that people would travel from near and far to visit. Beginning on 210 Chestnut Street in Philadelphia, where they opened their first Phrenological Museum, they relocated to New York in 1835 and then, in 1838, reopened the museum in Clinton Hall, an imposing structure in the center of the city's business district.[4]

In 1841, working with an artist who had developed a new casting technique, they began collecting life casts of the heads of many of America's most prominent men. These lifelike facsimiles, intermixed with more hypothetical sculptures of famous historical figures, constituted a phrenological Hall of Fame, offering visible evidence of the conformation of greatness. These heads were juxtaposed with the skulls of ostensibly inferior types, including thieves,

murderers, Negroes, Indians, cannibals, idiots, pirates, and other disreputable types.5 This dualistic display would become a central exhibit in Fowler and Wells's museum, known as the Phrenological Cabinet. Acquiring the bust and skull collection of George Combe, the group was proprietor, by 1842, of a museum containing over one thousand specimens, offering an engaging material narrative about eminence and degeneration, intelligence and stupidity, good and evil. Following a practice established on the road, entry into the museum was free. Thousands upon thousands came to visit, and attendance at the Phrenological Cabinet rivaled that of Barnum's American Museum.

After viewing the impressive exhibits, visitors were invited to enter an examination room where, for a fee of one to three dollars, one of the Fowler brothers, or a trained assistant, would perform a formal examination. Carefully, an exam would begin with gross measurements of the head, using a tape measure to determine the "distance between the opening of the ears and the crown of the head; [the] distance between the root of the nose and the projection at the base of the head, also the circumference of the head."6 In order to determine the size of particular organs of the brain, each corresponding to a specific faculty or propensity, the laying on of hands was necessary. Solemnly the phrenologist would feel for enlargements, indentations, and underdevelopment in particular areas of the cranium, meanwhile narrating his findings to a stenographer employed by the museum. The results of the reading were then recorded in an embossed hardcover volume known as the *New Illustrated Self-Instructor in Phrenology and Physiology, Together with The Chart and Character of* [name of visitor being examined] *As Marked by* [name of examiner, often O. S. or L. N. Fowler]. The hand-marked chart in the front of the book included an illustration of a phrenological head, which was followed by an extensive text explaining phrenology as it affected mentality, indicated character, and offered a comprehensive system of classification.

Beyond providing on-site examinations, the museum sold mementoes and publications that carried the study of phrenology into the home environment. Porcelain heads, bearing the inscription "L. N. Fowler," offered an attractive vernacular map of the brain's organs and their corresponding functions. Over the years these phrenological heads became iconic objects and were displayed in homes, offices, and private libraries as implicit evidence of the owners' character and erudition. The museum also sold busts of famous men and a wide range of publications, including the journal.

As the museum's reputation grew, and popular fascination with phrenology spread, the company of Fowler and Wells built a lucrative mail-order business, serving the needs of enthusiasts unable to visit the museum directly. A big part

of this business was comprised of books and pamphlets. By the mid-1850s, Orson Fowler's books enjoyed widespread sales; "half a million were in the hands of the American public."[7] Alongside the *American Phrenological Journal*, Fowler and Wells also published *The Student: A Family Miscellany and Monthly School-Reader*, aiming at the youth market and bringing phrenology into the schools. A third publication, *Life Illustrated*, was a general interest weekly aimed at families and filled with current events, literary and arts coverage, and reports on scientific discoveries.

The Fowler and Wells catalog of practical instruction books expanded significantly. It included a book on physiology for children, authored by Lorenzo's wife, Lydia Fowler, in 1848.[8] Anticipating the writings of Horatio Alger and Dale Carnegie, it also encompassed a series of how-to-do-it books offering lessons on the appropriate way to walk, talk, behave in social settings, and engage in business.[9]

As amateur phrenology societies began to spring up around the country, the mail-order business of Fowler and Wells provided them with casts of the museum's most famous and infamous specimens. Skulls went for twenty-five cents; busts for fifty. Skeletons were also available, along with other characteristic objects for display. Ordering in bulk, phrenological outposts could create their own cabinets based on the authority of the museum in New York. Along with the sale of such paraphernalia, Fowler and Wells also published simple guidelines by which followers might learn to develop their own phrenological skills. In one handbook for amateurs, *Practical Phrenology*, the Fowlers offered step-by-step instructions to would-be examiners. A typical example of their guidance read as follows:

> You know a neighbor who has extreme Firmness in character—who is as inflexible as the oak, and as obstinate as a mule. Now, learn the location of the phrenological organ of Firmness . . . and apply that location to his head—that is, see whether he has this organ as conspicuous as you know him to have this faculty in character, and if you find a coincidence between the two, you have arrived at a strong phrenological fact.[10]

Yet, phrenological accessories and books were not the only items for sale. Fowler and Wells branched out and became an early innovator in the development of mail-order marketing. Long before Richard Sears founded the enterprise that would become Sears, Roebuck and Company, Fowler and Wells was

already actively engaged in this important aspect of American consumer culture. Customers could order suspenders and breast pumps, sewing machines and thermometers, seeds for planting and dental tools, dress-making manikins and farming equipment. The publishing company also diversified, printing and distributing the second edition of Walt Whitman's *Leaves of Grass*.[11] (Whitman had printed an abbreviated first edition on his own.) At the urging of Charlotte Fowler, the company also published Susan B. Anthony and Elizabeth Cady Stanton's *History of Women's Suffrage*.

To the Fowler brothers, the museum was far more than a business or a tourist attraction. It was the centerpiece of a strategy to promote phrenology as a way of life or, as put forward in the *American Phrenological Journal*, "to Phrenologize Our Nation, for thereby it will reform the world."[12] In order to publicize their efforts, the Fowlers made a practice of seeking out prominent Americans for phrenological readings. Among their subjects were Ulysses S. Grant, Senator John Tyler, the well-known antislavery congressman Charles Sumner, the abolitionists Theodore Weld and Arthur Tappan, a wealthy businessman who helped to fund the underground railroad, the noted transcendentalist Margaret Fuller, the poets Walt Whitman and John Greenleaf Whittier, the sculptors Hiram Powers and James Stout, the poet and journalist William Cullen Bryant, the American Red Cross founder and suffragist, Clara Barton, and the leader of the raid on Harper's Ferry, John Brown, whose 1847 reading declared him "firm as the hills," "too blunt and free spoken," and "often misunderstood." These readings, which were widely publicized, created a visible link between phrenology and influential Americans, adding to the reputation and credibility of the Fowlers and Wells's enterprise.[13]

The appeal of phrenology as a practical science was infectious. Following a serious rail accident, for example, Horace Greeley proposed the idea that if train engineers were subjected to systematic phrenological testing, railroad accidents could be prevented.[14] The educator Horace Mann proclaimed that the doctrines of phrenology had arrived on the scene just in time to "save the race from destruction. Had their advent been delayed much longer," he mused, "it is doubtful whether men would have been able to discover them at all."[15] For Harriet Beecher Stowe, phrenology "sifted into the language, its terminology was as convenient in treating human nature as the algebraic signs in numbers."[16]

Edgar Allen Poe also adopted the argot of the science, complimenting his fellow poet, William Cullen Bryant, for his "prominent organs of Ideality." In Poe's tale "The Fall of the House of Usher," Roderick Usher's physiognomy is a subject of great detail, but so too is his phrenological conformation, defined by "an

132

inordinate expansion above the regions of the temple," a generally understood sign of Ideality. In Charlotte Brontë's 1847 novel, *Jane Eyre*, the character of Mr. Rochester is described as lifting up his hair in order to reveal an ambiguous phrenological makeup. "He lifted up the sable waves of hair which lay horizontally over his brow, and showed a solid enough mass of intellectual organs, but an abrupt deficiency where the suave sign of benevolence should have risen." It is said that even Karl Marx "always judged the mental qualities of a stranger from the shape of his head."[17]

A phrenological reading by Lorenzo Fowler on July 16, 1849, altered Walt Whitman's life and creative work forever. From then on, he relied on phrenology as a tool for exploring human and national character. In *Leaves of Grass*, published by Fowler and Wells, he asked,

> Who are you indeed who would talk and sing to America?
> Have you studied out the land, its idioms and men?
> Have you learn'd the physiology, phrenology . . . of the land?[18]

Under the initial tutelage of Gall and Spurzheim, phrenology had attracted a great deal of public interest. But it still possessed a primarily scientific veneer. In the hands of the Fowlers and Samuel Wells, phrenology was becoming an American fascination, the center of a new lifestyle built around its practical teachings. Phrenology, the Fowlers and Wells instructed, could provide middle-class Americans with a step-by-step basis for self-improvement, vocational guidance, and employment counseling; it could be used as a tool for choosing friends and mates, and it could guide people through the treacherous waters of matrimony. In the company's periodicals, advice columns were familiar features, and articles linking a detailed understanding of the organs of the brain to a variety of life choices were common. The *New York Sun*, America's first mass-circulation newspaper, required all job applicants to submit a phrenological chart certified by Fowler and Wells.

For Anglo-America, phrenology was emerging as a guide for life and as a means for strengthening its self-confidence. According to its practitioners' wisdom, phrenological self-knowledge would provide adherents with the ability to assess their strengths and weaknesses, and instruct them toward greater personal success. As Orson Fowler wrote in *The Illustrated Self Instructor*:

> Within the last century, a new star or rather sun, has arisen upon the horizon of the mind—a sun which puts the finger of SCIENTIFIC

CERTAINTY upon every mental faculty, and discloses those physiological conditions which affect . . . thought, feeling or character.[19]

The purpose of an examination was to "record character," presenting a detailed breakdown of "those organic conditions which affect and indicate character." Upon receiving an examiner's record of "the power . . . of each function and faculty," a person could learn how to "perfect their characters and improve children." Insofar as weaknesses were identified, he explained, they "should be assiduously cultivated" to improve "character and conduct."[20]

Within the worldview of phrenology, character consisted of "two kinds, original and acquired." While the first was "inherited from parents" and was the basic raw material that an individual had to work with, the other was subject to the influence of personal habits, good or bad, injecting an element of choice into a physiological science that was, at its birth, deterministic.[21] Under the stewardship of Fowler and Wells, cranial science was fusing with an idea of moral discipline and self-improvement that dated back to *The Autobiography of Benjamin Franklin*.

The Fowlers and Wells included instructive object lessons within their writings, stories designed to provide readers with a clear sense of the choices that they faced in life. A tale about two boys, both endowed with similar cranial potential, is a case in point. The first "having chosen the way of righteousness, the upward path" is rewarded with a gratifying existence. "He is a loving, cherished husband, a kind father, a faithful friend, and an esteemed citizen." The other, who chose the "downward course, thinking he will enjoy himself and not submit to what he considers the strait jacket of moral discipline," ends up as "the miserable, inebriate or raving maniac." In the process, even the conformation of his head begins to deteriorate, becoming "coarse and rough in feature."[22]

As is evident in this story, part of the appeal of the helpful knowledge provided by phrenology was that it was presented to the public in a clear and understandable form. Gall and Spurzheim had articulated phrenology in complex medical terms. For both of them, phrenological analysis was a tool for diagnosing diseased as well as healthy constitutions. The Fowlers and Wells focused, instead, on presenting a picture of anatomy that would provide people with useful self-knowledge. Adopting an up-to-date idiom of photorealism, they maintained that phrenology was "the camera through which we may look at ourselves."[23]

In order to make the picture as clear as possible, they jettisoned the more arcane and pathologically oriented lingo that had permeated Gall and Spurzheim's earlier work. In his 1869 book, *How To Read Character*, Samuel Wells explained that the Fowler and Wells approach to phrenology sought to offer a

"simpler, and at the same time a more comprehensive system founded on anatomy."

> There are in the human body three grand classes or systems of organs, each having its special function in the general economy. . . . On this natural basis rests our doctrine of the temperaments . . . namely: 1. The Motive Temperament; 2. The Vital Temperament; and 3. The Mental Temperament.[24]

As O. S. Fowler explained these general types, the "Motive" was characterized by a "powerful, muscular, active" physique and included people who were enterprising, bold, and of good judgment. The "Vital" temperament could be spotted by a rotund figure and a "moderate sized head." This type was "self caring, money-making; better adapted to business than study." Last, "Mental" types had "angular and sharp" features and "ardent, intense feelings." This temperament constituted high intellect and was found, most often, in "brilliant writers and speakers."

According to this easily digested system of classification, the three temperaments were general human genres that, in many people, could be found in combination: some of this, some of that.[25] Because each temperament was associated with particular faculties, they could be used to choose a vocation, to hire an employee, to find a compatible husband or wife, and so on. In addition to overall temperament, the development of particular organs and regions of the brain provided even more detailed information about each type or combination of types. All of this exposition was tied to a system of practical advice.

The Self Instructor included tips on how to link temperament, faculties, and life choices. If, for example, one wished to become a clergyman, a "mental temperament" was required, "to give him a decided predominance of MIND OVER his animal propensities; a large frontal and coronal region, the former to give him intellectual capacity, and the latter to impart high moral worth, aims, and feelings, elevation of character and blamelessness of conduct."

Merchants, obviously, should exhibit a "Vital Temperament," as this is a vocation relying on the organic faculty of Acquisitiveness, which was well developed in Vital types. Other faculties required of merchants included "Calculation," for maintaining accounts, and "Adhesiveness," as this would "enable them to make friends of customers, and thus retain them."

Lawyers should be combinations of Mental and Vital, intelligent, with a

love of "money making." Mechanics, as one might expect, should be Motive, to provide them with "muscular power and love of labor." Among the faculties required of mechanics, both Constructiveness and Imitation were essential, as these would "enable [the craftsman] . . . to use tools with dexterity, work after a pattern, and easily learn to do what they may see others do."

Physicians, beyond being mental, required developed faculties of "Destructiveness, lest they shrink from inflicting the pain requisite to cure." "Phrenology," boasted *The Illustrated Self Instructor*, "will predict whether or not a boy will succeed in this profession. The same is true of Dentistry."[26]

If phrenology for men focused on their capacity for worldly activity and for a variety of vocations, phrenology as it was applied to women paid primary attention to issues of domesticity. According to the Fowler brothers, who subscribed to conventional Victorian stereotypes, differences between the conformation of the heads of men and women justified this asymmetrical emphasis.

> Another important argument in favor of phrenology may be drawn from the difference in the conformation of the heads of the two sexes. In the female character, fondness for children and general attachment, are undoubtedly predominating and controlling passions, much stronger, indeed, than the same passions in the male sex; and, accordingly, we find the organs of adhesiveness and, particularly, philoprogenitiveness [or parental love], so strongly developed in the female head as to elongate, and even deform, the middle portion of the back part of the head, affording a sure sign by which to enable the phrenologist to distinguish the female from the male head. . . . The reasoning organs are not so strongly developed in the softer, as in the nobler sex; . . . and, accordingly, we find the former less distinguished for originality and power of thought than the latter.[27]

In studying the heads of phrenological subjects, a general rule of thumb was that size mattered. The enlargement of a particular organ of the brain, corresponding to a particular faculty, was seen as a sign of power in this area. An enlarged region of "parental love," for example, indicated that a woman would be a "good mother." If a woman was underdeveloped in this organ, she was "unmotherly," unfit to raise children.[28] In a man with a highly developed organ of "self-esteem," the exercise of "authority" came naturally. People with small organs for this faculty were characterized by a propensity for "submission." Accompanying the discussion of each faculty in the *Self Instructor* were good and bad examples of each, with contrasting illustrations

2. PARENTAL LOVE.
(Philoprogenitiveness.)

No. 45.—THE GOOD MOTHER. No. 46.—THE UNMOTHERLY.

REPRINTED FROM O. S. AND L. N.
FOWLER'S *THE NEW ILLUSTRATED
SELF-INSTRUCTOR*, 1868; FROM
THE COLLECTION OF THE EWEN
LIBRARY

offering a basis for invidious comparison. Alongside a discussion of the faculty of Veneration, which determined Devotion, Adoration of a Supreme Being, and the "disposition to PRAY, WORSHIP and observe religious rites," were drawings of two skulls. At the top of the page, with a large, spherical coronal region (upper part of the cranium), was the skull of "Diana Waters, who went about Philadelphia, praying and exhorting all she met to repent and pray to God." Below, with an undersized,

No. 74.—DIANA WATERS, WHO WENT ABOUT PHILADELPHIA, PRAYING AND EXHORTING ALL SHE MET TO REPENT AND PRAY TO GOD.

No. 75.—A NEGRO MURDERER, WHO IGNORED ALL RELIGION.

bowl-shaped coronal region, was the skull of "A Negro Murderer, who ignored all religion."[29] With each lesson for self-instruction, readers were provided with images of self and other, models to be guided by, miscreants to look down on. "Comparisons are Odious," noted Samuel Wells, quoting an old saying, "but in the name of science they are more justifiable."[30]

In spite of these general correlations between size and substance, the Fowlers argued, "any faculty may be improved by cultivation and may deteriorate through neglect." While each organ was described as "normally Good," it was also "liable to Perversion" in unseemly circumstances.[31] Amativeness, the organ of sexual love, under ordinary circumstances

REPRINTED FROM O. S. AND L. N. FOWLER'S *THE NEW ILLUSTRATED SELF-INSTRUCTOR*, 1868; FROM THE COLLECTION OF THE EWEN LIBRARY

endowed people with a capacity for monogamy and the birth of offspring. In many ways, it was the organ that provided the basis for family life. Under deleterious cir- cumstances, however, this same organ may run amok. "Perverted, it occasions a grossness and vulgarity in expression and action; licentiousness in all of its forms, a feverish state of mind; and depraves all other propensities . . . and renders the love-feeling . . . gross, animal and depraved."[32]

Similar contingencies surrounded all of the organs. The organ of Acquisitiveness which, when large, could lead to success in business, could also, under mean circumstances, inspire a thief or a murderer. Simultaneously, underdevelopment in the Acquisitive organ could prompt extreme generosity, as was the case with one "Mr. Gosse [who] . . . gave away two fortunes."[33]

In many ways Fowler and Wells popularized ideas developed by Spurzheim: that the organs of the brain provide the basis of character, and that the faculties were inherently good and subject to improvement. They increased the number of faculties from Spurzheim's thirty-five to thirty-seven, but their primary revision of phrenological dogma was to reinsert physiognomy into the picture. Though the brain was still seen as the determining factor, other aspects of human appearance provided readable signs for analyzing character. "[A]ll the phrenological organs," wrote O. S. Fowler, "have likewise their facial poles."[34] In the anonymous streets of New York, or in other cities and towns where strangers were ubiquitous, the ability to make quick judgments on the basis of physical traits was a survival skill and took its place within phrenology's practical teachings.

One of the primary physical distinctions that the Fowlers noted regarded the separation between "fineness" and "coarseness" in hair.

> Fineness of texture manifests exquisiteness of sensibility as seen by contrasting human organisms with brutes or fair-haired with coarse haired. Accordingly, those who are coarse-haired are coarse in feeling and coarse-grained throughout. While those finely organized are fair-minded and thus in all other textures of hair, skin, etc.

For the Fowlers, this dualism was of particular importance, as it reflected on issues of race and social class in mid-nineteenth-century America. Coarse hair was primarily associated with blacks and other "swarthy" people, fine hair with Anglo-Americans. This implicitly ethnic line of demarcation provided an ostensibly scientific physical foundation for entrenched class distinctions.

Coarse-haired persons should never turn dentists or clerks, but should seek some outdoor employment and would be contented with rough work . . . while dark and light fine-haired persons may choose purely intellectual occupations and become lecturers and writers. Red-haired persons [perhaps a reference to working-class Irish] should seek outdoor employment for they require a great amount of air and exercise, while light fine-haired should choose occupations involving taste and mental acumen, yet take bodily exercise enough to tone and vigorate their system.[35]

In the annals of modern stereotyping, the nose has stood out as a central feature for the diagnosis of character, and the Fowlers placed a great deal of emphasis on this attribute. "The more cultivated, advanced the race, the finer the nose," declared Samuel Wells. Among Caucasians he added, noses tend to be "elegant, refined and beautiful." Such noses were an indication of culture and civilization.

"The daughter of a noble house," Wells waxed about a beautiful lace-curtain Irish woman, was marked by a nose that was "fully developed and symmetrical." Among lower-class Irish, "bog-trotters whose sole birthright is the degradation and brutality transmitted through as many generations of ignorance and vulgarity," the nose was, predictably, "developed only in the direction of deformity." He continued, "The nose alone . . . tells the story of its wearer's rank and condition."[36]

In describing the physiognomy of the nose, distinctions of character based on race were unambiguous, clearly written for an Anglo-American audience. Wells's description of "The Secretive Nose" offers a case in point.

The breadth of the wings [of the nose] next to the face indicates the faculty of concealment. Shut the mouth and expand the nostrils. This sign is large in the Negro, the Chinese, the North American Indian, and in most savage and half-civilized tribes. It disposes one to seek concealment, to hide things and to lie low and keep dark. . . . The Negro is very secretive and generally "don't know nuffin bout it" when you endeavor to extract any information from him. The Chinese are still more remarkable for the same trait of character. A sign of this facility is generally found larger in women than in men.[37]

As might be expected, a correspondence between Jews and their noses provided a sure opportunity for analyzing racial character. "The Jewish Nose," wrote Samuel Wells, offered a clear indication of "commercialism."

The Commercial Nose indicates a worldly shrewdness, insight into character, and the ability to turn that insight into a profitable account. . . . Acquisitiveness is not indicated by the outline of the ridge, but by the breadth of the nose which is universally great.[38]

139

Physiognomy 55

action, geniality, a love of the practical rather than the ideal.

23. THE HAWK OR JEWISH NOSE.

This peculiar nose is universally regarded as typical of the Semitic race, who from time immemorial have always been distinguished by this characteristic feature (Fig. 12). In the time of Moses, a flat or insignificant nose was considered as a deformity, and its possessor not deemed worthy to even present an offering at the altar (Lev. 21 : 18). Convex in shape, the nostrils sharply cut, this nose resembles the beak of a bird. It is usually abnormally large, and does not harmonize with or balance the other features. Intellectual power and talent are indicated, and capacity for concentration, also aggressiveness, coarseness, lack of refinement, and the pointed contour speaks of cruelty and disregard of the feelings of others.

FIG. 12.
Jewish nose.

24. THE POINTED OR ACUTE NOSE.

The pointed nose is thin in substance, the skin tightly drawn over the bone. It descends in a

Leila Lomax, an early twentieth century phrenologist, included this passage on the "Jewish Nose," in a book on "How to Read Character in the Face and Determine the Capacity for Love, Business, or Crime." REPRINTED FROM LEILA LOMAX'S, *PHYSIOGNOMY*, 1905

Professor Fowler added a pinch of venom to this portrait: "Acquisitiveness is on each side of the middle portion of the nose, at its junction with the cheek, causing breadth of nose in proportion to the money-grasping instinct as in Jews."[39]

Beyond facial features, gait, and style of dress offered phrenologists useful information for profiling others. Here, too, race and social class provided a basis for generalizations. While a cultivated gentleman could be counted on to walk with pride and elegance, wrote Wells, those of the lower classes were marked by "a slow heavy tramp . . . in keeping with the 'don't care' spirit of the lower 10,000, be they white or black."

Regarding dress, Wells maintained that cultivated, middle-class individuals favored "soft and blended hues." Modest and reserved, they "display the best taste in dressing as to not attract attention." "The ignorant, the low and gross," on the other hand, "prefer strong colors." He continued,

> The untutored African selects for his or her adornment the most gaudy colors and they are fond of "rigging themselves out," in showy finery. The same characteristic is true of the Indian and, to some extent, the low white man or woman.

To Wells, the most offensive aspect of this style of adornment was its visibility. Those people whom he would wish to avoid, make themselves garishly unavoidable. "Coarse and ignorant persons who have the means to do so, often dress in 'negro finery' . . . the brighter the color the better, the point to be gained by them is simply to attract attention."[40]

Phrenology characterized itself as a practical science of self-improvement, yet its vast literature—into the end of the nineteenth century—clearly indicated that the study of phrenology would not redeem all peoples. Aiming its message at middle-class Americans who were unnerved by the steady influx of working-class immigrants and—after 1863—a free black population, phrenology's advice was directed almost entirely at Anglo-Americans, often citing the other groups as examples of inbred degeneracy. If "cultivated" Americans were physiologically fit for improvement—blessed, in general, with large frontal and coronal regions—the other races were burdened by overdeveloped animal propensities and small capacity for thought, artistic creativity, and moral fortitude. Surrounded by a growing number of this latter category, Samuel Wells warned that Americans must be vigilant in avoiding the influence of these lower classes. "You must avoid all those habits

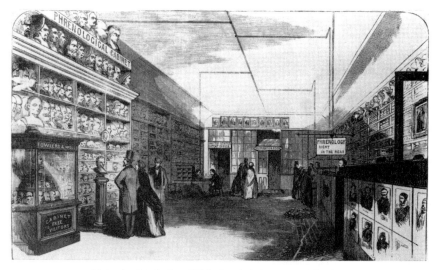

The interior of the Fowler and Wells phrenological museum at 308 Broadway
From the *New-York Illustrated News*, Vol. 1 (February 18, 1860)

REPRINTED FROM *THE NEW-YORK ILLUSTRATED NEWS*, 1860

which minister to the animal passions and strive to elevate yourself far above the gross and growing multitude."[41]

Adding teeth to this warning, Wells, the Fowlers, and others in the phrenological fraternity offered vivid depictions of the multitude, its physical characteristics and its impulsive passions. In 1863, for example, when the working class of New York was largely Irish, O. S. Fowler reported: "We find, in the uncultured classes of the white, the protrusive mouth (jaws and teeth) and the retreating forehead, such as commonly appear in the Negro."[42] During this period, demeaning caricatures of the Irish routinely showed them with simian features, similar to those found in white portrayals of black people. Corresponding to these features was a set of allegedly fixed behavioral patterns. Regarding "the African race as found in America," the Fowler brothers wrote, "the size of their heads is generally moderate or small." They then proceeded to describe the conformation of their organs and the propensities it gave rise to.

Their extremely large hope, would make them very cheerful and little anxious about the future; and with their large approbativeness and small acquisitiveness, they are extravagant and predisposed to lead a life of ease and idleness. . . . Their small reasoning organs would give them but

142

little depth and strength of intellect, and a feeble judgment with very little talent for contriving and planning. Their very large pholoprogenitiveness, adhesiveness, and imitativeness, would make them extremely attached to their families and the families of their masters.

Coinciding with these traits, the Fowlers maintained, were some that posed dangers or affronts to the welfare of refined society. "Their variable selfish organs would cause those extremes of temper and character which they display, sometimes running into cunning, thievishness, and general viciousness and cruelty."[43]

Wells's description of Africans in America covered similar ground. First, to his mind, they were virtually indistinguishable from one another. "The Ethiopian Race is characterized physiognomically by a comparative long face; cheekbones projecting forward; a flat nose with wide nostrils; thick lips; wooly hair; projecting jaws; deep-seated eyes . . . and a black skin." With this standardized package, he proclaimed, came a thoroughly predictable temperament.

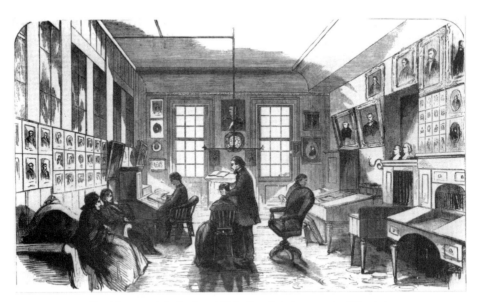

Examining room at the Fowler and Wells phrenological museum at 308 Broadway
From the *New-York Illustrated News*, Vol. 1 (February 18, 1860)

REPRINTED FROM *THE NEW-YORK ILLUSTRATED NEWS*, 1860

[T]he typical negro, from temperament, he is slow and indolent, but persistent and capable of great endurance. . . . He is sensuous, passionate, affectionate, benevolent, docile, imitative, cunning, politic and unprincipled. He lives in the real rather than the ideal without thinking of the past or the future. He is a child in mental development, has the virtues and faults of a child, and like a child is capable of being controlled, disciplined, educated and developed.44

Indians as described by the Fowlers are indistinguishable from those described by Combe, as exemplified by the following from O. S. Fowler:

In a great number of Indian heads and skulls, from many of the different American tribes, has fallen under the author's observation and inspection; and he has found, as a general state common to them all, an extreme development of destructiveness, secretiveness and cautiousness. . . . Their extreme destructiveness would create a cruel, blood-thirsty and revengeful disposition—the disposition common to the race—which, in connection with their moderate or small benevolence would make them turn a deaf ear to the cries of distress, and steel them to such acts of barbarity as they are want to practice, torturing the hapless of their vengeance.45

The Chinese and other members of the "Mongolian Race" were seen as more intelligent but functioned like automata, lacking humor and imagination. Like Ethiopians' but with different features, their faces, Wells maintained, were incapable of expressing individuality.

The distinctive traits of the Mongolian are a broad flat face, with the parts imperfectly distinguished; a short, thick and generally concave nose; small black eyes the orbits of which rise in an oblique line from the nose to the temple; eyebrows barely perceptible; hair coarse, straight, black and not abundant; beard slight or entirely wanting; and a complexion of tawny olive.

These physical traits went along with a laundry list of strictly phrenological observations.

Combativeness, Destructiveness, Acquisitiveness, Secretiveness, Cautiousness and Constructiveness are all generally full or large, while Ide-

ality, Mirthfulness and Causality are more or less deficient; and we herein see the organic cause of the half-blind but persistent mechanical activity; the tireless patient industry, and the energetic, though instinctive rather than intelligent, pursuit of material ends that distinguish the race.

Just as phrenologists drew condescending comparisons between children and Africans, women were generally dismissed as a distinct and inferior group, Charlotte Fowler's connection to the suffrage movement notwithstanding. James W. Redfield, a colleague of the Fowlers and Wells, argued that the animalistic organs in women made it impossible for them exercise the powers of thought or circumspection.

A too great predominance of the affections in women (which is indicated by too large a back head or too small forehead, or sometimes both) leads to ungovernable passions, to tempests, and to the exercise of the affections without the restraint of reason or prudence. This is the case of those who fall into hysteria. . . . Not having the reasoning faculties to govern them, an unusual disturbing cause is sufficient to throw them into a "tumult," and this has a corresponding effect on the body.[46]

Such intrinsically flawed groups of people had no chance against what American phrenologists saw as the superior cranial conformation attributed to European men. "The special organs in which the Caucasian brain most excels and which distinguishes it from those of all less advanced races, are Causality, Mirthfulness, Ideality and Conscientiousness; the organs of these faculties being invariably small in savage and barbarian tribes," wrote Samuel Wells. The Caucasian skull, he continued, stands out in its "beautiful proportions" and "magnificent intellectual and moral development. It will be seen, how widely the crania of the other races differ from this in every aspect."[47]

This judgment provided a justification for the historic cruelties endemic to the rise of a modern world system. Given phrenological disparities, European conquest was inevitable.

Nelson Sizer, who edited the *American Phrenological Journal* from 1859–1863, cheerfully wrote of Europe's dominance over the rest of the world and attributed it to the holy grail of head size:

The European head is much larger than that of the Hindoo, the Chinese, the New Hollander, the African, or the Peruvian Indian. The subjugation of millions of Hindoos by 50,000 Englishmen, the British conquest of China, and that of a handful of Spaniards over a whole nation of Peruvians, and similar triumphs in Mexico; the enslavement of the African by the English races in Europe and America is a significant proof that large heads are more powerful than small ones, and that those nations having small heads are easily conquered and governed by those having large heads and a more favorable endowment of brain.[48]

In the late eighteenth century, under the sway of Joachim Winckelmann's codification of the Greek ideals of beauty, art and aesthetics had played a major role in the rise of physiognomy and racial science. Johann Casper Lavater routinely referred to classical artworks for his archetypes of both "corporal beauty" and "corporal deformity." Blumenbach's categories relied heavily on neoclassical aesthetic standards to distinguish human beauty from the faces of degeneration. Petrus Camper's anatomical studies, and his infamous facial angle, used Winckelmann's Apollo as the criterion against which the different races could be measured and ranked. In phrenology, too, the relation between art and science played an important role. Against the rigor of phrenological computations, however, even many classical artworks did not measure up. Both Gall and Spurzheim, for example, believed that the Venus de Milo did not live up to her reputation of quintessential beauty. Dr. William Lawrence, a British student of phrenology and racial science, reported in 1821, "Gall and Spurzheim judiciously observed that the head of the Venus was too small for an intellectual being; and that the Goddess of love was thus represented by an idiot." Against the Venus, Lawrence upheld Blumenbach's Georgian woman. Here, he believed, "the physical and moral are well-combined; the personal charms, which enchant the senses, are most joined to those rational enjoyments which command esteem and respect and satisfy judgment."[49] In a similar vein, O. S. Fowler took on the reigning exemplar of male beauty. Disparaging "the perfumed effeminacy of the Apollo of the Belvedere," he maintained that the famed statue failed to embody manly phrenological expectations.[50]

George Combe also contributed to the field of phrenological art criticism. Looking at the female image of Liberty, an often bare-breasted neoclassical vision popularized in paintings and on medals after the French Revolution, Combe noted that this widely circulated image was burdened by an "unlimited exercise of the animal propensities." He explained,

146

> She is a female figure with a villainously low, and retreating forehead, deficient moral organs, and an ample development of the base and posterior regions of the brain, devoted to the propensities. Her hair is flying back in loose disorder and her countenance expresses vivacity and passion but never wisdom.

Given Combe's special relationship with America, he was particularly disturbed that early American coinage had borrowed this image, along with its craniological deformities, from the French. To rectify this egregious blunder, Combe proposed a redesigned Liberty for Americans that would conform more accurately to phrenological standards.

> Liberty, as I should draw her, would possess large moral and intellectual organs with moderate propensities. I should arrange her hair in simple elegance, and imprint serene enjoyment, dignity and wisdom on her brow. She should represent moral liberty, of the unlimited freedom to accomplish all that is good, and the absence of every desire to do evil. Such alone is the liberty after which you should aspire.[51]

In 1886, when Auguste Bartholdi's statue of "Liberty Enlightening the World" was raised above New York Harbor, Combe's wish would be granted. Modestly attired, with hardly the hint of breasts or, for that matter, femininity, the phrenological conformation of this revised Liberty would have pleased Combe to no end. Her high, broad vertical forehead spoke of reason and intelligence; the book embraced in her left forearm accentuates this trait. Unlike her late-eighteenth-century precursor, who had so enraged Combe, the regions of the propensities and passions in this Liberty were moderate and restrained. Her hair was coifed neatly and close to the skull, revealing a most excellent cranium. Juxtaposed with Lorenzo Fowler's famous phrenological head, the model of Lady Liberty could easily have served in its stead.

Between the 1830s and 1860s, these ideas left a deep imprint on the thinking of some of America's most prominent artists. The Fowlers had close relations with the artists of the "American Renaissance," as did George Combe. Combe, in fact, wrote a book in 1855, *Phrenology Applied to Painting and Sculpture*, which—like Camper's earlier work—offered physiological instructions for artists interested in achieving phrenological truth.[52]

In the mid-1830s, Lorenzo Fowler had examined the head of Hiram Powers,

the nation's premier neoclassical sculptor. The experience had convinced Powers
that his sculptures should emphasize the prominent organs of a subject's head.

As he prepared to produce a bust of Daniel Webster, he began with a close
phrenological examination of the statesman and orator. Taking a cast of Webster's
head, he brought it to Fowler for a consultation. Together they noted Webster's
broad forehead and great strength in the "region of the faculty of language." Web-
ster's prodigious moral organs, they added, counteracted ample animal regions
that "would have sent to the penitentiary a score of ordinary men."53 Only after
this methodical evaluation did Powers feel ready to begin cutting stone.

Henry Tuckerman, a contemporary art critic and biographer, attributed Pow-
ers's success less to the sculptor's artistic capabilities than to the exceptional cra-
nial conformations of the subjects that he sculpted. Those who sat for Powers,
Tuckerman observed, were "rare and emphatic types of American character and
physiognomy, such as modern sculptors seldom enjoy."54

During George Combe's stay in America, many artists went out of their way
to visit the illustrious Scotsman. One of these pilgrims was Rembrandt Peale,
son of the founder of Peale's Museum and a devotee of phrenology, who had
enjoyed the privilege of attending what would be Spurzheim's final lecture. Peale
was established as a portrait painter, also a painter of historical tableaus. His por-
traits of George Washington and Thomas Jefferson and his canvas of "Washing-
ton Before Yorktown" remain major pieces of artistic Americana.

In 1810, Peale had ventured to Paris to paint the portrait of F. J. Gall, and
years later in the United States, he sought out Combe for a similar purpose. As
Combe visited Peale's studio, he surveyed the walls and took note of what he saw.
Commenting on the painting of "Washington Before Yorktown," he praised
Peale's rendition of the general's spacious forehead, a sure sign of Ideality, but felt
that the wig that he wore in the picture masked his subject's benevolence. In future
paintings, Peale took greater care to emphasize the organs and propensities of his
subjects.

Peale joined Combe on the lecture circuit briefly and spoke explicitly of the
essential relationship between art and phrenology. "Whatever truth there may be
in the systems of phrenology," he proclaimed, "it is certain that all artists, espe-
cially sculptors, necessarily form conclusions in its favor. . . . [N]othing is more
offensive in a work of a modern tyro [that is, novice] in sculpture, than a mal-con-
formation of skull."55

Following on these early developments, the physician and painter William
Rimmer published an illustrated book entitled *Art Anatomy* in 1877, to assist
artists in their quest for craniological accuracy. This comprehensive visual inven-

tory of phrenological types offered aesthetic reference points from which painters and sculptors might gain informed inspiration. Beyond a catalog of customary phrenological typologies, Rimmer also included Camper's geometric guidance for attaining the proper relationship between race and facial angle.[56]

This ongoing exchange between phrenological ideas and the visual arts accentuates the extent to which concerns regarding cranial conformation had infused the fabric of American culture in the nineteenth century. What had begun in the early 1800s as a medical theory regarding brain localization had grown exponentially and flowered into a mass popular enthusiasm. In academic art it also informed the aesthetic rendering of national identity. In oil portraits and marble busts that continue to punctuate tours of official Washington, and in the faces that populate American currency, "good heads" and strong organs proliferate as symbols of moral character. Though unintelligible to most people today, the footprints of phrenology remain everywhere to be seen.

As a phenomenon of art, science, and popular culture, phrenology represented a watershed in the history of modern stereotyping. Like much of the scientific and aesthetic theory that preceded it, phrenology relied on the presentation of ideal types, rigid, physically determined paradigms that, beginning with Linnaeus, were assumed to constitute the true system of nature.

Like natural history museums, the phrenological cabinet was, to a large extent, organized with this assumption in mind. Its shelves included tangible examples of superior and illustrious men, endowed with heads that—according to phrenological theory—explained their greatness. Juxtaposed with these were heads and skulls that nature had burdened with deficient physiologies, explaining their savagery, their criminality, and their inability to control their passions—their inherent need to be dominated.

The annals of phrenology were infused with this racial and sexual essentialism, providing an allegedly scientific foundation for the preeminence of Caucasians in general, male Anglo-Americans in particular. Fowler and Wells publications were filled with an endless succession of dualistic comparisons and invidious illustrations, indicating the high and the low as it applied to each of the organs and propensities. While some of the "lesser" people might benefit from the paternalistic cultivation of their faculties, ultimately their small heads, protruding jaws, and insufficient brows, according to phrenological dogma, served as insurmountable barriers to parity. This outlook, like the taxonomies of human difference that preceded it, identified social inequality with natural law.

Yet, alongside this belief in fixed human typologies, phrenology was also committed to the idea of human improvement. While cranial structure might exert a great deal of influence, the philosophy of Fowler and Wells, and that of their disciples, proposed that phrenology provided lessons by which self-help and the achievement of excellence were possible.

For an Anglo-American middle class, phrenology addressed its growing sense of insecurity and dislocation. In the eighteenth century, when America was a small-scale entrepreneurial and agricultural society, the middle class was sure of its place and importance in the scheme of things. By the 1830s, as the nation was beginning to be transformed into an urban industrial society—increasingly populated by strangers from without and from within—middle-class life became permeated by a gnawing anxiety, a desperate search for a revival of meaning and confidence. At the same time, expanding commercial opportunities presented some men, such as the Fowlers, with the possibility of moving beyond their humble origins. For these aspirational denizens of a parvenu middle class, step-by-step instruction in the arts and sciences of self-improvement was of considerable utility.

As an ameliorative or perfectionist science, phrenology offered Anglo-Americans a sense of reassurance and indispensable behavioral guidance. In their tours through the phrenological cabinet, they were presented with physical evidence of European superiority, of the decadence of non-Europeans, and of the fallen from within their own ranks. In the hands-on examinations that followed, apprehensive and aspiring visitors were reminded that their heads were essentially sound. Insofar as specific organs or propensities were in need of improvement, as indicated on their charts in the *Illustrated Self Instructor*, phrenology also offered steps by which adherents could refine themselves and serve as paragons in their communities. Along with encouragement, however, phrenology sounded a sense of alarm: surrounded by the corrupting influences of urban life, and challenged by the animal vitality of the "coarse" working classes, Anglo-Americans must take heed.

Not all those who were cranially endowed, O. S. Fowler warned, would make the right life choices. Without careful attention to their organs and propensities, the prevailing conditions of society were "most unfavorable for the preservation of the balance of the temperaments." The mental acuity that the middle class possessed, he observed, was being debilitated by a pronounced deterioration of its physical vitality.

[I]n the inhabitants of our cities and villages, the mental temperament greatly predominates, and the vital is weak, as is evinced by their sharp

features, thin faces, and haggard looks, whilst . . . the working class generally have finely developed heads, with but little cultivation, that is they have natural talent, with little acquired learning.[57]

It is little wonder that, as a supplement to craniological instruction, diet and exercise became important arenas addressed by this prescriptive science. In light of this development, a business partnership between Samuel Wells and Sylvester Graham, the vegetarian food reformer and inventor of the graham cracker, makes a good deal of sense.[58] Living by phrenological principles and following the role models provided by the positive ideal types that permeated the literature of phrenology was the formula by which the nation would survive. The road toward perfection of the middle class was necessary for its continued existence.

These two ideas, essentialism and perfectionism, coexisted within phrenology, separating it from the eighteenth-century sciences out of which it sprang, pointing it forward to twentieth-century stories of before and after, of transformation. This paradoxical affiliation, the idea that some individuals are blessed with a boundless, if imperiled, position to improve themselves, to become the beneficiaries of progress, while others are hopelessly ensconced in stagnant, predetermined positions of imperfection, would continue to shape the history of American stereotypes.

13
THE PENCIL OF NATURE

There is a charcoal sketch of Thomas Jefferson in profile, done by a French artist, Charles Fevret de Saint-Memin. In many ways it appears unremarkable, a plain hand drawing of the President of the United States and author of the Declaration of Independence. And then a simple fact emerges that alters the way we see it.

While the details of Jefferson's face express the artist's perspective, the outline of Jefferson's head is a direct tracing from the President's shadow, captured by Saint-Memin in 1804, using a French invention known as the physionotrace. Perfected in 1786 by Gille Louis Chrétien, the instrument consisted of a "pointer attached by a series of levers to a pencil." With it, "an operator could trace on paper a profile cast onto glass."[1] Another device, a pantograph, was used to transfer the profile, usually in miniature, onto a copper plate, permitting the reproduction of multiple copies of the President's profile.

Though the fine points of Jefferson's physiognomy are Saint-Memin's subjective rendering, the conformation of his skull—phrenology's touchstone through which character can be divined—lingers on as a relic of the real Thomas Jefferson, forged by light and shadow. Even in its relative crudeness, its distance from what we today expect of our visual records, there is still something magical, ghostlike about its aura. It is as if some vestige of Jefferson, long dead, still remains in our presence.

1804 Silhouette Portrait of Jefferson by Charles Fevret de Saint-Memin.
COURTESY OF THE WORCESTER MUSEUM OF ART

Saint-Memin's recording of Jefferson's head was made in the early nineteenth century, but it embodied a longing for visual truth that had been a European obsession for centuries. The camera obscura had been a step in the direction of such tangibility, and by the late seventeenth century, new efforts were under way to capture and fix reality on a flat surface.

One of the most significant steps in this direction was the development of a technique of hand tracing shadows cast onto oiled paper, using a candle as a light source.

A SURE AND CONVENIENT MACHINE FOR DRAWING SILHOUETTES.

This is the Character I would assign to the silhouette of this Young person; I find in it, Goodness without much Ingenuity; Clearness of Idea, & a ready Conception, a mind very industrious, but, little governed by a lively Imagination, & not attached to a rigid punctuality; We do not discern in the Copy, the Character of Gaiety which is conspicuous in the Original; but the Nose is improved in the silhouette, it expresses more Ingenuity.

REPRINTED FROM JOHN CASPER LAVATER'S *ESSAYS IN PHYSIOGNOMY*. VOLUME II, LONDON, 1810; FROM THE COLLECTION OF THE EWEN LIBRARY

The traced shadows—then laid over black paper and cut out—were called silhou-
ettes, named for Etienne de Silhouette, finance minister for Louis XV of France,
who relaxed by cutting shadow profiles. In England, these profiles were known,
simply, as shades. Throughout much of the eighteenth century—in France, Eng-
land, America, and Russia—silhouette portraits and scenes became a fashionable
art form, collected and hung as domestic decorations, sometimes inscribed on
ivory and worn in miniature as jewelry.

With the publication of Johann Casper Lavater's *Essays in Physio*gnomy, how-
ever, silhouette portraiture began to gain status as a form of physiognomic evi-
dence, a scientific tool for discerning the quality of a person's character. Lavater
devoted a considerable portion of his *Essays* to "shades" and cut or drew silhouettes
of some of the most prominent men and women of his day. To Lavater, shades
omitted a good deal of physiognomic information. They were, after all, "only the
boundary line of half the countenance." Yet they were, "when the light is at a proper
distance, and falls properly on the countenance to take the profile accurately, the
truest representation that can be given of a man. . . . [I]t is the immediate expres-
sion of nature, such as not the ablest painter is capable of drawing."

Though his book took a wide range of visual evidence into account, Lavater
claimed that shades provided him with more useful information than did other
art forms or even firsthand observations. "I have collected more physiognomon-
ical knowledge from shades alone," he wrote, "than from every other kind of por-
trait . . . [and] have improved physiognomonical sensation more by the sight of
them, than by the contemplation of ever mutable nature."[2] From a properly pro-
duced shade, crucial evidence—inscribed by nature—became available in its
truest form, including the conformation line of the brow, nose, lips, chin, and
neck, as well as the back of the head and neck. Together, he maintained, these ele-
ments of the profile offered an indispensable insight into "nature's truths."[3] Fol-
lowing these general observations, Lavater went on to analyze the shapes of moral
character in a diversity of profiles.

Given Lavater's lofty reputation as a man of ideas, the impact of his illustrated
discourse on silhouettes was considerable. From decorative diversions they were
quickly transformed into serious credentials of character. In the wake of Lavater's
blessing, silhouette sittings became fashionable among some of Europe and
America's most powerful and influential people. Catherine the Great of Russia,
King George III of England, the American President George Washington, and
other leaders felt compelled to have their esteemed portraits preserved in this
form, hoping to leave irrefutable optical evidence of their superior cranial merit.
So, too, did Johann Wolfgang von Goethe, a close friend of both Lavater and

Gall, who began cutting silhouettes of his own.[4] Jefferson's physionotrace portrait, no doubt, was in keeping with this novel tradition.

The fascination with silhouettes continued, and with it, a business grew up that allowed ordinary folk the opportunity to have their profiles and characters cut in black paper for posterity to admire. They offered a kind of democratic visible immortality. Silhouette portraits were kept in family albums along with other keepsakes, and as Anglo-America expanded westward, across what is now the United States, traveling silhouette cutters, carrying candles, scissors, and paper, became affordable portrait artists of the frontier. As late as 1839, Auguste Edouart, a French silhouette maker, built a business in the United States, producing profiles of nearly four thousand Americans including six presidents and a number of other prominent politicians and public figures.[5]

By the 1830s, other genres of popular culture were emerging that were predicated on the idea of offering mass audiences unprecedented access to the informational veracity of images. In 1832, in England, the Society for the Diffusion of Useful Knowledge launched a publication, *The Penny Magazine*, with this objective in mind. With a circulation near 200,000, it was filled with realistic woodcut engravings that were also marketed internationally to other publications in the form of stereotype plates. The images then reappeared in magazines throughout Europe, broadening public entrée to their instructive content.

> The Penny Magazine printed woodcuts depicting British and foreign topography, natural history, the fine arts, and modern engineering and scientific marvels. Foreign places and exotic plants and animal life which were completely out of the range of daily experience were therefore considered particularly good subjects for illustration.

On page one of the first issue, the magazine's editors announced their intent. Drawing images from around the globe, they proclaimed, they would annihilate physical limits that kept most people from this kind of earthly knowledge. They would also strike a blow for democracy, though primarily through the agency of images.

> Cheap communication breaks down the obstacles of time and space— and thus bringing all ends of a great kingdom as it were together, greatly reduces the inequalities of fortune and situation, by equalizing the price of commodities, and to that extent making them accessible to all.[6]

The Penny Magazine was part of a new democratic mission to provide the opportunity of visual enlightenment and virtual travel to those unable to embark on actual journeys. Another example of this effort was Charles A. Goodrich's book, *The Universal Traveler*, which was published in the United States in 1836. Along with an extensive text, the book included finely detailed woodcuts of strange people from strange lands and offered a glimpse of primordial people and their habitats. The expressed goal of this book was not unlike that of *The Penny Magazine*.

> It is a privilege of but few, to visit and observe distant countries and different nations. . . . The majority are necessarily cut off from this species of amusement and information. . . . We will hold up a picture by which, in the comfort of your home, you may see whatever is worthy of inspection, just as a literal traveler would see it.

Yet this democracy was clearly not a privilege to be enjoyed by everyone. In Europe and America, where many were convinced of the natural hierarchy of humanity, it is not surprising that Goodrich asserted that his pictures of the world beyond would only remind readers of the consecrated place they occupied in the order of things. Goodrich proclaimed to readers that *The Universal Traveler* "will make you more satisfied than ever with our own country—its state of society, morals, religion, education, government . . . and all the circumstances that contribute to national happiness."[7] Though relying on the medium of woodcuts, these publications rested on the assumption that these images bore the irrefutable imprint of the real.

The dialog between silhouettes and these mass-distributed wood engravings is a familiar one. The silhouette portrait, as it evolved in Europe and America, served a voucher of personhood, testimony to the lasting value of an individual's existence. It was, more than anything else, a tribute to the self. Wood engravings in mass magazines and travel books, on the other hand, introduced viewers to the physical and social physiognomy of strangers. Unlike the silhouette, these images served as records of the other.

If the camera obscura, linear perspective, silhouette images, and woodcut illustrations could only reflect, imitate, trace, or disseminate a semblance of truth, it was the development of another innovation that constituted a sea change in the search for the real as the eye would see it. From the 1820s onward, photography—more than anything before it—appeared actually able to capture and then sustain the real. With the rise of photography, image and truth became inseparable as never before. In a thunderous fusion of vision and chemistry, miraculous new pictures now seemed to be factually descended from the visible world.

Not unexpectedly, the steps leading to the discovery of photographic processes drew heavily on scientific and aesthetic experiments dating back to Alhazen, Roger Bacon, and Leonardo da Vinci. Using precisely ground lenses, the camera obscura had permitted artists and scientists to examine and sketch three-dimensional sights on a flat surface with remarkable clarity and brightness. The invention of photography as we know it simply required the development of techniques and materials that could fix and hold these fleeting observations realistically, giving them an uncanny perseverance as perpetual mementos of a receding past. As Susan Sontag has noted, photography made possible a permanent "inventory of mortality."[8]

The time was ripe for photography. The early nineteenth century witnessed a rapid growth of scientific knowledge and the development of new industrial processes. Invention was a common pastime of artists, artisans, and entrepreneurs. As is the case with most inventions, so with photography the idea of a single inventor may be a convenient fact to teach schoolchildren, but it is not accurate. The idea of photography was in the air, and its creation was the simultaneous endeavor of several men. Given the long historic competition for political, economic, and scientific dominance between England and France, it is hardly surprising that both countries hold to their own genealogies of photography.

In France, two men came together in the story. One was Joseph Nicephore Niépce, a lithographer from Chalons-Sur-Saone who had developed a technique that replaced conventional lithography stones with tin plates. With little artistic talent of his own, he began experimenting with materials that might record images from a camera obscura. Initially, in 1817, he used a resin from a coniferous tree that, he had noticed, turned from yellow to green when exposed to light. When this resin failed to work in a camera obscura, he turned to bitumen, a hydrocarbon that, when painted onto a prepared metal plate, was capable of recording rudimentary images through the lens of a camera box. Using this

technique, in 1827, Niépce took the first "heliographic" image, a scene of a dove-cote (pigeon coop) taken from his back window. Shadowy and vague, yet strangely alluring, this first hazy photograph required an exposure of eight hours but demonstrated that a long historical quest was on the verge of its reward.

Shortly, Niépce entered into a partnership with Louis Daguerre, a painter who had built one of Paris's most popular attractions, the Diorama. The Diorama consisted of a large, darkened, circular theater surrounded by a vast panoramic landscape painted on a staggered series of flat layers, creating the illusion of depth. Through alterations in lighting and other effects, Daguerre was able to simulate the changing of time and season, including dramatic storms as part of the show. This wildly popular entertainment, which drew visitors from all over Europe, was part of the ongoing effort to replicate the real.

Parallel to his theatrical enterprise, Daguerre was also possessed with the notion of giving permanence to images as seen in the camera obscura. Given this obsession, it is little wonder that he and Niépce entered into a contractual collaboration in 1829, pooling their creative and scientific resources. When Niépce died in 1833, Daguerre continued the mission on his own, achieving dramatic success by 1837.

Daguerre's most important technical contribution was based on his observation that silver, with its tendency to tarnish when exposed to the elements, was especially sensitive to light. Certain silver compounds accelerated this tendency considerably, silver iodide in particular. Coating a copper plate with silver and exposing it to iodine vapors, Daguerre produced a light-sensitive plate that could record a remarkably sharp image when exposed through the lens of a camera obscura. Using this plate, and accelerating its responsiveness to light by processing it in mercury vapors, exposure time dropped dramatically. Employing a stop bath, which arrested the plate's light sensitivity, Daguerre was now able to produce a fixed and permanent high quality "photographic" image. Each image was one-of-a-kind and required conducive viewing circumstances to be seen as positives. A fragile jewel, each image was encased in glass for its protection.

Calling his invention the Daguerreotype, he capitalized on it as a trade name and was eloquent in its praise. Even more than Lavater's silhouette images, these achieved, Daguerre publicly proclaimed, "the spontaneous reproduction of nature." Though a painter, Daguerre wished to separate his technique from the whims of artistic talent. His method, he argued, simply permitted nature to take its course. "The Daguerreotype is not merely an instrument which serves to draw Nature; on the contrary it is a chemical and physical process which gives her the power to reproduce herself."

158

Though today it is generally understood that photographs are influenced by aesthetic and selective choices made by the photographer, the vocabulary that is used to describe photography still holds to Daguerre's claim that his invention worked spontaneously, without human intervention. In daily parlance we continue to talk about "taking" photographs, as if snatching them from the physical world, rather than making them.

Daguerre's background in the entertainment business had instructed him well in the arts of promotion, which he realized would be necessary for his invention to take hold. He was convinced that, if properly sponsored, his invention would become a fascination among the European "leisured" classes.[9] In order to ensure its advancement, Daguerre decided to sell his process to the French government. Approaching the Chamber of Deputies through some scientist-politicians in its ranks, Daguerre's strategy paid off when the distinguished astronomer and deputy François Arago spoke before the Chamber on behalf of the purchase. Struck by the "unimaginable precision" of Daguerre's images, "drawn by nature's most subtle pencil, the light ray," Arago maintained that government purchase of the daguerreotype technique would elevate France's position in physics and astronomy, contribute to "archeology and the fine arts," allow for the preservation of historic records, and stimulate economic progress.[10] The deal was finalized in January 1839, and by the end of the year, "Daguerréotypomanie," as the French press named it, was rampant.[11]

By 1840, the daguerreotype had arrived in the United States, promoted by Samuel F. B. Morse—a painter and leader in electromagnetic telegraphy—who had seen it in France and advocated its importation. As had been the case in Europe, the technology's magic was in its ability to produce an optical model of truth. While painters had been using optical devices for centuries, the capacity for painting to mimic the science of optics was limited. Photography, however, was capable of being as accurate as any optical device. Edgar Allan Poe wrote magazine articles describing the daguerreotype's ability to stand up to scientific standards.

> The Daguerreotype plate is . . . infinitely more accurate in its representation than any painting by human hands. If we examine a work of ordinary art, by means of a powerful microscope, all traces of

PORTRAITS
AU DAGUERRÉOTYPE.

'M. BROGLIE, venant de Paris, élève de M. DAGUERRE, fait des portraits en couleur naturelle et en noir, de 6 à 10 fr. Il vend des appareils et enseigne cet art dans sa plus grande perfection. On le trouve tous les jours de 7 heures du matin à 5 heures du soir, Grand'rue, 18, au fond de la cour.

A French newspaper advertisement for a daguerreotype portrait photographer.
REPRINTED FROM *LES AFFICHES DE STRASBOURG*, JUNE 18, 1845

resemblance to nature will disappear—but the closest scrutiny of the photogenic drawing discloses only a more absolute truth, a more per- fect identity of aspect with the thing represented.[12]

More succinctly, the great American photographer Robert H. Vance described the daguerreotype as "the stereotyped impression of the real thing itself."[13]

When Poe invoked the powers of "photogenic drawing," it was not a phrase acquired from the Frenchman Louis Daguerre. Instead, it was the description of photography employed by one of its other inventors, Daguerre's chief rival from across the Channel, the Englishman William Henry Fox Talbot. In order to sketch visual memories of his extensive travels, Talbot began using a camera obscura while visiting Italy in 1823 and 1824. Despite the pristine clarity of visions collected with this device, Talbot found drawing with it a "practice somewhat difficult to manage, because the pressure of the hand and pencil upon the paper tends to shake and displace the instrument."

A child of the landed nobility, Talbot had considerable time and resources to pursue his interest in capturing optically accurate pictures of the environment. Impressed by "the inimitable beauty of the pictures of nature's painting which the glass lens of the Camera throws upon the paper in its focus," he began searching for ways to permanently hold onto these "fairy pictures, creations of a moment . . . destined as rapidly to fade away." On honeymoon in 1833, again in Italy, he pondered the possibility of creating a "pencil of nature."

Light where it exists, can exert an action, and, in certain circumstances, does exert one sufficient to cause changes in material bodies. Suppose, then, such an action could be exerted on the paper; and suppose the paper could be visibly changed by it. . . . Such was the idea that came into my mind. Whether it had ever occurred to me before amid floating philosophic visions, I know not, though I rather think it must have done so, because on this occasion it struck me so forcibly.[14]

Thunderstruck by this series of suppositions, Talbot began, in 1834, looking into the still primitive field of chemistry for compounds that, when applied to paper, might achieve the visible changes he sought. Artistic and scientific pursuits continued to unfold in unison. Like Daguerre, Talbot was aware that silver compounds were "particularly sensitive to the action of light" and, upon returning to England, he began a series of experiments. Beginning with silver nitrate, which

160

did not produce results, he turned to silver chloride as a light-sensitive coating. With this compound he was able to create pictures using the camera obscura, learning that a bath in hyposulfite of soda was able to halt light's action on the silver, fixing the image. "This characteristic of hypo," reports Naomi Rosenblum, "had been discovered in 1819 by John Herschel, . . . a prominent astronomer, physical scientist, and friend of Talbot," who had educated both Talbot and Daguerre to the role that a hypo bath (as it is still called) could play in the fixing of photographs.[15]

Talbot's experiments linking light sensitivity to the camera obscura began bearing fruit by the late 1830s. Unlike the daguerreotype, a unique image engraved on a silver plate, Talbot's "photogenic drawing," "Talbotype" or "Calotype" (from the Greek *kalos*, for beauty) technique produced a "negative." Where light struck the paper, it became dark; where light did not, the paper remained white. From these negatives, Talbot was then able to print, using light on sensitized paper, multiple "positive" images. (The terms "negative" and "positive" in this process were coined by Talbot's friend Herschel, who also suggested the use of the term "photography.") Though Talbot kept his discoveries to himself, the elements of modern photography had been born.

In 1839, when Daguerre's invention was announced, Talbot was, at first, crestfallen, believing that he had been one-upped by the Frenchman. Writing in 1844, Talbot recalled:

> Such was the progress which I had made in this inquiry at the close of the year 1838, when an event occurred in the scientific world, which in some degree frustrated the hope with which I had pursued, during nearly five years, this long and complicated, but interesting series of experiments—the hope, namely, of being the first to announce to the world the existence of the New Art—which has been since named Photography.
>
> I allude, of course, to the publication in the month of January 1839, of the great discovery of M. Daguerre, of the photographic process which he has called the Daguerreotype.

When the French Académie des Sciences announced this remarkable invention, without any details of the process, Talbot believed that his and Daguerre's processes were the same. Battling for ownership, Talbot, in January 1839, presented his discovery of "photogenic drawing," in great detail, to the British Royal Society and to the newspapers. It was, according to the photo historian

Beaumont Newhall, the first publication of "a workable photographic system anywhere in the world." Daguerre's methodology followed in August, 1839.[16]

Bragging rights can be claimed in both directions. Talbot's techniques, creating negatives that could generate multiple positives, provided a foundation for the advance of modern photography and, later, cinema. On the other hand, Daguerre's one-of-a-kind images, though they required special conditions for viewing, were much sharper and more detailed than Talbot's. In addition, Daguerre had discovered "latent development," a process that required the chemical processing of exposed plates in order for their images to be seen but diminished exposure time dramatically. When Talbot began to employ this process in the fall of 1840, his exposure times were reduced from half an hour to about thirty seconds, allowing him to photograph living subjects. With "latent development," the quality of Talbot's pictures improved significantly. When, in 1851, glass collodion plates replaced Talbot's paper negatives, producing remarkably clear photographic prints, the battle was over. While Daguerre's precious images lin-

The cover page for a small numbered edition of *The Pencil of Nature*. REPRINTED FROM WILLIAM HENRY FOX TALBOT'S *THE PENCIL OF NATURE*

gered as treasured keepsakes, the daguerreotype process began to fade from photography's stage. So, too, did Daguerre, who died that same year.

The "phantom objectivity" of photography was envisaged by William Henry Fox Talbot from its inception. In an attempt to record and demonstrate the remarkable promise of this new invention, in 1844, he began publishing a series of six folios, which together would become the first "mass produced" book illustrated with photographs, *The Pencil of Nature*. In it, he offered a prescient soliloquy on the veracity and varied utilitarian possibilities of the photographic image.

Printing out twenty-four photographs for each copy, Talbot reiterated Daguerre's claim that photography was not the flawed creation of the human hand but an exact scientific replica.

[T]he plates of this work have been obtained by the mere action of Light upon sensitive paper. They have been formed or depicted by optical and chemical means alone, and without the aid of any one acquainted with the art of drawing. It is needless, therefore, to say that they differ in all

162

respects, and as widely as possible, in their origin, from plates of the ordinary kind, which owe their existence to the united skill of the Artist and the Engraver.

They are impressed by Nature's hand; and what they want as yet of delicacy and finish of execution arises chiefly from our want of sufficient knowledge of her laws.

"The Open Door." REPRINTED FROM WILLIAM HENRY FOX TAL-
BOT'S *THE PENCIL OF NATURE*

Following an extensive text, in which Talbot discussed the development of his photographic endeavors, are pages displaying a series of representative photographs, arranged to offer readers an opportunity to understand the quality of photographic images and the potential uses to which photography might be applied.

One of his images, "The Haystack," provided readers with an object lesson in photography's precision. Referring to this picture, in which every straw is clearly delineated, Talbot noted, "One advantage of the discovery of the Photographic Art will be, that it will enable us to introduce into our pictures a multitude of minute details which add to the truth and reality of the representation, but which no artist would take the trouble to copy faithfully from nature."[17] In a way that would be wasteful in the conventional production of artworks, photographs permit the near-instantaneous recording of "minutiae." In a society that was intent, in a variety of arenas, on examining and analyzing small physical details, this capacity of photography would, of itself, win many adherents.

In his discussions of several other plates, Talbot anticipated the role that photographic processes would play in the truthful reproduction of previously rare or unique objects and artworks. Forecasting xerography, or photocopying, he included one plate, "FACSIMILE OF AN OLD PRINTED PAGE," to suggest that printed materials might be photographed and reproduced in multiple. Similarly, paintings and lithographs, sculptures and architectural wonders, panoramas of entire cities, and botanical specimens now held the possibility of mass production and distribution, bringing distant realities closer to home.

Photography, as it emerged from the efforts of Niépce, Daguerre, and Talbot, presented a rendition of the real that was unprecedented. Looking at

photographs, viewers assumed that they now had access to flawless replicas of people, places, and things. Because of their mobility, photographs were also capable of moving objective truths across great distances, altering people's comprehension of the world itself. One of the most common early uses of photography was the photographing of scenes from distant lands, offering Europeans and Americans a sense of having firsthand knowledge of people and places that they had previously only heard or read about. The world was becoming smaller through a traffic in appearances, and a market in images that sustained European visions of the exotic and the primitive around the world became a core component of personal, public, and scientific photographic collections. While the ability to publish halftone photographs in newspapers and magazines would not be perfected until the 1890s, published engravings, marked by the authoritative phrase "from a photograph," lent an aura of genuineness to portrayals of current events, faces of the famous and infamous, scenes from the outer reaches of empire.

Yet photographs were deficient in one crucial area. They lacked depth, a palpable sense of solidity. In the search for verisimilitude, this third dimension demanded its facsimile. Given this, it is not surprising that while Niépce, Daguerre, and Talbot labored at the perfection of photorealism, others were working on processes that would simulate binocular vision, a three-dimensionality that a viewer would want to reach out and touch.

One of these was the British savant Sir Charles Wheatstone. Though without formal training, Wheatstone was one of the most formidable scientific minds of the nineteenth century. Having taught himself to read French, German, Italian, Latin, and Greek, he read widely and from these readings accumulated an enormous quantity of technical knowledge. His inventions ranged from acoustics to optics, electricity to high-speed telegraphy, and, coming from a musical family, he also took time to invent, patent, produce, and market the concertina. Alongside these weighty credentials, Wheatstone was a student of phrenology, with a library containing the works of F. J. Gall and George Combe.

In the area of three-dimensional image making, Wheatstone drew on a common form of amusement. For centuries before the development of photography, some few individuals, when they gazed at two side-by-side pictures, would see the images merge in their mind's eye, creating the illusion of a single view with depth and solidity. Some were able to "free view" in this way without effort. Others, over time, trained themselves to do it. Many tried and tried without success. Wheatstone, who was gifted with this capacity, began, in the late 1820s, to think about developing an optical device that would make

Two early versions of the Holmes-Bates stereoscope. FROM THE *PHILADELPHIA PHOTOGRAPHER*, JANUARY 1869, REPRINTED COURTESY OF PAUL WING, *STEREOSCOPES: THE FIRST HUNDRED YEARS*, 1996

the three-dimensional viewing of image pairs available to those who had previously been frustrated in their efforts.

Sir Charles was aware of Euclid's observation that each eye views the world from a faintly different perspective. The free viewing of image pairs was based on this understanding; each image was slightly different from the other, mimicking the perspective of the two eyes. While a small number of people were capable of performing optical fusion without assistance, Wheatstone was convinced that an instrument could be designed to "aid in the process." He called this instrument the "stereoscope," from the Greek for "solid viewing." By 1832, he had developed his first device, which used mirrors, and in 1838, one year before Talbot's debut, he presented his findings in an extensive paper delivered to the Royal Academy.

His first image pairs were simple line drawings, but by 1852 Wheatstone presented a second paper to the Academy in which he described the use of photographic pairs in which the realism of photography was amplified by the credible impression of physical mass. For his first photographic pairs, Wheatstone went to familiar sources. He first approached William Henry Fox Talbot, who produced for him "stereoscopic Talbotypes of full size statues, buildings, and even portraits of living persons." Though Daguerre was dead, Wheatstone relied on disciples "for daguerreotypes executed for the stereoscope."

Yet even before Wheatstone delivered his second paper to the Royal Academy, a popular enthusiasm for stereoscopes and stereographs—as the photographic pairs mounted on cards were called—had already emerged. Building on Wheatstone's innovations, a number of others had added to the quality of

stereo viewing. One was a prominent Scottish scientist, Sir Daniel Brewster, who, in 1849, substituted prismatic (lenticular) lenses for Wheatstone's mirrors, producing an optically superior viewer that converged side-by-side images with unprecedented effectiveness. Taking cues from Brewster, a Parisian optical firm led by the optician M. Jules Duboscq "began to make lenticular stereoscopes for sale and also to produce fine stereo daguerreotypes." It was Duboscq who received the first patent on the stereoscope in 1852.[18]

One year earlier, a spectacular, now legendary exhibition of industrial wonders opened in London in the magnificent Crystal Palace. Within this extraordinary edifice of iron and glass, an exhibit of Duboscq's stereoscopes and stereographs created a sensation, gaining the official approval of Queen Victoria herself. Paul Wing, historian of stereography, tells the story.

> It was Duboscq's instruments and views exhibited at the Crystal Palace in 1851 that attracted the particular attention of the Queen. Before the closing, Sir David [Brewster] presented a beautiful Duboscq stereoscope with his views to her majesty.
>
> It was the beginning of a tremendous surge in popularity. Large numbers of stereoscopes were brought in from France and opticians of all kinds devoted themselves to the manufacture of the instruments.[19]

Shortly, stereoscopes in a wide variety of designs infused an enormous and growing market. Some handheld instruments were intended for personal home viewing. Simple designs were aimed at a large middle-class market, while elaborately ornamented scopes found their way into the hands of the wealthy. Other models, large tabletop viewers and floor models that could rotate through a great number of stereographs with the twist of a knob, helped turn stereo viewing into a public entertainment as well.[20]

As a business, stereoscopes and views grew by leaps and bounds. Feeding an insatiable hunger, factories produced stereographs on steam-driven machinery, photographs "mounted on cards using assembly line methods." In the United States, where the vogue attracted millions, views were mass marketed "through mail-order and door-to-door sales."[21]

Not all were thrilled. In 1859, in a bitter commentary, the French poet Charles Baudelaire decried the charismatic power that stereo viewing was inflicting on a starry-eyed public. Following on the heels of photography, which Baudelaire denounced as a palliative for the "multitude," signaling the demise of art and the ruin of the imagination, "[i]t was not long before thousands of pairs of

greedy eyes were glued to the peep holes of the stereoscope, as though they were the skylights of the infinite."[22]

For most people, however, these skylights were irresistible, and stereography became the television of the mid-to-late nineteenth century. Many companies emerged to feed the frenzy. In England by the late 1850s, "The London Stereoscopic Company, the first major concern to produce stereoscopic photographs had sold about 500,000 stereoscopes and two years later, they claimed a listing of over 100,000 different views." In the United States there was a similar explosion of stereography, and numerous businesses grew in response to a burgeoning market. In the 1890s, with the perfection of halftone processes, American companies produced stereo pairs using photolithography and pumped out twenty-five thousand views per day.[23]

These stereographs, which were often sold in sets, featured varied subject matter mirroring the fascinations of the time, including physiognomy and racial science. There were imposing heads of great men, along with comic racial stereotypes, many using blackface. There were pictures of distant lands and the near-naked primitives who inhabited them. Ominous Indians and romanticized cowboys were also part of the mix. One set of cards, "The New Woman," mockingly depicted the emasculation that would result from women's suffrage. On the other side, pornographic images of voluptuous three-dimensional nudes invited male viewers in for a feel.

Other cards documented industrial wonders. Disasters, industrial and natural, were also a common theme. Some sets were instructional, teaching soldiers the proper use of gas masks or drinkers the dangers of their evil habit. Other cards offered lessons in crime and punishment. One of these had a text recounting the story of a murder on its backside and a three-dimensional stereo view of the murderer's hanging on the front. By the 1890s, stereo views were also being used for advertising, as in the case of Sears, Roebuck and Company, which offered mail-order customers a firsthand look at the legendary Chicago site from which their coveted goods emanated.

One of the most important contributors to the popularization of stereoscopes and stereographs in America was Oliver Wendell Holmes, poet, essayist, physician, and professor of anatomy at Harvard, also father of a future Supreme Court justice.

Holmes was also an amateur photographer, with a strong belief in the edifying powers of visual information. Though he dismissed phrenology "as an attempt to estimate the money in a safe by the knobs on the outside," he had,

in fact, been examined by Lorenzo Fowler. Perhaps it was Fowler's less than stunning evaluation of Holmes that had prompted this negative comment on phrenology.[24] While rejecting phrenology, however, Holmes was a strong and vocal "believer in physiognomy."

A medical student named Holyoke once had occasion to call on him, and as soon as he had introduced himself Dr. Holmes said: "There, me

This mass-produced stereograph (1904) could spirit people from the comfort of their homes to the Holy Land. FROM THE COLLECTION OF THE EWEN LIBRARY

A modern stereograph: "Sol and Scotty." ARCHIE BISHOP, 2000

friend, stand there and let me take an observation of you." He then fetched an old book from his library which contained a portrait of Holyoke's grandfather, who had also been a physician. He compared the two faces, saying: "Forehead much the same; nose not so full; mouth rather more feminine; chin not quite so strong; but on the whole a very good likeness, and I have no doubt you will make an excellent doctor."[25]

Given this faith in the instructive value of appearances, Holmes's interest in photography makes sense, as does his interest in that arena of photography that provided, it seemed, the greatest degree of truthfulness: stereography, which he termed "sun sculpture." Following this interest, he joined Joseph L. Bates, a Boston lens maker, in the creation of an inexpensive, compact, and lightweight instrument that was ideal for viewing cheap, widely available paper stereographs. Their device, known as the Holmes-Bates stereoscope, permitted almost anyone to enjoy the stimulating pastime of viewing 3-D images from around the world in the comfort of their homes. The Holmes-Bates design became the standard and remained in production until 1939. Today, fine-looking Holmes-Bates kits, crafted in Canada, are still available to stereo enthusiasts.

14

FACIAL POLITICS

The Holmes-Bates stereoscope was but an expression of Oliver Wendell Holmes's belief that photographs and stereographs had forever altered the physics of perception, the relationship between the material world and the ways that people see it. His ideas about photography and the stereoscope were presented in three articles published between 1859 and 1863 in an influential new magazine, *The Atlantic Monthly*.

Prior to the appearance of the these articles Holmes was little known as a public figure. When *The Atlantic Monthly* commenced publication in 1857, its editor, James Russell Lowell, focused on convincing his brilliant friend, Dr. Holmes, to become a contributor to the magazine. With this publication, Holmes' eminence grew.

Holmes's pieces on photography—which included "The Stereoscope and the Stereograph" [1859], "Sun-Painting and Sun-Sculpture" [1861], and "Doings of the Sunbeam" [1863]—offer a remarkable opportunity to listen in on the musings of person born in an age before photography, contemplating the impact of this earthshaking invention.

For Holmes, photography and stereography had the capacity to entrap the fleeting moment. It was "a mirror with a memory," which could defy the passage of time itself, maintaining a vivid register of the past that had previously relied on vicissitudes of recollection. In its capacity to offer an apparently solid view of a subject, the stereograph, he added, would "become the card of introduction to make all mankind acquaintances."

Holmes was enthralled by the ability to render depth. "The first effect of looking at a good photograph through the stereoscope is a surprise such as no painting ever produced. The mind feels its way into the very depths of the picture. . . . There is such a frightful amount of detail, that we have the same sense of infinite complexity which nature gives us. . . . [T]he stereoscopic figure spares us nothing."

Perhaps Holmes's most stunning observation was the extent to which he understood these unsparing images as surrogates, rather than replicas, portable and valid substitutes for the physical world.

> Form is henceforth divorced from matter. In fact, matter as a visible object is of no great use any longer, except as the mould on which form is shaped. . . . There is only one Coliseum or Pantheon; but how many millions of potential negatives

have they shed—representatives of billions of pictures,—since they were erected! Matter in large masses must always be fixed and dear; form is cheap and transportable. We have got the fruit of creation now, and need not trouble ourselves with the core. Every conceivable object of Nature and Art will soon scale off its surface for us. Men will hunt all curious, beautiful, grand objects, as they hunt the cattle in South America, for their skins, and leave the carcasses as of little worth.[1]

In a world increasingly dominated by a culture of money, the notion that paper representations were even more valuable than tangible objects was becoming a commonplace belief, shaping the fabric of everyday life on almost every level. Holmes acknowledged the connection between stereographs and money when, in one of his articles, he suggested that a "comprehensive system of exchanges" be developed "so that there may grow up something like a universal currency of these bank-notes, or promises to pay in solid substance, which the sun has engraved for the great Bank of Nature."[2] In another of his articles, here speaking of carte-de-visite, Holmes made a similar comparison, referring to the "card-portraits" as "social currency, the sentimental 'greenbacks' of civilization."

Within his celebration of the "greatest of human triumphs over earthly conditions, the divorce of form and substance," Holmes paid tribute to the extent to which photographs, by the early 1860s, had achieved the status of truth.

This status provided an underpinning for many of the social uses of photography that developed from the 1840s onward. Talbot had anticipated many of these in *The Pencil of Nature*. In two illustrated examples, Talbot discussed uses of photography that would become particularly pertinent to the cataloging of human types. One, at first glance, may appear little connected. It is a photograph of a cabinet of porcelain vessels and objects, teapots, cups and saucers, pitchers, vases, and the like. In describing this picture, however, Talbot opened up a train of thought that was remarkably clairvoyant.

From the specimen here given it is sufficiently manifest, that the whole cabinet of a Virtuoso and collector of old China might be depicted on paper in little more time than it would take him to make a written inventory describing it in the usual way. The more strange and fantastic the forms of his old teapots, the more advantage in having their pictures given instead of their descriptions.

Evaluating the potential uses of such an inventory, Talbot anticipated the role that cameras and photographs would shortly play as a form of legal evidence, exhibits that would be taken for truth in courts of law.

> And should a thief afterwards purloin the treasures—if the mute testimony of the picture were to be produced against him in court—it would certainly be evidence of a novel kind; but what the judge and jury might say to it, is a matter which I leave to the speculation of those who possess legal acumen.

Legal experts took little time to answer Talbot's question. Court and police practices were soon changed by the use of photography. By the 1870s, criminals and crime scenes were being photographically documented in France, a practice that spread almost immediately. Correspondingly, the entire documentation of human types would be similarly affected. From the mid nineteenth century onward, the taxonomies of human difference were systematically recorded and validated by photographic evidence.

Essential to this development was another of Talbot's predicted uses of photography: portraiture. While long exposure had favored the photographing of inanimate objects, reduced exposure time made the depiction of human subjects more and more possible. Talbot elaborated on this possibility:

> Portraits of living persons and groups of figures form one of the most attractive subjects of photography. . . . When the sun shines, small portraits can be obtained by my process in one or two seconds, . . . larger portraits require a somewhat longer time.

Yet, exposure was still too slow for documenting people in motion, and Talbot suggested that orchestrated studio settings, and the training of subjects to keep still, would be necessary for the tempting field of photo portraiture to evolve. The pencil of nature, it seems, required managerial intervention. Portraiture dictated an assertion of will by a photographer over a submissive subject. Stagecraft was a necessary component of photographing people.

> [I]f we proceed to the City, and attempt to take a picture of the moving multitude, we fail, for in a small fraction of a second they change their positions so much, as to destroy the distinctness of the representation. But when a group of persons has been artistically arranged, and trained

by a little practice to maintain an absolute immobility for a few seconds of time, very delightful pictures are easily obtained.

The required compliance of photographic subjects led portraiture in two different directions. One robbed subjects of their personhood, the other granted personhood, providing subjects with a sense that they were people of consequence.

For unwilling subjects forced to submit to the camera's gaze—slaves, captives, inmates in prisons and asylums, victims of colonialism ruled by the gun—photo portraiture and "mug shots" would become a mainstay of forensic, medical, military, and anthropological record-keeping, a tool of control, and a way of identifying the stigmata of degeneration, separating "undesirables" from entitled populations. While Talbot did not specifically foresee this use, his insight into photography as objective, indisputable evidence portended such early uses of photo portraiture.

One of the first and most promiscuous arenas in which portraits were employed as proof of innate human inequality was, not surprisingly, in the field of natural history. Here, the quest for objective measures of inferiority had been a passion for nearly a century. The founding father of ethnographic photography was Etienne Serres, professor of anatomy and natural history at the Musée d'histoire naturelle in Paris. Beginning in 1841, Serres employed Louis-Auguste Bisson to make daguerreotypes of skulls, casts, and other human remains held in the collection of the museum. Then, in 1844, Serres was introduced to the daguerreotypes of E. Thiesson, whose portraits of a Botocudo couple (Indians from the interior of Brazil) impressed him with their clarity of detail. From this point forward, Serres was convinced that, beyond photography's capacity to record dead objects in the museum's cabinets, it could also serve as a vital tool in gathering anthropological evidence about living beings.

To some extent, ethnographic photography was carried into the field as explorer-scientists surveyed the peoples of Africa, Polynesia, and other "exotic" colonial realms. But, according to Serres, such photographic safaris were not required. The mobility of Empire allowed for the photographing of "natives" in the comfortably detached context of the laboratory. "No longer will it be indispensable to undertake long journeys to research human types," Serres announced to the French Academy of Science in 1845. "These types will come to us, thanks to the increasing progress of civilization. They are in our great cities and seaports all the time."[3] Serres and photographers such as

Louis-Auguste Bisson, Henri Jacquart, Emile Deramond, Louis Rousseau (son of Jean Jacques Rousseau), Charles Guillain, and Roland Bonaparte (a nephew of Louis-Napoleon) were erecting a visual edifice that, supported by the new science of statistics, had become a trademark of French anthropology by the late 1850s.4 173

By the end of the nineteenth century, Serres and his successors assembled a collection of photographic documentations of human types, living and dead, that, according to conservative estimates, exceeded 200,000 items. Simultaneously, in England, the Royal Anthropological Institute was building a comparable collection.5

While Talbot did not fully foresee the impact of ethnographic photography, he did predict the arrival of a more familiar definition of portraiture. For willing subjects, such as family groups, people could be arranged in "so many varying attitudes, as to give much interest and a great air of reality to a series of such pictures." Family and individual portraits—which, within a decade of Talbot's description, were easily and inexpensively available through an explosion of commercial portrait studios—graced more and more people's walls and increasingly transformed albums of keepsakes and silhouettes into family photo albums.

Given his own upper-class background, Talbot imagined that portraiture would be of particular interest to the "English Nobility," which had previously relied on oil portraiture to provide a record of its lineage. Now, he rejoiced, aristocrats could finally assemble visual genealogies that they could rely on "with confidence!" What Talbot failed to see was that photo portraiture would reach far beyond the nobility, the long-established subject of oil paintings.

Today, we take for granted that we have easy access to pictures of ourselves, families, and friends, visual records of our existence that remain and live, even after death. From this perspective, it is easy to forget that, before the invention of photography, the vast majority of humankind had never seen itself in the form of a realistic image. Portrait studios, inexpensive Kodak box cameras, and, in the 1920s, the arrival of photo booths in "five and dimes," changed all this forever. The portrait, once an irrefutable mark of social inequality, had evolved into a ubiquitous prerogative of democracy.

The road to this democracy of images was paved with collodion plates and a flood of other innovations for recording and ennobling the human countenance. As early as 1844—the same year that Talbot's book was published—the son of a poor Irish farmer in upstate Warren County, New York, opened a photographic portrait studio in the buzzing downtown business area of New York City, a stone's

throw from Fowler and Wells's Phrenological Cabinet. Both enterprises were engaged in documenting human heads, and the studio stood across the street from Barnum's American Museum.

The portrait studio was owned and operated by Mathew Brady, who would become America's premier photo-portraitist and, years later, the leading visual historian of the Civil War. Having arrived in New York around 1839, Brady, it is generally thought, was introduced to daguerreotyping around 1840 by Samuel F. B. Morse. After working for a while in the manufacture of fine cases for daguerreotypes, Brady moved from packaging to the product itself. When he opened his studio, the entrance included "Daguerre's Miniature Gallery," a sampling of his portrait work. Though his prices were set somewhat higher than those of local competitors, he offered a quality of portraiture that set his apart from the average studio. By 1851, the high quality of his work was rewarded with a medal at the Crystal Palace Exhibition in London. Responding to this award, and two others garnered by Americans, the newspaper publisher Horace Greeley "used the occasion to boast that the booming U.S. daguerreotype industry was . . . evidence that America had surpassed its European rivals in scientific progress, commercial energy, and aesthetic creativity."[6]

Mathew Brady. FROM THE NATIONAL ARCHIVES COLLECTION

With such boosters as Greeley, Brady's reputation grew. By the late 1850s, his studio was an enormously successful enterprise. Huge numbers came to view his exhibition of famous portraits, the august faces of eminent American "men and mothers," as he put it.[7] If one were deemed important enough, Brady or one of his assistants would take a portrait, adding one more face to the growing "Gallery of Illustrious Americans."

Brady was particularly adept at staging portrait sessions, accentuating the dignity in his subjects, also using touch-up techniques to rid them of unattractive features, such as furrows and moles. One beneficiary of Brady's technique was Abraham Lincoln, whom he photographed after a resounding speech delivered at the Cooper Institute in New York on February 27, 1860. Preparing Lincoln for the portrait, Brady "modified Lincoln's gangling appearance by pulling up the candidate's collar to make his neck look shorter; he also retouched the photograph to remove the harsh lines in Lincoln's face."

Engravers at *Harper's Weekly* copied the photograph meticulously, and it was published in that magazine, and also in *Frank Leslie's Illustrated Weekly*, the first mass- 175
circulation illustrated magazine published in the United States. Reproduced in posters and buttons, the image became a centerpiece of Lincoln's run for president. Brady had offered Americans their first photographic glimpse of a presidential candidate. According to Lincoln, Brady's physiognomically altered portrait was in large part responsible for his election. "Brady and the Cooper Institute made me President," he exclaimed.[8]

Brady's fame was built on portraits of great Americans as well as foreign subjects. Among the many who sat for him or his operators were Daniel Webster, Clara Barton, Jenny Lind, Chief Justice Roger Taney, the actor Edwin Forrest, Walt Whitman, Martin Van Buren, Zachary Taylor, John C. Calhoun, John James Audubon, Millard Fillmore, Ulysses S. Grant, Robert E. Lee, Rembrandt Peale, P. T. Barnum, Jefferson Davis, Stephan Douglas, Admiral David Farragut, Edwin and John Wilkes Booth, Charles Sumner, William Seward, and, of course, Horace Greeley and Abraham Lincoln, as well as Lincoln's wife, Mary Todd Lincoln, and their beloved son, Tad.

Many of his subjects were believers in phrenology and expected their portraits to communicate strong phrenological features. In this regard, Brady was a master, in part because of his artistry, and also because he, himself, was a devotee of phrenological science.

Brady had encountered Lorenzo Fowler and phrenology in 1844, while engaged in a project to photograph men who hardly matched the renown of his later, more respectable subjects. The meeting occurred when Brady was commissioned by Eliza Farnham, matron of the female wing of Sing Sing, "Mount Pleasant Prison."

Farnham was a phrenologist who had been recruited by Lorenzo Fowler while she was a seminary student in Albany, New York. He was impressed by the conformation of her head, which he declared "'masculine' with 'immense' causality." Bitten by the bug, she filled the prison library with phrenological texts, among them Marmeduke Sampson's *Rationale of Crime and Its Appropriate Treatment; Being a Treatise on Criminal Jurisprudence Considered in Relation to Cerebral Organization*. The book, written by a follower of George Combe, was a phrenological study of criminals and convicts, published in England in 1840.

When Farnham decided to publish an illustrated edition of *Rationale of Crime* in the United States, she hired Brady to shoot daguerreotype portraits of prisoners at New York's infamous Blackwell's Island prison, to provide a photographic basis for sketches that would appear in the book. Lorenzo Fowler and Mathew

S. S

S. S. is a vagrant, and inmate of what is termed the Luna House, on Blackwell's Island. He is an Irishman; was formerly a prize-fighter; was sent to the State Prison for five years for assault and battery, with intent to kill, and since his liberation, a period of some six or eight years, has spent most of his time in the city and county prisons of New-York. Before his mind became deranged, he exhibited great energy of passion and purpose, but they were all of a low character, their sole bearing being to prove his own superiority as an animal. He was both vain and selfish.

The drawing shows a broad, low head, corresponding with such a character. The moral organs are exceedingly deficient, especially benevolence, and the intellect only moderately developed. The whole organization, indeed, indicates a total want of every thing like refined and elevated sentiment. If the higher capacities and endowments of humanity were ever found coupled with such a head as this, it would be a phenomenon as inexplicable as that of seeing without the eye, or hearing without the ear.

Tudor Horton's engravings of prisoners on Blackwell's Island were based on daguerreotypes made by Mathew Brady in 1844. The description on the page reveals the influence of phrenology on students of criminal jurisprudence. REPRINTED FROM MARMADUKE B. SAMPSON'S *RATIONALE OF CRIME*, 1846, U.S. EDITION EDITED BY ELIZA W. FARNHAM, MATRON OF MOUNT PLEASANT STATE PRISON

Brady worked hand in hand, the former pointing out characteristic types of offenders, the latter documenting them with photographic portraits.[9] Just as **177** Brady would later refine techniques for embellishing the appearance of his subjects, his grim portraits of unwilling subjects at Blackwell's Island "feature brutish or deranged looking people."[10]

While Brady's early role as a photographer of criminals would recede as he developed a reputation as the portrait photographer of great men and women, his connection with phrenology persisted. He enthusiastically submitted to a head examination, and his knowledge of phrenological faculties—and their relationship to the propensities, sentiments, and intellect—infused his aesthetic sensibility.[11]

From the 1840s, Brady's portraits were costly and, for the most part, documented the faces of an elite clientele of politicians, entertainers, and celebrities. His skill as a photographer and self-promoter gained him fame and set the gold standard that other, more affordable, studios tried to imitate.

These less expensive studios abounded, and, by the mid-1850s, vast numbers of individuals and groups visited them to have their pictures taken. Following the Brady model, the front room of a portrait studio often included a cabinet of exemplary portraits, to indicate the photographer's skill.

Writing in the *Brooklyn Daily Eagle*, Walt Whitman— poet, phrenologist, and self-proclaimed man of the people— saw in these cabinets the true stories of America. Following a visit to one of these studios, he wrote:

Walt Whitman, photographed by Mathew Brady. Whitman's *Leaves of Grass* was published by phrenologists Fowler and Wells, and he was a firm believer in phrenology. FROM THE NATIONAL ARCHIVES COLLECTION

> What a spectacle! In whatever direction you turn your peering gaze, you see naught but human faces! There they stretch, from floor to ceiling— hundreds of them. Ah! what tales might those pictures tell if their mute lips had the power of speech! How romance, then, would be infinitely outdone by fact.

Whitman was so taken with the photograph's ability to communicate the matter-of-fact nature of a person that when he self-published an abbreviated first edition of *Leaves of Grass* in 1855 (prior to the Fowler and Wells edition), he included a pictorial frontispiece, a daguerreotype-inspired steel engraving of himself, and omitted his name from the title page. Since the early days of physiognomy, authors' portraits often abutted title pages—as visual testimony to their intellect—but none before had thought to use an image in place of a name. In his

review of the poetry collection, the writer Charles Eliot Norton concurred with Whitman's unusual decision, stating that "the name is merely incidental; while the portrait affords an idea of the essential being from whom these utterances proceed."[12]

For some, the cases of daguerreotypes or printed photographs offered visitors a readable inventory of social and physiognomic typologies, a perfect opportunity to exercise their phrenological acumen. In 1855, an article appearing in *Gleason's Pictorial and Drawing Room Companion* reported:

> If you have seen one of these cases, you have seen all. There is the militia officer, in full regimental. . . . There is the family group, frozen into wax statuary attitudes, and looking very solemn, as if they were assembled for a funeral. There is the fast young man, taken with his hat on and a cigar in his mouth; the belle of the locality, with a vast quantity of plaited hair and plaited jewelry, looking supremely killing; and there is the pet baby, a podgy creature, with hydrocephalic head and dropsical body . . . There is the intellectual man of the locality, with a tall forehead and piercing eyes, and the young poet, a pretty looking fellow, but infinitely conceited.[13]

As was the case with Brady, studios were organized to enhance a subject's appearance. Clothing, backdrops, and suggestive props were available to simulate prosperity where it did not exist. Itinerant photographers, traveling from town to town, charging twenty-five cents to a dollar for a portrait, broadened even further the number of people whose status was certified in pictorial form.

New technical developments made portraiture a possibility for nearly everyone, and accelerated their spread. On Broadway, cheap miniatures known as "tin-types" could be had for "two cents each!" This access, Oliver Wendell Holmes announced, meant, "pauperism itself need hardly shrink from the outlay required for a family portrait-gallery."[14]

In 1854, in France, a photographer named André Disdéri, introduced *cartes-de-visite* (card portraits), small (2.5 x 3.5 inch) portraits shot by a multilens camera that burned eight images onto one glass negative. Printed on photographic paper and cut up, these relatively inexpensive cards began to replace the printed calling cards that had previously been used as a token of a visit. Beginning as an accoutrement of bourgeois and upper-class life, carte-de-visite portraits of the rich and famous, including royalty, began to circulate, and celebrity-card collecting became a widespread hobby.

In 1861, Alexander Gardener, who ran Brady's "National Photographic Art Gallery" in Washington—which had opened in 1858—purchased four cartes-
de-visite cameras for Brady. Some of Brady's pictures had been circulated as card portraits beforehand, but from 1861 onward, Brady's portraits, in the form of cartes-de-visite, were marketed on a grand scale, escalating his legendary status.

With his entry into the portrait card business, Brady once again began to produce portraits of phrenological deviants. This time, it was not prisoners who sat for the great photographer but human anomalies from Barnum's American Museum. In his new studio (1860), known as the National Portrait Gallery, he made portraits of Barnum's freaks, including Henry Johnson, known popularly as "What Is It?" or "Zip"; "General Tom Thumb," the famous midget, and his diminutive spouse, Lavinia Warren; the original "Siamese Twins," Chang and Eng; the "Fiji Cannibals"; "Annie Jones," the bearded lady; the armless wonder, "Admiral Dot"; and the Lucasie albino family. Photo cards such as these, sold at Barnum's Museum, became routine souvenirs at freak shows everywhere, collected by gawkers very much like baseball cards are collected today.[15]

In a short time, cartes-de-visite portrait studios were everywhere, and nearly anyone could have these distributable personal portraits taken. People placed them in family albums alongside *cartes* of friends and public figures. This mix, a visual dialog between private persons and famous faces, created an imagistic equality or, at least, placed anonymous individuals in relation to the role models they hoped to emulate. Simultaneously, cartes-de-visite of circus and sideshow freaks also began to circulate and make their way into albums, providing people with visible evidence of their own physiognomic superiority.

This eruption of portraiture was not simply a matter of vanity. In Europe and in the United States, where the conformation of the head and face was widely seen as an index of civilization, these portraits served as a kind of physiognomic data. In public galleries, such as Brady's National Portrait Gallery, the ideal heads of America's leading figures provided viewers with visual models with which to compare themselves. In carefully orchestrated middle-class portraits, more ordinary people sought to present evidence of their own physiognomic or phrenological qualifications, certificates of inclusion that placed them among the elevated sectors of society. Portrait studios were organized to achieve this result.

The link between physiognomy, phrenology, and portraiture became an integral component of Fowler and Wells's business. Given the apparent physical veracity of stereo views, and their capacity to communicate a vision of the human head as

180

a solid object, by the late 1850s, they began to sell sets of stereographs documenting the diversity of characteristic phrenological types.[16]

Beyond using photography as a way of transmitting information, Fowler and Wells also used it to offer customers the option of having their heads examined from a distance. This was clearly not the ideal circumstance for an analysis, wrote Samuel Wells, but it would certainly do if a visit to the Museum was impossible, or if no "graduate of the American Institute of Phrenology" was nearby. For five dollars, mail-order examinations were readily available by the 1860s.

Just as Lavater had carefully laid out step-by-step rules by which reliable physiognomic portraits should be produced, using "English black lead pencils" and "Indian ink," Wells provided mail-order subjects with guidelines to ensure the phrenological objectivity of the photographs submitted.

> Have two photographic profiles and full front taken especially for this purpose. Have the hair smoothed (not fizzed, or curly) to show the contours of the head. Send these to us with the following measurements; Distance between the opening of the ears and the crow of the head, Distance between the root of the nose and projection at base head (occipital spine), also the circumference of the head. Enclose the fee and be sure to send your name and address. Also your age, and color of hair and eyes.[17]

Delia, a slave woman, was photographed by J. T. Zealy as part of Prof. Agassiz's project to document the idea that the different races belonged to different and unequal species. FROM THE COLLECTION OF THE PEABODY MUSEUM OF ARCHAEOLOGY AND ETHNOLOGY

The physiognomic information that nineteenth-century Europeans and Americans divined from photo portraiture was the subject of frequent reiteration. Portraits of the willing and unwilling—of those who sought to be photographed and those who were photographed as objects of "scientific" investigation—when juxtaposed with each other offered sustenance to those who believed in the truths of facial politics.

The Swiss biologist and Harvard professor Louis Agassiz, for example, after visiting Mathew Brady's gallery in New York, later told the photographer that he had spent hours marveling at the extraordinary conformation of "public men's physiognomies." Agassiz, strongly committed to the

idea of the natural racial superiority of Caucasians, found in Brady's portraits of eminent Anglo-Americans a silent affirmation of their inherent supremacy. In 1850, in order to provide himself with visible evidence of the inferiority of Africans, Agassiz hired a South Carolina daguerreotypist, J. T. Zealy, to take over two thousand portraits of slaves, coerced subjects forced to stand stripped to the waist, while rigidly uniform front, back, and profile views were taken. These portraits provided evidence of the link between the slaves' facial structures and their supposedly diminished "mental abilities."[18] Looking at these pictures today, one observes a mournful tale of human misery and a quiet dignity amid the predicament of captivity, undermining their original status as objective scientific evidence of inferiority.

Oliver Wendell Holmes was far more explicit regarding the physiognomic value of portrait photography. He had been impressed by Samuel Morton's craniometric studies and Morton's sensibility; to some extent, this feeling informed his evaluation of portraiture.[19] While storefront studios routinely provided costumes and props to mask the class and character of people who came to have their pictures taken, Holmes swore that portraits offered a window to the soul that no form of visual dissembling could disguise.

> Attitudes, dresses, features, hands, feet, betray the social grade of the candidates for portraiture. The picture tells no lie about them. There is no use in their putting on airs; the make-believe gentleman and lady cannot look like the genuine article. Mediocrity shows itself for what it is worth, no matter what temporary name it may have acquired. Ill-temper cannot hide itself under the simper of assumed amiability. The querulousness of incompetent complaining natures confesses itself almost as much as in the tones of the voice. The anxiety which strives to smooth its forehead cannot get rid of the telltale furrow. The weakness which belongs to the infirm of purpose and vacuous of thought is hardly to be disguised, even though the moustache is allowed to hide the center of expression.
>
> All parts of a face doubtless have their fixed relations to each other and to the character of the person to whom the face belongs. But there is one feature, and especially one part of that feature, which more than any other facial sign reveals the nature of the individual. The feature is the mouth and the portion of it referred to it is the corner. . . . Here we may read the victory and defeats, the force, the weakness, the hardness, the sweetness of a character.

Given Holmes's near religious belief in the revelatory nature of facial photographs, their ability to provide evidence of a person's character and intentions, it was hardly a stretch when he offered the idea that archives of portraiture might be systematically assembled to identify social and physiological miscreants, to analyze the faces of degeneration, to track the stigmata of criminality through a "series of faces . . . carefully studied in photographs," and to enhance the common good of society.[20] Though Holmes never took action in this direction, many others would. A photographic archive of good and evil, of solid citizen and criminal, of intelligence and stupidity, of morality and wickedness would be a legacy of Western society that would commence at the time Holmes was writing and would persevere, in art, in science, and in myriad forms of popular culture on to the present.

THE COSTERMONGER'S TONGUE AND ROGET'S THESAURUS

By the 1840s, the population of London was approaching 2.3 million, making it the most populous city in the world. It was also one of the most densely inhabited, as people flooded the city from a wide range of locales. Some came from the British countryside, others from Ireland. Jews, Italians, Romany (gypsies), and other migrants arrived from various parts of Europe, while Africans and colonials from the subcontinent of India (commonly referred to as Hindoos) came from the outer reaches of the British Empire.

Living in impoverished eastern and southern parts of the city (such as Bermondsey, the New Cut, and the Whitechapel Road), apart from the middle and upper classes, many among this expanding population were street people: vagrants, day laborers, peddlers, street performers, beggars, pickpockets, prostitutes, paupers, and other inhabitants of what was seen by proper Londoners as a strange and dangerous world.

Responding to the fusion of fear and fascination that London's more staid population felt toward these people, a writer and editor named Henry Mayhew began, in the 1840s, to report on the lives, labors, language, and diversions of the wandering "vagabonds" of the city. Formerly editor of the satirical magazine *Punch*, Mayhew resigned his post to devote his literary energies to recording the social realities of London's "street folk," relying heavily on words coming "from the lips of the people themselves." His articles began

HENRY MAYHEW.

[*From a Daguerreotype by* BEARD.]

REPRINTED FROM MAYHEW'S *LONDON LABOUR AND THE LONDON POOR*, 1861

184

appearing in *London's Morning Chronicle* in 1845. In 1851, Mayhew began publishing his articles and additional materials in a four-volume study entitled *London Labour and the London Poor*. These books would become the first major sociological study of poverty in an urban environment. When they appeared, they broke dramatically from the dry, dispassionate idiom of prior government studies, known as "blue books." *London Labour and the London Poor*, Mayhew wrote in a preface to the first volume, was the "first commission of inquiry into the state of the people, undertaken by a private individual, and the first 'blue book' ever published in twopenny numbers," a reference to the pieces that first ran in the *Morning Chronicle*. Mayhew's style was entertaining and colorful, quoting at length from vernacular interviews with "Street Sellers" ("costermongers and patterers"), "The Street Irish," "Female Street-Sellers," "Children Street-Sellers," and others. His writings offered a vivid picture of street life. An interview with the seller of song lyrics, for example, quoted extensively from the lyrics themselves, providing a rare taste of the popular culture of the lower classes in mid-nineteenth-century London.

LONG-SONG SELLER.

" Two under fifty for a fardy'!"

[*From a Daguerreotype by* Beard.]

REPRINTED FROM MAYHEW'S *LONDON LABOUR AND THE LONDON POOR*, 1861

Mayhew's ear for the "unvarnished language" of the people was extraordinary, and his books remain captivating to read. The expressed intent of his study, however, was reformist. He sought to evoke a sympathetic response from England's upper classes.

> My earnest hope is that the book may serve to give the rich a more intimate knowledge of the sufferings, and the frequent heroism under those sufferings, of the poor—that it may teach those who are beyond temptation to look with charity on the frailties of their less fortunate brethren—and cause those who are in "high places," and those of whom much is expected, to bestir themselves to improve the condition

of a class of people whose misery, ignorance, and vice, amidst all the immense wealth and great knowledge of "the first city in the world," is to say the very least, a national disgrace to us.[1]

185

In tandem with these good intentions, Mayhew embraced many of the prejudices of his time. In the opening chapter of volume 1, for example, he began with an extensive reference to James Prichard, a leading racial scientist and the author of *The Natural History of Man*, and itemized Prichard's "three principal varieties" of human types: "the hunters and savage inhabitants of the forest," "the wandering races," and "the most civilized races, those who live by the arts of cultivated life." Mayhew relied on Prichard's description of the physiognomic traits native to each group, indicating that while savages are "most distinguished by the term 'prognathos,' indicating a prolongation or extension of the jaws," the wanderers "have broad lozenge-shaped faces (owing to the great development of the cheek bones) and pyramidal skulls." These people have "a greater relative development of the jaw and cheek

HINDOO TRACT SELLER.
[From a Daguerreotype by BEARD.]

REPRINTED FROM MAYHEW'S *LONDON LABOUR AND THE LONDON POOR*, 1861

bones," which, according to Prichard, "indicates a more ample extension of the organs subservient to sensation and the animal faculties." Alongside these characterizations, Mayhew also accepted Prichard's description of "civilized races or settlers," people who have a "greater relative development of the bones of the skull—indicating as it does a greater expansion of the brain, and consequently of the intellectual faculties."

In categorizing the people of the street, Mayhew counted them among the "wandering tribes," physiologically brutish and intellectually inadequate. Playing off Prichard's categories, Mayhew mused on the deficiencies found among the wanderers, who, he believed, were well represented on the streets of London.

Whether it be that in the mere act of wandering, there is a greater determination of blood to the surface of the body, and consequently a less quantity to the brain, the muscles being thus nourished at the expense of the mind, I leave physiologists to say. But certainly be the physical cause what it may, we must allow that . . . there is a greater development of the animal than of the intellect or moral nature of man, and that they are all more or less distinguished . . . for their use of slang language—for their lax idea of property—for their general improvidence—their repugnance to continuous labour—their disregard of female honour—their love of cruelty—their pugnacity—and their utter want of religion.[2]

Throughout *London Labour and the London Poor*, Mayhew provided visible evidence of the inhabitants and occupations of the street. Part of a generation of journalists who fortified their reportage with the realism of photography, Mayhew hired a daguerreotypist, Richard Beard, to photograph the subjects of his interviews. Peppered throughout his study are wood engravings, each certified by the imprimatur, "From a Daguerreotype by Beard," offering wealthy Londoners the voyeuristic satisfaction of examining the meager or menacing physiognomies of London's poor.

Yet, far more dramatic than these engravings was Mayhew's nonstop insertion of spoken vernacular from the street. The "use of slang language," transliterated into text, was everywhere in evidence. To the eyes and ears of proper Britons, vigilant guardians of the Queen's English, there could be no more eloquent testimony than this as to the degraded state of the lower classes.

Not disconnected from his espoused desire to promote social reform, Mayhew supported this attitude. Like the conformation of their heads, the disorganization of street folks' language was an indication

THE LONDON COSTERMONGER.
" Here Pertaters! Kearots and Turnups ! fine Brockello-o-o!"
[*From a Daguerreotype by* BEARD.]

REPRINTED FROM MAYHEW'S *LONDON LABOUR AND THE LONDON POOR,* 1861

of their moral and intellectual condition. Mayhew discussed the "Language of Costermongers" as a case in point.

> The slang language of the costermongers is not very remarkable for originality of construction; it possesses no humour: but they boast that it is known only to themselves; it is far beyond the Irish, they say, and puzzles the Jews. The root of the costermonger tongue, so to speak, is to give the words spelt backward, or rather produced rudely backward . . . With this backward pronounciation, which is very arbitrary, are mixed words reducible to no rule and seldom referable to any origin, thus complicating the mystery of this unwritten tongue; while any syllable is added to a proper slang word, at the discretion of the speaker.
>
> Slang is acquired very rapidly, and some costermongers will converse in it by the hour. The women use it sparingly; the girls more than the women; the men more than the girls; and the boys most of all. The most ignorant of all these classes deal most in slang and boast of their cleverness and proficiency in it.

The condemnation of vernacular language as vulgar and ungodly was part of the Catholic Church's historic argument on behalf of Latin as the only acceptable written language. As spoken languages, such as English, gained literary legitimacy, this attitude changed, but, to many minds, the peculiarities of lower-class vernaculars continued to be a mark of inferiority and the subject of ridicule. To a large extent, this view continues today. The perceived mangling of proper language is a tenacious aspect of derogatory stereotyping. For Mayhew, in the 1840s and 1850s, a glossary of slang usage offered readers an amusing opportunity for such disdain.

"[I]n my present chapter," Mayhew contended, "the language has, I believe, been reduced to orthography [written alphabetic form] for the first time." He offered some juicy examples, beginning with money:

Flatch	Halfpenny
Yenep	Penny
Net-yenep	Tenpence
Couter	Sovereign
Ewif-gen	Crown

He then moved to some common phrases:

188

A doogeno or dabheno?	Is it a good or bad market? . . .
On	No
Say	Yes
Tumble to your barrikin	Understand you
Top o' reeb	Pot of beer
Doing dab	Doing bad
Cool him	Look at him
Cool the esclop.	Look at the police.
Cool the namesclop.	Look at the policemen.

THE IRISH STREET-SELLER.

"Sweet Chany! Two a pinny Or-r-ranges—two a pinny!"

[*From a Daguerreotype by* BEARD.]

REPRINTED FROM MAYHEW'S *LONDON LABOUR AND THE LONDON POOR*, 1861

To members of the costermonger ranks, jargon such as this was what permitted them to communicate with one another without having to worry about outsiders listening in. "The police don't understand us at all," one costermonger bragged to Mayhew. "It would be a pity if they did."3

For Mayhew, however, their jargon distanced costermongers from the idiom of common courtesy and manners, from the culture of civility. "The costermonger's oaths, I may conclude, are all in the vernacular; nor are any of the common salutes, such as 'How d'you do?' or 'Good-night' known to their slang."4 Many middle- and upper-class Englishmen perceived the mounting presence of crude colloquialisms in their midst as a threat to the mother tongue, something that demanded immediate and decisive action.

In 1852, one year after Mayhew's volumes began appearing, a cosmic event in the history of lexicography took place that seemed to offer an appropriate

response: a systematic defense of the English language. The event was the pub-
lication of the first edition of the *Thesaurus of English Words and Phrases Classified* 189
and Arranged so as to Facilitate the Expression of Ideas and Assist in Literary Compo-
sition, the brainstorm of a physician named Peter Mark Roget.

Until his death in 1869, Roget continued to work on improving his The-
saurus, and he personally oversaw the publication of twenty-five new editions of
the book. During these years, Roget worked closely with his son, John L. Roget,
who carried on the project of expanding and refining the details of the book when
his father died. The Roget family dynasty maintained control of the enterprise
for one hundred years. Upon John's death in 1908, his son and partner, Samuel
Romilly Roget, assumed the helm and continued to advance the enterprise until
his death in 1952, exactly a century after his grandfather had first published the
Thesaurus. The unusual lineage of blood and outlook insured that the philo-
sophical attitude of this influential reference volume maintained a consistent
vision long after its originator was gone.

Peter Mark Roget first began to work on the project in 1805, at the age of
twenty-six. In the forty-six years between the work's inception and its publication,

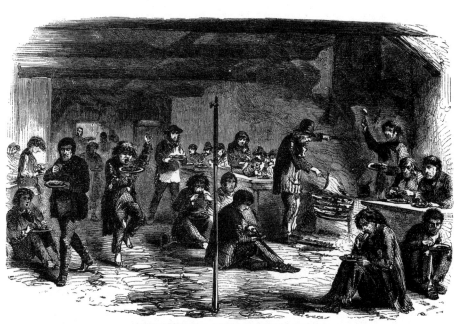

A DINNER AT A CHEAP LODGING-HOUSE.

REPRINTED FROM MAYHEW'S *LONDON LABOUR AND THE LONDON POOR*, 1861

190 Roget was occupied with a diverse range of other innovative undertakings and activities. In 1814, he helped to bring the slide rule to its modern form, adding the capacity to calculate roots and powers to its previous ability to multiply and divide. Roget's invention, which he termed the "log-log" slide rule, was the foundation of devices used by mathematicians for a century and a half, until electronic calculators superseded them. When he published a paper on his slide rule in *Philosophical Transactions*, he gained a prominence that led to his election to the Royal Society.5 As his biographer, D. L. Emblen, has written, this was the moment of Roget's arrival as a British man of ideas.

> Within five years from his appearance in London [in 1809, where he took a post teaching at the London Medical School] a promising but obscure young doctor from the provinces, Roget had won acceptance by the most exclusive club of the metropolis. . . . He could now write his name, as he meticulously did thereafter, "Peter Mark Roget, M.D., F.R.S." Those three letters [signifying Fellow of the Royal Society] must have seemed to him—as, indeed, in many respects they were—the keys to the city.6

THE LONDON SWEEP.

[*From a Daguerreotype by* Beard.]

REPRINTED FROM MAYHEW'S *LONDON LABOUR AND THE LONDON POOR*, 1861

Continuing to practice medicine, Roget was concerned with tuberculosis, the uses of nitrous oxide, the workings of the brain, and the nature of visual perception. In 1824, Roget presented a paper to the Royal Society that drew on his fascination with optical phenomena. He had written previously on optical matters, but this carefully illustrated paper would have earth-shaking consequences, providing a theoretical foundation for one of the defining fixtures of contemporary culture: motion pictures. The paper concerned his discovery of "persistence of vision." Entitled "Explanation of an Optical Deception in the Appearance of the Spokes of a Wheel Seen Through

Vertical Apertures," the paper contended that when people see an object or an image, a trace of that sight remains in the mind's eye for one-sixteenth of a sec- 191 ond, even after the stimulus of that sight has disappeared from view. Initially inspired by a chance observation—a moving wagon wheel seen passing by his house through vertical venetian blinds—Roget asked the driver to repeatedly pass by his home. Closely studying and sketching what he saw, he eventually produced a precisely illustrated paper that explained, for the first time, "that an impression made by a pencil of rays on the retina, if sufficiently vivid, will remain for a certain time after the cause has ceased."[7]

Roget did little to follow up on this discovery, but for others it caused a considerable stir. By the phenomenon of "persistence of vision," a series of still images, each recording a minute kinesthetic change, could blend into one another in the mind, creating the optical illusion of motion. While motion pictures as we know them would take some time to develop—and required the rise of photography and Eadweard Muybridge's photographic studies of motion—experiments building on Roget's thesis began to take place almost immediately. Two years after Roget's paper, Sir John Herschel produced the illusion of motion from still images using what he called the "Thaumatrope." Subsequently, Stroboscopes, flip-books of pictures, and animated magic-lantern experiments, using drawings on glass strips, continued to affirm Roget's analysis. The idea of the cinema had been born. On the "peculiarity" of Roget's discovery, wrote film historian Arthur Knight in 1959, "rests the fortune of an entire motion-picture industry."[8]

THE STREET RHUBARB AND SPICE SELLER.

[From a Daguerreotype by BEARD.]

REPRINTED FROM MAYHEW'S *LONDON LABOUR AND THE LONDON POOR*, 1861

Roget's social philosophy, along with his precise scientific mind, helps to illuminate the aim of the Thesaurus. While he rejected phrenology as a "flimsy" theory, and engaged in a prolonged feud on the subject with George Combe and his brother Andrew, Roget was more than open to physiognomic determinism. As a

medical man he had been deeply influenced by the thinking of J. F. Blumen-
bach, the father of racial science. He had also been prejudiced by the lectures
of Dr. William Lawrence, which later were published as *Lectures on Physiology,
Zoology, and the Natural History of Man*, delivered at the Royal College of Sur-
geons. Rejecting the brotherhood of mankind, Lawrence had proclaimed that
the different races represented unconnected and unequal species, with Euro-
peans occupying the supreme position.

> Compare the ruddy and sanguine European with the jet-black African,
> the red man of America, the yellow Mongolian, or the brown South
> Sea Islander: the highly civilized nations of Europe, so conspicuous
> in all that can strengthen and adorn society, or exalt and dignify human
> nature, to a troop of naked, shivering New Hollanders, a horde of
> filthy Hottentots, or the whole of the more or less barbarous tribes
> that cover mostly the entire continent of Africa. Are these all brethren?
> Have they descended from one stock? Or we must we trace them to
> more than one, and if so, how many Adams must we admit?9

Another important influence on Roget was Baron Cuvier, the comparative
anatomist who had dissected and removed the genitalia, for public display, from
Saartjie Baartman's lifeless body. Inspired by such mentors, and by their belief
in natural inequality, Roget must have been troubled considerably by the phys-
iognomically challenged and multihued street wanderers of London.

Yet accompanying his biases, Roget, like Mayhew, believed that reform
might improve, or at least control, the character of England's lower classes. Edu-
cational instruction, and the imposition of order on a disorderly world, stood at
the center of Roget's reformist views. One example of this belief was his central
role in the creation of the Society for the Diffusion of Useful Knowledge in
1826. Roget's biographer, D. J. Emblen, summarizes the society's objectives:

> In the spring of 1827, the society began an ever-expanding publication
> program, issuing treatise after treatise, usually in the form of fort-
> nightly sixpenny numbers, aimed to place in the working man's hands
> the best of modern science written in nontechnical language.

Roget wrote for and edited many of the Society's publications, and his trea-
tises on electricity, galvanism, magnetism, and electromagnetism were later
published as books from the Society's library. While Roget's specific role in the

enterprise is unclear, it was the Society for the Diffusion of Useful Knowledge that began, in 1832, publishing *The Penny Magazine*, the immensely popular illus- trated weekly that was designed to instruct the masses on a wide range of worldly subjects.

Roget's most systematic work regarding the need for public edification, however, was his Thesaurus, an encyclopedic compendium of words and ideas. It was hardly the first attempt to catalog and define words, but its structure was both new and ingenious. Unlike a dictionary, which offers definitions but organizes words illogically, according to the arbitrary dictates of the alphabet, the Thesaurus was designed to situate each word in its proper place, within the universe of possible ideas and meanings. To create a coherent universe in which words—each a small celestial body, each part of a larger constellation of ideas—would hover, Roget created an intricate system of classification, not unlike Linnaeus's *Systema Naturae*. He explained,

> The principle by which I have been guided in framing my verbal classification is the same as that which is employed in the various departments of Natural History. Thus the sectional divisions I have formed correspond to Natural Families in Botany and, and the filiation of words presents a network analogous to the natural filiations of plants or animals.[10]

Just as Linnaeus had inscribed each life form within a hierarchy of development, Roget's architecture of language moved from words expressing elemental existence to those expressing greater and greater levels of intellectual, emotional, and philosophical complexity. In a city where the language of the street was marked by a seeming chaos, Roget's system was designed to place every word within a highly ordered structure of organization. "It is of the utmost consequence," he wrote in the introduction to the first edition, "that strict accuracy should regulate our use of language, and that every one should acquire the power and the habit of expressing his thoughts with perspicuity and correctness."[11]

To ensure the clear and precise use of words, Roget subdivided the English language into six primary classes, each defined numerically to empha-

Peter Mark Roget. FROM THE COLLECTION OF THE EWEN LIBRARY

194 size its exactitude. The first, he explained, "derived from the more general and ABSTRACT RELATIONS among things, such as Existence, Resemblance, Quantity, Order, Number, Time, Power." The second general class addressed "SPACE" and included occurrences specific to space, "Motion, or change of place." The third included properties of the "MATERIAL WORLD; namely, the Properties of Matter, such as Solidity, Fluidity, Heat, Sound, Light, and the Phenomena they present, as well as the simple Perceptions to which they give rise." Roget's fourth class of ideas expressible by language pertained to matters of the "INTELLECT and its operations." This included the Acquisition, the Retention, and the Communication of Ideas. The fifth class encompassed "ideas derived from the exercise of "VOLITION; embracing the phenomena and results of our Voluntary and Active Powers; such as Choice, Intention, Utility, Action, Antagonism, Authority, Compact, Property, etc." Roget's last class comprehended "all ideas derived from the operation of our SENTIMENT AND MORAL POWERS: including our Feelings, Emotions, Passions and Moral and Religious Sentiments." The trajectory of his classes moved from basic existence to human intellect and will, ending with spiritual concerns.

Within Roget's classes, there were further subdivisions into "sections," "subsections," and "topics," or "heads of signification," each assigned a specific number. In the back portion of the Thesaurus was an alphabetical listing of words, each word followed by a list of its various possible connotations. Each of these was followed by a number, such as 563 or 876, which permitted a user to locate that word as it related to similar words and ideas, also situating it within the overall cosmos of possible meanings. The alphabet, which dominated most English reference books, was here subservient, simply a tool that carried a user to a precise and mathematical organization of ideas in relation to one another and in relation to an all-encompassing totality.

The method of the Thesaurus was shaped by an ongoing juxtaposition of opposites, usually placed side by side in the original text to underline the contrast. Class four, for example, which incorporated ideas and words pertaining to human intellect, also contained, nearby, words and ideas indicating deficiencies in this regard. In class six, which contained religion, the "topic" of Worship was followed by those of Idolatry and Sorcery, Piety by Impiety and Irreligion.

Roget's objective was not to provide writers and speakers with stylistic instruction. Just as art and science had carried on a centuries-long quest for precise visual truth, *Roget's Thesaurus* offered its devotees linguistic truth, the opportunity to express themselves in a way that was absolutely true to their

intentions. Given the abuses of language that Roget saw and heard everywhere around him, he viewed his Thesaurus as a response to an urgent social need.

> False logic, disguised under specious phraseology, too often gains the assent of the unthinking multitude, disseminating far and wide the seeds of prejudice and error. Truisms pass current, and wear the semblance of profound wisdom, when dressed up in the tinsel garb of antithetical phrases, or set off by an imposing pomp of paradox. By the confused jargon of involved and mystical sentences, the imagination is easily inveigled into the belief that it is acquiring knowledge and approaching truth. A misapplied or misapprehended term is sufficient to give rise to fierce and interminable disputes. . . . [A]n artful watchword, thrown among combustible materials, has kindled the flame of deadly warfare, and changed the destiny of an empire.[12]

Roget's concern with the destiny of empire infused his work, which presented, in its numerical universe, an imperial and hierarchical worldview. Section 875, for example, containing words related to "NOBILITY" included "gentility," "quality," "order," "fashionable world," "man of distinction," and "gentleman." Across the page, on the other side of the tracks, were words associated with "COMMONALITY," including "low condition," "the vulgar herd," "the crowd," "the mob," "rabble," "the scum," "the dregs of society," "nobody," "vermin," "bog-trotter," "Hottentot," "savage," "barbarian," "cockney," and "uncivilized." Category 563, pertaining specifically to improper language, placed the word "slang" adjacent to "barbarism," "dog-latin," and "broken English."

Section 983 covered words associated with "true faith" and "Christianity." Across the page, 984 provided a lexicon of "heresy" including "heathen," "Paganism," "Judaism," "Islamism," "antichrist," "bigot," and "fanatic." In 431, exploring the quality of "BLACKNESS," Roget and his son placed "negro" in the same category as "denigrate," "to blacken," "Ethiopic," and "nocturnal."[13]

This outlook continued to define the Thesaurus well into the twentieth century. In the 1911 edition, overseen by a young Samuel Roget, the section for "COMMONALITY" (876) added "democracy" to a list including "low life," "trash," "swinish multitude," and "vulgar herd." "MALEFICENT" (913) became even more virulent than it had been in earlier editions, which had included "evil doer," "anarchist," "savage," "barbarian," and "monster." Now, added to the list were "Apache," "Red Skin," "Mohawk," "the great unwashed," and "dangerous classes," a common euphemism for the urban poor.[14]

In the 1920s, Samuel Roget added decimal points to the Thesaurus's numerical system, to enhance its precision and, in the process, to spotlight invidious comparisons and associations. An imperial and hierarchical sensibility remained intact.

In a 1946 edition, "COMMONALITY" (874) combined "the great unwashed" with "the great unnumbered," perhaps a reflection of Peter Roget's conviction that numbers were the intellectual property of gentlemen. Also included are phrases from Shakespeare, "the beast with many heads" and "the blunt monster with uncounted heads."

Under topic 948, "Good Person," "nature's nobleman" is followed shortly by "Christian" and "White Man." The word "black," on the other hand, is found under the topics "Vice" (945) and "Badness" (649) and is situated in groupings that include "evil," "horrible," "odious," "vile," "monstrous," and "cursed." Not far from this, the word "heathen," under 984.20, occupies the same category as "Kaffir," a derogatory term employed by the British to describe blacks in South Africa.

In the grandson's editions, distaste for the language of the street also remained evident. In a section of class four (INTELLECT), in which words about language were considered (560.2), "vernacular language" and "vulgar tongue" stand together. Nearby, in 560.3, "accepted speech; literary language; [and] correct or good English" occupy the same space as "the king's or queen's English" and "classicism." Two steps down the road, "Barbarism" and "Colloquialism" define an entire "head of signification," number 563. Common speech, such as that found in Mayhew, was equated not only with barbarity but with "abuse of language," "vulgarity," and "foreignism."

In 1970, D. Emblen maintained that "by the most modern estimates, approximately twenty million copies of *Roget's Thesaurus* have been issued since 1852."[15] The persistence of Roget's original vision, so to speak, is nothing short of remarkable.

While Roget suggested that his masterwork would provide a "proper implement" for the acquisition and expression of linguistic truth, it is clear that his demarcation of meanings was shaped by his own particular version of truth and reflected the ideas and attitudes of empire and class position. As we learn in the story of Adam in the book of Genesis, naming is a prerogative of power. With modernity, systems of classification emerged as the ultimate form of naming. Though Roget was concerned with language, not skulls, he was part of a historic tendency to impose a distinctly Eurocentric order upon the varieties of human existence and

expression. Natural history, as carved out by eighteenth- and nineteeth-century Europeans and Americans, presented a vision of nature in which Caucasians stood above the "degenerate" races. The "filiations" of the Thesaurus offered a similar taxonomy of truth. Like natural history, it also had global aspirations.

The long-term goal of the Thesaurus, as expressed by Roget in 1852, was ultimately to do away with all colloquialism, all remnants of local identity, and to create an imperial language that would span the globe. He termed this a "strictly philosophical language," which could "limit the fluctuations to which language has always been subject" and create "an authoritative standard for its regulation."

> The probable result of the construction of such a language would be its eventual adoption by every civilized nation; thus realizing that splendid aspiration of philanthropists—the establishment of a Universal Language. . . . Is there at the present day, then, any grounds for despair that at some future stage of that higher civilization to which we trust the world is gradually tending, some new and bolder effort of genius towards the solution of this great problem may be crowned with success, and compass an object of such vast and paramount utility? Nothing, indeed, would conduce more directly to bring about a golden age of union and harmony among the several nations and races of mankind than the removal of that barrier to the interchange of thought and mutual good understanding between man and man, which is now interposed by the diversity of their respective languages.[16]

Elsewhere in the city, a street vendor, relying on a different system of meanings, winked knowingly at a friend and exclaimed, "Cool him. Cool the esclop."

INTERLUDE

16
REVERBERATIONS OF CHANGE

Early in 1848, Alexis de Toqueville came before the French Chamber of Deputies with trepidation in his heart. Social and political rumblings were running through the streets of Paris, and he felt compelled to issue an ominous warning. "We are sleeping on a volcano," he declared. "Do you not see that the earth trembles anew? A wind of revolution blows, the storm is on the horizon." These dire comments were inspired by current events, the Revolutions of 1848, by the passing of an old order, and by the rise of "The Age of Capital."[1] In Western Europe and the United States, subsequent decades would be shaped by the tumultuous pandemonium that Tocqueville foresaw.

At the center of the storm lay two cataclysmic developments. First came the triumph of democratic revolutions that, while they did not enhance the lives of the multitude, brought down the aristocracy and placed the bourgeoisie in an unprecedented position of social, political, and economic power. Inseparable from this change was the rapid and far-reaching development of industrial capitalism, which dramatically transformed the contours of production and survival on a global scale. Water- and steam-powered factories, employing poorly paid wage laborers, fueled an unparalleled rise in the ability to manufacture materials and the machines by which industry would grow and fortunes would be made. The Civil War in the United States, which brought an end to slavery in the South, also stoked the fires of industry and the consolidation of capitalist wealth in the North.

With the demand for cheap labor, desperate people from rural backgrounds migrated into cities looking for work. With this migration, urban populations in Western Europe and America soared, as did poverty and destitution. In the United States, the migration of rural and artisan peoples was international. Between the 1840s and the 1870s, over nine million souls left Europe in search of a livelihood. Most of these found their way to the United States. Later migrations from Europe to America would dwarf these numbers. An industrial working class was taking shape. Agricultural rhythms and artisan craftsmanship were giving way to mechanized semi- and unskilled labor, generating "wage slavery" and alienation.

The intensification of factory production spurred other developments. The need to move raw materials and manufactured products gave birth to modern systems of transportation. Railroads, steamships, and manmade waterways proliferated, providing

domestic and international channels serving a large-scale industrial system of production and trade. In prior centuries, merchant capitalism had relied on global methods for moving human and material cargoes, but the coal- and steam-powered technologies of nineteenth-century industry exponentially increased the magnitude and speed of portage.

Even more astonishing was the appearance of a high-speed technology for communicating information. Electric telegraphy—developed in England by Sir Charles Wheatstone (also the inventor of the stereoscope) and William Cooke, and promoted in the United States by Samuel F. B. Morse—created a qualitative change in the physics of human contact. Now, as never before, it was "possible for the intercommunication of Thought to take place without bodily presence."[2] By the late 1850s, two thousand words an hour could be transmitted along these modern highways of intelligence. For industrial commerce, telegraphy was essential, connecting businessmen and suppliers in a way that allowed for instantaneous consultation and commerce across vast distances.

Telegraphy also changed the nature of journalism, profoundly expanding its reach. If, prior to its development, the passage of news depended on local networks or correspondence by mail, often taking days or weeks, the telegraph created immediate access to occurrences far and wide. With the emergence of the wire services such as Reuters, founded in 1858, the boundaries of news seemed to be infinite.

In 1851, an underwater cable connected England with the continent of Europe. In 1866, a transatlantic cable linked North America and England. By the 1870s, a global network was in place. While much of the world's population still conversed by slow and traditional means, and vast regions remained unwired, industrial centers had a world at their fingertips.

The historian Eric Hobsbawm eloquently summarized these developments:

> [With] the railway, the steamer and the telegraph "which finally represented the means of communication adequate to modern means of production"—the geographical size of the capitalist economy could suddenly multiply as the intensity of its business transactions increased. The entire globe became part of this economy. The creation of a single expanded world is probably the most significant development of . . . [the] period.[3]

Within this vortex, radical philosophies predicated on the apparently infinite

powers of science and industry and, inspired by a commitment to the idea of change, flourished. Breaking from static ideas of order promulgated by religion and the authoritative taxonomies of science, new theories emerged that were founded on a belief in the powers of human action to transform society and harness the laws of nature. The explosion of socialist and anarchist thinking during the 1840s was a resounding sign of this development.

In the same year that Tocqueville sounded an alarm to the Chamber of Deputies, a newly elected member of France's National Assembly, an anarchist named Pierre-Joseph Proudhon, served as a public advocate for an increasingly politicized industrial working class. Enraged by the exploitation of labor that was accompanying the Industrial Revolution, Proudhon championed the cause of revolution in response, calling for end to the institution of property. This idea was first put forward in 1840, in a widely read book entitled *What is Property? An Inquiry into the Principle of Right and of Government*. In the book's opening, he asked the question, "What is slavery?" and answered, "It is murder!" Following upon this, his answer to the question, "What is property?" was short and straightforward. "It is theft," he wrote, dismissing a fundamental capitalist faith. By property, Proudhon, and subsequent radical thinkers, did not mean the personal belongings of individuals or families, but the property system on a grander scale. Their conception of property referred to the social machinery of production as well as the earth and its resources. These, they

A Chinese tapestry of Karl Marx.
FROM THE COLLECTION OF THE EWEN LIBRARY

believed, were what one seventeenth-century English radical had termed "a common treasury," belonging to all people. As radical working-class politics and ideas of popular democracy grew in ensuing decades, Proudhon and his ideas continue to play their part.

Ultimately, more influential were the ideas of Karl Marx and Friedrich Engels. What differentiated their theories from those of other socialists or anarchists was the central notion that the history of social and economic relations was, and would continue to be, the driving force of change and, in the end, revolution. In The *Communist Manifesto*, another product of 1848, the two German exiles, living in England, argued that human history could only be understood as a scientifically verifiable process of transformation and progress. Beginning in a primitive communal state, humankind had moved through a series of developmental stages, each containing the seeds of its own destruction. Feudalism and its

system of property and labor had been defeated by a budding capitalism that had first emerged on the margins of feudalism. By the nineteenth century, this once upstart capitalism had become a behemoth.

> The modern bourgeois society that has sprouted from the ruins of feudal society has not done away with class antagonisms. It has but established new classes, new conditions of oppression, new forms of struggle in place of the old ones.4

Until the modern era, scarcity, for most people, had been an unavoidable fact of life. Famines and drought in a pretechnological age were cruel and inescapable victories of nature over human need. The triumph of capitalism, however, had, according to Marx and Engels, altered this earliest imbalance forever.

> The bourgeoisie, during its rule of scarce one hundred years, has created more massive and more colossal productive forces than have all preceding generations together. Subjugation of nature's forces to man, machinery, application of chemistry to industry and agriculture, steam-navigation, railways, electric telegraphs, clearing of whole continents for cultivation, canalization of rivers, whole populations conjured out of the ground—what earlier century had even a presentiment that such productive forces slumbered in the lap of social labor?5

Through industry, technology, and commerce, capitalists had built an apparatus that was, at last, capable of fulfilling people's ancient longing for material well-being. Yet capitalism's market-driven underpinnings and profit motive had, for working people, produced conditions of social and economic immiseration. Capitalism, Marx and Engels wrote, had created

> a class of labourers who live only so long as they find work, and who find work only so long as their labour increases capital. These laborers, who must sell themselves piecemeal, are a commodity, like every other article of commerce, and are consequently exposed to all the vicissitudes of competition, to all the fluctuations of the market. Owing to the extensive use of machinery and to division of labour, the work of the proletarians has lost all individual character, and consequently, all charm for the workman. He becomes an appendage of the machine, and it is only the most simple, most monotonous, and most

easily acquired knack, that is required of him. . . . [A]s the repulsiveness
of the work increases, the wage decreases.

This inherent contradiction between the utopian potential of modern indus-
try and the systematic exploitation of labor, they argued, provided a scientific
basis for the inevitable demise of capitalism. Out of class conflict and proletar-
ian revolution a new world would be built, unencumbered by the profit motive,
with the betterment of humanity as its primary objective. The history of oppres-
sive class relations, Marx and Engels maintained, will have come to an end. These
ideas, along with those of Proudhon and other theories and practices of social-
ism, gained adherents among a vast number of industrial workers and also
affected middle-class intellectuals who embraced socialist ideas as the key for
improving the social order, by reform or revolution.

Though less cataclysmic than Marxism, and extending far beyond the scope of
human history, Charles Darwin's *On The Origin of Species by Means of Natural
Selection, or The Preservation of Favoured Races in the Struggle for Life* offered
another scientific vision of change. First published in 1859, Darwin's book—
today known by the less controversial title *The Origin of Species*—proposed the
notion that a "slow process" of "Natural Selection" propelled the evolution of life
forms and ensured that only the most vital forms would survive. Darwin pre-
sented evolution as a prolonged journey, stretching across countless millennia, in
which "favorable variations chance to occur," giving rise to "incipient species" that
are more suited to survive in the ongoing "struggle for existence." Along the way,
carried by the natural laws of heredity, those organisms and species less capable
of survival begin to fade away.

> Owing to this struggle for life, any variation, however slight, and from
> whatever cause proceeding, if it be in any degree profitable to an indi-
> vidual of any species, in its infinitely complex relations to other organic
> beings and to external nature, will tend to the preservation of that indi-
> vidual, and will generally be inherited by its offspring. The offspring
> also, will thus have a better chance of surviving, for, of the many individ-
> uals of any species which are periodically born, but a small number can
> survive. I have called this principle, by which each slight variation, if use-
> ful, is preserved, by the term of Natural Selection, in order to mark its
> relation to man's power of selection.

Unlike Marx, however, Darwin did not believe that human intervention could lead to the significant improvement of life. While he acknowledged that man's "power of selection" had brought about "great results" in the breeding of animals and plants to serve human needs, he saw the slow, unconscious process of natural selection as a far more potent force. It is, he argued, "immeasurably superior to man's feeble efforts, as the works of Nature are to those of Art."[6] Darwin held an unwavering belief in the importance of natural selection as the decisive element in the ongoing struggle for existence.

His writings, like those of Marx and Engels, spawned a wide range of interpretations. In his Introduction to *Dialectics of Nature* (1876), Engels used Darwin's theory to belittle the assumptions of free-market economics and to defend the principles of socialism.

Darwin did not know what a bitter satire he wrote on mankind, and especially on his countrymen, when he showed that free competition, the struggle for existence, which the economists celebrate as the highest historical achievement, is the normal state of the animal kingdom. Only conscious organization of social production, in which production and distribution are carried on in a planned way, can elevate mankind above the rest of the animal world.[7]

ON

THE ORIGIN OF SPECIES

BY MEANS OF NATURAL SELECTION,

OR THE

PRESERVATION OF FAVOURED RACES IN THE STRUGGLE FOR LIFE.

By CHARLES DARWIN, M.A.,
FELLOW OF THE ROYAL, GEOLOGICAL, LINNÆAN, ETC., SOCIETIES;
AUTHOR OF 'JOURNAL OF RESEARCHES DURING H. M. S. BEAGLE'S VOYAGE
ROUND THE WORLD.'

LONDON:
JOHN MURRAY, ALBEMARLE STREET.
1859.

The right of Translation is reserved.

First edition. FROM THE COLLECTION OF THE EWEN LIBRARY

Others, fearing and despising "the great unwashed," fixed their sights on the notion of "Favoured Races" and employed Darwin's ideas to uphold the natural righteousness of social inequality. Even before Darwin published *The Origin of Species*, the English philosopher Herbert Spencer, in an article entitled "Progress: Its Laws and Causes" (1857), argued that social inequities reflect only the unbiased influence of evolution and natural law. When it appeared, Darwin's theory was quickly used to substantiate this notion. Spencer was more influential than Darwin in the late nineteenth century, particularly in the United States.[8] Followers of Spencer in England, American robber barons such as Andrew Carnegie, and Prof. William Graham Sumner of Yale, argued that Darwin had finally provided a scientific explanation for existing social and racial discrepancies. Coining the term Social Darwinism, they claimed that people of position and wealth were simply victors in a world guided by "the survival of the fittest." Those at the bottom were less fit; their

social circumstances were the outcome of their inherent degeneracy. The American Sumner articulated the essence of this theory.

> Let it be understood that we cannot go outside of this alternative: liberty, inequality, survival of the fittest; not liberty, equality, survival of the unfittest. The former carries society forwards and favours all its best members; the latter carries society downwards and favours all its worst members.[9]

While often attributed to Darwin, the phrase "survival of the fittest" did not originate with him. It came, in fact, from Herbert Spencer. Reflecting the mean spirit of his time, Darwin, when he published the sixth edition of *The Origin of Species* in 1872, first included the phrase, attributing it directly to its author. Revising a passage from earlier editions (as quoted above), Darwin now explained:

> I have called this principle, by which each slight variation, if useful, is preserved, by the term natural selection, in order to mark its relation to man's power of selection. But the expression often used by Mr. Herbert Spencer, of the Survival of the Fittest, is more accurate, and is sometimes equally convenient.[10]

With ideas such as this percolating in the air—and in a world where measurement and photography were becoming the prevailing instruments of truth—it is little wonder that some people, in defense of the existing social order, began to imagine that fitness and unfitness could be objectively documented. It was a short step toward the idea that human intervention could be applied to accelerate nature's laws, bringing about a perfection that natural selection was bringing about far too slowly. From these ideas, new institutions for separating the fit from the unfit would emerge, as well as sciences that claimed they could systematically improve the quality of the human race. The field of criminal anthropology, and a novel science called eugenics, provided the practical and intellectual environment in which these conceits would flourish and, in the century to come, wreak havoc.

PART III

THE FACES OF DEGENERATION

17

IDENTIFYING THE GROUP WITHIN
THE INDIVIDUAL

In 1878, Sir Francis Galton, a prominent Fellow of the Royal Society, made a presentation to the Anthropology Section of the British Association for the Advancement of Science in Plymouth. To a spellbound audience he described and illustrated a photographic experiment that had been occupying his energies since the summer of the previous year.

Beyond his own considerable reputation, Galton was a member of one of Britain's most illustrious scientific families. His grandfather, Erasmus Darwin, had been a well-respected "physician, poet and philosopher," and his cousin, Charles Darwin, had shaken the world of natural history, in 1859, with the publication of his *Origin of Species*.

Things had not always been promising for Francis Galton. As a young man, he had begun studies in mathematics and medicine at Cambridge but had proven a run-of-the-mill student and never completed his degree. Discouraged by his unimpressive performance at university, a twenty-seven-year-old Galton, who had been interested in phrenology for some time, paid a visit to the London Phrenological Institute in 1849, to have his head examined with the hope that it would provide him with guidance for the future. This was not his reading. As a student at King Edward's School, Galton's head had been examined by a Cambridge phrenologist to see whether his performance on an examination the next day could be predicted. The examiner was impressed by the boy's head and noted that he had only once before encountered an organ of "causality" as developed as this, and that was when he had examined a bust of Francis's grandfather, Erasmus Darwin. As a student at Cambridge, Galton was again examined, this time by a famous German phrenologist who remarked positively on Galton's outstanding organ of "self-esteem."

In 1849, at the Phrenological Institute, Galton was examined once again, this time by its chief phrenologist. Following the reading, Galton was informed that, if he could transcend his youthful "enjoyment of the lower pleasures," the conformation of his head indicated a promising future.[1]

That future, it turned out, would not be determined by formal education, but by the death of his father, the banker and arms maker Tertius Galton, who left his son a vast

fortune. With this inheritance, Galton, like many before him, embraced the life of "a gentleman scientist," as he himself put it, and in time gained fame for his worldly explorations and scientific endeavors.

Over Galton's lifetime, much of his work would cross paths with that of his cousin Charles, but his talk at the British Association focused on the development of something he called composite portraiture. This work had begun following a request made of him in the late 1870s by Sir Edmund Ducane, Her Majesty's Inspector of Prisons. Ducane, as Galton narrated it, had called upon him and provided him with thousands of photographs "of criminals, in order to discover and to define the types of features, if there be any, that are associated with different kinds of criminality. Photographic composites, composite portraiture, or generic images, as he variously called his technique, was a novel method of interconnecting photographic data that Galton developed in response to Ducane's request.[2]

Galton's procedure owed a great deal to statistical innovations pioneered more than thirty years earlier by Adolphe Quetelet. Quetelet was a student of the French astronomer Arago, who also championed Louis Daguerre. Quetelet became the royal astronomer of Belgium, but he "gained international reputation not so much for astronomy, but as a statistician and population biologist."[3] In 1844, using an astronomical principle called the Law of Error, Quetelet had measured the chest sizes of five thousand Scottish soldiers. Each soldier had his own particular measurement, but together these data, along with other measurements he took, permitted Quetelet to establish the physical dimensions of what he called the average, or normal, soldier. In short, while each member of a given group had his or her own peculiar individuality, the "average" characteristics of that group could be determined by calculating those individuals into an "ideal type." Once established, the ideal type could help to define the general qualities that characterized racial groups, deviants, criminals, and other undesirables, or, as in the case of Quetelet's initial experiment, the average Scottish soldier. By creating the idea of a "normal" man, Quetelet also created a statistically defined benchmark against which others could be judged, insofar as they approximated or deviated from the norm. The problematic social implications of his work are still present today.

Galton, using the technique of composite portraiture, and instruments of his own invention, hoped to create a visual equivalent of Quetelet's notion of a statistical ideal. His technique, as he later described it, was based on the premise that, if photographs of different members of a defined group could be merged

into one image—like Quetelet's statistics—it would reveal a "pictorial average," an "ideal type" image of the group to which the different members belonged.

> [I]f we have the portraits of two or more different persons taken in the same aspect, and under the same conditions of light and shade, and . . . if we put them into different optical lanterns converging on the same screen, and carefully adjust them—first, so as to bring them to the same scale, and, secondly, so as to superpose them as accurately as the conditions admit—then the different faces will blend surprisingly well into a single countenance. If they are not very dissimilar, the blended result will always have a curious air of individuality, and will be unexpectedly well defined; it will exactly resemble none of its components; but it will have a sort of family likeness to all of them, and it will be an ideal and an averaged portrait.4

Moving beyond projections on screens, Galton developed instruments for taking and printing composite portraits. These "generic images," he was convinced, permitted the identification of the group within the individual, revealing the extent to which an individual conformed to the expected qualities of the group.

The images provided by Ducane fell into three general categories. The first two groups of pictures Galton described as "men undergoing severe sentences for murder and other crimes connected with violence; the other of thieves." A third group consisted of men convicted as perpetrators of sexual crimes.

As Galton presented his compelling visual data to the British Association, he reported on the "physiognomic classes" that characterized each group and presented composite portraits of ideal murderers, forgers, thieves, sex criminals, and so on. These portraits, he contended, provided visual depictions of what average criminals looked like, how they deviated from the physiognomy of a higher class of people. While he acknowledged that these portraits could not be used to identify criminals at random, he believed that they might be employed to identify those "liable to fall into crime." Yet the facial features of his composite criminals also troubled Galton. While he found that the individual pictures of criminals were clear in their expressions of "villainy," when unified into a composite, this villainy began to recede from view, and what was left was simply a compound representation of "humanity of a low type," the class of people from which criminals most often came.5 The iniquitous markings of a "criminal type," which he had hoped to identify, were not clearly revealed. Dealing with photographs of male and female tuberculosis patients, he attempted to capture

COMPOSITE OF
5 CRIMINALS.

COMPOSITE OF
4 CRIMINALS.

COMPOSITE OF
9 CRIMINALS.

CO-COMPOSITE
OF ALL.

Four of Galton's composite criminals. REPRINTED FROM ELDRIDGE AND WATTS'S *OUR RIVAL THE RASCAL*, 1897, FROM THE COLLECTION OF THE EWEN LIBRARY

the general physiognomy of disease. While he believed that these composites offered an accurate visual average of the patients, he was dismayed by the fact that the "generic images" were devoid of the "wan look" that he had noted in the portraits of individual patients. Indeed, the composites were remarkable for their splendor. He recalled: "The result is a very striking face, thoroughly ideal and artistic, and singularly beautiful. It is, indeed, most notable how beautiful all composites are. Individual peculiarities are all irregularities, and composite is always regular."[6]

For Galton, composite portraiture was not only a tool for demarcating the physiognomy of degeneration. Like Quetelet, who first measured sturdy Scottish soldiers, Galton believed that composites could also be employed to provide an ideal representation of fitness. With the help of Charles Darwin's son, who was a lieutenant in a regiment of Royal Engineers, Galton combined pictures of "twelve officers . . . and an equal number of privates" that the younger Darwin had taken for him. "The result," he wrote with pride, "is a composite having an expression of considerable vigour, resolution, intelligence, and frankness." This composite portrait of Royal Engineers, he believed, "probably gives a clue to the direction in which the stock of the English race might most easily be improved."[7]

This comment, about improving the racial stock, spoke to another invention of Galton's: eugenics, to be addressed in a subsequent section.

Concurring with Galton's own observations, the editors of *The Photographic News*, in the issue of April 17, 1885, commented on the exquisite beauty encountered in "composite portraits." Ordinary photographs of people, they noted, are "merely an exact representation of one phase of the sitter's individuality." In composites, however, one approached the aesthetic ideals canonized by Joachim Winckelmann, who had written about Greek statues as composite representations of beauty, melded from the perfect parts of various, otherwise imperfect individuals. In Galton's photographs, the editors waxed eloquent, acclaiming its "indefinite number of phases" as "recalling the ideal pictures of the great masters."[8]

Despite his failure to precisely pictorialize the villainy of crime or the debilitation of disease, Galton remained enthusiastic about the potential for "composite portraiture," and he continued with his experiments. He believed, for example, that composites could offer families an ideal amalgamation of themselves, a visual synthesis of their genealogies.

> I think it can be turned to most interesting account in the production of family likenesses. The most unartistic productions of amateur photography do quite as well for making composites as those of the best professional workers, because their blemishes vanish in the blended result. All that amateurs have to do is to take negatives of the various members of their families in precisely the same aspects (I recommend either perfect full-face or perfect profile), and under precisely the same conditions of light and shade, and send them to a firm provided with proper instrumental appliances to make composites from them. The result is sure to be artistic in expression and flatteringly handsome, in expressing the members of the family. Young and old, and persons of both sexes, can be combined into one ideal face. I can well imagine a fashion setting in to have these pictures.[9]

Beyond this ability to capture the essence of a family's "likeness," Galton believed, composite photography could be employed to further the exactitude of racial science. "It is the essential notion of a race that there should be some ideal typical form from which the individuals may deviate in all directions, but about which they chiefly cluster, and towards which their descendents will cluster."

In his composite of the Royal Engineers, he believed he had located the

216

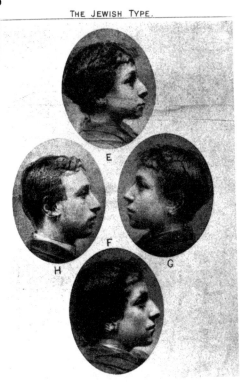

THE JEWISH TYPE.

Composites analyzed by Joseph Jacobs. REPRINTED FROM *THE PHO-TOGRAPHIC NEWS*, APRIL 17, 1885

"ideal typical" essence of the English race to which he belonged. Properly followed, he reasoned, it would be advantageous to produce "typical pictures of [the] different races of men," and following this assumption, he began to produce additional racial portraits, commencing, in 1883, with the Jews.[10]

In 1885, Galton was asked by the *Photographic News* "to send specimens of photographic composites" as illustrations for that weekly periodical. Luckily, Galton had recently been asked by the Council of the Anthropological Institute to provide composites for an evening discussing "the race characteristics of the Jews." This invitation offered him an opportunity to publicly display examples from his second effort at producing racial composites.

I had ... sorted out for exhibition at that meeting a few composites of Jewish faces I had made some time ago. They are, I think, the best specimens of composites I have ever produced. . . . [T]he individual photographs were taken with hardly any selection from among Jewish boys in the Jews' Free School . . . They were children of poor parents, dirty little fellows individually, but wonderfully beautiful, as I think, in these composites. The feature that struck me the most, as I drove through the adjacent Jewish Quarter, was the cold scanning gaze of man, woman, and child, and this was no less conspicuous among the schoolboys. There was no sign of diffidence in any of their looks, nor of surprise at the unwanted intrusion. I felt, rightly or wrongly, that every one of them was coolly appraising me at market value, without the slightest interest of any other kind.[11]

While Galton's narration expressed a common stereotype of Jews as a people who reduce all things to their pecuniary value, a Jewish member of the Council, Joseph Jacobs, had in fact, commissioned the composite portraits that Galton produced. Jacobs was a leading student of English and Celtic folklore but, as president of the Jewish Historical Society, he was also interested in the anthropological characteristics of the Jewish race. To a certain extent, he was particularly interested in responding to an ongoing debate that swirled around him: whether modern Jews were direct descendents of the people of the Old Testament. He hoped that Galton's composites might help to provide an answer. In an article written for the *Photographic News*, Jacobs, with disarming candor, recounted his initial reasons for approaching Galton.

> Most people can tell a Jew when they see one. There is a certain expression in Jewish faces which causes them to be identified as such in almost every instance. Being engaged in some investigation into Jewish characteristics generally, I was anxious to discover in what this 'Jewish expression' consists. It occurred to me that Mr. Galton's method of composite portraiture would enable us to answer this question with some degree of exactitude. I accordingly applied to him about two years ago, and he kindly consented to 'compound' some Jewish types. I procured for him photographs of Jewish lads from the Jewish Working Men's Club, and of Jewish boys from the Jews' Free School, and he was good enough to compound them.[12]

On the evening designated for a discussion of "the race characteristics of the Jews," Galton opened the event with a presentation of the Jewish composites he had produced, making few comments and deferring to Mr. Jacobs, who, he said, "will furnish you with his own views as to how far these composites succeed, in his opinion, in presenting the typical features of the modern Jewish face."[13]

In his own presentation, Jacobs announced that he was astounded by the depth and eloquence of the images Galton had crafted. "Of the fidelity with which they portray the Jewish expression," he asserted, "there can be no doubt."

> The composites . . . carry with them conclusions of scientific importance. If these Jewish lads . . . yield so markedly individual a type, it can only be because there actually exists a definite and well-defined organic type of modern Jews. Photographic science thus seems to confirm the conclusions I have drawn from history, that, owing to social isolation

and other causes, there has been scarcely any admixture of alien blood amongst the Jews since their dispersion.

While anti-Semites would draw similar conclusions regarding the separate and distinct nature of a Jewish race, and use this as an argument for the Jews' inherent wickedness, Jacobs believed that this uncontaminated consanguinity offered an explanation for the particular gifts of the Jewish people. First, however, he summarized the physiognomic qualities revealed so beautifully in Galton's portraits. His summary, again recalling anti-Semitic stereotypes, focused on the Jewish nose. In his detailed exploration, however, he deviated from the conventional characterization that identified a Jew as having "a long nose." Instead, Jacobs noted the unique conformation of Jewish nostrils.

> The nose does contribute much towards producing the Jewish expression, but it is not so much the shape of its profile, as the accentuation and flexibility of nostrils. . . . And in the profile components . . . it will be observed that every face has the curve of the nostril more distinctly marked than would be the case in the ordinary Teutonic face, for example.

Carrying on a tradition founded by Petrus Camper, Jacobs's scientific evaluation of the Jewish nose was enhanced by a detailed discussion of how artists might portray this definitive feature.

> A curious experiment illustrates this importance of the nostrils towards making the Jewish expression. Artists tell us that the best way to make a caricature of the Jewish nose is to write a figure 6 with a long tail; now remove the turn of the twist . . . and much of the Jewishness disappears; and it vanishes entirely when we draw the continuation horizontally. We may conclude then, as regards the Jewish nose, that it is more the nostril than the nose itself which goes to form the characteristic Jewish expression.

But, Jacobs added, "[I]t is not alone this 'nostrility' which makes a Jewish face so easily recognizable." He elaborated, disagreeing with some of Galton's conclusions, and argued that the eyes of the composite offered a window to a peculiarly Jewish intellect and imagination.

I fail to see any of the cold calculation which Mr. Galton seems to have noticed in the boys. . . . There is something more like the dreamer and thinker than the merchant. . . . In fact, on my showing this to an eminent painter of my acquaintance, he exclaimed, "I imagine that is how Spinoza looked when he was a lad," a piece of artistic insight which is remarkably confirmed by the portraits of the philosopher, though the artist had never seen one.

Jacobs completed his physiognomic profile, detailing other features that contributed to the expression of the Jewish type.

The predominating characteristic of the forehead is breadth, and perhaps the thick and dark hair encircling it has something to contribute to the Jewishness of the face. The thickness of the lips, and especially a characteristic pout of the lower one, come out markedly in components and composites, both full faced and profile. . . . Finally, the heavy chin, especially marked in the profile composites, confirm the popular association of this feature with the quality of perseverance so ingrained in the Jewish nature.

Jacobs's correlation of physiognomy and character was in tune with the spirit of his time and echoed ideas dating back to Lavater. Speaking of the evolution from child to adult, he noted that "a thoughtful expression in youth, transformed into a keen and penetrating gaze by early manhood." Yet despite his effort to provide an interpretation of that which was revealed by Galton's composites, Jacobs modestly acknowledged that "words fail most grievously" as a tool for describing "the most living of all things, human expression." Far better than words, he concluded, the pictures offered a pristine and articulate portrait of his race.

Galton's composites say at a glance more than the most skillful physiognomist could express in many pages. The "best definition," said the old logician, "is pointing with the finger" . . . and the composites here given will doubtless form for a long time the best available definition of the Jewish expression and the Jewish type.

Jacobs began his talk by indicating that he would be addressing the question of "the modern Jewish face." Yet, as he proceeded, it became clear that he believed that the worth of the scientific evidence provided by Galton far exceeded the limits of the present.

220

Describing the utility of composites, Galton had argued that they provided an average around which a group would "cluster" and a picture of an ideal type that would constitute a normative standard for future generations as well. This sense of the hereditary value did not escape the gaze of Jacobs, yet for him, the extent to which composites defined the destiny of future generations was of less interest than the way that they offered an uncanny corridor to the past. Looking at the compound image of young Jewish boys, prepared from photographs taken in 1883, Jacobs thought that he could make out the faces of the ancients. To some extent, this mystical sense of time travel was rooted in the assumption of an uninterrupted Jewish bloodline, its history revealed in a singular image of the consummate Jewish face.

> In the present instance, as the components can in all probability trace back to a common ancestor, the composite face must represent, if it represents anything, this Jewish forefather. As the spectroscope has bridged over the abysm of space, and has told the composition of Orion's Belt, so the photographic lens seems, in these composites, to traverse the aeons of time and bring up into visible presentment the heroes of the past. In these Jewish composites we have the nearest representation we can hope to possess of the lad Samuel as he ministered before the Ark, or the youthful David when he tended his father's sheep.

In years to come, Jacobs would be somewhat more cautious regarding the link between modern Jews and the prophets and heroes of the Torah. Anthropometry, the systematic measurement of the human body in its details, suggested that Jewish heads, with their broad brows, were not consistent with the "long-headed" physiognomy of present-day Semitic peoples. Others—primarily anti-Semitic anthropologists who refused to acknowledge that people such as the Jews around them could have peopled or produced the Old Testament—argued that modern Jews were a mongrelized people, hardly the descendants of the "chosen" ancient Israelites. In responding to these arguments, Jacobs held to the idea of Jewish purity, but he was forced to defend against these positions, ascribing broad heads, not to hybridization, but to the Jews' distinctive "cerebral development" over time.[14]

Returning to that evening in 1885, it is difficult to digest Joseph Jacobs's earnest endorsement of Galton's visual stereotypes of the "Jewish race." Knowing what

we do about the future uses of Jewish "difference," and of images very much like Galton's, Jacobs's sunny disposition toward these composites is almost unfathomable. Yet, he could not have comprehended the grim future that lay ahead.

What is clear is that at the very moment Galton was producing his "photographic composites," he was also engaged in defining and promoting another scientific endeavor. He named this enterprise eugenics, after the Greek *eugenes*, which he translated as, "good in stock, hereditarily endowed with noble qualities."[15]

Like "composite portraiture," Galton's eugenics was a study of human typologies. Also like "generic images," it fulfilled Walter Lippmann's later definition of stereotyping as a procedure that shapes the meaning of "evidence in the very act of securing the evidence."

In eugenics, Galton employed photography, anthropometry, and the systematic gathering of statistical data, in order to identify those whose hereditary makeup was exemplary—the English in particular, Caucasians more generally—and those whose hereditary legacy threatened to pollute the race. If Darwin's evolutionary theory indicated that, over a period of millennia, natural selection generated adaptive changes in species, Galton reasoned that systematic breeding strategies, guided by enlightened scientists such as himself, could be employed to hasten what had previously been left to nature. Within fifty years, these ideas, buttressed by composite visions of Jewish degeneracy, would provide a justification for genocide, a systematic attempt to remove the burden of Jewish heredity from the European racial picture.

18
FINDING THE INDIVIDUAL WITHIN THE GROUP

In 1892, Sir Francis Galton traveled to Paris in order to spend a few brief hours with a man named Alphonse Bertillon. Since the mid 1870s, when he launched a series of photographic experiments, Galton had been committed to the idea that photography could furnish essential information for the scientific evaluation of human beings. Impressed by Bertillon's considerable reputation as one of the most sophisticated technical photographers in Europe, Galton hoped that his visit to Paris would help to perfect the accuracy of his photographic research. Both men were staunch advocates of photography as a tool for the study of human subjects, yet the routes that brought them to this conviction were significantly different.[1]

Galton's "composite portraiture," which was used to create visual renditions of "ideal" physiological types, was but one more excursion in an enterprise that had risen to the forefront of European scientific thinking with the publication of Linnaeus's *Systema Naturae* beginning in 1735. From that time onward, the taxonomic order of living things was predicated on the idea that the character of each individual organism was defined by its relationship to a clearly demarcated physical standard. As Europeans drew the world's population into the filaments of a vast economic web, a methodical delineation of distinct and

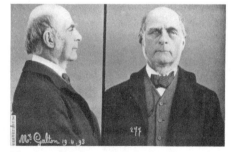

Mugshot of Galton, taken by Bertillon at their meeting in 1893. REPRINTED FROM KARL PEARSON'S *THE LIFE AND LABOUR OF FRANCIS GALTON*

dissimilar human categories provided an intellectual framework that transformed the often-brutal habits of power into the natural outcome of scientific verities. Modernity and civilization, as portrayed by Europe, were well served by these ostensibly objective systems of classification.

Yet, in other aspects of modern life, such categorical groupings were of little use and could, in fact, interfere with the exercise of control. With the growth of cities and—by the mid nineteenth century—urban populations of more than a million, circum-

224

stances were arising that demanded the ability to zero in on and identify individuals, lest they be lost within the anonymity of the mass. Radical political movements, which flourished from the 1830s onward and accelerated after 1848, made the identification of particular individuals a burning priority for those in power, both in Europe and the United States. Beyond these explicitly political motivations, the apprehension and punishment of conventional criminals, who were adept at disappearing in the miasma of the multitude, also lent urgency to the priority of developing techniques for sifting through the "faceless crowd" in search of incorrigible miscreants. The most significant move in this direction began to unfold in Paris in the 1870s, and its architect was Alphonse Bertillon.

By the middle of the nineteenth century, Paris was a seething metropolis of 1.3 million people, the second-largest city in Europe. The French capital also had a legendary history as a volatile center of radical egalitarian politics and revolutions. The French Revolution of 1789 provided a momentous paradigm for the overthrow of monarchy and aristocracy and for the arrival of "the common man" on the political stage. In the Revolution of 1848, workers barricaded the streets of Paris, only to be defeated by forces from the countryside, haunted by the specter of socialism in the year that Marx and Engels published *The Communist Manifesto*.

Then, in March of 1871, on the heels of France's defeat in the Franco-Prussian war, these politics exploded once again in a convulsion that shook the society to its roots. With a Prussian-backed government under Adolphe Thiers holding power in Paris, and German occupiers within city limits, a civil war erupted, and for three months a popular government led by workers and disaffected soldiers seized control of the city, proclaiming the Commune de Paris on March 28. Though regiments of the French army entered Paris and viciously defeated the revolutionaries in an eight-day siege, killing over thirty thousand, the nerves of the Parisian bourgeoisie were shattered, and the Paris Commune would provide an alarmist rallying point for the forces of law and order for decades to come.

Inadvertently, photography emerged as a powerful weapon in the crushing of the Commune. During those three revolutionary months, buoyant communards enthusiastically disseminated and exchanged *carte-de-visite* portraits of themselves, also posing for group photographs. As the French army moved into the city, these photographs provided it with visible evidence of the individuals involved in the uprising and were used to track down and kill thou-

sands of participants.[2] This fact was not lost on Alphonse Bertillon, and would become a keystone in the first modern system of criminal identification that he developed while working, eight years later, as a clerk in the offices of the Préfecture de police in Paris.

In the year of the Commune, Bertillon was a young man of eighteen who had not yet found his calling. Like the young Galton, Bertillon was a mediocre student. Adding insult to injury, he had been expelled for misconduct by a number of schools and was proving an embarrassment to his family. He did eventually pass his baccalaureate in science and literature, but given his formidable intellectual lineage, this was hardly a distinction.

Bertillon's father, Louis Adolphe Bertillon, was an internationally acclaimed statistician and physical anthropologist. Influenced by the work of Quetelet, the elder Bertillon assembled statistics from anthropometric body measurements and, in the mid-1840s, published an important study on the question of average heights, focusing on the importance of respecting racial differences in the calculation of meaningful averages. Holding many ideas in common, he and Paul Broca were close associates.

Louis Adolphe also had a life-long friendship with a man named Achille Guillard who, in 1855, coined the term "demography" in a path-breaking book, *Elé-*

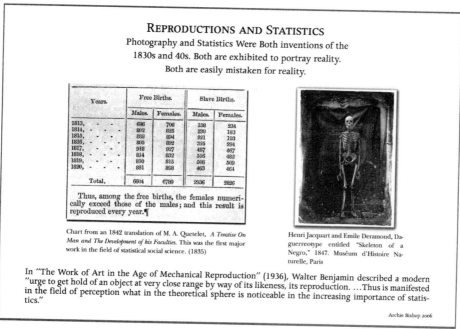

REPRODUCTIONS AND STATISTICS
Photography and Statistics Were Both inventions of the
1830s and 40s. Both are exhibited to portray reality.
Both are easily mistaken for reality.

Years.	Free Births.		Slave Births.	
	Males.	Females.	Males.	Females.
1813,	696	706	138	234
1814,	802	825	230	183
1815,	868	804	221	193
1816,	805	892	325	294
1817,	918	927	487	467
1818,	814	832	516	482
1819,	810	815	506	509
1820,	881	838	463	464
Total,	6604	6789	2936	2826

Thus, among the free births, the females numerically exceed those of the males; and this result is reproduced every year.¶

Chart from an 1842 translation of M. A. Quetelet, *A Treatise On Man and The Development of his Faculties.* This was the first major work in the field of statistical social science. (1835)

Henri Jacquart and Emile Deramond, Daguerreotype entitled "Skeleton of a Negro," 1847. Muséum d'Histoire Naturelle, Paris

In "The Work of Art in the Age of Mechanical Reproduction" (1936), Walter Benjamin described a modern "urge to get hold of an object at very close range by way of its likeness, its reproduction. ...Thus is manifested in the field of perception what in the theoretical sphere is noticeable in the increasing importance of statistics."

Archie Bishop 2006

226

ments de statistique, ou démographie comparée [Elements of Statistics, or Comparative Demography]. Demographic analysis, Guillard claimed, provided an invaluable tool for comprehending "the natural and social history of the human species," and he, along with Bertillon's father, promoted and promulgated the field of demography, which continues to dominate the social scientific description of human beings—physically, behaviorally, and psychologically.

All three men—Louis Adolphe Bertillon, Achille Guillard, and Paul Broca—gained international recognition as pioneers of anthropometric and statistical methods. In 1859, they helped found the Society of Anthropology in Paris, an organization for the study of anthropometry, statistical analysis, and racial differentiation. As a laboratory and school were added in 1867 and 1875, respectively, the prominence of the society as a center for anthropological research grew.

While the younger Bertillon did not achieve the academic status of his father, he was watching and listening attentively. He also paid close attention to his maternal grandfather, Louis Adolphe's partner Achille Guillard, whose daughter, Zoé, Louis Adolphe had married in 1850.

Though a troublesome student, Alphonse Bertillon grew up surrounded by the tools and techniques of anthropometric measurement, with an unfailing belief in the certitude of statistical analysis, and in a milieu where photography was being enthusiastically adopted as a powerful form of anthropological evidence. In "The Work of Art in the Age of Mechanical Reproduction," a still influential essay written in 1936, Walter Benjamin observed that within his world, photography and statistics, though both disembodied forms of representation, were widely accepted as measures of truth. Photography in the "field of perception," he maintained, and statistics in "the theoretical sphere" shared an unassailable air of authority.[3]

Interestingly, in the young Bertillon's world, this link had been established a decade or more before his birth. Photography and statistics were both innovations of the 1830s. Both had deep roots in France, where Daguerre, Quetelet, and Serres had achieved simultaneous, if not fully equal, prominence by 1840. During the 1840s and 1850s, the French anthropological community increasingly employed and conjoined these newly minted forms of evidence as the warp and woof of ethnographic exploration. As Quetelet, followed by Bertillon's father and grandfather, pioneered in the fields of statistics and demography, his associates—including Broca—embraced photography as a tool that could provide irrefutable proof of essential human differences.

These facts and fascinations embedded themselves in Alphonse Bertillon's mind. Even in the turbulence of his early years, he was beginning to contem-

plate new applications for anthropometry and photography that would, in time, shape his future and earn him worldwide prominence.

Into his mid-twenties, Bertillon bounced around without any clear sense of direction. Without any formal vocational training, and unable to assume his father's mantle as a gentleman scientist, Alphonse seemed unemployable. Desperate, he turned to his father for help. In 1879, his father called in a favor and procured a clerical job for his twenty-six-year-old son at the Paris Préfecture de police. There he performed a series of routine tasks.

Attempting to combat the tedium of his deskwork, Bertillon began working on a project designed to provide him with a degree of scholarly escape. Following in the footsteps of his father's intellectual circle and their forebears, he commenced work on a book that he hoped would present the ethnographic discoveries of anthropology to a general audience. Though published in 1882 to a dearth of critical acclaim, *Les Races Sauvages*, [The Savage Races], offered a boilerplate rehashing of ideas that had been knocking around the field of natural history for over a century.

Writing about the "Bushmen," for example, Bertillon was indistinguishable from Baron Cuvier, Samuel Morton, or Paul Broca.

> What contributes most to making their [baboon-like] physiognomy, is the projection of their jaws together with the flattening of the cartilages of the bones of the nose. The result is that their profile, instead of being convex like the Caucasian type, is concave like that of the apes. . . . Besides, the capacity of the Bushman skull is very weak: 1250 cubic centimeters on average; that of the Parisian is 1560. The brain is consequently very small and distinguishes itself even more by the simplicity of its convolutions, which are reminiscent of our senile. In our country, an individual with a similar brain would be an idiot.[4]

Bertillon was also at ease pontificating on the quality of character demarcating different racial groups. Evoking the words of George Combe almost exactly, Bertillon pronounced:

> The black is not well made for freedom. While the indigenous people of North America prefer death to slavery, the black willingly sacrifices his freedom to save his life; and this is why Africa has always been the center of the ignominious trade in human flesh.[5]

While his racist ethnography marked Alphonse Bertillon as a product of his family and civilization, in the field that he would pioneer, and gain fame for, he stepped away from conventional thinking on the value of classifying humans by type. Ironically, it was the routine and meaningless milieu of his day job that provided him with a source of inspiration. Spurred by the often ineffective procedures of police work that he witnessed daily, he began to develop an idea of how systematic measurement, combined with the assiduous recording of physiognomic details and photographic documentation, could solve one of the major problems facing a police force in a city of nearly a million and a half people: how to identify habitual criminals.

At that time, the police paid little attention to such matters. Political events had focused their efforts on the suppression of socialists, anarchists, and other radicals. Meanwhile, urban crime was becoming an increasingly vexing problem. Drawing on ideas that had percolated around him for years, Bertillon proposed that every time a person was arrested, a series of bodily measurements should be taken and recorded on a card. Organized in a complex filing system, Bertillon was convinced that these cards could provide a foolproof database that would allow the police to know whether a detainee had been arrested or convicted before.

Bertillon's scheme was premised on the notion that no two individuals were exactly alike. While he accepted the validity of statistical averages, he was drawn toward Quetelet's Law of Error. With meticulous record-keeping, he believed that Quetelet's Law could permit the police to know, in detail, the particular ways in which each suspect deviated from the average. Measurements, along with systematically posed photographs and a close examination of anatomical details, Bertillon maintained, were the modern tools of police work that would make it virtually impossible for a wrongdoer to hide from the incriminating traces of his own unique identity.

Bertillon's method began with a series of eleven measurements, each recorded on a specialized card of his own design. The first of these was a measurement, with calipers, of the length of the head from front to back. Following this first measurement, head lengths were divided into three now familiar groupings: large, medium, and small. The second dimension to be recorded was the width of the head. An examiner would then go into the first three groupings, which were based on head length, and break each of these into another threesome of large, medium, and small, creating nine separate anthropometrically defined clusters. Similar measurements were done of the middle and little fingers of the left hand, the length of the left foot, the length

of the left forearm from the elbow to the tip of the outstretched middle finger, the vertical height of the right ear, the full height of the prisoner, the length of his outstretched arms, the vertical length of his trunk, and so forth. Following each of eleven precise measurements, every subgroup was again divided into three, eventually producing eighty-one separate subgroups, which were then stored in a specially designed filing cabinet.

229

Now, every time a suspect was brought into the Préfecture de police, he would be subjected to the same sequence of measurements, and his card would be filled out and filed. According to Bertillon, no two individuals could have the same combination of measurements, so if a card already in the file matched a newly taken series of calculations, it meant that that the detainee was already in the system, along with an account of his prior arrests and convictions.

In addition to a standardized series of measurements, which included adjustments made for amputees, Bertillon instructed that each card should also include an inventory of "scars and peculiar marks that every individual more less exhibits and . . . the notation, according to a special vocabulary, of the color of the eye, hair, or beard, as well as the form and dimensions of the nose."

Bertillon became fixated on the minutiae of the human countenance and waxed eloquent on the revelatory powers of particular body parts. As his system developed, Bertillon produced a colorful chart classifying patterns found in the irises of the eyes, including tint, rings, and mixes of pigmentation. Similarly obsessive

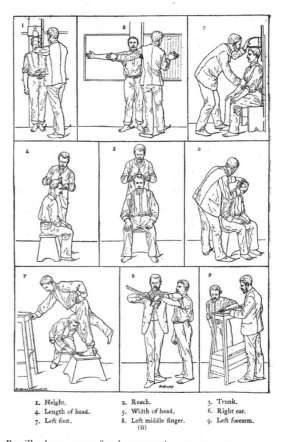

ABSTRACT OF

THE ANTHROPOMETRICAL SIGNALMENT

1. Height.	2. Reach.	3. Trunk.
4. Length of head.	5. Width of head.	6. Right ear.
7. Left foot.	8. Left middle finger.	9. Left forearm.
	(ii)	

Bertillon's sequence of anthropometric measurements. REPRINTED FROM ALPHONSE BERTILLON'S *SIGNALETIC INSTRUCTIONS INCLUDING THE THEORY AND PRACTICE OF ANTHROPOMETRICAL IDENTIFICATION*, CHICAGO, 1896; FROM THE COLLECTION OF THE EWEN LIBRARY

230

classification systems were elaborated for nose shapes, for conformations of the ear, and for categorizing finger and fingernail shapes, among other physical attributes. The ear, he believed, was of particularly importance, since it was "unchangeable in form from birth." To Bertillon, "this organ," more than any other, was "the immutable legacy of heredity and intrauterine life," and he began assembling a huge photographic collection of different ear shapes and configurations. He did the same with noses, brows, chins, and other physical features, eventually combining them on a single chart, the *Tableau synoptique des traits physionomiques*, a synoptic tableau of physiognomic traits.[6]

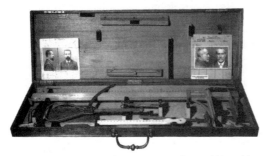

Bertillon's toolbox, including two mug shots of himself on "signaletic cards." COURTESY OF THE PREFECTURE DE POLICE, PARIS

On the front side of each of Bertillon's filing cards were two photographs of the detainee, one a frontal portrait of the head, the other a portrait in profile. He termed these first, systematically gathered mug shots "speaking portraits," and his Tableau synoptique was specifically designed to serve the police in their study and comprehension of these *portraits parlés*.

Informally assembled photographic "rogues galleries" had been part of police work in many countries since the invention of the daguerreotype, but Bertillon took forensic photography to a new level, applying strict standards and directives to the gathering of photographic data. To a great extent, his methods were informed by Paul Broca's 1865 book, *Instructions générales sur l'anthropologie*. When Broca came to the subject of ethnographic photography, he called for exact representations of full face and profile, achieved through a careful and uniform system of posing subjects. In police photography, Bertillon did the same.[7]

In a book he wrote on legal photography, Bertillon offered readers a set of meticulous instructions. All "speaking portraits" must be taken using a specialized apparatus, to ensure that conditions were the same for each set.

> It is absolutely essential that the subject's head should be uncovered at the time the profile and full-face photographs are taken. . . . With the full-face pose, as well as the profile, be careful to see that the subject seats himself squarely upon the chair, his shoulders as far as possible at the same height, his head resting against the head-support with his gaze horizontal.

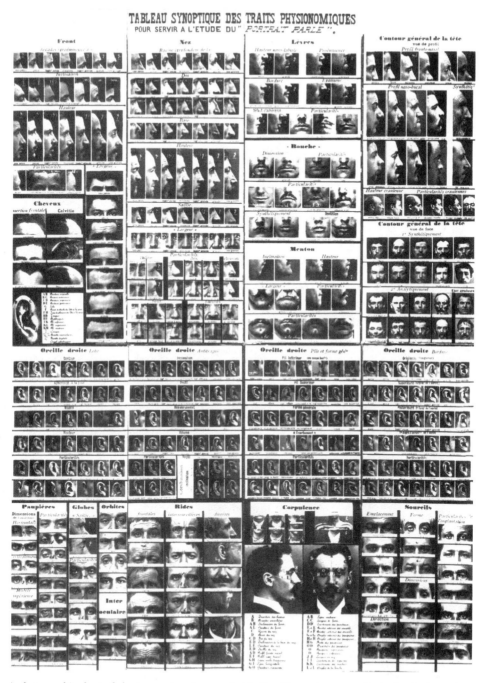

A photographic chart of physiognomic traits compiled by Bertillon to instruct police in the close examination of suspects. COURTESY OF THE PREFECTURE DE POLICE, PARIS

232

Lighting conditions were also specified, and, true to his anthropometric roots, Bertillon declared that each picture must be taken at exactly same distance from a subject. To achieve this uniformity, given the vicissitudes of morphology, Bertillon instructed that the subject of the photograph should hold vertically, along the left side of his face, "a narrow wooden ruler upon which a strip of white paper twenty-eight centimeters has been previously pasted."

> The operator, holding in his hand a card four centimeters in length will . . . approximate [the camera] to the subject, until the twenty-eight centimeters on the ruler gives on the ground-glass plate of the dark chamber of the camera an image reduced to four centimeters, as he can readily assure himself by placing his card upon it.

Once the correct distance between the camera and the subject has been achieved, "cleats" should be nailed to the "floor of the studio at the required distance, so that the chair and the photographic apparatus can be instantly replaced in their respective position."[8]

Despite the fastidious precision of Bertillon's method, the Préfecture de police was slow to embrace it. It would require significant expense and a total alteration of entrenched police procedures. In the face of Bertillon's ongoing overtures to his superiors, all encouraged him to focus on his clerical tasks. Yet, Bertillon persisted and began to assemble data on his own, at his own expense, and built a filing cabinet designed for his system. Taking measurements and photographs, he continually enlarged his inventory of identification cards.

Then, in February of 1883, an event took place at the Préfecture de police that turned the head of an influential police inspector and eventually led to the adoption of Bertillon's system. With the inspector in the room, Bertillon was taking measurements of a number of suspects, all calling themselves "Dupont." As the eleven standard measurements were being taken of the sixth Dupont, Bertillon was struck by an impression that he had seen this man before, and even had a vague mem-

Bertillon taking measurements of a prisoner's head. COURTESY OF THE PREFECTURE DE POLICE, PARIS

ory of having measured him. In examining his features, Bertillon also noticed a small mole near the brow. Once the data gathering was complete, Bertillon went to his 233 office, and, there, in the middle section of the cabinet, in a drawer containing fifty cards, Bertillon discovered a card that matched all of Monsieur Dupont's measurements unerringly. On the front-face photograph, the mole was visible. Dupont, it turned out, was a man who had been previously arrested using the name Martin. In both instances, the crimes were identical: a theft of empty bottles.

Bringing his discovery to the attention of the inspector, Bertillon had finally made his case. It was the photograph, with all of its persuasive clarity, that convinced police authorities that Bertillon was worth listening to. From that time on, Bertillonage became a standard procedure for the Préfecture de police in Paris. By 1888, the former desk clerk had been elevated to a newly created position as Chief of the Bureau of Identification of the Préfecture of Police in Paris. His techniques would move from the police station to the streets, where he applied a comparable system for measuring, photographing, and codifying crime scenes.

By the early 1890s, Bertillon was legendary, and Bertillonage became an internationally applied approach. In the United States, following its demonstration at the Columbian and St. Louis Expositions, it was adopted by a number of big city police departments, beginning with Chicago, where a National Bureau of Criminal Identification was established in 1898. Reporting on an exhibit on police photography in the

Fig. 25. DESIGNATION OF THE PARTS OF THE EYE.

3, Left upper eyelid; 4, Left lower eyelid; 5, Inner point of left eye and lachrymal caruncle; 6, Outer point of left eye; 7, Sclerotic, or white of the eye; 8, Pupil; 9, Iris.

Fig. 27. PLAN OF THE EAR.

Border, A B C D E, divided into the *Original,* A B, *Superior,* B C, *Posterior,* C D, and inferior, D E, portions.

Lobule, E F G H, examined from the point of view of its contour, E F, its adherence to the cheek, F H, its model G and its Dimension.

Antitragus, H I, examined from the point of view of its inclination, its profile, its degree of *reversion* forwards and its Dimension.

Internal folds, separated into inferior, I K, superior, K L, and middle, K M, branches.

Bertillon drawings. REPRINTED FROM ALPHONSE BERTILLON'S *SIGNALETIC INSTRUCTIONS INCLUDING THE THEORY AND PRACTICE OF ANTHROPOMETRICAL IDENTIFICATION,* CHICAGO, 1896; FROM THE COLLECTION OF THE EWEN LIBRARY

International Herald Tribune, Mary Blume relates that Bertillon's photographic techniques soon began to be applied to a range of noncriminal subjects, foreshadowing controversial practices that continue to be employed at the expense of people's dignity and rights.

> Bertillonage was so successful that it was soon extended to cover not only known and suspected criminals but potential nuisances to public order such as foreigners (1893) and Gypsies, who in 1912 were required to carry identity photographs.[9]

Delivering a presentation to the Anthropology Society in Paris in 1890, Alphonse Bertillon was lavish in his praise of ethnographic studies as the inspiration for his system of criminal identification. Anthropology and ethnographic methods of photography, he stated, had provided an unprecedented scientific basis for criminal identification. In the future, he continued, this scientific basis would become the acknowledged underpinning of police work around the world. "No doubt the police will apply to their chases," he predicted, "the rules of anthropology."

> All police work is an affair of identification, to see an individual in the milieu of the crowd. To achieve this goal, authorities search for an infallible method for describing the individual, the equivalent of the general "type" that anthropologists search for in identifying human groups.[10]

Yet despite his admiration of the physical anthropology that his father and grandfather had helped to establish, Bertillon employed a method that rejected the search for ideal types, which had been an enduring fixture of ethnography and natural history. Even if racial typologies were appropriate in the study of darker-hued people, the notion of general types was antithetical to Bertillon's system. Bertillonage was founded on the assumption that the average person, the ideal type, "simply does not exist." It was singularity—not similarity—that provided Bertillon with the power to find his man.[11] While Bertillon's widely circulated photographs and descriptions of faces and body parts would lead some to the idea that there were identifiable "criminal types," Bertillon's method rested on the assumption that criminals were unique individuals and that this, more than their membership in a group, was their Achilles' heel.

CRIMINAL TYPES

By the early 1890s, barely a decade after the Préfecture de police in Paris adopted his techniques for criminal identification, Alphonse Bertillon's fame had soared. He was heralded as a forensic visionary. His meticulous system of bodily measurements, abetted by his precise photographic methodology, embodied what Michel Foucault would much later describe as a microphysics of power, an apparently foolproof capacity to apprehend and punish a lone malefactor within the daunting complexity of the modern city.[1] Refitting the tools of anthropology and racial science, Bertillon had demonstrated their practical utility within the milieu of urban life. Globally, his system became a standard practice in many police departments. Beyond France, Bertillonage was installed by authorities in Russia, Japan, Spain, Italy, Argentina, and some cities in Germany and the United States. His innovations captured the attention and admiration of a growing number of behavioral scientists as well.[2]

If prior applications of anthropometry and ethnographic photography had been driven by the exigencies of global empire, Bertillonage piqued the imagination of a new breed of criminologists and public administrators who increasingly perceived the city as a dangerous world in need of being subdued. "This epoch is characterized by the growth of cities," wrote W. T. Harris, United States Commissioner of Education in 1893. Within this context, he continued,

> Peculiar problems arise, and no one of these problems is more important than that of dealing with the population consisting of the three weakling classes— the criminals, the paupers, and the insane. For the weaklings tend to collect themselves and form slums wherein the educative influence of the family and social life is all-powerful to continue the youth in the same lines of unthrift and crime which his parents have followed.

For Harris, "the management of the abnormal classes of society" was a burning issue that could not be ignored.[3]

In the United States, voting rights, extended to free black men and inherited by the children of poor immigrants in the decades following the Civil War, only exacerbated the perils that Harris described. This situation was already evident in Charles Loring Brace's

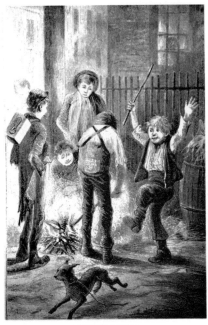

STREET ARABS.

legendary study, *The Dangerous Classes of New York*, published in 1872. Brace, who founded the Children's Aid Society in 1853, anxiously observed the thousands of "outcast street-children" living in the slum neighborhoods of New York, likening the threat they posed to respectable society to that posed by "Indians to Western settlers." These children, "who live on the outskirts of society, whose wits are sharpened like those of the savage, and their principles no better," were, to Brace, particularly menacing because they stood to become America's next generation of "voters." Impoverished, often the children of immigrants unschooled in the ethics of Protestantism, these youthful offenders endangered the city's "property . . . morals and . . . political life." Easily beguiled by "demagogues," Brace maintained they were a powder keg waiting to explode, a ready source of "domestic outbreaks and violations of law."4

This imminent danger, he believed, had become manifest during the Draft Riots of 1863.

> Who will ever forget the marvelous rapidity with which the better streets were filled with a ruffianly and desperate multitude, such as in ordinary times we seldom see—creatures who seemed to have crawled from their burrows and dens to join in the plunder of the city—how quickly certain houses were marked out for sacking and ruin, and what wild and brutal crimes were committed on the unoffending negroes?5

Writing in 1872, one year after the Paris Commune, Brace was not ignorant of the transnational implications of such urban unrest, describing the role played by women in the "horrible scenes" of the Draft Riots, as comparable to that found "in the Communistic outbreak in Paris." Though women were not yet enfranchised in either France or the United States, their entry into political life was, for Brace—among many others—a sure sign of breakdown.

In Europe, the specter of urban unrest was yielding similar predictions of an impending era that would be ruled by the wanton violence of inferior segments of society. Perhaps the most eloquent spokesman for this perspective was the French sociologist Gustave Le Bon. A close associate of Paul Broca, Le Bon transferred anthropology's judgments about lesser races into an analysis of a human menace that lurked in the streets of Paris. Propelled by memories of the Paris Commune, Le Bon, in 1895, released his book, *The Crowd: A Study of the Popular Mind*, which became an instant handbook for increasingly anxious upper and middle classes. It was translated into nineteen languages within one year of its appearance.

Le Bon described the world around him as one in which all customary systems of social control had broken down. Ideas of popular sovereignty, spurred by a democratic age, had dealt a deathblow to the venerable hierarchies of church and state that had shaped European history into the late eighteenth century. While the "outward front" of Old Europe was still visible, it was "in reality an edifice crumbling to ruin, which nothing supports, and is destined to fall in at the first storm." Democratic conceits, he complained, were breeding an environment in which "the populace is sovereign, and the tide of barbarism mounts."

> To-day . . . the voice of the masses has become preponderant. The destinies of nations are elaborated at present in the heart of the masses, and no longer in the councils of princes. The entry of the popular classes into political life . . . is one of the most striking characteristics of our epoch of transition. The masses are trying to destroy society as it currently exists.

Shocked by the invasion of the crowd—collectively and as a confederacy of voters—Le Bon set out to provide an anatomy lesson on the mental life of the masses. This disquisition, he believed, was necessary if statesmen were to have any hope of controlling the volatile energies of the multitude.

Le Bon's lament was not simply a rejection of democratic values. Democracy, he argued, was empowering sectors of society that bore the marks of biological degeneration. As Blumenbach had maintained that Ethiopians, Mongolians, Malay, and American Indians were the result of deterioration from the pure and pristine nature of the Caucasian race, Le Bon saw the urban masses as populated by degeneracy and "extreme mental inferiority." With their rise, he declared, Europe's "racial heritage is breaking down."[6]

Though claiming the rights of citizenship, the crowd "descends several rungs in the ladder of civilization."

The special characteristics of crowds . . . such as impulsiveness, irritability, incapacity to reason, absence of judgement and of critical spirit, the exaggeration of the sentiments . . . are almost always observed in beings belonging to inferior forms of evolution—in women, savages, and children, for instance. . . . [The crowd] acts . . . more under the influence of the spinal cord than the brain.7

Cesare Lombroso.
© BETTMANN/CORBIS

In the shadow of such speculations, Bertillon's ability to ferret out individuals, while useful, did not respond to a growing belief that criminality and degeneracy were endemic among the urban poor. While his system of measurements and photographic documentation was invented to isolate the individual from the group, a growing number of early criminologists supposed that from archives such as those assembled by Bertillon, science could begin to divine the general physiognomic characteristics of the criminal class. With such profiles in hand, they reasoned, crime could be predicted even before it caused injury to society.

A Promethean figure in the search for a "criminal type" was Cesare Lombroso. Born to a prosperous Jewish family in Verona in 1835, he would gain renown as the founder of the "Positive School of Criminology" which began to take shape in Italy during the years that Bertillon was formulating his system for criminal identification in Paris.

To some extent, the historian Mary Gibson argues, the genesis of Italian criminology was an outgrowth of upper- and middle-class social anxieties that were rampant in the period following the unification of Italy in 1871. Previously a fragmented agglomeration of diverse people, regions, and dialects, the new Italy, centered in Rome, appeared to many an uncontrollable entity. This sense, no doubt, was fueled by longstanding racial patterns, in which fair-skinned inhabitants of the wealthy north viewed the "swarthy" peasant population of the *mezzogiorno* (southern tier) as a lesser breed of people. With some trepidation, the newly formed nation brought all of these people under the common rubric of *l'Italiani*.

"Crime," real or imagined, became a growing topic of concern. The contours of the problem, as perceived in Italy, bring to mind the apprehensions expressed by middle-class Parisians, Londoners, and New Yorkers, who increasingly saw their own cities as being overtaken by strangers. Gibson explains:

The black forebodings of [Italian] criminal anthropologists could create a "moral panic" only in an era of fundamental social change, marked by an expanding and mobile population. The visibility of increasing numbers of outsiders—especially on city streets—gave residents a sense of being engulfed by the unknown. This was especially true of the nineteenth-century middle class whose culture rejected social life on doorsteps and in the piazza for more decorous family life within the home. It is not surprising that the growing and increasingly influential bourgeoisie of united Italy equated the contemporaneous explosion of population with an explosion in crime. The fact that the clothing, language, and manners of newcomers identified them as poor made them only more alien to members of the middle and upper classes.[8]

In this context, Lombroso's positivist school took issue with those who saw criminals as products of their moral environment. In England, for example, prevailing thought saw the criminal as "a normal man who has gone wrong." This outlook was consistent with the phrenology of the Fowlers and Welles, which analyzed human propensities as capable of either good or evil, depending upon circumstance.

In Italy and throughout much of Europe, however, Lombroso's theory "that the criminal is the abnormal man who cannot go right" quickly took hold as the predominant way of thinking. To Lombroso, whom the historian Henry T. F. Rhodes described as "one of the three greatest alienists who had ever lived,"

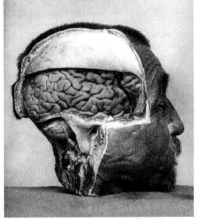

Lombroso's ideas about criminal types quickly spread. This photograph of a criminal's head and exposed brain was taken by police officials in Buenos Aires, 1890.

criminality was an objective, physiologically discernible condition, not unlike racial difference. "Lombroso claimed that criminals were an anthropological type, that a criminal could be recognized by the shape of his skull in exactly the same way that anthropologists differentiate the races of mankind by their mean cranial measurements."[9]

Ostensibly predicated on empirical scientific evidence, carefully gathered and presented with an unwavering certitude that only science, religion, and, at times, politics are capable of, Lombroso's perspective was tremendously persuasive to his followers. Lombroso's theories also drew from the still influential legacies of

240

Lavater and Gall. He was born into a world where physiognomy and phrenology had convinced many that a person's outward countenance—particularly the conformation of the head—provided a telltale map of the soul that resided within. Anthropometry, under the stewardship of Broca, had also left its mark, as did Camper's "facial angle." In short, prevailing theories of racial science and human inequality provided an intellectual foundation upon which Lombroso built the edifice of what became known as criminal anthropology.

Like many scientific theories, Lombroso's was founded on an often-repeated tale of epiphany. While serving as the doctor in charge at several insane asylums and prisons in the north of Italy, Lombroso happened upon a peculiar discovery in 1871, while performing an autopsy on a "famous brigand" named Giuseppe Vilella (sometimes spelled Villella). Lombroso had made the acquaintance of Vilella when the latter was an inmate, and the doctor was taken aback by the "cynical effrontery" of the boastful brigand. Upon the felon's death, it fell upon Lombroso to perform an autopsy. There, on the mortuary slab, Dr. Lombroso had a startling "revelation."[10] Vilella's skull and spinal cord, he surmised, bore marks that, as recounted by Gibson, "reminded Lombroso of an anatomical feature typical of some 'inferior races' in Bolivia and Peru as well as 'the lower types of apes, rodents, and birds.'"[11]

Lombroso's own account of the autopsy adds lurid drama to Gibson's summary.

> On his death one cold gray November morning, I was deputed to make the post-mortem, and on laying open the skull I found on the occipital part, exactly on the spot where a spine is found in the normal skull, a distinct depression which I named median occipital fossa, because of its situation precisely in the middle of the occiput as in inferior animals, especially rodents. This depression, as in the case of animals, was correlated with the hypertrophy of the vermis, known in birds as the middle cerebellum.
>
> At the sight of that skull, I seemed to see all of a sudden, lighted up as a vast plane under a flaming sky, the problem of the nature of the criminal—an atavistic being who reproduces in his person the ferocious instincts of primitive humanity and the inferior animals. Thus were explained anatomically the enormous jaws, high cheekbones, prominent superciliary arches, solitary lines in the palms, extreme size of the orbits, handle-shaped or sessile ears [without discernible lobes], found in criminals, savages, and apes, insensibility to

pain, extremely acute sight, tattooing, excessive idleness, love of orgies, and the irresistible craving for evil for its own sake, a desire not only to extinguish life in the victim, but to mutilate the corpse, tear its flesh, and drink its blood.[12]

Following this initial breakthrough, Lombroso feverishly studied and, whenever possible, dissected a succession of criminal bodies, elaborating further on his anatomy of evil. He routinely compared the bones of criminals with ethnographic specimens found in natural history collections, noting "the singular coincidence between the abnormalities found in criminal men and those observed in the normal skulls of the colored or inferior races." Criminals, he concluded, were "savages living in the middle of flourishing European civilization."[13]

While differing with Bertillon in his general approach to criminology, Lombroso was an admirer and made considerable use of the Frenchman's anthropometric tools and photographic techniques to add precision in his delineation of criminal physiognomy.[14] His first major work on the topic, *L'Uomo delinquente* [Criminal Man], which enjoyed five editions between 1876 and 1897, made heavy use of Bertillon's methods in laying a case for a diagnostic criminal type, which he termed "the born criminal."

This was a phrase borrowed from his disciple Enrico Ferri, who also encouraged Lombroso to acknowledge that some "normal" people were capable of committing criminal acts. These were defined as "occasional criminals" and "criminals by passion." Yet within Lombroso's forensic cosmology, these were the exceptions. For the most part, he saw criminal activity as the byproduct of innate atavism, something that could be detected through close physical examination.

> The criminal by nature has a feeble cranial capacity, a heavy and developed jaw, a large orbital capacity . . . an abnormal and asymmetrical cranium, a scanty beard or none, but abundant hair, projecting ears, frequently a crooked or flat nose.[15]

Other "anomalies exhibited by criminals" included "prehensile" feet, "cheek-pouches," "enormous development of the middle incisors . . . and angular or sugar-loaf form of the skull common to criminals and apes." There was also a "projection of the lower part of the face and jaws (prognathism) found in negroes and animals, and supernumerary teeth (amounting in some cases to a double row as in snakes) and cranial bones (. . . as in the Peruvian Indians)."[16]

242

"[T]hese characteristics," Lombroso asserted, "pointed to one conclusion, the atavistic origin of the criminal, who reproduces physical, psychic, and functional qualities of remote ancestors." Behavioral characteristics, he maintained, only affirmed this conclusion.

> The criminal by nature is lazy, debauched, cowardly, not susceptible
> to remorse, without foresight; fond of tattooing; his handwriting is
> peculiar, signature complicated and adorned with flourishes; his slang
> is widely diffused, abbreviated, and full of archaisms.[17]

This interest in language mirrors that of Henry Mayhew (*London Labor and The London Poor*) who cited the vernacular of costermongers as proof of an inferior intellect. While Mayhew had focused on the inversion of words among London's street people, Lombroso, interested in documenting atavism, asserted that there were inherent connections between criminal linguistics and the speech patterns of primitive peoples. Like Mayhew, Lombroso conceded that one function of slang was to "elude police investigations," yet the idiom's structural components yielded significant anthropological data as well.

> [Slang] is a peculiar jargon used by criminals when speaking among
> themselves. The syntax and grammatical construction of the language
> remain unchanged, but the meanings of words are altered, many
> being formed in the same way as in primitive languages; i.e., an object
> frequently receives the name of one of its attributes. Thus a kid is
> called "jumper," death "the lean or cruel one," the soul "the false or
> shameful one," the body "the veil," the hour "the swift one," the
> moon "the spy," a purse "the saint," alms "the rogue," a sermon "the
> tedious one," etc. Many words are formed as among savages, by ono-
> matopoeia, as "tuff" (pistol), "tic" (watch), "guanguana" (sweetheart),
> "fric frac" (lottery).

Like the criminal's spoken language, the handwriting, Lombroso argued, was also a mark of degeneracy. Peculiarly intricate and "adorned with flourishes," their highly ornamental penmanship, along with their tendency to decorate their bodies with tattoos, provided another objective link between the ethnography of criminals and primitives. To a modern man of letters such as Lombroso, whose faith in austere truths was unwavering, such unrestrained ornamentation was diagnosed as a vestige of atavism.

In his analysis of handwriting and tattooing, Lombroso was citing but two examples of what he saw as criminals' innate tendency to think and speak in pictures. Like preliterate people, the criminal was most at ease when communicating by symbols.

> One of the strangest characteristics of criminals is the tendency to express their ideas pictorially. . . . Books, crockery, guns, all the utensils criminals have in constant use serve as a canvas on which to portray their exploits. From pictography it was but an easy step to hieroglyphics like those used by ancient peoples. The hieroglyphics of criminals are closely aligned to their slang, of which in fact they are only a pictorial representation, and, although largely inspired by the necessity for secrecy, show, in addition, evident atavistic tendencies.

Like Mayhew's glossary of costermonger slang, Lombroso offered a taxonomy of some representative criminal symbology.

> For instance, to indicate the President of the Tribunal, they use a crown with three points; to indicate a judge, the judge's cap. . . .
> Police Inspector—a hat like those worn by the Italian soldiers who are called Alpini (a helmet with flat top and an upright feather on the left side).
> Public Prosecutor—an open-mouthed viper.
> Carabineer—a bugle.
> Theft—a skull and crossbones.
> Commissary of the Police—a dwarf with the three-cornered hat worn by the carabinieri.[18]

To Lombroso, tattoos extended the penchant for primeval pictorialism to the criminal's own skin.

> This personal decoration so often found on great criminals is one of the strangest relics of a former state. It consists of designs, hieroglyphics, and words punctured in the skin by a special and very painful process.
> Among primitive peoples, who live in a more or less nude condition, tattooing takes the place of decorations or ornamental garments, and serves as a mark of distinction or rank. When an Eskimo slays an enemy, he adorns his upper lip with a couple of blue stripes, and the warriors of Sumatra add a special sign to their decorations for every foe they kill. . . .

Among the Maoris, tattooing is a species of armorial bearings indicative of noble birth . . .

In modern times this custom has fallen into disuse among the higher classes and only exists among sailors, soldiers, peasants, and workmen.

Although not exclusively confined to criminals, tattooing is practiced by them to a far larger extent than by normal persons. . . . Recidivists and born criminals, whether thieves or murderers, show the highest percentage of tattooing. Forgers and swindlers are rarely tattooed.

Another fact worthy of mention is the extent to which criminals are tattooed. Thirty-five out of 378 criminals examined by Lacassagne were decorated, literally, from head to foot.

In a great many cases, the designs reveal violence of character and a desire for revenge. A Piedmontese sailor, who had perpetrated fraud and murder from motives of revenge, bore on his breast between two daggers, the words: "I swear to revenge myself." Another had written on his forehead, "Death to the middle classes," with a drawing of a dagger underneath. A young Ligurian, the leader of a mutiny in an Italian Reformatory, was tattooed with designs representing all the most important episodes of his life, and the idea of revenge was paramount. On his right forearm figured two crossed swords, underneath them the initials M. N. (of an intimate friend), and on the inner side, traced longitudinally, the motto: "Death to cowards, Long live our alliance."

Alongside his detailed description of criminal self-decoration, Lombroso also noted a tendency among malefactors to leave their mark on others. Lovers were routinely branded on the face, "not from motives of revenge, but as a sign of proprietorship, like the chiefs of savage tribes who mark their wives and other belongings."[19]

Today such judgments may sound bizarre, particularly at a time when tattooing has become de rigueur among young professionals, creatives, and people of business. Yet in Lombroso's time, when social distinction was often measured by the yardstick of literacy, a person's inclination to think and communicate in pictures, rather than in paragraphs, was accepted—especially among middle-class writers—as an inherent sign of degeneracy.

In Le Bon's study of the popular mind, for example, he asserted that the "crowd thinks in images." This primitive tendency, he maintained, was a mark

of irrationality, of people "perpetually hovering on the borderland of uncon-sciousness," impervious to logic.

In the fields of architecture and design, where the early rumblings of mod-ernism were being felt, Lombroso's ideas were clearly in the air. Ornamentalism was routinely cited as a deleterious remnant of an archaic past, something to be expunged forthwith. In his 1908 manifesto, "Ornament and Crime," for exam-ple, the famed Austrian architect Adolf Loos announced a direct correlation between criminality, primitivism, and unnecessary decoration.

While acknowledging that among the Papuans of New Guinea the "urge to ornament one's face and everything within reach" was in keeping with their pre-civilized state, Loos insisted that in the higher civilization of Europe such prac-tices existed only at the dark margins. "The modern man who tattoos himself is either a criminal or a degenerate," he argued. "There are prisons in which eighty percent of the inmates show tattoos. The tattooed who are not in prison are latent criminals . . ." From this formulation, Loos derived a "radical aesthetic purism" which stood at the heart of his architectural and design philosophy.

> What is natural to the Papuan and the child is a symptom of degener-acy in the modern adult. I have made the following discovery and I pass it on to the world: The evolution of culture is synonymous with the removal of ornament from utilitarian objects.[20]

Lombroso and his positivist disciples made names for themselves by detailing the physiognomy, language, and aesthetic proclivities of criminal men. By the 1890s, however, their work extended to an examination of women generally and of female criminality in particular. In pivotal ways, the work on women was dif-ferent from that which addressed masculine crime. If the analysis of "criminal man" was predicated on the notion that the "normal" European male was an advanced and civilized type of individual, work on the "female offender" assumed that women, as a sex, constituted an inferior subspecies within the human race.

Despite an articulate and widespread movement for women's equality, Lom-broso drew upon chauvinistic assumptions that had justified female oppression for millennia. He threw around numbers and performed numerous experiments that codified and reiterated threadbare ideas of female inferiority. Women's penchant for hysteria, he asserted, was far greater than men's, by a ratio of "twenty to one."[21] Using anthropometric tools, he systematically documented the relative brain weights and skull sizes of male and female subjects, positing that women's heads and brains were smaller and, therefore, substandard.

Unwilling to grant the possibility of patriarchal aggression, he decried women's tendency to slander their fathers, brothers, doctors, and priests with accusations of "indecent behavior" as but one more indication of their defective characters.[22]

He also pointed to the absence of women among the great thinkers of European culture. As he encountered exceptions, he dismissed them as degenerates, people who occupied a sexual middle ground between male and female. Such women were rejected as lacking in true female characteristics. George Sand, George Eliot, and Madame de Staël, important nineteenth-century literary figures, were libeled by name, set apart from their gender because of large "masculine" heads, coarse features, "unkempt" appearance, and overall ugliness. While the great feminist author of *A Vindication of the Rights of Woman*, Mary Wollstonecraft, did not conform to such defamatory physical categorizations, Lombroso explained her away as "the daughter of a moral idiot and a maniac."[23]

In *L'Uomo delinquente*, Lombroso maintained that criminals routinely exhibited a high threshold of pain matched up against normal men. Comparative experiments that he did on men and women, using electrical shocks applied to the hands, faces, tongues, breasts, and even genitalia, ascribed relative insensitivity to pain as an inborn quality of the "weaker sex" overall. Because for Lombroso, high pain sensitivity was a marker of "cerebral evolution," he maintained that females, like male criminals, comprised a lower form of development.

Moving on from these initial studies of the "normal woman," Lombroso, with the assistance of his disciple and future son-in-law, Giuglielmo (William) Ferrero, published *The Female Offender* in 1893. It quickly gained international attention; by 1895, translations had appeared in Germany, France, England, and the United States. (*The Female Offender* was one of the first of Lombroso's books to come out in English. A Putnam edition of *Criminal Man According to the Classification of Cesare Lombroso* did not appear until 1911, as a summary translation of Lombroso's book by his daughter, Gina Lombroso-Ferrero. A full English translation has never been published.)

Beginning with the assumption that in "female animals, in aboriginal women, and in the women of our time, the cerebral cortex, particularly in the psychical centers, is less active than in the male," Lombroso's book focused primarily on the hitherto invisible subject of female criminals. For the most part, Lombroso conceded that criminality was far less frequent among women than men and that even women who commit crimes tend to be "less essentially criminal" than their male counterparts.[24] Among women, he

believed, "occasional" rather than "born" delinquency was the norm. Yet "when depravity in woman is profound," as in those who commit murder, poison, arson, and infanticide, among other offenses, the physical signs of the criminal type were also present.

In women, Lombroso argued, this "brand of criminality" was not always immediately evident. For a time, he wrote, the comeliness of adolescent beauty could serve as a disguise behind which inborn evil hid. In young women, a superficial attractiveness sometimes covered the stigmata of degeneration that were more easily diagnosed among male offenders.

Time, however, would prove the undoing of such camouflage. With age, he argued, the soft contours of tender flesh gave way to reveal harsh masculine characteristics. "And when youth vanishes, the jaws, the cheek-bones, hidden by adipose tissue, emerge, salient angles stand out and the face grows virile, uglier than a man's; wrinkles deepen into the likeness of scars, and the countenance, once attractive, exhibits the full degenerate type which early grace had concealed."[25]

Lombroso's definition of female crime included a wide range of offenses. Yet his most virulent judgement was reserved for women who, he wrote, were not generally understood to be criminals: prostitutes.

In prehistoric times, he maintained, crime was rare among women. Yet "the woman of pleasure," he continued, was already peddling her wares. "The primitive woman was rarely a murderess; but she was always a prostitute." This primeval type of womanhood, he argued, was even more evident among prostitutes than among female criminals.

> The female criminal is a kind of occasional delinquent, presenting few
> characteristics of degeneration, little dulness, &c, but tending to multi-
> ply in proportion to her opportunities for evil-doing; while the prosti-
> tute has a greater atavistic resemblance to her primitive ancestress, the
> woman of pleasure, and . . . has consequently a greater dulness of touch
> and taste, a greater propensity for tattooing, and so on.[26]

While incorrigible woman criminals betrayed, over time, an atavistic physiognomy, most of Lombroso's "female offenders" bore the traits of a modern women and were drawn towards crime by circumstance. Among prostitutes, however, atavism was their essence. Noting that among the "primitive" races, women were physically stronger and more precocious than their civilized counterparts, Lombroso found that the prostitutes he studied embodied similar traits.

248

In order to understand the significance and the atavistic origin of this anomaly, we have only to remember that virility was one of the special features of the savage women. In proof I have but to refer the reader . . . to the portraits of Red Indian and Negro beauties whom it is difficult to recognize for women, so huge are their jaws and cheekbones, so hard and coarse their features. . . .

The [male] criminal being only a reversion to the primitive type of his species, the female criminal [here referring to the prostitute] necessarily offers the two most salient characteristics of primordial woman, namely precocity and a minor degree of differentiation from the male—this lesser differentiation manifesting itself in the stature, cranium, brain, and in the muscular strength which she possesses to a degree so far in advance of the modern female.[27]

Alongside masculine features, the prostitute was remarkable for her unusually small cranial capacity and for a tendency towards obesity. This latter characteristic, Lombroso noted, paralleled traits commonly found among "Hottentot, African, and Abyssinian women."[28]

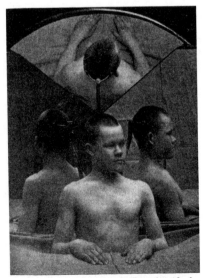

Prisoner being photographed to identify the "stigmata of degeneration," Elmira. REPRINTED FROM HAVELOCK ELLIS'S, *THE CRIMINAL* (1910 EDITION); FROM THE COLLECTION OF THE EWEN LIBRARY

In his day, Lombroso's theories made him one of Europe's most influential public intellectuals. Luminaries, including Max Weber, Gaetano Mosca, Robert Michels, Max Nordau, and others, flocked to his home, savoring audiences with the man considered a founding father of modern psychiatry. Nordau, whose 1892 book, *Degeneration*, assailed the decadence plaguing fin-de-siècle European art and literature, dedicated his dim prognosis for the future to his "Dear and Honoured Master," Lombroso.[29]

The author of over thirty books, Lombroso also gained a popular following among visitors to the Museum of Criminal Anthropology, which he established in Turin, and attendees of one of the many public presentations he made at expositions that he held. Among intellectuals and middle-class Europeans, Lombroso had become a celebrity.[30]

In the United States, prison reformers made practical application of Lombroso's work early on. By the mid-1880s, at the recently opened New York State 249 Reformatory at Elmira, detailed physiognomic studies were performed on all inmates. Using photography and anthropometric tools, the prison management

Outstanding Ears (Elmira).

"Signs of criminality," Elmira.
REPRINTED FROM HAVELOCK ELLIS'S,
THE CRIMINAL (1910 EDITION); FROM THE
COLLECTION OF THE EWEN LIBRARY

A GROUP OF DULLARDS (ELMIRA).

A GROUP OF SEXUAL PERVERTS (ELMIRA).

250

minutely recorded the population's physical traits, classifying the men into subgroups. Under the leadership of Superintendent Zebulon Reed Brockway and Hamilton D. Wey, the reformatory physician, a systematic catalog of "biological criminals" was assembled in order to separate those capable of being reformed from those who were inveterate criminals. Measurements of physical features (ears, noses, chins, etc.) were taken, along with photographs isolating innate perverts and dullards from inmates of a more intelligent and redeemable variety. Under the influence of Lombroso, Brockway and Wey themselves became well known for their anthropological contributions to penology, their ability to identify those for whom no amount of reeducation or prison discipline could improve a fundamentally defective nature.[31]

Alongside such practical applications, a growing scientific literature in the United States also disseminated Lombrosian ideas. Arthur MacDonald, a nationally prominent educator, published a book entitled *Criminology* in 1893.[32] Having heard Lombroso lecture in Europe, MacDonald was the first to delineate criminal anthropology for a general audience in the United States. He dedicated his book to the great Italian psychiatrist, who returned the favor with an "Introduction." Seven years later, August Drahms, Protestant minister to the inmates at San Quentin, published a major contribution to the literature, *The Criminal: His Personnel & Environment*. The book, which enlarged Lombroso's imprint on American criminology, also included an introduction by his eminence.[33] Lombroso's influence was growing. By 1904, G. Frank Lydston, a distinguished physician, professor, and author, published *The Diseases of Society*, a book that reiterated Lombroso's perspectives on atavism and criminality and brought his ideas into the canon of American medical science.[34]

Yet, in spite of his influence on criminology, Lombroso's gaze reached beyond offenders as conventionally understood. Seeking to illuminate other realms of society, the diagnosis of atavism was also applied to the world of arts and letters. The stigmata of degeneracy, he insisted, were found not only among prison populations. Many of his same conclusions were applied to celebrated artists and writers. Intellectual and creative gifts were found in tandem with "moral insanity."[35] Lombroso's 1888 study, *The Man of Genius*, offered a disapproving analysis of the intellectual pantheon.

While most celebrated genius as the high point of civilization, Lombroso viewed the Olympians of Western culture through a glass darkly. "Just as giants pay a heavy ransom for their stature in sterility and relative muscular and mental weakness," he intoned, "so the giants of thought expiate their intellectual force in degeneration and psychoses." Repudiating customary adulation, Lombroso

coolly observed "that the signs of degeneration are found more frequently in men of genius than even in the insane."36

Citing shortness of stature, "delayed development," "cranial asymmetry," "lefthandedness," and "cretin-like physiognomy" as sure indices of degeneration, he undertook a "sad mission to cut through and destroy with the scissors of analysis the delicate and iridescent veils" that cloaked the man of genius, from which few could escape. Among his scientifically verified degenerates and madmen he included Socrates, Plato, Aristotle, Alexander the Great, Erasmus, Spinoza, Mozart, Beethoven, Rembrandt, Balzac, Schopenhauer, Dostoyevsky, and, ironically, Charles Darwin, the pioneer of evolutionary theory.

Gustave Le Bon, Lombroso reported, had done anthropometric studies of the skulls of French luminaries—including Descartes—and found them larger than average, but Lombroso noted that many celebrated geniuses had either small brains or brain anomalies. Among these were Jean Jacques Rousseau, Pascal, Immanuel Kant, Shelley, and even Baron Cuvier, whose famously voluminous brain was "affected by dropsy."37

Corresponding with such physiognomic data was a litany of mental and behavioral perversions. Among these, he included an inborn tendency for "melancholy," abuse of drugs and alcohol, hallucinations, and both "emotional anæsthesia" and hedonism.38 Rousseau was a "monomaniac" who was "dominated by his senses." Schopenhauer was "genuinely hypochondriacal," believed in "table-turning" and—while hating women and Jews—remembered dogs "in his will." Gogol "gave himself up for many years to unrestrained onanism."39 These personal morsels were offered not as idiosyncrasies, but as common expressions of the genius type.

Among "poets and artists," Lombroso added, "criminality is, unfortunately, well marked."40 So, too, was insanity. His analysis of Charles Baudelaire, in this regard, was unrelenting.

> He was descended from a family of insane and eccentric persons. It was not necessary to be an alienist to detect his insanity. In childhood he was subject to hallucinations; and from that period, as he himself confessed, he experienced opposing sentiments; the horror and the ecstasy of life; he was hyperaesthetic and at the same time apathetic; he felt the necessity of freeing himself from "an oasis of horror in a desert of ennui."
>
> [. . .] He desired to be original at all costs; gave himself to excess in wine before high personages, died his hair green, wore winter garments in summer and vice versa. He experienced morbid passions in love. He

loved ugly and horrible women, negresses, dwarfs, giantesses; to a very beautiful woman he expressed a desire that he might see her suspended by the hands to the ceiling that he might kiss her feet; and kissing the naked foot appears in one of his poems as the equivalent of the sexual act.[41]

If Baudelaire and others offered Lombroso shocking and sensational biographies for analysis, some men of genius did not. Their madness was masked by a veneer of ordinariness, their "features and cranial form . . . almost always normal." These people Lombroso called "Mattoids," an umbrella term for those who were often appealing but who, under the surface, were "semi-insane persons." Such people could be found among artists and writers, but Lombroso also included religious and political agitators within this typology. Due to their Mattoid sensibilities, they were able to observe and understand events that might pass by the minds of ordinary people and, by pointing out these events and explaining them vividly, they appeared prophetic. Charismatic leaders were often members of this group, visionaries whose madness spoke to the needs of ordinary people. Among this type, Lombroso included Martin Luther.[42]

Advocates of popular democracy and social revolution were also Mattoids, people whose particular vision was shaped by an obsession for self-sacrifice. Among this group were people who threatened the "destiny of nations."

> Their greater intellectual power, the depth and tenacity of their convictions, and the very excess of altruism which compels them to occupy themselves with public affairs, render them more dangerous, and more inclined to rebellion and regicide, than other insane persons.[43]

If Cesare Lombroso's most enduring contribution to scientific thought was his systematic portrayal of criminal types, his anthropologies of the evil genius, the intellectual weakling, the irrational woman, the feral prostitute, and the seductive but treacherous rebel demonstrated that his vision of society overall was driven by a search for generic human typologies. If particular physiognomies, and their corresponding behavioral tendencies, could mark who was likely to commit a crime, Lombroso also refined a worldview that assumed that the taxonomy of good and evil, more generally, could be codified with precision. This, he proclaimed to some critics in Geneva, was his great contribution. "What do I care whether others are with me or against me? I believe in the type. It is my type; I discovered it; I believe in it and I always shall."[44]

Despite the persistence of criticisms, by 1900, Lombroso's theories had become
accepted science. In this arena, they endured, remarkably, well into the twenti-
eth century. To fully appreciate the impact of his way of thinking, however, one
must look beyond the annals of social, biological, and behavioral science. In his
vivid, sometimes lurid, descriptions of criminal atavism, of evil genius, of capti-
vating leadership, Lombroso produced an innovative fusion of stereotypes that
was being disseminated on an international scale. It included physiognomic and
phrenological ideas that had been brewing for more than a century. It drew upon
insights found in Mayhew's discussion of language as an indicator of social dif-
ference. Lombroso also looked to aesthetics and style as gauges of respectability
or turpitude. This mix of physiognomy, speech, and personal ornamentation,
which had long been an element of live theatrical performance, provided uncom-
plicated close-up formulas that—with the inventions of motion pictures, mass
magazines, tabloid newspapers, sound recording, and radio—would flourish in a
transnational mass entertainment culture which needed to define, for audiences
from differing backgrounds, the contours of character as quickly and simply as pos-
sible. In a modern, mass-mediated culture, typecasting would become a lingua
franca, a way of presenting easily identifiable human types while demanding a
minimum effort on the part of spectators, readers, or listeners.

PART IV

NORDIC NIGHTMARES

20

THE AMAZING RACE

In 1890 Havelock Ellis, a thirty-one-year-old physician, walked away from his medical practice to enter England's inner circle of socialist intellectuals and writers, which included George Bernard Shaw, Edward Carpenter, and Olive Schreiner. A radical sexual reformer who championed women's rights, homosexuality, masturbation, and sex education, Ellis gained fame as a controversial pioneer in the study of human sexuality. His renown grew in the wake of his *Studies in the Psychology of Sex* (six volumes, published between 1897 and 1910), and other writings that challenged the edifice of Victorian morality.

Yet, beyond his heretical sexual views, Ellis had a number of other interests. One of these found expression in a book originally published in 1890, entitled *The Criminal*. The objective of this volume was to bring the new science of criminal anthropology to the attention of a British readership. On the Continent, the work of Cesare Lombroso and his disciples was widely known and already influential. England, on the other hand, had been virtually unaffected by the Italian school. Ellis sought to change this. "This little book," he opened the preface to the first edition, "is an attempt to present to the English reader a critical summary of the results of the science now commonly called criminal anthropology."

> During the last fifteen years these studies have been carried on with great activity. . . . In these matters we in England have of recent years fallen far behind; no book, scarcely a solitary magazine article, dealing with this matter has appeared among us. It seemed worth while to arouse interest in problems which are of personal concern to every citizen, problems which are indeed the concern of every person who cares about the reasonable organization of social life.[1]

The book served its purpose well. Not only did it popularize Lombroso's theories in Britain, but, more than any other book, it gave life to the field of criminal anthropology in the United States. In both countries it sold well and went through numerous printings and editions.[2]

In lurid detail, Ellis laid out the categories of criminality: the "political criminal," the "criminal by passion," the "insane criminal," the "occasional criminal," the "habitual criminal," and—in reference to Lombroso's "born" or "congenital" type—the "instinctive criminal." He also addressed the causes of crime.

Prior to 1890, British thinking on the source of criminal behavior had primarily focused on social or environmental conditions. These, Ellis willingly acknowledged. "It is impossible to over-estimate the importance of the social factor in crime." Yet a singular emphasis on sociological factors, he implored, was insufficient.

> [W]e cannot deal wisely with the social factor of crime, nor estimate the vast importance of social influences in the production or prevention of crime, unless we know something of the biology of crime, of the criminal's anatomical, physiological, and psychological nature.[3]

Ellis paid tribute to Charles Darwin, who, he maintained, had provided the scientific basis for such studies. Evolution was not simply a process marking the progressive development of species through a process of "favorable variations." As new and improved species evolved, traces remained of those individuals less fit to meet the struggle for survival. These "atavistic" residues, defined by peculiar anatomical and behavioral stigmata, provided a foundation for the theory of innate criminality.

> Darwin's Origin of Species, published in 1859, supplied for the first time, and furnished that atavistic key . . . These circumstances combined to render possible, for the first time, the complete scientific treatment of the criminal man as a human variety.[4]

Recounting the history that brought criminal anthropology into being, Ellis paid lavish tribute to Della Porta, Lavater, Gall, Broca, and Lombroso as innovators in the discovery and identification of human typologies.[5] From there, he proceeded to delineate the peculiar physical and psychological characteristics found among the criminally born. Conformation of the ears, face, and skull, as well as pallor, features of hair and eyes, sexual organs, and other physical charcteristics, he argued, offered diagnostic signs of inherent delinquency. Ellis added that these signs could often be found among "savage" races of people deemed inferior by the assumptions of natural history.

Like Lavater more than a century earlier, Ellis asserted an irrefutable corre-
spondence between aesthetics and moral worth. "Beautiful faces, it is well known,
are rarely found among criminals. The prejudice against the ugly and also against
the deformed is not without sound foundation."[6]

Following Lombroso's lead, Ellis also enumerated a number of behavioral
characteristics that marked the instinctive offender. The use of slang, tattooing,
a "deficient sensibility . . . to pain," the "inability to blush," he contended, all
separated born criminals from more evolved members of the population.[7]

In citing chapter and verse from Lombroso and other criminal anthropolo-
gists, the first edition of *The Criminal* was primarily a review of existing literature.
"There is," Ellis humbly acknowledged, "nothing original in this book."[8]

In his conclusion, however, he strayed from an English faith in conventional
education as a preventative social measure against crime. Cultivation of the mind
alone was not enough. Schooling must be "as much physical and moral as intel-
lectual, an education that enables him who has it to play a fair part in social life."

Yet, given his belief in prenatal criminality, Ellis advised that schools must
also develop and employ mechanisms for detecting "refractory and abnormal
children at the earliest period, to examine them carefully, and to ensure that each
shall have the treatment best adapted to him." In the first edition of *The Crimi-
nal*, this call for treatment was vague and tentative, filled with homilies on the need
to "quicken the social and individual conscience," and about procreation as "the
highest of human functions . . . which carries the most widespread and incalcu-
lable consequences." Yet there he stopped. "This is not the place," he wrote, "to
develop these various consequences which flow from our consideration of the
nature and treatment of the criminal."

By 1912, however, when the fourth edition of *The Criminal* appeared, this
tentativeness had subsided. Earlier versions of the book had included some pic-
tures, but this "revised and enlarged" edition was heavily illustrated with pho-
tographs—many taken at the reformatory at Elmira—offering visible evidence of
atavistic traits. In his introduction to the new edition, Ellis had become something
of a crusader. If criminal behavior was an inborn trait, he reasoned, those indi-
viduals who were "unfit to become the parents of a fine race" should "abstain
from procreation." Employing the words of Jesus as quoted in the book of
Matthew (19:12), Ellis urged that such people should become "'eunuchs for the
Kingdom of God's sake.'" Given the difficulties facing the enforcement of vol-
untary abstinence in the bedroom or the alley, however, he suggested that
stronger measures might be called for.

Personally I have in the past been definitely opposed to castration for this end. I am, indeed, still opposed to actual castration, especially if compulsory; there are serious objections to it. But sterilisation coming short of actual castration can now easily be performed in either sex . . .

Medical intervention, Ellis proposed, might be systematically employed to terminate the perpetuation of congenital criminal behavior. Behind this conviction lay the widely heralded arrival of a scientific enterprise known as eugenics. Through eugenics, Lombroso's vision of inborn criminality would move far beyond prison walls and police stations and take flight as an aggressive and far-reaching social project. If Marx supposed that the lower strata of society were destined to inherit the future, eugenicists saw the lower orders as filled with degeneracy and promoted biological engineering as a tool for preventing "the deterioration of the race." Even some who traveled in middle- and upper-class socialist circles were drawn to this idea as a rational instrument for social improvement.

In Ellis's introduction to the 1912 edition of *The Criminal*, he favorably noted the founding, in 1908, of the Eugenics Education Society in England, and cited its journal, *The Eugenics Review*. Also in 1912, Ellis published *The Task of Social Hygiene*, which matured the development of his emerging train of thought. It was imperative, he wrote, to cleanse society not only of its born criminals but of the "moral imbeciles" who proliferated among the lower classes: inebriates, tramps, mental defectives, prostitutes, and the unemployed.

The task of Social Hygiene which lies before us cannot be attempted by this feeble folk. Not only can they not share it, but they impede it; their clumsy hands are forever becoming entangled in the delicate mechanism of our modern civilization. Their very existence is itself an impediment.[9]

The roots of the eugenics movement can be traced to a man we have already encountered: the inventor of composite portraiture, Sir Francis Galton, scion of one of England's most distinguished families, a man prominent in science, letters, and industry. His maternal grandfather, Erasmus Darwin (1731–1802), was a Fellow of the Royal Society, a towering figure in British medicine and an influential naturalist and botanist. He translated Linnaeus's *Genera plantarum* into English and his *Zoonomia*, or *The Laws of Organic Life*, offered one of first

recognized theories of evolution. He was also a widely read poet, whose verse fantasized about the emotional and sensual lives of plants. In 1802, the year of his death, he penned a poem, "The Temple of Nature," which presented some of his ideas on evolution.[10]

> Organic life beneath the shoreless waves
> Was born and nurs'd in ocean's pearly caves;
> First forms minute, unseen by spheric glass,
> Move on the mud, or pierce the watery mass;
> These, as successive generations bloom,
> New powers acquire and larger limbs assume;
> Whence countless groups of vegetation spring,
> And breathing realms of fin and feet and wing.

Erasmus married twice, fathering twelve children. His first marriage, to Mary Howard, led to the birth of Robert Darwin, who would himself become a Fellow of the Royal Society, a leading physician and, in 1809, the father of Charles Darwin. Charles's mother, Susanna Wedgwood, was the daughter of Josiah Wedgwood, who pioneered the industrialization of pottery making and developed a world famous porcelain line that still bears his name.

His second marriage, to Elizabeth Pole, produced Violetta Darwin who, in 1822, gave birth to Charles Darwin's cousin, Francis Galton. Galton's father, Samuel Tertius Galton, despite his Quaker lineage, became wealthy as a banker and a dealer in armaments. Francis Galton would, in time, inherit a large portion of Tertius's vast fortune.

As a young man, Galton floundered around in search of a calling. At sixteen, his parents launched an educational plan for him that, they hoped, would lead to a career in medicine, an esteemed family trade. While a student at Trinity College, Cambridge, Galton deserted medicine and threw himself into the study of mathematics. Then, at eighteen, possessed by wanderlust, and subsidized by his family's wealth, Galton embraced the vocation of world traveler. "In the spring of 1840," he wrote, "a passion of travel seized me as if I had been a migratory bird. While attending lectures at King's College I could see the sails of the lighters moving in sunshine on the Thames, and it required all my efforts to disregard the associations of travel which they aroused."[11]

Thus began a ten-year period of travel that took him throughout Europe to the slave markets of Constantinople, where he was fascinated by Circassian beauties offered for sale as servants or concubines. Galton wrote his father that he

262

was so entranced by one young woman that he considered purchasing her for himself.[12] He also visited Khartoum, Alexandria, Damascus, Jericho, and Jerusalem. In Syria, he encountered another slave market and commented that the African girls being sold there seemed particularly pleased by their impending future as human chattels. "The girls were delighted to talk to us of place known to them as well as ourselves. They seemed as merry as possible at the prospect of being sold and of soon finding, each of them, a master and a home."[13]

For Galton, like many wealthy young Englishmen of his day, travel offered an opportunity to visit "barbarous" lands and to offer broad, if unfounded, generalizations regarding the people he encountered. Nowhere did this become more evident than on his two-year exploration of South Africa that began in April 1850. What started as a trip intended for sightseeing and big-game hunting, soon became an opportunity for Galton to fixate on the peoples he encountered. Though untrained in the field, this wealthy traveler assumed the mantle of an ethnologist. Rendering snap judgments on the deficiencies of black Africans, he commenced what would become a lifelong obsession, seeking to substantiate the natural inequality of human beings according to race, class, and bloodline.

Galton's South African travels were recounted in his first book, *Tropical South Africa*, published in 1853. Initiating his reputation as a man of science, the book rendered familiar verdicts on the natural propensities of natives in the region. Describing the Damaras, a Khoisan-speaking Bantu people living in southwest Africa (today Namibia), for example, Galton—ignorant of their history as cultivators of land, keepers of herds, with proficiency in mining and metal work—declared them completely devoid of the capacity for self-reliance.

> These savages court slavery. You engage one of them as a servant, and you find that he considers himself as your property, and that you are, in fact, become the owner of a slave. They have no independence about them, generally speaking, but follow a master as a spaniel would. Their hero-worship is directed to people who have wit and strength enough to ill-use them. Revenge is a very transient passion in their character; it gives way to admiration of the oppressor. The Damaras seem to me to love nothing; the only strong feelings they possess, which are not utterly gross and sensual, are those of admiration and fear. They seem to be made for slavery, and naturally fall into its ways.[14]

Echoing the sentiments of Samuel Morton and George Combe, Galton placed responsibility for slavery directly on the shoulders of its victims. Slavery was not an institution of conquest, but a destiny shaped by human difference.

In South Africa, Galton also began toying with anthropometry to secure measurements that would afford numerical authority to his observations. Versed in mathematics, and knowledgeable in the use of the sextant, Galton developed a cunning technique for taking human measurements from afar, doing away with the need to enlist the cooperation of his subjects. He described in detail his strategy for determining the buttocks size of a Damara woman he termed "a Venus among Hottentots."

> I was perfectly aghast at her development and made inquiries upon that delicate point as far as I dared among my missionary friends. . . . [The] object of my admiration stood under a tree, and was turning herself about to all points of the compass, as ladies who wish to be admired usually do. . . . [I] recorded a series of observations upon her figure in every direction, up and down, crossways, diagonally, and so forth, and I registered them carefully upon an outline drawing for fear of any mistake; this being done I boldly pulled out my measuring tape and measured the distance from where I was to the place where she stood, and having thus obtained both base and angles, I worked out the results by trigonometry and logarithms.

Years later, Galton recalled that his low evaluation of "Negro" intelligence was initially inspired by his South African journey.

> Let us then compare the Negro race with the Anglo-Saxon, with respect to those qualities alone which are capable of producing judges, statesmen, commanders, men of literature and science, poets, artists, and divines. . . . The number among the negroes of those whom we call half-witted men is very large. Every book alluding to negro servants in America is full of instances. I was myself much impressed by this fact during my travels in Africa. The mistakes the negroes made in their own matters were so childish, stupid, and simpleton-like, as frequently to make me ashamed of my own species.[15]

Following his African expedition, Galton began to direct his attentions to his British homeland. While vast chasms might divide the "Anglo-Saxon" from the

"Negro race," he was convinced that Anglo-Saxon society itself was in jeopardy, threatened by the "natural" inequalities that determined the mental and moral traits of each social class. In the face of a ballooning lower-class population, he believed, a deterioration of the British race was under way.

To a large extent, Galton's ideas regarding inherent human inequality were fortified in 1859 with the publication of his cousin's *Origin of Species*. "It made a marked epoch in my mental development, as it did in human thought generally," he reflected in his 1908 memoirs.[16] While Darwin focused on the evolutionary survival of "favored races in the struggle for life," Galton was appalled by the perpetuation of unfavored members of the human species, who took all too long to fade away by the interminable workings of natural selection. If superior, average, and inferior sectors of humanity could be identified, Galton mused, the survival of the fittest might be achieved by swifter means.

The first task at hand was to develop tools for distinguishing the fit from the unfit. The idea of heredity, central to Darwin's theory, offered Galton a place to begin. Ten years after Darwin's *Origin*, his cousin Francis published *Hereditary Genius: An Inquiry Into its Laws and Consequences*. In this book, he sought to demonstrate that genius was something carried from generation to generation by hereditary means through family lineage. Studying records of families noted for their reputation among contemporaries and subsequent generations, also marked by "qualities of intellect and disposition, which urge and qualify a man to perform acts that lead to reputation," Galton noted that among remarkable men in statesmanship, military leadership, religion, and science and the arts, pedigree was the decisive factor. Genius was not a matter of chance, but something innate to certain lineages. While he assembled family trees to demonstrate the ancestry of genius, he also employed anthropometric and statistical data that established genius as a measurable and objectively defined quality.

Galton was, by instinct, a bean counter. As a young man, he amused himself by observing and categorizing the people around him. Walking through cities in the British Isles, he performed informal studies of beauty among the women he "passed in streets or elsewhere," ranking them according to three classifications: "attractive, indifferent or repellent." Keeping daily records of this "beauty data," using a crude punch-card system, Galton concluded that London housed the most beautiful women, while Aberdeen was a Mecca for homeliness.[17]

Sitting in on lectures at the Royal Geographical Society, Galton fought the dullness of these events by developing a system for measuring the degree of bore-

dom experienced by audience members. Counting "the number of their fidgets" and yawns as indices of tedium, Galton's penchant for gathering statistical data found a playful outlet, even in august gatherings. Galton's personal motto, repeatedly expressed throughout his life, was: "Whenever you can, count."[18]

By the time he wrote *Hereditary Genius*, Galton possessed a compulsion to count that was educated by the field of statistical science, founded by Quetelet. Through measurement, he believed, he could determine statistical averages that would encapsulate the essential qualities of a given sector of the population.

Galton's book on genius attempted to quantify and categorize men according to reputation and natural ability. Beginning with measures of height, he used a chart to demonstrate that the majority of the population gravitates toward an average measurement, between 5' 2" and 5' 10". A far smaller number occupies the realm of elevated stature, considered a mark of nobility. Galton himself stood at over six feet. Those at the low end, between 4' 6" and 5' 2", while sparser than the average, were nevertheless more populous than those of formidable height. After conducting similar comparisons using chest size, he then proceeded to develop a projection of averages and standard deviations by comparing scores on the test for admission to the Royal Military College. All of this measurement led to the devel-

CLASSIFICATION OF MEN ACCORDING TO THEIR NATURAL GIFTS

Grades of natural ability, separated by equal intervals		Numbers of men comprised in the several grades of natural ability, whether in respect to their general powers, or to special aptitudes							
Below average	Above average	Proportionate, viz. one in	In each million of the same age	In total male population of the United Kingdom, say 15 millions, of the undermentioned ages:					
				20–30	30–40	40–50	50–60	60–70	70–80
a	A	4	256,791	641,000	495,000	391,000	268,000	171,000	77,000
b	B	6	161,279	409,000	312,000	246,000	168,000	107,000	48,000
c	C	16	63,563	161,000	123,000	97,000	66,000	42,000	19,000
d	D	64	15,696	39,800	30,300	23,900	16,400	10,400	4,700
e	E	413	2,423	6,100	4,700	3,700	2,520	1,600	729
f	F	4,300	233	590	450	355	243	155	70
g	G	79,000	14	35	27	21	15	9	4
x all grades below g	X all grades above G	1,000,000	1	3	2	2	2	—	—
On either side of average			500,000	1,268,000	964,000	761,000	521,000	332,000	149,000
Total, both sides			1,000,000	2,536,000	1,928,000	1,522,000	1,042,000	664,000	298,000

The proportions of men living at different ages are calculated from the proportions that are true for England and Wales. (Census 1861, Appendix, p. 107.)
 Example.—The class F contains 1 in every 4,300 men. In other words, there are 233 of that class in each million of men. The same is true of class f. In the whole United Kingdom there are 590 men of class F (and the same number of f) between the ages of 20 and 30; 450 between the ages of 30 and 40; and so on.

A chart from *Hereditary Genius* detailing the distribution of intelligence and ability among the English population. REPRINTED FROM FRANCIS GALTON'S *HEREDITARY GENIUS*, 1869

opment of a chart entitled "Classification of Men According to Their Natural Gifts," which provided an underpinning for his study of illustrious family lines.[19]

Projecting a "total male population of the United Kingdom" as fifteen million, his table divided white men of Britain into fourteen categories, separating the high from the low man. Women were unaccounted for in his study. He determined that, by a ratio of 7:3, quality was passed on through the male line. Negro men, he argued in a chapter entitled "The Comparative Worth of Different Races," required an entirely different scale, adjusted downward to accommodate their congenitally limited capacities.[20]

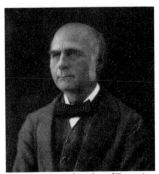

Francis Galton, founder of Eugenics.
REPRINTED FROM KARL PEARSON'S *THE LIFE, LET-TERS, AND LABOUR OF FRANCIS GALTON*

Those at the top of Galton's chart of white men (categories A, a, B, b) constituted the most deficient forms of "mediocrity" among the British race. According to his calculations, these combined categories constituted nearly half of the male population, 418,070 per million—an unsettling fact for an elitist such as Galton. Categories C, D, and E, encompassing 63,563, 15,696, and 2,423 per million respectively, included people ranging from high mediocrity to the somewhat gifted. Those in the E class, he wrote, represented the solid middle class, destined to achieve success in life.

Those in categories F, G, and X were the highest grade of individuals, men who had achieved eminence through their "special aptitudes." Together, these categories encompassed a far more exclusive club, amounting, according to Galton's calculation, to a mere 248 individuals per million. The G category represented only 14 men per million, and the X category, the summit of his system, represented 1 individual per million, the leading lights of the nation, such as himself. F, G, and X were conspicuous in the family trees of high reputation that provided a focal point for his book. "Capacity, zeal and vigour" were outstanding among men of such a lineage.

Dwelling on hereditary genius, while downplaying hereditary wealth as a determinant of opportunity, Galton created a taxonomy of inborn ability that provided nothing less than a scientific justification for the entrenched British class system. In an age of democratic movements, the argot of statistical science was being employed to uphold that which ecclesiastical and hierarchical authorities had safeguarded in the past.

Galton's *Hereditary Genius* offered a primarily arithmetical description of the British population, and its crushing mediocrity. Its author did, however, pre-

sent an idea that was prescriptive in nature and foreshadowed the direcction his thinking would take in years to come. Toward the end of his book, Galton bemoaned that in England the "improvident" and "unambitious" elements of society tend to marry early and reproduce prolifically. Meanwhile, the "abler classes" tend to marry late and have fewer children. This disparity meant that it was the lesser among the population who acquired the primary role in keeping up "the breed." The eventual outcome of this process, he predicted, would be that "the race gradually deteriorates, becoming in each successive generation less fitted for a high civilization, although it retains the external appearance of one, until the time comes when the whole political and social fabric caves in and a greater or less relapse to barbarism takes place." In the face of such an emergency, Galton speculated "the wisest policy" would be "that which results in retarding the average age of marriage among the weak, and in hastening it among the vigorous classes." Visions of human husbandry were taking wing in his methodical mind.[21]

Galton's perspective flew in the face of the egalitarian thinking that, in England and elsewhere, had been accelerating since the seventeenth century. "It is in the most unqualified manner," he pronounced in *Hereditary Genius*, "that I object to pretensions of natural equality."[22]

Even Galton's cousin, Charles Darwin, was swayed by this argument. He wrote to Galton on the occasion of *Hereditary Genius's* publication.

> My Dear Galton—I only read about 50 pages of your book . . . , but I must exhale myself, else something will go wrong in my inside. I do not think I ever in all my life read anything more interesting and original—and how well and clearly you put every point! . . . You have made a convert of an opponent in one sense, for I have always maintained that, excepting fools, men did not differ much in intellect, only in zeal and hard work; and I still think this is an eminently important difference. I congratulate you on producing what I am convinced will prove a memorable work.

Galton was clearly flattered by his famous cousin's endorsement, but steadfastly unwilling to yield to Darwin's ideas about the importance of "zeal and hard work." Years later, he wrote in his memoirs, "The rejoinder that might be made to his remark about hard work, is that character, including the aptitude for work, is heritable like every other faculty."[23]

In the decades that followed the publication of *Hereditary Genius*, Galton's obsession with "intrinsic" human differences was transformed into a purport-

268

edly corrective science. If stark distinctions were scientifically measurable, it was a short route between discovering the tools for identifying excellence and inadequacy and the application of those tools "to improve the inborn qualities of a race . . . [and] develop them to the utmost advantage."[24] A fascination with statistical science was propelling Galton toward the invention of practical designs for social engineering. His speculation on the need to reverse the disparity of birth rates among the British population was one of his first forays in this direction.

Four years after *Hereditary Genius* appeared, he proposed a scheme for improving the racial makeup of Africa in a letter to the *Times of London*. Like many of his contemporaries, Galton was convinced that black Africa was essentially incapable of achieving a high state of civilization. Galton insisted that even an outstanding black man such as Toussaint l'Ouverture, who led the Haitian revolution against the French, would only qualify as an F on his scale of white British males.[25] In an article in *MacMillan's* magazine in 1865, entitled "Hereditary Talent and Character," he judged that even when an African child was withdrawn from his habitat and raised in a civilized setting, he immediately regressed to "contented barbarism" when returned to the jungle, all vestiges of civilized training having evaporated.[26]

In light of this hereditary handicap, Galton proposed extraordinary measures. A man of the world, who had judged the efficacy of many peoples, he suggested that Chinese settlements be established on the East Coast of Africa, "in the belief that the Chinese immigrants would not only maintain their position, but that they would multiply and their descendents supplant the inferior Negro race." Given the fact that the Chinese "thrive in all countries . . . being perfectly able to labor and multiply in the hottest climates," the processes of natural selection would inevitably favor the survival of the Chinese and lead to the disappearance of Africa's unfavoured race. "The gain would be immense to the whole civilized world if we were to out-breed and finally displace the negro, as the [negro] . . . has displaced the aborigines of the West Indies." This protracted plan for genocide, propped up by a bogus rendition of Caribbean history, was inseparable from Galton's unwaveringly imperialist outlook and his condescending belief in what Kipling would later term "the White Man's burden."

This bizarre proposal for international evolutionary engineering, Galton maintained, was the result of careful deliberation regarding which race of people could best improve the population profile of Africa. He rejected the "Hindoo" as "inferior to the Chinaman," and the "Arab" as "little more than

an eater up of other men's produce; he is a destroyer rather than a creator, and he is unprolific."

The Chinese, however, would be the perfect breed to transplant, given Europeans' inability to flourish in the hot African climate.

> The Chinese emigrants possess an extraordinary instinct for political and social organization; they contrive to establish for themselves a police and internal government, and they give no trouble to their rulers so long as they are left to manage those matters by themselves. They are good-tempered, frugal, industrious, saving, commercially inclined, and extraordinarily prolific.[27]

Alongside this fanciful proposition, in Great Britain, Galton pursued his passion for "race improvement" in more concrete terms, developing tools and procedures for subjecting the entire British population to detailed genealogical, anthropometric, and photographic documentation. His experiments in composite photography offered him the capacity to create ideal-type portraits, representing the median physiognomy of different sectors of the British population. This procedure was closely related to his use of statistics to identify the average typologies of different social groups in numerical terms.

By 1883, in a book entitled *Inquiries into Human Faculty and Its Development*, the ultimate objective of Galton's data gathering began to become clear. Human breeding could be systematically managed to ensure the improvement of the British race, as well as other civilized peoples. In the book, Galton coined a new word, "eugenics," to describe the application of scientific knowledge to stem the tide of racial deterioration and bring about the perfection of the bloodline. Galton took the term from the Greek *eugenes*, meaning "good in stock, hereditarily endowed with noble qualities."[28] Over the next several decades, this idea would amplify into a movement, leaving considerable wreckage in its wake, but for Galton, in the early 1880s, it pointed out the task at hand: the systematic assessment of the British population.

Already by the 1860s, Galton had seen the "pressing necessity of obtaining a multitude of exact measurements relating to every measurable faculty of body or mind." His first thought was to encourage schools to "weigh and measure" all students, but this idea materialized only sporadically. By 1882, Galton believed that an aggressive national policy needed to be implemented. He called for the establishment of "anthropometric laboratories" throughout the nation. Within reach of everyone, these centers would allow every man to "get himself and his children

weighed, measured, and rightly photographed and have each of their bodily faculties tested, by the best methods known to modern science."[29] As he conceived of it, collected data would include a measurement of "energy," a man's ability to "work at full stretch, day by day"; a detailed medical history; and records of arm strength, eye movement, and the ability to visualize "in the mind." His desire to precisely measure mental processes signaled the dawn of "psychometrics."[30] This field of inquiry would drive the efforts of a perception management industry that would take flight in the twentieth and twenty-first centuries. Photographic records, not surprisingly, would be a standard aspect of every examination. Each anthropometric study would provide a vivid profile of its subject and, over time, of its subject's development or deterioration. Together, these records would permit Galton and other anthropometric scientists, to codify the inherited distinctions that divided the United Kingdom and imperiled its fate. Given his belief in the importance of heredity, he appealed, in 1884, to the Royal Statistical Society to aid him in his gathering of family records by publicizing his enterprise. "It will be observed," he wrote to the Council of the Statistical Society, "that I offer [monetary] prizes . . . to those who shall furnish me with the best extracts from their own family records." The format of these should follow guidelines presented in his "Record of Family Faculties," a publication that adapted family information to "statistical purposes."[31] The Royal Society enthusiastically cooperated.

Then, opportunity knocked. In the spring of 1884, a monumental fair was scheduled to open in London, the International Health Exhibition. Its exhibits would parallel the industrial pride and hoopla that had defined such spectacles since the erection of the Crystal Place.

As plans for the exposition were underway, Galton imagined that the fair would provide an ideal setting for an anthropometric laboratory. Given the number of visitors expected at the fair, and the entertainment factor that could attract throngs to a well-conceived installation, Galton had a brainstorm. He would turn anthropometric data-gathering into an amusement of the first order. "My principal object in establishing the laboratory," he later wrote, "was to familiarize the public with the methods of anthropometry, and at the same time to register facts that might hereafter be of use in individual life histories."[32]

He devised a scheme whereby fairgoers would subsidize the "working expenses" of his endeavor. In a poster to promote the anthropometric laboratory, he invited "those who desire to be accurately measured," to pay a fee of three to four pence, "to obtain timely warning of remediable faults in development, or to learn of their powers." Those who participated in his investigation

were guaranteed the opportunity to have their data listed in an anonymous but "methodical register," so as to further "anthropometric experiment and research, and for obtaining data for statistical discussion." In a second register the names would be listed for posterity. Upon the conclusion of each session, every paying customer would be given an original record of his examination. Carbon copies would be retained for Galton's research. In an era when many viewed science with innocent wonder, the chance to become a part of science was a considerable lure.33

On May 5th, when the International Health Exhibition opened, Galton's Anthropometric Laboratory was a conspicuous presence. Thirty-six feet long, it included instruments of his invention, designed to measure "Human Form and Faculty." Galton surrounded his lab with a see-through enclosure that offered fairgoers an opportunity to view the fascinating procedures going on inside, the better to draw people in. "Persons of all ranks went to it," he reported.34

Even before the fair, Galton had garnered considerable buzz around his anthropometric antics. Prior to the fair, he delivered frequent public lectures in which he promoted his hereditary theories and demonstrated how his original measuring devices could be used to vindicate them. He also employed an ingenious gadget, which he called a quincunx, to visualize the law of distribution, upon which his theory of hereditary genius, mediocrity, and degeneracy rested. The device made the bell curve, for the first time, visible and accessible to a wide audience. Galton also popularized the idea that statistics offered a truthful and scientific picture of human

Galton's Anthropometry Lab at the health exposition. FROM THE COLLECTION OF THE EWEN LIBRARY

ANTHROPOMETRIC
LABORATORY

For the measurement in various ways of Human Form and Faculty.

Entered from the Science Collection of the S. Kensington Museum.

This laboratory is established by Mr. Francis Galton for the following purposes:—

1. For the use of those who desire to be accurately measured in many ways, either to obtain timely warning of remediable faults in development, or to learn their powers.

2. For keeping a methodical register of the principal measurements of each person, of which he may at any future time obtain a copy under reasonable restrictions. His initials and date of birth will be entered in the register, but not his name. The names are indexed in a separate book.

3. For supplying information on the methods, practice, and uses of human measurement.

4. For anthropometric experiment and research, and for obtaining data for statistical discussion.

Charges for making the principal measurements:
THREEPENCE each, to those who are already on the Register.
FOURPENCE each, to those who are not:— one page of the Register will thenceforward be assigned to them, and a few extra measurements will be made, chiefly for future identification.

The Superintendent is charged with the control of the laboratory and with determining in each case, which, if any, of the extra measurements may be made, and under what conditions.

H & W. Brown, Printers, 20 Fulham Road, S.W.

Facsimile of a poster advertisement for Galton's lab in the Kensington Museum. FROM THE COLLECTION OF THE EWEN LIBRARY

272

talents and deficiencies. In the wake of these lectures, his celebrity had grown and his presence at the fair was a noteworthy attraction.

Men and women (at a ratio of 4:1) lined up, eager to have their forms and faculties recorded. The procedure was performed by hand, with the aid of Galton's instruments, and each examination included seventeen measurements and lasted about a half-hour. Despite the time-consuming methods being used, the lab processed about ninety people a day. By fair's end, more than nine thousand people had entered the register.35

Galton's laboratory was an enormous success. Word spread and, when the fair closed, it was transplanted to the South Kensington Museum, where it con-

For Private Information only.

QUESTIONS *A*, CONCERNING THE KINDRED OF THE APPLICANT.

On the Fraternity consisting of the Applicant and of his *whole* Brothers and Sisters. Write A by the side of the figure in the first column that refers to the Applicant.

Register	Names or Initials in order of Birth	Sex M. or F.	If deceased	
			Age at Death	Cause of Death
1 2 3 ⋮				

Register	Initials	Notable achievements of any brother or sister of the Applicant that fall within the purview of this Certificate

We certify that to the best of our knowledge the above account is correct, also that with the exceptions mentioned below, no member of this Fraternity has ever suffered from Insanity, Epilepsy or other severe form of nervous disease.

Exceptions giving full particulars. If no exceptions write the word "None"	

Signatures of { Writer of the above notice. / The Applicant.

The last paragraph and the corresponding paragraphs of Questions B and C must be on a separate sheet marked "confidential." F. G.

QUESTIONS *B*, CONCERNING THE KINDRED OF THE APPLICANT.

On the Fraternity consisting of the Father of the Applicant and of the Father's *whole* brothers and sisters. Write F by the side of the figure in the first column that refers to the Father, and describe his achievements more fully than those of his brothers.

Register	Names or Initials in order of Birth	Sex M. or F.	If deceased	
			Age at Death	Cause of Death
1 2 3 ⋮				

Galton's form for gathering family histories. REPRINTED FROM KARL PEARSON'S *THE LIFE, LETTERS, AND LABOUR OF FRANCIS GALTON*

tinued to draw more than a thousand visitors a year during a residence of three years. At the Museum, the range of measurements and data collected expanded ²73 from seventeen to thirty-three, now including fingerprints, which he believed might contain hereditary markers.

While Galton eventually abandoned this assumption, his interest in the subject grew, and in 1892 he would publish a book called *Fingerprints*, which argues that no two persons' fingerprints are alike—the chance of two people's being the same is 1 in 64 billion—and which presents a detailed system for reading fingerprints, still in use. The terms "Galton points" and "Galton details" continue to be employed by forensic experts, to identify particular characteristics of a print.

Register	Initials	Notable achievements of any brother or sister of the Father of the Applicant that fall within the purview of this Certificate

We certify that to the best of our knowledge the above account is correct, also that with the exceptions mentioned below, no member of this Fraternity has ever suffered from Insanity, Epilepsy or other severe form of nervous disease.

Exceptions giving full particulars. If no exceptions write the word " None "	

Signatures of { *Writer of the above notice.* / *The Applicant.*

QUESTIONS *C*, CONCERNING THE KINDRED OF THE APPLICANT.

On the Fraternity consisting of the Mother of the Applicant and of the Mother's *whole* brothers and sisters. Write M by the side of the figure in the first column that refers to the Mother, and describe her achievements more fully than those of her sisters.

Register	Names or Initials in order of Birth	Sex M..or F.	If deceased	
			Age at Death	Cause of Death
1				
2				
3				
⋮				

Register	Initials	Notable achievements of any brother or sister of the Mother of the Applicant that fall within the purview of this Certificate

We certify that to the best of our knowledge the above account is correct, also that with the exceptions mentioned below, no member of this Fraternity has ever suffered from Insanity, Epilepsy or other severe form of nervous disease.

Exceptions giving full particulars. If no exceptions write the word " None "	

Signatures of { *Writer of the above notice.* / *The Applicant.*

Word of Galton's anthropometry continued to spread, in part because he took his show on the road, bringing his instruments to demonstrate at a number of scientific gatherings. In addition, new anthropometric laboratories began to be established, in Oxford, Cambridge, Dublin, and Eton. Mobile labs traveled around Ireland and Scotland.

The pile of data was growing, and with it the conviction that a "deterioration of the race" was under way. Given relative birth rates among the different classes, with the lower classes being most prolific, it was clear to those who subscribed to Galton's idea of eugenics that something had to be done. The rapid growth of a eugenics movement in the early decades of the twentieth century was a palpable sign of the extent to which Galton's concerns, and his judgments upon the majority of Englishmen, were shared by many in Britain's middle and upper classes.

In his autobiographical *Memories*, his most widely read book, Galton provided readers with a clear rational for the implementation of eugenics as an enforced social policy.

> I think that stern compulsion ought to be exerted to prevent the free propagation of the stock of those who are seriously afflicted by lunacy, feeble-mindedness, habitual criminality, and pauperism. With a humane and well-informed public opinion, I cannot doubt that our democracy will ultimately refuse to consent to that liberty of propagating children which is now allowed to the undesirable classes . . . A democracy cannot endure unless it be composed of able citizens; therefore it must in self-defense withstand the free introduction of degenerate stock . . .
>
> This is precisely the aim of Eugenics. Its first object is to check the birth-rate of the Unfit, instead of allowing them to come into being . . . The second object is the improvement of the race by furthering the productivity of the fit by early marriages and healthful rearing of their children. Natural Selection rests upon excessive production and wholesale destruction; Eugenics rests on bringing no more individuals into the world than can properly be cared for, and those only of the best stock.[36]

The idea that it was necessary to limit the birthrate of the lower classes was one that had been circulating in England and elsewhere since the end of the eigh-

teenth century. It was then that Thomas Malthus published *An Essay on the Prin-*
ciple of Population, which bemoaned a rapid "overpopulation" of Britain that the
existing means of subsistence was unable to support. Blaming the fecundity of
the poor for this predicament, Malthus proposed that it was necessary to consider
means for lowering their birthrate to a level less injurious to society.

In Francis Galton, a long-deceased Malthus found an enthusiastic champion.
To garner support for his ideas, Galton, his closest colleague, Karl Pearson—
who oversaw a eugenics laboratory at the University of London—and other dis-
ciples founded the Eugenics Education Society in 1908, along with a journal, *The
Eugenics Review.* The objective of the Society was to attract eligible people to the
cause, set up local chapters for the promotion of eugenics and, according to Gal-
ton, raise money that could be used to "start couples of worthy quality in their
married life."[37]

Philanthropy, as conventionally conceived, was usually defined as charity for
the poor. To Galton, this belief only exacerbated the decline of the stock.

> It is known that a considerable part of the huge stream of British charity
> furthers by indirect and unsuspected ways the production of the Unfit; it
> is most desirable that money and other attention bestowed on harmful
> forms of charity should be diverted to the production and well-being of
> the Fit. . . . It would clearly be advantageous to the country if social and
> moral support as well as timely material help were extended to the desir-
> ables, and not monopolized as it is now apt to be by the undesirables.[38]

Against current trends, Galton was proposing a new definition of philan-
thropy. It would identify families of outstanding quality and provide help "when-
ever help is really needful," to suitable couples. National leaders, Galton argued:

> [S]hould regard such families as an eager horticulturalist regards beds of
> seedlings of some rare variety of plant, but with an enthusiasm of a far
> nobler and more patriotic kind. For since it has been shown elsewhere
> that about 10 per cent of the individuals born in one generation provide
> half the next generation, large families that are also eugenic may prove
> of primary importance to the nation and become its most valuable
> asset.[39]

The prospect of human horticulture attracted devotees throughout much of
the Western world. In England, the Fabian socialists Sidney and Beatrice Webb

276

saw eugenics as a solution to a deterioration of the Anglo-Saxon race that, they believed, posed a threat to the possibility of building a socialist society. George Bernard Shaw looked to eugenics as the only hope for civilization. So, too, did H. G. Wells.

In France, where racial science had a long history of legitimacy, Comte Georges Vacher de Lapouge's writings married racism to Darwinism, presenting the struggle for existence as a struggle between different racial and religious groups. His book, *Social Choices* (1896), presented race-mixing as a threat to Aryan genius and proposed strict controls over human reproduction.[40] His ideas were heavily influenced, already by the 1880s, by Galton's eugenics. In 1886, shortly after Galton had coined the term, de Lapouge told his students at Montpelier:

> The theory of Mr. Galton on eugenics—the laws which regulate the production, the conservation and the propagation of superior families . . . can, by a wise selection, permit the substitution of a superior humanity in the future for the humanity of today.[41]

Others followed this lesson, and in 1912 the French Eugenics Society was founded by an alliance of doctors and statisticians.

Germany also provided a fertile environment for the growth of eugenic thinking. Wilhelm Schallmeyer's *Heredity and Selection in the Life History of Nations* (1903), after winning a competition for the best book on the social influence of Darwinism, became the "standard German work in eugenics." Following the book's publication, an associate of Schallmeyer, Alfred Ploetz, founded the Race Hygiene Society in Berlin, which promoted eugenic theory and practice.[42] In the period following the First World War, a radical strain of eugenics would take hold and, in the name of purifying the Aryan race, would become the bedrock of Nazi racial policies.

The international power and influence of eugenics was brought to light in 1912, when the Eugenics Education Society held the First International Congress of Eugenics in London. Among those in attendance were major politicians, medical men, inventors, and academics. Charles Darwin's son Leonard served as president of the Congress. British delegates included the Lord Chief Justice, the president of the College of Surgeons, Anglican bishops, the vice-chancellor of the University of London, and Winston Churchill, then First Lord of the Admiralty.

Heading the German delegation was Alfred Ploetz, founder of the Race Hygiene Society. De Lapouge came from France. An illustrious delegation

from the United States also attended. David Starr Jordan, chancellor of Stanford University and a major American biologist, led the delegation. Other prominent American eugenicists at the gathering included Alexander Graham Bell and Harvard's president emeritus, Charles Elliott. At the close of the Congress, it was decided that a Second International Eugenics Congress would be held in New York in 1915. While war interrupted this plan, the Congress would take place at the American Museum of Natural History, on Central Park West, in 1921.[43]

21
MORONS IN OUR MIDST

The choice of New York as the setting for the Second International Congress reflected the enthusiastic response that eugenics was receiving in America. That the Congress would convene at the American Museum of Natural History (AMNH) spoke to the important role that the institution was playing in the popularization of scientific racism and ideas of inherent human inequality. The museum, in fact, housed a monumental "Hall of the Age of Man," dedicated to the premise of evolution, which, in statues and grand murals by Charles R. Knight, "presented a grandly orchestrated illustration of the proposition that the human races had been created as separate species, and ascended from dark beetle-browed brutes to the fair artists and chieftains of the North."[1]

Yet the idea that heredity was the key factor in the explanation of human difference had entered the American stage far earlier. In many ways, the Congress was a historic outcome of an aggressive sociological movement that had been gaining steam for over forty years. It dated back to 1875, when R. L. (Richard Louis) Dugdale published an influential study that would canonize invidious hereditary thinking as a mainstream American faith.

Born to a wealthy English couple in Paris in 1841, Dugdale moved with his family to New York when he was ten. Following in his father's footsteps, he became a businessman by profession, but Dugdale had more interest in the budding field of sociology, particularly the ways that statistics appeared capable of providing numerical certainty to the description of social problems.

By the early 1870s, his sociological interests, aided by an inheritance, eclipsed the place of business in his life. In this regard, an alliance with a man named Elisha Harris proved fortunate. Harris had been an innovator in the accumulation of health statistics in New York, and later he became corresponding secretary of the New York Prison Association. In that capacity, Harris had begun developing data on the prison population of the state. Keeping tabs of family names that recurred in prison records, he uncovered a family in Ulster County that was extraordinarily prolific in its production of convicts, criminals, paupers, beggars, vagrants, prostitutes, and syphilitics, going back seven generations.

Harris's remarkable discovery gained renown when Charles Loring Brace cited it glowingly in an article on pauperism, published in 1875. Oliver Wendell Holmes, Sr., also wrote excitedly about Harris's research. "If genius and talent are inherited as Mr.

Galton has so conclusively shown," Holmes asked in *The Atlantic Monthly*, why shouldn't "deep-rooted moral defects and obliquities show themselves, as well as other qualities in the descendants of moral monsters?"[2] Yet, it was Dugdale who brought major attention to Harris's statistical findings.

Shortly after his discovery, Harris dispatched his friend Dugdale to Ulster County to study this degenerate bloodline more fully, all the way back to its suspected female founder, "Margaret, Mother of Criminals." Dugdale's book, *"The Jukes": A Study in Crime, Pauperism, Disease and Heredity*, was the outcome of this assignment. In Harris's introduction, he heralded Dugdale's profound sociological contribution.

> Rarely has such a patient and philosophical inquirer as Mr. Dugdale penetrated the social Hades of the dangerous classes, and in their own abodes so photographed them as vagabonds, as offenders, as the outdoor poor of a county, as felons and miscreants,—that their unvarnished picture is recognized by all who ever saw these "Jukes" or any of their kind.[3]

Melding statistics with colorful prose, Dugdale invented the pseudonym "Jukes" to describe the family lineage he had studied, and his book soon became a best seller, not only in the United States but also in Europe, where an emerging eugenics movement saw it as proof of their theories. The word "Jukes," the historian Nicole Rafter writes, quickly became "a synonym for degeneracy on both sides of the Atlantic."[4]

Dugdale maintained that pauperism and crime were hereditary tendencies, marked over time by "different gradations of waning vitality." Addicted to "sexual orgasms," he added, the degenerates' indefatigable desire to copulate only "perpetuates their idiocy" from generation to generation.[5] Among middle-class Americans, fixated on the rise of the "dangerous classes," Dugdale pointed the way toward practices that would seek to interfere with the procreation of "degenerate" stock. Dugdale eventually revealed that the "Jukes" were an amalgam of several families. Subsequent studies revealed that he had omitted those "Jukes" who became respectable members of the community.[6] For decades, however, the influence of his shocking portrayal endured.

The success of Dugdale's book, in and of itself, offers little insight into why America became such fertile soil for the growth of eugenics. In large measure, it was a confluence of major social developments, from the mid nineteeth cen-

tury on, that fueled the coming obsession with hereditary engineering. Central to these developments was the changing profile of the American populace.

One aspect of the change was spawned by the demise of slavery. In the years following the Civil War, a free black population was demanding the right to exercise its newly won citizenship. For a brief period, as Northern troops occupied the South, African Americans experienced for the first time a world without slave masters. They voted. They ran for, and won, political offices. They saw the light of freedom and its promises.

For many whites, deeply committed to a belief in "the negro's" inborn inferiority, this new body of citizens posed a terrifying prospect. When federal troops were withdrawn in 1877, the old master class began to assume power once again and, by the 1890s, launched a reign of terror against the free black population.

A central argument that was used to justify the installation of Jim Crow laws (legalizing racial segregation) was the danger of race pollution that was presented as the inevitable outcome of free relations between the races. Of particular concern was the prospect of interracial sex and the allegedly disastrous results it would bring.

While coercive sexual relations between white men and black women had been integral to slaveholders' Southern comfort, this was viewed as an insignificant problem, not a danger to the perpetuation of the white race. The mating of black men with white women, however, was another story. The result of such unions, it was claimed, would bring about what one writer would later characterize as "the rising tide of color against white world-supremacy."7 This eventuality was to be prevented at all cost. A forty-year epidemic of lynchings provided black men with a gruesome warning of what would happen to those suspected of even looking at a white woman. Simultaneously, miscegenation laws (the term introduced in 1863, come from the Latin *miscere*, to mix, and *genus*, race) provided a legal foundation against black-white conjugations.

Adding to white Americans' anxiety regarding the purity of the race was the arrival of millions of immigrants from Ireland, Eastern Europe, Southern Italy, and China between the 1850s and the early 1900s. While American industrial development was deeply dependent on these people for a cheap labor supply, successive waves of new immigrants, often with large families, presented an implicit demographic time bomb. Given immigrant prolificacy, those "old immigrants," coming from British and Teutonic stock, feared that their control over America's future was on the wane, soon to be supplanted by members of less advanced races.

These fears began to coalesce into a movement when, in 1891, Francis Amasa Walker, president of the Massachusetts Institute of Technology and former director of the Bureau of the Census, warned that "old stock" America was in the pro-

cess of being overrun by immigrants. This problem, he argued, was being exacerbated by a trend toward smaller families among the Anglo-American middle class. This decline in the birth rate of the "old stock," faced with the fertility of the "new," constituted what Walker termed "racial suicide."

In 1898, following its victory in the Spanish-American War, the United States emerged as a new imperial power. Given the demands of empire, and the need for old-line America to assert its "vigor" on an international scale, Walker's line of thinking began to accelerate. This was no time for Anglo-American complacency. "We cannot avoid the responsibilities that confront us in Hawaii, Cuba, Porto Rico, and the Philippines," intoned President Theodore Roosevelt in 1899.[8] The future of America depended on the white race's capacity to reproduce and remain strong. Yet dangers lurked.

In 1899, Senator Albert Beveridge of Indiana—who claimed it was "the mission of our race, trustee of God," to impose civilization on a barbarous and decadent world—stood before his colleagues in the Senate and called for an end to smugness and passivity:

> God has not been preparing the English-speaking and Teutonic peoples for a thousand years for nothing but vain and idle self-admiration. No! He has made us the master organizers of the world to establish systems where chaos reigns. . . . He has made us adept in government that we may administer government among savages and senile people.[9]

Simultaneously, Roosevelt, the former Rough Rider, warned that many Americans were recoiling from the responsibilities of the nation's recently achieved global power. We face, he argued, the danger of a "shameful page in our history."

> The timid man, the lazy man, the man who distrusts his country, the over-civilized man, who has lost the great fighting, masterful virtues, the ignorant man, and the man of dull mind, whose soul is incapable of feeling the mighty lift that thrills "stern men with empires in their brains"— all these shrink from seeing the nation undertake its new duties.[10]

The tide of immigration, which was altering the composition of America's population, and bringing "savage and senile people" into its midst, only heightened this sense of urgency. Relative birth rates, which favored the immigrants, were seen as a mounting calamity.

In 1901, Edward A. Ross, America's foremost sociologist, employed the term "race suicide" in an article published in the *Annals of the American Academy of* 283 *Political and Social Science*:

> For a case like this I can find no words so apt as "race suicide." There is no bloodshed, no violence, no assault of the race that waxes upon the race that wanes. The higher race quietly and unmurmuringly eliminates itself rather than endure individually the bitter competition it has failed to ward off by collective action. The [Anglo-American] working classes gradually delay marriage and restrict the size of the family as the opportunities hitherto reserved for their children are eagerly snapped up by the numerous progeny of the foreigner. The prudent, self-respecting natives first cease to expand, and then, as the struggle for existence grows sterner and the outlook for their children darker, they fail even to recruit their own numbers.

By 1903, President Roosevelt adopted the phrase "race suicide" to describe what he saw as a growing weakness in the Anglo-American stock. Two years later, before the National Congress of Mothers, he implored the group to understand that the conduct of "family life" had taken on a vital national significance.

The "destiny of the generations to come after us," he told his audience, was in their hands. Decrying the values of "ease" and "self-indulgence," he proclaimed that the goal of life is not simply to "taste a few good things."

> [I]f the average family in which there are children contained but two children the nation as a whole would decrease in population so rapidly that in two or three generations it would very deservedly be on the point of extinction, so that the people who acted on this base and selfish doctrine would be giving place to others with braver and more robust ideals. Nor would such a result be in any way regrettable; for a race that practised such a doctrine—that is, a race that practised race suicide—would thereby conclusively show that it was unfit to exist, and that it had better give place to people who had not forgotten the primary laws of their being.

One practical response to these ominous pronouncements was the creation, in St. Louis, of the American Breeders Association in 1903. Founded by David Starr Jordan—a prominent marine biologist, the president of Stanford University, and a leading eugenicist—the organization was devoted to the study of hereditary social problems and to education of the population in eugenics. The

organization led investigations of feeble-mindedness, insanity, criminality, pauperism, and a panoply of other ostensibly inherited medical defects. It also explored the perils posed by the mongrelization of the white race and sought to promote legislation that would forward the agenda of eugenics, "creating a healthier, saner society in the future."[11]

Pursuing Galton's dream of assembling everyone's hereditary profile, the Breeders Association pioneered the compilation of eugenic records in the United States. Aided by Carnegie and Harriman money, the group oversaw the establishment, in 1910, of the Cold Spring Harbor Eugenics Record Office (ERO), on Long Island. Funding also came from John D. Rockefeller, and, following its establishment in 1912, large contributions came from The Rockefeller Foundation. In 1912 and 1913 alone, the foundation gave one hundred million dollars to the Cold Springs Harbor Records Office.[12] Rockefeller and Carnegie Foundation support for the ERO continued for decades. Between 1936 and 1939, for example, the Rockefeller Foundation gave fellowships and scholarships to Third Reich "genetic" scientists, to sponsor residencies at the Cold Spring Harbor eugenics facility.[13]

The ERO was established to serve as a national repository of eugenic profiles. Its board of directors was chaired by Alexander Graham Bell. Charles Davenport, who had headed the Breeders Association's Committee on Eugenics, served as resident director of the ERO. Harry Laughlin, who would become a globally influential figure in the eugenics movement, served as its superintendent.

Using data-gathering techniques established by Galton, including photography, the center was devoted to documenting the superior, standard, and inferior bloodlines of the nation, in order to "build up an analytical index of the inborn traits of American families." Other "Functions of the Office," as enumerated in its founding statement, included training people to gather eugenic data, maintaining a "field force actually engaged in gathering such data," offering advice "concerning the eugenical fitness of proposed marriages," and the publication of the office's research findings.[14] Measuring, photographing, and interviewing families, the ERO assembled records that noted physical traits—such as eye, hair, and skin color—but also documented conduct, talent, and intelligence.

In 1912, as David Starr Jordan led the American delegation to the First International Eugenics Congress in London, the American Breeders Association became the American Genetics Association, and began to publish the *Journal of Heredity*, an ongoing chronicle of eugenic findings.[15] A dissemination of eugenic ideas was moving forward rapidly. Aided by robber-baron money, lead-

ing natural history institutions, along with prominent scientists, sociologists, and psychologists, lent magisterial credence to the idea of systematic breeding.

The development of the IQ scale by Alfred Binet, director of the psychology laboratory at the Sorbonne, only furthered this development, if inadvertently. In 1905, Binet published an article entitled "New Methods for the Diagnosis of the Intellectual Level of Subnormals," in the prestigious *L'Année Psychologique*. This study led to the development of the Binet-Simon numerical scale that identified intelligence levels according to mental age, with subnormals at the bottom end of the scale (below 80) and the superior (120+) and the very superior (130+) at the high end. Though Binet never claimed that IQ was an inherited characteristic, Henry Goddard, an associate of the Eugenics Record Office, translated Binet's scale, transporting it to the United States, where it was reborn as a device for gauging hereditary mental ability. In 1906, Goddard opened a laboratory and the Department of Research for the Study of Feeble-mindedness in Vineland, New Jersey, where research followed the assumption of hereditary intelligence. It also housed "feeble-minded" inmates, separating them from society, and from each other, to ensure that they would be unable to reproduce. At Vineland, he coined the term "moron" to describe "high-grade defectives,"[16] people who were capable of entering into and functioning in mainstream society, often undetected, but whose genetic flaws endangered the long-term vitality of the race. This term expanded the conventional taxonomy of retardation, which included "idiot" and "imbecile," individuals whose mental capacity was patently impaired. Goddard's new category allowed diagnosticians to classify socially functional people among the feeble-minded.

Goddard's psychometric system was built on an American sociological literature founded by Dugdale and also subscribed to Galton's eugenics. Attempting to lend further scientific basis to his theories, Goddard was among several eugenicists who helped popularize the mid-nineteenth-century experiments of Gregor Mendel, an obscure Austrian monk who demonstrated the influence of heredity through the hybridization of pea plants.

In 1912, Goddard came out with a best seller, *The Kallikak Family: A Study in the Heredity of Feeble-Mindedness*. The book established his reputation as a leading scientist of hereditary intelligence. *The Kallikak Family* enthralled a mass audience; its accessible and provocative prose narrated a gripping story of good and evil. Unlike the often-impregnable charts that limited access to Galton's and other eugenicists' work to specialists, Goddard's book included vernacular graphics that made the visual presentation of information far easier to understand.

Believing in the power to diagnose the quality of human character at a glance, he also included photographs illustrating the faces of degeneration. In this sense, he was a descendent of Lavater, the phrenologists Fowler and Wells, and, of course, Lombroso.

With spellbinding clarity, the book told the tale of a particular family to demonstrate that feeble-mindedness was hereditary. Feeble-minded family trees, Goddard argued, hung heavy with the fruit of degeneracy. Their progeny included alcoholics, the sexually immoral, criminals, the deaf, people with tuberculosis, and those of the "Mongolian type" (people with Down's Syndrome).

His study of the Kallikaks (a pseudonym) began with Deborah, an eight-year-old, who was found in an almshouse and brought to be studied and confined at Vineland. Born to a woman who lived in a small, tightly knit farming community, Deborah, Goddard reported, belonged to a family that "carefully conducted investigations . . . [showed] had always been notorious for the number of defectives and delinquents it had produced; and this notoriety made it possible to trace them back for no less than six generations."[17]

Taking advantage of interviews and local records, Goddard traced Deborah's lineage back to one Martin Kallikak, a "Normal" fifteen-year-old militiaman during the American Revolution who had an illicit fling with a "Nameless Feeble-minded girl" he met in a tavern. Martin had two children with the girl, a son, whom his mother named Martin, Jr., keeping the father's surname alive, and Rhoda. Martin, Jr., Goddard reported, was born a mental defective and later sired nine children, at least five of whom were determined to be "Feeble-minded." Of the others, two were "Undetermined" (not enough data), and two were "Normal." From there, a multigenerational lineage that led to Deborah had produced 480 offspring.

As with Dugdale, and in the book of Genesis, it was a woman who passed on the burden of original sin. And the burden, Goddard reported, was considerable. Of the 480 descendants, "One hundred and forty-three of these, we have conclusive proof, were or are feeble-minded, while only forty-six have been found normal. The rest are unknown or doubtful."

Of the 480, he continued,

Thirty-six have been illegitimate.

There have been thirty-three sexually immoral persons, mostly prostitutes.

There have been twenty-four confirmed alcoholics.

There have been three epileptics.
Eighty-two died in infancy.
Three were criminal.
Eight kept houses of ill fame.

Goddard's definition of "undetermined" suggested that degeneracy was, in all probability, more widespread in the bloodline. It often meant, he explained, "not that we knew nothing about the person, but that we could not decide."

> They are people we can scarcely recognize as normal; they are not what we would call good members of society. But it is very difficult to decide without more facts whether the condition that we find or that we learn about, as in the case of older generations, is or was really one of true feeble-mindedness.

The feeble-minded Kallikak line had married or mated with people of a similar type, "so that we now have on record and charted eleven hundred and forty-six individuals," who, Goddard claimed, also exhibit a high level of degeneracy.[18]

Martin, Sr. conveniently produced a control group for Goddard. From couplings with his "Lawful Wife," who was "a Normal woman," a respectable line of offspring came forth. For Goddard, the combination of Martin's licit and illicit offspring inspired the name Kallikak, from the Greek for beauty (*kallos*) and bad (*kakos*). The two lines provided what he saw as positive proof of his theory.

Deborah, whose story opens the book, was a continuation of tendencies carried on over six generations.

> [She] is a typical illustration of the mentality of a high-grade feeble-minded person, the moron, the delinquent, the kind of girl or woman that fills our reformatories. They are wayward, they get into all sorts of trouble and difficulties, sexually and otherwise, and yet we have been accustomed to account for their defects on the basis of viciousness, environment, or ignorance.
>
> It is also the history of the same type of girl in the public school. Rather good-looking, bright in appearance, with many attractive ways, the teacher clings to the hope, indeed insists, that such a girl will come out all right.

"Our work with Deborah," Goddard contended, "convinces us that such hopes are delusions." He explained, beginning with a question:

> "How do we account for this kind of individual?" The answer is in a word "Heredity,"—bad stock. We must recognize that the human family shows varying stocks or strains that are as marked and that breed as true as anything in plant or animal life.[19]

Social work, a widespread activity among middle-class reformers of the time, could, of itself, yield no improvement, he asserted. The problem was not limited to the social environment, as these people often claimed, but to the inferior stock that was overtaking society. The problem could only be solved, he maintained, if superior beings took on the responsibility of isolating and eliminating these defectives.

> [N]o amount of work in the slums or removing the slums from our cities will ever be successful until we take care of those who make the slums what they are. Unless the two lines of work go on together, either one is bound to be futile in itself. If all of the slum districts of our cities were removed to-morrow and model tenements built in their places, we would still have slums in a week's time, because we have these mentally defective people who can never be taught to live otherwise than as they have been living. Not until we take care of this class and see to it that their lives are guided by intelligent people, shall we remove these sores from our social life.
>
> There are Kallikak families all about us. They are multiplying at twice the rate of the general population, and not until we recognize this fact, and work on this basis, will we begin to solve these social problems.[20]

Deborah, he reported, would create no further damage. As an inmate at Vineland, she would be unable to reproduce. Yet, degeneracy reached far beyond Deborah. It was a seething crisis that demanded the implementation of aggressive social policy. In concluding *The Kallikak Family*, Goddard proposed some measures that might be taken to stem the deluge of "the moron type." One solution was to create colonies of morons, where inmates were segregated from one another, and the ability to procreate would be prohibited. He projected that such institutions—of which Vineland was a model—would, within one gener-

ation, reduce the moron population by two-thirds. A second way out that he raised was surgical "asexualization" or, as he preferred to call it, "sterilization." "The operation itself is almost as simple in males as having a tooth pulled. In females it is not much more serious. The results are generally permanent and sure."[21]

Goddard acknowledged that some might object to such measures, because of the social and emotional consequences that might result from enforced sterilization. He believed that these concerns were probably "more imaginary than real." Nonetheless, he allowed that further research into the impact of these operations was necessary before sterilization should be implemented on a grand scale.

While the Kallikaks were a multigenerational family of poor rural Americans—whom many would stereotype as white trash—Goddard soon turned his attentions to the foreign-born. While Congress had passed a law prohibiting the entry of mentally defective immigrants as early as 1882, the law was extremely difficult to enforce. The bodies passing through the Ellis Island registry room were too many, and methods of evaluation were not fully formed.

In 1910, however, when Goddard visited Ellis Island, he began thinking about how the Binet scale, along with other techniques developed at his Vineland laboratory, could be used to screen out "mental defectives" before they might enter and contaminate American soil. Trading on the fame he achieved from the publication of *The Kallikak Family*, he returned to the island in 1913 with two of his special female examiners from Vineland. He favored women as examiners, because he believed that "women seem to have closer observation than men" and could spot the signs of degeneracy simply by looking. Their superior intuitive powers, he claimed, could identify it fairly accurately, "without the aid of the Binet test at all."[22]

Thus began the installation of an evaluation process that became standard practice. The process included, first, a visual examination of immigrants—by trained women, looking for telltale signs. Likely defectives were separated out. Next, this segregated group was subjected to additional tests, including measurements of vocabulary and time perception. A special version of the Binet scale was also adapted for Ellis Island.

The results of these examinations confirmed Anglo-American prejudices about the "new stock" flooding their cities. Of incoming Jews, 83 percent were deemed to be morons. Among Hungarians, it was 80 percent. Italians did not fare much better, with a moron percentile of 79. Worst of all were those coming from Russia, who set the high mark of 87 percent. From these data, as reported in his 1917 book, *Intelligence Classification of Immigrants of Different Nationalities*, Goddard con-

cluded, "these immigrants were of surprisingly low intelligence. The immigration of recent years is of decidedly different character from the early immigration. . . . We are now getting the poorest of each race. The intelligence of the 'third class' immigrant is low, perhaps of moron grade."[23]

The human cost of these procedures would be significant. From 1913 onward, there was a systematic deportation of "defective" would-be Americans, which grew exponentially from year to year. By 1924, with the passage of the Johnson-Reed Act closing the door on immigration, the effort to protect the racial stock of America—assisted by Goddard's science of typecasting— had become the law of the land.

A mounting eugenics movement provided support for this development as a growing number of prominent Americans embraced its premises. Among these, Madison Grant, a corporate lawyer, was a pivotal and influential figure. Though he had no formal scientific training, he had been active in racial-science circles since the turn of the century. A founding member of the New York Zoological Society, it was he who, earlier on, had arranged to put Ota Benga on display with the apes at the Bronx Zoo. In 1916, now a trustee of the American Museum of Natural History, Grant published a book that converted many politicians, scientists, and social reformers to eugenic theory and practice. Like Goddard's work, Grant's best-selling book helped to popularize eugenics in the public mind, providing a theoretical underpinning for the ostensibly qualitative differences separating "old" from "new" immigrants. Published in 1916, the book drew a readership that would expand dramatically over the next decade as eugenics attracted more and more adherents.

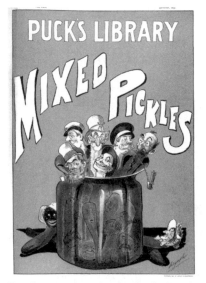

Popular magazines aimed at Anglo-America routinely mocked immigrants and free blacks.
COURTESY OF STEVEN HELLER

The book, *The Passing of the Great Race*, was, in the author's own words, a manifesto designed to awaken his "fellow Americans to the overwhelming importance of race and to the folly of the 'melting pot' theory, even at the expense of bitter controversy." Its authority was validated by a preface written by Henry F. Osborne, cousin of J. P. Morgan and president of the American Museum of Natural History. By 1924, Grant would boast that *The Passing of the Great Race* had helped to persuade Congress

to pass "restrictive measures against the immigration of undesirable races and people."[24]

Grant's book was heavily indebted to the ideas of Francis Galton. It also rested on MIT professor William Z. Ripley's 1899 work, *The Races of Europe*.[25] Ripley had argued that Europe was divided into three distinct racial types, identifiable by stature, coloring, and the shape and size of the head: the Teutonic, the Alpine, and the Mediterranean. The Teutonic race, which he described as tall of stature with blond hair, represented the highest form and the purest blood. At the other end was the Mediterranean, with the lowest "cephalic index" and the greatest resemblance to Africans.

Grant substituted the term "Nordic" for "Teutonic," but he fully subscribed to Ripley's taxonomy and displayed a particular interest in the question of stature. "No one can question the race value of stature who observes on the streets of London the contrast between the Piccadilly gentleman of Nordic race and the cockney costermonger of the old Neolithic type."[26]

More importantly, Ripley's designations provided Grant with a tool for distinguishing between the early, more advanced Nordic immigrants to North America (Britons, Germans, and Scandinavians) and those degenerate types (Italians, Jews, Slavs) who were presently flooding American cities. This new migration, Grant believed, constituted an imminent danger to the vitality of "The Great Race" that had historically shaped the contours of American culture and society.

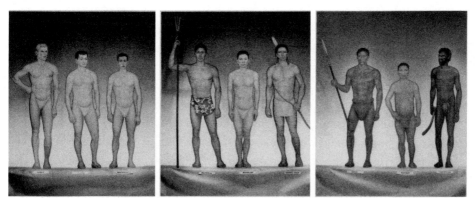

A case from the American Museum of Natural History's Hall of Man, containing models of the different racial types in descending order: Nordic, Alpine, Mediterranean, Polynesian, Mongolian, American Indian, Negro, Bushman, Australian. This exhibit was part of the backdrop for the Second International Eugenics Congress in 1921. FROM THE COLLECTION OF AMERICAN MUSEUM OF NATURAL HISTORY.

The new immigrants were no longer exclusively members of the Nordic race . . . European governments took the opportunity to unload upon careless, wealthy and hospitable America the sweepings of their jails and asylums. The result was that the new immigration, while it still included many strong elements from the North of Europe, contained a large and increasing number of the weak, the broken, the mentally crippled of all races drawn from the lowest stratum of the Mediterranean basin and the Balkans together with hordes of the wretched submerged population of the Polish ghettos. Our jails, asylums, and almshouses are filled with this human flotsam and the whole tone of American life, socially, morally and politically, has been lowered and vulgarized by them.[27]

A second danger Grant identified was the rise of a free black population after the Civil War. While "Negroes," he believed, were capable of being useful members of society when subservient, the raising of blacks to the status of citizenship had generated a grave predicament.

The Negroes in the United States, while stationary, were not a serious drag on civilization until in the last century they were given the right of citizenship and were incorporated in the body politic. . . .

[O]nce raised to social equality their influence will be destructive to themselves and to the whites. If the purity of the two races is to be maintained they cannot continue to live side by side and this is a problem from which there can be no escape.[28]

The impact of the antislavery movement, Grant contended, reached beyond its implications for the "Negroes" and had blurred distinctions over the definition of who is an American in broader terms. "The agitation over slavery was inimical to the Nordic race, because it thrust aside all national opposition to the intrusion of hordes of immigrants of inferior racial value and prevented the fixing of a definitive American type."[29]

Grant's anxieties were built on a staunchly antidemocratic foundation. He argued that the American tradition of democracy was itself contributing to the racial disintegration that vexed superior people like himself. "The tendency in a democracy is toward a standardization of type and a diminution of the influence of genius," he maintained. "A majority must of necessity be inferior to a picked minority and it always resents specialization in which it cannot share."

Madison Grant unabashedly preferred "government by the wisest and best, always a small minority in any population."30

Immigration, however, propelled by the exigencies of American industry, was on the verge of destroying a born race of leaders. The process had been developing for some time, when "the American sold his birthright in a continent to solve a labor problem."

> During the last century the New England manufacturer imported the Irish and French Canadians, and the resultant fall in the New England birthrate at once became ominous. The refusal of the native American to work with his hands when he can hire or import serfs to do manual labor for him is the prelude to his extinction and immigrant laborers are now breeding out their masters and killing by filth and by crowding as effectively as by the sword.31

The promise of citizenship to the incoming horde, along with the granting of the franchise to freed slaves, only intensified the impending disaster. In transferring "power from the higher to the lower races," the Nordic had "intrusted [*sic*] the government of his country and the maintenance of his ideals to races who have never succeeded in governing themselves, much less any one else." In their hands, Grant bemoaned, democracy was giving rise to "its illegitimate offspring socialism," an expanding political tendency among the laboring classes.32 The Protestant values that Grant believed had kept America on keel since the beginning were also on the wane. Immigration was breathing life into "the recrudescence of obsolete religious forms," a clear reference to the influx of Catholic and Jewish immigrants.

Most terrifying of all, Grant believed that immigrants were beginning to blend into the American stock. "They adopt the language of the Native American, they wear his clothes, they steal his name and are beginning to steal his women." This last development would lead to the inevitable mongrelization and disappearance of the Nordic American foundation upon which the glory of the nation had been achieved.

As he contemplated countermeasures, Grant came out strongly for schemes that would diminish the birthrate of the "lower races," and make sexual relations between white Anglo-Americans and other groups a crime. Hybridization, he believed, could only diminish the quality of the European races.

> The cross between a white man and an Indian is an Indian; the cross between a white man and a Negro is a Negro; the cross between a white

man and a Hindu is a Hindu; and the cross between any of the three European races and Jew is a Jew.33

The last of these hybrids was, for Grant, the most ominous. Intermarriages were taking place and the "dwarfish stature, peculiar mentality and ruthless concentration on self-interest" of the Jew was in the process of being "engrafted upon the stock of the nation."34

Facing this inevitable breakdown, Grant advocated the strict enforcement of existing "laws against miscegenation." He also believed that these laws must be "greatly extended" to prohibit other types of sexual union "if the higher races are to be maintained."35

Ultimately, however, the salvation of the higher races required far more severe measures. "The laws of nature," he announced, "require the obliteration of the unfit, and human life is valuable only when it is of use to the community or race." We must, he implored, bring about "the elimination of the least desirable elements in the nation by depriving them of the power to contribute to future generations." The ideal method for this would be for the state to implement "sterilization" policies. These, he wrote, would provide

> a practical, merciful and inevitable solution to the whole problem and can be applied to an ever widening circle of social discards, beginning always with the criminal, the diseased and the insane and extending gradually to types which may be called weaklings rather than defectives and perhaps ultimately to worthless race types.36

Eugenicists, Grant showed, were not simply thinkers; they were doers. By the time Grant's book was published, schemes like those he proposed were already under way. On March 9, 1907, Indiana had enacted the nation's first "compulsory sterilization" law, which permitted "the compulsory sterilization of any confirmed criminal, idiot, rapist, or 'unimprovable' in a state institution whose condition had been determined to be 'unimprovable' by an appointed panel of physicians."37 Other states followed with similar laws, though they proved difficult to enforce.

Responding to the inadequacy of existing laws, Harry Laughlin of the Eugenics Records Office in Cold Spring Harbor published a "Model Eugenical Sterilization Law" in 1914. Laughlin, a notorious advocate of racial cleansing, was a close associate of Madison Grant, Lothrop Stoddard (who would publish *The Rising Tide of Color Against White World Supremacy* in 1920), and

ERO Resident Director Charles Davenport. The model law was intended to
instruct the eugenics movement on the drafting of enforceable legislation, to legal-
ize the obligatory sterilization of "socially inadequate" individuals who were
"maintained wholly or in part by public expense." Included among the inadequate
were the "feebleminded, insane, criminalistic, epileptic, inebriate, diseased, blind,

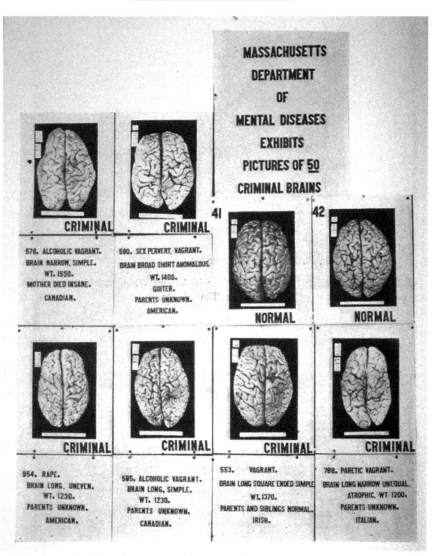

Exhibit from the Second International Eugenics Congress. COURTESY OF THE COLD SPRING HARBOR
LABORATORY ARCHIVES

deaf; deformed; and dependent." It encompassed "orphans, ne'er-do-wells, tramps, the homeless and paupers."38

Yet, despite the fact that by 1924 over six thousand people had been involuntarily sterilized in America, three-quarters of them in California, many state courts had declared state sterilization laws unconstitutional. Amid the height of women's suffrage agitation, the "New Jersey Supreme declared the law unconstitutional because it violated the woman's protection under the equality clause of the Fourteenth Amendment." Elsewhere, judgments based on a lack of due process interfered with the implementation of sterilization laws.39

Frustrated by these setbacks, Laughlin and his colleagues began collaborating with lawmakers in Virginia to devise legislative language that could survive court challenges. Together, they developed legislation based on a newly amended version of Laughlin's Model Sterilization Law. This time, their calculated efforts paid off. The "ACT to provide for the sexual sterilization of inmates of State institutions in certain cases" was passed by the Virginia legislature on March 29, 1924, and signed into law by the governor the following day.

Under the new law, superintendents of state institutions were given the power to recommend sterilization of an inmate or patient if they deemed it beneficial to "the health of the individual patient and the welfare of society." After a petitioning process to a special board, a response to the issue of due process, "the sterilization of metal defectives" had state sanction. According to the law, males were to be sterilized by "the operation of vasectomy," females by "salpingectomy," cutting the Fallopian tubes.

> The said special board may deny the prayer of the said petition or if the said special board shall find that the said inmate is insane, idiotic, imbecile, feeble-minded or epileptic, and by the laws of heredity is the probably potential parent of socially inadequate offspring likewise afflicted, that the said inmate may be sexually sterilized.40

With the deliberately worded Virginia law now in place, the next step for Harry Laughlin was to locate a likely subject whom he and his cohort could use to test the law in the courts. Their goal was to reach the United States Supreme Court, where, if they were successful, forced sterilization would be upheld as the law of the land. The unsuspecting victim of this legal plot was a seventeen-year-old girl named Carrie Buck. Though the girl had a record of being a good student, she was the offspring of a woman who came from that portion of the Southern population commonly referred to as poor white trash.

Carrie's mother, Emma, was a woman with a sordid reputation. An outcast in the community of Charlottesville, she had what authorities described as "a record of immorality, prostitution, untruthfulness and syphilis." Such moral judgments were underwritten by the fact that Carrie was an "illegitimate" child.[41] Defined by the respectable establishment as one of "the shiftless, ignorant, and moving class of people," Emma was diagnosed "feeble-minded" and sent, in 1920, to the Virginia Colony for Epileptics and Feeble-minded in Amherst County. Emma was one of many who inherited this fate. The historian Edwin Black recounts, "It was not unusual for Virginia to use its Colony for Epileptics and Feeble-minded as a dumping ground for those deemed morally unsuitable. Classifying promiscuous women as morons was commonplace." Dr. Albert Priddy, superintendent of the Virginia Colony during the years in question, acknowledged this openly: "The admission of female morons to this institution has consisted for the most part of those who would formerly have found their way into the red light district and become dangerous to society."[42]

When Carrie Buck was three, she was taken away from her mother and went to live with the family of a local police officer, J. T. Dobb. When she was seventeen, her caretaker family discovered that she was pregnant. The only record in which Carrie was able to tell her own story was in her unheeded assertion that Dobb's nephew had "forced himself on me."[43]

The Dobbs dismissed her claim, blaming Carrie alone for her shameful state. Believing that the apple never falls too far from the tree, her irate guardians had her committed to the Virginia Colony for Epileptics and Feeble-minded, where her mother was already an inmate. Given her origins and her pregnancy out of wedlock—in an era when such occurrences were seen as a sign of moral depravity—Carrie had no social leverage with which to defend herself. When she entered the institution, there was no official record of her contention that her foster parents' nephew had raped her. Sitting unaware, she was about to become a perfect guinea pig for testing the Virginia Law.

Albert Priddy, head doctor at the Virginia Colony, was himself a eugenicist

Carrie Buck and her mother, Emma. FROM THE COLLECTION OF THE ARTHUR ESTABROOK PAPERS, M. E. GRENANDER DEPARTMENT OF SPECIAL COLLECTIONS AND ARCHIVES, UNIVERSITY AT ALBANY

298

and closely associated with Harry Laughlin. Believing that the population of immoral women in Virginia was becoming too large to handle, Priddy saw eugenic sterilization as a desirable social solution. Stalking his asylum for a likely test case, he decided that Carrie, a fallen woman and the child of a feeble-minded woman, was the ideal candidate.

Shortly after the passage of the Virginia law, which he had helped to draft, Priddy declared that Carrie, her mother, and even her seven-month-old baby, Vivian, were feeble-minded or, in the case of the baby, "not quite normal." He recommended that Carrie be sterilized to bring an end to a bloodline of degenerates. "I arrived at the conclusion that she was a highly proper case for the benefit of the Sterilization Act, by a study of her family history; personal examination of Carrie Buck; and subsequent observation since admission to the hospital."44

Madison Grant, author of *The Passing of the Great Race*, was an unseen engineer of the anti-immigration legislation that passed in 1924. He was also responsible, earlier in the century, for placing Ota Benga in the Bronx Zoo.

In September 1924, the Colony Review Board upheld Priddy's recommendation. "Carrie is feeble-minded," the Board found, "and by the laws of heredity is the probably potential parent of socially inadequate offspring likewise afflicted. . . . [H]er welfare and that of society will be promoted by her sterilization."45 With this, the outrage continued to unfold.

Irving Whitehead, a founder of the Virginia Colony and himself a staunch eugenicist, was assigned the role of being Carrie's ostensible champion, cynically coming to her defense in order to launch a premeditated legal battle. Meanwhile, "expert" witnesses against Carrie were encouraged by Priddy to study up on the literature of heredity and degeneracy. The Jukes and The Kallikak families, he believed, would provide a credible scientific ancestry into which Carrie, her mother, and her daughter could be placed.46

After losing at her first trial and in a subsequent appeal at the state level, Carrie had her case reviewed by the United States Supreme Court (*Buck* v. *Bell*) in the fall of 1926. In a shameful ruling that vindicated eugenics, the Supreme Court dignified the movement with the highest level of respectability. Delivering the 8 to 1 majority decision on May 27, 1927, Associate Justice Oliver Wendell Holmes, Jr., determined:

> We have seen more than once that the public welfare may call upon the best citizens for their lives. It would be strange if it could not call

upon those who already sap the strength of the State for these lesser sac-
rifices . . . in order to prevent our being swamped with incompetence. It
is better for all the world, if instead of waiting to execute degenerate off-
spring for crime, or let them starve for their imbecility, society can pre-
vent those who are manifestly unfit from continuing their kind. The
principle that sustains compulsory vaccination is broad enough to cover
cutting the Fallopian tubes.

He concluded with the words "Three generations of imbeciles are enough."[47]
These stinging words were a reference to Carrie's family, but they also encapsu-
lated the social outlook of the eugenics movement more generally. Such eugeni-
cists as Madison Grant maintained that, for a period of three generations—sixty
years, beginning with the end of the Civil War—the noble American racial stock
had been contaminated by an inundation of defective lineage: low-grade Euro-
peans and emancipated African Americans. Beyond sealing Carrie's fate, the
Court's decision provided the legal foundation for using sterilization as a tool for
stemming this three-generational tide of alleged imbecility.

On the morning of October 19, 1927, Carrie Buck became the first person
sterilized under the Virginia law, setting off a rash of involuntary sterilizations
throughout the United States. In short shrift, thirty states would have steriliza-
tion laws amended to follow Laughlin's Virginia model. Sterilization would
routinely be employed in the name of halting the propagation of "the unfit."
Between 1907 and 1968, an estimated sixty thousand forced sterilizations would
take place in the United States. Eugenic sterilization practices would also be
exported to America's new colonial holdings, most notably Puerto Rico, where
one-third of the female population was sterilized between the 1920s and 1965.[48]

Equally disturbing was the impact of American sterilization laws in Europe,
Germany in particular. In a personal note to Madison Grant, Hitler referred to
The Passing of the Great Race as his "Bible," and Laughlin's model law provided the
basis for the Third Reich's Sterilization Law, passed in 1934. In Nazi Germany,
350,000 unwilling subjects would eventually go under the surgeon's knife. In
1936, in gratitude for Laughlin's contributions to the purification of the Aryan
race, the University of Heidelberg gave him an honorary doctorate.[49] Lothrop
Stoddard, whose books direly portrayed widespread threats to the Aryan race
and had been featured in Nazi educational materials, visited Berlin in 1940 and
was escorted around town by the Reich's minister of propaganda, Joseph
Goebbels. He also was granted an exclusive interview with the Führer himself.
It is worth adding that Rockefeller money, which had been so important in the

Notice the sample sentence:

People hear with the eyes <u>ears</u> nose mouth

The correct word is ears, because it makes the truest sentence.

In each of the sentences below you have four choices for the last word. Only one of them is correct. In each sentence draw a line under the one of these four words which makes the truest sentence. If you can not be sure, guess. The two samples are already marked as they should be.

SAMPLES { People hear with the eyes <u>ears</u> nose mouth
{ France is in <u>Europe</u> Asia Africa Australia

1 The apple grows on a shrub vine bush tree............................ 1
2 Five hundred is played with rackets pins cards dice.............. 2
3 The Percheron is a kind of goat horse cow sheep............... 3
4 The most prominent industry of Gloucester is fishing packing brewing automobiles.. 4
5 Sapphires are usually blue red green yellow...................... 5

6 The Rhode Island Red is a kind of horse granite cattle fowl........ 6
7 Christie Mathewson is famous as a writer artist baseball player comedian.......... 7
8 Revolvers are made by Swift & Co. Smith & Wesson W. L. Douglas B. T. Babbitt. 8
9 Carrie Nation is known as a singer temperance agitator suffragist nurse.......... 9
10 "There's a reason" is an "ad" for a drink revolver flour cleanser................ 10

11 Artichoke is a kind of hay corn vegetable fodder......................... 11
12 Chard is a fish lizard vegetable snake.............................. 12
13 Cornell University is at Ithaca Cambridge Annapolis New Haven.................. 13
14 Buenos Aires is a city of Spain Brazil Portugal Argentina.................. 14
15 Ivory is obtained from elephants mines oysters reefs.................. 15

16 Alfred Noyes is famous as a painter poet musician sculptor.................. 16
17 The armadillo is a kind of ornamental shrub animal musical instrument dagger..... 17
18 The tendon of Achilles is in the heel head shoulder abdomen.............. 18
19 Crisco is a patent medicine disinfectant tooth-paste food product.............. 19
20 An aspen is a machine fabric tree drink........................ 20

21 The sabre is a kind of musket sword cannon pistol..................... 21
22 The mimeograph is a kind of typewriter copying machine phonograph pencil....... 22
23 Maroon is a food fabric drink color............................ 23
24 The clarinet is used in music stenography book-binding lithography............. 24
25 Denim is a dance food fabric drink......................... 25

26 The author of "Huckleberry Finn" is Poe Mark Twain Stevenson Hawthorne...... 26
27 Faraday was most famous in literature war religion science............. 27
28 Air and gasolene are mixed in the accelerator carburetor gear case differential...... 28
29 The Brooklyn Nationals are called the Giants Orioles Superbas Indians............ 29
30 Pasteur is most famous in politics literature war science................. 30

31 Becky Sharp appears in Vanity Fair Romola The Christmas Carol Henry IV........ 31
32 The number of a Kaffir's legs is two four six eight................... 32
33 Habeas corpus is a term used in medicine law theology pedagogy....... 33
34 Ensilage is a term used in fishing athletics farming hunting................ 34
35 The forward pass is used in tennis hockey football golf............ 35

36 General Lee surrendered at Appomattox in 1812 1865 1886 1832................. 36
37 The watt is used in measuring wind power rainfall water power electricity.......... 37
38 The Pierce Arrow car is made in Buffalo Detroit Toledo Flint.................. 38
39 Napoleon defeated the Austrians at Friedland Wagram Waterloo Leipzig.......... 39
40 An irregular four-sided figure is called a scholium triangle trapezium pentagon..... 40

Plate VIII. Alpha Test 8: Information (Form 8).

A page from Yerkes's U.S. Army Alpha IQ test. REPRINTED FROM C. C. BRIGHAM'S *A STUDY OF AMERICAN INTELLIGENCE, 1923.*

Plate XIV. Beta Test 6: Picture Completion.

A page from Yerkes's U.S. Army Alpha IQ test. REPRINTED FROM C. C. BRIGHAM'S *A STUDY OF AMERICAN INTELLIGENCE, 1923.*

development of the eugenics movement in the United States, also provided seed money for eugenic research under the Nazis.⁵⁰

While the Supreme Court decision put the ultimate stamp of approval on the eugenics agenda, the social respectability of eugenics in the United States had been growing for some time. By 1912, as we have seen, IQ testing at Ellis Island

was being used to screen out "defectives" among incoming immigrants. Then, in 1917, as the United States prepared to enter into the First World War, eugenic practices received further government sanction. Headed by the Harvard psychology professor Robert M. Yerkes, an illustrious group of eugenicist testing experts gathered at Henry Goddard's Vineland facility to devise an IQ test to be given to all new recruits. Now enlisted at the rank of Colonel, Robert Yerkes proceeded to supervise the testing of two million American draftees.

If taken as gospel, the results of the Army testing offered a troubling snapshot of the intelligence level of the nation overall. Among new recruits, the test revealed, nearly half qualified as "morons." Stephen Jay Gould presents a chilling assessment of the Army test results: "The average mental age of white American adults stood just above the edge of moronity at a shocking and meager thirteen." African American soldiers, as measured by the test, showed an "average mental age of ten."

Among immigrant soldiers, the test results indicated, "the average man of many nations is a moron," with the lowest mental ages assigned to Southern and Eastern European conscripts. Regarding Jews, one of the testing team triumphantly reported, "our figures . . . tend to disprove the popular belief that the Jew is highly intelligent."[51]

The testing instrument itself made such results almost inevitable. Questions presumed that intelligence could be measured in terms of one's familiarity with an American middle-class education, lifestyle, and set of beliefs. In a society in which many still lived without electricity, a question such as, "The watt is used in measuring wind power, rainfall, water power, electricity?"

What chance is there of justice with this jury?

OUR DEFECTIVE JURY SYSTEM.

Images like these portrayed an influx of immigrants and free blacks as a threat to American institutions. Such portrayals gave support to Jim Crow law and helped lay the path toward anti-immigration legislation. REPRINTED FROM *JUDGE MAGAZINE*, CIRCA 1915; COURTESY OF STEVEN HELLER

favored those whose lives were already electrified and who had achieved a certain level of science education. Similarly, a question asking whether "air and gasoline 303 are mixed in the accelerator, carburetor, gear case, differential" would have been impenetrable for the majority of the population that still had no first-hand experience with automobiles. Specialized knowledge of science and technology, economic geography, and American history and literature served as a persistent index of intelligence on the test. Knowing the meaning of "ensilage," for example, required experience in large-scale farming. Knowing the primary industry of Gloucester entailed a detailed knowledge of New England's economy.

Another question, asking whether the phrase "There's a reason" comes from an "'ad' for a drink, revolver, flour, [or] cleanser?" relied on a test-taker's fluency with the slogans of a nascent consumer culture, an exper-tise that poor people, particularly immigrants, had little access to. Draftees were also asked if Crisco was "a patent medicine, disinfectant, toothpaste, [or] food product?" Those still accustomed to homemade shortening—lard, chicken fat, butter, and olive oil—were at a clear disadvan-tage.

Harry Laughlin. FROM THE COLLEC-TION OF THE AMERICAN PHILOSOPHICAL SOCIETY

Detailed knowledge of white-dominated major league baseball, or the rules of football, also qualified as a sign of intelligence. Still other questions, such as, "The number of a Kaffir's legs is: 2, 4, 6, [or] 8," assumed that familiarity with Western European ethnographic terminology was a mark of aptitude, as opposed to education and cultural bias. As one of test designers explained, in defense of the testing instrument, "If a person . . . knows what a Zulu, or a Korean, or a Hottentot, or a Kaffir, or a Papuan is, he very obviously knows the number of his legs."[52] For those soldiers unable to read, a visual test—with a similar predisposition—was administered. In both cases results were a fait accompli.

Testers cited the skewed outcome that flowed from these tests as providing objective proof of America's impending demise. If, in the past, facial angle, physiognomy, and pedigree served to validate conceits of human inequality, IQ testing helped to install a tyranny of numbers that bore no relation to any observable physical quality or family history. Measures of IQ rested purely on a blind faith that the tests were impartial. Though announced with grim faces, the widely circulated Army test results were a godsend for the eugenics movement, and anti-immigration forces in particular.

Henry Fairfield Osborne, Director of the American Museum of Natural His-

304

tory, callously summarized the eugenics movement's perspective on the allegedly indisputable value of the Army IQ test and its findings.

> I believe these tests were worth what the war cost, even in human life, if they served to show clearly to our people the lack of intelligence in our country, and the degrees of intelligence in different races who are coming to us, in a way which no one can say is the result of prejudice . . . We have learned once and for all that the negro is not like us. So in regard to many races and subraces [*sic*] in Europe we learned that some which we had believed possessed of an order of intelligence perhaps superior to ours were far inferior.[53]

Beyond the bugaboo of mental age, another factor that fueled the popularity of eugenics among middle- and upper-class Americans was the growing politi-

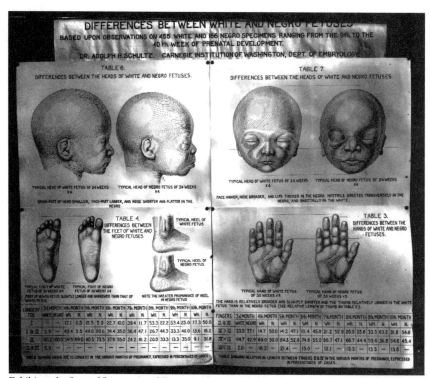

Exhibit at the Second International Eugenics Congress held at the American Museum of Natural History. FROM THE COLLECTION OF THE AMERICAN MUSEUM OF NATURAL HISTORY.

cal divides between themselves and the working classes. Before and throughout
the war, many poorly paid laborers, foreign-born as well as native, were actively 3°5
engaged in anticapitalist politics. Socialist, communist, and anarchist ideas were
circulating in response to an economic system that blatantly benefited the rich and

Exhibit at the Second International Eugenics Congress. FROM THE COLLECTION OF THE AMERICAN MUSEUM OF
NATURAL HISTORY.

306 "well-born." When the Russian Revolution took place in the fall of 1917, the perceived danger, particularly of America's huge immigrant population—nearly half the people in the United States were immigrants or children of immigrants—took on a new sense of urgency. Many immigrant radicals were deported during the war, under the direction of Attorney General A. Mitchell Palmer. Still, after the war, the "immigrant problem" persisted in the minds of many.

When, in the autumn of 1921, some of Europe and America's most upright luminaries gathered at the American Museum of Natural History for the Second International Congress of Eugenics, revulsion over Army test results, along with a growing anxiety over immigrants and their politics, weighed heavily on the delegates' august minds.

American Museum of Natural History President Henry F. Osborne greets Leonard Darwin, Charles Darwin's son, at the Second International Eugenics Congress. FROM THE COLLECTION OF THE AMERICAN MUSEUM OF NATURAL HISTORY.

Leaders of the Congress were America's principal advocates of scientific racism, eugenic sterilization, and restrictive immigration legislation. They included AMNH Director Henry Osborne, president of the Congress; Madison Grant, treasurer; Lothrop Stoddard, publicity officer and author of *The Rising Tide of Color Against White Supremacy*; and Harry Laughlin, director of exhibits. Laughlin's exhibits were graphic and sensationalistic, calculated to offer visible evidence of human inequality. One exhibit included plaster-of-Paris fetuses—some white, some black—and argued that unborn black children are markedly less intelligent than unborn whites.[54]

Delegates to the Congress included future President Herbert Hoover, Alexander Graham Bell, Charles Darwin's son Leonard, and Gifford Pinchot, governor of Pennsylvania. Delegations included those from France, England, Italy, Belgium, Czechoslovakia, Norway, Sweden, Denmark, Japan, Mexico, Cuba, Venezuela, India, Australia, and New Zealand, an indication of the far-reaching influence of eugenic thought. For differing political reasons, Germany and the Soviet Union were not invited to the conference, but the writings of American eugenicists were already finding an avid readership in both countries. In Germany, in particular, this notion was gaining adherents through the translated works of Grant, Stoddard, and Laughlin.

Many of the papers delivered at the Congress offered current scientific think-
ing on relatively arcane biological issues. These included meiosis, genetic anoma- 307
lies in fruit flies, and heredity in single-celled organisms. More importantly,
however, the Congress provided a bully pulpit for screeds against miscegenation
and the contamination of the American racial stock by wretched races of people.

Osborne and Grant began laying the political foundation for this antiblack,
anti-immigrant emphasis when they founded the Galton Society in 1918. The
Society, which met monthly at the Museum, was limited to an "old stock" mem-
bership. Delineating the group's racial covenant, Grant proposed the establish-
ment of the Galton Society in the following terms:

> My proposal is the organization of an anthropological society . . . with a
> central governing body, self elected [sic] and self perpetuating, and very
> limited in numbers, and also confined to native Americans who are anthro-
> pologically, socially, and politically sound, no Bolsheviki need apply.[55]

The primary objective of the group was to close down immigration from East-
ern Europe, Italy, and Japan, the latter a target of resentment on the West Coast.
At Galton Society meetings, members elaborated anti-immigration arguments,
using Army IQ testing data, and started to prepare testimony to be given when anti-
immigrant legislative action unfurled. Osborne and Grant brought the results of
these deliberations to the floor of the Eugenics Congress when it convened.

Osborne revealed this fiercely anti-immigration agenda as he delivered his
keynote address to the Congress on September 22, 1921:

> We are engaged in a serious struggle to maintain our historic republican insti-
> tutions through barring the entrance of those who are unfit to share the
> duties and responsibilities of our well-founded government . . .
> The true spirit of American democracy that all men are born with
> equal rights and duties has been confused with the political sophistry that
> all men are born with equal character and ability to govern themselves.

Reiterating the eugenic doctrine that educational and environmental influences
could not turn a pig into a horse, he proclaimed that, in order for eugenical fit-
ness to be restored and for American values to be upheld, the influx of bad blood
had to be stemmed. "As science has enlightened government in the prevention
and spread of disease, it must also enlighten government in the prevention of the
spread and multiplication of worthless members of society."[56]

308

In order to disseminate the ideas driving the Second International Congress of Eugenics, graphic materials from Harry Laughlin's exhibits were sent to members of the Senate and House of Representatives. Eugenics Congress leaders believed that these would arm sympathetic legislators in a congressional debate over the admission of foreigners that was already under way. As anti-immigration legislation began to be drafted, these materials were prominent in the House Immigration Committee's hearing rooms.57

The Chair of the Committee, Republican Rep. Albert Johnson from the State of Washington, needed no convincing. Since he ran for Congress in 1912, he had been an outspoken denunciator of the foreign-born, particularly following an attempt by the radical Industrial Workers of the World (IWW) to organize lumbermen in his region. He was also a close friend of Madison Grant and subscribed to Grant's eugenic theories. As the committee deliberations moved forward, he called on Grant and Laughlin to provide expert testimony, and in the year leading up to the passage of what would be generally known as the Johnson Immigration Bill, he served as honorary chairman of the Eugenics Research Association.

Representing a majority of the rank and file of America's political leadership, eugenics proponents were hardly an "outside lobby." These leaders, like Grant, and many other "respectable" citizens, argued that immigrants were hereditarily incapable of participating in a democracy and that immigration restriction was essential in order to preserve the Nordic stock of society.

A stunning example of the reach of this outlook is evidenced in a 1921 editorial written for *Good Housekeeping* magazine by the vice president of the United States—soon to be president—Calvin Coolidge. Entitled "Whose Country Is This?", Coolidge's editorial argued that many new immigrants were constitutionally incapable of assuming the responsibilities of citizenship and should be excised from society.

> American liberty is dependent on quality in citizenship. Our obligation is to maintain that citizenship at its best. We must have nothing to do with those who would undermine it. The retroactive immigrant is a danger in our midst. His discontent gives him no time to seize a healthy opportunity to improve himself. His purpose is to tear down. There is no room for him here. He needs to be deported, not as a substitute for, but as a part of his punishment.

Beyond deportation, Coolidge maintained, protection against retroactive

immigrants must be exercised before anyone is permitted to migrate to the
United States.

> We might avoid this danger were we insistent that the immigrant,
> before he leaves foreign soil, is temperamentally keyed for our national
> background. There are racial considerations too grave to be brushed
> aside for any sentimental reasons. Biological laws tell us that certain
> divergent people will not mix or blend. The Nordics propagate them-
> selves successfully. With other races, the outcome shows deterioration
> on both sides. Quality of mind and body suggests that observance of
> ethnic law is as great a necessity to a nation as immigration law.

The long-term vitality of the United States, Coolidge argued, depended on
the nation's ability to restrict the influx of unsuitable immigrants.

> We must remember that we have not only the present but the future to
> safeguard; our obligations extend even to generations yet unborn. The
> unassimilated alien child menaces our children, as the alien industrial
> worker, who has destruction rather than production in mind, menaces our
> industry . . . The dead weight of an alien accretion stifles national
> progress. But we have a hope that cannot be crushed; we have a back-
> ground that we will not allow to be obliterated. The only acceptable
> immigrant is the one who can justify our faith in man by a constant rev-
> elation of the divine purpose of the Creator.[58]

If Coolidge voiced the outlook of the mainstream, there was some notable
opposition in Congress and at well-attended antirestriction rallies. Giving voice
to those targeted by the Johnson-Reed Act, at one rally Rabbi Stephen Wise of
New York protested that "the Nordic Race [was] devised to prove its [own] supe-
riority, and in order to prove the inferiority of some of the great races of the
earth which are unacceptable to the inventors of the Nordic." Opposition, as in
Wise's case, came primarily from people who were themselves of "new" immi-
grant backgrounds, easy for old-line Americans to ignore or dismiss. In
Congress, the New York delegation led a fight against restriction, but here too,
its spokesmen were "new" Americans—Fiorello LaGuardia, Nathan Perlman,
and Samuel Dickstein.[59]

The Johnson Bill passed by overwhelming margins in both houses. It limited
the migration of Jews, Italians, and Slavs to 2 percent of the 1890 rate of arrival, turn-

ing back the clock and thus favoring the migration of "Nordic" types. Taking sides with white farmers against Japanese farmers on the West Coast, the Act halted all immigration from Japan. There was no need to exclude the Chinese; their entry had already been barred in 1882. In 1924, when President Calvin Coolidge signed the Johnson Bill into law, he blessed it with the words, "America must be kept American."[60] The spigot had all but closed.

While there were significant, if politically marginalized, voices that questioned eugenic policies and concepts, eugenics had become mainstream thinking in America. Even Margaret Sanger, the progressive founder of the modern birth control movement, linked the mission of contraception to that of eugenics in the 1920s, hoping to broaden her base. While she believed that some of the movement's ideas were stodgily Victorian or "inspired by class . . . and sex bias," the bedrock language of eugenical thinking was permeating her vocabulary. Her 1922 book, *Pivot of Civilization*, contained an introduction by H. G. Wells, the science-fiction writer and well-known eugenicist. In the book, Sanger declared "the lack of balance between the birth-rate of the 'unfit' and the 'fit,' [to be] admittedly the greatest present menace to the civilization."[61]

In her fourth chapter, entitled "The Fertility of the Feeble-Minded," she began with a forceful polemic, stating:

> There is but one practical and feasible program in handling the great problem of the feeble-minded. That is, as the best authorities are agreed, to prevent the birth of those who would transmit imbecility to their descendants. Feeble-mindedness as investigations and statistics from every country indicate, is invariably associated with an abnormally high rate of fertility. Modern conditions of civilization, as we are continually being reminded, furnish the most favorable breeding-ground for the mental defective, the moron, the imbecile.[62]

Writing a guest editorial for *Collier's* magazine in 1925, Sanger described the imperative need for action. "We are spending billions, literally billions," she wrote, "keeping alive thousands who never in all human compassion, should have been brought into this world. We are spending more in maintaining morons than developing the inherent talents of gifted children. We are coddling the incurably defective, and neglecting potential geniuses." To dramatize her point, she quoted the distinguished California botanist, Luther Burbank, who had been, along with Henry Osborne, a founder of the Eugenics Committee of the American Breeders Association in 1906:

America . . . is like a garden in which the gardener pays no attention to the weeds. Our criminals are our weeds, and weeds breed fast and are intensely hearty. They must be eliminated. Stop permitting criminals and weaklings to reproduce. All over the country to-day we have enormous insane asylums and similar institutions where we nourish the unfit and criminal instead of exterminating them. Nature eliminates the weeds, but we turn them into parasites and allow them to reproduce.[63]

If Galton had seen society as a garden that needed to favor its finest flowers, Burbank's vision evoked a field overrun with crabgrass, desperately in need of selective defoliation.

Sanger was frustrated by the eugenics leadership's refusal to accept "birth control," as she coined it, as an effective eugenic tool. Stuck in a vision of womanhood that fixated on a healthy middle-class woman's obligation to give birth to a large family, men such as Grant, Osborne, Davenport, and Laughlin, who believed that Anglo-American women held the future of the race in their loins, found the idea of contraception to be anathema. Sanger argued with the leadership over this issue, and she successfully brought Lothrop Stoddard to her side. Nonetheless, throughout the 1920s she, along with many of her generation of intellectuals and social reformers, supped with the eugenics movement. When it came to hereditary thinking, Madison Grant and his associates continued to represent the prevailing worldview.

One shining exception to the academic hegemony of eugenics was the anthropologist Franz Boas. Early in his career, Boas had contributed, if inadvertently, to American racialist attitudes. At the Columbian Exposition, he brought peoples from around the world to inhabit model villages on the fair grounds. He hoped these exhibits would educate fairgoers and counteract the narrow condescension with which many Americans viewed people from non-Western cultures. When he discovered that the people in his exhibits had become part of a bizarre sideshow, he was outraged at having participated in their public humiliation.

His anthropological work from then on represented a fierce effort to discredit scientific racism. On a methodological level, he questioned Galton's anthropometric approach that served as an underpinning for eugenics. If Galton believed that anthropometric studies revealed ideal types, congregating around "average" percentiles, Boas argued that averages "have no meaning whatsoever." Intermixing of one kind or another, he argued, is common and ongoing. In the process, it is variety rather than type that best describes a population. "Whenever [an average] has been applied," he maintained, "it has proved to be misleading inso-

far as it suggests always that a certain percentile grade represents certain groups of individuals." In short, for Boas statistics were often employed to promulgate a convenient fiction.[64]

Invariably, such heresies against prevailing ethnographic dogma put Boas at odds with American eugenicists from early on. Rejecting Ripley and Grant's assertion that a person's race could be determined through measurement of the cephalic index (the ratio of the breadth of the head to its length, expressed as a percentile), Boas undertook a study of immigrants and their children that threw this scientific faith into question. With support from the United States Immigration Commission, he carefully measured the length and width of more than seventeen thousand subjects' heads. When he computed their cephalic indexes, Boas revealed that, according to his calculations, American-born children of immigrants had larger cephalic numbers than their parents. Environment, climate, and nutrition, it seemed, were variables unaccounted for by the rigid assumptions of racial science. When he published his findings in *Changes in Bodily Form of Descendants of Immigrants*, the budding eugenics movement saw it as an act of war.[65] Madison Grant attacked his evidence, which he defined as "Melting Pot" theory, as the work of a Jew defending the Jews.[66] Grant's book, *The Passing of the Great Race*, was, in large part, a broadside against Boas's idea of adaptation and change.

Boas saw differences among people, not in terms of biologically determined hierarchy, but as the products of history and circumstance. He believed in the intrinsic equality of humankind and sought to look into the ways that shared experience, over time, explained the variety of cultures. While this view—as advanced by his students Margaret Mead, Zora Neal Hurston, Ruth Benedict, Ashley Montagu, and others—would eventually provide the groundwork for modern anthropology, in the 1920s, Boas was a lone voice. Despite his continuing work, and his contention that eugenic ideas were dangerous—particularly coming from such imposing institutions as the American Museum of Natural History—eugenics in America continued to prosper. Ideas about inherent racial inequality, aimed at recent immigrants and African Americans, would persist in shaping the agendas of hereditary science and government policy. These ideas also framed the eugenicists' dismissal of Boas. As Lothrop Stoddard sneered at the congressional hearings on immigration and naturalization, Boas's work was simply "the desperate attempt of a Jew to pass himself off as 'white.'"[67]

22
EUGENICS GOES TO THE FAIR

Advocates of sterilization, immigration restriction, and—in Margaret Sanger's case—contraception all understood eugenics as a tool for discarding undesirables from the human stock. The measures they installed were designed to eradicate the threat posed by the "morons" in their midst. Yet alongside this preemptive approach, the 1920s also saw the flowering of another side of eugenics, one that transformed the practice of self-conscious breeding into an "educational" form of family fun.

To some extent, this development traced back to 1915 and the San Francisco Panama Pacific Exposition. As planning for the fair moved forward, members of an organization known as the Race Betterment Foundation—created in 1906 by Dr. John Harvey Kellogg, the cereal tycoon—saw a golden opportunity to promote eugenics in the public mind. In 1914, the Foundation had held its First National Conference on Race Betterment in Battle Creek, Michigan, the headquarters of Kellogg's cereal business. At that conference, in his presidential address, Dr. Kellogg called for the establishment of contests, which would offer prizes for the "finest families and the best health and endurance records." He also called for the creation of a "Eugenics Registry Office . . . to establish a race of human thoroughbreds."[1]

A year later, Kellogg saw the San Francisco Exposition as an ideal venue for bringing his ideas to a wider audience. He and his Race Betterment colleagues proposed that the fair, which was slated to highlight a potpourri of recent social, political, and economic developments, become the site for a Second National Conference, which could draw fairgoers into discussions of how best to improve the racial stock of America. In conjunction with the conference, a Race Betterment Exhibit was to be set up in the Palace of Education, contrasting images of degenerate stock with those of ideal humanity, represented by reproductions of Greek statuary, including, of course, the Apollo.[2]

The home state of Luther Burbank, California was already a major center of eugenic thinking, and organizers were thrilled by the prospect of housing the conference and exhibit. As a formal tribute to the eugenic imagination, they declared one week of the fair's duration "Race Betterment Week."

Attendance at the Race Betterment Conference was astounding; more than ten thousand people came. The Race Betterment Exhibit Booth was also a magnet of attention. Members of the Race Betterment Foundation, including Leland Stanford, the railroad

314

magnate and founder of Stanford University, and Stanford's president, David Starr Jordan, were thrilled at the success of their efforts.[3]

The central purpose of the Race Betterment presence at the San Francisco Exposition was to initiate the development of a "eugenic registry," which would record people's pedigrees and provide a database that could be used to arrange eugenical marriages that would bear high-quality offspring. Interviewed by the *San Francisco Chronicle*, Kellogg suggested that contests could be held, and awards given to the fittest of families.[4]

Medal given to Fitter Family Contest winners.
COURTESY OF THE COLD SPRING HARBOR LABORATORY ARCHIVES

This idea would take hold dramatically during the 1920s and 1930s, the heyday of American eugenics. During the 1920s, Fitter Families for Future Firesides contests, or Fitter Family Contests, as they were generally called, became a fixture at state and local fairs around the United States. Organized by the American Eugenics Society, founded in 1916, these contests sought to engage white, rural, native-stock families in the eugenic mission. State and county fairs had long provided venues where excellence in breeding was competitively judged. The Family Fitness contests simply extended the practice to humans. Mary T. Watts and Dr. Florence Brown Sherbon of the University of Kansas organized the first contest, which was held at the Kansas Free Fair in 1920.

Sherborn's inspiration for the contest was driven by what she saw as a glaring contradiction among farm families of the region. "No farmer," she wrote, "will breed his stock to scrubs, but too often he sanctions the marriage of his children to members of scrub families." Watts described her vision of the event in more positive terms, explaining, "We say, while the stock judges are testing the Holsteins, Jerseys, and whitefaces in the stock pavilion, we are judging the Joneses, Smiths, & the Johns."[5]

Following Watts's logic, Fitter Family contests were held in "human stock" pavilions. The contests simply asked rural and small-town families to apply to their children the care with which farmers bred their livestock and crops. This sensibility is palpable in a poem by Rose Trumball of Scottsdale, Arizona, that

appeared in the guide book to the 1920 Kansas Free Fair. Posing an acerbic challenge to the Kansas farm population, it was entitled "To the Men of America." 315

> You talk of your breed of cattle,
> And plan for the higher strain;
> You double the food of the pasture,
> And keep up the measure of grain;
> You draw on the wits of the nation,
> To better the barn and the pen;
> But what are you doing, my brothers,
> To better the breed of men?
>
> You boast of your Morgans and Herefords,
> Of the worth of the calf or a colt,
> And scoff at the scrub and the mongrel,
> As worthy a fool or a dolt;
> You mention the points of your roadster,
> With many a 'wherefore' and 'when',
> But ah, are you conning, my brothers,
> The worth of the children of men?
>
> And what of your boy—Have you measured
> His needs for a growing year?
> Does your mark, as his sire, in his features,
> Mean less than your brand on the steer?
> Thoroughbred—that is your watchword
> For stable and pasture and pen—
> But what is your word for the homestead?
> Answer, you breeders of men![6]

In preparation for each Fitter Family Contest, a group of eugenics examiners collected family histories. Following this task, a second group of examiners including doctors, pediatricians, ear-nose-throat specialists, dentists, psychologists, and evaluators of physical structure tested each member of the family in a variety of areas. Medical and psychological profiles were drawn up on special forms, designed for the occasion. Eugenic quality was then noted according to an A, B, C, D, and F scale.

Contests were held in a variety of categories: "Most Eugenic Baby," "Best

Couple," and "Best Family" contests held in small (one child), medium (two to four children) and large (five or more children) family competitions. Individual contestants and families in each category also posed before judges and were photographed, sometimes in swimsuits, to provide visual evidence of their pedigree. Winners received silver trophies, and stories about them were a regular front-page feature in local and regional newspapers. All families and individuals with a B+ or higher rating in "eugenics" received a bronze medal with the inscription, "Yea, I have a goodly heritage."

To advance their cause, the American Eugenics Society (AES) employed many of the modern publicity tactics that were rapidly taking hold in the United States during the 1920s. The contests themselves were calculated to be "newsworthy" public events, inviting coverage. The AES also cultivated contacts to ensure that contest plans, schedules, and the names of winners were disseminated across the nation by the Associated Press, and stories were picked up in "leading state papers" and in smaller "farm and home papers."

"Opinion leaders," as public relations wizard Edward Bernays labeled them

Fitter Family Contest winners, large-family category. FROM THE COLLECTION OF THE AMERICAN PHILOSOPHICAL SOCIETY

in the 1920s, were also targeted as vehicles for building the eugenics movement and Fitter Family contests. Letters were sent to "executive officers of medical and other organizations." Public health nurses and local health commissioners were also instructed on the value of eugenic breeding.[7] Religious leaders of "fit" communities were provided with materials promoting the cause of human husbandry.

Contest results were also sent to teachers of sociology and biology in state secondary schools and colleges, with the intention of carrying the eugenic version of "survival of the fittest" into the classroom.[8] Steven Selden, professor of education at the University of Maryland, reports that such efforts were extremely successful in schools throughout the United States.

> By 1928, eugenics was a topic in 376 separate college courses, which enrolled approximately 20,000 students. A content analysis of high school science texts published between 1914 and 1948 indicates that a majority presented eugenics as a legitimate science. These texts embraced Galton's concept of differential birth rates between the biological 'fit' and 'unfit,' training high school students that immigration restriction, segregation, and sterilization were worthy policies to maintain in American culture.[9]

Although Clarence Darrow, in 1926, wrote a scathing critique of eugenics in *The American Mercury*, the science textbook that his famous defendent—John Thomas Scopes—used in the science classes he taught contained a sizeable body of material that presented eugenics as valid scientific knowledge.[10] If Darrow, himself, was a vocal critic of eugenics, his client was not. Scopes's textbook, George William Hunter's *Civic Biology—Presented in Problems*, linked evolutionary science with discussions of five unequal races of mankind. Hunter ended his description of the four lower races with an encomium to the "the highest type of all, the

Eugenics Building at Kansas State Fair, 1925, site of the Fitter Family Contest. FROM THE COLLECTION OF THE AMERICAN PHILOSOPHICAL SOCIETY

Caucasian, represented by the civilized white inhabitants of Europe and America."[11] The book also called for policies that would segregate male from female defectives and outlaw "intermarriage and the possibility of such a low and degenerate race."[12] To substantiate this argument, Hunter's textbook quoted heavily from Dugdale's *The Jukes* and Goddard's *The Kallikak Family*.[13] Another of his touchstones was Charles Davenport's 1911 book, *Heredity in Relation to Eugenics*.

While the Scopes Trial is often presented as a simple battle between the enlightenment of evolutionary theory vs. antediluvian creationism—an interpretation propagated by Jerome Lawrence and Robert E. Lee's 1955 play *Inherit the Wind*, further popularized by Stanley Kramer's 1960 star-studded film—the science and politics of the day complicated the issues somewhat. While Scopes taught evolution, he also taught eugenics, linking Darwin's theory to notions of inherent racial inequality. Simultaneously, the theory of evolution disturbed William Jennings Bryan, "The Great Commoner" who was the Democratic candidate

Fitter Family Contest winners, small-family category. FROM THE COLLECTION OF THE AMERICAN PHILOSOPHICAL SOCIETY

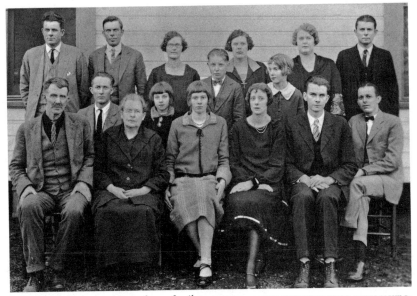

Fitter Family Contest winners, large-family category. FROM THE COLLECTION OF THE AMERICAN PHILOSOPHICAL SOCIETY

for President in 1896. While Bryan is depicted in "Inherit the Wind" as a Bible-thumping know-nothing, his opposition to evolution was propelled by its link to an active eugenics movement.

Because of Scopes's last-minute plea of guilty, encouraged by Darrow to carry the case to appeals court, Bryan never delivered his planned summation. Newspapers and magazines published it, however, and it was widely read. It also appeared in pamphlet form. To bolster his case against the teaching of evolution, Bryan quoted at length from Darwin's *Descent of Man* to demonstrate the extent to which evolutionary theory gave support to the idea of eliminating "the weak" from the human stock. He included the following passage from Darwin:

> With savages the weak in body or mind are soon eliminated; and those that survive commonly exhibit a vigorous state of health. We civilized men, on the other hand, do our utmost to check the process of elimination; we build asylums for the imbecile, the maimed, and the sick; we institute poor laws; and our medical men exert their utmost skill to save the life of everyone to the last moment. There is reason to believe that vaccination has preserved thousands, who from a weak constitution would formerly have succumbed to small-pox. Thus the weak members of civilized society propagate their kind. No one who has attended to the breeding of domestic animals will doubt that this must be highly injurious to the race of man . . . We must, therefore, bear the undoubtedly bad effects of the weak surviving.[14]

Current uses of evolution, Bryan argued, went "against the public welfare," and were callously applied as an argument against the progressive principle of social improvement. The hereditary determinism of the 1920s routinely argued that the human lot was predestined, impervious to programs for social change. Bryan responded that evolution could only obliterate people's sense of possibility and hope.

> Evolution is deadening to spiritual life of a multitude of students . . . [T]he evolutionary hypothesis is that, by paralyzing the hope of reform, it discourages those who waiver for the improvement of man's condition. Every upward looking man or woman seeks to lift the level upon which mankind stands, and they trust that they will see beneficent changes during the brief span of their own lives. Evolution chills their enthusiasm by substituting aeons for years.

In his indictment of evolution, the specter of eugenics and of the amoral nature of science was an underlying theme. As Bryan wrote in the summation, "science is a magnificent force, but it is not a teacher of morals. It can perfect machinery, but it adds no moral restraints to protect society from the misuse of the machine." Evolutionary theory's "only program for man is scientific breeding," he added, "a system under which a few supposedly superior intellects, self-appointed, would direct the mating and the movements of the mass of mankind."[15]

Bryan's Christianity, while scriptural, was also infused with a staunch belief in social justice, in the democratic principle of the common good. He was also an anti-imperialist in an age of American empire. His recurrent invocation of Christ affirmed a compassionate moral compass he found absent in the cold calculations of science and power.

As the Scopes trial brought eugenics, in the guise of evolution, to national attention, the advocates of eugenics continued their popular, itinerant approach to spreading the good news, fair by fair, town by town. The underlying assumption of Fitter Family Contests was that winners were most likely to produce a first-class lineage, outstanding representatives of the "Nordic" race. Family planning as practiced by eugenicists was embraced with a sense of noble zeal, a commitment to a higher cause. The father of one prize-winning family in Georgia, school principal James E. Kelley, told the *Savannah Press*, "I believe in practicing what I preach and I am preaching the doctrine of keeping fit. This contest gave me an opportunity to invoice the physical and mental condition of my entire family." Mrs. Kelley indicated, "I mean to keep on the job each day of the next 365 and bring up our score. It may be good this year but it will be better next."[16]

Even for nonwinners the act of participating in a competition indicated that a family identified with the goal of bettering the stock and would work actively to contribute to the common objective of race improvement. Invariably, contestants were of "white with northern and western European heritage."[17] The American tradition of "self-help" had now been joined with a toxic mission of race purification.

In order to sanctify this marriage, fairgoers routinely viewed graphic traveling exhibits portraying "unfit" members of society and reminding them of birth-rate differentials and the constant threat of "race suicide." Exhibits would move from fair to fair, sometimes appearing twice a week in different towns, offering people a vivid eugenic education.

One such exhibit, adorned with flashing red electric lights, provided an object lesson in comparative statistics. Under the slogans "SOME PEOPLE ARE BORN TO BE A BURDEN ON THE REST" and "LEARN ABOUT HEREDITY. YOU CAN HELP TO CORRECT THESE CONDITIONS," data were presented to instruct people on the dangerous state of American life, urging them to breed more vigorously.

One panel of the exhibit announced, "Every 48 seconds a person is born in the United States who will never grow up mentally beyond that stage of a normal 8 year old boy or girl." Above the sign, a light flashed every forty-eight seconds. In contrast, another panel in the exhibit indicated, "Every 7 1/2 minutes a high grade person is born in the United States who will have ability to do creative work and be fit for leadership. About 4% of all Americans come within this class." Here the light flashed every seven and a half minutes. A third panel read, "Every 50 seconds a person is committed to jail in the United States. Very few normal persons ever go to jail." A light punctuated this disturbing proclamation.

In association with the Fitter Families for Future Firesides contests, such exhibits were clearly designed to encourage "normal" fairgoers to double their efforts in the bedroom. The contests provided them with opportunity to show off the results of such unions. Fitter Family Contests emerged during the 1920s, a period when the custom of arranged marriages was, in a wide range of cultures,

Poster displayed at a **Human Stock Pavilion.** FROM THE COLLECTION OF THE AMERICAN PHILOSOPHICAL SOCIETY

322

giving way to the ideal of marriage as a choice driven by romance. The spectacle of eugenics competitions at the fair represented the reconsecration of the idea of arranged marriage, now given the blessing of sound scientific breeding practices.

When eugenics went to the fair, a sunny vision of ideal American families parading across the stages of "human stock" pavilions, or portrayed with loving affection on the front pages of newspapers, became a part of twentieth-century American culture. In the process, the value of competing to be the "normal family" entered the theater of American life. This cheery "Father Knows Best" cliché stood in stark contrast with hate-filled calls for the eradication of the hordes of undesirables who were sullying American soil.

In 1922, only one year after the Second International Congress of Eugenics, Walter Lippmann's employment of the term "stereotype" entered the American lexicon. Lippmann, himself, was a harsh critic of eugenics, and assailed the Army IQ tests as "a new chance for quackery in a field where quacks breed like rabbits."

> The danger of the intelligence tests is that in a wholesale system of education, the less sophisticated or the more prejudiced will stop when they have classified and forget that their duty is to educate. They will grade the retarded child instead of fighting the causes of his backwardness. For the whole drift of the propaganda based on intelligence testing is to treat people with low intelligence quotients as congenitally and hopelessly inferior.[18]

In *Public Opinion*, Lippmann maintained that stereotypes were a "repertory of fixed impressions" that people "carry about in [their] . . . heads." "For the most part," he explained, "we do not first see, and then define, we define first and then see." For him, intelligence testing was a living example of the delusional nature of perception.

> Without offering any data on all that occurs between conception and the age of kindergarten, they [the testers] announce on the basis of what they have got out of a few thousand questionnaires that they are measuring the hereditary mental endowment of human beings. Obviously, this is not a conclusion obtained by research. It is a conclusion planted by the will to believe.[19]

In fact, much of what came out of the eugenics movement conformed to ideas about stereotyping that Lippmann laid out in *Public Opinion*. Stereotypes, he 323 explained, "mark out certain objects as familiar or strange, emphasizing the difference, so that the slightly familiar is seen as very familiar, and the somewhat strange is sharply alien." In many ways the mental universe of eugenics did precisely that. In its vilification of "rural white trash," "defective" urban immigrants, and African Americans enjoying the rights of citizenship, all sense of common humanity gave way to exaggerated phantasms of hereditary evil. Simultaneously, public spectacles of "fitter families" asserted meaningful bonds between people that had little grounding other than that of racial identity. This was a rendition of reality, as Lippmann observed, that served mainly to defend Anglo-America's customary "position in society."

The Nordic solidarity preached by leaders of the eugenics movement played on an idea of America that, in the anxious minds of those who followed their lead, fit "as snugly as an old shoe." In a society where new and unfamiliar populations were claiming the right to become Americans, the old guard fought furiously to defend its mental barricades. Lippmann described this struggle as an essential component of the stereotyping process. "No wonder," he wrote, "that any disturbance of the stereotypes [people hold] seems like an attack on the foundations of the universe." But, as Lippmann reminded his readers, it was not the universe that was under attack, but a particular universe that was inevitably being challenged by the changing face of the nation.

In order to defend their universe, eugenicists seized upon stereotypes of the past. Though they claimed to be modern scientists, and many were based in large cities, the image of America that they projected and promoted was one located in the shrinking boundaries of the traditional heartland. While some of the "defectives" targeted by eugenicists were rural or small-town folk—such as the Kallikaks or Carrie Buck—the overwhelming dread that drove eugenics saw the city as the primary locus of peril, the environment that was placing the nation under siege.

To some extent, this attitude made sense. While a place such as New York City housed venerable Anglo-American institutions such as the Museum of Natural History, it was also a magnet that was drawing millions of immigrants into its teeming streets. This movement was true of many cities, where Eastern Europeans and Italians were shaping the ethnic landscape. Adding to this immigration, the years immediately following the First World War saw a great migration of black people out of the South, into such Northern cities as Chicago, Detroit, Cleveland, and New York. Last, the city had long been typed as a den of iniquity, hous-

ing a congregation of thieves, inebriates, bohemians, radicals, con men, and women of ill repute. If social hygiene and ethnic cleansing were eugenic goals, this vision of the city provided the perfect mark.

In counterpoint, rural and small-town America, less affected by the "new" migrations, was canonized as a wellspring of the wellborn. Socially and economically, rural and small-town America was beginning what would be an ongoing process of decline. Nonetheless, such regions reverberated—and continue to reverberate—as icons of an America where moral values, and mental and physical health were still intact. At county and state fairs, where Fitter Family Contests were a major attraction, the stereotypical "charm of the familiar, the normal, the dependable," as Lippmann described it, was sanctified as a dividing line between "a goodly heritage" and its enemies. Here the eugenics movement promoted a vision of the perfect family: a sturdy, old-stock father; a mother of similar blood, committed to being the eager breeder of prize calves; and a brood of tow-headed children who were the chosen, those who would serve as emblems of a better future. Opposed was the stark depictions of people deemed to be without "a goodly heritage," immigrants, newly emancipated black citizens and the feeble-minded whose heritage would subject them to enforced violence, discrimination, slander, and ridicule under the eugenics rubric.

This dualism, separating absolute good from unmitigated evil, was the language of stereotype translated into a blend of science, politics, and popular culture in the initial decades of the twentieth century. Yet beyond eugenics, other developments were afoot that would contribute to the triumph of typecasting as the lingua franca of the modern world.

THE MODERN BATTLEGROUNDS OF TYPE

DAT FAMOUS CHICKEN DEBATE

In 1852, when Dr. Roget first introduced his *Thesaurus of English Words and Phrases* to British readers, he made it clear that his primary objective was to provide them with a toolbox that would "facilitate the expression of ideas and assist in literary composition." The *Thesaurus*, he believed, could sensitize people to the intricacies of meaning, narrowing the troublesome gap between what people say and what they mean to say. Ultimately, Roget hoped that his efforts would lead to the development of a precise and universal language that would do away with "that barrier to the interchange of thought and mutual good understanding between man and man, which is now interposed by the diversity of their respective languages."[1]

Yet alongside his utopian vision of a philosophically exact language, Roget was also a realist. Living in Mayhew's London, he was well aware that he inhabited a world in which a cacophony of tongues marked out the differences between people of different classes, cultures, and nations. In spite of his own prejudices, which are well represented in the *Thesaurus*, it was this recognition that convinced Roget to include a wide array of colloquial terms in his fastidiously organized linguistic universe. As noted in his "Introduction," the *Thesaurus* contained "many words and expressions, which the classical reader might be disposed to condemn as vulgarisms, or which he, perhaps, might stigmatize as pertaining rather to the slang than to the legitimate language of the day."

Roget's embrace of slang was pragmatic. In deciding which words should be incorporated, he wrote, "I could not have attempted to draw any strict lines of demarcation; and far less could I have presumed to erect any absolute standard of purity. My object," he continued, " . . . is not to regulate the use of words but simply to supply and to suggest such as may be wanted on occasion, leaving the proper selection entirely to the discretion and taste of the employer."

In the United States, when the first American edition of Roget's tome appeared, its editors believed that "the discretion and taste of the employer" was not to be trusted. They made the decision to eliminate all slang from the compendium. In a society still grappling with establishing a civilized national identity, perhaps the editors felt that this exclusion would better serve the development of the nation. Yet as a guide to both spoken and written idioms, this omission made little sense. By the time a second edition appeared in 1854, slang terminology was restored, albeit in a separate section at the

328

end of the book. This separation emphasized a demarcation between proper and improper language that Roget, himself, was unwilling to make. Subsequent American editions of the *Thesaurus* dropped this policy of linguistic segregation and restored Roget's original methodology, mixing vernacular terms into its text.

Regarding the inclusion of slang expressions in his system, however, Roget, a respected man of science and letters, felt compelled to offer a literary rationale for their presence.

> If a novelist or a dramatist, for example, proposed to delineate some vulgar personage, he would wish to have the power of putting into the mouth of the speaker expressions that would accord with his character; just as the actor . . . who had to personate a peasant would choose for his attire the most homely garb and would have just reason to complain if the theatrical wardrobe furnished him with no suitable costume.[2]

The ability to put words in the mouths of others, Roget believed, was an essential prerogative of novelists and playwrights, and his goal was to provide an idiomatic wardrobe out of which they could select the most effective means for characterizing people they had little knowledge of. While Roget's system identified colloquial speech as the guttural province of "bog-trotters" and "barbarians," it was also a necessary implement for any writer wishing to portray the lives of "the great unwashed."

Sociologists, ethnographers, and criminal anthropologists, from Mayhew to Lombroso, embraced this aspect of slang. If language was a marker of respectability, it was also a diagnostic gauge by which early social and psychological scientists sought to distinguish the boundaries of moral turpitude. In the social sciences, as they evolved from the mid nineteenth century onward, the mangling of language was seen as a sure sign of lowly rank and inherent criminality.

In *The Criminal*, for example, Havelock Ellis devoted an entire chapter to the topic of "Thieves' Slang." He began his discussion of the topic with the observation that "every profession, every isolated group of persons, almost every family possesses a more or less extended set of words and phrases which are unintelligible to strangers."

Among all social groups, however, it was the criminal classes that were most adept in their employment of an argot indecipherable to all but themselves.

For this reason, Ellis believed, students of criminology must learn to understand the vernacular of the street, in order to pinpoint those "registered in the army of evil-doers."

329

Like Mayhew's decoding of the language of costermongers, Ellis began to unpack the nomenclature of crime, offering criminal narratives in their original tongue, followed by translations in a more coherent form. Quoting one pick-pocket's account of his arrest verbatim, readers were introduced to an impenetra-ble lyric:

> I was jogging down a blooming slum in the Chapel, when I butted a reeler, who was sporting a red slang. I broke off his jerry, and boned the clock, which was a red one, but I was spotted by a copper who claimed me. I was lugged before the beak, who gave me six doss in the steel.

In Ellis's translation, the meaning of this patter was illuminated. The power of the criminal to elude the comprehension of the criminologist had ostensibly been broken.

> As I was walking down a narrow alley in White-chapel, I ran up against a drunken man who had a gold watch guard. I stole his watch, which was gold, but was seen by a policeman, who caught me and took me before the magistrate, who gave me six months in the Bastille (the old House of Corrections), Coldbath Fields.

Such translations of criminal patois were not simply designed to introduce readers to an unfamiliar lexicon. The slang of criminals, Ellis and others con-tended, provided irrefutable evidence of their animalistic mentality. If civilized man was at home with the metaphysical workings of the mind, criminal man expressed all things in crassly physical terms. To Ellis, the study of criminal language pro-vided a corridor into the mindset of those who spoke it.

> The chief interest of the slang of habitual criminals is psychological. It furnishes us with a curious insight into the mental processes of those who invent and use it; it is itself an embodiment of criminal tenden-cies . . . It is full of metaphorical expressions of objects named after their attributes. Nearly everything is degraded, sometimes with coarse and fantastic wit. 'While the imagination of the poet gives a soul to animate objects,' remarks M. Joly, 'the imagination of the criminal transforms

330

> living forms into things, assimilates man to animals.' . . . Everything
> is thus vulgarized. The criminal instinctively depreciates the precious
> coinage of language.

The "degraded" language of criminals, Ellis concluded, was comparable to that of the "savage," it was an indicator of a "psychic atavism" that linked felons and miscreants with those he defined as subhuman races.[3]

The practice of regarding language as a signpost of inferiority was not limited to scientific circles. In the arts, peculiarities of speech had long been a basic tool for defining character. In the years following the Civil War, this artistic license became a basic element of American popular culture, offering white America an opportunity to libel the humanity of free blacks and recent immigrants. One of the most flamboyant examples of this was the evolution of the blackface minstrel show as a fixture in an emerging mass culture.

The origins of American minstrelsy dated back to the 1820s, a period when antislavery activism was beginning to the shake the foundations of society. Within the abolitionist movement, which included many white opponents of slavery, free black people also emerged as powerful and eloquent voices. The importance of this cannot be underestimated; the folklore of slavery consistently vilified blacks as childlike, stupid, dishonest, and incoherent.

Such ideas were affirmed by the mainstream American press. Disparaging the free black population of New York City in 1826, a writer for the *New York Enquirer* offered a boilerplate rendition of the characterizations that habitually maligned the personhood of blacks. "The 15th part of the population of this city is composed of blacks. Only 15 are qualified to vote. Freedom is a great blessing, indeed, to them. They swell our list of paupers, they are indolent, and uncivil."

In 1827, when John Russworm and Samuel Cornish founded *Freedom's Journal*, the nation's first African-American newspaper, it was this kind of defamation they wished to dispel. In a front-page declaration of principles they announced:

> We wish to plead our own cause. Too long have others spoken for us.
> Too long has the publick been deceived by misrepresentations, which
> concern us dearly, though . . . there are many in society who exercise
> towards us benevolent feelings; still (with sorrow we confess it) there
> are others who make it their business to enlarge upon the least trifle,
> which tends to the discredit of any person of colour; and pronounce

anathemas and denounce our whole body for the misconduct of this
guilty one . . . [I]t shall ever be our duty to vindicate our brethren.4 33**1**

Over a two-year period, the newspaper
denounced slavery, lynchings, and other systematic
wrongs committed against "people of colour." The
paper also included slave narratives, moving firsthand
memoirs of those who had escaped from bondage. In
1829, its last year of publication, *Freedom's Journal*
published "Walker's Appeal," a four-part series of
articles by David Walker, a free black tailor and one
of the paper's subscription agents. In it, Walker called
for slaves to rebel against their masters.

While *Freedom's Journal* lasted for only two years,
it marked the beginning of an African-American lit-
erary tradition that would grow throughout the nine-
teenth century and flourish in the twentieth. By the
start of the Civil War, twenty-four black papers were
in print, including the *North Star* and other newspa-

FROM THE COLLECTION OF THE WISCONSIN STATE
HISTORICAL SOCIETY

pers published by Frederick Douglass, the great antislavery orator. An articulate
black voice, actively seeking to counteract common stereotypes, was taking flight.

Yet flanking this development was the emergence of the minstrel show, a vastly
popular entertainment that reinforced the vanities of white racism. One year after
Cornish and Russworm began publishing their paper, a white man named
Thomas "Daddy" Rice launched his career as a blackface dancing buffoon named
"Jim Crow." Rice's character was a crippled black slave who shuffled and sang,
wearing big clown shoes, hay in his hair, and speaking jumbled English. A black
man concocted by a white man, Jim Crow was the portrayal of an inherently fool-
ish and irresponsible slave who served to validate the perpetuation of white con-
trol. From this 1828 creation an industry would flow.

In 1843, Dan Emmett's Virginia Minstrels brought minstrelsy into the main-
stream of American entertainment. First performing in New York's Bowery
Amphitheatre, and offering an entire evening of blackface amusement, Emmett's
four-person show transmogrified Thomas Rice's Jim Crow into a full-fledged
popular genre. The theater historian Lee Davis has summarized the stagecraft of
the Virginia Minstrels:

The form was so natural, it seemed improvised—and in fact, much of the evening, because of the talents of the four, was. But most of all, there was exuberance and excitement. The minstrels, in their wide-eyed, large-lipped, ragged-costumed absurdity, rolled onto the stage in a thundercloud of energy which hardly ever dissipated. They insulted each other, they baited each other, they made mincemeat of the language, they took the audience into their fun, and, in one night, they added a new form to show business in America—in fact, the world.5

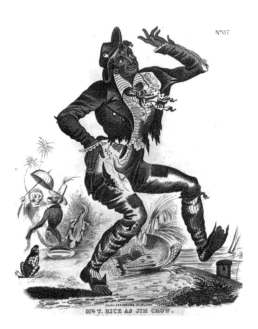

N°67

Mr T. RICE AS JIM CROW.

Soon, across America, itinerant minstrel troupes sprang up, providing local white audiences with farcical visions of black people that highlighted their untrustworthiness, laziness, and illogical trains of thought. Groups such as the Christy's Minstrels, Dockstader's Minstrels, Buckley's Serenaders, Sweeney's Minstrels, and other ensembles presented an image of slavery as a comfortable and happy home for human chattels. All of this minstrelsy was couched in a pseudo-black dialect that provided verbal evidence of black inferiority. Whites in the south were used to listening to talk among slaves, slave music as well, and often found it impenetrable.

Leroi Jones (aka Amiri Baraka) in his 1963 classic, *Blues People*, offers the following comment on this inability for slave masters to understand the language of their human property.

What is called now a "Southern accent" or "Negro speech" was once simply the accent of a foreigner trying to speak a new and unfamiliar language, although it was characteristic of the white masters to attribute the slave's "inability" to speak perfect English to the same kind of "childishness" that was used to explain the African's belief in the supernatural. The owners, when they bothered to listen, were impressed that even the songs of their native American slaves were "incomprehensible" or "unintelligible."6

To some extent, the distance between black and white English also served the interests of slaves. Unlike the Western musical tradition, music among African Americans, Jones explains, performed a distinctly "functional" role within plantation life. Like many code languages, it permitted people to converse about their conditions and their desire to escape in ways that slave masters would be unable to understand. Jones reports that slave masters became aware of this subversive use of music and—insofar as they could recognize it—began to suppress it under threat of severe punishment.

> [R]eferences to the gods or religions of Africa were suppressed by the white masters as soon as they realized what these were—not only because they naturally thought of any African religious customs as "barbarous" but because the whites soon learned that too constant evocation of the African gods could mean that those particular Africans were planning on leaving that plantation as soon as they could! The use of African drums was soon prevented too, as the white man learned that drums could be used to incite revolt as well as to accompany dancers.[7]

In the minstrel show, any sense of black dissatisfaction was erased. Black speech and music, as represented, were reduced to childish nonsense or expressed a nostalgia for slavery that had no connection to the soul of African American speech or to a living musical tradition that would, in time, come to dominate American popular genres: the blues, jazz, rock 'n roll, and hip hop.

Amid the spectacles of minstrelsy, certain recognizable stock characters began to emerge, generating a standardized racist culture across the breadth of the continent. "Brudder Bones" and "Brudder Tambo" were typical blackface characters, grinning comedian-musicians whose mischievous and garbled antics at the ends of a semicircle gave grief to an aggravated white-faced character who occupied the middle of the line. This stock character, known as "Mr. Interlocutor," spoke in a flowery oratory that parodied a white, upper-class manner of speaking.[8]

Other staple characters also took the stage. One was the venerable "Jim Crow," the simple-minded, happy-go-lucky plantation slave. Another was the "Mammy," a rotund and loyal household slave, devoted to her "white family." Her perpetual, big-lipped smile and wide eyes spoke to her contentment within a supposedly humane slave system. The "Zip Coon," also dubbed "Scipio Africanus," was a caricature of an urban free black man, a shiftless object of mockery who, all dressed up in absurdly exaggerated finery, represented the innate black inability to exercise the responsibilities of freedom.

334

Music was an essential element of the shows. White men in blackface employed instruments previously crafted and played only by slaves, such as the banjo. The banjo—or banjar, banza, or banshaw, as it was variously known among blacks—was indigenous to Africa and spread through the American colonies as plantation slavery took hold. Other instruments appropriated by minstrel players were also rip-offs of homegrown, black instruments, including the drum/tambourine, bones, and spoons. Brudders Tambo and Bones were named after the instruments they played.

To middle- and upper-class Americans, such instruments represented what one Boston newspaper described as "the depth of popular degradation," the province of "the jig-dancing lower classes of the community."9 While the banjo eventually earned some musical respect, its initial inclusion in the minstrel show—along with other black instruments—offered clichéd symbols of the debased culture of the people being represented.

While costume was an essential element in minstrelsy, it was the use of language, more than any other element, that set blacks apart from the ideals of "civilized" white society. Songs, written by such composers as Stephen Foster—a Northerner from Pittsburgh with no firsthand knowledge of Southern life—were an integral part of the minstrel show. In their lyrics, garbled "negro" language was fused with white ideology. A central tenet of this ideology was that blacks sought servitude and longed for the familiar security of plantation life. They were, as the story went, incapable of surviving amid the burdens of liberty. Though attributed to E. P. Christy, Stephen Foster's 1851 song, "Old Folks at Home," an "Ethiopian Melody," is a classic example of this mixture, the imaginary lament of a former slave.

Way down upon de Swanee ribber,
Far, far away,
Dere's wha my heart is turning ebber,
Dere's wha de old folks stay.

All up and down de whole creation,
Sadly I roam,
Still longing for de old plantation,
And for de old folks at home.

All de world am sad and dreary,
Ebry where I roam,

Oh! darkeys how my heart grows weary,
Far from de old folks at home.

All round de little farm I wander'd
When I was young,
Den many happy days I squander'd,
Many de songs I sung.

When I was playing wid my brudder,
Happy was I,
Oh! take me to my kind old mudder,
Dere let me live and die.

All de world am sad and dreary,
Ebry where I roam,
Oh! darkeys how my heart grows weary,
Far from de old folks at home.

One little hut among de bushes,
One dat I love,
Still sadly to my mem'ry rushes,
No matter where I rove.

When will I see de bees a humming,
All round de comb?
When will I hear de banjo tumming,
Down in my good ole home?

All de world am sad and dreary,
Ebry where I roam,
Oh! darkeys how my heart grows weary,
Far from de old folks at home.[10]

Other minstrel songs reiterated this theme. "Oh! Carry Me Back to Ole Virginny," first performed by Dan Emmett's Virginia Minstrels, offered a similar nostalgia for plantation life. The confederate anthem, "Dixie," written by Dan Emmett, and performed by the Virginia Minstrels on the eve of the Civil War, also puts words in the mouth of a mournful slave, longing for the succor of bondage.

I wish I was in de land ob cotton,
Old times dar am not forgotten,
Look away! Look away!
Look away! Dixie Land.
In Dixie Land whar I was born in
Early on one frosty mornin'.
Look away! Look away!
Look away! Dixie Land.

Den I wish I was in Dixie,
Hooray! Hooray!
In Dixie Land I'll took my stand,
To lib an' die in Dixie,
Away, away,
Away down south in Dixie . . .

Dar's buckwheat cakes an' Ingen' batter,
Makes you fat or a little fatter;
Look away! Look away!
Look away! Dixie Land.
Den hoe it down an' scratch your grabble.
To Dixie's land I'm bound to trabble,
Look away! Look away!
Look away! Dixie Land.[11]

Another Foster song, attributed to Christy when first performed in 1848, told the story of Ned, a dying and devoted slave, whose hard work in life had earned him his final reward, to go "whar de good Niggas go."

Dere was an old Nigga, dey call'd him uncle Ned—
He's dead long ago, long ago!
He had no wool on de top ob his head—
De place whar de wool ought to grow.

Den lay down de shubble and de hoe,
Hang up de fiddle and de bow:
No more hard work for poor Old Ned—
He's gone whar de good Niggas go,

No more hard work for poor Old Ned—
He's gone whar de good Niggas go.

His fingers were long like de cane in de brake,
He had no eyes for to see;
He had no teeth for to eat de corn cake,
So he had to let de corn cake be.

Den lay down de shubble and de hoe,
Hang up de fiddle and de bow:
No more hard work for poor Old Ned—
He's gone whar de good Niggas go,
No more hard work for poor Old Ned—
He's gone whar de good Niggas go.

When Old Ned die Massa take it mighty hard,
De tears run down like de rain;
Old Missus turn pale and she gets berry sad,
Cayse she nebber see Old Ned again.

Den lay down de shubble and de hoe,
Hang up de fiddle and de bow:
No more hard work for poor Old Ned—
He's gone whar de good Niggas go,
No more hard work for poor Old Ned—
He's gone whar de good Niggas go.

On occasion, before the Civil War, minstrel lyrics spoke to the dangers that blacks in flight might expect to encounter. Stephen Foster's 1848 "Oh! Susannah," was the story of an enslaved black man who has left Alabama in order to reunite with his "true love," sold away to another owner in Louisiana. Leaving "wid a banjo" on his knee, the man recounts the perils that haunt such illicit travels.

I jumped aboard de telegraph, and travelled down de ribber,
 D 'lectric fluid magnified, and killed five hundred nigger.
De bullgine bust, de horse runs off, I really thought I'd die;
 I shut my eyes to hold my breath: Susanna, don't you cry.

Between the 1840s and through the Civil War, blackfaced white entertainers put counterfeit words into the mouths of African Americans, transforming the conditions of human oppression into a widely popular aesthetic. To some extent, this bogus interpretation was a response to an authentic and compelling black voice, remarkable in its expressiveness, that was becoming increasingly vocal during the same period.

The most prominent narrator of the actual experience of slavery was Frederick Douglass. Born a slave in Maryland, he escaped from bondage in 1838. In a famous episode, which he told over and over, Douglass, unlike most slaves, learned to read as a child. His white mistress, unaware of the ban against slaves being taught to read and write, had begun by teaching him to read the Bible. He was a rapid and voracious learner. When his owner, Master Hugh, discovered this skill, he put a quick end to his wife's transgression, announcing, as Douglass recalled it:

> Learning to read will spoil the best nigger in the world. If he learns to read the bible it will forever unfit him to be a slave. He should know nothing but the will of his master. . . . If you teach him how to read, he'll want to know how to write, and this accomplished, he'll be running away with himself.[12]

Nonetheless, Douglass's formidable facility with written and spoken words had begun. In secret, he devoured books and developed fluent writing skills. He soon ran "away with himself."

Becoming involved in the antislavery movement in the early 1840s, Douglass became a persuasive firsthand witness to the brutalities of slavery. In 1845, he published the first of several autobiographies that would become central to the canon of abolitionism, *Narrative of the Life of Frederick Douglass, An American Slave: Written By Himself*. With the aid of white abolitionist leaders, Wendell Phillips and the editor of *The Liberator*, William Lloyd Garrison, Douglass became a favorite speaker at antislavery rallies. Douglass, maintaining a stentorian presence, put the lie to the argot of minstrelsy. Insofar as Douglass used slave dialect in his writings, he did so to communicate the critical content that rested within it. Recalling a holiday song, sung by bondsmen on a plantation where he lived, a keen awareness of the injustices of slavery is palpable.

> We raise the wheat,
> Dey gib us corn;

We bake de bread,
Dey give us de crust;
We Sift the meal,
Dey gib us de huss;
We peel de meat,
Dey gib us de skin;
And dat's de way
Dey takes us in;
We skim de pot,
Dey gib us de liquor,
And say dat's good enough for nigger.[13]

Douglass was not alone. William Wells Brown, the son of a white slave owner and one of his black slaves, also gained recognition as a speaker and writer. Escaping from slavery in Kentucky in 1834, Brown became a notable antislavery orator in Buffalo, New York, an important stop on the Underground Railroad. On this legendary escape route he served as a conductor, working on a steamer carrying slaves to freedom in Canada. In 1847, he published the *Narrative of William W. Brown, A Fugitive Slave, Written by Himself*, which appeared in several American and British editions by 1850, gaining him a recognition second only to Douglass.

Offering a female perspective in 1861, Harriet Jacobs, using the name Linda Brent, published *Incidents in the Life of a Slave Girl: Written by Herself*. A house slave owned by a doctor in North Carolina, Brent illuminated the predatory sexual dynamics of slavery, the power assumed by white masters over their female slaves. She opened the narrative with a statement of authenticity and with a caveat.

READER, be assured this narrative is no fiction. I am aware that some of my adventures may seem incredible; but they are, nevertheless, strictly true. I have not exaggerated the wrongs inflicted by Slavery; on the contrary, my descriptions fall far short of the facts.[14]

Such firsthand accounts offered vivid alternatives to the vision of slavery promoted by minstrelsy. In the "written by himself/herself" declaration that concluded each narrative's title, the author was saying something about the power of literacy to give voice to the voiceless. Yet the audience reached by such accounts could not match the magnitude of that exposed to the disdainful humor

of blackface theater. Even many Northerners who held antislavery sentiments believed "the negro" to be inferior, innately ill-equipped for the duties of citizenship. Minstrelsy, which continued to be performed in the North, confirmed such attitudes.

From the 1870s onward, the modern machinery of mass production altered the connection between minstrelsy and its audience. If, in antebellum America, blackface comics and musicians were part of a successful live entertainment business, the postwar years saw the flowering of an industrial system that transformed the key ingredients of the minstrel show into nationally distributed consumer products.

Live minstrelsy continued in the postwar years, but its scale and repertoire changed significantly. So, too, did the composition of its theatrical troupes. Spectacles became larger and more extravagant, and the targets of minstrel humor broadened, still using the old staple of blackface but now more stridently targeting American Indians and a variety of new immigrant groups.

The ridicule of women's rights, which had been an element in earlier minstrel shows, became more mean-spirited as the women's suffrage movement, and the ideas of female equality, grew. Male entertainers in drag became a fixture, inverting mainstream definitions of masculinity while, at the same time, conveying their ingrained hostility towards women.[15] Yet blackface remained the central idiom of the minstrel genre.

Ironically, many of the minstrel players, particularly in postwar years and stretching into the twentieth century, were themselves victims of racial prejudice. While the first minstrel players came from "old" Anglo stock, soon immigrant Irish entertainers began to permeate the ranks of minstrelsy. Later, it would be Jewish entertainers who would dominate the minstrel shows and, then, vaudeville. Given the odium that Anglo-America expressed toward people from these two groups, one wonders why they would have participated in such comedic character assassinations of a people. The historian Michael Rogin suggests that by corking up, these immigrant entertainers hoped to blend into a white American mainstream that, for the most part, continued to despise them. If, in deriding blacks, they could change type and become "white," the Irish, the Jews, and other immigrant groups might—after decades of scorn as unwanted outsiders—participate in "the fable of membership," a mythic sense of belonging.[16]

As live shows became more elaborate, large urban publishing houses started producing and disseminating minstrel scripts and sheet music, turning white

homes and communities, throughout the nation, into do-it-yourself venues for blackface entertainment. The sheet music carried minstrel songs into any home with a piano. Cover illustrations for these tunes bore familiar racist caricatures, "Coons" and "Pickaninnies" fulfilling timeworn bromides about black behavior: eating watermelons, cutting people with razors, and acting on their irrepressible obsession with stealing chickens.

Scripts, mass-marketed as "Ethiopian Farces," "Darkey Plays," "Black Face Plays," and "Ethiopian Dramas," were published by a wide variety of companies—T. S. Denison, Robert M. Dewitt, Samuel French & Sons, Eldridge Entertainment House, Dick & Fitzgerald, W.H. Baker & Co.—located primarily in the North: New York, Chicago, Boston, and Franklin, Ohio. Each publisher produced an extensive list of blackface scripts, including those entitled "The Darkey Breach of Promise Case, A Nigger Mock Trial"; "The Darkey Phrenologist"; "Wake Up! A Negro Sketch Known as Psychological Experiments, Psychology, Bumps and Lumps, Bumpology, etc."; "Black Ole Bull, An Original Ethiopian Sketch"; "A Henpecked Coon"; "The Booster Club of Blackville"; "One Hambone for Two"; "De Low-Down on Scientifics"; "Ghoses Er Not Ghoses: A Negro Debate"; "Dat Famous Chicken Debate: The University of Africa (Aff.) vs. Bookertea College (neg.)"; and "The Coon and The Chink."

Each play provided costuming and make-up instructions. Introducing "The Coon and the Chink," for example, the dramatist Walter Carter offered the following description of characters:

COON.—A tall, lanky, ignorant and unpolished negro. Makeup, comedy black-face. Costume.—Short trousers and coat with short sleeves, crushed silk hat, worn out shoes, long white cloth gloves, white socks, dress shirt, exaggerated high collar, and big soft carelessly tied bow-tie.

CHINK.—A short, thin, middle-aged Chinaman. Very stupid and ignorant in disposition. Makeup, typical close shaven wig with queue. Costume.— Typical Chinese coat, trousers and slippers, coat of plain bright colored material, trousers dark satin.[17]

In order to facilitate amateur productions, publishers also marketed many of the accouterments necessary to put on a show. On the inner back covers of their minstrel scripts, Samuel French & Sons advertised decorative paper cut-outs that could be used to create an authentic-looking theatrical setting.

A most effective Proscenium can be formed by utilising the paper made for this purpose. Three pieces of wood are merely required, shaped according to this design, and covered with the paper; the proscenium having the appearance of light blue puffed satin panels, in gold frames, with a Shakespeare medallion in the center.

Puffed satin paper, size 20 inches by 30 inches, per sheet, 25¢.

Imitation Gold Bordering, per sheet, 25¢ making 14 feet

Shakespeare Medallion, 18 inches in diameter, 50¢

Scenery was available, for doors, windows, fireplaces, and full stage sets of gardens, forests, and suitable interiors. To complete the package, French & Sons also sold makeup kits that included burnt cork for the face, whiting for the lips, and ludicrous crepe wigs.[18] Mongolian makeup was included as well.

T. S. Denison's company catalog offered "imitation diamond rings, dice and razor blades, white gloves and spats, wigs for Uncle Tom and Topsy, even huge rubber hands and feet for endmen [Bones and Tambo]." A half-mask was described as "suitable 'for the colored chicken thief.'" Dennison sold two shades of blackface, one dark and one "super fine Creole for the yellow wench roles." The catalog also included eyeglass and nose sets, now associated with Groucho Marx, then called the "Jew Nose."[19]

Complementing this market in amateur minstrel-show paraphernalia, the images associated with blackface theatrical culture were being appropriated by a burgeoning mass market in consumer goods. Most of the four thousand objects housed at the Jim Crow Museum of Racist Memorabilia, at Ferris State University in Michigan, provide testimony to the extent that the worldview of minstrelsy reached beyond the stage and had become an integral part of the material culture of a consumer society in formation. As industrialism took flight in the late 1870s, racist imagery permeated its product lines.

In 1874, the McLoughlin Brothers of New York manufactured a puzzle game called "Chopped Up Niggers." Beginning in 1878, the B. Leidersdory Company of Milwaukee, Wisconsin, produced Nigger-Hair Smoking Tobacco. . . . In 1917, the American Tobacco Company had a NiggerHair redemption promotion. NiggerHair coupons were redeemable for "cash, tobacco, S. & H. Green stamps, or presents."[20]

With middle-class whites as the primary consumers of early mass-produced goods, there was a ready-made market for such products, which included toys,

Denison's Black-Face Series

Price, 25 Cents Each, Postpaid

A DARK SECRET

Colored farce of mystery, by Jeff Branen; 4 males 1 female. Time, 30 minutes. This screaming story of the adventure of a negro detective and his dusk assistant has made thousands roar when presented on the professional stage, and is now available in print for amateurs everywhere. Three characters are white-face.

THE BOOSTER CLUB OF BLACKVILLE

A colored comedy concoction, by Harry L. Newton; 10 minutes. Time, 25 minutes. A political burlesque with the funniest negro cast of characters imaginable. They are all running for some kind of an office; judge, chicken inspector, razor inspector, crap game inspector, etc. Particularly suitable for a minstrel afterpiece.

A HENPECKED COON

Darky monologue, by Arthur LeRoy Kaser; 1 male. Time, 10 minutes. Ephraneous is unpleasantly aware of the fact that he has a wife, and he appeals to all married men for sympathy. The recital of his grievances against his better half is just one laugh after another.

AXIN' HER FATHER

Farce, by O. E. Young; 2 males, 3 females. Time 25 minutes. Old Peppercorn, very deaf, has three daughters, Priscilla, Pamela and Polly. Augustus, Priscilla's suitor, attempts to ask the old man for permission to marry her. Peppercorn, failing to understand him, and thinking he is insulted, begins the fun. The excitement multiplies with each succeeding incident.

WHAT YOU GOT?

Blackface comedy act, by Wade Stratton; 2 males. Time, 15 minutes. Julius, a "cullud gem'man," is curious about the contents of Billius' jug. His curiosity costs him "fo' bits foh one li'l' measly shot" and the discovery that Billius has been trying it on the dog.

ONE HAMBONE FOR TWO

Controversial talking act, by Arthur LeRoy Kaser; 2 females. Time, 10 minutes. Two "cullud" ladies engage in a polite duel for the heart and hand of one Hambone Johnson. Miss Dingleberry, who puts on airs, is sure of her conquest, but it takes Miss Wringer, the lowly laundress, to bring home the bacon—not to mention the ham!

T. S. DENISON & COMPANY, 623 S. Wabash Ave., Chicago

postcards, ashtrays, detergent boxes, fishing lures, packaged food, children's books, dolls, matchbooks, salt and pepper shakers, and a wide variety of other household and novelty items. Each reiterated hackneyed visions of simple-minded, shiftless, sometimes menacing blacks on store shelves throughout the nation. Each became normalized as a decorative or utilitarian element in the daily lives of white America.

344

The massification of minstrelsy in the latter decades of the nineteenth century challenges a common assumption about the rise of a modern, mass-mediated culture in the United States. The rise of the movies is often cited as the historical moment when a unified national media culture began to take hold. Yet before that, the industry that promoted minstrelsy—publishing scripts and sheet music for amateur performances in churches, schools, community centers, and homes—was already infusing local environments with nationally distributed standardized packages of cultural symbols. Selling identical stage settings and make-up kits, providing players in different locales with the same detailed instructions on how to ensure that costumes communicated an impression of ignorance and outlandishness, these industries built markets using traditional social networks as the tracks along which a common national culture would begin to travel. Consumer products helped to seal the deal.

COURTESY STEVEN HELLER

It was the subject matter and language of these plays, however, that best illuminates their social and political significance. By the mid-1870s, and accelerating after the withdrawal of federal troops from the South, the spirit and scope of minstrelsy experienced a dramatic change. Some minstrel plays continued to present wistful representations of slavery. "Uncle Eph's Dream: An Original Negro Sketch," from 1874, dramatized the story of an elderly black man wandering through the ruins of the Old South, longing for the plantation as it used to be. Unable to find his family, he bemoans the damage wreaked by the Union Army during the Civil War. His old plantation, and the life he enjoyed there, lay in tatters.

> Dar's no use ob talking, old Eph is most broken hearted and can't get no 'teligence from nobody; no one can tell de old man wherfe his wife and children am gone to. When I left here five years ago ebery thing looked prosperous, but now, look at it, ebery ting is gwan to runin. I remember when I used to walk along dis road by de plantation, te field hands used to cry out to me, how does you, Uncle Eph? Den I used to sit under de shade ob de tree and listen to de little birds sing and read

my little bible; take off my hat to de white folks as dey passed by, and dey
used to gib me silver; but it's all gone now! No birds sing, no white gem- **345**
blem gib me silber; no, no, all gone—de war skeered dem all away; now
de white gemblem won't look at me.[21]

Increasingly, however, maudlin tributes to slavery gave
way to humiliating depictions of free blacks bumbling their
way through the maze of emancipation. One favorite context
was the courtroom, where blacks were routinely presented as
incapable of navigating the legal system, turning it into a
farce. The 1898 play "The Darkey Breach of Promise Case,
A Nigger Mock Trial" presents two obtuse black lawyers
haggling over a dispute between a man and a woman. In its
muddled dialog, the inability of blacks to comprehend legal
matters is linked to issues of gender equality. The lawyers,
Snowball and Brass, address the judge and jury:

Minstrel scripts included
advertisements for mass pro-
duced proscenium decora-
tions, scenery, props, and
makeup. AUTHOR PHOTOGRAPH

SNOWBALL. Yer washup, an' gentlemen ob de jury: Dis
am one ob de most 'scruciatin' cases dat ebber I remem-
ber in all my long susperience ob de outraged laws ob
cibilized sassiety—dat ob a lubin', trustin', an' manly
buzzum being' converted into a skaotic mass ob trubble
by de act ob a shemale, who, aldough wearin' de form
ob a human bein'—

BRASS. I takes objection to dee term 'human bein'," yer washup; my client
am a lady.

SNOWBALL. Den, yer washup, an' gentlemen ob de jury, dis lady, who
am *not* a human bein, hab so played upon de feelin's ob my client, Jose-
phus Jellybrain, dat de place where his heart once existed am now a com-
plete vackyum, full ob nuffin' but grief an' despair.

An inability to fathom modern scientific knowledge was also an ongoing
theme. In one play, the Interlocutor tries to engage Tambo in a serious discus-
sion of astronomy.

INTERLOCUTOR: Tambo, do you know anything about astronomy?

346 TAMBO: I haven't met the lady in years.

INTERLOCUTOR: No, no. Astronomy is the study of the nebular hypothesis, the study of planets. For instance, do you know that the sun is so far away it would take two thousand years for a wireless message to reach there?

TAMBO: Maybe you better send a picture postcard.

INTERLOCUTOR: Good heavens, man, don't you realize that the sun is often at a distance ninety-three million miles?

TAMBO: Oh, that must be out near New Rochelle![22]

At a time when phrenology was still fashionable, several plays featured phrenologists. In Charles White's 1874 play, "Wake Up! A Negro Sketch Known as Psychological Experiments, Psychology, Bumps and Lumps, Bumpology, etc.," the gobble-de-gook of blackface and scientific lexicography come together, playing to the audience's racism and anti-intellectualism in one fell swoop. In it, a blackface comic named Hemmingway asks the then famous Professor Fowler to comment on the head of "young Bill."

HEMMINGWAY: Professor, what is de reason dat his head am so much harder dan any other head in de family?

PROF. FOWLER: Simply because the valetudinary hypothesis of the cram disorganizes the currency functions of the digestion pad, which causes great moisture and elasticity in the external velocipede, and fills up the rotary antelope with a dusenberry compound of culinary impediments.

HEMMINGWAY: (Astonished) My gracious! I neber know'd dat he had that.[23]

Two decades later, in "The Darkey Phrenologist: A Nigger Absurdity," Prof. Mephistopheles Faust has replaced the real-life Fowler. Delivering a lecture, Professor Faust interacts with an audience member. In this play, phrenol-

ogy provides an opportunity to deride "negro" intelligence and to put forward the idea that blacks are inherently criminalistic. We encounter the two characters discussing a phrenological diagram of the head. The assault on the character of African Americans was unremitting, summoning up theories of racial science that defined "Ethiopians" as atavistic remnants of primitive humanity.

ORLANDO: (points to diagram) Dis ain't *her* picture, am it?

PROFESSOR: No, yer niggeramus. It am a frenerological diergram ob de human head, wiv all de organs marked down on it, an' not a portrait at all.

PROFESSOR: (hits him again) Sit down, an' don't interrupt de course ob de lecture—def ine an' sloping front shows such a total want ob sense an' reberence, dat dar's no room for any. Dar's not a doubt, my friends, dat nature kermenced to make a head ob dis object, but she must hab been interrupted in the process, an', bein' on piece-work, like a machine-shop laborer, neber went back ter finish de job. . . . De perdigious prominence at de back ob de object am where de animal bumps lies. Yer can see from de furdest part ob de room de two bumps protrudin' from behind de enormous ears, which, dough dey am much larger dan dose of any udder animal ob de same asinine nature, am not near capacious enuff to cub-ber de two enormous bumps, which, bein' as big as turkey eggs, am vis-ible 'bout half a mile away. Dese, my friends, am de organs ob destruction, an', by deir size, probe wivout a doubt dat de subjec' now under manipulation couldn't help kermittin' a murder, eben if he tried eber so much to avoid doin' so.

Plays like this were being published and distributed during a time when Jim Crow legislation—legalized racial segregation—was becoming the law of the land. This was also an era of frequent public lynchings, murderous statements about what happens to blacks who overstep their bounds. Slavery had been abol-ished, but the dominant white culture was working overtime to put black people back in their place. "The Darkey Phrenologist" offered a humorous, pseudosci-entific explanation of why "White World Supremacy," as Lothrop Stoddard termed it, must be maintained.

One of the most lucid examples of the way that minstrel scripts provided humorous justification for repressive or, if necessary, violent measures against free blacks is found in Walter S. Long's 1915 script, "Dat Famous Chicken Debate."

348 Published in a year when antiblack, anti-immigrant agitation was reaching fever pitch, the play used current issues regarding the proper place of African Americans in society as the foundation for its scenario. This farcical debate—a common format in minstrel shows—pitched representatives from two fictional black institutions against each other. The proposition in question: "Resolved, That Stealing Chickens Ain't No Crime." The "University of Africa" argued the affirmative position, while "Bookertea College" argued the negative.

Written instructions for those who wished to put on "Dat Famous Chicken Debate" encouraged amateur performers to make it as hilarious as possible.

> This darkey debate may be a very funny number on your program . . . Where stage facilities are available all the humorous settings of a darkey clubroom may be used . . . The costumes of the debaters, the judges and others may be as funny or as ragged as desired.

Yet behind the laughter lay serious issues regarding the relationship between black people and white law. "Rufus Rastus Johnsing" and "Nebuchadneazer Jones," representing "The University of Africa," open the debate arguing that stealing chickens is not a crime because black people had no voice in writing the laws that govern them. Citing Lincoln's Emancipation Proclamation and President Woodrow Wilson's ideas on the rights of independent citizens, they offered an argument that, in spite of its linguistic buffoonery, offered a well-reasoned argument.

> RUFUS: Whoever hearn tell ob niggers makin' laws 'gainst de stealin' ob chickens. I defies both ob you Africans ober dar ter show dese gemmens one single law 'gainst de stealin' ob chickens what a black man hab made. Now, yall admits dat Marse Lincoln hab done made de niggers a free n' independent people. Marse Woodrow's new book on Scientific Government say dat a free an' independent people can only be ruled by laws wat dy makes fer deyselves. . . . Now ef de niggers am a free an independent people, an' ef a free an' independent people can only be ruled by laws dat dey make fur dyselves, den de white folks' laws dey don't 'ply ter de niggers, an' since dere caint be crime widout a law, an' since de niggers neber has made no law 'gainst the stealin' ob chickens, I maintains dat it ain't no crime ter steal chickens, an' I axes yall ter considerate carefully on de 'bove argument, an' don't pay no 'tention ter dose other niggers 'cause dey hab done gone back on dere color.

Bookertea College, however, argues for total accommodation, a position associated with Booker T. Washington—founder of Tuskegee Institute—who is cited 349
in the script. Bookertea maintains that, regardless of the disenfranchisement of
blacks, it is incumbent upon them to accept their position and respect the law. Outraged by the gall of their opponents, Bookertea's "Hezakiah Gitdar" and
"Ephram Pullemdown," offered a vehement response.

> HEZAKIAH: I has listened ter dat lack man until my face hab done grew
> red lak de insides ob a watermillion, blushin' fer shame. I has done heard
> him sinuation dat all niggers steals chickens an' den take up fer dem
> 'cause he hab done stole chickens hisself. I doesn't believe dat all niggers
> steals chickens. An ef some niggers does steal chickens some time, dose
> niggers ain't civilized, dey ain't fitten ter pattern after, an' de civilized cul-
> lud gemmens should jes' 'sider dem as de black sheep ob der flock. Look
> at Mr. Booker Washington, do he steal chickens? No, suh, he do not. He
> cud sleep all night in a hinhouse on de night befo' Protracted meetin' an'
> not eben dream of a pot pie.

In retort, the University of Africa reasserted its position, which has now disintegrated into an accolade to the wondrousness of chicken.

> NEBUCHADNEAZER: Mr. Gladstone he say as how de means by which we
> does any thing may be justified by de end in view. Now let's take stealin'
> chickens as de means, an' a big fat juicy rooster as de end in view—(wait
> a minnit, niggers, don't git 'cited yet). Now jes' imagination a nigger on
> dat rooster's tail. . . . Mr. Rooster he kinder turn his haid ter one side, an'
> de nex' minnit he done drap in de bag. Now, my fren's, jes' 'magination
> dat nigger goin' home. Dat rooster seem lak he already in de pot. Crime
> or no crime, dat nigger are happy, an' de Bible say as how only good
> people can be happy.

Bookertea's response, couched in the idiom of religious hokum, offers a powerful rebuke of such thinking, defending lynchings for those blacks who dare to
disregard the white man's power.

> EPHRAM: Everybody knows dat de nigger am descended from Ham. Yit
> de no 'count niggers ob dis day an' time dey don't care nothing tall
> about Ham. Dat are why dey are ter be punished. Leave dat fowl alone

I say, an' turn yer thoughts to Ham. Dat are de only way da de cullud folks can turn aside dax awful punishment dat am waitin' fer dere race, eben as de angel ob de Lawd waited fer Balaam in de straight an' narrow way. Look out niggers dat sword am boun' ter fall, an' mark my words 'twill mow you down lak corn befo' de knife. Dat are de day when the earth shall ring wid wailin' an' de nashing ob dentistry, an' all de niggers will be moanin' fur deyselves. An' above de noise ob weepin' and' respair will be heered de rooster's voice a-crowin' in de mawnin'. He say, 'Brek dat nigger's neck.' I tell you now my frens, yer mus' leave dat fowl alone or he gwine ter hab his vengeance on yer sho's you bawn.[24]

Rarely is the potential for art to serve as a tool in defense of social oppression seen so clearly, but "Dat Famous Chicken Debate" was merely an extension of an American theatrical genre that reached back to the time of slavery and would continue into the age of cinema.

If minstrelsy was the invention of white performers, after the Civil War it began to draw free black entertainers into its web. With emancipation and the need to earn a living, black performers were increasingly drawn into a Faustian bargain. In order to find work in a Jim Crow world, many had to assume roles created by white minstrelsy. Some early black minstrels were able to perform without make-up; their naturally dark hues serving as satisfactory masks. By this 1890s, however, natural skin tones were viewed as an effrontery to a minstrel tradition that expected its "negroes" to be black as coal, and had developed its craft behind the cover of burnt cork.

To perform in a country increasingly unsympathetic to its black citizens, African Americans were forced to conform to the conventions of the art form. W. C. Handy, the "father of the blues," began his professional career in the mid-1890s as a member of a group called Mahara's Minstrels, an itinerant company of black artists who, like their white counterparts, wore blackface make-up. In his 1941 autobiography, Handy recalled the thorny early stages of black professional entertainment in America:

The minstrel show at that time was one of the greatest outlets for talented musicians and artists. All the best talent of that generation came down the same drain. The composers, the singers, the musicians, the speakers, the stage performers—the minstrel show got them all.[25]

In their performances, black minstrels were required to live up to white expectations. Many of them claimed to be former slaves, even when they were not, and therefore lent an imprimatur of legitimacy to their portrayals of plantation life. Yet beneath this aura of authenticity, black minstrels were expected to confirm the humiliating caricatures born of the white minstrel show. Black participation in minstrelsy provided an unprecedented pseudorealism to the shows. With blacks portraying themselves in demeaning roles, racist caricatures of innate "negro" predilections received a black stamp of approval. While minstrel shows offered black entertainers an opportunity to enter American show business for the first time, they also served to keep the prevailing culture of racial inequality alive.

This was the fatal dilemma of black minstrelsy. On the one hand it afforded widespread audiences—black and white—an opportunity to experience the prodigious talents of African-American performers for the first time. On the other, the context of these talents inhibited the advancement of a free black population.

Acceptable roles for black performers were limited by the strictures of white-run entertainment business, and these limits would survive far beyond the era of minstrelsy.[26] Some, such as the filmmakers Spike Lee and Robert Townsend, have persuasively argued that the social and cultural influence of this nineteenth-century amusement continues to haunt American popular culture to this day.

According to Dr. Roget, who included colloquial language in his *Thesaurus*, access to slang terminology would provide writers with words that would permit them to more faithfully represent people from the lower depths of society. Havelock Ellis argued that a familiarity with slang offered criminologists a better opportunity to truly understand the inner workings of the criminal mind.

In minstrelsy, however, an ersatz-slang—the invention of white writers—fostered the dissemination of a malleable, instrumental, and defamatory version of black culture that would appeal to the prejudices of white audiences. If these scriptwriters had any familiarity with black people, it was hardly empathetic. To them, blacks were being true to themselves only when they occupied subservient positions. Minstrelsy, its absurd images and twisted language, offered these dramatists the ability to fortify what W. E. B. Du Bois predicted would emerge as the most significant issue of the twentieth century, "the color line."

Other art forms would soon move in to uphold the banner of white supremacy. In 1914, only a year before "Dat Famous Chicken Debate" was published, D. W. Griffith's colossal *Birth of a Nation* carried a similar—less humorous and more overtly vengeful—message into a silent and mesmerizing new medium that would accelerate the range of mass culture, the motion pic-

ture. In Griffith's historical drama, the dangers posed by a free black population were writ large, in harsh visual terms, on a silver screen. The vigilantism of the Ku Klux Klan assumed the role of America's savior. Carrying on the minstrel tradition, all of the main African-American characters were played by whites in blackface.

The entrenchment of blackface portrayals as a staple of American culture, however, did not go unanswered. By the early years of the twentieth century, a growing number of educated middle-class African Americans expressed anger at stereotypes that served to uphold subjugation of "colored people." Facing unchecked white violence, and an ongoing vilification of their humanity, an emerging urban black intelligentsia began turning stereotype into contested ground.

To a certain extent, these people were inspired by other developments that followed the end of the Civil War. The rise of inexpensive photo portraiture had, from its beginnings, challenged traditional relations between social class and the opportunity to have one's face and family recorded for posterity. Photo studios, which sprang up throughout the United States from the early 1850s, were frequented by all kinds of people, and with the emancipation of the black population, more and more African Americans visited photographers and brought home visions of themselves that enunciated their personhood and dignity.

Frederick Douglass, writing in the 1870s, predicted that this expanded access to images, of themselves and of their world, would become a defining element of the new freedom that black people had achieved.

> Heretofore, colored Americans have thought little of adorning their parlors with pictures . . . Pictures come not with slavery and oppression and destitution, but with liberty, fair play, leisure and refinement. These conditions are now possible to colored American citizens, and I think the walls of their houses will soon begin to bear evidence of their altered relations to the people about them.[27]

While white culture was vilifying the Negro population, within black neighborhoods, new forms of cultural expression were taking hold, generating visions of the community that celebrated the accomplishments of the "New Negro," a term coined by a black journalist in the 1890s.[28] One important arena in which social progress was illuminated was in the growing num-

ber of black-owned photo studios and businesses that commenced operations from the Reconstruction period onward. The historian of photography Deborah Willis reports that a growing battery of black photographers were generating newly respectful visions of Negro life, recording conscientious families, active church organizations, and the important contribution of educational institutions to the community.

> [M]ost images made by white Americans showed blacks as subordinate to the dominant race, but photographers began to record images of black people seeking an education, new lives, new identities, new prospects, and new jobs (often in urban centers)—alternative and positive images of the black experience . . . The photographic image was considered as powerful as the written word as black people struggled to persuade the American public to change their notions about race and equality.[29]

Amid the lethal racial climate of the early 1900s, some black leaders were inspired to employ this alternative photographic record as a weapon against the standard iconography of racism. When Thomas Calloway, a black lawyer and educator, learned that a world's fair celebrating the new century was scheduled to open in Paris in April of 1900, he contacted his old friend and college classmate, W. E. B. Du Bois. Calloway thought that the Paris Exposition would provide an ideal venue for presenting distinguished representations of black people rarely seen in white-controlled environments. Du Bois, a highly regarded sociologist who would become one of the founders of the National Association for the Advancement of Colored People, the NAACP, agreed, and they set out on developing a plan.

The outcome of their discussions was to mount "The American Negro Exhibit," a photographic tribute to the "New Negro." World's fairs, as recently as the 1893 Columbian Exposition in Chicago, had habitually included exhibits of "native villages" that demeaned the culture and humanity of nonwhite peoples. In Chicago these defamatory spectacles had provoked a strongly worded critical response from two of America's most important black journalists, the antilynching activist Ida B. Wells and the venerable Frederick Douglass. The Paris Exposition was similarly slated to include living displays of "lesser" peoples from Europe's colonial conquests in Asia and Africa. Since fairs were routinely used to denigrate Europe and America's human prey, Calloway and Du Bois reasoned, the Exposition might serve as an ideal platform for battling this proclivity.

A European capital, in particular, offered a tempting setting for "The Amer-

ican Negro Exhibit." Paris was the home of natural history, a field that placed blacks at the bottom of the human chain, often defining them as missing links

Portraits of a young woman and a young man from The Negro Exhibit at the Paris Exposition. FROM THE COLLECTION OF THE LIBRARY OF CONGRESS; COURTESY OF DEBORAH WILLIS

between civilized humanity and the animal kingdom. European racial science had also lent legitimacy to the American system of plantation slavery, maintaining that servitude was part of Africans' essential makeup.

Given these realities, Calloway described the Paris Exposition as a critical environment to penetrate and challenge. In a letter to Booker T. Washington, asking for his support, Calloway underlined the critical role that the exhibit could play. In his call for support of the exhibit, he noted:

> Everyone who knows about public opinion will tell you that the Europeans think us a mass of rapists, ready to attack every white woman exposed, and a drug in civilized society. This notion has come to them through the horrible libels that have gone abroad whenever a Negro is lynched, and by the constant reference to us by the press in discouraging remarks. . . .
>
> How shall we answer these slanders? Our newspapers they do not subscribe for, if we publish books they do not buy them, if we lecture they do not attend.
>
> To the Paris Exposition, however, thousands upon thousands of them will go and a well selected and prepared exhibit, representing the Negro's development . . . will attract attention . . . and do a great

and lasting good in convincing thinking people of the possibilities of the Negro.[30]

355

The central element of "The American Negro Exhibit," when it was finally launched, was a collection of 363 photographs, each selected as a representative example of the social and economic progress of "a small nation of people." This phrase, a break from the governing definitions of natural history, reflected the desire of the exhibit's organizers and supporters to honor African Americans as a nation of people rather than a biologically determined race.

Defying common stereotypes, the exhibit was calculated to present a truer portrayal of the "typical Negro," one that most Europeans had never seen. A collection of individual and group portraits, also work places, churches, and the interiors of homes, the exhibit placed a spotlight on industry, education, and progress. Books, newspapers, and other writings were highlighted in the exhibit to demonstrate what Calloway called "the negro's mental development."[31]

Those schooled by the physiognomy of racist caricatures were confronted with something far different. Offering visible evidence of the dignity and beauty of African Americans, the exhibit, according to Du Bois, confronted fairgoers with images that "hardly square with conventional American ideas."[32]

Many of the photographs shown in the exhibit were gathered from black photographers in Georgia. This state was selected as a source, in part, because it already had a significantly large black middle class. African Americans from elsewhere also supported and contributed to the

A pharmaceutical laboratory at Howard University featured in the Negro Exhibit at the Paris Exposition. FROM THE COLLECTION OF THE LIBRARY OF CONGRESS; COURTESY OF DEBORAH WILLIS

exhibit, which they saw as an imperative response to the visual slurs that routinely defamed the character of their communities. Atlanta University, Fisk University, Hampton University, Howard University, and Tuskegee Institute all provided photographs to illustrate the quality of higher education offered by these insti-

356

tutions.33 Together, the exhibit resisted common assumptions about American blacks as a backward people. The cultural historian Shawn Michelle Smith sums up its mission:

> Unlike the exoticized displays of African villages that reinforced white European estimations of their own "civilized" superiority in relation to "Negro savages," the American Negro Exhibit of the Paris Exposition represented African Americans as thoroughly modern members of the Western world.34

The photographs in the exhibit, according to the historian David Levering Lewis, provided a startling visual brief on behalf of "characteristics and virtues of which most whites, either in ignorance or from bigotry, believed most blacks to be devoid."

> Dark-skinned citizens whose features betoken undiluted African ancestry gaze in high-collared or bonneted distinction from offices, pews, and parlors . . . Indeed, many of them portray people of such idealized European appearance that, as intended, they must have confounded the aesthetics, affronted the self-esteem, and trumped the civilizationist assumptions of the white people who came to see the Negro section.35

The composing room of the *Planet*, a black newspaper in Richmond, Virginia, featured in the Negro Exhibit at the Paris Exposition. FROM THE COLLECTION OF THE LIBRARY OF CONGRESS; COURTESY OF DEBORAH WILLIS

Between April and November of 1900, fifty million people attended the Paris Exposition. While the number of those who visited "The American Negro Exhibit" is unknown, and its impact on white attitudes is impossible to gauge, its very existence constituted a significant step in what would become an increasingly urgent struggle of black people to define themselves, through their own words and images, in a predominantly white world.

24
MALE AND FEMALE CREATED HE THEM

By the late nineteenth century, in Europe and the United States, challenges to old structures of authority, and their repertoire of stereotypes, were becoming increasingly vocal. While traditional advocates of innate human inequality held tight to their position, new voices were beginning to emerge. As entrenched taxonomies began to wobble, their adherents became increasingly strident. Even today, there are those who uphold the old-time religions regarding social, ethnic, and sexual distinction. Occasionally, they take their stand at the most unexpected moments.

It was a wintry Friday in January of 2005, when the president of Harvard University spoke to a closed-door session at a conference of the National Bureau of Economic Research in Cambridge, Massachusetts. The conference's theme concerned issues relating to the underrepresentation of women and minorities in the "Science and Engineering Workforce."

President Lawrence H. Summers was neither a scientist nor an engineer, but he had a formidable academic reputation. When he received his Ph.D. in economics from Harvard in 1982, he had already been an assistant and associate professor at MIT for three years. At the age of twenty-eight, one year after completing his doctorate, he returned to Harvard as "one of the youngest individuals in recent history to be named as a tenured member of the University's faculty."[1] Beyond his academic achievements, Summers had worked extensively in government, eventually becoming Secretary of the Treasury in 1999. Upon leaving that post, he did a stint at the prestigious Brookings Institution in Washington, DC, serving as the Arthur Okun Distinguished Fellow in Economics, Globalization, and Governance. In 2001, he returned triumphantly to Harvard to serve as its twenty-seventh president.

Addressing the fifty select academics that attended his session, Summers carried the prestige of America's most hallowed university. Turning to the question of why so few women had achieved stellar positions on the faculties of the nation's major research universities, he scandalized many in his audience when he declared that this gender inequity might be due to "issues of intrinsic aptitude, and particularly of the variability of aptitude; and that those considerations are reinforced by what are in fact lesser factors involving socialization and continuing discrimination."[2] While acknowledging that

358

bias may have something to do with the underrepresentation of women in the sciences and mathematics, Summers suggested that innate differences between the sexes might be a far more significant determinant.

The furor that ensued was enormous, occupying front pages for a considerable length of time. Unlike most academic leaders of the past, Summers was

"The woman made me do it." DOMENICO ZAMPIERI'S "THE REBUKE OF ADAM AND EVE," 1626; AUTHOR PHOTOGRAPH

In this fourteenth-century woodcut, a more egalitarian vision of male and female is evident. In informal surveys, which is Adam and which is Eve is an issue of some debate. AUTHOR PHOTOGRAPH

speaking to a professoriate that was no longer exclusively male. The masculine monopoly over university faculty positions, though still influential, had been broken in the wake of feminism and civil rights activism. Reflecting on Summers's anachronistic pronouncement, Denise D. Denton, Dean of Engineering at the University of Washington, said that his remarks had "provoked an intellectual tsunami." Angrily confronting him behind closed doors, she implored that it was time to "speak truth to power." The truth she invoked was that the notion of women's innate intellectual inferiority was a relic of a time when women had no access to institutions of higher learning. She and others were astounded by President Summers's "ill-informed remarks," which had no place in the company of thinking people.

While 2005 was an inopportune moment for a highly visible intellectual leader to be voicing such opinions, Lawrence Summers was hardly the first man of learning to propose that women were inherently inferior to men. If anything, his ill-advised statement represented the wisdom of the ages.

Prevailing religious doctrines have long justified women's subordinate role. The domination of women by men, within the official sanctums of the Judeo-Christian tradition, was rooted in the fall from grace that led God to expel Adam and Eve from the Garden of Eden. Through her behavior and her weakness, so the story goes, Eve incurred a fate that would be visited upon those of her sex for all time.

Yet, according to some interpreters, Eve was not Adam's first wife; the subservient position of women not so clear-cut. Adam's first wife, some have argued, was called Lilith, created as Adam's equal. Even the Bible and Torah are confusing on this point. While there is no direct mention of Lilith in the Book of Genesis, even in the wake of many redactions, the first chapter still contains a mysterious passage where the creation of man and woman appears to take place concurrently.

> So God created man in his own image, in the image of God created He him; male and female created he them. And God blessed them, and said unto them, "Be fruitful and multiply, and replenish the earth, and subdue it: and have dominion over the fish of the sea, and over the fowl of the air, and over every living thing that moveth upon the earth."[3]

Drawing their argument from portions of the Talmud and the Dead Sea Scrolls, the biblical scholars Robert Graves and Raphael Patai have contended that Adam could not tolerate Lilith's position of equality. As a result, he and Lilith "never found peace together."

[W]hen he wished to lie with her, she took offence at the recumbent posture he demanded. "Why must I lie beneath you?" she asked. "I also was made from dust and am therefore your equal." Because Adam tried to compel her obedience by force, Lilith, in a rage, uttered the magic name of God, rose into the air, and left him.4

Though stricken from the canon of mainstream religions, such alternative renditions of creation, and of other biblical events, were rife among Christians and Jews for several hundred years following the death of Jesus. Some of these suppressed stories came to light in 1945, when an Arab peasant, Muhammad 'Alí al-Sammán, discovered a large ancient clay vessel inside a cave near Nag Hammadi in Egypt. Inside the jar was a trove of papyrus manuscripts containing gospels and other writings dating back to a period beginning shortly after the crucifixion but branded as heresies as Christianity became a church and took hold as an organized, increasingly powerful religion. When the Roman Emperor Constantine converted to Christianity, and then legalized the Church in 313, all such remaining writings were outlawed and those discovered, burned.

The Nag Hammadi Library, Coptic translations of these forbidden "Gnostic Gospels," provided moderns with the first glimpse of an ancient opposition to what would become the official story. According to Elaine Pagels, one of the foremost scholars of these early texts, some of them speak of the creation of "male and female" in the "image and likeness" of God as a sign that God is a duality, "both masculine and feminine—both Father and Mother."

This version of creation, she writes, carried into Jesus' teachings as revealed in the banned texts. "One group of Gnostic sources claims to have received a secret tradition from Jesus through James and through Mary Magdalene. Members of this group prayed to both the divine Father and Mother: "From Thee, Father, and through Thee Mother, the two immortal names, Parents of the divine being, and thou, dweller in heaven, humanity, of the mighty name."5

Within many of these early groups, some scholars maintain, men and women enjoyed an equal status; the unity of male and female was celebrated as a sacred bond. According to this perspective, Mary Magdalene and Christ were the most intimate partners in God. She was his closest companion, and his trust in her far exceeded that which he conferred on his male disciples. The Gospel of Philip, one of the Nag Hammadi manuscripts, states that Jesus loved her more than any of his other followers, and many of his male disciples were deeply jealous.

The companion of [the Savior is] Mary Magdalene. [But Christ loved] her more than [all] the disciples, and used to kiss her [often] on her [mouth]. The rest of [the disciples were offended]. . . . They said to him, "Why do you love her more than all of us?" The Savior answered and said to them, "Why do I not love you as [I love] her?"[6]

According to the Gospel of Mary Magdalene, Mary sees Jesus rising from the tomb, and he speaks to her through a vision. She reports his message back to the other disciples. Among all of them, Peter is most threatened by her special access to Jesus.

> And Peter added:
> "How is it possible that the Teacher talked
> in this manner with a woman
> about secrets of which we ourselves are ignorant?
> Must we change our customs,
> and listen to this woman?
> Did he really choose her, and prefer her to us?"
> Then Mary wept,
> and answered him:
> "My brother Peter, what can you be thinking?
> Do you believe that this is just my own imagination,
> that I invented this vision?
> Or do you believe that I would lie about our Teacher?"

Another disciple now steps in, reminding Peter that the belittling of women was not part of Jesus' teachings.

> At this, Levi spoke up:
> "Peter, you always been hot-tempered,
> and now we see you repudiating a woman,
> just as our adversaries do.
> Yet if the Teacher held her worthy,
> who are you to reject her?
> Surely the Teacher knew her very well,
> for he loved her more than us.
> Therefore let us atone,
> and become fully human."[7]

Pagels reminds us that none of these ideas or manuscripts remains in that privileged group of writings known as the New Testament. They were purged, she writes, as Christianity developed its official tenets.

> Every one of the secret texts which Gnostic groups revered was omitted from the canonical collection, and branded as heretical by those who called themselves orthodox Christians. By the time the process of sorting the various writings ended—probably as late as the year 200—virtually all the feminine imagery for God had disappeared from orthodox Christian tradition.[8]

With the defeat of the Gnostics, the New Testament became the word of God, Jesus would become "Christ, the Son of the living God," and Peter would become his most trusted apostle. As told in the Gospel According to Saint Matthew (16:18–19), Jesus assigns Peter the job of building his organization. "And I say also unto thee, That thou art Peter, and upon this rock I will build my church; and the gates of hell shall not prevail against it. And I will give unto thee the keys of the kingdom of heaven."

Catholicism's triumph, and the building of Church with Peter as its first pope, depended on the successful and often brutal suppression of a female worship that persisted in the beliefs of early Christians. Women were now marked as a tainted sex, and an exclusively male priesthood was sworn to celibacy. Mary Magdalene was branded as a whore.

While there has been a growing interest in Gnostic beliefs in recent decades, the prevailing religions continue to hold to an expurgated canonical text. In official descriptions of Creation, for example, the name of Lilith does not appear, in spite of the story told in Genesis, chapter 1. Curiously, in chapter 2, it is man alone who is created by God out of "the dust of the ground." Woman does not yet exist.

Having "breathed into his nostrils the breath of life," God proceeds to give Adam dominion over the earth and the privilege of naming "every living creature." Yet Adam is bereft of human companionship, and a woman is created to assuage his loneliness.

> And the Lord God caused a deep sleep to fall upon Adam, and he slept: and he took one of his ribs, and closed up the flesh instead thereof; and the rib, which the Lord God had taken from man, made He a woman, and brought her unto the man.

> And Adam said, "This is now bone of my bone, and flesh of my flesh;
> she shall be called Woman, because she was taken out of man."9

Here, even in the beginning, woman is created in response to man's desires. The man is given the power to name her, and his rule over her would become even stronger after the disgrace of original sin.

Interestingly, the Peshitta, which serves as the basis for the Holy Bible used in the Eastern Orthodox churches, presents the creation of woman in a somewhat different light. Prior to her creation out of Adam's rib, this version suggests that woman is created on a par with man.

> Then the Lord God said, it is not good that the man should be alone; I
> will make him a helper who is like him. . . .
>
> And Adam gave names to all cattle, and to all fowl of the air, and to
> all wild beasts; but for Adam there was not found a helper who was equal
> to him.10

Equal or not when she was first created, things would soon turn badly for woman. When God had first created Adam, he offered him eternal life in paradise, with one caveat.

> And the Lord God commanded the man, saying "Of every tree of the
> Garden thou mayest freely eat: but of the tree of the knowledge of good
> and evil, thou shalt not eat of it: for in the day that thou eatest, therefore
> thou shalt surely die."

In violation of God's first commandment, woman is enticed by the serpent to eat from the tree. Not only does she eat of it, but she also convinces Adam to take a bite of its fruit.

"Walking in the garden in the cool of the day," God discovers their transgression. Turning to Adam, an angry God asks, "Hast thou eaten of the tree, whereof I commanded thee that thou shouldest not eat?"

In fear and trembling, Adam points his finger at his helper. "The woman whom Thou gavest to be with me, she gave me of the tree, and I did eat." With an expression of cosmic paternal chagrin, God then turns to the woman and says, "What is this that thou hast done?"

For their act of disobedience, both are expelled from Paradise, destined to pay harsh wages for their sin. To Adam, who was initially offered the promise of

364

eternal life, death now would be inevitable. He would also live in suffering. "Because thou hast hearkened unto the voice of thy wife, and hast eaten of the tree . . . cursed is the ground for thy sake; in toil shalt thou eat of it all the days of thy life."

For the woman—whom Adam would shortly name Eve—the punishment would be even graver. Beyond enduring Adam's curse, she was burdened with an additional sentence. As man was required to submit to God's will, woman would submit to man. As God told Eve: "I will greatly multiply thy pain and thy travail; in pain thou shalt bring forth children; and thy desire shall be to thy husband, and he shall rule over thee."[11]

Into the modern era, this biblical account served to explain and uphold the legitimacy of the ruling patriarchal culture. With the rise of secular thought, however, science began to displace religion as the dominant voice of authority regarding natural and material phenomena.

In a world that increasingly embraced the notion that scientific investigation could yield verifiable truths, distinctions between male and female began to assume a mantle of objectivity, upheld by the laws of nature. This was evident in the mid eighteenth century, when Linnaeus wrote his *Systema naturae*.

In Linnaeus's schema all living things, from flowers to beetles to the races of man, conformed to clearly defined ideal types. Each distinct type identified a particular group or species, excluding all others from membership. Specimens or organisms that did not correspond to an ideal type were dismissed as anomalies or freaks of nature.

While his system created a hierarchical universe comprised of unique plant and animal species, another exclusionary assumption was embedded within it. Male and female also constituted ideal types: separate, distinct and unequal; each bearing physical and mental traits that were poles apart. This belief infused his categorization of plants as well as animals, often seeing human conventions as his model for differentiation.

This premise of the essential inequality between men and women, rooted in nature, remained firmly in place well into the age of democratic revolutions. In the self-proclaimed Age of Reason, the figure of Liberty may have been represented as a woman, but most Enlightenment men considered women to be a lesser subspecies, incapable of exercising the rights of citizenship.

A case in point was Jean Jacques Rousseau, whose 1754 *Discourse on the Origins of Inequality*, maintained that all forms of injustice resulted from flawed political institutions that, throughout history, had encroached on mankind's natural rights.[12] In 1762, he opened his book *The Social Contract* with the famous

democratic mantra: "MAN is born free; and everywhere he is in chains." While this invocation may have inspired such early feminists as Mary Wollstonecraft, 365 Rousseau himself did not approach the inequalities between men and women as an injustice.

In *Emile*, also published in 1762, he wrote at length about the "natural" disparities that made man a creature of "reason," suited for the requirements of civil society, and woman a creature whose "charms" and "wiles" were her most potent attributes, most properly exercised in the domestic sphere. Alongside Rousseau's eloquence on matters of human equality, he saw men and women possessed of intrinsically different dispositions.

> The one should be active and strong, the other passive and weak. It is necessary that the one have the power and the will; it is enough that the other should offer little resistance.
>
> Once this principle is established it follows that woman is specially made to please man. If man ought to please her in turn, the necessity is less urgent. His merit is in his power; he pleases because he is strong. . . .
>
> If woman is made to please and to be subjected, she ought to make herself pleasing to man instead of provoking him.

These ardent distinctions were occasioned by the subject matter of *Emile*, a book encapsulating Rousseau's thinking on what a proper and natural education should be. In it, he insisted that the education of each sex must be different, to each according to its nature. "Once it is demonstrated that men and women neither are nor ought to be constituted the same, either in character or in temperament," he wrote, "it follows that they ought not to have the same education."

Facing the challenges of an incipient feminist movement that embraced democracy as a call for women's equality, Rousseau argued that the folly of educating the sexes in the same way would disturb their essentially dissimilar constitutions.

> Woman is worth more as a woman and less as a man. When she makes a good use of her own rights, she has the advantage; when she tries to usurp our rights, she stays beneath us. . . .
>
> To cultivate the masculine virtues in women and to neglect their own is obviously to do them an injury. . . . When they try to usurp our privileges they do not abandon their own. But the result is that being unable to manage the two, because they are incompatible, they fall below their

own potential without reaching ours. . . . Believe me, wise mother, do not try to make your daughter a good man in defiance of nature. Make her a good woman, and be sure it will better for both for her and us.

To a mother willing to follow Rousseau's instructional advice, he offered some suggestions:

Daughters must always be obedient, but mothers need not always be harsh. To make a girl docile you need not make her miserable; to make her modest you need not terrify her. . . . Her dependence need not be made unpleasant; it is enough that she should realize that she is dependent.

. . . The daughter should follow her mother's religion, the wife her husband's. Even when that religion is false, the docility which leads mother and daughter to submit to nature's laws would blot the sin of error in the sight of God. Unable to judge for themselves they should accept the judgement of father and husband as that of the church.

Such ideas were founded on Rousseau's conviction that women were innately passive and incapable of systematic thought. Reading the transcript of Lawrence Summers' speech to the National Bureau of Economic Research, one can only wonder if it was Rousseau who was his spiritual godfather. "Woman observes," Rousseau wrote, "man reasons."

The search for abstract and speculative truths, for principles and axioms in science, for all that tends to wide generalization, is beyond a woman's grasp; their studies should be thoroughly practical. . . . For the works of genius are beyond her reach, and she has neither the accuracy nor the attention for success in the exact sciences. As for the physical sciences, to decide the relations between living creatures and the laws of nature is the task of that sex which is more active and enterprising, which sees more things, that sex which is possessed of greater strength and is more accustomed to the exercise of that strength.[13]

With these words Rousseau—the champion of freedom—constructed an iron cage. In a world where "great men" would increasingly use elaborate systems of scientific categorization to underwrite the verifiable "truth" of human

inequality, woman was defined as inherently unfit to render such judgements. With "works of genius . . . beyond her reach," she must be excluded from the 367 erudition that would be repeatedly employed to deny her any civil or intellectual standing in the world beyond the home. She could be the named, but she could never be the namer.

Rousseau's insistence, his detailed codification of difference, must be juxtaposed with an alternative perspective on women and education that had been gathering steam since the last decades of the seventeenth century. Caught up in the spirit of the early Enlightenment, a growing number of voices had begun to draw links between the principle of liberty and the rights of women. The full and equal education of women—specifically, upper- and middle-class women—was seen as a vital precondition of liberation.

As early as 1673, Bathsua Makin, tutor to the daughters of English royalty, proposed the establishment of an academy for young women. In "An Essay to Revive the Ancient Education of Gentlewomen," Makin offered a curriculum that would be taught in such a school. Along with subjects conventionally seen as appropriate for women—dancing and singing, for example—Makin's education for girls also incorporated the study of astronomy, geography, arithmetic, history, and philosophy, along with Greek, Latin, Hebrew, and French.[14]

By 1694, Mary Astell, one of the earliest feminist writers in English, published *A Serious Proposal to the Ladies for the Advancement of Their True and Great Interest*. In this anonymously published volume, Astell advocated the establishment of secular convents where women might go to gain serious knowledge. "How can you be content to be in the world like tulips in a garden to make a fine show and be good for nothing?" she challenged her readers.[15]

Not all arguments for the education of girls came from women writers. Daniel Defoe, best known as the author of *Robinson Crusoe*, in 1719, issued "The Education of Women," a diatribe against the enforced ignorance of women. "I have often thought of it as one of the most barbarous customs in the world, considering us as a civilized and Christian country, that we deny the advantages of learning to women." While Defoe was not an advocate of what he termed "female government," he believed that highly educated women would be far more felicitous companions for men than the women of "folly and impertinence" whose sole training was "to stitch and sew or make baubles."[16]

Rousseau's doggedness about gender, then, was a response to discomforting revolutionary ideas that were, in many ways, an unintended consequence of his own. This sequence is clear in the writings of Mary Wollstonecraft. *A Vindication of the Rights of Women* (1791) was both inspired by and, at the same time, a

repudiation of Rousseau's ideas. While Wollstonecraft's thinking was deeply influenced by Rousseau's concept of natural education, she angrily condemned his bifurcation of education as it applied unequally to boys and to girls. Written as a critique of *Emile*, *A Vindication* argued that any education that fostered submissiveness was in direct conflict with Rousseau's general principles regarding freedom.

> [T]he most perfect education, in my opinion, is an exercise of the understanding as is best calculated to strengthen the body and form the heart . . . in other words, to enable the individual to attain such habits of virtue as will render it independent. . . . [I]t is a farce to call any being virtuous whose virtues do not result from the exercise of its own reason. This was Rousseau's opinion respecting men. I extend it to women.[17]

Rejecting the notion that separate, unequal education was necessitated by nature, Wollstonecraft maintained that training in submission was simply motivated by men's "love of power." Women, she insisted, must be "considered not only as moral, but rational creatures." Their instruction should proceed "by the same means as men, instead of being educated like a fanciful kind of half being—one of Rousseau's wild chimeras."[18]

Within less than fifty years, Wollstonecraft's ideas would inspire an activist movement for women's emancipation. Her call for equal education for boys and girls expanded into a broad critique of male dominance, overall, as an affront to the principle of liberty. Women began to confront the hypocrisy of self-proclaimed democratic men.

In Seneca Falls, New York, in 1843, the first women's rights convention was held, and issued a stinging statement. The women opened their Declaration of Sentiment and Resolutions with words borrowed from America's most famous democratic manifesto, the Declaration of Independence.

> When, in the course of human events, it becomes necessary for one portion of the family of man to assume among the people of the earth a position different from that which they have hitherto occupied, but one to which the laws of nature and of nature's God entitle them, a decent respect for the opinions of mankind requires that they should declare the causes that impel them to such a course.
>
> We hold these truths to be self-evident: that all men and women

are created equal; that they are endowed by their Creator with certain inalienable rights; that among these are life, liberty, and the pursuit of happiness. . . .

Throughout the Seneca Falls declaration the wrongs of men replaced those of the King.

The history of mankind is a history of repeated injuries and usurpations on the part of men toward women, having in direct object the establishment of an absolute tyranny over her. To prove this, let facts be submitted to a candid world.[19]

As such radical challenges to conventions that had long shaped relations between the sexes accelerated in the second half of the nineteenth century, the governing thought continued to assert that men and women were fundamentally dissimilar and that civilization required the rule of men. The movement to abolish slavery had inflamed an anxious, often violent culture of racism, which only grew after the Civil War in the United States. Similarly, the demand for women's rights provoked a crisis for masculinity and fueled increasingly dismissive and harsh judgments upon the innate qualities of womanhood. Regarding the education of women, Gustave Le Bon, the French author of the groundbreaking study *The Crowd*, spoke for many male intellectuals of his generation.

The desire to give them the same education, and as a consequence, to propose the same goals for them is a dangerous chimera. . . . The day when misunderstanding the inferior occupation which nature has given her, women leave the home and take part in our battles, on this day a social revolution will begin and everything that maintains the sacred ties of the family will disappear.[20]

In the field of natural history and in the physiological and sociological sciences, such convictions became more and more virulent. Against the backdrop of mounting feminist thought and action, men of learning used every device at their disposal to prove, objectively, the inferiority of the female sex. While routinely paying lip service to women's instinctive propensity to nurture, the notion that a normal woman could venture beyond the home, and into society, was deemed unimaginable and unsafe. Those who stepped into the public

370

sphere were seen either excessively masculine or tending toward criminal and immodest behavior.

In phrenology, a good woman's most developed "organs" were found toward the back of the skull, above the primitive brain stem, where "domestic propensities," resided. Here could be found the organs of "love of home" and "love of children," precariously close to the perilous regions of "reproductive love" and "love of sex," which made a woman's confinement within the home indispensable to her and society's well-being.

Stringent binary oppositions regarding gender were routine in established science and society. In measuring crania, phrenologists, anthropologists, and criminologists all concurred that women's brains were, on average, smaller and lighter than men's, and, therefore, deficient. Lombroso's studies of criminal types were infused with this assumption. His friend Le Bon, the founder of social psychology, likened the impetuous crowd to a woman, driven by irrational passions. Medical men agreed, inventing an entire field for the treatment of women's "nervous disorders," and popular entertainments regularly reinforced this outlook. But in the midst of this belief, countervailing forces were at play.

One challenge to the idea of inborn male superiority was spurred by an incipient field of cultural anthropology, which broke with the craniometric obsessions that had driven most anthropological studies to that time. Perhaps the most comprehensive synthesis of these new cultural studies was written by Friedrich Engels. Heavily influenced by the anthropological writings of Lewis Henry Morgan (*Ancient Society*, 1877) and Johann Jakob Bachofen (*Das Mutterrecht*, or *Mother Right*, 1861), Engels's *Origin of the Family, Private Property and the State* (1884) maintained that the disparities of power between men and women were not based on their inherent natures but were the result of social and historical circumstances, rooted in antiquity.

Engels contended that the earliest organized human communities lived according to the principles of a benevolent matriarchy. Classless and communal, he explained, these groupings owned neither land nor herds of animals. They derived their sustenance from the relatively uncultivated nature that surrounded them.

According to Engels, a sexual division of nature existed, but it was cooperative and egalitarian. As hunters, men were responsible for bringing meat to the table, while women took care of the social spaces in which the extended families lived, planting, preserving, and preparing food, maintaining the collective living space. Within such societies, he wrote, women were honored and lived

freely. Since it was women who gave birth to children, family identity was natu-
rally passed on through the mother line. When new conjugal bonds were estab-
lished between social groups, males would move from their family of origin into
the family circles of their mate. Under such circumstances, the physical domina-
tion of one sex by another served no practical purpose.

The coming of private property, initially in the form of livestock, changed all
of this. As animals were domesticated, and organized breeding expanded the herd,
the province of men was transformed into something unprecedented: property.
With this development, the custom of defining lineage through women proved
a serious problem. As long as "descent was reckoned according to mother right,"
and the mother line determined a person's family grouping or "gens," males had
no mechanism for passing on their property to their sons.

In response to this impasse, Engels speculated, men invented patriarchy, a
system of inheritance that would travel through the father line, insuring that they
and their male progeny would maintain ownership of the herd. As women bear
children, and fatherhood is inherently uncertain, this called for severe measures.
In an attempt to guarantee that their offspring would indeed be their own, men
forcibly inhibited the social and sexual lives of their wives. In order for patrilin-
eage to work, a woman whose function was that of bearing heirs could not live
freely. She was cut off from all unauthorized social contact. While male sexual-
ity was unregulated, the law of monogamy was imposed on women, save those
whose task was to fulfill the extramarital desires of men. A wife was to be ruled
by her husband, "reduced to servitude." She became "the slave of his lust and a
mere instrument for the production of children." This development, Engels
declared, constituted "the world historical defeat of the female sex."[21]

Unlike the biblical account, where God ordained female inferiority, or the
scientific lore of innate differences, Engels defined gender as a social construc-
tion. He argued that male supremacy was not part of a divine or natural plan but
a product of economic life, an artifact of male ownership and acquisitiveness.
The triumph of patriarchy, he concluded, had decisively shaped the dominant
institutions of Western civilization: the family, religion, and the state.

Engels's argument was not simply an exploration of antiquity but was
prompted by the world in which he lived. If patriarchy was an ancient mechanism
for preserving agricultural and mercantile wealth, the late nineteenth century
was inhabited by people who, for the most part, had been divested of such prop-
erties. The means of production, even agricultural production, were being seized
by a band of wealthy capitalists. For most others, patriarchal restrictions against
women, while still strong in the minds of men, were becoming obsolete.

Industrial capitalism was dismantling the land-based economic structures on which patriarchy had long rested. As a growing number of women were being employed as factory workers, and as middle-class women were openly questioning their customary position in the home, a sense of urgency and unease saturated middle-class dogmas about the "natural" roles of men and women.

This unease was well founded. "Instability rides the mind of modernity," it has been said, and the rise of industrial production and larger-scale capitalist agriculture were destabilizing the relationship between the family and society at large.[22] The footings on which traditional families stood, as units of home production, were crumbling. For middle-class families in particular, the products of a new consumer economy were rendering much of "women's work" outmoded. While these developments created a crisis for many men, it also offered unprecedented opportunities for women. New ideas were entering the public sphere.

Engels had argued that the inhibition of female sexuality and mobility was an outgrowth of traditional economic forms. For a man to pass land, or even a small business, to his sons, the patriarchal system was utilitarian. By the latter decades of the nineteenth century, however, control over agriculture and business had been seized by a smaller and smaller coterie of men. For those divested of land and business ownership, the rationale for patriarchy was becoming increasingly fragile. While Victorianism erected a formidable line of defense against these trends, a growing number of heretics began to imagine a world where the restriction of women's social and sexual behavior would no longer be enforced.

In the United States, one of the most radical critics of patriarchal sexuality was Victoria Woodhull, an entrepreneurial feminist, named for Queen Victoria, whose ideas and actions defied the basic tenets of Victorianism. In a world where women were supposed to limit their horizons to the home front, Woodhull pursued a career in finance, founding the first women-run brokerage firm in the United States in 1871. This, in itself, violated social standards of propriety, and she was ridiculed by many of the men who, before her invasion of their turf, had monopolized the stock exchange. She was denounced in the popular press for her "brazen immodesty as a stock speculator on Wall Street."[23]

Her radicalism reached far beyond her business enterprise, however. In spite of her business dealings, she embraced socialism and was the first to publish Marx and Engels's *Communist Manifesto* in the United States. Yet unlike many socialists, who maintained conventional ideas about sex, Woodhull's

outlook saw monogamy as an institution that systematically oppressed women, those who were most expected to live by its laws. Condemning "the sham 373 respectability" of marriage as nothing more than "legalized prostitution," she struck out for the principle of free love, relations freed of their restrictions and based purely on desire. "Yes, I am a free lover. I have an inalienable, constitutional and natural right to love whom I may, to love as long or as short a period as I can; to change that love every day if I please."[24]

In Woodhull, a new and emancipated definition womanhood was being proposed, based on the changing conditions of society and the pandemonium of modernity. These condition, she argued, posed an unprecedented opportunity for "reform of all sorts."

> Who can calculate the immense revolution that such a state of things will make in every sphere and department of human affairs. . . . [T]here is no calculating the velocity of human progress and growth of society. . . . [W]e are just at the turning point from an old fogy and conservative order of things, which has predominated through all the past periods of history. . . . [I]ndeed this progress has begun already; that we have entered on the descending grade, and so passed the turning point; that we call this a wonderful and exceptional age in the world's history.

Yet standing between these "wonderful" possibilities and their realization, Woodhull identified "a few grand hindrances" to be overcome.

> Despotism, slavery and oppressive restrictions on women are or have been the chief barriers. Despotism still lingers on the stage in Europe, but shudders with instinct of its own early destruction or decay. Slavery has just met with its quietus. Hindrances to the freedom of women are rapidly yielding, and will dissolve into nothing sooner than either of the other obstructions referred to, as there are a thousand causes favoring that revolution.

While retrospect reveals that "hindrances to the freedom of women" would not fall as easily as Woodhull believed, already by the 1870s, a new imagination was emerging that would soon begin to alter the landscape of sexual archetypes.

This view would be carried forward in the visionary writings of Charlotte Perkins Gilman, a leading feminist thinker, who rang the death knell for chattel womanhood in her book *Women and Economics* (1898). She looked to modern

industrialism as a force that could emancipate women from their dependence on men for survival, what Woodhull had characterized as "legalized prostitution."

Gilman believed that it was only through entering society at large, and working within that society alongside men, that women's emancipation was possible.

> Our poorer girls are going into the mills and shops; our richer ones into arts and professions or some kind of educational or philanthropic work. Why? To work. To work is not only a right, it is a duty. To work to the full capacity of one's powers is necessary for human development—the full use of one's best faculties—this is the health and happiness for both man and woman.[25]

"We are the only animal species," she wrote, "in which the female depends on the male for food, the only animal in which the sex-relation is also an economic relation." With modern industry freeing women of many of their home duties, she believed, women could now move beyond the home and free themselves from their "sexuo-economic" burden.[26]

While dominant thinkers were working overtime to assert age-old understandings of male and female, predicated on the centrality of home life, Woodhull and Gilman believed that modernity was opening the door to a sweeping reconfiguration of sex. As Gilman articulated it:

> While the sexuo-economic relation makes the family the center of industrial activity, no higher collectivity than we have today is possible. But as women become free, economic, social factors, so becomes possible the full social combination of individuals in collective industry. With such freedom, such independence, such wider union, becomes possible also a union between man and woman such as the world has long dreamed of in vain.[27]

As Gilman wrote these words, a reconfiguration of sex was taking place more broadly, beginning to infiltrate thinking about the body, the mind, and the nature of sexuality itself.

25
THE RETURN OF THE REPRESSED

By the end of the nineteenth century, feminists in the United States and Europe openly entertained the notion that altered relations between the sexes stood near on the horizon. Historic definitions of male and female, they believed, were about to be obliterated, replaced by a new egalitarianism. Yet their optimism was counterbalanced by many who saw feminism as a threat to the foundations of family and civilization, and who argued that sexual inequality was an iron law of nature, God, and social equilibrium.

Otto Weininger.

Yet, even amid the rigid insistence that male and female were distinct types, seeds of sexual ambiguity were beginning to sprout. One of the most unlikely and, at the same time, telling instances of this was the 1903 publication of *Sex and Character*, a spectacularly influential book. Soon translated into a myriad of languages, the book contained the mental meanderings of a twenty-three-year-old Viennese prodigy named Otto Weininger.

As an adolescent at the Gymnasium, Weininger was already drawn toward the outer reaches of knowledge. Shortly, at the University of Vienna, he gained a reputation for brilliance. His friend, Hermann Swoboda, described Weininger's inquisitive mind with rapture:

> He was quite indefatigable as he brought up question after question during our frequent small parties, which lasted late into the night or into the early morning. Abstract regions, from which others would turn away with a cold shiver, were his real home. He was, in short, a passionate thinker, the prototype of a thinker.[1]

Sex and Character—his first and last book—took these intellectual energies and aimed them at unraveling what one admirer, the Swedish playwright August Strindberg, termed "the hardest of all problems . . . the woman problem."[2] On its surface, Weininger's book shared many masculinist attitudes of the time. It was virulently

375

misogynist, an openly hostile rejoinder to the struggle for women's rights, and upheld the notion that male and female are clearly delineated and different types. "However degraded a man may be," he wrote, "he is immeasurably above the most superior woman, so much so that comparison and classification of the two are impossible."[3]

The inability to compare them according to a common yardstick lay in the divergent relationship between each sex and its inherent sexuality.

> The condition of sexual excitement is the supreme moment of a woman's life. The woman is devoted wholly to sexual matters, that is to say, to the spheres of begetting and reproduction. Her relations to her husband and children complete her life, whereas the male is something more than sexual. . . . The greater absorption of the human female by the sphere of sexual activities is the most important significant difference between the sexes.
>
> The female . . . is completely occupied and content with sexual matters, whilst the male is interested in much else, in war and sport, in social affairs and feasting, in philosophy and science, in business and politics, in religion and art. . . .
>
> The female principle is, then, nothing more than sexuality; the male principle is sexual and something more.[4]

Many of these declarations may sound familiar. But Weininger was also entering uncharted territory. While he used the terms "man" and "woman" throughout his book, he did not believe that any individual actually embodied either definition in its purest form. Real people, he maintained, occupied a diversity of positions along a spectrum that divided the ideal male from the ideal female.

> Amongst human beings the state of the case is as follows: There exist all sorts of intermediate conditions between male and female—sexual transitional forms. . . . [W]e may suppose the existence of an ideal man, M, and of an ideal woman, W, as sexual types, although these types do not actually exist. Such types not only can be constructed, but must be constructed. As in art so in science, the real purpose is to reach the type, the Platonic Idea. The intermediate condition actually existing between two absolute states of matter serve merely as a starting for investigation of the "types". . . . So also there exist only the

intermediate stages between absolute males and females, the absolute
conditions never presenting themselves.5

With these words, and in the pages that followed, Weininger introduced the
idea that sexual identity was fluid and indeterminate. While he shared many of
the ideas that were transmitted by the Judeo-Christian tradition, he also sup-
posed that all people, in differing degrees, were shaped by "a permanent bisex-
ual condition." His feelings about women favored the male ideal, but his
assumption about human beings more generally was that each person lived in a
state of sexual ambiguity. An ideal male, if one existed, would be male within
every cell of his body. The same would be true for the ideal female. In reality, how-
ever, while individuals might come close to this pristine state, psychological and
biological uncertainty was, to a greater or lesser extent, manifest.

Just as physical anthropology, phrenology, and physiognomy erected a typo-
logical hierarchy of physical and mental ideals according to racial and ethnic ten-
dencies, Weininger created a bisexual pecking order that ranged from the
feminine type, which had no morals and was "mindless," to the masculine type,
which was capable of lofty morality and transcendent thought. "[T]he duality of
man and woman," he maintained, speaking of these ideals, "has gradually devel-
oped into complete dualism, to the dualism of the higher and lower lives, of sub-
ject and object, of form and matter, [of] something and nothing."6

In this dualistic view of humanity, however, lay a murky range of variations,
where the actualities of human sexuality resided. Sometimes they approached
the ideal, in other cases their bisexual nature was more pronounced, but in all
people, some degree of their identity was shaped by that of the opposite sex.7

While Weininger claimed bisexuality as his own discovery, the idea was hardly new.
In the late nineteenth century, the premise that all embryos began their lives
bisexually was widely accepted in "scientific discourse on sexuality."8 In the 1896
edition of his *Psychopathia sexualis*, the Viennese psychiatrist Richard von Krafft-
Ebing wrote of sexual differentiation as something that took place in embryos only
after the twelfth week. Prior to this date, he affirmed, all embryos were physio-
logically "bisexual." Homosexuality, he asserted, was a psychopathology deriving
from an inadequate development out of this primal embryonic state. Others who
had previously discussed "bisexuality" or "sexual intermediacy" included the pio-
neer sex researchers Karl Heinrich Ulrichs, Havelock Ellis, and Magnus
Hirschfeld, a doctor who viewed bisexuality and homosexuality not as "perver-
sions," but as natural manifestations of sexual preference.

In 1897, Wilhelm Fliess—Sigmund Freud's closest collaborator at the time—told Freud of his "conviction that all human beings had a bisexual constitution." When Freud told one of his patients about Fliess's still confidential theory, it led not only to an irreconcilable split between Freud and Fliess, but also contributed to Weininger's ostensible discovery. Freud's patient, a student undergoing a training analysis, had been Hermann Swoboda, Weininger's close friend. Fliess never forgave Freud for his complicity in what he saw as Weininger's theft of his own—as yet unpublished—theory of bisexuality.[9]

Yet, if earlier theories of bisexuality had defined it as either pathological or natural, for Weininger it provided a moral scale upon which all people could be judged. A man might have strong female tendencies, yet still be a male; a woman might have masculine tendencies, and still be a female. Veering too far from the ideal state, however, was a symptom of a disorder. Jews were one example of this. Though born of Jewish parentage, Weininger embraced the anti-Semitism that was rampant in his milieu. Along with his conversion to Christianity, he viewed Jews as a people who were fatally flawed by female characteristics.

> Of the divine in man, of "the God who in my bosom dwells," the Jew knows nothing. . . . For the God in man is the human soul, and the absolute Jew is devoid of a soul.
>
> It is inevitable, then, that we should find no trace of belief in immortality in the Old Testament. Those who have no soul can have no craving for immortality, and so it is with the woman and the Jew.

Identifying with "the Aryan man," he continued to dissect the mental and moral failures of Jews and women, born of soullessness, as well as with an insatiable love of material things.

> Just as Jews and women are without extreme good and evil, so they never show genius or the depth of stupidity of which mankind is capable. The specific kind of intelligence for which Jews and women alike are notorious is due simply to the alertness of an exaggerated egotism; it is due, moreover, to the boundless capacity shown by both for pursuing any object with equal zeal, because they have no intrinsic standard of value.[10]

A far more alarming disorder diagnosed by Weininger was the growing power of feminist ideas—even among men—in fin-de-siècle Europe. He blamed this, in part, on the influence of "modern Judaism." Primarily, however, he attributed it to the insidious influence of overly masculine women.[11]

> A woman's demand for emancipation and her qualification for it are in direct proportion to the amount of maleness in her. Emancipation . . . is not the wish for an outward equality with man, but . . . the deep-seated craving to acquire man's character, to attain his mental and moral freedom, to reach his real interests and his creative power. I maintain that the real female element has neither the desire nor the capacity for emancipation in this sense . . . though so-called "women" who have been held up to admiration in the past and present, by the advocates of women's rights, as examples of what women can do, have almost invariably been what I have described as sexually intermediate forms.
>
> George Eliot had a broad, massive forehead; her movements, like her expression, were quick and decided, and lacked all womanly grace. The notorious Madame Blavatsky is extremely masculine in her appearance.[12]

Due to the essential disjuncture between the male and female principles, these masculine intermediates, inevitably encumbered by the limits of femaleness, could never reach the goal of equality. "Man has everything within him. . . . The woman can never become a man."[13]

> The idea of making an emancipation party, of aiming at a social revolution, must be abandoned. Away with the whole "woman's movement," with its unnaturalness and artificiality and its fundamental errors.
>
> It is most important to have done with the senseless cries for "full equality," for even the malest woman is scarcely more than 50 percent male, and it is only to that male part of her that she owes her special capacity or whatever importance she may eventually gain.[14]

Weininger's theories were not based on any scientific research. They were more akin to the science of first impressions that marked Lavater's *Essays in Physiognomy*, published more than two hundred years earlier. He openly acknowledged this intellectual lineage. "I am inclined to believe," he wrote, "that the assumption of a universally acquired correspondence between mind and body may be a hitherto neglected fundamental function of our mind. It is certainly the

case that everyone believes in physiognomy and actually practices it." Young Otto certainly did. Walking through the streets of Vienna, he propped up his theories by making instant judgements on the people he passed. He also employed photographic evidence to support his hunches.

> I myself made investigations in the following way. I obtained a set of photographs of aesthetically beautiful women of blameless character, each of which was a good example of some definite proportion of femininity, and I asked a number of my friends to inspect these and select the most beautiful. The selection made was invariably that which I had predicted.[15]

Voyeurism and speculation appear to have been Weininger's primary methodologies. When the young Weininger came to visit him with an outline for his book in 1901, Sigmund Freud was deeply troubled by its impressionistic core. Freud warned Wieininger that he must base his analysis of sexuality on extensive empirical research. "The world wants evidence, not thoughts," Freud told him.[16] Weininger had no patience for such advice and moved feverishly forward with his project.

When he published *Sex and Character* in 1903, Weininger believed he had produced an original work of genius, a contribution of world-historic significance. While he hoped that it would be greeted with adulation, he was also aware that his ideas might be objectionable to some. Shortly after publication he wrote to a friend, "There are three possibilities for me—the gallows, suicide, or a future so brilliant that I don't dare to think of it."[17]

Ultimately, it was the middle option that won out. On October 4, 1903, before he could learn how enthusiastically many in Europe and elsewhere would embrace his ideas, he shot himself. Befitting his delusions of grandeur, he chose the house in Vienna where Beethoven had died as the site for his flamboyant suicide.

Though Weininger never witnessed it, an expanding interest in bisexuality—and in the varieties of human sexuality overall—seized the minds and lives of a growing number of people in the early decades of the twentieth century. Weininger's book contributed to this interest, not always in ways he would have appreciated, but it was others who took the lead in exploring the vicissitudes of sex. Most influential among these was Freud, who publicly approached the topic of bisexuality in his book, *Three Essays on the Theory of Sexuality*. First

published in 1905, it went through many subsequent revisions, and had a considerable influence on psychoanalytic thinking.

Unlike Krafft-Ebing, who saw bisexuality as a brief developmental state in the physiological growth of normal embryos, or Weininger who approached bisexuality as morally problematic, Freud saw bisexuality as an ongoing and powerful force in the bodies and psyches of all people. Even "normal" men and women, he observed, retain some physical remnant of their early embryonic form. "In every normal male or female individual, traces are found of the apparatus of the opposite sex. These either persist without function as rudimentary organs or become modified and take on other functions."[18]

As his thinking evolved, however, "these long-familiar facts of anatomy," became a secondary concern. He focused more and more on bisexuality as a psychological factor in people's libidinal makeup throughout their lives.

When children are first born, he wrote, their gender identity is unformed. Their desires are undifferentiated because of what he termed an infant's "polymorphously perverse disposition." In this state, any person, any body part, or any bodily function that gives pleasure is experienced as desirable. A critical influence that ushers children from their polymorphous beginnings to an evolved sexual identity, regardless of orientation, is the

Sigmund Freud, 1906. FROM THE COLLECTION OF THE EWEN LIBRARY.

repressive sublimation of those inclinations that are deemed unacceptable. "Among the forces restricting the direction taken by the sexual instinct [are] . . . shame, disgust, pity and the structures of morality and authority erected by society."[19]

Later, in *Civilization and Its Discontents*, Freud elaborated on the casualties of this repression. Regarding sexuality, Freud saw the civilizing process as part and parcel of other forms of subjugation and policing that accompanied the triumph of European empire.

> In this respect civilization behaves towards sexuality as a people or a stratum of its population does which has subjected another [people] . . . to its exploitation. Fear of a revolt by the suppressed element drives it to stricter precautionary measures. A high water mark in such a development has been reached in our Western European civilization . . . as regards the sexually mature individual, choice of an object is restricted

to the opposite sex, and most extra-genital satisfactions are forbidden as perversions. The requirement, demonstrated in these prohibitions, that there shall be a single kind of sexual life for everyone, disregards the dissimilarities, whether innate or acquired, in the sexual constitution of human beings; it cuts off a fair number of them from sexual enjoyment, and becomes the source of serious injustice.

Yet, in spite of these formidable "psychical inhibitions," Freud saw persistent "unconscious forces," bisexual longings, that could not be fully suppressed, even within those understood to be "healthy" men and women. When *Three Essays on Sexuality* first appeared, medical experts saw what they called sexual "perversions," gratifications that stepped beyond the heterosexual genital embrace, as signs of "degeneracy or disease." This was their diagnosis of homosexuality. Freud broke decisively from this judgment:

> Everyday experience has shown that most of these extensions [beyond authorized sexual intercourse] . . . are constituents which are rarely absent from the sexual life of healthy people, and are judged by them no differently from other intimate events. If circumstances favour such an occurrence, normal people too can substitute a perversion of this kind for normal sexual aim for quite a time, or can find place for the one alongside the other.

In fact, Freud took issue with the very notion of "perversion" as it was most often applied.

> No healthy person, it appears, can fail to make some addition that might be called perverse to the normal sexual aim; and the universality of this finding is in itself enough to show how inappropriate it is to use the word perversion as a term of reproach.[20]

Among those substitutions for the "normal sexual aim," he included homosexual acts or desires.

> Psychoanalytic research is most opposed to any attempt at separating off homosexuals from the rest of mankind as a group of a special character. By studying excitations other than those that are manifestly displayed, it has found that all human beings are capable of

making a homosexual object-choice, and have in fact made one in their unconscious.

Ultimately, Freud maintained, people who limited themselves to either heterosexual or same-sex unions were equally affected by the powers of repression.

> [P]sychoanalysis considers that a choice of an object independently of its sex—freedom to range equally over male and female objects—as it is found in childhood, in primitive states of society and early periods of history, is the original basis from which, as a result of restriction in one direction or the other, both the normal and inverted [homosexual] types develop.[21]

In an autobiographical essay that appeared in 1925, Freud maintained that "the primacy of the genitals," a mental tyranny that shaped common understandings of sex, only created a barrier obscuring the core of human sexual nature, which was formed "in the very early days of the libido's development."

> The detaching of sexuality from the genitals has the advantage of allowing us to bring the sexual activities of children and of perverts into the same scope as those of normal adults. The former have hitherto been entirely neglected and though the latter have been recognized it is then with moral indignation and without understanding. . . . The most important of these perversions, homosexuality, scarcely deserves the name. It can be traced back to the constitutional bisexuality of all human beings. . . . Psychoanalysis enables us to point to some trace or other of homosexual object-choice in everyone. If I have described children as 'polymorphously perverse', I was only using the terminology that was generally current; no moral judgement was implied by the phrase.

Perhaps the idea that was most frightening to the guardians of sexual morality was Freud's contention that childhood was a highly sexual stage in life.

> My surprising discoveries as to the sexuality of children were made in the first instance through the analysis of adults. But later (from about 1908 onwards) it became possible to confirm them in the most satisfactory way and in every detail by direct observations upon children. Indeed, it is so easy to convince oneself of the regular sexual activities of children

that one cannot help asking in astonishment how the human race can have succeeded in overlooking the facts and in maintaining for so long the agreeable legend of the asexuality of childhood. This surprising circumstance must be connected with the amnesia which, with the majority of adults, hides their own infancy.[22]

In Freud, deeply held dogmas about male and female were beginning to crumble. His ideas rejected fixed definitions of men and women, sending shockwaves through Western culture. The idea that there was a simple division between male and female had endured for centuries, fortified by religious, scientific, and sociological thinking. When sexual ambiguity surfaced as a concept in the late nineteenth century, most interpreters saw it as a mark of aberrance, a deviation from the norm in which the genders were defined by a set of identifiable characteristics.

Before Freud, Weininger had popularized the idea that all people had a bisexual nature, but he saw it as a failing, an inability to live up to clearly differentiated sexual ideals. In Freud, bisexuality, homosexuality, forms of stimulation that were not exclusively confined to the genitals, even polymorphous childhood sexuality, entered the realm of normalcy, albeit a normalcy that was universally wounded by social and parental prohibitions. In presenting such ideas, he opened up Pandora's box. A broad variety of sexual practices and identities were inextricably linked to one another in the psychic and biological lives of all men and women. In philosophical and medical literature, the foundations of sexual typecasting were slowly beginning to shift.

From the late nineteenth century onward, as biology, psychology, and theoretical inquiries engaged the issue and meaning of universal bisexuality, social developments were also under way that were making the variations of human sexuality a conspicuous element of public life. Forms of affection that had been historically concealed and outlawed were emerging into the light of day. While these surfacings remained unacceptable to respectable society, they were, on the other hand, becoming visible beyond clandestine sexual subcultures.

One of the most spectacular examples of evolution this was the widely publicized trial of the Irish author Oscar Wilde. One of Europe's most famous and flamboyant literary figures, Wilde married Constance Lloyd in 1884 and had two children with her, while, at the same time, having numerous sexual encounters with young men. These had not caused much of a problem for Wilde until 1891 when, at the age of thirty-eight, he took up with a twenty-two-year-old

poet, Lord Alfred Douglas. Douglas was the son of the Marquess of Queensberry, a Scottish nobleman best known for setting up the modern rules of prizefighting.

385

Enraged by his son's unswerving love for Wilde, the Marquess denounced Wilde as "a sodomite." Wilde, in turn, brought libel charges against Lord Douglas's irate father. A trial ensued. The prosecution began fairly smoothly for the celebrated author, but the trial took a turn in the Marquess's favor when his lawyer, Edward Carson, began to cross-examine Wilde. He confronted him and the court with evidence of a succession of relationships with young men. What had previously been a private matter became glaringly public, particularly as it was luridly depicted in newspapers.

In 1895, shortly before the trial began, England had enacted the Criminal Law Amendment Act, which "made it a crime for any person to commit an act of 'gross indecency.'" "The Act had been interpreted," writes the legal scholar Douglas Linder, "to criminalize any form of sexual activity between members of the same sex." When Carson announced his intention to bring a parade of Wilde's sexual partners to testify, and in fear of this law, Wilde was convinced by his lawyer to withdraw the case. It was too late. Within weeks, it was Wilde who was on trial, facing "twenty-five counts of gross indecencies and conspiracy to commit gross indecencies."23

One of a series of photos of Wilde, age 27, during his tour of America in 1882, taken by Napolean Sarony, an eminent photographer of celebrities.
COURTESY OF RMP ARCHIVES

Toward the end of the trial, the prosecutor, Charles Gill, asked Wilde the meaning of "I am the love that dare not speak its name," the last line in "Two Loves," a poem written by young Lord Douglas in 1894. Wilde responded:

"The love that dare not speak its name" is . . . such a great affection for a younger man . . . such as Plato made the very basis of his philosophy, and such as you find in the sonnets of Michelangelo and Shakespeare. It is that deep spiritual affection that is as pure as it is perfect. It is in this century misunderstood, so much misunderstood that it may be described

as the "Love that dare not speak its name," and on account of it I am placed where I am now. It is beautiful, it is fine, it is the noblest form of affection. There is nothing unnatural about it.[24]

Rather than a cold object of clinical discussion, here, Wilde, if only for brief moment, took transgressive sexuality out of the hands of experts and gave it a voice of its own. The jury was moved, and was unable to "reach a verdict on most of the charges."[25]

Within three weeks the charges were reinstated and Wilde was on trial again. This time the outcome would be less favorable. He was found guilty on nearly every count and sent to prison. At Reading Gaol, where he was incarcerated, he wrote *De Profondis*, a lament on his fate, on the repressive terrain of Victorian society, and on the compassionate laws of nature.

> Society as we have constituted it, will have no place for me, has none to offer; but Nature, whose sweet rains fall on just and unjust alike, will have clefts in the rocks where I may hide, and secret valleys in whose silence I may weep undisturbed. She will hang with stars so that I may walk abroad in the darkness without stumbling, and send the wind over my footprints so that none may track me to my hurt: she will cleanse me in great waters, and with bitter herbs make me whole.

Oscar Wilde died three years after his release from prison, but in his testimony, and in the words above, a new voice was evolving, one that would indelibly affect the public autobiographies of human sexuality. From the early twentieth century on, in the writings of sexual radicals and in newly emerging forms of public behavior, "a single kind of sexual life for everyone" was being openly challenged.

Edward Carpenter was an avatar of this movement. Born in 1844 into a well-to-do, bourgeois English family, he followed an educational path not unlike that taken by many males of his background. At Trinity Hall, Cambridge, he studied mathematics and was then ordained as an Anglican minister.

This well-trod path continued until he encountered Walt Whitman's democratic epic, *Leaves of Grass*, in 1868. It left an irrevocable imprint on his life and his ideas. Though Whitman was not a socialist, his fiercely egalitarian spirit inspired Carpenter toward utopian socialist thinking. Embracing the cause of the working class, Carpenter soon emerged as a leading figure in a growing English socialist movement. After his parents' deaths, he used his inheritance

to establish Millthorpe, an experimental commune near the industrial city of Sheffield in 1883. At Millthorpe, his socialist ideas were put into practice on a small scale. Within this visionary community, the economic outlook of socialism was fused with a passion for sexual emancipation, a decisive assault on the strict Victorian moral codes that held British society in their grip. 387

This passion was inextricably linked to Carpenter's own sexuality. From early adulthood, Carpenter's sexual interest in men was already evident. In the safe haven of Millthorpe, however, this orientation took flight as he openly embraced his homosexuality and began developing a political perspective that advocated social, economic, and sexual change.

In the 1890s, Carpenter commenced a forty-year love relationship with George Merrill, a man from a working-class background. He also started publishing pamphlets exploring what sexuality would be like in a truly "Free Society." His pamphlets spoke for women's independence, for the separation of marriage from patriarchy, and for the diverse manifestations of sexual feeling and practice. The last of these, "Homogenic Love: and its Place in a Free Society," explored homosexuality as a natural form of love, one that in premodern societies, he argued, had been an integral element in the intimate rites of humankind.

While the Labour Press in Manchester had published his earlier pamphlets, "Homogenic Love," because of its controversial subject matter, was printed for private circulation only. In 1895, however, Carpenter planned to include it in a book of his "papers on the relations of the sexes," to be entitled *Love's Coming-of-Age*. When the book finally appeared in 1896, "Homogenic Love" was nowhere to be found. The notoriety of the Oscar Wilde trial, and an ensuing frenzy of homophobia, convinced Carpenter that the time was not propitious for the publication of such ideas. On the contrary, it would be dangerous to do so.

Carpenter bided his time, and in 1906, an expanded fifth edition of *Love's Coming-of-Age* appeared. The topic of homosexuality resurfaced, and in the book, Carpenter again addressed the varied nature of sexuality and the extent to which it would flourish in a free and egalitarian society.

No doubt the Freedom of Society in this [sexual] sense, and the possibility of a human life which shall be the fluid and ever-responsive embodiment of true Love in all its variety of manifestations, goes with the Freedom of Society in the economic sense. When mankind has solved the industrial problem so far that the products of our huge mechanical forces have become a common heritage, and no man or woman is the property-slave of another, then some of the causes which

388

compel prostitution, property-marriage, and other perversions of affection, will have disappeared; and in such [an] economically free society human unions may take place according to their own inner and true laws.[26]

This book was followed by *Intermediate Sex* (1908), a portion of which had already appeared in the new edition of *Love's Coming-of-Age*. Here, Carpenter expanded his argument on behalf of the natural place that homosexuality deserves among the varieties of human experience. He opened, paradoxically, with a frontispiece that quoted from Weininger's *Sex and Character*.

> The improbability may henceforth be taken for granted of finding in Nature a sharp cleavage between all that is masculine on the one side and all that is feminine on the other; or that any living being is so simple in this respect that it can be put wholly on one side, or wholly on the other, of the line.

Turning Weininger on his head, Carpenter rejoiced in "the immense diversity of human temperament and character relating to sex and love." If Weininger looked to the outer ends of the spectrum for his ideals, Carpenter rejected the ideals outright. He saw the intermediate space as the true locus of a widely disparate range of normal sexualities. Much of *Intermediate Sex*

Anti-feminist stereograph, 1897. FROM THE COLLECTION OF THE EWEN LIBRARY.

addressed male and female homosexuals, or Uranians, as he called them, a term coined by Ulrichs in the 1860s.

While most medical and legal authorities continued to dismiss homosexuals as degenerate or diseased, Carpenter saw them as a robust and highly capable population, albeit one that had been forced to live "beneath the surface of society." Writing of males, he noted,

> [M]any are fine, healthy specimens of their sex, muscular and well-developed in body, of powerful brain, high standard of conduct, and with nothing abnormal or morbid of any kind observable in their physical structure or constitution.[27]

Yet, in these men, he also described a tendency to reject many of the social conventions of masculinity. Among many Uranian men, he noted, "[W]e find a man

SUFFRAGETTES LEAVING CITY HALL, NEW YORK 10/28/08
499-3

who, while possessing thoroughly masculine powers of mind and body, combines with them the tender and more emotional soul-nature of the woman— and sometimes to a remarkable degree."[28]

Among Uranian women, Carpenter observed numerous individuals who physically conformed to common standards of beauty but who, in temperament, declined the stereotype of the weaker sex. Among "normal specimens of the homogenic woman," he explained,

> we find a type in which the body is thoroughly feminine and gracious . . . but in which the inner nature is to a great extent masculine; a temperament active, brave, originative, somewhat decisive, not too emotional; fond of out-door life, of games and sports, of science, politics, or even business; good at organization, and well-pleased with positions of responsibility, sometimes indeed making an excellent and generous leader.[29]

Carpenter believed that these socially maligned people, including himself, stood on the threshold of a transformed society that would no longer marginalize them but embrace them within the human community. He thought that "modern thought and investigation" regarding bisexuality had opened the door, if only a crack. If people could make peace with the seeds of bisexuality residing within them, and acknowledge Uranians as kindred spirits, this tolerance would lay the groundwork for a utopian future in which the entire basis of civilization would be transfigured. Eros and affection would replace the compulsory boundaries of law and economic life.

> [I]t is possible that the Uranian spirit may lead to something like a general enthusiasm of humanity, and that the Uranian people may be destined to form the advanced guard of that great movement which will one day transform the common life by substituting the bond of personal affection and compassion for the monetary, legal and other external ties which now control and confine society.[30]

This was Carpenter's fantasy: a socialist world in which sexual difference was no longer of any consequence. While he dreamed of the coming of a Uranian avant-garde, however, events were happening in the real world that gave him considerable hope.

To him, the women's rights movement was creating the necessary wedge for

transformation, slowly beginning to erase the imposed oppositions of gender, challenging the idea that inequality was ordained by God, or by nature. Unlike Weininger, Carpenter saw the movement for women's equality as part of a general and welcome development. He also believed that "the arrival of the new woman," in addition to signaling a potential "rapprochement between the sexes," also provided an opportunity to recognize sexuality in ways that society had, until then, effectively submerged.

> If the modern woman is a little more masculine in some ways than her predecessor, the modern man (it is to be hoped), while by no means effeminate, is a little more sensitive in temperament and artistic in feeling than the original John Bull. It is beginning to be recognised that the sexes do not or should not normally form two groups hopelessly isolated in habit and feeling from each other, but that they rather represent the two poles of one group—which is the human race; so that while certainly the extreme specimens at either pole are vastly divergent, there are a great numbers in the middle region who (though differing corporeally as men and women) are by emotion and temperament very near to each other.[31]

Living until 1929, Carpenter was able to see one of the defining moments in the reformation of gender: women's right to vote. By far the most influential victory came in the United States in 1920, the culmination of more than seventy years of struggle. By 1928, women of the United Kingdom had joined their American sisters. In both societies, the political equality of women had become the law of the land.

The "New Woman," already a force by 1900, came of age in the 1920s. In a variety of ways, she was dismantling outmoded characterizations of womanhood. The leap forward reached beyond the ballot box. Middle-class women, the foot soldiers of the suffrage movement, swarmed into the workplace, engaged in sports, remained single for longer, practiced birth control, and, more than ever before, pursued higher education.

Commenting on the rise of the new womanhood in *The Nation* in 1924, the psychologist Beatrice M. Hinkle argued that, for the first time, women's affections were now free to develop, thrusting aside the restrictive fetters of the past. What Gilman had termed the "sexuo-economic" relationship was giving way, Hinkle maintained, to a new kind of love that could be felt and expressed without repressive stipulations.

392

As long as women were dependent on men for the support of themselves and their children there could be no development of a real morality, for the love and the feeling of the woman were so intermingled with her economic necessities that the higher love impulse was largely undifferentiated from the impulse of self-preservation. True morality can only develop when the object or situation is considered for itself, not when it is bound up with ulterior and extraneous elements which vitiate the whole. The old morality has failed and is disintegrating fast, because it was imposed from without instead of evolving from within. . . .

One thing, however, is clearly evident: women are demanding a reality in their relations with men that heretofore has been lacking, and they refused longer to cater to the traditional notions of them created by men, in which their true feelings and personalities were disregarded and denied.[32]

Two images of the "New Woman." The 1927 "New Woman" to the right embodies the flapper ideal: lean, small breasted and scantily clad, but she is still a photographic trophy, an ornament to be seen. The one on the facing page, in a 1926 Kodak advertisement, has taken charge of the camera if not the ship. FROM THE COLLECTION OF THE EWEN LIBRARY.

Some prominent women supported such ideas in word and action. In 1923, Fanny Hurst, a well-known novelist, made public that she and her husband would 393 no longer live according to archaic family conventions. Each would have his and her own living space, to enhance the freedom of their marriage. She made her case for a free, sexually equal definition of marriage in an interview with the *New York Times*.

Take the marriage structure as it now stands. It's old fashioned, it's drafty, it's leaky, the roof sags, the timbers shake, there's no modern plumbing, no hardwood floors, no steam heat. We don't feel comfortable in it. We've outgrown the edifice, but we don't dare get out of it. . . .

Those of us who dare shiver at the cold of the old edifice, plan our structure differently. We study the plans of many architects and build our house to suit our particular and peculiar needs. We put in hardwood floors, sanitary plumbing, steam heat, many windows . . .

Kodak Keeps the Story

Just "click" the shutter of this easily-worked camera and to-day's good times become to-morrow's good pictures.

Autographic Kodaks *$6.50 up*
At your dealer's

Eastman Kodak Company, Rochester, N.Y., *The Kodak City*

394

Not the least satisfactory arrangement of the new marriage structure, is the privacy it gives, the little self-respecting privacies which the old kind of marriage seemed to revel in breaking down. . . .

[T]he place of the woman of intelligence is not inevitably in the kitchen worrying about pot and pan trifles, not at the front door every evening waiting tremulously for the step of her John and fearful lest the roast be not overdone. Her place is where she can give the most service and get the most out of life.33

The Hair Mode Accepts Feminism

Almost every evening one sees an entirely new hair mode worn at smart social affairs. One style has almost disappeared from chic gatherings. —the sleek boyish bob. There is little attempt made to imitate long hair styles by artificial means. The younger set has not abandoned its habit of frank revealment—it does not know how to dissemble. The boyish bob grows longer in the natural course, and youthful invention devises new and charming ways, to dispose of lengthening ends in gentle ringlets, on forehead and cheek.

Not everyone is joining the long haired ranks—far from it! One of the most charming of the short haired modes is the baby bob just above, with the hair in most flagrantly irrepansible ringlets all over the head. When the hair is inclined to curl a little, a deeper curl may be acquired by wetting the hair and combing it backward in front and upward in back and sides.

In back the ends are curled and bunched together with the aid of pins and combs, until these ends are long enough to roll over a little pad into a small round bun. As the hair grows longer, the pad is discarded, and the ends lengthened out into a figure eight, as above worn flat and close to the head.

When the hair of an older woman is properly cut and coiffed, straight lines are avoided: the hair is waved diagonally to produce a swirled effect. This insures a lovely classical line, as pictured here. The front side view with its short right side parting and diagonal wave off the forehead, above: the back view with deeply waved upward swirl, on the left.

Even mainstream women's magazines, focusing on "housekeeping," "fashion," and "beauty," assumed the language and symbolism of the "new woman."

From *Today's Woman and Home*, March, 1928.
Courtesy GA-GA Pictures

FROM THE COLLECTION OF THE EWEN LIBRARY

While popular culture did not yet invite Uranians to the dance, modern women were openly asserting their independence, eagerly breaching the borderlines of sexual convention in the family, in public life and in sundry arenas of personal expression.

Among many young, middle-class women in Europe and America, long tresses gave way to close-cut "bobbed" hair. Clothing strayed from fashions that hobbled women's activities, most notably corsets, which had accentuated a woman's reproductive regions (breasts and hips) at the expense of her ability to breathe. Young women took on a boyish or androgynous look: mobile, vertical, and lean. Wearing knee-length skirts, even trousers in private settings or at the beach, once-confined women were now freer to move. Flappers flattened their breasts against their bodies, creating a silhouette that was neither male nor female according to traditional standards. Some women publicly donned the evening garb of men, cross-dressing as a symbol of a newly won freedom from restraint.

As mass-produced fashions, movies, picture magazines, and trend-conscious advertising aided and abetted these developments, conservative stereotypes of male and female were becoming, in the eyes of a growing number,

out of date. The daring couturier Coco Chanel promoted a mannish look in many of her designs, and they were widely imitated for an expanding mass market. Paul Poiret, the first French designer to promote mass fashion for women in the United States, openly "waged war" on corsets in the name of "liberty."34 **395**

By 1924, Jacques Boulenger, editor of the weekly *L'Opinion* in Paris, declared that the modern woman was the embodiment of a new age.

> Without a doubt she is freer in behavior than women before the war. . . . Nestled in the arms of her partner, she dances without a corset; she swims in a maillot . . . above all, she has a taste or desire for independence, or rather . . . is absolutely determined to be independent.35

In the United States, the validity of new "independent" styles for women became a subject in popular magazines. In the April 1927 issue of *Pictorial Review*, two articles by prominent women discussed the propriety of bobbed hair. The opera singer Mary Garden, in her article entitled "Why I Bobbed My Hair," explained that "Bobbed hair is a state of mind and not merely a new manner of dressing my head."

> I consider getting rid of our long hair one of the many little shackles women have cast aside in their passage to freedom. . . . To my way of thinking, long hair belongs to the age of general feminine helplessness. Bobbed hair belongs to the age of freedom, frankness, and progressiveness.36

The movie star Mary Pickford, known as "America's Sweetheart," did not cut her locks. Explaining why, she reported that, in spite of her inner desire to cut her hair short, her long curls "have become so identified with me that they have become almost a trademark." Her fans would not hear of it and, she admitted, "I am by nature conservative and even a bit old-fashioned."

Nonetheless, she did not subscribe to the notion that long hair makes a "woman more feminine." In fact, she expressed "doubt as to whether it does or not. . . . Of one thing I am sure: she looks smarter with a bob, and smartness rather than beauty seems to be the goal of every woman these days."

Detailing numerous pressures upon her to keep her hair long, she acknowledged some ambivalence about her trademarked self.

> Now, after giving all these arguments against the bob, I feel the old irresistible urge, and it is quite likely that some day in frenzied haste cast-

ing all caution to the winds, forgetting fans and family, I shall go to a coiffeur and come out a shorn lamb to join the great army of the bob.[37]

Some might find this pop symposium on hair bobbing trivial, but beneath its surface lay ideas that were dividing society. For some, these ideas provided a much longed-for corridor to emancipation. For many others who still held to customary notions of gender—particularly men who saw their power in danger—the turmoil of transition was too much to bear.

Writing about stereotypes in 1922, Walter Lippmann noted that the habitual pictures of reality that people carry inside their heads could not be taken lightly.

The commodification of "New Woman" style was well underway by the mid-twenties. FROM THE COLLECTION OF THE EWEN LIBRARY

People hold onto them, close and dear, to defend their "position in society." They offer a familiar, "more or less consistent picture of the world . . . [that] fits as snugly as an old shoe." When events occur that interrupt this sense of comfort, the reaction is often violent. "[A]ny disturbance of the stereotypes," he wrote, "seems like an attack on the foundations of the universe."

The new woman, and the social metamorphosis she represented, was such a disturbance. It threw into question gender ideals that had reigned in Western culture time immemorial.

In the 1920s, venomous criticism of the new woman was widespread. In France, the historian Mary Louise Roberts reports, Pierre Drieu la Rochelle, a reactionary novelist, denounced the new woman as emblematic of a world that "no longer has sexes." A Parisian law student complained that the female sex had abandoned its femininity and destroyed the essence of French womanhood.

These beings—without breasts, without hips, without 'underwear', who smoke, work, argue, and fight exactly like boys and who, during the night at the Bois de Boulogne, with their heads swimming under several cocktails, seek out savory and acrobatic pleasures on the plush seats of 5 horsepower Citroens—these aren't young girls!

There aren't any more young girls! No more women either![38]

In the United States, anger over new arrangements of gender often mixed with nervousness about other suspected threats to stability. Some critics linked 397 the rise of feminism with the creeping tide of Bolshevism. "The Spider Web Chart," a widely disseminated diagram linking women's antiwar and social reform activities with anti-Americanism, was published by the War Department in 1923. At the top of the chart, which listed the names of prominent feminists and women's organizations, were the words "The Socialist-Pacifist Movement in America Is an Absolutely Fundamental and Integral Part of International Social-ism." Beneath the chart, a poem underlined this claim.

> Miss Bolsheviki has come to town,
> With a Russian cap and a German gown,
> In women's clubs she's sure to be found,
> For she's come to disarm AMERICA . . .
>
> She uses the movie and lyceum too,
> And later text-books to suit her view,
> She prates propaganda from pulpit and pew,
> For she's bound to disarm AMERICA.[39]

Henry Ford, using the nom de plume "An American Citizen," echoed this perspective in the *Dearborn Independent,* in an article entitled "Are Women's Clubs 'Used' by Bolshevists?" "Grave danger," he wrote, "threatens the progress of organized womanhood in the world today."

> Leadership of women's organizations has fallen into the hands of radicals to an alarming extent. . . .
> Women are drawn in through all sorts of camouflage interests—their dislike of war, their sympathies for prisoners, most of all by the frothy eloquence which depicts a woman's crusade against all evil, while at the same time their leaders are using the rawest form of political bludgeoning on politicians in the capitals, and are often in communication with the fountains of "red propaganda" in this and other countries. Of course, the good women who make up the rank and file are not supposed to know this.[40]

A 1925 magazine article made similar links, here in the arena of women's fashion. Examining the abandonment of corsets in 1920s fashion trends, one writer

asked, "Are corsets only another obsolete tradition to be cast aside to the uncharted freedom of the Bolshevist figure?"[41]

Cesare Lombroso's daughter, Gina Lombroso Ferrero, believed that 1920s styles were "artificial and degenerate," and were the process of destroying the morality of women, particularly in the United States, where, she argued, "feminism was born."

> [B]y adopting trousers and smoking, woman hopes that men will bring forth no more excuses for leaving her at home. Woman today has won the right to bob her hair, to dress in men's attire, to have her own clubs like man, to insult man like a courtesan, to dress—or rather to undress—like a courtesan, to change love and clothing like a courtesan.[42]

Another connection that concerned some antifeminists was the emergence of black culture in northern cities. According to this argument, jazz, in particular, was a primal and seductive force that was loosening morals and imperiling white middle-class youth, girls as well as boys. John R. McMahon, writing in the *Ladies Home Journal* in 1921, sounded the alarm.

> Anyone who says the "youth of both sexes can mingle in close embrace"—with limbs intertwined and torso in tact—without suffering harm, lies. Add to this the position the wriggling movement and sensuous stimulation of the abominable jazz orchestra with its voodoo-born minors and its direct appeal to the sensory center, and if you can believe that youth is the same after this experience as before, then God help your child.[43]

Ferrero, outraged by the sexual promiscuity and "atavism" of recent years, argued that the feminism of the new woman was but a passing fad, one that could bring no enduring satisfaction. Writing in 1927, she predicted that calls for female emancipation had run their course and that most women, even in the United States, would soon flock to the solace of their traditional position.

> The woman of today is tired of all these artificial gains in which she has trifled her time away in these last years; she longs, as it were, for a slice of plain bread to satisfy her hunger. Once convinced there is no other way to love and win love than by a return to the old morality, she

will resign herself thereto much more quickly than the world imagined, and the greater the excesses of flirtation will become, the more willingly and rapidly will she come back into the old hive, for such excesses will always and increasingly alienate those permanent affections which she yearns for more than anything else in life.

Let woman make this her aim, and it will appease her longings better than freedom, independence, the franchise, wealth, power, or glory.44

This position would not go away—and it doggedly persists among cultural conservatives—but neither would the challenge posed by feminism and the phenomenon of the new woman. If anything, by the latter third of the twentieth century, the scope of sexual revolution would become more far-reaching than Ferrero could have imagined.

The debate over the "new woman" in the 1920s was but the tip of an iceberg. If the "new Negro" was aimed at undermining white stereotypes, and sought to present a vision of black America that was respectable and conformed to conventional middle-class norms, the new woman was a brazen assault on those norms.

On a theoretical level, Freud, Carpenter, and others had opened up the idea that sexuality was essentially ambiguous, that bisexual and polymorphous inclinations, though often submerged, occupied the core of the human psyche. By the 1940s and 1950s, Alfred Kinsey's path-breaking studies of *Sexual Behavior in the Human Male* (1948) and *Sexual Behavior in the Human Female* (1953) took sexuality out of the closet, putting meat on the bones of these theories. He and his staff presented a startlingly detailed—for some, scandalizing—taxonomy of sexual behaviors in

Clara Bow, known as the "It Girl," to describe her magnetic sexual allure, was Hollywood's first great "sex symbol," the personification of the "New Woman."

400

America that revealed a multitude of so-called perversions that were commonly practiced below the persistent, though increasingly out-of-touch, radar of official moralism.

Infinite variety, rather than rudimentary dualism, was the underlying truth of human sexuality. As Kinsey explained in *Sexual Behavior in the Human Male*:

> Males do not represent two discrete populations, heterosexual and homosexual. The world is not to be divided into sheep and goats. Not all things are black nor all things white. It is a fundamental of taxonomy that nature rarely deals with discrete categories. Only the human mind invents categories and tries to force facts into separated pigeon-holes. The living world is a continuum in each and every one of its aspects. The sooner we learn this concerning human sexual behavior, the sooner we shall reach a sound understanding of the realities of sex.[45]

On a social level, feminism and the debut of the new woman were also arguments against the notion that sexuality was fixed or that gender identity was written in stone. In words, appearances, and deeds, a new generation of women, and those men who joined with them, was shaking the underpinnings, not only of male supremacy, but also of sexual absolutism itself.

The clash between new freedoms and old anxieties was explosive. In the name of civilization, the keepers of traditional family values would wage war against the infidels of ambiguity. From the first skirmishes in the early 1900s, the battle has continued for more than a century.

26
WRITING HISTORY WITH LIGHTNING

Modern systems of typecasting evolved over a period of centuries. They were the intrinsic outcome of an emerging global economy, entrenched patterns of unequal development, the egalitarian challenge of democratic ideas, and the unfolding of a world in which the company of strangers was becoming more and more routine. Within this historical matrix, premises of inborn human inequality infused new scientific, aesthetic, and religious cosmologies, transforming the categorization of human types from an ancient, parochial practice into the globally influential apparatus of Western popular culture.

While links between taxonomies of human difference and popular culture began to take hold from the late eighteenth century onward, the twentieth century witnessed an exponential magnification of this phenomenon. Propelled by the powers of mass production, the consequent need to nurture and stimulate mass markets, and the growth of a media-saturated consumer culture, typecasting became a pivotal component of an all-encompassing commercial panorama. It saturated the ether of both public and private imaginations.

More than anything else, it was the birth of motion pictures, beginning in the 1890s, that provided a sorcerer's laboratory for the industrialization of stereotype. For many, the very word "typecasting" brings Hollywood to mind. It was here that the accumulated repository of human types became an essential raw material in the manufacture of generic formulas that would define the American film industry.

Clearly, typecasting was an aspect of theatrical productions long before Hollywood. Dramas, as a matter of course, required actors to assume fixed character types representing different sectors of humanity. Mythic archetypes were also an ancient mainstay of dramatic characterization.

By the mid nineteenth century, reflecting the ethos of industrialism, facial politics was being standardized and systematized in the schooling of actors and orators. Francois Delsarte—the most important influence on acting technique prior to Stanislavsky—developed a method to train actors in the fine points of gesture and facial expression, so that they might precisely emulate the characters they were portraying. L'Abbé Delaumosne, one of Delsarte's most prominent disciples and popularizers, described the painstaking inquiries that led to what would become, in published form, *The Delsarte System of Oratory*.

402

Delsarte's investigation into expression had grown out of his frustration with the lack of organization and consistency in his Paris Conservatory training. . . . On the one hand he wanted to base his work on the realities of "nature." To this end he studied how people in everyday situations express character and emotion and how the instruments of expression (body, voice, and breath) actually function. He conducted research observing people in all kinds of situations, even in death or during the process of dying. On the other hand, Delsarte sought basic principles underlying what was specific and individual, universals that he was sure existed.[1]

Delsarte's search for universals was closely linked to the outlook of physiognomy and phrenology. Just as these popular sciences claimed to provide detailed road maps of human character, Delsarte held that "all art presupposes rules, procedures, a mechanism, a method which must be known."[2] The essentials of character, he argued, could be visually and accurately determined from countenance and gesture. Studying these essentials, an actor, using facial and bodily expression, could accurately portray any human variation. "Aesthetics," according to Delsarte, was "henceforth freed from all conjecture." It would now "be truly established under the strict forms of a 'positive science.'"[3]

The details of Delsarte's science were also inseparable from the physiognomic sciences of his day. His supposedly comprehensive semiotics of expression will sound familiar to any student of the history of typecasting.

GESTURE.

CRITERION OF THE EYES.

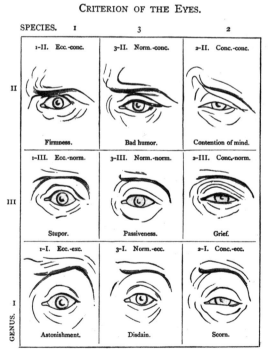

Delaumosne, *The Art of Oratory System of Delsarte* (1882) Courtesy GA-GA Pictures

This illustration of Delsarte's dramatic physiognomy categories eye gestures and their meaning. REPRINTED FROM ABB'E DELAUMOSNE'S *DELSARTE SYSTEM OF ORATORY.*, 1893; FROM THE COLLECTION OF THE EWEN LIBRARY

The face is the mirror of the soul because it is the most impressionable agent, and consequently the most faithful in rendering the impressions of the soul.

Not only may momentary emotions be read in the expression of the features, but by an inspection of the conformation of the face, the aptitude, thought, character and individual temperament may be determined. . . . A criterion of the face is indispensable to the intelligent physiognomist.[4]

. . . A small eye is a sign of strength; a large eye is a sign of languor. A small oblique eye (the Chinese eye), when associated with lateral development of the cranium, and ears drawn back, indicates a predisposition to murder. . . .

The lowered brow signifies retention, repulsion: it is the signification of a closed door.[5]

If physiognomy was an essential component of the Delsarte system, the scientifically informed employment of gesture was equally important. "Persuasion," he noted, "is the office of gesture." To carry along an audience, particularly given its distance from the proscenium, an informed and embellished use of body language was essential.

In 1895, in *The Crowd*, Gustave Le Bon argued, "theatrical representations, in which the image is shown in its most clearly visible shape, always have an enormous influence on crowds."[6] This conviction, which would come to inform the development of modern propaganda techniques in the twentieth century, was already established as an axiom of Delsarte's system by the 1860s. When the system first reached American readers in 1882—more than a decade before Le Bon would dissect the irrational mentality of the crowd—Delsarte's discussion of "audience" prefigured the core of Le Bon's social psychology.

An audience must not be supposed to resemble an individual. A man of the greatest intelligence finding himself in an audience, is no longer himself. An audience is never intelligent; it is a multiple being, composed of sense and sentiment. The greater the numbers, the less intelligence has to do. To see, to act upon an individual by gesture would be absurd. The reverse is true with an audience; it is persuaded not be reasoning, but by gesture. . . . It is not ideas that move the masses; it is gestures.[7]

In his quest to uncover those rhetorical prescriptions that could be used to mesmerize, and then lead, the urban masses, Le Bon was clearly influenced by

404

Delsarte's system of oratory. In *The Crowd*, however, he sought to carry the system onto the stage of modern politics. "It is not . . . the facts in themselves that strike the popular imagination, but the way in which they take place and are brought under notice. It is necessary that . . . they should produce a startling image, which fills and besets the mind."[8]

While politics and theater would become more and more indistinguishable over the next century, it was a budding movie industry that provided a pivotal testing ground for Delsarte's conception of how to move an audience. In the United States, the system exerted considerable influence on both professional and amateur theatrics from the 1880s onward. With the dawn of motion pictures in France and the United States, Delsarte's persuasive strategies were mechanically reproduced and standardized on the silver screen. His instructions helped to shape the exaggerated melodramatic style that characterized much of early silent film acting. Beginning his career as an actor for the stage, D. W. Griffith, among other early filmmakers, was influenced by the Frenchman's methods.

Yet, the movies posed a challenge to the idea that trained actors were an indispensable component of the photoplay. As opposed to live theater, where a carefully cultivated voice was vital, the silence of the movies and the optical magic of the medium offered filmmakers a new opportunity to communicate the multiplicity of human types.

In 1924, one of film's first major theorists, Béla Balázs, described this shift. Speaking of the power of the close-up, he wrote, "What appears on the face and in facial expression is a spiritual experience, which is rendered immediately visible without the intermediary of words." If a stage actor, using Delsarte's method, was forced to reach to the balcony with his gestures, modern cinematic camera work brought the face itself to center stage, unfettered by extraneous surroundings. Filling the screen, the inner workings of temperament and feelings became manifest as was never before possible in theater.

Echoing Lavater's physiognomic determinism, and clearly influenced by the dramatic teachings of Delsarte, Balázs cited the movies' capacity to employ a "microphysiognomy" that could instantly demonstrate the contours of character. While photography had achieved this in the capture of an isolated moment, cinema carried this power into the realm of time-based storytelling. The capacity to communicate emotions to an audience was undergoing a sea change. As Balázs explained it:

> [T]he film is about to inaugurate a new direction in our culture. Many
> million people sit in the picture houses every evening and purely

through vision, experience happenings, characters, emotions, moods, even thoughts, without the need for many words. For words do not touch the spiritual content of the pictures and are merely passing instruments of as yet undeveloped forms of art. Humanity is already learning the rich and colorful of gesture, movement and facial expression. This is not a language of signs as a substitute for words. . . . It is the visual means of communication, without intermediary of souls clothed in flesh. Man has again become visible.9

Delineation of character, however, was not simply the outcome of new film techniques, it was also a product of modernity itself. In a society in which urban life provided an endless parade of diversity, one could simply go to the street, or the drugstore, to find the type that was needed, the person whose face was deemed suitable. While gesture continued to reign throughout the silent era, Delsarte's applied aesthetics, predicated on an exhaustive dramatic training, began to give way, particularly in the selection of "extras," to a casting process that looked to employ, rather than emulate, living physiognomic examples of the desired type. In his 1916 study of early American cinema, the psychologist Hugo Münsterberg described the procedure:

> If the photoplay needs a brutal boxer in a mining camp, the producer will not . . . try to transform a clean, neat, professional actor into a vulgar brute, but he will sift the Bowery until he has found some creature who looks as if he came from that mining camp and who has at least the prize fighter's cauliflower ear. . . . If he needs the fat bartender with his smug smile, or the humble Jewish peddler, or the Italian organ grinder, he does not rely on wigs and paint; he finds them all ready-made on the East Side.10

If Thomas Ince's 1915 drama, *The Italian*, did not feature an actual immigrant in the title role, George Beban, who played the main character, was bedecked in a wardrobe that was sociologically authentic, secured from the streets. Ince recounted the story.

> One day, he [Beban] caught sight of an immigrant coming ashore at the Battery. George flanked him and in good Italian offered to take over everything on the stranger's back in return for a fair price paid therefore. George secured the complete outfit, including headgear and foot-

gear, for ten dollars, and despite its notorious age and fears for another hard winter, called it a bargain.[11]

Beautiful girls were the harvest of similar expeditions. Prowling the streets, "talent" scouts could easily find their prey and introduce them into a budding machinery of renown. One result was the "glamour girl," a pretty young woman lured from the mundane particularities of her life and systematically transformed into a marketable replica. The pioneering film director Cecil B. DeMille explained the process with more than a dollop of derision.

> [T]hey all look alike. Just as if they were stamped out of the mint like silver dollars. . . . They've been coming in one door and going out the other . . . and could keep right on coming in and going out in a continuous circle and I wouldn't know one from another.
>
> The girls themselves have nothing to do with this. Many of them are distinctive and different when they arrive. But they don't come out that way. The eyes, the lips, the mouth, the hair are all done in a certain typed way. Their faces look like slabs of concrete.
>
> Maybe the average Hollywood glamour girl should be numbered instead of named.[12]

Alongside Hollywood's replication compulsion was another tendency that plucked individuals out from the group, transforming them into "stars." Audience enthusiasm and box office receipts were the forces that drove this development. If an actor or actress proved popular, by virtue of a particular look or manner, they and their profitable filmic identity would become inseparable. This defined the first of Hollywood's celebrities: Lillian Gish, the virgin; Mary Pickford, the plucky girl; Charlie Chaplin, the little tramp; Theda Bara, the dangerously seductive vamp; Douglas Fairbanks, the swashbuckling adventurer; Rudolph Valentino, the Latin lover. In movie after movie, they would reproduce themselves, responding to carefully cultivated audience expectations, and making studios rich.

If, by the 1920s, a rising star system helped to transform Hollywood into an empire of celebrity, the phenomenon of typecasting extended far beyond the stars. It was a fundamental component of storytelling in this compelling new medium. Using generic formulas that left little space for character development, filmmakers routinely employed easily recognizable types, providing sug-

gestible audiences with what Walter Lippmann called "handles for identifica-
tion," instantaneous signals that stimulated visceral responses.

To some extent, middle-class film audiences that flocked to movie theaters
from the mid-1910s onward carried a historically cultivated "repertory of stereo-
types" that would become emblematic of Hollywood filmmaking. Beginning in
the early nineteenth century, visits to natural history museums and world's fairs,
mass instruction in physiognomy and phrenology, and familiarity with photo-
graphic archives of good and evil became mainstays of popular culture. In the
United States, the popular phenomenon of minstrelsy and, by the early twenti-
eth century, the budding field of eugenics, helped to popularize a worldview in
which people were regularly characterized by a simple, effortlessly digestible cul-
tural shorthand. Stereotype was the lingua franca of modernity. Civilization and
barbarism, moral strength and weakness, intelligence and stupidity, and a range
of other dualities, were a legacy that people brought to the movies and that the
movies gave back to them in spades.

The most notorious example of this phenomenon was D. W. Griffith's *The Birth
of a Nation*, which opened in February, 1915, originally under the title *The Clans-
man*, after the 1905 novel on which it was based. Thomas Dixon, a close friend
and former classmate of President Woodrow Wilson, wrote the book, which he
subtitled *An Historical Romance of the Ku Klux Klan*.

Shortly, given its now familiar title, *The Birth of a Nation* almost single-hand-
edly transformed the movies from a storefront amusement, enjoyed largely by
working-class tenement dwellers, into a legitimate form of entertainment for
white middle- and upper-class Americans. The most expensive spectacle of its
time, this movie commanded ticket prices that were set to ensure that only those
with discretionary income would be permitted to enter the theater.

Adding to this aura of respectability, President Woodrow Wilson selected
Griffith's three-hour epic as the first movie ever screened at the White House.
Perhaps he was motivated, in part, by the film's conspicuous use of quotations from
Wilson's five-volume *History of the American People*, published in 1902 as Wilson
began his eight-year tenure as president of Princeton University. Repeatedly
cited in the film's section on Reconstruction, Wilson's texts added intellectual
authority to the idea that black citizenship was a disaster and defined the Ku Klux
Klan as the saviors of civilization.

One quote from Wilson that appears in the film decries the chaos that followed
the enfranchisement of the black Southern population. "In the villages," Wilson
intoned, "the negroes were the office holders, men who knew none of the uses

of authority, except its insolences." (Wilson and Griffith both insisted on spelling Negro with a small *n*.)

The only solution to this catastrophe, Wilson concluded, was a righteous white rebellion against the bedlam of emancipation. "The white men were roused by a mere instinct of self-preservation . . . until at last there had spring into existence a great Ku Klux Klan, a veritable empire of the South, to protect the Southern country."

While generations of cinema scholars have chosen to ignore the film's vitriolic content—fixating instead on Griffith's notable formal innovations—the movie, in its context, was a wholesale assault on America's free black population. Using the Civil War and Reconstruction as its setting, Griffith's portrayal of the aftermath of emancipation employed primarily blackface white actors to present a picture of black America that was consumed with a lust for white women, intrinsically unreliable, and incapable of exercising the privileges of citizenship. Emancipation, the film argued, through a mix of simple visual representations and lengthy historical texts, constituted the "veritable overthrow of civilization in the South," a phrase also taken from Wilson's tome. At a moment when Jim Crow laws were at their zenith and lynchings common, the film championed a white reign of terror against free, inherently unruly, blacks as the only hope for the nation.

Woven into this diatribe stood pervasive racial typologies that were rooted in the eighteenth century and carried forward into the nineteenth and twentieth by the nexus of art, science, and popular culture. Representing the chivalry and virtue of white civilization is the Cameron family, gracious Southern slave owners, whose Anglo-American paradise is overrun by the Civil War and, following Lincoln's assassination, plagued by the humiliation of the "white South under the heel of the black South," another phrase taken from Wilson.

The perpetrator of this disgrace is Austin Stoneman (played by Ralph Lewis), a deformed caricature of Pennsylvania Congressman Rep. Thaddeus Stevens, a resolute advocate of full citizenship for freed slaves. Stern and single-minded, Stoneman plans for a radical reconstruction of the South, stoked by the goading of his scheming "mulatto" housekeeper and mistress. Played by a white actress in make-up (Lydia Brown), this tawny Jezebel employs Delsarte's methods to the extreme. With madly darting eyes and histrionic gestures, she incites her receptive white lover to impose a new era of black rule over the South.

Chosen to lead the rebellion is Silas Lynch, a megalomaniacal "mulatto" whose insatiable thirst for white women is played to the hilt by a white actor,

George Siegmann. Lynch's eventual undoing comes when his hunger for power and "Aryan" women turns into a demonic proposal of marriage to the blond and beau- 409
tiful Elsie Stoneman (Lillian Gish), daughter of the Radical Republican leader. As she runs from his leering eyes and stalking grasp, Lynch declares: "I will build a black empire with you as queen by my side." Elsie, as Richard Schickel describes her, is the embodiment of "imperiled innocence."[13] This narrative of black men (apes, as well) kidnapping blond white women, to take them as their concubines, was an oft-told tale in the folklore of racial science.

The theme of miscegenation and its dire consequences runs through the film. In a heartrending episode, one of the most famous in the film, an animalistic black soldier named Gus (Walter Long in burnt cork) menacingly trails the innocent

Stoneman's plan for a radical reconstruction of the South is stoked by the goading of his scheming mulatto housekeeper and mistress. Played by a white actress in makeup (Lydia Brown), this tawny Jezebel employs Delsarte's methods to the hilt.

410

Little Sister of the Cameron family (Mae Marsh) into the woods. She notices him and, sensing his predatory sexual desires, runs frantically to the edge of a cliff in a hapless attempt at escape. Like Lynch, Gus wants Little Sister as his bride. To protect her honor, she chooses death, leaping from the cliff to her tragic demise.

Whites played all of the primary "Negro" roles in *The Birth of a Nation*. Applying Griffith's adherence to the Delsarte method, they telegraphed their treacherous motives by accentuated facial gesticulations, with an emphasis on leering eyes and exaggerated movements of the brow. To highlight Lynch's innate cruelty, one scene shows him gratuitously kicking a dog. This behavior is in stark contrast to the Camerons, whose love and affection for animals is manifest repeatedly throughout the film, a mark of their essential decency.

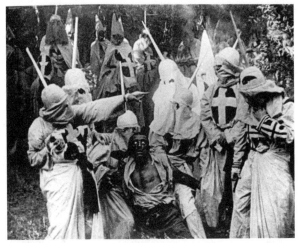

In *Birth of a Nation* the heroism of the Ku Klux Klan is exemplified by their capture of the renegade black soldier, Gus (Walter Long in blackface), the menacing stalker of Little Sister, the ideal of white Southern womanhood. Rather than submit to him she leaped to her death.

The only two sympathetic black characters—also played by whites—are a doting Mammy (Jenny Lee) and a devoted Uncle Tom character (John McGlynn), who remain "faithful" to the Camerons, their old masters, and yearn for the carefree days of slavery. Again and again, Mammy scolds and beats up on the "uppity" blacks who have taken over.

Much has been written about the main black characters in *The Birth of a Nation*, and how they, following the minstrel tradition, were impersonated by whites. The film, however, made ample use of black extras. While these extras did not have individualized roles, they were employed to depict happy-go-lucky slaves, dancing and singing to the amusement of their masters and, later, those who committed some of the most egregious "outrages" of postwar racial equality.

One example, set at a Southern Union League rally of newly enfranchised ex-slaves, uses black extras to portray them in a state of mindless frenzy. Push-

ing the link between freedom and miscegenation, they carry signs demanding "Equal Rights, Equal Politics, Equal Marriage."

When the Little Colonel (Henry Walthal), hero of the Confederacy and scion of the Cameron clan, describes a Negro jury acquitting a black man who had murdered a white, we are shown a jury that is composed of black extras, while the acquitted murderer is played by a white in blackface, wearing the ridiculous garb of an "Ethiopian farce." Implicit was a visual argument that real black juries would sanction violence against whites and set incompetent buffoons free. The history of white juries since Reconstruction reveals that the opposite has more often been the case.

In a subsequent scene, whites are intimidated at polling places, while blacks exercise their franchise, sometimes voting twice. The state legislature soon falls into black hands. Here again, African American extras were employed to represent an uncouth assembly of monsters, swigging whisky, eating chicken with their hands, and placing bare feet on their legislative desks. This scene, which mingles blacks and blackface whites in outlandish minstrel attire, communicated the Negroes' congenital unfitness to exercise the responsibilities of democracy. This sense is punctuated at the end of the scene, when the Assembly passes a bill legalizing intermarriage. The new law provokes joyous celebration among the sex-crazed legislators and palpable fear among the few whites, who look on from the gallery.

In the streets of Piedmont, mob scenes were also populated with black extras, here playing delirious freedmen driving a once-proud Southern civilization toward the brink of ruin. Using African-American players, Griffith added authenticity to white conceptions of unfettered blacks running amok. In the process, blacks, looking to earn a wage, were asked to validate Anglo-America's greatest fears.

In *Public Opinion*, Walter Lippmann wrote, "By the same mechanism through which heroes are incarnated, devils are made."[14] In *The Birth of a Nation*, both heroes and devils corroborate Lippmann's dictum. The presentation of whites throughout the film is relentlessly stereotypical.

They are gallant and civilized. Even on the eve of war, they celebrate at a formal ball, men in their handsome gray uniforms, women in gowns with petticoats. The Cameron daughters, Margaret and Little Sister, are both Southern belles, delicate but determined monuments to honor and purity. Elsie Stoneman, a Northern white woman, is also demure, uninterested in politics, and a classic nurturer. Serving as a voluntary nurse during the Civil War, she tends to the broken and the wounded regardless of their political affiliation. It is in this context that she encounters the Little Colonel, injured in battle. As she nurses him, they also fall in love.

Among white men, Dr. Cameron, the family patriarch, is portrayed as the "kindly master," whom the audience is asked to sympathize with as he endures the ordeals of humiliation. Set against this benevolent vision is the vengeful abolitionist Stoneman, the only major white character who is negatively depicted. Stonemen is dark and brooding, arrogant and willful in pursuing his misguided scheme to bring blacks to power in the South. Beyond his taste for "mulatto women," his imperfections as a white man are evidenced by a limping gait and by his constant fidgeting with a black, ill-fitting wig. Ultimately, it is only when his daughter is assaulted by his former protégé Lynch that he comes to terms with his whiteness and discovers the folly of his ways.

The most heroic white character, stereotype of the Southern cavalier, is the Little Colonel. A hero in war, it is he who is most disturbed by the debauchery of Reconstruction. Gentle and sensitive, with a dashing mustache and romantic eyes, when provoked, he is capable of immeasurable heroism. Believing that whites must come to "the defense of their Aryan birthright," he organizes a righteous militia to stem the mounting tide of barbarism. Observing that blacks are inherently afraid of ghosts—a common storyline in minstrelsy and early silent film—the Little Colonel comes up with a brilliant idea: to dress his army in white sheets.

This is the birth of the Ku Klux Klan. In *The Birth of a Nation*, these men are the unquestioned saviors of white civilization. As they ride against the evils perpetrated by free blacks, these valiant horsemen foreshadow the depiction of the Cavalry coming to the rescue, a theme that will become an earmark of the Hollywood Western.*, [15] This moment brought audiences to their feet, cheering the rescue of a nation. Here, "human destruction," as Walter Benjamin would put it, was transformed into "an entertainment of the first order."

Even as Klansmen on horseback stand menacingly at polling places, to intimate blacks from registering to vote, they are presented as guardians of all that is virtuous. This guardianship is underwritten by a victory parade that closes the film. Here the Klansmen ride triumphant, with Margaret Cameron and Elsie Stoneham—symbols of white womanhood—riding at the head of the march, aglow under the watchful protection of their hooded redeemers. In an epilogue, Jesus hovers over the scene, offering his blessing. At film's end, North

* John Ford, the premiere director of the Western, was an extra in Griffith's famous Klan Ride. His white robe blinded him and he bumped into a tree, causing him to fall off his horse. He spent the rest of the day watching the scenes unfold, learning a most valuable lesson used in his making of his classic Stagecoach and other Western films.

and South are reunited, dedicated to safeguard Aryan supremacy against the onslaught of the unfit. It is this new nation whose birth is chronicled by Griffith's epic. 413

The Birth of a Nation was a concoction of one-dimensional stereotypes and a vision of people as occupying fixed and unequal positions within the great chain of being. Yet it took the incendiary racial politics of its day, from Jim Crow to the eugenics movement, and turned them into one of the most indelible examples of a carefully crafted movie's uncanny capacity to rivet "the sense and sentiment" of an audience.

The film caused no little alarm. The newly founded National Association for the Advancement of Colored People (NAACP) mounted a massive boycott. In its pamphlet, "Fighting a Vicious Film: Protest Against *The Birth of a Nation*," the organization rebuked it as "three miles of filth." W. E. B. DuBois, editor of the *NAACP Crisis* editorialized against it. Jane Addams, the respected founder of Hull House in Chicago and a charter member of the NAACP, told the *New York Post*, "You can use history to demonstrate anything when you take certain of its facts and emphasize them to the exclusion of others." She condemned *The Birth of a Nation* as "a pernicious caricature of the Negro race . . . unjust and untrue."[16] Thorstein Veblen commented, "Never before have I seen such concise misinformation."[17] Ohio, true to the Union cause, banned the film. Nevertheless, its initial run was eleven months and it remained, for years, an unprecedented source of box-office revenue. As late as 1948, it was estimated that *The Birth of a Nation* had grossed more money worldwide than any other film.

Seven years after its appearance, Walter Lippmann paid uneasy tribute to the film's formidable persuasive powers.

> Your hazy notion, let us say, of the Ku Klux Klan, thanks to Mr. Griffiths [*sic*], takes vivid shape when you see The Birth of a Nation. Historically it may be the wrong shape, morally it may be a pernicious shape, but it is a shape, and I doubt whether anyone who has seen the film and does not know more about the Ku Klux Klan than Mr. Griffiths [*sic*], will ever hear the name again without seeing those white horsemen.[18]

27
MOVABLE TYPES

As was the case with many early silent films, all of the characters in *The Birth of a Nation* played to type. Devoted to Delsarte's positive science of theater, filmmakers for the most part presented a worldview in which each cast member signified a fixed identity that remained static throughout the duration of the narrative.

Yet, simultaneously, it was also increasingly evident that motion pictures, more than any medium before them, were particularly suited for illustrating visual metamorphosis. The first to demonstrate this capacity was Georges Méliès, a French magician who began making short films in 1896. On the stage, sleight of hand, the artifice of diversions, and mechanical devices combined to create the fantasy that a magician was capable of accomplishing paranormal feats. Making objects and living things appear and disappear, changing them from one form to another, defying the laws of gravity—this was the established domain of the illusionist.

At his Théatre Robert-Houdin, where he performed his shows, Méliès had long used magic-lantern projections as part of his conjuring act. When Méliès saw France's first cinématographe exhibition—produced by his countrymen, the brothers Auguste and Louis Lumière—he was overcome by the potential uses of this new technology. Adapting a British prototype, he designed his own camera, the Méliès Kinétograph, and began shooting.[1]

According to the film historian David A. Cook, Méliès discovered the miraculous powers of the Kinétograph by mistake.

One afternoon in the fall of 1896, while Méliès was filming a Parisian street scene, his camera jammed in the process of recording an omnibus as it emerged from a tunnel. When he got the machine working again, a funeral hearse had replaced the omnibus, so that in projection the omnibus seemed to change into the hearse.[2]

This accidental visual occurrence revealed to Méliès something wondrous about the motion picture. With careful planning of shots, and strategic editing, one could create a parallel universe in which the laws of time and space were defied. With this in mind, he began producing astonishing illusions on film. While many of his more than five

416

hundred movies followed theatrical conventions of melodrama, these films included interludes in which displays of cinematic magic were inserted as transitional diversions with no clear connection to the storyline.

Many early filmmakers saw motion pictures as particularly suited for the depiction of visual truths—faithful simulations of objective reality. As Woodrow Wilson remarked after seeing *The Birth of a Nation*, the cinema was capable of "writing history with lightning."[3] On the other hand, Méliès, along with numerous magicians who experimented with the medium, demonstrated that movies could transcend "the real," speaking in the language of dream, fantasy, and imagination. By the end of the First World War, less than five years after Griffith's epic, these magical capacities of cinema began to infuse Hollywood narratives and, in the process, send typecasting in new directions.

Miraculous transformations became increasingly common elements of the story line. A major innovator in this development was Cecil B. DeMille, who started making films in 1913. Into the late 1950s, DeMille directed and/or produced films in a panoply of genres, achieving fame and success in each of them. He made westerns, biblical and historical epics, romantic comedies, and science-fiction thrillers. In the last years of his life, DeMille continued to be a box office marvel, closing his directing career with *The Ten Commandments* (1956), a remake of a sizzling spectacle he had first produced in 1923.

Within his enormous body of work, one theme appears again and again. Beginning in the years following the First World War—a time when mass-produced goods, advertising and a consumer culture were promising Americans the possibility of escaping the limits of their lives—DeMille repeatedly employed the filmic canvas to puncture rigid visions of class and gender.

A classic example of this theme was his 1919 photoplay, *Male and Female*. Set in class-bound England, initially on the estate of the Earl of Loam and his family, the film presents a servant's eye view of idle, self-centered, and aimless individuals, living in an excessive splendor that they assume to be their birthright. This vantage point, in and of itself, broke the conventions of type, offering a narrative from the perspective of those rarely given a voice.

To the Earl's family, the people who work for them—Tweeny, a scullery maid, a young boy who delivers newly polished shoes to their bedroom doors each morning, and William Crichton, a deferential butler who oversees the serving staff—have no purpose in life other than to serve the needs of the family. Again and again, we see this supposed nobility as an unconscious collection of spoiled, capricious, and overly pampered snobs. The eldest daughter, Lady Mary (Gloria Swanson) is lazy and overindulged, but also presented as

a siren, first lolling suggestively in her bed, and then being bathed in her extravagantly appointed bathroom, in what was considered at the time an audaciously 417 prurient scene. Despite her sex appeal, she is a difficult mistress for the serving staff, fussily quibbling over the temperature of her bath water and the doneness of her toast.

Less appealing are the men of the household, who are presented as bumbling drones. Even amid entrenched boundaries of social status, Crichton is presented as manlier, and more sexually desirable, were it not for the taboos that divided class from class. Lord Brockhurst, Lady Mary's suitor, is a stereotypical lecher, a foil to emphasize the natural grace of her butler.

The only visible crack in the facade of aristocracy, to this point, is an unsanctioned relationship between one of Lady Mary's friends and her chauffeur. Admitting the affair, she asks, "Can a woman be happy in love with a man beneath her station—her chauffeur?" For Mary, this is folly. "Kind belongs with kind," she advises her friend, "and you can never change it."

Afterward, Lady Mary remarks to Crichton, "Rather democratic you servants are getting." His response foreshadows things to come. "You may never know what's in a man—if they return to nature."

The test of "a man" soon follows. On a sailing voyage to the South Seas, with Crichton and Tweeny accompanying the Earl and his family, the ship is wrecked by jagged rocks, and all aboard are reduced to a state of nature on an island where they find refuge. While the family desperately attempts to uphold the master-servant relationship, the wilderness reveals the emptiness of their aristocratic status, a creation not of nature but of a discriminatory society.

If idleness was a mark of superiority in England, it is a liability on the island. The Earl and his children are distinctly unfit to cope with the demands of their new existence. As one of the film's many oracular titles notes, "It is one thing to be a Peer in England and another to be a Peer in the Jungle." Only those who can work with their hands, and have a stockpile of practical know-how, are capable of taking charge. Declaring, "All must serve. No work, no food," Crichton assumes leadership.

Against traditions of social distinction, long the bedrock of typecasting, DeMille offers a romantic portrayal of natural rights, where the old world is turned upside down, and servants become kings. Here, unspoken affections, prohibited by the decorum of conventional life, begin to bloom. Mary, "no longer a great Lady" becomes, for Crichton, a "'woman,' a very helpless beautiful woman." Tweeny, who also carries a torch for Crichton, competes with Mary for the former butler's love. Each scampers for the opportunity to serve his every need.

Shortly, the competition is settled, and Mary and Crichton are about to be wed. At that very moment, Tweeny spies a ship passing by the island. A signal is deployed to call attention to their plight, and they make a sudden return to civilization.

Back home, "Heredity, Tradition and London" reassert themselves. The Earl takes credit for Crichton's inventive leadership, as the butler silently acquiesces to the lie. While Lady Mary secretly pines for Crichton, she reluctantly returns to her world, and he to his. Having discovered his own natural nobility, however, Crichton finds servitude is no longer acceptable. Crichton and Tweeny get married and leave class-bound England for the democratic promise of America. As the film ends, they happily till the soil and experience a return to nature in the New World, a place where servants can become upstanding citizens and where the class distinctions of Old World Europe hold no weight.

Stereotypical portrayals abound throughout this film, but they are remarkable in their fluidity. The pompous Earl of Loam and his sons become laughable and pathetic in the crucible of nature. Lady Agatha, Mary's younger sister, discovers that the "condition of her face" is less important than the ability to "face conditions." Lady Mary is changed from a coddled princess, who believed that her hands were there to be manicured, to someone who is forced by circumstance to "work with her hands."

More importantly, Crichton, a dutiful fixture in an aristocratic world, emerges as a natural leader, a man whose inherent dignity takes flight when freed from the fetters of pomp and ceremony. In the end, he emerges as a spokesman for an America where anyone can become the person that he wishes to be.

In certain ways, this story is not new. While Horatio Alger never demeaned the upper classes in his novels, he is famous for stories of transformation from poverty to wealth in urban America. *Male and Female*, itself, was based on *The Admirable Crichton*, a stage play by J. M. Barrie, whose interest in role reversal is evident in his more famous *Peter Pan*. But in bringing this and other stories to film, a nascent industry that had relied on set and familiar types was evolving into a "Dream Factory," a phrase coined by the anthropologist Hortense Powdermaker.

In *Male and Female*, a bizarre sequence is dropped, unexpectedly, into the ostensibly real-life events that make up the body of the narrative. Serving no dramatic purpose other than to offer up a sumptuous spectacle, the scene presents a fantasy world in which Crichton is transfigured into an ancient King of Babylon, sitting bored upon his throne. Lady Mary enters the scene as a beautiful Christian slave, first wearing rags but soon adorned in an exotic outfit and

an elaborately feathered headdress. She immediately attracts the king's interest. Unwilling to submit to his sexual demands, she is relegated to a cage filled with hungry lions. With Mary lying motionless beside one of the cats, the film then shifts back to the island refuge where she now is found lying amorously on Crichton's lap.

While the Babylonian sequence is strangely out of place in relation to the rest of the film, it offers a glimpse of what may have been passing through the central characters' minds. It also carries forward the spirit seen earlier in Méliès' magical interludes. Reaching across centuries and civilizations, the scene serves as a tribute to film itself as a medium of dreams, obliterating the limits of time and space. More significant than the ability to recreate a semblance of reality, DeMille would write, movies had the capacity "to photograph thought."[4] These departures from supposedly objective occurrences, into the fantasy lives of characters, would become a recurrent feature in a number of his films.

If *Male and Female* offered the elixir of nature as the context of conversion, many of DeMille's other films situated transformation squarely in the middle of a modern consumer culture. In some, such as *Old Wives for New, Why Change Your Wife, Don't Change Your Husband*, middle-class women in danger of losing their husbands are able to save and revitalize their marriages by discarding frumpy, old-fashioned clothing and replacing it with stylish, sexually appealing attire, purchased in modern department stores. For enthusiastic, young audiences, among them women disenchanted with the restrictions of Victorian morality, such films offered prescriptions for self-improvement, for being sexually appealing and keeping your man. As presented, all of these aims could be fulfilled across the span of a retail counter. Avid shopping, more than natural nobility, was the key to success in these consumption dramas. In the expanding universe of what Guy Debord would later term the "spectacular commodity society," a person could shed the burden of an undesirable identity and, through the right purchases, break the shackles of type.[5]

Looking beyond the screen, Lloyd Lewis, writing in *The New Republic*, encapsulated the moviegoing experience, arguing that it liquidated the burden of traditional values—to paraphrase Walter Benjamin—particularly for female audiences.[6] It allowed middle-class women to step out of the strictures of their lives, into an enchanted erogenous zone, where romantic fantasies were both permitted and encouraged.

> In the dim auditorium which seems to float in a world of dreams and where the people brushing her elbows on either side are safely remote,

an American woman may spend her afternoon alone. Romantic music, usually played with a high degree of mechanical excellence, gives her a pleasant sensation of tingling. Her husband is busy elsewhere; and on this music, as on a mildly erotic bridge, she can let her fancies slip through the darkened atmosphere to the screen, where they drift in rhapsodic amours with handsome stars. In the isolation of this twilight palace, she abandons herself to these adventures with a freedom that is impossible in the legitimate theatre, where the lights are brighter and the neighboring seat-holders always on the edge of her vision: the blue dusk of "deluxe house" has dissolved the Puritan strictures she had absorbed as a child.[7]

In *Forbidden Fruit* (1921), DeMille took the makeover of female leads a step further. Here, Mary Maddock, a shabby but industrious seamstress who is married to a working-class ne'er-do-well, opens the film in the employ of a wealthy oil tycoon and his wife. When the oil magnate learns that a man he hopes to do business with will be attending a dinner party unaccompanied, he and his wife offer Mary the sum of twenty dollars if she will dress up and "vamp" their wealthy guest. In order to prepare the young seamstress for her flirtatious assignment, the woman of the house orders an entire new wardrobe for her tattered, but pretty, employee. Delighted by this exciting opportunity to play-act, Mary removes her wedding ring without a thought.

Mary is stripped down and remade into an enchanting seductress. Boxes of "lingerie, slippers, stockings, gloves and fans" are carried in by boys in livery. "Jeweled by Tiffany, gowned by Poirot, perfumed by Coty," the once homely Mary becomes a dazzling beauty, dressed to kill. While the film contends that "clothes go a long way to make the woman," other accoutrements in her metamorphosis include the acquisition of ladylike manners, including the knowledge of which fork goes with each course at dinner. This theme will embed itself in American popular culture and become a mold for such runaway hits as *My Fair Lady* (on both stage and screen), *Working Girl*, and *Pretty Woman*, the tale of a skanky streetwalker who, in a spree of shopping and etiquette lessons, is passed off as a glamorous catch in a business environment filled with high rollers.

In *Forbidden Fruit*, however, DeMille once again underlined his outer story, with several fantastic retreats to the fairy tale world of Cinderella, with Mary's assuming the role of the raggedy girl who is turned into a princess. If the story of the remade seamstress occupies a milieu defined by consumerism, the fan-

tasy sequences ultimately carry the audience to "a magnificent eighteenth-cen-
tury court that is a feast for the eyes."[8] Here, a visual psychic corridor is estab-
lished between the hyperbolic promises of a consumer culture and visions of
splendor that were set by European royalty. Not only will working-class Cin-
derellas win their princes; they will also be enveloped in a world of material
grandeur. As the film concludes, Mary has shed her lowlife husband, married the
oil baron's debonair son, and escaped the once iron cage of class. Immutable type
had given way to the prospect of transmutation.

The ornate, if superficial, grandeur of movie-palace interiors offered a gold-
leaf simulation of royalty, placing audiences in an environment that was tied to
the fantasy environments seen on the screen. The implicit politics of such cultural
venues created a strange amalgam of egalitarianism and monarchy. The irony of
this mix was not lost on Lloyd Lewis.

> The royal flavor of democracy it is: for in the "deluxe house" every man
> is a king and every woman a queen. Most of these cinema palaces sell all
> their seats at the same price,—and get it; the rich man stands in line with
> the poor; and usually tipping is forbidden. In this suave atmosphere, the
> differences of cunning, charm, and wealth, that determine our lives out-
> side, are forgotten. All men enter these portals equal, and thus the
> movies are perhaps a symbol of democracy. Let us take heart from this,
> and not be downcast because our democratic nation prudently reserves
> its democracy for the temple of daydreams.[9]

DeMille's golden touch was rooted in his prodigious ability to hone in on
the dream lives of his audiences. He offered them, if only in the temporary
radiance of the movies, a sense that their most improbable wishes could be ful-
filled. In the never-ending quest for box office receipts, studios saw DeMille's
films as templates for success, and they were widely imitated, if not always
equaled.

From the earliest days of American motion pictures, there was a powerful link
between the stories on the screen and the lives of audiences. Early nickelodeon
films, which were produced largely for immigrant, working-class viewers, often
told tales that related directly to the conditions of their lives. Many of these short
features dealt with poverty, social injustice, and the corrupt abuses of wealth.
These films were made up of cinematized visual facts, assembled to offer clear social
arguments.

Shortly, storefront nickel houses, visited by tenement dwellers, would give way to movie palaces and increasingly middle-class audiences. This was the context for *The Birth of a Nation*, but here, too, the "history writ by lightning" used ostensibly objective evidence that seemed palpably real to its spectators. The narrative on the screen inscribed itself on the lives of inflamed white audience members. It helped to revive a moribund Ku Klux Klan and spurred a massive growth in membership, in the North as well as the South, that would continue into the Second World War.

With DeMille, however, the connection between image and audience was fatefully altered. If previous genres had been built on an edifice of realism, offering persuasive renditions of visual truth, DeMille's truths visualized peoples' emotional yearnings, and offered them formulas for happiness that were premised on the bounty of a rising consumer culture. Fantasy was the new reality, and film, more than any medium before it, was able to blur the line between lived experience and imaginary longings.

By the early 1920s, this phenomenon was established as an earmark of American popular culture. It was Buster Keaton, the great American surrealist, who took this emotional bond between movies and their audiences and turned it into the subject matter of film itself. His 1924 classic, *Sherlock, Jr.*, remains one of the most eloquent and entertaining commentaries on the increasingly ambiguous boundaries separating everyday life from the limitless mobility of dreams.

Joseph Frank Keaton was the child of traveling performers. Appearing on the vaudeville stage beginning at the age of three, he was no stranger to legerdemain. His parents were close friends of Harry Houdini, who gave him the nickname "Buster." Magic, and the wonder it provoked, was an influential part of his upbringing. As a filmmaker, it deeply affected his approach to storytelling.

Sherlock, Jr. begins with Keaton playing a poor and inept young man named, simply, The Boy. With fantasies of becoming a great detective, he stumbles along, sweeping up refuse and running the projector at a small nickelodeon movie theater. There are no fancy costumes, no elaborate sets, only an everyday life that is shaped by his conspicuous lack of money.

Yet this pitiable, not very smart fellow is also likable and, in a series of sight gags, also very funny. Beyond his desire to be a renowned sleuth, his real-life longing is to win the heart of The Girl. Unable to pay for a large assortment of chocolates, he settles for a one-dollar box. On his way to woo The Girl, he

takes out a pencil and changes the one-dollar price tag on the bottom of the box
to read four dollars. 423

The Girl accepts his gift without concern for price, and then the two of them
sit slightly apart on a love seat in what becomes one of the most tentative hand-
holding scenes ever filmed. He then gives her an engagement ring, along with his
detective's magnifying glass, so that she can see the nearly microscopic stone.

While this awkward courtship is going on, another man, a city slicker known
as The Sheik, enters the house, also with the idea of visiting The Girl. Spying the
bumbling love scene, he is about to leave, when he notices a pocket watch in The
Girl's father's jacket, which hangs in the entrance hall. Stealing the watch, he
pawns it for four dollars, and uses all of the money to buy the large assortment
of chocolate that The Boy could not afford.

Box in hand, The Sheik returns to The Girl's house, and woos her from under
The Boy's nose. As he fondles her and outrages The Boy, the father discovers
that his watch is missing.

Keaton's character eagerly jumps into action, offering his detective skills to solve
the crime. When he begins searching people, just as his detective manual
instructs, The Sheik, to avoid discovery, slips the four-dollar pawn ticket into
The Boy's pocket. When The Sheik casually recommends that The Boy also be
searched, the ticket is found, matching the forged price on the box of candy The
Boy had given to The Girl. With such incriminating evidence, The Boy is for-
ever banished from the house and, totally dejected, returns to the movie house
to project the film that is playing there.

The Girl is very unhappy at this turn of events and takes the ticket back to the
pawnshop, asking the broker what the man who pawned the watch looked like.
At that moment, The Sheik passes by the pawnshop window, and the broker
points him out. Halfway through the movie, the crime is solved, at least on the
level of facts.

This is a moment in the history of film, however, when such simple real-life
solutions no longer hold much weight. The characters are still caught in the mun-
dane world that opened the film, but here, Keaton inserts a fantasy sequence that
takes DeMille's fantasy scenes a step further. DeMille's fantasies carry the audi-
ence away from the real-life story, but Keaton's emanates seamlessly from the
context of real life.

While The Girl is solving the crime, The Boy dozes off after he has started
projecting an elegantly staged feature film, *Hearts and Pearls*, which has the look
of one of DeMille's consumption dramas. Leaning against the projector, asleep,
The Boy suddenly steps out of his own body, leaving his real self behind and

carrying a newly emerging self into the world of dream. Looking out of the window of the booth, at the film on the screen, he notices something miraculous. All of the actors unexpectedly change into the people in his real-life drama. The outer story has given way to an inner story, in which his world is propelled into the DeMille-like elegance of a Hollywood movie. Descending from the booth and moving down the theater aisle, he climbs onto the stage and jumps into the movie, leaving the real world behind.

This is a difficult task to achieve, and he is unceremoniously tossed back into the audience by The Sheik, now a man in a tuxedo who is in the middle a different story. The Boy is persistent and reenters the screen. This time around, he is visibly confused by sudden scene changes, physically buffeted by a flurry of edits and vastly different settings. This sequence explores the distinction between life as it is lived and life as it takes place in the movies. Despite this tension, the dreaming Boy is soon drawn into the movie's plot. The outer world dissolves and *Hearts and Pearls* becomes his—and the audience's—reality.

In this reality, a theft has also occurred. A string of pearls has been purloined by The Sheik. The Girl is the victim of this crime, and in an attempt to recover the stolen jewels, she and her father call on the world's greatest detective, Sherlock, Jr. Not surprisingly, it is The Boy who plays this role, but instead of being an inept sad sack, he is dapper and brilliant, living in lavish quarters and stylishly attired in a silk top hat and tails, toting a gentleman's walking stick.

Unlike The Boy, Sherlock, Jr. is omniscient and lives a charmed life. Whatever the obstacle, he always prevails. As he enters the mansion where the theft has taken place, he carries a formidable reputation and strikes fear in the heart of the thief and his accomplices. Employing a battery of amusing but deadly devices to bring an end to the investigation, his foes make repeated attempts on his life. In one attempt after another, Sherlock outwits and frustrates his adversaries.

With the pearls stolen, and The Girl kidnapped, Sherlock and his assistant, Gillette (The Girl's father from the outer film, here transformed into a trusty sidekick), begin a quest to recover the pearls, save the girl, and bring the evil-doers to justice. Every step along the way is achieved by complex magic tricks, disappearing acts, and wondrous escapes that transform vaudeville magic into sophisticated cinematic special effects. The pursuit—including a hilarious chase scene, in which Sherlock rides the handlebars of Gillette's motorcycle, long after Gillette has fallen off—carries the audience far beyond the concocted fantasies of DeMille's films. In *Sherlock, Jr.* film fantasy becomes an integral and essential part of the plot. When the dashing detective finally realizes that

Gillette is no longer with him and begins to wobble, he is thrown from the bike into the window of the house where The Girl is being kept hostage. His flight 425 through the window knocks her captor unconscious, and, after a brief chase that turns out badly for the thieves, Sherlock brings The Girl and her pearls home in a strange twilight sailing scene.

At this moment, The Boy wakes up and finds himself back in the projection booth. The Girl quickly appears, informing him that she has solved the crime and that all is forgiven. Resuming their awkward courtship, The Boy, inspired by his dream world, continually looks to the screen for instructions on how to suavely woo his darling.

With the original actors of *Hearts and Pearls* back in place, the hero of the film genteelly places a ring on the heroine's finger. The Boy fumbles around in his pockets, looking for the ring with its minute gem, and places it on The Girl's finger. When the hero on the screen embraces the heroine and follows this with a long kiss on the lips, The Boy desperately seeks to reenact the scene but only manages a quick and hesitant embrace. In the final moment of the film, The Boy looks at the movie, where a "one year later" scene reveals a happy couple, bouncing twin babies on their knees. With inadequate instructions on how to get from here to there, The Boy quizzically scratches his head and looks thoroughly baffled. With this back-to-earth splash of cold water, the film ends.

If DeMille's films cast a powerful thrall over their audiences, offering viewers happy-ending fables of transformation, in Keaton's masterpiece, the power of movies has become the decisive force within the story. It is a penetrating commentary on the extent to which people, already by the early 1920s, were imagining their own personal triumphs and transitions through the lens of the motion picture, Keaton sets up both a corridor and a contest between everyday life and movie fantasy.

Throughout the film, as far-fetched as the inner story may be, it provides an opportunity for a bungling small-town boy to project his desires into the plot and to identify with a polished urbane hero, an early incarnation of James Bond. Midway through *Sherlock, Jr.*, the question of who stole the pocket watch has been answered. But in this movie, facts alone are not enough to sate the imagination. As Le Bon had written nearly thirty years earlier, indoctrinating the masses requires a "startling image, which fills and besets the mind."

In Keaton's vision, such images have come to dominate American cultural experience, providing seductive if improbable models for the reconstruction of personal life. The Boy only gains self-esteem when he is able to imagine himself as the world-famous detective he dreams of being. *Hearts and Pearls* offers this opportunity. Boyhood fantasy and movie magic become inextricably intertwined. People can transcend the objective limits of their lives, Keaton suggests, but only if they give themselves over to the principle of life's becoming a movie.

The final scene, in which The Boy and The Girl are reunited, offers a critical reflection on what is gained and what is lost in the bargain. The Boy repeatedly attempts to be a masterful lover, looking out from the projection booth onto the screen for his cues. At the end of the scene, however, the distance between movies and real life reasserts itself. If The Boy and The Girl are to find true love, they will have to rely on the resources of their lives.

Sherlock, Jr. is an inventive tribute to the deep-seated place that movies had gained in the public imagination by 1924. Its plot revolves around this fact, and explores the ways that commercial culture provided audiences and consumers with promises of personal change that defied the notion that people were defined by a fixed identity. At the same time, Keaton concluded with the discrepancy between movie fantasy and lived experience and maintained that it is only in the arena of everyday life that meaningful happiness can be achieved.

Not all would agree. The modern phenomenon of celebrity, which took flight in the 1920s, offered an alternative interpretation. Intimately connected with the expanding firmament of stardom, were a publicity machine and fan magazines that told ostensibly real-life tales of people who had been snatched from the predicament of anonymity and transformed into faces recognized by millions. The ability to transcend type, and become someone new and envied, was taking hold as a common American mythology.

The historian Robert Sklar's description of "the movie star" helps to explain why such tales of before and after resonated with so many people. "Acting abil-

ity, traditionally defined, did not indicate star potential. Previous experience or training did not necessarily play a part," in the rise to stardom.[10] The formula for 427 screen success was ineffable and, as such, it became an easily absorbed ambition in a mass society where being seen and being known were emerging as the most important marks of achievement.

In 1924, the same year that *Sherlock, Jr.* appeared, a survey of adolescent girls revealed the extent to which the phantom of Hollywood acclaim had begun to penetrate their life goals and reveries. "Many times have I had dreams of having the world at my feet," reported one respondent. "I have dreamed of . . . charming millions, winning fame and fortune," indicated another. One imagined, "I was before a large audience. . . . It was a great success." A kindred spirit offered a similar fantasy: "The whole world applauded me."[11]

These were not only imaginings. In the years following the First World War, thousands of young people, most without acting experience, migrated to Hollywood with the hope of achieving stardom. Young women, in particular, made the move, partly to assert their newly gained independence, but more importantly to be discovered. As Sklar writes, "[W]hat the women wanted was to be actresses. They could see that other girls, many still in their teens, without acting experience, were making it. Why not they?"[12]

Clara Gordon Bow was one of these girls. Born destitute in Brooklyn in 1905, she was rejected by her family and was a shy and insecure child. Clara went to the movies for escape and spent hours imitating her favorite actresses in front of the mirror, assembling herself into an image. With carefully practiced poses in hand, she, like many other young women, started entering beauty and film contests, often sponsored by fanzines, with the hope of making it. In 1921, at the age of sixteen, she won The Fame and Fortune Contest and was soon catapulted from a self-doubting street urchin to one of Hollywood's most unforgettable sex symbols, the "It Girl," as she would become known.[13] For every Clara Bow, of course, there were countless others who rode the coattails of this fantasy without success. But the fantasy endured, and continues to endure, as one of America's most characteristic visions of personal change.

Fantastic metamorphoses, like those presented by DeMille and Keaton, occupied a realm of enchantment. Much like advertisements that argued that a bottle of Listerine could enhance your life forever, or that a stick of gum would allow you to "chew your little troubles away," dreamlike film narratives were like magic potions. The promises they offered could not be actualized in the lives of the moviegoing public.

Occasionally, however, a tale of before and after rang true to a significant sector of the audience: immigrants and the American-born children of immigrants. When these greenhorns arrived at Ellis Island and stepped on American soil, they were immediately targeted by the Aryan wrath of the eugenics movement. They were defamed for allegedly polluting America's Nordic heritage. Yet the years of the most intense migration also witnessed the birth of motion pictures, and these very people were also among the cinema's first audiences. They flocked to the movies, embracing cinema as one of the few accessible components of the new world they had entered. Sitting in darkened theaters, they were inspired by images on movie screens and lured by the prospect of becoming "Americans."

Much to the chagrin of old-line Anglo-America, movies and other forms of mass entertainment became a primary lubricant for the Americanization of immigrants. Attracted to the bright lights of popular entertainment, many recent arrivals, particularly the young ones, sought to imitate American styles and American ways with a vengeance. Concurrently, the flamboyant new entertainment industry, feeling its oats from the early twentieth century onward, was one of the few arenas that invited immigrants to enter its ranks and help shape the contours of modern American popular culture. One of the most noteworthy examples of this was Al Jolson.

Born in Lithuania in 1886, Asa Yoelson came to America with his family within a decade. His father was a cantor, the honored singer of prayers and chants in Jewish synagogues. As a teenager, Asa was performing, not in synagogues, but in burlesque houses and on the vaudeville stage. Here he became Al Jolson, and soon he emerged as a wildly popular entertainer, known for his lilting renditions of ballads and ragtime songs. In 1909, Jolson joined Lew Dockstader's Minstrels, a group that had first been formed in the 1880s and that, by the early 1900s, was one of America's few remaining large-scale minstrel troupes. Here, for the first time, Jolson appeared in blackface, shortly to become a trademark of his career.

With Dockstader, Jolson was a showstopping soloist, less a buffoon and more of a modern crooner, whose chemistry with an audience became legend. From here, Jolson moved to Broadway where his fame as America's foremost popular vocalist soared.

By 1918, he was sharing the stage with Enrico Caruso, the most famous operatic tenor of his time. As his career went through the roof, his sense of self was becoming grandiose. Mounting the stage right after Caruso had performed, Jolson told his audience, "You ain't heard nothing yet," a line that

would soon be immortalized in a movie called *The Jazz Singer*. The son of parents whose sense of identity remained in the old country, and in an insular Jewish community, Al Jolson cast off his roots to become, in his own words, "the world's greatest entertainer."

This status was underlined in 1927, when he starred in *The Jazz Singer*. Considered by many to be the first "talking picture," most of the film is still a silent-screen melodrama, with titles inserted in lieu of spoken words. Sound sequences were reserved, almost exclusively, for Jolson's singing performances. Today, the movie is often reviled for its objectionable use of blackface, but the story was, at its core, a chronicle of the transformation from immigrant to American. In many ways, it was Jolson's story.

The Jazz Singer was based on a 1921 short story (later a stage play) by Sampson Raphaelson, "The Day of Atonement." In the film, Jolson played the part of a young singer who, against the wishes of his father, Cantor Rabinowitz—played by the Swedish-born actor, Warner Oland—abandons his family's multigenerational musical commitment to the ritual chants the synagogue to become a ragtime entertainer.

The film opens in the ghetto of New York, "throbbing to that rhythm of music which is older than civilization." In a montage of scenes, the audience is introduced to the immigrant world of the Lower East Side: men attending synagogue, pushcarts lining streets, children riding a transportable merry-go-round. But most of all, it is a world of dense crowds, where individuals blend into a mass.

The scene then moves to the old-world home of the cantor and his wife Sara, the parents of young Jakie Rabinowitz. Adding to the visual evidence already seen—his long beard and the rabbinical skull cap that he wears—a title inserts that the cantor is a man who "stubbornly held to the ancient traditions of his race." Without a second thought, he assumes that his son will be the next in an unbroken, five-generation line of Cantor Rabinowitzes. More attuned to the temptations of the world that surrounds their parochial existence, Sara plaintively responds, "Maybe our boy doesn't want to be a Cantor, Papa." While the father cannot imagine anything else, Jakie's mother already seems to be aware of her son's rebellious American ambitions.

The film then carries the audience to a saloon, replete with hard-drinking men and painted ladies, where (in the first sound sequence) an adolescent "Ragtime Jakie's" ambitions are being realized as he joyously sings a jazzy rendition of "My Gal Sal," accompanied by a honky-tonk piano player. The youngster is in seventh heaven, belting out popular songs to an enthusiastic gathering.

Unfortunately, his transgression is discovered by a member of Cantor Rabinowitz's synagogue, Moishe Yudleson, who, horrified, runs off to inform on the boy.

Cantor Rabinowitz is furious at his son, dragging him out of the saloon by his collar and home for a beating. For Jakie, this is the last straw. His mother, distraught by her husband's unyielding tyranny, fears she will lose her son. Her fears are soon realized. That night—as his father sings "Kol Nidre" at Yom Kippur services and his mother, sitting among the women, weeps—Jakie runs away from home, stopping momentarily to pocket a photograph of his beloved mother.

In the next scene, years later, Jakie Rabinowitz has become Jack Robin, performing a tryout at Coffee Dan's in San Francisco. Standing before a combo made up of black and white musicians, he sings a sentimental ballad, "Dirty Hands, Dirty Face." For this number, the white musicians—a violinist and a pianist—predominate. To the audience's applause, he responds, in the middle of this sound sequence, "Wait a minute. Wait a minute. You ain't heard nothin' yet," reprising the old line for posterity.

Here he shifts from a Victorian ballad into a rousing jazz number, "Toot, Toot, Tootsie." Highlighting his identity as a "jazz singer," the black musicians on stage are featured more actively for this hip, syncopated tune. In the wake of this number, the audience goes wild. Jack Robin has arrived.

His arrival comes in two forms: artistic and social. First, Jack has been recognized as a musical prodigy. Second, he has made his bones in the eyes of a mainstream, white public. This achievement is underlined by the flirtatious admiration of a gentile woman, the beautiful dancer Mary Dale. Jack has seen Mary on stage in the past and compliments her. Mary offers to help his career. A budding relationship between a cantor's errant son and a gorgeous symbol of American popular culture has begun.

The segments of the film that follow offer a back-and-forth between Jack's growing success and his parents' rigid adherence to what is presented, for the most part, as an archaic way of life. While Sara grieves for her son and laments that Jakie has taken up with a *shiksa*, Cantor Rabinowitz stubbornly maintains that he has no son. A title informs the audience that these people are out of tune with the modern, rapidly changing society that their son has enthusiastically joined. "For those whose faces are turned toward the past," the title reads, "the years roll by unheeded—their lives unchanged."

Jack's career moves full speed ahead, and after a stint in Chicago, he lands a part in a Broadway revue: *April Follies*, at the illustrious Winter Garden Theater. This is the dream of a lifetime and, in a series of titles with larger and

larger print he exclaims, "NEW YORK!," "BROADWAY!," "HOME!," and, good boy that he is, "MOTHER!" When he arrives at rehearsal, he discovers **431** that it was Mary who had arranged his being hired for the show, and a warm friendship starts to evolve into romantic love.

But things at home are complex and increasingly anguished. His first visit in New York is with his beloved mother. She grins with pride as Jack sings Irving Berlin's "Blue Skies," initially as a slow ballad and then—after telling Mama that he is going to move her to the Bronx, take her to Coney Island, and buy her a pink dress—lapses into a jazzy, ragtime version of the same song. She is unfazed by his rejection of the past, even as he tells her that he has changed his name.

The felicity is suddenly broken when Cantor Rabinowitz returns home. Hearing Jack's sacrilegious music being played on his sacred piano, he is livid with anger. "Stop!" he cries, in one of the few dialog scenes presented in sound. And then, in titles, "You dare to bring your jazz songs into my house. I taught you to sing the songs of Israel to take my place in the synagogue." Jack's response is an apostasy: "You're of the old world! If you were born here, you'd feel the same as I do. Tradition is all right but this is another day! I'll live my life as I see fit." Once again feeling betrayed, the father rejects the son. "Leave my house! I never want to see you again—you jazz singer!"

Jack returns to Broadway and to rehearsals for his soon-to-open show. He is once again happy in this setting. Yet, his release from the imperatives and pains of family is short lived. "Grief, stalking the world, has paused at the house of Rabinowitz."

With Yom Kippur approaching, the Cantor has fallen deathly ill. Yudleson arrives at the theater and, pushing his way through the backstage door, implores Jack to come to his father's bedside. He also pleads with Jack to step in for the dying Cantor and sing "Kol Nidre" for Yom Kippur, the Day of Atonement. Rejecting an appeal laced with disapproval of Jack's secular milieu, Yudleson asks, "Would you be the first Rabinowitz in five generations to fail your God?" Jack comes back at him, "We in the show business have our own religion, too—on every day, the show must go on!"

Cantor Rabinowitz's condition worsens and, in his delirium, he dreams of Jakie singing "Kol Nidre." When Sarah hears this, she—Yudleson in tow—makes her own journey to the Winter Garden. Before she arrives, we see a deeply torn Jack, sitting in his dressing room before a final dress rehearsal, reassuring Mary of his unwavering commitment to the show's going on. But she senses his torment, saying that she can see from his face that he is worried about his father. As Jack casu-

432

ally smears on blackface makeup and dons a nappy wig—the first time he appears this way in the film—he responds in a title: "I'd love to sing for my people—but I belong here—but there's something, after all, in my heart—maybe it's the call of the ages—the cry of my race." Gazing painfully into mirror in blackface, Jack finds his reflection giving way to a vision of his father singing in the synagogue. Perhaps this is an unconscious acknowledgment that his old-world Jewish father and the black man that Jack blithely mimics on the stage occupy analogous positions at the outer margins of white America.

When his mother and Yudleson arrive at the dressing room, they do not recognize Jack. "He talks like Jakie," Yudleson says, "but he looks like his shadow." (The original shooting script reads, "It talks like Jakie but it looks like a nigger.") Once his mother realizes that it is Jack, and not a black man, whom she sees, she commences to put a full-court press on her guilt-ridden son. Divided between two worlds—the old one of his ancient "race," and the new one of America—Jack reluctantly makes his choice. He takes the stage and sings a syrupy Victorian lyric entitled, "Mother of Mine."

Listening from the wings, his tearful but understanding mother is overwhelmed by the beauty of his song. Having seen the light, she blesses his conversion from Jew to American, from Jakie Rabinowtiz to Jack Robin. "Here he belongs," she says. "If God wanted him in His house, he would have kept him there. He's not my boy anymore—he belongs to the whole world now."

But Jack's Americanization cannot be morally justified until he makes peace with his dying father and bids a respectful farewell to his roots. Following the dress rehearsal, he rushes home, where he and his father have a loving bedside reconciliation. Mary and the producer of *April Follies* arrive at the Rabinowtiz home to convince a now ambivalent Jack that he must return to the theater for opening night. Mary reminds him that—using his own words—his "career came before everything."

Jack remains tormented by the unbearable choice he has before him: to give up the biggest chance of his life and "queer" his future on Broadway, or to break his mother's heart. In true Hollywood fashion, the agonizing dilemma resolves itself. The remarkably sympathetic producer cancels opening night and, as his father is in his death throes, Jack solemnly, and with a mournful tear in his voice, sings "Kol Nidre," wearing his father's cantorial robes. Listening to his son from the apartment that is perched over the tabernacle, the old Cantor utters his last words: "Mama, we have our son again."

In the next room, Mary and the producer also listen. Momentarily tran-

scending show-business dogma, Mary finally comprehends the ambiguous identity of her lover, the Americanized immigrant. "A jazz singer—singing to his 433 God," she tells the producer. The producer, moving beyond pecuniary interests, nods in agreement.

In the final scene, appearing in *April Follies*, which has now opened, Jack sings the most famous—for many, the most infamous—song in the film. Wearing minstrel regalia—blackface, accentuated lips, a nappy wig and white gloves—and adopting a faux-Negro dialect, he belts out a conventional, longing-for-the-old-plantation number. As his mother listens with delight from the first row, tears of joy in her eyes, Jack falls to his knees and croons:

> My little Mammy!
> My heart strings are tangled around, Alabamy.
> Mammy! I'm comin'
> I hope I didn't make you wait!
> Mammy! I'm comin'!
> Oh God, I hope I'm not late.
> Mammy! Don't ya know me?
> It's your little baby!
> I'd walk a million miles for one of your smiles!
> My Mammy!

With this stirring finale, the film ends. This routine, which Jolson had performed on stage for years, remained his signature number for the rest of his life.

Situated within the long history of typecasting, *The Jazz Singer* straddles a sagging fence. The closing scene and the matter-of-fact way that Jack Robin prepares to perform, by applying burnt cork to his face, were part of a century-old minstrel tradition that, in the face of mounting challenges to slavery and segregation, sought to reinforce the principle of white supremacy through the vehicle of popular entertainment. From early on, a close association with minstrelsy had propelled Al Jolson's career, and his reliance on a hackneyed blackface stereotype was inseparable from his stardom. Even in a changing world, where many other entertainers had dispensed with this device, he doggedly blackened up, as if unaware of the social injuries this guise had inflicted over the years.

Ironically, however, blackface was Jolson's ticket out of the ghetto and into the mainstream of American culture. Against a universe of fixed types, his story, and the story of the film, revealed the new possibility of emancipation from the vise-

434

like grip of typecasting, the potential for a person to escape the stigmata of a reviled "race" and become an accepted and admired member of the dominant culture.

This central aspect of *The Jazz Singer* echoed developments that were taking place beyond movie screens in the 1920s. By the beginning of the decade, more than half the population of the United States was made up of either immigrants or the children of immigrants. In spite of the anti-immigration law of 1923 and the eugenicists who had promoted it, the face of America had been irrevocably changed. Amid this reconfigured demography, even many old-line Americans began to explore strategies for "Americanizing" the foreign-born and their children. The burgeoning consumer culture, always in search of new markets, underwrote this transformation.

Jack Robin makes the ultimate journey from Jew to white American when he "blackens up," a prerogative historically reserved for whites playing minstrel roles. Forced to choose between two cultures, the old and the new, he expresses his anguish to his beautiful "shiksa" girlfriend, Mary. FROM THE BILLY ROSE COLLECTION, THE NEW YORK PUBLIC LIBRARY FOR THE PERFORMING ARTS, ASTOR, LENOX AND TILDEN FOUNDATIONS.

For young immigrants, or first generation Americans, much about the brave new world they inhabited made the prospect of shedding the burden of ethnicity enticing. In *The Jazz Singer*, the generational struggle between Jakie Rabinowitz and his father resonated with the lived experiences and conflicts of many.

Only a few years before the film appeared, Anglo-America had routinely vilified Jews, along with many other recent immigrants, as members of an unfit and distinctly alien race of people. In order to emphasize this otherness, Jews were typically categorized as "Orientals," separating them from the Caucasian standard of normalcy.

Tellingly, a Swedish-born actor, Warner Oland, was chosen to play Cantor Rabinowitz, the "stubborn" flag bearer for the "ancient traditions of his race." Though not Jewish, Oland, from the beginning of his film career, was repeatedly cast as Oriental characters, primarily Chinese. Aspects of his physiognomy, particularly his eyes, seemed to fit the bill. Though trained as a Shakespearean actor, he was typically typecast in ethnic roles. He would gain

fame as the evil Dr. Fu Manchu, and for a popular series of films, in which he played
the likable, if inscrutable, Chinese detective, Charlie Chan.

With Oland as Cantor Rabinowitz, the *The Jazz Singer* positioned this char-
acter within what, for white America, was a foreign and unfamiliar race. The
Cantor, along with Yudleson and members of the synagogue were stereotypical
Jews, not unlike those imagined by anti-Semites of the time. They looked differ-
ent, acted, and dressed differently from Anglo-Americans. Their countenances
spoke of apartness.

Sara Rabinowitz, on the other hand, was a different kind of generic charac-
ter, an adoring mother whose love of her son transcended the boundaries of the
familiar Jewish type. Played by the character actress Eugenie Besserer—not
known for playing ethnic types—Sara embodied the stereotype of doting moth-
erliness. Her understanding of her son's assimilationist ambitions, and her will-
ingness to support Jack's transformation from Jew to American, marked her as a
bridge between one identity and another.

This was a story about Jews beginning to become white, or nearly white, in a
society that had, to that time, fiercely rejected the idea. It is not disconnected
from stories of other immigrant groups—Irish, Italians, Slavs, and so on—slowly
passing through the threshold of difference into the fortunate sanctum of white
America. While few would achieve Jolson's spectacular success, more and more
former outsiders were beginning to gather under the umbrella of a more inclu-
sive definition of America.

Inclusion, however, still had severe racial limits. In many ways, this situation
was dramatized by the dressing-room episode, when Jack nonchalantly puts on
blackface makeup. It was at this moment, when Jack first blacked up—one of the
most objectionable scenes in the movie—that he took on a white rather than a Jew-
ish identity. Historically, minstrel entertainment was a prerogative of white
America. Behind its surface of humor lay often violent claims of white superior-
ity. When Jack—or Jolson—assumed this prerogative, he broke from the
marginal condition of his Hebrew lineage and embraced the status of being an
American white man, if only an assimilated one. This was the Faustian bargain
that faced many offspring of foreign parentage, people who were previously
defined as unacceptable. In order to truly become an American, one needed to
internalize the notions of racial inequality that had, for so long, been implicit to
the American heritage.

When, toward the end of the picture, Jack filled in for his dying father to sing
the "Kol Nidre," Mary's adoring reaction shed additional light on Jack's ontolog-
ical transformation. From the moment we met her, Mary was the quintessence

of old-line American self-confidence. She knew she belonged. An established performer, and a *shiksa*, she embodied all that Jack aspired to. Her growing and unconditional affection for him signaled a historic juncture when what, in the past, would have been seen as pollution of the native stock, had become less threatening. In an increasingly heterogeneous society, an Americanized Jew no longer belonged to another race. A different background perhaps; but it was the present and the romance that mattered most. There might be one last "Kol Nidre," a gesture of sentiment, but "Mammy" would continue to provide the foundation of Jack's, and Jolson's, repertoire. Above all, they were jazz singers in a "Jazz Age."

PERSISTENCE OF VISION

The Jazz Singer was a deeply ambiguous film. It unceremoniously upheld racial stereotypes but, at the same time, suggested the possibility of a breakout from frozen, inescapable types. Yet, if Hollywood, in the 1920s and 1930s, occasionally contested an essentialism that had guided ideas of human difference since the eighteenth century, old ways of seeing remained deeply entrenched. Fixed typecasting, and the use of conventional taxonomies, endured as prevailing elements in the formulaic movie genres that came to dominate and define the industry.

As if guided by the ghost of Cesare Lombroso, filmmakers habitually built, and continue to build, stories around identifiable criminal types or evil geniuses. Samuel Morton's *Crania Americana* was recharged by the western film genre, where voiceless and violent Indians waited, ominously, at the frontiers of civilization. To erase this threat, Griffith's night-riding Klan was reborn as the United States Cavalry, heroically participating in the mass slaughter of those whose inherent "nature"—as phrenologist George Combe had described it—meant that they preferred "extermination" rather than submission to European rule.

The sophistication of Anglo-American elites also became a staple in Hollywood films, where elegant dress, sumptuous surroundings, and the swift repartee of people who rarely seemed to need to work for a living became earmarks of the romantic comedy. As window dressing for this genre, black actors often appeared, but strictly as servants, fulfilling what racial scientists had long argued was the natural disposition of the "Ethiopian" race.

The persistence of stereotype can still be spotted in almost any American film, as well as in all other media forms—fiction and nonfiction. Archaic misrepresentations are not easily broken. As Walter Lippmann observed, "any disturbance of" deeply ingrained stereotypes constitutes, for most people, "an attack on the foundations of . . . [their] universe." If stereotyping endures, however, the overarching worldview that shaped these mental categories is rarely visible.

This invisibility is characteristic of the way that stereotypes most often appear. While their evolution was inseparable from social and historical developments that forged the rise of a modern world system, they took on a life of their own in the emergence of a modern mass culture. They served the requirements of media formulas that sought to

avoid the burdens of complex character development in favor of trouble-free indicators of good and evil. In the process, they were, and are, routinely separated from their moorings in history, becoming floating signifiers that can easily be applied to serve any given objective.

Occasionally, however, disembodied symbols and their past history are reunited. One of the most popular productions of Hollywood's Golden Age provides an arresting example of this situation. In Merian C. Cooper and Ernest B. Schoedsack's 1933 blockbuster, *King Kong*, the racial and sexual mythologies of Western civilization were seamlessly merged with the systematic ranking of human types intrinsic to the story line.

Cooper and Schoedsack were well groomed for the task. Cooper had been a globetrotting adventurer, drawn to danger. In 1916, as a member of the Georgia National Guard, he ventured to Mexico to fight the revolutionary army of Pancho Villa. After the Russian Revolution, he was a captain and pilot in an American brigade that went to fight the Bolsheviks in 1919 and was shot down and spent nine months in a Soviet prison. Schoedsack, a former cameraman for Mack Sennett, became an Army photographer in the First World War and then went to Eastern Europe to fight Bolshevism as well. In 1920, in the Ukraine, Schoedsack met Cooper, and they commenced a long friendship and collaboration. They began working together as documentary filmmakers, specializing in films about exotic peoples. Their first film, *Grass* (1925), was shot in Persia and told the story of a primitive tribe and its dangerous semiannual trek, bringing their herds to and from pastureland. Their second film was a fictional narrative posing as a documentary. *Chang: A Drama of the Wilderness*, focused on a primitive but courageous Laotian tribesman, Kru, and his family. Shot in a remote Siamese jungle inhabited by leopards, tigers, and a fearsome—mythical—herd of elephants known as "Chang," the story of Kru was totally scripted and conveyed the tale of a brave and simple man's conquest over the beasts of the jungle. While Kru's children in the film were his own, his wife was played by the wife of a friend, whom Cooper and Shoedsack deemed more comely than Kru's actual wife. Leopards and tigers were captured in traps for the movie and forced to fulfill their "malevolent" roles in the script. Several were killed on camera. Kru and his fellow tribesmen were given rifles and were then directed to dispense with the ostensibly marauding cats, but given the Laotian's taboo against killing tigers, the cats were executed by Merian Cooper off camera, though the slayings would be attributed to the tribesmen. The mythical elephants were rented for thirty thousand dollars from the private herd of the King of Siam.

Self-styled adventurers, Cooper and Schoedsack had Eurocentric ethnography in their blood. In *Chang*, the idea of the jungle provided fertile soil for highly manipulated dramas. The commercial success of these two "documentaries," and their explicitly fictional film, *The Most Dangerous Game* (1932), only underwrote this conviction.

King Kong was the definitive jungle-adventure movie. Its genealogy reached back to the early written accounts of colonial voyagers that provided an allegedly factual basis for the field of natural history. One of these was the French-American adventurer Paul Belloni Du Chaillu's *Explorations and Adventures in Equatorial Africa*. Among other topics, this 1861 book paid detailed attention to the "king of the African forest," a large male gorilla that Du Chaillu encountered, and killed, in the Sierra del Crystal mountains in Gabon, on the west coast of Africa. Du Chaillu is believed to be the first white man to see an African gorilla, as well as numerous other species, and when he returned to the United States from the expedition that led to the book, he brought countless stuffed birds and quadrupeds that he had killed during his travels. The gorillas he brought with him were the first to be displayed in the United States and England.

Along with descriptions of his observations, Du Chaillu's book included some African folklore about gorillas. Characterizing the large ape as a "hellish dream creature—of that hideous order, half-man, half-beast," Du Chaillu wrote of gorillas' reported penchant for running off with women and of ravishing them.[1]

By the late nineteenth century, English fiction writers were transforming the assumptions of natural history into the groundwork for a new imperialist literature, which included novels and poetry. One of the first to gain fame was H. Rider Haggard, whose *King Soloman's Mines* (1885), *She* (1887), and subsequent novels presented intrepid European travelers entering into Africa, or other "primitive" regions, and encountering fierce but ultimately submissive natives whose natural inferiority to whites was an ongoing theme. In *She*, a primitive African tribe, the Amahagger, serve "She-Who-Must-Be-Obeyed" in fear and awe. "She" is the immortal, all-powerful, golden-haired Queen Ayesha, "a tall and lovely" white woman. "Instinct with beauty in every part, and also with a certain snake-like grace."

Another of these writers was Haggard's close friend, Rudyard Kipling, who applied similar assumptions to stories of India, a land filled with both noble and base savages, which required British rule. In an 1899 poem, encouraging the United States to embrace the mantle of colonialism, Kipling coined the phrase, "The White Man's Burden." It was the inescapable duty of whites conquerors, he wrote, to rule over their "new-caught, sullen peoples, Half devil and half child," in order to "serve . . . [their] captives' needs."[2]

AS A BOY, MERIAN COOPER was deeply influnced by Paul B. Chaillu's 1861 book, *Explorations & Adventures in Equatorial Africa*, which left a profound mark on his imagination. Du Chaillu's was the quintessential tale of the "Great White Hunter," told by himself, in which domination of human and animal wilds were recounted with great drama. In the engraving from the book, right, Du Chaillu assumes a relaxed pose as he casually he observes an exorcism. His adventures inspired Cooper's personal journey as a self-styled adventurer and as a filmmaker. Du Chaillu's book was filled with fabulous and vivid misinformation, including ostensible sightings of Troglodytes and other European "observations" seen in descriptions of Africa going back for centuries.

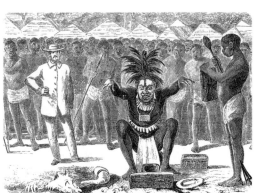

Of particular interest to Du Chaillu was the Gorilla (left, from his book), which he annointed the true king of the jungle. Some natives, he related, believed that certain gorillas contained "spirits of departed negroes."

One local account told of a gorilla abducting "two Mbondemo women." While one of the two escaped, the gorilla was said to have taken liberties with the other, before she was able to flee.

There were also tales of gorillas routing and killing natives warriors, imprisoning others. When the gorillas finally released their prisoners, "the nails of their fingers and toes…[were] torn off by their captors."

Tales like these entered American folklore, largely as a result of being translated and transformed for the screen in Cooper and Schoedsack's 1933 blockbuster, *King Kong*.

Archie Bishop 2006 THE GORILLA. FRONTISPIECE.

King Kong took this oft-repeated assumption, in which white civilization, equipped with superior technologies, travels through time and space to discover and then dominate the vestiges of primitive life, and brought it spectacularly to the screen. Interestingly, Peter Jackson's 2005 remake of the film, accentuates this mythology by including "natives" who are far more primordial, menacing, and atavistic then those seen in the original. In a world in which racial stereotyping has come increasingly under attack, Jackson's horrific portrayal of dusky "natives" is astonishing.

The original movie's outlook was shaped by Cooper's personal history and literary influences. Scion of a multigenerational family of cotton planters, he was raised on his father's stories of the Confederacy, and he embraced white Southern preconceptions about blacks' innate inferiority. As a youth he had also been deeply affected by the writings of Du Chaillu, Haggard, and Kipling.3 His reading of Du Chaillu, he told one interviewer, had set him on his life's path. "I made up my mind right then," he stated, "that I wanted to be an explorer."4

The film, paying tribute to Hollywood's already Promethean sway over the public imagination, tells the story of a daring, if reckless, documentary filmmaker, Carl Denham, a man with an established reputation for filming a menagerie of exotic dangers in the wild. The character appears to have been based, in large part, on Merian Cooper.

As the film opens, Denham is planning his ultimate voyage: a visit to a mysterious locale, beyond the charted world and occupied by something so strange and perilous that he will not even let his crew in on its secret. To insure that his new film will do well at the box office, Denham decides—even against his own best judgment—to pander to public tastes and bring "a pretty face" along for the ride, in order to insert a "love interest" into the story. Given his reputation, however, he has been unable to find an agent willing to put an actress in such peril.

Desperately, he follows a path blazed by other filmmakers, trolling the streets of New York, mired in the Great Depres-

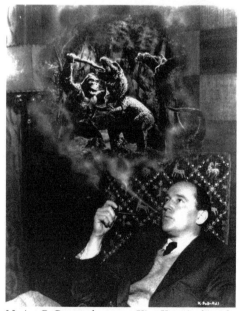

Merian C. Cooper dreams up King Kong in this publicity still. KING KONG © RKO PICTURES, INC. LICENSED BY WARNER BROS. ENTERTAINMENT INC. ALL RIGHTS RESERVED.

442

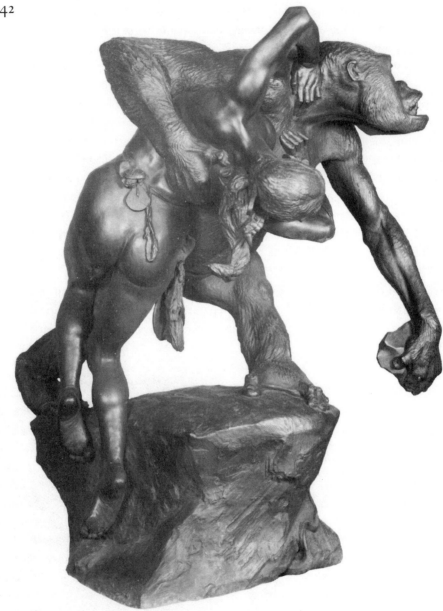

This sculpture was part of a bronze group at the entry of the Hall of Man at the American Museum of Natural History. As eugenicists entered for the Second International Eugenics Congress, this figure—claiming to be a document of scientific fact—greeted them. Quite a show! FROM THE COLLECTION OF THE AMERICAN MUSEUM OF NATURAL HISTORY

sion, looking for the right type. At a fruit stand, he sees a tattered and hungry girl— Ann Darrow, played by the legendary Fay Wray—stealing a piece of fruit. As the 443 irate vendor threatens to call the cops, Denham steps in. He pays for the fruit, and then, when he examines his famished quarry, he immediately notices that, in spite of her ragged condition, this striking blonde is the girl that he wants.

Taking Ann out for a much-needed meal, and assuring her that his intentions are honorable, Denham offers her a job that will lead to "money and adventure and fame. It's a thrill of a lifetime," he adds, "and a long sea voyage that starts at six o'clock tomorrow morning." True to type and fully submissive, Ann complies, placing her future in Denham's hands. This vision of the helpless, but good-hearted, beauty, incapable of survival without male protection, strides the span of centuries and characterizes Ann Darrow throughout the film.

Shortly, the film moves to the high seas, to the edge of unexplored regions. Aboard the S. S. *Venture*, Denham begins to disclose the objective of the expedition. Unfolding an old map he had gotten from a Norwegian skipper in Singapore, he shows it to the ship's captain and first mate. Denham explains that this is a hand-drawn chart of Skull Island, a miraculous place where, according to legend, there lives a primordial and horrific creature "that no white man has ever seen." This monster, he continues, is the lord of the island, ruling over two domains. One is a prehistoric wilderness, where he lives and where no humans are found. The second is located on the other side of a giant wall that traverses

Left to right: *King Kong* movie poster (Italian); WWI Brute Poster; *The Day the Earth Stood Still* movie poster.

the island. Here lives a primitive, dark-skinned tribe that worships the fearsome Kong, as the legendary monster is known.

In describing the wall as a miraculous feat of engineering, Denham echoes an argument made by Blumenbach, Cuvier, Morton, and others to explain the advanced civilizations of ancient Egypt, the Near East, and India. Racial scientists insisted that only white people were capable of building such marvels, and, therefore, they included the peoples of North Africa, the Fertile Crescent, and western India among the Caucasian race. Denham explains the existence of the wall in similar terms. While the present natives of the island live in its shadow, they do not possess the refined intelligence that would have been required to build it. Recalling the mythic tales of racial degeneration, he declares that it was "built so long ago that the people who live there have slipped back, forgotten the higher civilization that built it."

As the voyage proceeds toward its murky destination, and those aboard nervously await the unknown, the ship becomes a small universe of clichés. Asserting male dominance through his role as director, Denham gives Ann Darrow, his acquiescent ingénue, an onboard screen test. Wearing a diaphanously revealing costume, Ann is commanded to emulate the terror and defenselessness she would experience in the face of the island's horrific potentate. Cranking his camera, Denham barks his orders.

Look up slowly, Ann. That's it. You don't see anything. Now look higher. Still higher. Now you see it. You're amazed. You can't believe it. Your eyes open wider. It's horrible, Ann, but you can't look away. There's no chance for you, Ann. No escape. You're helpless, Ann, helpless. There's just one chance, if you can scream. But your throat's paralyzed. Try to scream, Ann. Try. Perhaps if you didn't see it, you could scream. Throw your arms across your eyes and scream, Ann, scream for your life!

Against this standard rendition of female vulnerability are stereotypes of sturdy and purposeful white men, annoyed that their masculine realm has been encroached upon by a woman. Most outspoken in this direction is Jack Driscoll, "tough guy" and first mate. Though concerned for Ann's safety, he associates women with "trouble," telling her "This is no place for a girl. You're all right, but . . . women, women just can't help being a bother. Made that way, I guess."

Beneath this vociferous chauvinism, however, Driscoll shares Adam's fatal weakness for the female sex and begins to fall for Ann. To an observant Denham, who has obviously read his Genesis, a weakness for women will inevitably

lead to the downfall of man. As he witnesses Driscoll's growing ambivalence, Denham insults the first mate's masculinity. "You have gone soft on her?" he asks 445 rhetorically. "I've never known it to fail: some big, hard-boiled egg gets a look at a pretty face and bang, he cracks up and goes sappy."

Against this slur, Driscoll defends his manhood. "You think I'm going to fall for any dame?" he scoffs. To underscore the hypermasculinity that typifies Denham's Caucasian crew, there is a sexless and laughable Chinese cook on board, Charlie, babbling away in broken English as he peels potatoes: kitchen work. He is dressed in a familiar coolie costume, as is his little pet monkey who hops around playfully.

The topographies of race and gender gain momentum as the stalwart voyagers, Ann Darrow in tow, disembark on Skull Island. Looking upon the giant wall, the Captain reiterates Denham's thoughts about its origins, noting, "It might almost be Egyptian." Furtively, they witness the island's dusky inhabitants partaking in a frenzied festival of worship to their god, Kong. Though Skull Island is ostensibly located in the Indian Ocean, "way west of Sumatra," its natives are clearly modeled after trite visions of Africa, "the dark continent," and are played, primarily, by African-American extras.

Notably, America's first major black movie actor, Noble Johnson, assumed the role of tribal chief. While reduced in the picture to a grunting, animalistic savage, Johnson was in fact the founder, in 1916, of the Lincoln Motion Picture Company. It was the first black-owned film studio in the United States, and there he produced stories of black life that were designed to emphasize the dignity of their characters and counteract common stereotypes. Ironically, to support these productions, Johnson appeared in many Hollywood films, where he was repeatedly expected to play racist renditions of Negro servants, African natives, wild Indians, or barbaric Arabs and Hindus. When his company closed down in 1921, he continued to play compromising parts—the only roles open to him and other black actors—one of which was a black devil in a 1924 film version of Dante's *Inferno*, viciously whipping a bound and naked white woman.

The only other credited native was the "Witch Chief," played by a Mexican-born actor, Esteban "Steve" Clemente (or Steve Clemento, as he appears in the credits). Like Johnson's, Clemente's career was defined by one perfidious racial stereotype after another. The great Jim Thorpe, an American Indian who gained fame for his prodigious athletic achievements, was an uncredited native dancer in the film.

Along with Johnson, Clemente, and Thorpe, whose relatively light complexions were blackened for their parts, other revelers are dressed as gorillas, reasserting the timeworn European hypothesis that Africans were missing links, occupying a middle ground between apes and humans. Others have bone-like

motifs painted on their faces, a central fixture of the cannibal stereotype. Adding to the combination of devil and child, all wear ridiculous fright wigs, borrowed from the wardrobe of minstrelsy. Highlighting their uncivilized primitivism, the tribe is about to offer a young maiden to become Kong's "bride." A jungle beat, familiar to any filmgoer, fills the air, part of a powerful, plot-driving score by composer Max Steiner.

When Denham jumps out of hiding to film the spectacle, the island chief sees the white man and immediately halts the ceremony. Threateningly, he and a coterie of witch doctors move toward the interlopers. Then, suddenly, the chief notices Ann and is bowled over by the beauty of "the golden woman." Speaking mumbo-jumbo with the Captain—who turns out to be quite the linguist—the chief demands that Ann be sold to him, in exchange for six women of his tribe.

This episode is one more rehash of the subhuman black man coveting a blond white woman. It is the same mythology that underpinned lynch law, and the macho Denham seems unfazed, caustically remarking, "Yeah, blondes are scarce around here." Holding off the natives with rifles, Denham and his party return to the ship, awaiting a time when they will be able to land again and resume making their film.

Back on board, with no male protection nearby, Ann stands on the deck, dreamily swooning over Jack, who has just revealed his feelings for her. Meanwhile, in the dark waters below, a native's canoe has stealthily pulled up alongside the ship. With Ann's back against the railing, she is snatched, kidnapped by two of the island's inhabitants.

The next time we see her, her arms are splayed amid a torchlight ceremony. Black men dance menacingly above her. Her eyes are filled with terror. The drumbeat intensifies as she is prepared to become the ultimate offering to Kong. Following a customary ritual, the natives open a giant gate in the ancient wall that protects and separates them from Kong's kingdom. With Ann fruitlessly struggling, men drag her toward a sacrificial altar and bind her arms to carved posts topped by human skulls. A blonde captive, in the lust-driven hands of a dark and barbaric people, awaits a dreadful fate that preoccupies the deep unconscious of Western Civilization: the ravishing of a white woman by a hulking black monstrosity.

The natives retreat to their side of the wall, closing the gate behind them. Soon, they summon their god with an enormous gong and wait above the wall to watch their tribute being taken. Then, with thunderous roars, Kong approaches the sacrificial altar. A gargantuan black ape, he is obviously the king of this jungle. At the sight of his golden trophy, he beats his massive chest.

With Ann ineffectively struggling to free herself, Kong effortlessly takes her. He is plainly smitten by her pure white beauty and holds her gently in his enormous hand. This scene, and much of what follows, reiterates a basic tenet in the folklore of racism that evolved as a indispensable component of colonial conquest.

When white Europeans first explored Africa, they brought back fantastic tales of male apes' insatiable desire for human females. Accounts of African women being carried off by oversexed apes abounded among Europe's gentleman travelers, but alongside these circulated a far more appalling story that asserted apes' special craving for fair-haired white women. Given a perceived kinship between Africans and apes that possessed the inventors of natural history, King Kong stands as a spectacular, twentieth-century monument to the doctrines of racial science. Novel film technologies—stop action animation, rear projection, supplied by the special pioneer, Willis H. O'Brien, and the groundbreaking sound design of Murray Spivak—added an unprecedented vividness to entrenched European preconceptions.

Reinforcing a fixation of Western culture the dark and menacing natives of Skull Island prepare their golden-haired prize for the ultimate sacrifice.

When Ann's abduction is discovered, Denham, Driscoll, and the captain round up a well-armed landing party and head to the island to rescue Ann. Easily subduing the natives with a few gunshots, they open the gate and, leaving the captain and some sailors behind to safeguard an escape route, they enter Kong's world.

As the rescue crew follows the giant ape's footsteps, Kong carries Ann deeper and deeper into his primal realm. This is a place where time has stopped and where modernity encounters its primordial past. As Kong fights off a parade of prehistoric monsters, mostly dinosaurs, his ferocious dominance is vividly demonstrated. Yet, with Ann, he is protective and possessive, what Kipling would call a childlike devil. Coddling her in his hand, he playfully tears off her dress to get a better look at her beguiling form, then sniffs his fingers to breathe in the pleasure of her scent. In spite of his soft spot for her, she remains a terrified captive.

In its quest, the rescue party makes its way into the "heart of darkness," a world these white men do not control. They successfully kill a stegosaurus with a gas bomb and bullets, but the worst is yet to come. One by one, they fall prey to the primordial evils of this vast jungle. The first to die are eaten by dinosaurs, and, then, the last of the crew is easily dispensed with, shaken off a log into a ravine below, by a furious Kong.

In the wake of the carnage, only Denham and Driscoll survive. Denham heads back to the ship to gather more gas bombs and reinforcements. Alone in the jungle, Jack Driscoll, the archetype of Aryan manhood, pits the intelligence and courage of his race against the brute force of a formidable adversary. Hiding behind a rock, he awaits opportunity, and, in short order, wit wins out. When Kong puts down Ann to do battle with a pterodactyl—a flying dinosaur—Jack steals forward to rescue the damsel. In a bold feat, with Ann clinging to his back, he escapes the grasp of the predator.

With Kong on their heels, Jack and Ann finally reach the gate. With Jack carrying Ann limply in his arms, they pass through. The gate is secured behind them. By this time in the film, the once-ferocious natives have discovered their innate subservience and willingly assist the voyagers in fortifying the wall. As Kong reaches the closed gate and pushes to break through, tribal men vainly struggle to keep it shut.

Ann and Jack are only thinking about getting back on ship. Denham, true to his reputation, is only thinking box office. "We came here to get a moving picture," he muses, "and we found something worth more than all the movies in the world." If they can bring Kong back home alive, he reasons, "the whole world will pay to see this." Ignoring Driscoll's protests, Denham is triumphant.

As Kong breaks through the wall, chomping on some natives and squishing them under his enormous feet, other members of the tribe scream wildly, with hair 449 standing on end. But, as Kong moves forward, the superior technology of the West awaits him on the beach. A single gas bomb fells the beast, and the next thing we know, he is sailing for Broadway.

The narrative then shifts to New York City and the civilized world. The lights above a theater announce "KING KONG EIGHTH WONDER OF THE WORLD," while, inside, excited audience members speculate about the unknown show they

The persistence of such visions runs deep and sometimes turns up in unanticipated places. In 1975 Muhammad Ali, one of the twentieth century's most potent symbols against the persistence of racial barriers, offered a powerful case in point. Though he fought against racial stereo-types all of his life, the public hype he delivered for the "Thrilla in Manila," his third and most grueling ring battle against Joe Frazier, Ali continually employed clichéd racial taunts against his foe. Frazier was "so ugly," Ali proclaimed, he "should give his face to the Wildlife Fund!" "What will the People in Manila think? We can't have a gorilla for a champ. They're gonna think, lookin' at him, that all black brothers are animals. Ignorant. Stupid. Ugly. If he's champ again, other nations will laugh at us." QUOTATIONS FROM MARK KRAM, *GHOSTS OF MANILA*

are about to see. Soon, Denham walks out in front of a closed curtain and, with considerable hype, prepares his audience for astonishment.

> I'm going to show you the greatest thing your eyes have ever beheld. He was a king and a god in the world he knew, but now he comes to civilization, merely a captive on show to gratify your curiosity. Ladies and gentle, look at Kong—the Eighth Wonder of the World!

As the curtain opens, the fearsome Kong is chained to a crucifix on a platform. He is a freak on display in the tradition of Saartjie Baartmann, Ota Benga, and a parade of others who, for more than a century, had been commercially exploited to vindicate the racial conceits of Western society.

All is well until Ann walks on stage. Provoked by the sight of his object of desire, and enraged by the threatening flashbulbs of photographers, a reinvigorated Kong easily breaks through his "chrome steel" shackles. As Ann slips away under Driscoll's protection, the emancipated ape embarks on a devastating rampage through the streets of New York, derailing trains, crushing cars, and stomping people like ants. Like Le Bon's crowd, Kong is driven by the spinal cord, and by his passions. His instincts carry him to the window of a hotel room where Ann and Driscoll have taken refuge. Knocking Driscoll unconscious, Kong again holds Ann in his giant grip.

The urban jungle, however, is unfamiliar to Kong. Seeking a mountain where he can take refuge, he begins to climb the newly constructed Empire State Building—in 1933 the world's foremost testament to the genius of modern engineering. Here, atop the edifice of empire, Kong meets his fate. His hunger for the golden beauty, and for a safe perch where he can possess her, leads him toward a sky-high Waterloo. Standing on the top of the world's tallest building, the once mighty Kong has become a sitting duck. Buzzed by airplanes armed with machine guns (Cooper and Schoedsack cast themselves as the pilots), he desperately swats at them but is no match for these modern machines. Placing Ann down on a ledge, he makes one last, pathetic stand before the bullets finally take their toll and he tumbles 102 stories to the pavement below. In a closing effort to continue shaping events, Denham stands over the fallen Kong and writes his epitaph. "It wasn't the airplanes," he declares, "It was beauty killed the beast." In fact, it was Cooper and Schoedsack.

In the film's 105-minute running time, a story that had been evolving over centuries was recited stunningly for a modern public. In *King Kong*, typecasting was once again unified with the global history that stood behind it. The supe-

riority of Western Civilization, the necessity of conquering the savage beast, the lust of dark brutes for fair women, and the heroic account of the white man's bur- den were combined with ancient assumptions about the proper place of male and female to present a comprehensive way of seeing.

King Kong is not simply a film. It is a set of ideas, a series of systematically arranged images that infused Western art, science, religion, and popular culture for centuries. They stood at the heart of the American eugenics movement. In the same year that the film came out, 1933, these ideas and images were reaching toxic levels on the global stage. It should be no surprise that *King Kong* was Adolph Hitler's favorite film, for its outlook and assumptions were part and parcel of the belief system that gave credence to German fascism.

Though the Nazis fell in 1945, the stereotypic system of the film endured, and it would take decades before it would be seriously challenged. In the United States, the debate only began in the 1960s and 1970s, but, even then, the world according to *King Kong* has never fully been displaced. In politics and popular culture, it continues to sell tickets.

29

TALES OF BEFORE AND AFTER

The panic that infuses the tale of *King Kong* cannot be separated from the tenor of its time. The year 1933 was the zenith of the Great Depression, and the perils of dislocation and disorder flooded the American imagination. In March 1933, when the film opened, the country was in the grip of social and economic pandemonium. Per capita income was about half what it had been before deluge, and more than a quarter of the population was out of work, with no relief in sight.

The initial collapse came like a tidal wave. In less than a week, in late October of 1929, an ostensibly buoyant capitalist economy went into free fall. A sell-off of stocks on October 24—Black Thursday—was at first dismissed by Wall Street as the unfortunate result of "technical" glitches in the market. Bankers and brokerage houses assured investors that the economy was essentially sound.

By the beginning of the following week, however, this optimism evaporated. Over a two-day period, October 28 and 29—Black Monday and Tuesday—the stock market lost 25 percent of its value. By the end of October, the market was worth 40 percent less than it had been in early September of that year, and, by 1932, it was down nearly 90 percent. The human cost of these statistics is immeasurable, and the market would not fully recover until the mid-1940s.

In the wake of the crash, President Herbert Hoover launched an effort to uncover the problems that had contributed to the breakdown. In December 1929, he impaneled a President's Research Committee on Social Trends, a group of prominent social scientists charged with the task of explaining the circumstances that had led the nation to this calamity.

Wesley C. Mitchell, professor of economics at Columbia University, a renowned expert on "business cycles" and a former student of Thorstein Veblen and John Dewey, chaired the committee. The Director of Research was Prof. William F. Ogburn, of the University of Chicago. One of the most influential sociologists of the twentieth century, Ogburn coined the term "social trends" and was the originator of the still germane concept of "cultural lag," which he explained was,

> The source of most modern social changes today is the material culture.
> The material-culture forces changes in other parts of culture such as social

453

454

organization and customs, but these latter parts of culture do not change as quickly. They lag behind the material-culture changes, hence we are living in a period of maladjustment.[1]

Mitchell and Ogburn, along with four others, including the feminist Alice Hamilton, the only woman on the committee, were all involved in the Progressive movement and concerned with the ways that social problems and flux might be scientifically addressed and improved.

On October 11, 1932, in Herbert Hoover's foreword to the Report of the President's Research Committee on Social Trends, he explained its goals: "Since the task assigned to the Committee was to inquire into changing trends, the result is emphasis on elements of instability rather than stability in the social structure."[2]

By the time the two-volume survey, *Recent Social Trends in the United States*, was published, Hoover's failed administration, which had done little to ameliorate conditions, was on its way out of office. Yet, the report of the Committee, a vivid snapshot of America in the 1920s, remains a fascinating look at a society that, even before 1929, was experiencing the spasms of transformation and upheaval. Revisiting *Recent Social Trends* today, it is hard to avoid the extent to which it remains relevant to understanding of the social contours and conflicts that mark American society in the early twenty-first century.

The scope of the two volumes is extraordinarily wide. Following a summary of findings, *Recent Social Trends* contains chapters dealing with, among other issues, the changing composition of the American population, the rise of new technologies and agencies of communication, and the growing conversion of Americans from producers to consumers. The rise of a youth-oriented culture, the emergence of new leisure-time activities, and changes in the "Family and Its Functions," were also appraised. While the purpose of the report was to collect pertinent data, many of these topics detailed a shifting social milieu that was shaping, and would continue to shape, the dynamics of typecasting in the twentieth century.

In the opening portion of the report, drafted by Ogburn, the committee reviewed some of its findings. Here, one of the issues addressed was "Problems of Biological Heritage," employing a language that had taken hold forty years earlier in discussions of "race suicide." While far more tentative than hardcore eugenics literature, the report documented questions posed by the committee regarding fit and less fit elements of the population. "[S]election

and breeding for desirable qualities offer possibilities," they ventured. But there were certain obstacles that stood in the way. They noted that "breeders of live- stock," in spite of their limited understanding of chromosomes and heredity, had successfully improved the quality of the herd. With humans, however, they claimed, the issue of "control" was more problematic. "The difficulty in mating of combining sentimental and spiritual values with biological values" remained, and they counseled that more research was required before "higher eugenic ideals may emerge."

The notion that society was divided between those whose fertility should be encouraged and those whose hereditary lineage called for curtailment reiterated an American sense of self and other that had permeated racial theories, policies, and institutions throughout the life of the republic. This persistent assumption of human hierarchy was most evident in their recommendations regarding the need to continue sterilization practices in state and federally run institutions. The committee acknowledged, however, that this measure would have little impact on the overall population of "low grade" individuals.

> [I]mmediately urgent is the need of preventing individuals with undesired inheritable traits from having offspring. Such a policy could be enforced in the more marked cases of feeblemindedness, of which there are less than 100,000 in numbers in institutions, but for the large numbers outside of institutions, variously estimated in the millions, who is to decide?

The committee did not embrace eugenicist assumptions without question. In its discussion of "other objectionable types, the insane and criminal," the Report acknowledged, "it is not known that the factors producing them are inherited." Here the issue of detrimental societal influences entered the discussion. "Men often commit criminal acts because of social conditions. Crime fluctuates with the business cycle. In a similar manner, certain types of social experience conduce to insanity."[3]

In a chapter on "The Rise of Metropolitan Communities," the Chicago ethnographer R. D. McKenzie evaluated the extent to which modern cities were contributing to racial distinctions and prejudices. In Europe, from the thirteenth century onward, the growth of cities had spawned unprecedented interactions between strangers and had fed the rise of modern typecasting. In America, in the twentieth century, as the metropolis displaced rural and small-town life as a locus of national identity, many of these tensions were exacerbated.

For some, cities were breeding cosmopolitanism, a sense of worldliness that

posed the possibility of breaking down entrenched ideas of difference. "Now that immigration has receded almost to the zero point," McKenzie speculated, older immigrant sensibilities were likely to fade away. With this change, ethnic identity would be exchanged for an assimilated Americanism. This theme of transition was *The Jazz Singer*'s story and would be reiterated in a growing genre of Americanization tales. An example of this was *The Rise of the Goldbergs*. Beginning in 1929, the program was one of radio's most popular daily serials, and humorously dramatized the assimilation of an immigrant family into American life. The show, which reflected the biography of its creator, writer, and star, Gertrude Berg, remained on the air until 1955, a time when the assimilation of Eastern European Jews was fairly complete, and references to immigrant roots were not in style.

If some had the opportunity to break out of conventional clichés, however, the isolation of other groups was intensifying in the metropolis of the 1930s. Imposed patterns of racial segregation assumed a new face in the modern metropolis. Denied a chance to enter the dominant American culture, many were forced to fend for themselves. "The Negro and the Oriental," McKenzie noted, "tend to build up cities within the city. They establish their own institutions— theaters, churches, stores, clubs and dance halls." With a vast migration of black people from the rural South to the urban North, beginning in the First World War and accelerating during the 1920s, black cities within cities grew exponentially, usually moving into what McKenzie termed "declining areas."

For whites and Americanized immigrants, this segregation only fed a sense of distance. Many of them encountered "the Negro and the Oriental" primarily as workers relegated to menial jobs. These unequal relations were accentuated by derogatory representations in films, radio, print, and other avenues of an expanding media culture. While some white immigrant groups continued to be stereotyped in the media—and many old-line institutions still defined them as breeding grounds for crime, Bolshevism, and other social threats— the defamatory assault on people of color was unmitigated.

Yet within these expanding racial enclaves, important developments were taking place. Buffeted by centuries of oppression and humiliating stereotypes, black urban communities were becoming hothouses for new cultural perspectives. Under the rubric of the Harlem Renaissance, art, literature, and music produced by African Americans were altering the creative landscape and, to some extent, having an influence on a white culture that continued to bar black people from its midst. The fact that many whites were defining the twenties as The Jazz Age is but one large footprint of this influence.

Among black artists, musicians, writers, and intellectuals, the decade provided fertile ground for a growing debate over the role of "Aframericans," a 457 term coined by the black journalist George Schuyler, within the broader culture of the United States.

Schuyler, himself, in an article that appeared in *The Nation* in June 1926, rejected the idea of a definitive African American art. He was well aware that white America continued to harbor negative stereotypes of the Negro, yet he believed that black creativity should not embrace the idea of separateness. For him, this was not simply an ideological position. It was his refusal to accept the idea that there is such thing as an archetypal Negro.

First of all, there were enormous ethnic differences within black communities. The art forms of black people from "Charleston, S. C. . . . Northern Negroes, West Indian Negroes and African Negroes," he argued, are "no more expressive or characteristic of the Negro race than the music and dancing of the Appalachian highlanders or the Dalmatian peasantry are expressive or characteristic of the Caucasian race."

More importantly, however, he refused to accept the notion that black and white Americans were separated by essential differences. "It is sheer nonsense," he declared, "to talk about 'racial differences as between the American black man and the American white man.'"

Aside from his color, which ranges from very dark brown to pink, your American Negro is just plain American. Negroes and whites from the same localities in this country talk, think, and act about the same. Because a few writers with a paucity of themes have seized upon imbecilities of the Negro rustics and clowns and palmed them off as authentic and characteristic Aframerican behavior, the common notion that the black American is "so different" from his white neighbor has gained wide currency, the mere mention of the word "Negro" conjures up in the average white mind a composite stereotype of Bert Williams, Aunt Jemima, Jack Johnson, Florian Slappey, and the various monstrosities scrawled by the cartoonists. Your average Aframerican no more resembles this stereotype than the average American resembles a composite of Andy Gump, Jim Jeffries, and a cartoon by Rube Goldberg.[4]

In large measure, Schuyler was responding to a black intelligentsia that was committed to celebrating and creating distinctly African-American art forms that would be separate from those generated by white America. Given whites'

458

widespread rejection of blacks as equal constituents of American society, and the artistic vitality percolating in cities, this nascent nationalist perspective attracted a wide number of adherents. It was not a separatist perspective, as was the Back to Africa Movement led by Marcus Garvey, and showed a firm commitment to an American future in which racial equality would flourish. To get there, however, many argued for the need to discover and cultivate a particularly black American voice.

One of these was the great poet Langston Hughes, who wrote an acidic response to Schuyler in the next issue of *The Nation*. Characterizing people such as Schuyler as "Nordicized Negroes," Hughes argued that the "Negro Artist" in America stood at the base of a perilous "Racial Mountain." This mountain, he maintained, beckoned black artists to begin to climb it, "but this is a mountain standing in the way of any true Negro art in America—the urge within the race towards whiteness, the desire to pour racial individuality into the mold of American standardization, and to be as little Negro and as much American as possible." Apartness from this seductive mold, Hughes believed, was essential for black art and a black voice to flourish.

Looking around him, Hughes saw a growing black middle class as conspicuous champions of the racial mountain and as prime participants in the lie of assimilation that stood at its unreachable summit.

> In the North they [members of the Negro middle class] go to white theatres and white movies. And in the South they have at least two cars and a house "like white folks." Nordic manners, Nordic faces, Nordic hair, Nordic art (if any) and an Episcopal heaven. A very high mountain indeed for the would-be racial artist to climb in order to discover himself and his people.

For Negro artists to find themselves and their people, Hughes counseled, they must avert their eyes from these middle-class models. It was to ordinary people that artists must turn for inspiration, "the low-down folks" who constituted the "majority" of blacks.

> These common people are not afraid of spirituals . . . and jazz is their child. They furnish a wealth of colorful, distinctive material for any artist because they still hold their own individuality in the face of American standardization . . . and they accept what beauty is their own without question.5

At the heart of this debate—one that continues to divide many communities—was the issue of assimilation. It was akin to a debate among many immigrants and their children during the same period. For example, Abraham Cahan's *Jewish Daily Forward*, a major Yiddish newspaper, provided an ongoing forum in "Bintel Briefs" (letters to the editor) in which impassioned discussions of the issue took place. There was one key difference, however. If "white" immigrants were slowly, sometimes grudgingly, being invited into the sanctum of Americanism, the door remained shut to most black people. This barrier provided an inducement for the articulation of an autonomous black cultural identity.

In another chapter in the report, this one on "The Status of Racial and Ethnic Groups," sociologist T. J. Woofter, Jr. argued that the shutting down of European immigration was multiplying the number of segregated enclaves of American society. With a shortage of white immigrants willing to work for deplorably low wages, and with a declining white birth rate, an influx of "colored" peoples from Mexico and from America's colonial territories—Puerto Rico, Hawaii, and the Philippines—were altering the complexion, if not the prevailing biases, of mainstream society. These groups would create new cities within cities, and, along with blacks and Chinese, would become easy targets for typecasting by police, educational systems, the medical establishment, and, of course, the media. A society that depended upon the economic misery of these communities required it.

If Jakie Rabinowitz could reinvent himself as Jack Robin, the media of the 1930s, 1940s, 1950s, and 1960s—along with other institutions—would continue to employ racial stereotypes of African Americans, Asians, Latinos, and Polynesians. As represented by the conventions of white culture, they were stock characters whose mangled English, menial positions, and general untrustworthiness were innate characteristics, setting them apart from "true" Americans. The segregated fabric of society, entrenched inequities, and the racial dynamics of the entertainment and media industries provided a social and economic foundation for such relentless practices.[6]

Amid his discussion of race and ethnicity, Woofter raised a provocative question that still sheds light on the volatile social boundaries that undermine or maintain strict racial distinctions. Discussing the growing inclusion of "white immigrant" groups within the rubric of who is an American, he wrote:

> The adaptation of alien born white groups to American life is not so difficult a process as that of the colored races. The normal activities of industry and education accomplish the major assimilative processes; in community affairs aliens need further adjustments which are accom-

plished through the churches, special organizations and the press. Finally and most thoroughly assimilation takes the form of intermarriage with the native born.7

The increase in intermarriage between immigrants and native born was enhanced by a growing number of unions between people of different immigrant backgrounds. By 1930, more than half of the children born to white immigrants in New York State, one of the few states to keep records of this statistic, were of "mixed parentage."

Here we witness the extent to which a loosening of sexual taboos regarding who is an acceptable mate alters the topography of typecasting, creating a more inclusive and tolerant milieu. The relaxation of restrictions is not limited to issues of ethnicity and race. The 1920s was a period when conventional rules surrounding the sexual lives of women were forcefully being challenged, and intermarriage is more likely to occur when women are free to choose a husband without the approval of the parent generation. Conversely, stringent sanctions against intermarriage intensify the impulse to typecast and dehumanize outsiders and also tend to uphold traditional views regarding a woman's proper place.

In the early decades of the twentieth century, the strict exclusion of "new immigrants" from membership in the white race was an Anglo-American faith. The Nordic nationalist Madison Grant, among many others, vociferously argued that intermarriage would bring about the pollution and decline of the old Caucasian stock. Here—as is usually the case—racism, nationalism, and the promulgation of stereotypes were inseparable. These assumptions propelled the passage of the Johnson-Reed Immigration Act of 1924.

Yet, while new immigration was cut off, social transformations affecting those millions who got in under the wire were beginning to marginalize the importance of one's hereditary roots. While some held to a narrowly white sense of nation, the boundaries of whiteness were changing and, with them, the contours of American culture.

Woofter noted that there were black-white unions from the days of slavery onward. But these often involuntary relations, almost always between white men and black women, produced children who were usually abandoned by their fathers and remained within the African-American community, giving rise to what some white demographers were calling a "new brown race." In the South, where miscegenation laws were still being violently upheld, and in the ghettoized North these children remained outsiders.8

The impact of new "agencies of communication," surveyed in a chapter by Malcolm Willey and Stuart Rice, was another force that, according to *Recent Social* 461 *Trends*, was driving instability and change. Combining transportation and media under the rubric of "communication," a common practice in those days, Willey and Rice saw two countervailing tendencies altering the structure of social experience. On the one hand, an explosion of new technologies and the growth of new media and transportation industries were breeding a sense of disorder.

> The surface picture is one of chaos and conflict: railroads competing with bus lines, busses competing with street railroads, newspapers concerned over the broadcasting of advertisements, the motion picture competing with radio and already alarmed at the possibility of television.

At the same time, they saw these new developments creating an unprecedented amalgamation of society, narrowing the distances between people and places, giving rise to a shared and increasingly diverse national culture. In 1922, Walter Lippmann argued that new communication systems could be used to present "the somewhat strange" in terms that were "sharply alien," magnifying the power of stereotype. Simultaneously, as described by Willey and Rice, they could take the previously strange and make it more familiar, breaking down distance and increasing a nearness to a variety of cultural influences.

> The automobile, the airplane, the motion picture and the radio have all had their development since the turn of the twentieth century. Each new communication agency bids for public favor and its ultimate acceptance adds to the complexity of our civilization.[9]

A defining element within these new networks of communication was the growth of a consumer economy, which, for a growing number of people, was changing the experience of American life. The automobile was not simply a new mode of transportation, but also a durable consumer product that was leaving a deep imprint on people's sense of identity. If traditional communities, native born or ethnic, bred a connection to the group, the automobile society emphasized individuality and independence. In the past this was a luxury of the rich. Mass production and a commercial culture had altered the situation. People who had previously owned "no vehicle of private transportation" were, during the 1920s, becoming car owners.

With the acceptance of the automobile the individual citizen in virtually all classes of the population has acquired a vehicle that gives a freedom of control in personal transportation such as never before existed. Potential mobility is increased immeasurably and easy, swift movement over distances formerly traversed but rarely, is achieved. The result has been a transformation of social habits.[10]

In the process, old social and geographic distinctions were being dissolved, and many traditions were being liquidated. Automobiles made travel a leisure-time activity for more and more people. They created private spaces where young people could pursue romantic rendezvous apart from the customary sanctions of family and community. Car ownership had a profound social and psychological impact. It helped to free people from the group, provide them with a newfound sense of status, and embed them within the emerging identity of "the consumer."

This rite of becoming a consumer, while it continued to bypass millions of poor and working-class people, particularly in the agricultural sector, was an option extended to a growing number during the 1920s. The definition of "middle class" was shifting. In the years between 1919 and 1928, as indicated in *Recent Social Trends*, the average annual income of "Employed Wage Earners," in real earnings, grew by nearly thirty percent.[11] Complementing this rise, "standard hours of work in manufacturing industries" declined, and the amount of leisure time enjoyed by wage earners grew.[12] For many of those working in the industrial sector, this change meant that pay exceeded the amount needed for mere subsistence, and time allowed for the expenditure of the new discretionary income. For those who could afford to participate in the purchase of increasingly inexpensive goods, consumption appeared to serve as a leveling device. It offered a new definition of Americanism oblivious to type.

Throughout the 1920s, the growth of new media industries, the "agencies of mass impression," helped to propel this changing notion of national identity. Beyond their role as popular entertainments, movies, Willey and Rice observed, were transmitting and molding new "attitudes and social values."

"Editors of popular motion picture magazines," they reported, "are deluged with letters from motion picture patrons, unburdening themselves of an infinite variety of feelings and attitudes, deeply personal, which focus around the lives and activities inhabiting the screen world." They continued:

One editor receives over 80,000 such letters a year. They are filled with self-revelations which indicate, sometimes deliberately, more often unconsciously, the influence of the screen upon manners, dress, codes and matters of romance. They disclose the degree to which ego stereotypes may be molded by the stars of the screen.

Mass consumer industries, particularly those producing ready-to-wear garments, sought to exploit the "ego stereotypes" of potential customers. They regularly manufactured clothing that was "patterned" after fashions seen on the screen. "Commercial interests," Willey and Rice deduced, "appreciate the role of the motion picture as a fashioner of taste."

The burgeoning advertising industry, along with other agencies of commercial propaganda, actively jumped on a train where movies and movie stars drove the locomotive. If earlier advertising had often used testimony from European aristocrats, relying on the aura of their class superiority, in the 1920s movie stars— the people's royalty—were replacing these dated and undemocratic figurines. "Names and portraits of moving picture actors and actresses have . . . extensively been used for prestige purposes in the advertisements of various commodities."13

For the history of typecasting, the implications of these developments were enormous. If Hollywood, radio, and the consumer culture routinely relied on fixed types to sell their goods and tell their stories, they were simultaneously providing vehicles that transformed people into filmgoers, radio listeners, and buying publics who, more and more, shared common cultural symbols and aspirations.

While much about a consumer society celebrated ideas of individuality, Wiley and Rice warned that the growing consolidation of ownership in all the industries of mass impression posed a threat to the individual, promoting ego stereotypes that were designed to generate a predictable psychic standardization.

The prescience of their report is striking. They observed that old distinctions were, to some extent, being shattered, challenging deeply rooted taxonomies of human difference. At the same time, in the wake of these changes, they saw the emergence of a new America that was easily manipulated, psychologically uniform, and painfully lacking in character.

Mass impression on so vast a scale has never before been possible. . . . The individual, the figures show, increasingly utilizes these media and they inevitably modify his attitudes and behavior. What these modifications are to be depends entirely upon those who control the agencies. Greater possibilities for social manipulation . . . have never [before] existed.

464

> Agencies of mass impression subject the individual to stimuli of sight and sound that may serve to make him think and act, in some measure, like millions of his fellows. . . . With the concentration of these agencies the control over his behavior is increased.[14]

This concern over the dangers of psychological manipulation was not without basis. Beginning during the First World War and throughout the 1920s, the terrain of America's mental environment had changed considerably. First, in order to sell the war to dubious Americans, a large-scale government propaganda bureau was launched, giving rise to variety of new perception-management professions. After the war, many of these "compliance professionals" moved into the civilian sphere, promoting mass consumption and working to expand the demand for goods rolling off assembly lines faster than people could buy them. An unprecedented culture of promotionalism was taking hold in America and its central targets were existing and potential consumers.

With the United States' entry into the First World War, opposition to the war and critiques of the capitalist system were effectively silenced by a government-sponsored drive to rid the country of "Reds," led by Attorney General A. Mitchell Palmer. Throughout the 1920s, this antiradical atmosphere went on unabated, and free-market capitalism—much as it is in today's world—was elevated to the status of an unassailable secular religion. A devotional life, in this case, consisted of fervent consumption.

In volume 2 of *Recent Social Trends*, Robert Lynd, with the assistance of Alice Hanson, described this trend in what remains a powerfully incisive essay, "The People As Consumers." Lynd, with his wife and co-author Helen Merrill Lynd, had written the 1929 sociological masterpiece *Middletown: A Study in Modern American Culture*. This book used Muncie, Indiana, to evaluate many of the massive social changes that had taken place in the United States between the 1890s and the 1920s. One of these changes was the rise of a mass consumer culture, and in the *Recent Social Trends* essay, some of Middletown's observations were updated.

One of Lynd's fundamental arguments was that the twentieth century had, for many Americans, altered the nature of survival. "The great bulk of the things consumed by American families," he wrote, "is no longer made in the home and the efforts of family members are focused instead on buying a living."

This change reflected the rise of mass industrialism and the concomitant decline of small-scale, localized industries. With a dramatic increase in the ability to produce goods, a population rooted in preindustrial approaches to consumption constituted a problematic "neck of the bottle through which the

varied output of America's industrial machinery must somehow flow." A dispar- ity between the nation's population growth between 1900 and 1930 and a "quan- tity volume of manufactures" that far outpaced it heightened this challenge.[15]

In order to promote people's impulse to consume this surfeit of goods, busi- nesses began introducing a number of strategic innovations. In terms of making goods more "affordable," they started extending consumer credit to a wider and wider range of people. When the crash came, the mass forfeiture of this debt accelerated the collapse, but, in the short run, credit seemed to be another name for a "rising," if invisibly fragile, "standard of living."

Beyond the extension of credit, however, the expanding apparatus of persua- sion was one of the most defining developments of the 1920s. Lynd described this development both in terms of the ways it encouraged new business practices and in terms of the ways it was affecting the individual psyche. The two were closely intertwined.

In business, the modification of public thought and behavior became an obsession. Accompanying this fixation, a new stereotype was taking hold: the consumer. In the history of typecasting, this new typology signaled a shift from categories predicated upon biological or physical features to a category based on psychological vulnerabilities. In inventing the stereotypical consumer, business people sought to define an individual who was pliant and whose instinctive make- up could be known and easily engineered by marketing experts, informed by the social psychology of influence.

In constructing this quintessentially modern stereotype, many in business relied on the perspective laid out by Gustave Le Bon. Incapable of critical thought, the ideal consumer was not a bourgeois man of science but approxi- mated the mental life of the crowd. The consumer was driven by reflex and by passion, and was particularly susceptible to the influence of images and of theatri- cal spectacle. In Le Bon's schema, these characteristics defined the behavior of the crowd but were also found in "savages," "children," and "women."

Despite the fact that, in a family, husbands often wielded decision-making power over major expenditures, the "ideal consumer," as she was constructed in the 1920s, was a woman, often called "Mrs. Consumer."[16] Glamorizing the patri- archal practice of treating women like children—in need of constant supervi- sion—many of the messages aimed at "Mrs. Consumer" promised her the opportunity to hold on to perpetual girlhood. According to this formula, female success was defined by incessant, if presumably admiring, surveillance.[17]

It must be added that the stereotype of "the consumer," as delineated by corporate America, remained extremely white. Even as immigrants

466

entered the consumer sphere, the model they were encouraged to emulate—a model that would mark commercial ideals into the 1970s— were Nordic Anglo-Americans.

In business circles, there was a keen and instrumental awareness of "job insecurity, social insecurity, monotony, loneliness, failure to marry, and other situations of tension," as "subtle" factors influencing the inner lives of prospective consumers. This situation coincided with Alfred Adler's new diagnostic category, the "inferiority complex," a psychological state, often linked with appearance, that drove people to feel uncomfortable in their own skins, and to seek self-escape.[18] With these things in mind, media and manipulation strategies were joined to detect public unhappiness and transform it into sales. A systematic profiling of the public mind had begun. Lynd described it vividly.

> During the past two decades the business of selling commercial products . . . has advanced to an effective fine art. The tendency of contemporary merchandising is to elevate more and more commodities to the class of personality buffers. At each exposed point the alert merchandiser is ready with a panacea.[19]

To hasten the process of turning people into consumers, psychologically oriented advertising became an increasingly conspicuous element of the culture. "Advertising goes hand in hand with volume of production and retail distribution," he wrote. "It operates to increase the availability of goods and to turn out quickly kiln-dried habits of consumer acceptance."[20]

The intersection of business goals and consumer behavior was fortified by the element of "style." By the mid-1920s, the constant redesign of all sorts of products, and the emergence of what adman Earnest Elmo Calkins termed "style obsolescence," created a visible panorama of then and now. The desire to be in style linked an individual to the ever-evolving present, and to the requirements of the market. To be out of style, or dated, tied the individual to a past that was becoming increasingly anachronistic in a rapidly changing society.

This choice, which faced millions of Americans in the 1920s, reflected an important transition in business thinking. Lynd described it as a shift from "price to style" as the primary inducement for sales.

To merchants style and fashion offered an opportunity to extricate merchandising from the profit-wasting traditional emphasis on competitive prices, and to this end entire industries pooled their attack to make the consumer "style-conscious."[21]

The need to reshape the psyche of consumers required more than a capacity to profile their current mental lives. For a system built on continual style change and disposability, an aptitude for typecasting future desires was also necessary, and a "style forecasting" industry, which analyzed the products that future consumers would be willing to embrace, also came into being during these years.

Part of what made people with some disposable income susceptible to commercial imperatives was that the "personality buffers" attached to products regularly offered the possibility for a person to transcend type. With the right purchase, it was argued, one could move from being hemmed in by membership in a less fortunate group and acquire an appearance that indicated a rise in status.

The eighteenth-century physiognomist Johann Kaspar Lavater maintained that there was an irrevocable "correspondence between the external and internal man." This idea persisted in nineteenth-century science and popular culture. Well into the twentieth century, the notion that a person or group's physiognomic traits were reliable marks of character endured. To some extent, media typecasting and stock characterizations added weight to this premise.

Advertising and the consumer culture offered the prospect of a pass. The cosmetics industry of the 1920s, for example, advertised prominently in movie magazines, selling products that could give an ordinary woman the glamour of a star. From the early twentieth century onward the growing availability of inexpensive mirrors, once a luxury of the rich, made more people more conscious of how they looked and provided a pocket tool that could be used to "make oneself up." At a time when movies were providing mass-circulated ideals of beauty, the mirror provided an ever-ready personal movie screen for comparison and imitation. Cheap Kodak box cameras, which became available on a mass scale in 1900, only added to this opportunity.[22]

One of the first to capitalize on the connection between stardom and aspiration was Max Factor, a Russian Jewish immigrant born in 1877 who came to the United States in 1904. Beginning in St. Louis, he opened a studio in Los Angeles in 1908, selling wigs and makeup for stage and film actors. By 1920, the corridor between Hollywood movies and personal desire was well under construction, and he began to adapt part of his business for a filmgoing public.

As Kathy Peiss writes in *Hope in a Jar*, a history of the beauty industry, "Fac-

468

tor, an immigrant and craftsman devoted to the theatrical trade, left the actual development of the mass market to his Americanized children and a company specializing in new product promotions." By the late 1920s, Max Factor's civilian lines had a national following, and his ads proliferated in "mass-circulation movie and romance magazines."²³

If transcendence was possible, however, typecasting was an explicit component of Factor's marketing strategies and was adopted by other firms. Women were encouraged to identify their own type in relation to various "typologies of beauty," such as "dark and fair, foreign and exotic, ethereal and physical, to differentiate products and markets," writes Peiss. "Max Factor and other cosmetics firms created complexion analysis charts to help women choose their 'beauty type' and the best array of products."²⁴ Accompanying this was a separate black cosmetics industry, unattached to mainstream corporate America but profiting from what Langston Hughes described as a misdirected search for whiteness. Skin bleach and hair-straightening products accounted for many of the sales.²⁵

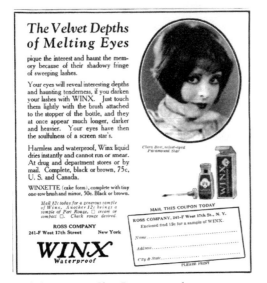

With this mascara, Clara Bow eyes can be yours. FROM THE COLLECTION OF THE EWEN LIBRARY.

While the cosmetics industry, along with the fashion industry, spoke persuasively to a broad audience of white American women who hoped to follow the stars, Max Factor's "Americanized" children were not only entrepreneurs but also symbolized a choice confronting many of their potential consumers. In an anti-immigrant milieu, foreign- or American-born children of immigrants, in particular, purchased lipsticks, other facial confections, and clothing to assume the look of a modern American and to separate themselves from the obsolete and tainted visage of their old world roots.

Even before the 1920s, people in the merchandising field saw the growth of goods consumption as an essential piece in the Americanization of immigrants. Frances Alice Kellor, who ran an advertising agency that placed ads in foreign-language newspapers, wrote in 1919, "American products and standards of living have not yet been bought by the foreign born in America." "National

advertising," and the consumption it would stimulate, she argued, was "the great Americanizer," something that would bring immigrants into the society and be good for business at the same time.

The opportunity to break Lavater's laws and change physiognomic type was accelerated by the appearance of cosmetic surgery as a medical specialty in the 1920s. This era saw the idea of beauty change from something that was inborn to something that could be acquired. The make-up and hair-care industries exploited and promoted this changed way of seeing. Cosmetic surgery had begun as reconstructive surgery, developed for facially disfigured soldiers during the First World War. After the war, it became a marketable procedure, when the doctors and dentists who had developed it began to offer their costly services to men and women who desired to construct their looks more thoroughly than cosmetics would allow. "One's face is one's fortune," proclaimed one surgeon. "The importance of first impressions cannot be overemphasized," added another.[26] Practitioners frequently publicized their work with "before and after" photographs, demonstrating their miraculous powers.

The well-publicized nose job of Fanny Brice, a popular Jewish entertainer, shed further light on cosmetic surgery's capacity to reconfigure identity. Condemning the procedure, the humorist Dorothy Parker quipped that Brice had "cut off her nose to spite her race." In self-defense, Brice spoke openly of her career-driven desire to move beyond the limits of ethnic typecasting.[27]

In *Essays on Physiognomy*, Lavater had maintained that the science of first impressions was based on the idea that dissembling could not alter certain basic physiognomic facts.

> Can any fashion the flat and short, into the well-proportioned and beautiful nose?
>
> Who can make his thick lips thin, or his thin lips thick?
>
> Who can change a round into a pointed, or a pointed into a round chin?
>
> Who can alter the colour of his eyes, or give them, at his pleasure, more or less lustre?
>
> Where is the art, where the dissimulation, that can make the blue eye brown, the gray one black?[28]

Cosmetic surgery—and, by the 1980s, colored contact lenses—offered a resounding response. All the above were open to improvement. Anyone who wished, and who had the means, could turn "corporeal deformity" into "corporeal

beauty." Along with less drastic measures, the countenance, Lavater's window to the soul, could be redone.

By the end of the 1920s, this way of thinking had begun to bear fruit. The promises born of the cosmetics industry, as it aimed its wares at native, immigrant, and mixed-parent consumers, were infusing advertising for all kinds of products. Tales of before and after were being used to sell toothbrushes, cars, soap, household appliances, even chewing gum.[29]

In the process of this imagistic scenario of change, demarcations of class, in the minds of some, began to shift from matters of economic power to distinctions between consumers and those too poor to call themselves by that name. Speaking of fashion, in 1929, the economist Stuart Chase summed up the perceptual swing.

> The function of clothes as a badge of social rank is enormously expanding over all classes in America for both sexes, but particularly for women. Only a connoisseur can distinguish Miss Astorbilt on Fifth Avenue from her father's stenographer or secretary. An immigrant arriving on the Avenue from the Polish plain described all American women as countesses. So eager are the lower income groups to dress as well in style, if not in quality, as their economic superiors, that class distinctions have all but disappeared. To the casual observer all American women dress alike. The movement to cut down the margin of class distinction . . . has made great headway since [World War One].[30]

While throughout the 1920s the gap separating the very rich from everyone else was extremely wide, as it is again today, the idea that consumption erodes class differences continues as a central component of a secular American religion. According to the creed, consumption and belonging go hand in hand.

CODA

RECENT SOCIAL TRENDS

If a pledge of abundance was the consumerist anthem of the 1920s, the collapse of the economy, beginning in October 1929, brought a jarring halt to the hubris of prosperity. With the crash and with rising unemployment, erstwhile consumers could not stay afloat. The very economy that had invented the religion of mass consumption had ground to a halt. With this, the distance between the consuming class and the poor dramatically narrowed. Poverty, more than consumption, was beginning to paint the mental picture of the average American.

With the coming of the New Deal and the federal funding of photographers and filmmakers who went out into the country to document the social and economic damage being wrought by the Depression, stereotypes began to shift. Franklin's Roosevelt's frequent use of radio, his Fireside Chats in particular, added to this change in social rhetoric. Forgotten men and migrant mothers—standing on breadlines, swept by dust storms, losing farms, driving beat-up jalopies looking for work—became the heroic icons of society. An idea posed by Langston Hughes in the 1920s, that Negro artists should take inspiration from "the common folks," was now reaching beyond the black population and becoming a more integrated artistic mission. In 1930s tributes to the common people, race distinctions began to break down, and conditions in black communities held a definite place in the overall picture. While segregation was legal or de facto throughout much of the nation, the portrait of a more inclusive, more egalitarian America was emerging.

In "chats" with his countrymen, Roosevelt constantly spoke on behalf of "the average man," and in his Second Inaugural Address (1937) he intoned, "I see one-third of a nation ill-housed, ill-clad, ill-nourished." In the visual, written, and spoken depictions of the Great Depression, the definition of who was an American was broadening to welcome the downtrodden, previously nonexistent in the universe of affirmative stereotypes.

Much of the popular culture of the period elaborated upon this picture. Mervyn LeRoy and Busby Berkeley's *Gold Diggers* of 1933 depicted a depression-era Broadway filled with unemployed performers in search of work. When a show is finally mounted, its stirring finale is a mournful musical tribute to the sorrows of "The Forgotten Man." A poor but dignified black woman, played by the actress Etta Moten and backed by a

chorus of Depression-era archetypes, begins a dirge, "Remember My Forgotten Man," and she is followed by Joan Blondell singing

> Remember my forgotten man,
> You had him cultivate the land;
> He walked behind the plow,
> The sweat fell from his brow,
> But look at him right now!

That same year, Moten became the first black performer to sing at the White House, invited there by Franklin and Eleanor Roosevelt.

Charlie Chaplin's *Modern Times* (1936) offered a scathing and hilarious critique of industrial capitalism, its abuse of workers, and its systematic creation of unemployment. *The Grapes of Wrath* by John Steinbeck (1939), and John Ford's film adaptation of the book (1940), presented a picture of rural poverty, heroic families driven from ancestral farms, the desperate search for work, and the power to survive because, "We're the people."

Another filmic homage was Preston Sturges's *Sullivan's Travels*, the story of a big-time Hollywood filmmaker who decides to ride the rails, to make a movie about "the people," to be called *O Brother Where Art Thou*. Disguising himself as a hobo, and without any traces of his former identity, Sullivan is confronted by dire conditions and suffering throughout America. His search provides him with a vivid picture of human dignity, in spite of hardship, as well as the snares in which ordinary people can get trapped, locked up, and forgotten.

During this time, corporations that had promoted the "classless" consumer society of the 1920s fell into widespread disgrace. In a 1935 Fireside Chat, Roosevelt excoriated the business mentality of the 1920s as one that had driven the nation to ruin. This superficially prosperous period, he told his listeners, was in reality a time when "individual self-interest and group selfishness were paramount in public thinking. The general good was at a discount."[1]

Two years later, in his second inaugural address, he chided business for holding on to this mindset. "Dulled conscience, irresponsibility, and ruthless self-interest" continued to jeopardize the common good.[2] The highest office in the land was, in its rhetoric and in a range of social democratic policies, siding with "the people" against captains of industry who he derided as a band of "economic royalists."[3]

His words and views reflected the outlook of people who had lost all faith in the idea that the "hidden hand" of unfettered capitalism, as Adam Smith had put 475 it, would bring about the greater good. In the culture of the 1930s, businessmen were often depicted as heartless profit seekers, plutocrats whose ability to live in excess, while their countrymen suffered, was regarded as a sign of uncaring immorality. To hear an acknowledgment of "the common man" that openly challenges privilege and speaks for the greater good offers both an insight into FDR's commitment to democratizing the social and economic fabric of America and a grim reminder of how such an approach to governing has become fugitive. "We are beginning to abandon our tolerance of the abuse of power by those who betray for profit the elementary decencies of life," Roosevelt declared in his 1937 inaugural address. His landslide victory in November 1936 underwrote the appeal of these ideas.

The attack on "economic royalists," by Roosevelt and many others, did not go unanswered. In a staunchly antibusiness environment, a strategic defense of corporate capitalism was organized. From 1935 onward, American corporations, under the umbrella of the National Association of Manufacturers, launched a well-funded The American Way campaign that sought to create a mental association between democratic ideals and the private-enterprise system, meanwhile tarnishing the New Deal with the brand of "socialism." Throughout the campaign—which was realized through billboards, radio programming, brochures, educational materials, and packaged news items—the vision of a happy and prosperous America resurrected a traditional Anglo-American iconography: parents with Northern European features and tow-headed children were depicted on generic Main Streets, far distanced from the sinister environs of the city. Within this propaganda campaign, those who questioned the values and practices of free-market capitalism were stereotyped as foreigners, Bolsheviks, and ill-adjusted malcontents, distinctly un-American. This campaign was not immediately successful, but it laid the groundwork for future battles over the definition of who and what is American. Ronald Reagan, for one, was enlisted as a soldier in this crusade in the years immediately following the Second World War. Though not directly visible, the American Way campaign's long-term impact on the politics of American society was substantial.

In spite of these anti–New Deal efforts, the 1930s gave rise to an infrastructure and to ideas that envisioned an inclusive consumer democracy, with the government as the instrument of public advocacy. Roads were built, rural areas were electrified, schools and housing were constructed, and the idea of general welfare was

promoted as an American birthright. Social security was established; the right of workers to organize was recognized; unemployment insurance was established; and, while never enacted, guaranteed healthcare for all Americans, regardless of circumstance, was projected as a governmentally guaranteed right of citizenship. If private enterprise could not do the job, millions believed, it was the role of government to step in and defend the interests of the people. While African Americans remained, for the most part, an underclass, the language and policies of the New Deal spoke to many of them and left a deep imprint on the goals of the civil rights movement as it emerged in the 1950s.

In order to break the hold of ingrained American stereotypes, the Works Progress Administration, a New Deal agency, started assembling a massive Life Histories collection, comprised of oral histories, reports, interviews, and case studies. These writings documented and validated the experiences of former slaves, members of various immigrant groups, the rural and urban poor, the unemployed, and others victimized by the crash and marginalized by the traditions of Nordic nationalism. Under the rubric of the Federal Writers Project, many leading authors participated in the realization of this effort, including Saul Bellow, John Cheever, Nelson Algren, and an increasingly visible group of African American writers including Ralph Ellison, Zora Neale Hurston, and Richard Wright.

Throughout these histories, writers sought to remain true to the people they interviewed and to produce documents that were both accurate and respectful, providing a human picture of an emerging American mosaic. Toward this end, Ralph Ellison spoke of his attempt to capture the essence of black speech in a way that would break from standards established by minstrelsy. "I tried to use my ear for dialogue to give an impression of just how people sounded. I developed a technique of transcribing that captured the idiom rather than trying to convey the dialect through misspellings."4

American arts and music from a variety of peoples and regions were also collected. These efforts to create a diverse portrait of the American people was a dramatic break from a history that had generated a monochromatic vision of America, with disregard and contempt for the varieties of people living on its shores. In a time of collective crisis and rethinking, taboos were loosening and, with them, a restrictive repertoire of stereotypes was being challenged. Just as the American Way campaign would have an enduring impact on our political environment, this unprecedented vision of a pluralistic, inclusive, and broadminded society continues to expand within the boundaries of

American culture, and informs many people's expectations of what America and democracy can be. 477

During the Second World War, the role of stereotype in society played out paradoxically. Anti-Japanese propaganda produced by the War Production Board was grotesquely racist, portraying the Japanese as rats caught in "Jap traps," as dark-skinned demons with huge fangs, and as predatory rapists walking off with helpless and naked white women slung over their shoulders. Some posters took their inspiration directly from blackface characterizations—bug-eyes, black skin, big lips—with only minor alterations in facial features to suit the occasion.

As is usually the case, such pictorial dehumanization coincided with an assault on people's rights, and a government policy leading to the internment of Japanese Americans in prison camps commenced shortly after the bombing of Pearl Harbor. Anti-Nazi propaganda, while it aimed at promoting national vigilance and portrayed an evil enemy, was not racially oriented and German Americans were not rounded up and sent to camps.

At the same time, the Second World War provided an opportunity to challenge long-established structures of power and the stereotypes they relied upon to maintain their legitimacy. Eugenics, which had taken wing as a movement in the United States and affected the laws of the land in significant ways, was discredited, as breeding and sterilization policies became central elements of the Nazi program of race purification. Many of the racial characterizations that had underpinned eugenics in the United States and were going full blast in Germany also fell into disrepute.

On other fronts, the conventional view that women could not perform a "man's job" was, at least for a time, manifestly rejected. With men shipping out to war, large numbers of women were

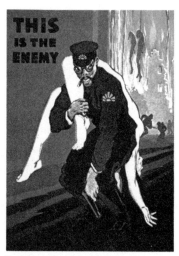

Ravishing the race, WWII style.
FROM THE COLLECTION OF THE HOOVER INSTITUTION

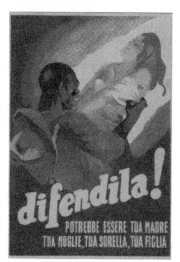

This Italian propaganda poster offers a familiar picture, in this case the threat posed by an Allied victory: "Defend Her! This could be your mother, your wife, your sister, your daughter."

recruited to work in factories, particularly in munitions, aircraft, and other essential industries. The image of a strong, able-bodied woman began to appear in the media of mass impression for the first time, and a new feminist archetype, Rosie the Riveter, entered the cultural mainstream. On posters, in magazines, newsreels, and popular songs, she became an American hero. While the immediate postwar climate tried to squeeze her back into "the bottle," Rosie anticipated a significantly altered role that women would play in American society.

The situation regarding African Americans was more complex. Throughout the war, the Army remained segregated and routinely placed white Southern officers in charge of black companies, to keep these potentially "shiftless" soldiers in their place.

Meanwhile, black leaders began to openly question America's commitment to democratic ideals and racial equality. They demanded the employment of blacks in munitions factories, and eventually these jobs began to open up. On the cultural front, the fight against an overtly racist enemy abroad was ingeniously linked with the need to fight racist enemies at home.

In 1942 the *Pittsburgh Courier* was the largest circulating black newspaper in the United States. With both local and national editions, the paper influenced black readers throughout the country. Robert L. Vann, editor and publisher of the *Courier* had long used the paper to speak out against American racism.

In 1932, Vann worked actively to shift the allegiance of black voters away from the Republicans, considered the historic party of Lincoln, to support the Democrat Franklin Roosevelt, who, he was convinced, would be more supportive of African American interests. During the same period, he led a national protest against the popular radio program, *Amos n' Andy*, for its demeaning representations of black people and black life.

With Vann's death in 1940, leadership of the paper was passed to Ira Lewis, the managing editor, but the paper's commitment to fighting racial injustice did not subside. Two months after the United States declaration of war on December 8, 1941, the *Courier* launched what was called the "Double V" campaign, suggested to the paper by a letter from reader in Wichita, Kansas, James Thompson. Simply put, the double V's of the campaign stood for Victory over "our enemies

One V was for victory over our enemies overseas. The second V was for victory over our enemies in the United States. This campaign was an early step in the Civil Rights Movement. REPRINTED FROM THE *PITTSBURGH COURIER*

from without," and Victory over "our enemies from within." If black soldiers
were going to risk their lives to defend freedom overseas, the campaign insisted, 479
it was time for them to come home to an America in which they would enjoy
freedom as well.

Adopting a logo and pushing the message on a wide range of fronts, the V-V
movement was picked up by other papers and caught hold in black communities
around the United States, challenging the nation to live up to its ideals. FBI direc-
tor J. Edgar Hoover pushed for charging the papers with sedition. John Sen-
gstacke, publisher of the *Chicago Defender*, and, later, of the *Courier*, went to
Washington to protest this attempt at violating the black press's First Amendment
rights. With support from Eleanor Roosevelt, he met with Attorney General
Francis Biddle, and the Justice Department did not move forward on Hoover's
charges.[5]

By January 1944, White House support for the civil rights of Americans,
"regardless of station, race, or creed," was increasingly articulate. When FDR
issued his Economic Bill of Rights during his State of the Union Message that year,
he called for the assurance of gainful employment and a decent standard of liv-
ing, This new Bill of Rights also called for the guarantee of adequate food, cloth-
ing, education, housing, and healthcare for all Americans. The notion of a nation
divided between us and them was giving way to the ideal of a universal we. The
passage of the Serviceman's Readjustment Act, commonly known as the G. I. Bill
of Rights, would, in the postwar years, provide money for veterans to seek "edu-
cation and training and loan guarantees for a home, farm or business." Implicit
was an extension of formerly middle-class privileges to sectors of the society—
children of immigrants, African Americans, many working-class people—that
had not previously had access to these newly established prerogatives.

In the wake of these developments, many social obstacles were being sur-
mounted. Communists would be hunted down and blacks would continue to live
in segregated conditions, but the G. I. Bill helped to create a "white middle class"
that crossed prior barriers of class and ethnicity. The growth of the suburbs, the
emergence of television, and the expansion of automobility created a consumer-
defined America that went far beyond that of the 1920s. A house in the suburbs,
a lawn, an automobile, and a flood of consumer goods broke the hold that had ghet-
toized many white ethnics before that time, and offered them entry into a
homogenous American public, albeit an overwhelmingly white American public.

While the stereotype of the consumer offered many people the accou-
trements of prosperity, it also reasserted a middle-class idea of femininity that
was confined to the home, breeding new consumers at a boom rate and shop-

ping compulsively. Rosie the Riveter disappeared, at least for a while, and Mrs. Consumer was reborn. A malaise soon emerged beneath the surface of this ideal, but for a while the ideal dominated the stereotypical American landscape.

This new landscape marked the reemergence of a corporate culture that had flourished in the 1920s but had become ignominious after the balloon of the 1920s burst. Between 1941 and 1945, war production had reinvigorated the industrial apparatus, and Roosevelt's government, pressed by the dire need for armaments and other war material, became less confrontational with business. After the war, businessmen worried among themselves that the antibusiness mentality of the 1930s might reassert itself. To counteract this possibility, corporations began to organize public-relations strategies designed to convince the public that the private-enterprise system could deliver the economic and social stability that the American people so desperately sought. The American Way reemerged as a patriotic slogan, maintaining that capitalism and democracy were two sides of the same coin and that governmental intervention was both unnecessary and dangerously "un-American."

This way of seeing was used as a battering ram against a universal health-care bill in 1948, and it stood at the heart of consumerism and McCarthyism as they forged the dominant culture of the 1950s. It was also a weapon that supported the privately built housing boom of the 1950s, and demoted the idea of public housing to the status of blight.

With a rebirth of xenophobia—a fear of all things foreign—during the period, the iconography of 1950s consumer culture and politics reconnected with Nordic images of America and Americans. Newly middle-class people of immigrant backgrounds were expected to embrace the primacy of whiteness, and those who held to their ethnic identity, or expressed concerns about social justice, were branded as Communists or pinkos. It was a dangerous time for independent thought, and blending into the stereotypical American ideal seemed the safest route to travel. A station wagon was the vehicle of choice.

For black Americans, and other "colored" communities, the barbeque was not so inviting. While the military was finally integrated following the Second World War and the great American pastime of baseball broke the color line in 1947, segregation, social injustice, and unequal opportunity doggedly remained, upheld by overworked racial stereotypes that placed all but white people in positions of otherness. The V-V campaign had not achieved its goals, and millions of black Americans, many recently returned

from fighting for their country, were painfully aware of the betrayal. A battle against the inequities of power and the typecasting that helped to maintain them broke out in the middle of the 1950s, as "stereotypical" white Americans were busy watering their lawns.

On a public level, the battle came in waves. To a certain extent the V-V campaign had led the way, but by the early 1950s, new expressions of outrage against racial stereotypes, and the treatment of black people more generally, were becoming vocal.

In 1951, as television entered its "golden age," the NAACP launched a campaign to have *Amos n' Andy* taken off the air. The program had been a colossal hit from its beginnings on radio in 1928. The radio program featured two white actors mouthing mangled minstrel dialects and remained on the air well into the 1950s. On television, black actors were employed to play out the comedy, and the NAACP denounced the program, in which "every character is either a clown or a crook."

By 1953, CBS canceled the show, though an analysis by the television historian Pam Deane indicates that the NAACP protest may not have been the decisive factor. With actual black actors playing the main characters on the program, its removal may also have been an attempt by advertisers not to offend white Southern viewers. Deane also argues that the growth of black protests against racial injustice in the 1950s, and a hostile response from many whites, added to advertisers' unwillingness to associate themselves with anything black in this new and increasingly pervasive medium. As Deane describes it:

> Fear of White economic backlash was of special concern to advertisers and television producers. The idea of "organized consumer resistance" caused advertisers and television executives to avoid appearing pro-Negro rights. One advertising agency executive, referring to blacks on television, noted in Variety, "the word has gone out, No Negro performers allowed."[6]

Similar concerns led to the cancellation of the popular *Nat "King" Cole Show* by NBC in 1957. While the program was a showcase for some of America's biggest stars, black and white, the presence of a black host, even such a crossover star as Cole, made it impossible to attract a national sponsor. "Cole himself explicitly blamed the advertising agencies' readiness to be intimidated by the White Citizens Councils, the spearhead of resistance to desegregation in Southern states," writes the media scholar John D. H. Downing.[7]

Citizen Executioners

On February 7, 2006, The New York Times reported on a study published by a team of Stanford University psychologists in late 2005. Their research was designed to ascertain the ways that prison executioners are able to administer lethal injections, or other deadly procedures, without suffering severe moral qualms. According to the Times, the capacity to violate "taboos against killing" rests on the psychological ability to morally disengage from the consequences of one's own actions. As Prof. Albert Bandura, one of the authors of the study told the Times, this process helps to "explain how people can be barbarically cruel in one moment and compassionate the next."

The *Times* offered details in this sidebar:

'Everyone Was Doing It'

Dr. Albert Bandura of Stanford University has studied the psychology of moral reasoning for decades. He has identified eight mechanisms that people use to rationalize immoral behavior.

Moral justification	Soldiers learn to see killing in the context of a larger good; terrorists may say they are punishing "nonbelievers."
Euphemistic labeling	"Collateral damage"; "clean, surgical strikes"; and having someone "taken care of" are all familiar examples.
Advantageous comparison	Comparing an enemy to Hitler to justify an attack; or excusing a reckless act by comparing it to worse transgression by a rival or predecessor.
Displacement of responsibility	Shifting the blame to a boss, a leader or another authority figure; "I was just carrying out orders."
Diffusion of responsibility	Sharing the responsibility for a transgression with others who took part, or who played indirect roles: "Everyone was doing it."
Disregard or distortion of consequences	Refusal to acknowledge the reality of the damage caused; rationalizing that "it wasn't all that bad."
Dehumanization	Assailing others as degenerates, devils, savages or infidels. Some torturers refer to their victims as "worms."
Blaming the victim	The people being cheated or attacked are "asking for it."

Given the history of typecasting, it is glaringly clear that the mindset of the executioner can reach epidemic proportions among a population-at-large. The psychological mechanisms detailed in the sidebar are routinely employed to prepare populations for war, to marginalize those deemed "undesirable," and to vindicate assaults on basic human rights. The executioner, it turns out, may be worshiping in the next pew.

The compulsory homogenization of white American culture in the 1950s also saw the elimination of white ethnic programs—such as *The Goldbergs* and *Life* **483** *With Luigi.* Yet the demise of *Amos n' Andy* was intimately connected to struggles over civil rights for African Americans that would reshape the American social terrain.

A landmark Supreme Court decision in 1954 (*Brown v. Board of Education of Topeka*) mandated an end to segregation in American schools, a major assault on the institution of Jim Crow. The following year, on December 1, 1955, Rosa Parks refused to give up her seat in the "white" front part of a bus in Montgomery, Alabama. Her arrest for this infraction of Jim Crow law led to the Montgomery bus boycott of 1956 and launched the career of a youthful Rev. Martin Luther King, Jr. In 1957, federal troops forced the integration of Central High School in Little Rock, Arkansas, superseding Governor Orville Faubus, who had tried to use the Arkansas National Guard to resist integration. In 1961, the University of Mississippi, located in the nation's staunchest bastion of segregation, was forcefully integrated.

Under a different name, the V-V campaign was becoming the struggle of the century. Federal actions represented a major turnabout in policy, reassigning troops to the South for the first time since Reconstruction. While the goal was to protect the long-ignored rights of African Americans, black activism and a rising black consciousness were undeniably the stimuli that forced these actions to be taken.

The civil rights movement, and the rise of a newly visible black culture, transformed and emboldened elements of the white population as well. On a cultural level, embedded stereotypes of black people gave way to an appreciative embrace of black forms of expression. Beat poets and novelists, along with satirical jaw smiths such as Lenny Bruce and Dick Gregory, saw the historic sounds of jazz and the blues as pivotal inspirations for a new, irreverent voice, challenging the cheerleaders of "white bread" Americanism.

Rhythm n' blues, traditionally known as "race music," fused with the country sound and gave birth to rock 'n' roll, a sexually charged fusion that brought blacks and whites together on stage and in the audience. Other interminglings would follow. Taboo, the psychic core of typecasting, was being tested.

A violent response followed. White racists denounced rock 'n' roll as "jungle music." Many radio stations refused to play it. Some ministers railed against "the beat" as the devil's work. But, still, they could not stop it.

The fusion reflected the rise of unprecedented relations between young black and white people, on a mass scale that would define the politics and cul-

ture of the 1960s and 1970s. The Freedom Rides and then, in 1964, the Mississippi Freedom Summer brought together a multiracial coalition of students from around the country who embodied a living model of human community not seen in the South since Reconstruction; rarely seen anywhere else in American life.

An emerging and prominent black consciousness propelled the civil rights movement in the 1960s. Initially, the demand was for inclusion, for an end to the color line, and for full participation in the promise of American life. Implicit in this struggle was the belief that centuries of typecasting must be left behind and that principles of racial equality must govern the ways that people saw and acted toward each other. In time, this perspective would be challenged by a separatist strain of nationalism, but for a significant moment, an ideal of social unity prevailed.

An allied and simultaneous development began to affect deeply implanted patterns of gender inequality as well. The appearance of a new feminism in the mid- to late-1960s echoed issues that had been percolating since the eighteenth century and responded with force against passive and one-dimensional ideals of femininity. It was a profound call for equality and, just as civil rights required questioning many of the fundamental structures of society, the women's liberation movement provoked a questioning of the fundamental structures of family and sexuality that assumed male dominance. Against objectified female stereotypes, pandemic in the mainstream culture, many began to look for an identity that celebrated women as active, thinking beings, as people who did not require the accouterments of a consumer culture, or a man by their side, in order to be complete.

American involvement in the Vietnam War, which went into full gear in 1965, offered another opportunity to imagine a world that moved beyond stereotypical blinders. The war was one long chapter in the disintegration of old European empires.

Following the Second World War, a devastated Europe was unable to maintain control over many of its historic colonies. One after another, independence movements shook colonial rule, and new postcolonial nations were being born. Vietnam was part of this development. While Vietnam was formerly part of French Indochina, the Vietnamese successfully defeated French Airborne and Foreign Legion troops in 1954 at the battle of Dien Bien Phu. This ended a war against French rule that had begun in the region in 1946. When the French withdrew, anti-Communism in America was at its height, and American military "advisors" and covert agents began filtering into the country to undermine the

Viet Minh, the anticolonial Vietnamese army that American leaders saw as a
major target in the ongoing fight against the "Red Menace."

After ten years of largely ineffective covert action, the American war began in
earnest and was pursued with many of the preconceptions that had shaped Euro-
pean readings of colonized people for centuries. Men who still carried the bag-
gage of racial science in their minds led the American war against the Vietnamese.
General William Westmoreland, who commanded American troops, offered a
cogent example of this attitude when he told a journalist, "The Oriental doesn't
put the same high price on life as does a Westerner. Life is plentiful. Life is cheap
in the Orient." Scientists had made similar judgments about American Indians in
the 1830s—that they were soulless savages who would rather die than submit.

Another preconception was that this "inferior" enemy would quickly suc-
cumb to America's daunting military superiority. The inability to imagine the
Vietnamese as resourceful fighters and as proud people who were defending
things that mattered—their lives, their homeland, and their values—was the fatal
flaw in America's decision to pick up where the French had left off.

Meanwhile, the war provided many Americans with an opportunity to witness
the arrogance of the nation's customary worldview in a new light. Some began to
see themselves as citizens of the world, and shortly a momentous antiwar move-
ment emerged, challenging the fundaments of American foreign policy and, more
significantly, an American Way of Life that was predicated on subjugating peo-
ple around the world. As the war wore on and preconceptions were unmasked,
the antiwar movement began to stir among ground troops, who saw the futility
of their mission firsthand. During the late 1960s, in Europe similar reevaluations
of Western superiority were taking place. Different ways of seeing, on many
fronts, were coalescing.

Concomitant to these historical shifts, a wide range of people in the United
States began to speak out on behalf of their formerly hidden humanity. In
1968, American Indians founded the American Indian Movement, initially
creating patrols to defend themselves against police brutality in Minneapolis.
By 1971, AIM would be a national coalition of chapters, asserting dignity and
demanding rights.

Similar rumblings were taking place among young Puerto Ricans, and The
Young Lords, a turf gang in Chicago, reinvented themselves in 1968 as an orga-
nization in defense of Puerto Rican rights. In 1969, a group of college students
in New York created an east-coast group and soon joined with their Chicago
comrades to form the New York chapter of a newly emerging Young Lords polit-
ical organization. An incipient Asian-American consciousness was emerging,

though less vociferously, during the same years. Among Latinos and Asians, as with the American Indian Movement, treatment by police was a central organizing issue.

All of these movements, beyond their call for full rights of citizenship, were percolating among segments of the population formerly relegated to the powerless margins of society. As is often the case with those whose social and economic power is limited, they were also people who were routinely dehumanized by typecasting. By extending their voices into civic life, they broke a long cultural silence and defied established boundaries governing who would be included in the public face of America.

Nowhere was this defiance more unsettling than in the period following the Stonewall Riots in Greenwich Village in 1969. Stonewall is generally considered the start of the gay rights movement. The riots, in response to a police action against patrons of a gay bar named the Stonewall Inn, gave rise to a politics that moved beyond issues of race, ethnicity, and heterosexual gender inequities and embodied a deeply disturbing assault on the prevailing sexual universe. Male and female homosexuals were demanding that their lives be allowed to emerge from the shadows and that their beings be accepted within the general community. In this simple and straightforward appeal, a taboo was being broken, an appeal that constituted a rebellion against heterosexual hegemony. It was a call for inclusion that panicked many people in their deepest recesses and continues to be the most threatening challenge to accepted ideas of normalcy.

These revolutionary incursions into the realm of public discourse and the breakdown of institutions that had upheld a uniform interpretation of the United States took place on a variety of levels. Beyond rhetoric and politics, these calls for inclusion contained stylistic strategies that flagrantly rejected the sterile standardization of 1950s and early-1960s consumer culture. Style, once dictated by Hollywood, Madison Avenue, and other wings of the consciousness industries, began rising from the streets. Many African American youth, resisting the conk, let their hair come in natural. Young women, raised on the idea that makeup and dresses were part of growing up, explored new avenues of appearance that stood apart from the iconic dictates of fashion. Neatly clipped young men let their hair grow long, and people started exploring their roots and forsaking their faith in mass-produced goods.

An attack on wastefulness, the embrace of indigenous ethnic cultures, the celebration of diversity, and the conspicuous assault on social and sexual taboos were not simply adaptations to "changing styles." They were part of an active and wholesale refusal of social norms, which they denounced as a plastic facade

covering the hypocrisies of everyday life. Beneath peace, there was war. Beneath freedom, regulation. Beneath justice, oppression. Beneath prosperity, the sys-
tematic destruction of the environment. Beneath the smiling face, wrote poet Allen Ginsberg, lay "a library filled with tears."[8] And beneath America lay the untold stories of those who had been hidden from history. The heritage of type-casting was eroding, and new renditions of humanity were coming to the sur-face. A vision of America that had begun to be seen in the 1930s, and had then gone into hibernation, was reawakening.

For some, these changes constituted an emancipation, new ways of seeing themselves and their world. For others, the world as they knew it was being turned upside down, and their investment in a comfortable, conflict-free Amer-ica was under siege. Alongside 1960s radicalism, a white backlash was gathering, a so-called "silent majority" seeking to stem the tide. Civil rights, while it opened up the world for black Americans, and captured the imaginations of many oth-ers, brought an angry white response against the rights being affirmatively extended to those who had been long denied. Men, in the face of women who no longer wanted to know "their place," often felt threatened, their biblical sense of masculinity undermined. Gay rights frightened nearly everyone who held to the religion of heterosexual normalcy. While opening new doors, the period of the 1960s and 1970s gave rise to a sharply divided United States and a sharply divided world that have defined much of the political landscape ever since.

The proverbial line in the sand separates sharply differentiated worldviews. The division is inseparable from the decline of a white Western monopoly over the powers of description. Typecasting is not simply about representation; it is the language of power. As new voices entered the public sphere and alternative descriptions of reality surfaced, a lexicon shaped by centuries of control was desta-bilized, and the locus of power was challenged.

As historic lines of power and possibility were challenged and began to shift to people damned by threadbare taxonomies, new images began to be projected, enriching and broadening the cultural tableau. In the United States these changes were indivisible from issues of empowerment. In the decades following the Sec-ond World War, particularly from the late 1960s onward, the political and eco-nomic topography of American life became unrecognizable and alarming to those whose comfort zone depended on old structures of power and inequality.

Job opportunities and income levels rose among previously second-class populations. The presence of women and minorities in elected positions grew exponentially, though certain havens—the presidency and, to a somewhat lesser extent, the Senate—have remained exclusive clubs. Heretofore all male, all

white professions became more diverse. For the millions who benefited from this sea change, the protection of long-denied rights, and the maintenance of an egalitarian, nondiscriminatory picture of America formed the cornerstone of their political vision.

Things have changed, yet, in crucial ways, they remain the same. This is the paradox of typecasting. In many ways we inhabit a world in which people, long denied, are out of the closet. This fact has transformed the fabric of the culture in significant and visible ways. At the same time, the new faces of the twenty-first century exist in the shadow of growing disparities of power. As long as these inequalities exist, the efficiency of splintering newly emergent people into distinct groups carries on and has become systematized using modern tools of measurement.

A powerful example of this situation is found in strategies of influence that have become solidified in the wake of the 1960s. While for many people diversity was a matter of being recognized as human and included within public life, for those engaged in marketing products and ideas, it reconfigured the physics of persuasion. Prior to the 1960s, images of America had been unvaryingly typecast in an Anglo-American mold. In advertisements, at anchor desks, and in mass entertainments, a narrow rendition of the American endured.

The movements of the 1960s alerted marketers, advertisers, and perception management specialists that people brought different outlooks to the world and that effective salesmanship required taking these outlooks into account. Beginning in the 1970s, segments of the population started being profiled in detail, and target marketing became established.

New instrumental and statistical stereotypes were developed—informed by race, ethnicity, economic class, and lifestyle—to describe the sensibilities that consumers, or audiences, or voters would bring to their decision-making process. In business, and, increasingly in politics, messages were customized to appeal to these stereotypical aggregates and, in the process, identity became raw material for the management of opinion and behavior.

Recent visions of distinct ethnic, racial, and sexual identities were initially grassroots responses to the effronteries of history and constituted the demand to be included in the larger American community. Soon, they would be repackaged to guide marketing and communications strategies. On the one hand, the principle of diversity challenged a culture in which America had been narrowly defined, excluding many from its official image. At the same time, new articulations of diversity contributed to a politics of difference that is routinely exploited to package messages for particular groups, at times dividing type against type, particularly in the political sphere. Self-defined groups became mar-

kets: the gay market, the Hispanic market, and so forth. Focus groups permit
further refinement of these categories and of the ways these categories intermix
in response to products or messages. On the surface lie a hundred flowers of
diversity—beneath the surface, calculated approaches to control.

The impulse to delineate predictable profiles has only been enhanced by com-
puterized technologies of mapping and surveillance. While ethnicity, physiognomy,
and sexual orientation may play roles in consumer decisions, or in political out-
look, individual profiles that are incrementally assembled by behavior-surveil-
lance programs, particularly on the Internet, provide finely tuned dossiers that are
intended to predict the way a particular "type" of person will think and behave.
These profiles are of great value to individuals or organizations that can profit from
them in promoting goods, services, entertainments, and political ideologies.

Similar technologies are used to track crime, and the incidence of crime, on
a block-by-block basis, in particular parts of a city. The very same machinery that
can locate a likely consumer or voter can be used to break a city down into law-
abiding regions, where people and businesses must be protected, and enemy ter-
ritories, where keeping people in check is a high priority. Policing is increasingly
based on these maps, and the simple fact of living in a "high-crime" neighborhood,
or looking like people who do, enhances the likelihood of being harassed or bru-
talized by law enforcement. These practices are inseparable from racial profiling
and hearken back to identification systems used to control colonized people, or
"savage" elements in the midst of civilization. The machinery may be new, but
the goals are longstanding.

It is at the crossroads between law enforcement and typecasting that the rela-
tionship between stereotype and power is most visible. It may lead to the mur-
der of a hard-working immigrant from Guinea who, reaching for his wallet,
receives forty-one bullets and a funeral in return. It may promote a mental envi-
ronment in which the arbitrary harassment, detainment, or brutalization of Mus-
lims or Sikhs—or anyone else whose complexion draws suspicion—becomes
tolerable in a society that prides itself on its respect for people's right to live freely.

Alongside these changes, many fundamental inequities have persisted, and with
them a different politics. The post–Second World War era has, in significant
arenas of social and economic life, exacerbated the gap between rich and poor.
Globally, wealth and political influence remain in the hands of a small number
of people. Powerful men in primarily Western nations continue to dictate the
terms of life lived by people around the world. A handful of corporations exer-
cise a stranglehold on world politics and define the terms and limits of economic

development. Globalization is widening the gap not only between rich and poor countries, but also between the rich and poor in supposedly wealthy countries. In the United States, for example, the gap between rich and poor is the widest it has been since the 1920s, with "the top 1 percent earning 17 percent of the gross income."9

For these dominant forces, the preservation of typecasting is indispensable. Few in numbers, would-be Masters of the Universe rely on strategies of consensus building that will generate feelings of identification between ordinary people, many of whom are experiencing hard times, and themselves. To achieve this effect, they wrap their agendas in a veil of homespun familiarity. They also vigorously promote and sustain corrosive images of those who stand in their way. In the process, they dip into a paint box that has been put together over the centuries.

Echoing George Combe and Samuel Morton, who provided a rationale for the extermination of American Indians, and reiterating a perspective that William Westmoreland brought to the Vietnam War, President George W. Bush justified the Iraq War as a righteous crusade against "an enemy that has no conscience."

> [T]hese people are brutal. They—they're the exact opposite of Americans. We value life and human dignity. They don't care about life and human dignity. We believe in freedom. They have an ideology of hate. And they're tough, but not as tough as America.10

In the face of such barbarians, plucked from Central Casting, the President's 2004 announcement that America's mission was to spread liberty and freedom around the world assumes a tone of divine calling akin to Manifest Destiny or the White Man's Burden. In a world of "new-caught, sullen peoples, Half devil and half child," as Kipling put it, Bush's pledge "to seek and support the growth of democratic movements and institutions in every nation and culture, with the ultimate goal of ending tyranny in our world," is but a sugarcoated assertion of freshly recharged imperial designs. The human tragedy of September 11, 2001, provided those with designs on Iraq's vast oil reserves with a golden opportunity to launch a preemptive war in the name of justice.

The irony of it all is that, despite insistent claims to the contrary, the men who plotted the attacks of September 11th had no links with Iraq or with Iraq's leadership. A calculated shift from Osama bin Laden to Saddam Hussein, from al-Qaeda to Iraq as the enemy, was the necromancy of leaders who envision a pub-

lic among whom reason and judgment play no role in its perception of the world.

In 1895, Gustave Le Bon wrote that for a leader to effectively communicate 491
his ideas to the masses, the ideas must be presented "in the guise of images, and
are only accessible to the masses under this form. . . . These image-like ideas are
not connected by any logical bond . . . and may take each other's place like the
slides of a magic lantern which the operator withdraws from the groove in which
they were placed one above the other."[11]

This rule of thumb continues to guide the drills of persuasion. For skilled prac-
titioners in the arts of mass impression, a vast historical museum of stereotypes is
readily available. Mental fragments, dislodged from their historical and philo-
sophical moorings but still poignant, capable of stirring up feelings, are waiting on
the shelves for use at any appropriate time. The state of perpetual war that
presently defines American politics is built on exhibits on loan from the Islamic wing
of the museum of stereotypes, whose collection dates back to the crusades.

Domestically, the growth of a corporate state and right-wing politics has also
promoted a culture of divisiveness built on a chimera of us and them. Claiming
to speak for a "simpler time" when unfettered capitalism was sacred, and rights
were severely limited, conservative strategists summon up a nostalgic illusion of
a society made up of small businesses and family farms, where ordinary people leave
their doors unlocked and have control over their lives.

In defense of this daydream, the broadening of the American template and the
questioning of archaic prejudices are slandered as threats to "our basic American
values." The campaign to eradicate the social, economic, and political gains that
accrued between the New Deal and the election of Ronald Reagan has been
recast under the catchphrase "culture wars," a euphemism for the struggle to
reinstate the principles of a society that was built on the premise of Anglo-Amer-
ican superiority. In the process, liberalism has been effectively demonized, erad-
icating the idea that government has an obligation to protect the people from
the excesses of private power. The ghost of Galton seems everywhere.

The Christian Right has played an important role in the resurrection of type-
casting as a strategy of power. At it first developed, Protestantism was predicated
on the notion that no authority could intervene between the individual believer
and God. Faith was a matter of continual self-examination in relation to the
Word. Protestantism rejected the notion that the clergy, or secular authorities,
should have the power to dictate a person's beliefs. Amid the culture wars, how-
ever, this foundational Christian doctrine has been disposed of.

Ministers routinely tell their congregations that God is angry with those who
question stipulated stereotypes of family, community, religion, and patriotism.

Challenges to sexual codes of belief are particularly diabolical and rampant across the land. It is the responsibility of good Christians, congregations are instructed, to uphold timeless definitions of good and evil, to save America from the devils of secularization. At the vortex of this imperative, homosexuality and the autonomy of women are typecast as the most ominous threats to morality and to life. In the name of God, these heresies must be exorcised. In the process, godliness claims its most gruesome historic role, as an unforgiving bludgeon against alleged heretics and infidels.

Nowhere was this trend more evident than on September 13, 2001, two days after terrorists committed deadly attacks on New York and Washington. On that day, Jerry Falwell offered an explanation of why the attacks had taken place. It was God's judgement against a fallen America.

> I really believe that the pagans, and the abortionists, and the feminists, and the gays and lesbians who are actively trying to make that an alternative lifestyle, the ACLU, People for the American Way, all of them who have tried to secularize America. I point the finger in their face and say, "You helped this happen."

Falwell was taken to task for his hateful interpretation of 9/11, but even in apologizing he reasserted its basic premise. "I do believe, as a theologian, based upon many scriptures and particularly Proverbs 14:23, which says, 'living by God's principles promotes a nation to greatness, violating those principles brings a nation to shame.'"[12] Unasked, but more pertinent, was the question of whether an arrogant claim to speak for God's principles is an indication of greatness or of shame. This is a question, not only for Reverend Falwell, but also for the Christian Right overall.

Bob Jones University, in Greenville, South Carolina, has long been an obligatory campaign stop for conservative politicians wishing to curry support among fundamentalist Christians. The liberal arts college, which promotes itself as standing "without apology for the old-time religion and the absolute authority of the Bible," also had a fifty-year restriction against "interracial dating." Regarding the policy, Jonathan Pait, Coordinator of Community Relations for BJU, explained in 1998:

> God has separated people for His own purpose. He has erected barriers between the nations, not only land and sea barriers, but also ethnic, cultural and language barriers. God has made people different

one from another and intends these differences to remain. Bob Jones
University is opposed to intermarriage of the races because it breaks
down the barriers God has established. It mixes that which God separated
and intends to keep separate.

While this spokesman for the "absolute authority of the Bible," acknowledged
that "there is no verse in the Bible that dogmatically says that races should not
intermarry," he insisted that "the whole plan of God as He has dealt with the
races down through the ages indicates that interracial marriage is not best for
man. . . . The people who built the Tower of Babel were seeking a man-glorify-
ing unity which God has not ordained. Much of the agitation for intermarriage
among the races today is for the same reason."

According to this remarkably candid exegesis, the unity of humankind goes
against God's wishes. Separation and enmity, rather than being the outcome of
human struggles for power and domination, are canonized as the plan of the
Lord, and are not to be trifled with.[13]

The rule against interracial dating was rescinded in March 2000, after can-
didate George W. Bush gave a campaign speech there, one that drew consider-
able criticism. To protect Bush's candidacy, President Bob Jones III abolished the
rule, but he refused to distance the University from the interpretation that had
given rise to the ban, insisting, "the principle upon which it was based is very
important."[14]

In the movement's hubris, the sanctity of individual belief, of nonintervention, has
given way to a vision of the church as an enforcer of taboos. The creation of a more
inclusive society required the shedding of naturalized dogmas of difference and the
abandonment of deep-seated restrictions on sexual life and on the choice of mates.
The reassertion of taboo narrows those choices once again and reaffirms a religion
of essential and unequal distinction. In the process, it provides a useful ecclesiasti-
cal cover for escalating inequities of power and wealth at home and abroad.

• • •

The poem began, "America, I've given you all and now I'm nothing." It was writ-
ten on January 17, 1956. The words were those of Allen Ginsberg, a gay, Jewish
cosmopolite, who wrote them and those that followed in a soon-to-be-radicalized
Berkeley, California.

To some extent the poem was a raucous declaration of independence from

the postwar American spectacle, the new consumer paradise in which television was a decontaminated tunnel of perception, and in which "Businessmen are serious. Movie producers are serious. Everybody's serious but me."

Ginsberg's "America," as the poem was named, was a response to history unfolding. "I've given you all and now I'm nothing" was an apt grievance for the children and grandchildren of slaves on whose backs a nation was built and whose payment had been racial defamation.

It was a fitting statement for mothers and daughters and sisters who had not had the vote until 1920 and who, in 1956, still lived under the thumb of unequal rights and with an intimate knowledge of sexual violence.

It was an indictment of those who had dubbed hard-working, poorly paid immigrants "polluters of the race," "morons," and "feeble-minded" parasites. "America I still haven't told you what you did to Uncle Max after he came over from Russia."

It spoke for people, at home and abroad, who were libeled in the media, in scientific tomes, in aesthetic verdicts, in dictionaries, and thesauruses, while, in their actual communities, they were hunted down by police or Army Rangers.

It was a call to arms for those who had long been denied a stake in the City on the Hill called America. "My mind is made up," Ginsberg's elegy warned, "there's going to be trouble."

If "America" was a clairvoyant anticipation of issues that would catch fire in the decades to come, it also provided a solemn epitaph for those who were brutalized by the history recounted in this book.

"I've given you all and now I'm nothing." These words also spoke for an innocent girl from Circassia, whose skull sat among the bone collection of Johann Friedrich Blumenbach, and who became an inspiration for the invention of the Caucasian race. Without being asked, she was turned into a benchmark for invidious comparisons with the skulls of those Asians and Africans and Malaysians and American Indians who were deemed by the judgments of racial science to be "degenerate."

"I've given you all and now I'm nothing" spoke for the dead Africans whose bodies were cut up for public edification by Petrus Camper. Or for Saartjie Baartmann who was poked and mocked in life, and who, after she died, had her genitals put on display at the Muséum national d'histoire naturelle in Paris. They spoke for Ota Benga, and for countless Bushmen, Laplanders, and live "Wild Indians" who served in the circuses of European superiority and on the midways of world's fairs as reminders of Western industrial progress. They spoke for the Inuit family that could not survive the humiliation of being exhib-

ited at the Museum of Natural History. They spoke for Renty, an African-born slave, and his American-born daughter, Delia, who were paraded half-naked **495** before the camera of J. T. Zealy to provide Louis Agassiz, the eminent Harvard zoologist, with visible evidence that Negroes and Europeans were the progeny of two different and unequal species. "I've given you all and now I'm nothing," say the dead Indians of the Americas whose crania were used by Combe and Morton to justify a path toward genocide.

The words are those of the Jewish schoolboys and prison inmates whose faces were photographically fused to locate the type within the individual, an enterprise that would lead to the criminalization of those with the wrong facial features, and to eugenics, a system designed to cut off the bloodlines of "the unfit." They are those of Giuseppe Vilella, whose corpse was dissected by Cesare Lombroso, to prove that the lower classes of European society shared the biological degeneracy of "the colored or inferior races." That they were "savages living in the middle of a flourishing European civilization." They spoke for Carrie Buck and her mother Emma, and her eight-month-old daughter Vivian, who were judged "feeble-minded" so that a small number of powerful men could safeguard the purity of the Nordic stock.

"I've given you all and now I'm nothing," say Oscar Wilde, and Tambo and Bones, and Edna Pontellier, the heroine of Kate Chopin's *Awakening*, who walks into the sea when faced with a world unable to fathom the idea an independent woman. "I've given you all and now I'm nothing," say Amadou Diallo and Matthew Shepard, two innocent men in the wrong place, at the wrong time, with the wrong guys.

• • •

Since September 11, 2001, much of the West has been gripped by a stereotyping frenzy. In the United States, it has been particularly virulent. It is an increasingly difficult time for those who look Muslim, or do not look "American," regardless of their thoughts, aspirations, or behavior. It is also a difficult time for those who dare to raise questions about where this typecasting is leading us, about the dismantling of civil rights and liberties that has come in its wake, and about the resurgent dream of empire that has shaped much of modern history.

In the cosmology of typecasting, the mental picture of evil assumes a vague shape. Within the socially reinforced familiarity of their own group, people readily acknowledge the importance of their individuality and of their individual

thoughts and actions. Within the constructions of the "foreign" or the "strange," however, images are indistinct. They blend into each other in an amorphous miasma of otherness. While the unfamiliar or the unknown can be broken down into categories when the pragmatics of power call for it, they can just as easily be eviscerated of all specificity. They can be seen as occupying no history, no geography, no urgency, or culture—no time, space, or explanation.

When this happens, they become an indistinguishable collection of threatening symbols, whose connection with one another lives primarily in the mind of the viewer, or in the cynical manipulations of the demagogue. When historical understanding and informed discussion give way to a simplistic theater of symbols, all ideas, information, knowledge, and experience are reduced to easily evoked feelings, separated from meaning. Thought is contemplative. Symbols incite reactions. When an enemy is invisible, living in caves on the other side of the earth or in the recesses of our darkest imagination, he is easily transformed into a phantom, the inchoate demon of fairy tales and childhood dreams.

Times like these, when the distinctions between the mental pictures of civilized humans and those of atavistic brutes are apparently unbridgeable, are particularly dangerous. The possibility of comprehension vanishes, is vilified as a sign of weakness, and primal fear takes over. People are required to make a choice. Will it be them or us? Patriot or collaborator? Human or a brute that must be disciplined by "shock and awe"?

The impulsive responses provoked by such imperatives are many. They may plant us in front of the television, where the pabulum of certainty can replace the inner doubts and existential loneliness that can come with critical thinking that is out of step. They may send us to action films where a divided world is crystal clear, where geopolitics becomes a storyline, where the righteousness of truth and justice win out. They may send us to the mall, where we can join the army of consumers and find a prefabricated sense of belonging. They may carry us online, in a desperate search for alternative ways of seeing, to connect with others under the cover of anonymity, or to escape into an immaterial world. They may send us to the plastic surgeon, who will eradicate all signs of aesthetic difference and provide us with a facade of normalcy. Though not conversant with Lavater's law of first impressions, some may walk the streets, ride the subways, or pass through airport checkpoints sizing up others and looking for the physiognomic signs of "moral deformity." They may send us to a house of worship, to be reassured that the choices we are making are God's choices. They may make many people susceptible to a blind faith in authority and an acceptance of authoritarian measures, even when

facts might compel them in other directions. They may send us into war, to destroy the brute and, perhaps, to become the brute, reconfigured in the name 497 of patriotic duty.

In a complex and dangerous world, the allure of the simple is addictive. There are choices to be made, but the habits of typecasting, despite their easy digestibility, can offer us little wisdom. We must educate ourselves to understand these habits, to know where they come from, and to demand a public language based on knowledge, understanding, and a belief in the possibility of egalitarian community. Without this, democracy cannot exist.

NOTES

CHAPTER 1: DIDOT'S INVENTION

1. *Encyclopedia Britannica*, 15th ed., s.v. "Chappell, Warren"; Chappell, *A Short History of the Printed Word*, 84.
2. Man, *Gutenberg: How One Man Remade the World with Words*, 125-126.
3. Gordon, *Stereotypy of Imagery and Belief as an Ego Defence*, 3.
4. Münsterberg, *The Photoplay: A Psychological Study*, 37, 41.
5. DeMille, *The Autobiography of Cecil B. DeMille*, ed. Donald Hayne, 144.
6. Lippmann, *Public Opinion*, 60-61.
7. Münsterberg, *The Photoplay: A Psychological Study*, 50.
8. Lippmann, *Public Opinion*, 105.
9. Ibid., 64-65.
10. Ibid., 59.
11. Ibid., 60-61.

CHAPTER 2: THE COMPANY OF STRANGERS

1. Braudel, *The Structures of Everyday Life: The Limits of the Possible*, Vol. 1, *Civilization & Capitalism 15th–18th Century*, 49.
2. Ibid., 479.
3. Fox-Genovese and Genovese, *Fruits of Merchant Capital: Slavery and Bourgeois Property in the Rise and Expansion of Capitalism*, 3–25.
4. Wallerstein, *The Modern World-System: Capitalist Agriculture and the Origins of the European World-Economy in the Sixteenth Century*, 108–109.
5. Chandler and Fox, *3000 Years of Urban Growth*, 117–118, 137.
6. Hill, *The World Turned Upside Down: Radical Ideas During the English Revolution*, 48–49.
7. Braudel, *The Structures of Everyday Life*, 490.
8. Rudé, *The Crowd in History: A Study of Popular Disturbances in France and England 1730–1848*, 63.
9. Meijer, *Race and Aesthetics in the Anthropology of Petrus Camper 1722–1789*, 57–58.
10. Wallerstein, *The Modern World-System: Capitalist Agriculture and the Origins of the European World-Economy in the Sixteenth Century*, 42.
11. Ibid., 91.
12. Williams, *Capitalism & Slavery*.

CHAPTER 3: CREATED EQUAL

1. Man, *Gutenberg: How One Man Remade the World with Words*, 164–190.
2. Chappell, A *Short History of the Printed Word*, 84.
3. Jefferson, *The Life and Selected Writings of Thomas Jefferson*, 261–262.

CHAPTER 4: VISUAL TRUTH

1. Berger, *Ways of Seeing*.
2. Steadman, *Vermeer's Camera: Uncovering the Truth Behind the Masterpieces*, 4; Hockney, *Secret Knowledge: Rediscovering the Lost Techniques of the Old Masters*, 205; *Encyclopedia Britannica*, 15th ed., s.v. "Al Hazen."
3. "Great Theosophists," *Theosophy* 26, no. 2 (December 1937): 50–56.
4. *Encyclopedia Britannica*, 15th ed., s.v. "Roger Bacon."
5. Hockney, *Secret Knowledge*, 206; Steadman, *Vermeer's Camera*, 178.
6. Richter, ed., *Selections from the Notebooks of Leonardo da Vinci*, 115–116.
7. Steadman, *Vermeer's Camera*, 6.
8. Ibid., 9–10.
9. Hockney, *Secret Knowledge*, 210; Steadman, *Vermeer's Camera*, 8.
10. Steadman, *Vermeer's Camera*, 10–11.
11. Hockney, *Secret Knowledge*, 210.
12. Steadman, *Vermeer's Camera*, 44–46.

CHAPTER 5: CURIOSITY CABINETS

1. Ross, "The Suppression of Important News," *Atlantic Monthly*, March 10, 1910, 363.
2. Altick, *The Shows of London*, 5–6.
3. Ibid.
4. Man, *Gutenberg: How One Man Remade the World with Words*, 59–64.
5. Farber, *Finding Order in Nature: The Naturalist Tradition from Linnaeus to E. O. Wilson*, 22.
6. Altick, *The Shows of London*, 12.
7. Farber, *Finding Order in Nature*, 23; Altick, *The Shows of London*, 14.
8. Farber, *Finding Order in Nature*, 24.
9. Ibid., 23.
10. Schiebinger, *Nature's Body: Gender in the Making of Modern Science*, 3; Altick, *The Shows of London*, 14; Richardson, *Death, Dissection and the Destitute*, 35.
11. Staehlin, *Original Anecdotes of Peter the Great*, 92–95, 234–235.
12. Altick, *The Shows of London*, 17–21.
13. Meijer, *Race and Aesthetics in the Anthropology of Petrus Camper 1722–1789*, 164.
14. Altick, *The Shows of London*, 15–26.
15. Farber, *Finding Order in Nature*, 13, 29.
16. Richardson, *Death, Dissection and the Destitute*, 35.
17. Bogdan, *Freak Show: Presenting Human Oddities for Amusement and Profit*, 29.
18. Ibid., 29, 32–33, 35, 127.
19. Schiebinger, *Nature's Body*, 115–116.
20. Farber, *Finding Order in Nature*, 91.

CHAPTER 6: PHYSIOGNOMY: THE SCIENCE OF FIRST IMPRESSIONS

1. Aristotle, *The History of Animals and Treatise on Physiognomy: Vol. VIII of The Works of Aristotle*, trans. Thoms Taylor. *See also* Aristotle, "Physiognomica"; Aristotle, *Prior Analytics*, trans. A. J. Jenkinson. In *Prior Analytics* Aristotle argues that it is possible to infer character from features, if it is granted that the body and the soul are changed together by the natural affections: "I say 'natural,' for though perhaps by learning music a man has made some change in his soul, this is not one of those affections which are natural to us; rather I refer to passions and desires when I speak of natural emotions. If then this were granted and also

that for each change there is a corresponding sign, and we could state the affection and sign proper to each kind of animal, we shall be able to infer character from features."

2. Simms, *A New Physiognomical Chart of Character*, 3.
3. Lavater, *Essays on Physiognomy One Hundred Physiognomical Rules, and A Memoir of the Author*, trans. Thomas Holcroft, 47.
4. Ibid., 47.
5. Ibid., 11.
6. Ibid., 95, 171.
7. Ibid., 83.
8. Ibid., 84.
9. Gordon, *Stereotypy of Imagery and Belief as an Ego Defence*, 390–391, 395–396.
10. Lavater, *Essays on Physiognomy*, 34.
11. Ibid., 35.
12. Ibid., 36.
13. Ibid., 186.
14. Ibid., 140–141.
15. Ibid., 163–164.
16. Ibid., 63–64.
17. Ibid., 339.
18. Jefferson, *The Life and Selected Writings of Thomas Jefferson*, 256.
19. Lavater, *Essays on Physiognomy*, 273.
20. Ibid., 339–340.

CHAPTER 7: THE TAXONOMY OF HUMAN DIFFERENCE

1. Lieberman, "Upending the Expectations of Science," *New York Times*, July 14, 2002.
2. Wilford, "A Fossil Unearthed in Africa Pushes Back Human Origins," *New York Times*, July 11, 2002.
3. "An Unexpected Face," *New York Times*, July 12, 2002.
4. Gould, *The Flamingo's Smile: Reflections in Natural History*, 93, 160.
5. Ibid., 161.
6. Linneaus, *Systema Naturæ Per Regna Tria Naturæ, Tomus I*, 9–33.
7. Schiebinger, *Nature's Body: Gender in the Making of Modern Science*, 11.
8. Ibid., 21–26.
9. Linneaus, *Systema Naturæ*, 20–23; Gould, *The Mismeasure of Man*, 404.
10. Linneaus, *Systema Naturæ*, 20–22.
11. Gould, *The Mismeasure of Man*, 71.
12. Meijer, *Race and Aesthetics in the Anthropology of Petrus Camper 1722–1789*, 169.
13. Schiebinger, *Nature's Body: Gender in the Making of Modern Science*, 153.
14. Blumenbach, *The Anthropological Treatises*, 265.
15. Ibid., 264.
16. Linneaus, *Systema Naturæ*, 211; Gould, *The Mismeasure of Man*, 402.
17. Blumenbach, *The Anthropological Treatises*, 265.

CHAPTER 8: CAMPER'S ANGLE

1. Burckhardt, *The Civilization of the Renaissance in Italy*, 123, 128.
2. Hauser, *The Social History of Art*, Vol. 2, *Renaissance, Mannerism, Baroque*, 93–94.
3. Mosse, *The Image of Man: The Creation of Modern Masculinity*, 29.
4. Hauser, *The Social History of Art*, Vol. 3, *Rococo, Classicism, Romanticism*, 142–143.
5. Mosse, *The Image of Man: The Creation of Modern Masculinity*, 28.

6. Hauser, *The Social History of Art*, Vol. 3, 141.
7. Mosse, *The Image of Man: The Creation of Modern Masculinity*, 29.
8. Ibid., 40–41.
9. Winckelmann, *The History of Ancient Art*, Vol. 11, trans. G. Henry Lodge, 48–49.
10. Ibid., 66.
11. Ibid., 87.
12. Ibid., 50.
13. Ibid., 36-37.
14. Camper, *The Works of the Late Professor Camper, on the Connexion Between The Science of Anatomy and The Arts of Drawing, Painting, Statuary, &c. &c. in Two Books. Containing A Treatise on the Natural Difference of Features in Persons of Different Countries and Periods of Life; and on Beauty, as Exhibited in Ancient Sculpture; With a New Method of Sketching Heads, National Features, and Portraits of Individuals with Accuracy, &c. &c.*, iii.
15. Meijer, *Race and Aesthetics in the Anthropology of Petrus Camper (1722–1789)*, 7.
16. Ibid., 8.
17. Ibid., 9.
18. Ibid., 18.
19. Richardson, *Death, Dissection and the Destitute*, xv.
20. Ibid., 143.
21. Ibid., xv.
22. Meijer, *Race and Aesthetics*, 19.
23. Camper, *The Works of the Late Professor Camper*, 18.
24. Ibid., 9.
25. Ibid., 42.
26. Ibid., 99–100.
27. Ibid., 50.
28. Meijer, *Race and Aesthetics*, 21.
29. Ibid., 120–121.
30. Blumenbach, *The Anthropological Treatises*, 235–236.
31. Schiebinger, *Nature's Body: Gender in the Making of Modern Science*, 149–150.

CHAPTER 9: TABLIER RASA

1. Schiebinger, *Nature's Body: Gender in the Making of Modern Science*, 168.
2. Winckelmann, *The History of Ancient Art, Vol. II*, trans. G. Henry Lodge, 92–93.
3. Altick, *The Shows of London*, 269.
4. Gould, *The Flamingo's Smile: Reflections in Natural History*, 294.
5. Ibid., 297.
6. Swarns, "Bones in Museum Cases May Get Decent Burial," *New York Times*, November 4, 2000.
7. Lawrence, "Physiology, Zoology, and the Natural History of Man," 367–368.
8. Schiebinger, *Nature's Body*, 64.
9. Lawrence, "Physiology, Zoology, and the Natural History of Man," 358–360.
10. Altick, *The Shows of London*, 270.
11. Ibid.; Schiebinger, *Nature's Body*, 169.
12. Schiebinger, *Nature's Body*, 169–170.
13. Cuvier, *Discourse on the Revolutionary Upheavals on the Surface of the Earth*, trans. Ian Johnston, 173.
14. Schiebinger, *Nature's Body*, 188.
15. Gould, *The Flamingo's Smile*, 298.
16. Ibid., 296.
17. Grant, *The Passing of a Great Race or The Racial Basis of European History*, 171.
18. Gould, *The Flamingo's Smile*, 296.

19. Ibid., 298–299.

20. Schiebinger, *Nature's Body*, 171–172.

21. Gould, *The Flamingo's Smile*, 291–292.

22. Freud, *Civilization and Its Discontents*, trans. James Strachey, 56–57.

23. Altick, *The Shows of London*, 279–281.

24. Bogdan, *Freak Show*, 47–48.

25. Kasson, *Amusing the Millions: Coney Island at The Turn of the Century*, 23–26.

26. Bogdan, *Freak Show*, 49–51; Harper, *Give Me My Father's Body: The Life of Minik, the New York Eskimo*, 94.

27. Harper, *Give Me My Father's Body*, 7–9.

28. Ibid., 19.

29. Ibid., 22, 25–26, 87–88.

30. Limerick, "Why Am I an Experiment?" *New York Times Book Review*, June 25, 2000.

31. Bradford and Blume, *Ota Benga, the Pygmy in the Zoo: One Man's Degradation in Turn-Of-The-Century America*, 114.

32. Ibid., 16, 164–165, 178, 179–190.

33. Bogdan, *Freak Show*, 238–240.

34. Bogdan, *Freak Show*, 56; Stanton, "Coney Island Freaks," http://naid.spprsr.ucla.edu/coneyisland/histart.htm.

35. Stanton, "Coney Island Freaks."

36. Bogdan, *Freak Show*, 195–197.

37. Harper, *Give Me My Father's Body*, 225–229.

38. Swarns, "Gaborone Journal: Africa Rejoices as a Wandering Soul Finds Rest," *New York Times*, October 6, 2000.

CHAPTER 10: SPURZHEIM'S FUNERAL

1. "Death of Spurzheim," obituary from *Boston Medical and Surgical Journal*, November 14, 1832.

2. Stern, *Heads and Headlines: The Phrenological Fowlers*, xii.

3. Davies, *Phrenology: Fad and Science, A 19th Century Crusade*, 18.

4. Stern, *Heads and Headlines*, xiv.

5. Combe, *Notes on the United States of America During a Phrenolological Visit in 1838-9-40*, Vol. 1, 16.

6. Van Wyhe, "Johann Gaspar Spurzheim (1776–1832), Gall's disciple and the man most responsible for popularizing phrenology," http://pages.britishlibrary.net/phrenology.

7. Gall to Joseph von Retzer, "On the functions of the brain, in man and animals," 1 October 1798 as quoted in "Biography: Franz Joseph Gall," http://www.whonamedit.com.

8. Stern, *Heads and Headlines*, x–xi.

9. Spurzheim, *Phrenology in Connexion With The Study of Physiognomy*, 156–157.

10. Ibid., 16–17.

11. Ibid., 31.

12. Gall to Joseph von Retzer, "On the functions of the brain, in man and animals," 1 October 1798 as quoted in "Biography: Franz Joseph Gall," http://www.whonamedit.com.

13. Gall to Joseph von Retzer, "On the functions of the brain, in man and animals"; Sabbatini, "Phrenology: The History of Brain Localization," Center for Biomedical Informatics, State University of Campinas, Brazil, http://www.epub.org.br/cm/no1-frenlog/frenlogia.htm.

14. Gall to Joseph von Retzer, "On the functions of the brain, in man and animals."

15. Van Wyhe, "Johann Gaspar Spurzheim (1776–1832), Gall's disciple and the man most responsible for popularizing phrenology," http://pages.britishlibrary.net/phrenology.

16. Van Wyhe, "Ridiculing Phrenology: 'this persecuted science,'" http://pages.britishlibrary.net/phrenology.

17. Stern, *Heads and Headlines*, xiv.

CHAPTER 11: CRANIA AMERICANA

1. Van Wyhe, "George Combe (1788–1858) The Most Prolific British Phrenologist of the Nineteenth Century," The History of Phrenology on the Web, http://pages.britishlibrary.net/phrenology.
2. De Guistino, *Conquest of Mind: Phrenology and Victorian Social Thought*, 5–6.
3. Van Wyhe, "George Combe (1788–1858) The Most Prolific British Phrenologist of the Nineteenth Century," The History of Phrenology on the Web, http://pages.britishlibrary.net/phrenology.
4. Ibid.
5. Spurzheim, *Phrenology in Connexion With The Study of Physiognomy*, 52–53.
6. George Combe, Appendix to Samuel George Morton, *Crania Americana or A Comparative View of the Skulls of Various Aboriginal Nations to which is prefixed An Essay on the Varieties of the Human Species*, 271–272.
7. Ibid., 283.
8. Morton, *Crania Americana*, 271–272.
9. Fredrickson, *The Black Image in the American Mind: The Debate on Afro-American Character and Destiny 1817–1914*, 14.
10. Combe, *A System of Phrenology*, 5th ed., 355.
11. Brown, *Bury My Heart At Wounded Knee*, 5; Ehle, *Trail of Tears: The Rise and Fall of the Cherokee Nation*, 106.
12. Shenton, *History of the United States to 1865*, 232.
13. Gould, *The Mismeasure of Man*, 82.
14. Morton, *Crania Americana*, 31, 97–98, 148; Morton, *Crania Aegyptiaca, or Observations on Egyptian Ethnography, Derived from Anatomy, History, and the Monument*.
15. Gould, *The Mismeasure of Man*, 88.
16. Morton, *Crania Americana*, 78.
17. Ibid., 5.
18. Ibid., 272, 282.
19. Morton, *Crania Americana*, 282–283; Gould, *The Mismeasure of Man*, 83–83.
20. Bank, "Of 'Native Skulls' and 'Noble Caucasians': Phrenology in Colonial South Africa," *The Journal of Southern African Studies* 22, (1996): 387–403.
21. Combe, *Notes on the United States of America During a Phrenolological Visit in 1838-9-40*, Vol. 2, 335.
22. Fredrickson, *The Black Image in the American Mind*, 74.
23. Gould, *The Mismeasure of Man*, 83.
24. Nott and Gliddon, *Types of Mankind: or Ethnological Researches Based Upon the Ancient Monuments, Paintings, Sculptures and Crania of Races and upon Their Natural, Geographical, Philological, and Biblical History*; Gould, *The Mismeasure of Man*, 62–104.
25. Schiller, *Paul Broca: Founder of French Anthropology, Explorer of the Brain*, 144; Gould, *The Panda's Thumb: More Reflections on Natural History*, 145.
26. Gould, *The Mismeasure of Man*, 115.
27. Gould, *The Panda's Thumb*, 145–146.
28. Gould, *The Mismeasure of Man*, 119.
29. Gould, *The Panda's Thumb*, 145–151.

CHAPTER 12: AN AMERICAN TALE

1. Stern, *Heads and Headlines: The Phrenological Fowlers*, 20.
2. Davies, *Phrenology: Fad and Science, A 19th Century Crusade*, 32.
3. Stern, *Heads and Headlines*, 58, 61.
4. Ibid., 31.

5. Wajda, "'This Museum of the Human Race': Fowler and Wells' Phrenological Cabinet and American National Character," http://www.personal.kent.edu/~swajda-phrenology.htm, 4.

6. Wells, *How To Read Character: A New Illustrated Handbook of Phrenology and Physignomy for Students and Examiners*, 192.

7. Stern, *Heads and Headlines*, 84.

8. Fowler, L. N., *Familiar Lessons on Physiology Designed for the Use of Children and Youth*, Vol.1 and 2, 3–4.

9. Stern, *Heads and Headlines*, 140-141.

10. Combe, *Notes on the United States of America During a Phrenolological Visit in 1838-9-40*, Vol. 2, 189.

11. Stern, *Heads and Headlines*, 31-32, 81–84, 106, 114, 136-137.

12. Ibid., 35.

13. Stern, *Heads and Headlines*, 19, 22; Davies, *Phrenology: Fad and Science, A 19th Century Crusade*, 38.

14. Fowler and Fowler, *Phrenology: A Practical Guide To Your Head*, x.

15. Colbert, *A Measure of Perfection: Phrenology and the Fine Arts in America*, 279.

16. Stern, *Heads and Headlines*, 82.

17. Stern, *Heads and Headlines*, 76; Colbert, *A Measure of Perfection: Phrenology and the Fine Arts in America*, 365; Brontë, *Jane Eyre*, 141; Davies, *Phrenology*, 38.

18. Whitman, *Leaves of Grass*, 293.

19. Fowler and Fowler, *The Illustrated Self-Instructor in Phrenology and Physiology with One Hundred Engravings and a Chart of the Character*, 11.

20. Fowler and Fowler, *New Illustrated Self-Instructor in Phrenology and Physiology*, vii–viii.

21. Fowler and Fowler, *The Illustrated Self-Instructor*, 46–47.

22. Wells, *The New Physiognomy or Signs of Character*, 553–555.

23. Stern, *Heads and Headlines*, 202.

24. Wells, *How To Read Character*, 18.

25. Fowler and Fowler, *The Illustrated Self-Instructor*, 17-20.

26. Fowler and Fowler, *New Illustrated Self-Instructor*, 176.

27. Fowler and Fowler, *Practical Phrenology*, 32–33.

28. Fowler and Fowler, *New Illustrated Self-Instructor*, 81.

29. Ibid., 124.

30. Wells, *The New Physiognomy or Signs of Character*, 222.

31. Ibid., 10.

32. Fowler and Fowler, *The Illustrated Self-Instructor in Phrenology*, 51–52.

33. Fowler and Fowler, *New Illustrated Self-Instructor*, 100–103.

34. Fowler and Fowler, *Phrenology*, 56.

35. Fowler and Fowler, *The Illustrated Self-Instructor*, 12–13, 31.

36. Wells, *The New Physiognomy or Signs of Character*, 188-189.

37. Ibid., 211–212.

38. Ibid., 195.

39. Fowler and Fowler, *Phrenology*, 56.

40. Wells, *The New Physiognomy*, 330–331, 533.

41. Wells, *How To Read Character*, 10.

42. Stern, *Heads and Headlines*, 204.

43. Fowler and Fowler, *Practical Phrenology*, 31–32.

44. Wells, *The New Physiognomy*, 390–391.

45. Fowler and Fowler, *Practical Phrenology*, 29.

46. Redfield, *The Twelve Qualities of Mind or Outlines of a New System of Physiognomy*, 10.

47. Wells, *The New Physiognomy*, 383.

48. Sizer and Drayton, *Heads and Faces and How to Study Them: a Manual of Phrenology and Physiognomy for the People*, 49.

49. Lawrence, "Physiology, Zoology, and the Natural History of Man," 291.

50. Colbert, *A Measure of Perfection: Phrenology and the Fine Arts in America*, 297.
51. Combe, *Notes on the United States of America During a Phrenological Visit in 1838-9-40, Vol. 2*, 335.
52. Colbert, *A Measure of Perfection*, 88.
53. Ibid., 170, 182-183.
54. Ibid., 170, 182.
55. Ibid., 167.
56. Ibid., 81-100.
57. Fowler, *Phrenology, Proved, Illustrated and Applied*, 23-24.
58. Colbert, *A Measure of Perfection*, 135.

CHAPTER 13: THE PENCIL OF NATURE

1. Rosenblum, *A World History of Photography*, 40-41.
2. Lavater, *Essays on Physiognomy One Hundred Physiognomical Rules, and A Memoir of the Author*, trans. Thomas Holcroft, 187-188.
3. Ibid., 193.
4. Carpenter, "Silhouette Art History," http://www.artist-doug-carpenter.i12.com.
5. Artlex Art Dictionary's official Web site, s.v. "Silhouette," http://www.artlex.com/ArtLex/s/silhouette.html.
6. Earle, ed., *Points of View: The Stereograph in America—A Cultural History*, 10.
7. Ibid., 9-10.
8. Sontag, *On Photography*, 70.
9. Trachtenberg, ed., *Classic Essays on Photography*, 11-13.
10. Ibid., 16, 18.
11. Rosenblum, *A World History of Photography*, 18.
12. Trachtenberg, ed., *Classic Essays on Photography*, 38.
13. Wood, *America and the Daguerreotype*, 150.
14. Talbot, *The Pencil of Nature*.
15. Rosenblum, *A World History of Photography*, 27.
16. Talbot, *The Pencil of Nature*.
17. Ibid.
18. Wing, *Stereoscopes: The First One Hundred Years*, 5-6.
19. Ibid., 5.
20. Rosenblum, *A World History of Photography*, 35, 198-199.
21. Ibid., 34.
22. Trachtenberg, ed., *Classic Essays on Photography*, 87.
23. Earle, ed., *Points of View*, 12, 18.
24. Davies, *Phrenology: Fad and Science, A 19th Century Crusade*, 130-131.
25. Sterns, *Cambridge Sketches*, 75.

CHAPTER 14: FACIAL POLITICS

1. Newhall, ed., *Photography: Essays & Images, Illustrated Readings in the History of Photography*, 57–58.
2. Ibid., 54, 57–58, 60-61.
3. Bajac and Planchon-de Font-Réaulx, *Le daguerréotype français. Un object photographique*, 77.
4. Jehel, "Photographie et anthropologie en France au XIXe siècle," 13–14; Bajac and Planchon-de Font-Réaulx, *Le daguerréotype français*, 369–381.
5. Edwards, ed., *Anthropology and Photography: 1860–1920*, 42–73.
6. Hartnett, *Democratic Dissent and Cultural Fictions of Antebellum America*, 151.
7. Newhall, ed., *Photography*, 46.

8. Smithsonian Institute, National Portrait Gallery's official Web site, "Mathew Brady's World," http://www.npg.si.edu/exh/brady; Kismaric, *American Politicians: Photographs from 1843 to 1993*; Newhall, ed., *Photography*, 48.
9. Stern, *Heads and Headlines*, 202; Hartnett, *Democratic Dissent*, 156.
10. Phillips, Haworth-Booth, and Squiers, eds., *Police Pictures: The Photograph as Evidence*, 18.
11. Stern, *Heads and Headlines: The Phrenological Fowlers*, 133.
12. Hartnett, *Democratic Dissent*, 167.
13. Earle, ed., *Points of View: The Stereograph in America—A Cultural History*, 12.
14. Newhall, ed., *Photography*, 64.
15. Bogdan, *Freak Show*, 12–16.
16. Stern, *Heads and Headlines*, 136–137.
17. Wells, *How To Read Character: A New Illustrated Handbook of Phrenology and Physignomy for Students and Examiners* [advertisement at back of book].
18. Hartnett, *Democratic Dissent and Cultural Fictions of Antebellum America*, 157; Sandra S. Phillips, Mark Haworth-Booth, and Carol Squiers, eds., *Police Pictures: The Photograph as Evidence*, 17–18.
19. Gould, *The Mismeasure of Man*, 83.
20. Newhall, ed., *Photography*, 70–71.

CHAPTER 15: THE COSTERMONGER'S TONGUE AND ROGET'S THESAURUS

1. Mayhew, *London Labor and The London Poor*, Vol. 1, *The London Street-Folk*, xiv.
2. Ibid., 1–3.
3. Ibid., 23.
4. Ibid.
5. Thornber, "Peter Mark Roget, 1779–1869," http://www.home.clara.net/craigthornber/Cheshire/ideasmen/roget.html.
6. Emblen, *Peter Mark Roget: The Word and the Man*, 118.
7. Ibid., 184–186.
8. Knight, *The Liveliest Art: A Panoramic History of the Movies*, 14.
9. Lawrence, "Physiology, Zoology, and the Natural History of Man" (lecture, Royal College of Surgeons, London, 1821), 211–212.
10. Roget, *Roget's International Thesaurus*, xv, 1n.
11. Ibid., x.
12. Ibid.
13. Roget, *Thesaurus of English Words and Phrases Classified and Arranged so as To Facilitate the Expression of Ideas And Assist In Literary Composition*, ed. C. O. Sylvester Mawson.
14. Ibid.
15. Emblen, *Peter Mark Roget*, 272.
16. Roget, *Thesaurus of English Words*, xv.

CHAPTER 16: REVERBERATIONS OF CHANGE

1. Hobsbawm, *The Age of Capital, 1848–1875*, 3.
2. Wallas, quoted in *PR!: A Social History of Spin*, by Stuart Ewen, 72.
3. Marx, in a letter to Danielson, 10 April 1879. As quoted in Hobsbawm, *The Age of Capital*, 3.
4. Marx and Engels, *Selected Works*, Vol. 1, 34.
5. Ibid., 39.
6. Charles Darwin, *The Origin of Species*, Signet Classic (London: Penguin Press), 52.
7. Marx and Engels, *Selected Works*, Vol. 11, 75–76.
8. Hofstadter, *Social Darwinism in American Thought*, 31, 44–50.
9. Ibid., 51.

10. Darwin, *The Origin of Species*, 75.

CHAPTER 17: IDENTIFYING THE GROUP WITHIN THE INDIVIDUAL

1. Gillham, *A Life of Sir Francis Galton: From African Exploration to the Birth of Eugenics*, 57–58.
2. Galton, *Memories of My Life*, 259; Gillham, *A Life of Sir Francis Galton*, 216–217; Galton, "Composite Portraiture," *The Photographic News*, July 8, 1881–July 15, 1881.
3. Gillham, *A Life of Sir Francis Galton*, 158.
4. Galton, "Composite Portraiture," 316.
5. Galton, *Inquiries into Human Faculty and Its Development*, 15.
6. Galton, "Composite Portraiture," 333.
7. Galton, *Inquiries into Human Faculty and Its Development*, 14.
8. *The Photographic News*, "Notes," April 17, 1885.
9. Galton, "Composite Portraiture," 333.
10. Gillham, *A Life of Sir Francis Galton*, 216–217.
11. Galton, "Photographic Composites," *The Photographic News*, April 17, 1885, 243.
12. Jacobs, "The Jewish Type and Galton's Composite Photographs," *The Photographic News*, April 24, 1885, 268.
13. Galton, "Photographic Composites," 243.
14. Jacobs, *Jewish Encyclopedia*, s. v. "Anthropology." Also available online at http://www.jewish encyclopedia.com.
15. Gillham, *A Life of Sir Francis Galton*, 207.

CHAPTER 18: FINDING THE INDIVIDUAL WITH THE GROUP

1. Rhodes, *Alphonse Bertillon: Father of Scientific Detection*, 191–192.
2. Phillips, Haworth-Booth, and Squiers, eds., *Police Pictures: The Photograph as Evidence*, 19.
3. Benjamin, "The Work of Art in the Age of Mechanical Reproduction," *Illuminations*, 223.
4. Bertillon, *Les Races Sauvage*, 3–5.
5. Ibid., 63.
6. Bertillon, *Instructions for Taking Descriptions for the Identification of Criminals and Others By Means of Anthropometric Indications*, trans. Gallus Muller, 17, 49–60; Blume, "A Rogues' Gallery in the Home of the Mug Shot," *International Herald Tribune*, February 26, 2000.
7. Jehel, "Photographie et anthropologie en France au XIXe siècle," 13–14.
8. Bertillon, *Legal Photography*, trans. Paul Brown, 1–10.
9. Blume, "A Rogues' Gallery in the Home of the Mug Shot."
10. Jehel, "Photographie et anthropologie en France au XIXe siècle," 13–14.
11. Rhodes, *Alphonse Bertillon*, 97.

CHAPTER 19: CRIMINAL TYPES

1. Foucault, *Discipline and Punish: The Birth of the Prison*, 139.
2. Ellis, *The Criminal*, 2nd ed., 276–277.
3. MacDonald, *Abnormal Man, Being Essays on Education and Crime and Related Subjects, with Digests of Literature and a Bibliography. Bureau of Education. Circular of Information No. 4, 1893*, 5.
4. Brace, *The Dangerous Classes of New York, and Twenty Years' Work Among Them*, ii.
5. Ibid., 30.
6. Le Bon, *The Crowd: A Study of the Popular Mind*, 205–207.
7. Ibid., 35–36.

8. Gibson, *Born To Crime: Cesare Lombroso and the Origins of Biological Criminology*, 14.
9. Ibid., 20–21.
10. Lombroso, introduction to *Criminal Man*, xiv.
11. Gibson, *Born To Crime*, 20.
12. Lombroso, introduction to *Criminal Man*, xvi-xvii.
13. Gibson, *Born To Crime*, 21, 24, 25.
14. Rhodes, *Alphonse Bertillon*, 192–193.
15. MacDonald, *Abnormal Man, Being Essays on Education and Crime and Related Subjects, with Digests of Literature and a Bibliography. Bureau of Education. Circular of Information No. 4, 1893*, 44.
16. Ferrero, *Criminal Man: According to the Classification of Cesare Lombroso*, 7-8.
17. MacDonald, *Abnormal Man*, 44.
18. Ferrero, *Criminal Man*, 43–44.
19. Ibid., 45–48.
20. Loos, "Ornament and Crime," 19–20.
21. Ferrero, *Criminal Man*, 92.
22. Ibid., 97.
23. Gibson, *Born To Crime*, 64–65.
24. Lombroso and Ferrero, *The Female Offender*, 110–111.
25. Ibid., 102.
26. Ibid., 111.
27. Ibid., 112–113.
28. Ibid., 21, 113–114.
29. Nordau, *Degeneration*, vii.
30. Gibson, *Born To Crime*, 21, 28, 30.
31. Rafter, *Creating Born Criminals*, 94–96, 101–102.
32. MacDonald, *Criminology*.
33. Fink, *Causes of Crime: Biological Theories in the United States, 1800–1915*, 100–101.
34. Rafter, *Creating Born Criminals*, 116–118. See also Lydston, *The Diseases of Society*.
35. Lombroso, *The Man of Genius*, vii, 6.
36. Ibid., v.
37. Ibid., 6–8, 10–11.
38. Ibid., 38–65.
39. Ibid., 81, 97, 99.
40. Ibid., 59.
41. Ibid., 70–71.
42. Ibid., 209, 242.
43. Ibid., 360–361.
44. Pick, *Faces of Degeneration: A European Disorder, c. 1848–c. 1918*, 121.

CHAPTER 20: THE AMAZING RACE

1. Ellis, *The Criminal*, vii-viii.
2. Rafter, *Creating Born Criminals*, 115.
3. Ellis, *The Criminal*, 24–25.
4. Ibid., 38.
5. Ibid., 28–40.
6. Ibid., 80.
7. Ibid., 112, 121.
8. Ibid., viii.
9. Ellis, *The Task of Social Hygiene*, 42–43.
10. "Erasmus Darwin: 1731–1802," a biography, http://www.ucmp.berkeley.edu/history/Edarwin.html; *BBC*. "Historical Figures: Erasmus Darwin, 1731-1802," http://www.bbc.co.

uk/history/historic_figures/darwin_erasmus.shtml; Gillham, *A Life of Sir Francis Galton: From African Exploration to the Birth of Eugenics*, 13–18.

11. Blacker, *Eugenics: Galton and After*, 20–23.
12. Gillham, *A Life of Sir Francis Galton*, 35.
13. Blacker, *Eugenics*, 26.
14. Ibid., 73.
15. Galton, *Hereditary Genius: An Inquiry Into Its Laws and Consequences*, 338–340.
16. Galton, *Memories of My Life*, 287–288.
17. Gould, *The Mismeasure of Man*, 107.
18. Blacker, *Eugenics*, 37.
19. Galton, *Hereditary Genius*, 68–75.
20. Ibid., 394–395.
21. Ibid., 406, 414–415.
22. Galton, *Hereditary Genius*, 14.
23. Galton, *Memories of My Life*, 290–291.
24. Galton, "Eugenics. Its definition, scope and aims."
25. Galton, "Hereditary Talent and Character," *Macmillan's Magazine*, 1865, 326.
26. Gillham, *A Life of Sir Francis Galton*, 157.
27. Galton, "Africa for the Chinese."
28. Galton, *Inquiries into Human Faculty and Its Development*, 24.
29. Galton, *Memories of My Life*, 244.
30. Gillham, *A Life of Sir Francis Galton*, 11.
31. Galton, "Record of Family Faculties."
32. Galton, "Retrospective of Work Done at My Anthropometric Laboratory at South Kensington," *Journal of the Anthropological Institute* 21, 1895: 32.
33. Galton, *Memories of My Life*, 245.
34. Galton, "Retrospective of Work Done at My Anthropometric Laboratory at South Kensington," 32.
35. Gillham, *A Life of Sir Francis Galton*, 211-213; Blacker, *Eugenics*, 38–39.
36. Galton, *Memories of My Life*, 311–323
37. Gillham, *A Life of Sir Francis Galton*, 338–339.
38. Galton, *Memories of My Life*, 322.
39. Pearson, *The Life, Letters and Labour of Francis Galton*, 403.
40. Mosse, *Toward the Final Solution: A History of European Racism*, 58–62.
41. Gillham, *A Life of Sir Francis Galton*, 337.
42. Ibid., 336.
43. Gillham, *A Life of Sir Francis Galton: From African Exploration to the Birth of Eugenics*, 345–346; Mehler, "A Brief History of European and American Eugenics Movements."

CHAPTER 21: MORONS IN OUR MIDST

1. Pierpont, "The Measure of America: How a Rebel Anthropologist Waged War on Racism," *New Yorker*, March 8, 2004.
2. Carlson, *The Unfit: A History of a Bad Idea*, 163-166.
3. Dugdale, *"The Jukes": A Study in Crime, Pauperism, Disease and Heredity, Also Further Studies of Criminals*, vi.
4. Rafter, *Creating Born Criminals*, 38.
5. Dugdale, *"The Jukes"*, 38, 60.
6. *Columbia Encyclopedia*, 6th ed., s.v. "Richard Louis Dugdale."
7. Stoddard, *The Rising Tide of Color Against White World-Supremacy*, title page.
8. Hofstadter, *Social Darwinism in American Thought*, 180.

9. Ibid.; *Congressional Record*, 56th Cong., 1st sess., 704-711. As quoted in *Social Darwinism in American Thought* by Richard Hofstadter.

10. Hofstadter, *Social Darwinism in American Thought*, 180.

11. Carlson, *The Unfit*, 194.

12. Black, *War Against The Weak: Eugenics and America's Campaign to Create a Master Race*, 36-37, 93-94.

13. Ibid., 313-314.

14. Founding Statement of the Eugenics Record Office, October 1, 1910. As quoted by Carlson in *The Unfit*.

15. Carlson, *The Unfit*, 195.

16. Gould, *The Mismeasure of Man*, 188.

17. Goddard, *The Kallikak Family*, 16.

18. Ibid., 17-19.

19. Ibid., 11-12.

20. Ibid., 70-71.

21. Ibid., 108.

22. Gould, *The Mismeasure of Man*, 195.

23. Gould, *The Mismeasure of Man*, 197; University of Indiana, "Human Intelligence," http://www.indiana.edu/~intell/kallikak.shtml.

24. Grant, *The Passing of a Great Race or The Racial Basis of European History*, xxiv.

25. Ripley, *The Races of Europe*, 103-130.

26. Grant, *The Passing of a Great Race*, 29.

27. Ibid., 89.

28. Ibid., 86-88.

29. Ibid., 86.

30. Ibid., 5, 7.

31. Ibid., 11-12.

32. Ibid., 12, 79.

33. Ibid., 18.

34. Ibid., 16.

35. Ibid., 60.

36. Ibid., 46, 51, 53.

37. Reilly, *The Surgical Solution: A History of Involuntary Sterilization in the United States*, 33.

38. Lombardo, "Eugenic Sterilization Laws."

39. Black, *War Against The Weak: Eugenics and America's Campaign to Create a Master Race*, 122; Carlson, *The Unfit: A History of a Bad Idea*, 248.

40. State of Virginia. Acts of Assembly. *Ch. 394—An ACT to provide for the sexual sterilization of inmates of State institutions in certain cases*, 569-571.

41. Black, *War Against The Weak*, 108; Carlson, *The Unfit*, 251.

42. Lombardo, "Eugenic Sterilization Laws,"110.

43. Black, *War Against The Weak*, 109; Carlson, *The Unfit*, 256; Lombardo, "Eugenic Sterilization Laws."

44. Carlson, *The Unfit*, 250.

45. Black, *War Against The Weak*, 113–114.

46. Ibid., 114–115.

47. *Buck v. Bell*, U.S. 292 (1926).

48. An excellent bibliography on the subject is found at http://www.library.wisc.edu/libraries/WomensStudies/bibliogs/puerwom.htm.

49. Lombardo, "Eugenic Sterilization Laws."

50. Black, *War Against The Weak*, 264–265, 317–318.

51. Gould, *The Mismeasure of Man*, 226–229, 255.

52. Brigham, *A Study of American Intelligence*, 29–30.

53. Gould, *The Mismeasure of Man*, 261.

54. Selden, *Inheriting Shame: The Story of Eugenics and Racism in America*, 19.
55. Ibid., 13.
56. Pierpont, "The Measure of America: How a Rebel Anthropologist Waged War on Racism," Black, *War Against The Weak*, 237.
57. Haraway, *Primate Visions: Gender, Race and Nature in the World of Natural Science*, 57.
58. Coolidge, "Whose Country Is This?" *Good Housekeeping*, February 1921, 13–14, 106–109.
59. Jacobson, *Whiteness of a Different Color: European Immigrants and the Alchemy of Race*, 86.
60. Pierpont, "The Measure of America: How a Rebel Anthropologist Waged War on Racism," 58.
61. Sanger, *The Pivot of Civilization*, 9.
62. Ibid., 23.
63. Sanger, "Is Race Suicide Probable?" *Collier's: The National Weekly*, August 15, 1925, 25.
64. Boas, "Remarks on the Theory of Anthropometry," 147.
65. Boas, "Changes in Bodily Form of Descendants of Immigrants."
66. McDaniel, "Madison Grant and the Racialist Movement: The Distinguished Origins of Racial Activism," *American Renaissance*, December 1997, 56.
67. Rogin, *Blackface, White Noise: Jewish Immigrants in the Hollywood Melting Pot*, 89.

CHAPTER 22: EUGENICS GOES TO THE FAIR

1. Selden, *Inheriting Shame: The Story of Eugenics and Racism in America*, 9.
2. University of Virginia. Department of American Studies official Web site, "Eugenics and the Race Betterment Movement," http://xroads.virginia.edu/~MA03/holmgren/ppie/ eug.html.
3. Kline, *Building a Better Race: Gender, Sexuality, and Eugenics from the Turn of the Century to the Baby Boom*, 14–15.
4. *San Francisco Chronicle*, 8 August 1915.
5. Squiers, *Perfecting Mankind: Eugenics and Photography*, 10.
6. Kansas Bureau of Child Research, "Fitter Families for Future Firesides: A Report of the Eugenics Department of the Kansas Free Fair, 1920–1924," 2.
7. Ibid., 3.
8. Ibid.
9. Selden, "Eugenics Popularization," 6.
10. Darrow, "The Eugenics Cult," *The American Mercury*, no. 8, 1926, 129–137.
11. Hunter, *New Civic Biology—Presented in Problems*, 195–196.
12. Ibid., 261–265.
13. Ibid., 261–263.
14. Bryan, *Bryan's Undelivered Speech, A Call to Christianity: The Great Commoner's Last Evolution Argument*, 24; Darwin, *The Descent of Man*, 138–139.
15. Bryan, *Bryan's Undelivered Speech, A Call to Christianity*, 22, 28.
16. "School Principal and Family Take Fair Top Honors," *The Savannah Press*, November 6, 1924.
17. "Fitter Family Contests," Eugenics Archive, Dolan DNA Learning Center, Cold Spring Harbor Laboratory.
18. Black, *War Against The Weak: Eugenics and America's Campaign to Create a Master Race*, 84; Gould, *The Mismeasure of Man*, 209–210.
19. Gould, *The Mismeasure of Man*, 204.

CHAPTER 23: DAT FAMOUS CHICKEN DEBATE

1. Roget, *Roget's International Thesaurus*, xv.
2. Ibid., xiii–xiv.
3. Ellis, *The Criminal*, 5th ed., rev. and enlarged, 201–211.
4. "To Our Patrons," *Freedom's Journal* 1, no. 1 (March 16, 1827): 1.

5. Davis, *Scandals and Follies: The Rise and Fall of the Great Broadway Reviews*, 31.

6. Jones, *Blues People: Negro Music in White America*, 22.

7. Ibid., 19, 28.

8. Kenrick, "That Shufflin' Throng," *A History of the Musical Minstrel Shows*, Parts 1 and 2.

9. Reese, "Thumbnail History of the Banjo," http://bluegrassbanjo.org/banhist.html.

10. Christy, *Old Folks at Home, Ethiopian Melody*. Actually written by Stephen Foster.

11. Emmett, "Dixie," http://ingeb.org/index.html.

12. Douglass, *My Bondage and My Freedom*, 92.

13. Smith, "The Nation Comes of Age," 578–588.

14. Brent, *Incidents in the Life of a Slave Girl. Written by Herself*, preface.

15. Toll, *Blacking Up: The Minstrel Show in Nineteenth-Century America*, 162–180; Rogin, *Blackface, White Noise: Jewish Immigrants in the Hollywood Melting Pot*, 30–31.

16. Rogin, *Blackface, White Noise*, 56–58, 45.

17. Carter, *The Coon and the Chink: A Vaudeville Sketch*, 2.

18. Leavitt and Eagan, *Black Ole Bull, An Original Ethiopian Sketch*, inner back cover.

19. Comer, "Every Time I Turn Around: Rite, Reversal and the End of Blackface Minstrelsy," http://www.angelfire.com/oh/hydriotaphia/crow.html.

20. Pilgrim and Middleton, "Niggers and Caricatures."

21. White, *Uncle Eph's Dream: An Original Negro Sketch, In Two Scenes and Two Tableaux*, 3.

22. Paskman, "Gentlemen, Be Seated!" 124.

23. White, *Wake Up! A Negro Sketch Known as Psychological Experiments, Psychology, Bumps and Lumps, Bumpology, etc.*, 5.

24. Long, *Dat Famous Chicken Debate: The University of Africa (Aff.) vs. Bookertea College (neg.)*, 2–11.

25. Toll, *Blacking Up: The Minstrel Show in Nineteenth-Century America*, 195.

26. Ibid., 200–202, 228–229.

27. Marzio, *The Democratic Art: Pictures for a 19th-century America: Chromolithography, 1840–1900*, 104.

28. Library of Congress. With essays by David Levering Lewis and Deborah Willis. *A Small Nation of People: W. E. B. DuBois and African American Portraits of Progress*, 52.

29. Ibid., 53.

30. Calloway to Booker T. Washington, in *The Booker T. Washington Papers*, vol. 5, 227. *See also* "Mixed Messages: Thomas Calloway and 'The American Negro Exhibit,'" by Milers Everett Travis.

31. Library of Congress. With essays by David Levering Lewis and Deborah Willis. *A Small Nation of People: W. E. B. DuBois and African American Portraits of Progress*, 17.

32. Ibid., 19.

33. Ibid., 33.

34. Ibid., 58–59.

35. Ibid., 30–31.

CHAPTER 24: MALE AND FEMALE CREATED HE THEM

1. Harvard University, "Lawrence H. Summers," http://www.president.harvard.edu/biography.

2. Rimer and Healy, "Furor Lingers as Harvard Chief Gives Details of Talk on Women," *New York Times*, February 18, 2005.

3. *The Bible: Designed to be Read as Living Literature*, 4.

4. Graves and Patai, *Hebrew Myths: The Book of Genesis*, 65.

5. Pagels, *The Gnostic Gospels*, 49–50.

6. Ibid., 64. See also *The Nag Hammadi Library: The Definitive Translation of the Gnostic Scriptures*.

7. Leloup, *The Gospel of Mary Magdalene*, 37–39.

8. Pagels, *The Gnostic Gospels*, 57.

9. *The Bible: Designed to be Read as Living Literature*, 6.

10. *Holy Bible: From the Ancient Eastern Text*, trans. George M. Lamsa, 9.

11. *The Holy Scriptures*, 6.

12. Rousseau, *Discourse on Inequality*.

13. Rousseau, *Emile*, 418–419.

14. Carraro, *The Literary Encyclopedia*, s.v. "Learned Ladies: 1650–1750."

15. Rowbotham, *Women, Resistance and Revolution: A History of Women and Revolution in the Modern World*, 31.

16. Defoe, "The Education of Women."

17. Wollstonecraft, *Vindication of the Rights of Women*, 20–21.

18. Ibid.

19. Kraditor, *Up From the Pedestal: Selected Writings in the History of American Feminism*, 184.

20. Gould, *The Mismeasure of Man*, 137.

21. Engels, *The Origin of the Family, Private Property and the State: In the Light of the Researches of Lewis H. Morgan*, 119–121.

22. Calverton and Schmalhausen, *Sex in Civilization*, 11.

23. Frisken, *Victoria Woodhull, Sexual Revolutionary: Political Theater and the Popular Press in Nineteenth-Century America*, 31.

24. Ibid., 38–40.

25. Gilman, *Women and Economics: A Study of the Economic Relation Between Men and Women as a Factor in Social Evolution*, 241.

26. Ibid., 5.

27. Ibid., 145.

CHAPTER 25: THE RETURN OF THE REPRESSED

1. Sengoopta, *Otto Weininger: Sex, Science and Self in Imperial Vienna*, 14.

2. Galton, "Africa for the Chinese."

3. Weininger, *Sex and Character*, 252.

4. Ibid., 88–90.

5. Ibid., 7–10.

6. Ibid., 297.

7. Ibid., 253.

8. Sengoopta, *Otto Weininger: Sex, Science and Self in Imperial Vienna*, 10.

9. Jones, *The Life and Work of Sigmund Freud*, Vol. 1, 314–317.

10. Weininger, *Sex and Character*, 315-316.

11. Ibid., 332.

12. Ibid., 65, 67–68.

13. Ibid., 188.

14. Ibid., 71.

15. Ibid., 60, 31–32.

16. Sengoopta, *Otto Weininger: Sex, Science and Self in Imperial Vienna*, 16–17.

17. Ibid., 19.

18. Freud, *Three Essays on the Theory of Sexuality*, 7.

19. Ibid., 97.

20. Ibid., 26.

21. Ibid., 11–12n.

22. Freud, *An Autobiographical Study*, 22.

23. Linder, "The Trials of Oscar Wilde: An Account," http://www.law.umkc.edu/faculty/projects/ftrials/wilde/wilde.htm.

24. Ibid., 24.

25. Ibid., 25.

26. Carpenter, *Love's Coming-Of-Age: A Series of Papers on The Relations of the Sexes*, 5th ed., 142–143.

27. Carpenter, *Intermediate Sex: A Study of Some Transitional Types of Men and Women*, 23.
28. Ibid., 32.
29. Ibid., 35–36.
30. Ibid., 116–117.
31. Ibid., 16–17.
32. Hinkle, "New Morals for Old: Women and the New Morality," *The Nation*, November 19, 1924, 541–543.
33. Mowry, *The Twenties: Fords, Flappers & Fanatics*, 182–184.
34. Roberts, *Civilization Without Sexes: Reconstructing Gender in Postwar France, 1917–1927*, 67–68.
35. Ibid., 19.
36. Garden, "Why I Bobbed My Hair," *Pictorial Review*, April 1927, 8.
37. Pickford, "Why I Have Not Bobbed Mine," *Pictorial Review*, April 1927, 9.
38. Roberts, *Civilization Without Sexes: Reconstructing Gender in Postwar France, 1917–1927*, 2, 20.
39. Jensen, "All Pink Sisters: The War Department and the Feminist Movement in the 1920s," in *Decades of Discontent: The Women's Movement, 1920–1940*. Also available online at http://www.jofreeman.com/polhistory/spiderman.htm.
40. Howard and Tarrant, eds., *Antifeminism in America: A Collection of Readings from the Literature of the Opponents to U. S. Feminism, 1848 to the Present*, 145.
41. Fields, "Fighting 'The Corsetless Evil': Shaping Corsets and Culture, 1900–1930," *Journal of Social History* 33, no. 2 (1999): 355.
42. Howard and Tarrant, eds., *Antifeminism in America*, 156.
43. McMahon, "Unspeakable Jazz Must Go," *Ladies Home Journal*, December 1921, 122. As quoted by Carolyn Johnston in *Sexual Power: Feminism and the Family in America*.
44. Howard and Tarrant, eds., *Antifeminism in America*, 157.
45. Kinsey et al., *Sexual Behavior in the Human Male*, 639.

CHAPTER 26: WRITING HISTORY WITH LIGHTNING

1. Delaumosne et al., *Delsarte System of Oratory*, 76.
2. Delaumosne, *The Art of Oratory, Systems of Delsarte*, trans. Francis A. Shaw, xi.
3. Delaumosne et al., *The Delsarte System of Oratory*.
4. Delaumosne, *The Art of Oratory*, 79–80.
5. Ibid., 76–77.
6. Le Bon, *The Crowd: A Study of the Popular Mind*, 68.
7. Delaumosne, *The Art of Oratory*, 48–49.
8. Le Bon, *The Crowd*, 71.
9. Balázs, *Theory of the Film, Character and Growth of A New Art*, 40–41.
10. Münsterberg, *The Photoplay: A Psychological Study*, 50.
11. Slide and Wagenknecht, *Fifty Great American Silent Films, 1912–1920: A Pictorial Survey*, 25.
12. McLuhan, *The Mechanical Bride: Folklore of Industrial Man*, 96.
13. Schickel, *D. W. Griffith: An American Life*, 217.
14. Lippmann, *Public Opinion*, 7.
15. Schickel, *D. W. Griffith*, 231.
16. Ibid., 283.
17. Cook, *A History of Narrative Film*, 79.
18. Lippmann, *Public Opinion*, 61.

CHAPTER 27: MOVABLE TYPES

1. Barnouw, *The Magician and the Cinema*, 45–48.
2. Cook, *A History of Narrative Film*, 14.

3. Ibid., 92.
4. DeMille, *The Autobiography of Cecil B. DeMille*, ed. Donald Hayne, 144.
5. Debord, *Society of the Spectacle*.
6. Benjamin, "The Work of Art in the Age of Mechanical Reproduction," *Illuminations*, 221.
7. Lewis, "The Deluxe Picture Palace," *The New Republic*, March 27, 1929, 58.
8. Higashi, *Cecil B. DeMille and American Culture: The Silent Era*, 100.
9. Lewis, "The Deluxe Picture Palace," 59.
10. Sklar, *Movie-Made America: A Cultural History of American Movies*, 74.
11. Fryer, *Women and Leisure*, 173–174.
12. Sklar, *Movie-Made America*, 75.
13. Robinson, *Hollywood in the Twenties*, 157–158. *See also* Stenn, *Clara Bow: Runnin' Wild*.

CHAPTER 28: PERSISTENCE OF VISION

1. Vaz, *Living Dangerously: The Adventures of Merian C. Cooper, Creator of King Kong*, 14–17.
2. Haggard, *She: A History of Adventure*, 108; Kipling, "The White Man's Burden: The United States and the Philippine Islands (1899)," *McClure's Magazine*, February 1899.
3. Wakeman, ed., *World Film Directors*, Vol. 1, *1890–1945*, 147–151.
4. Vaz, *Living Dangerously: The Adventures of Merian C. Cooper, Creator of King Kong*, 14.

CHAPTER 29: TALES OF BEFORE AND AFTER

1. Ogburn, *Social Change With Respect to Culture and Original Nature*, 196.
2. President's Research Committee on Social Trends, *Recent Social Trends in the United States: Report of the President's Research Committee on Social Trends Vol. I*, v.
3. Ibid., xxiii.
4. George A. Schuyler, "The Negro-Art Hokum," *The Nation*, June 16, 1926, 662–663.
5. Hughes, "The Negro Artist and the Racial Mountain," *The Nation*, June 23, 1926, 692–693.
6. McKenzie, "The Rise of Metropolitan Communities," 443–496; Woofter, Jr., "The Status of Racial and Ethnic Groups," 553–601.
7. Woofter, Jr., "The Status of Racial and Ethnic Groups," 593.
8. Ibid., 598–599.
9. Willey and Rice, "The Agencies of Communication," 167.
10. Ibid., 174.
11. Wolman and Peck, "Labor Groups in the Social Structure," 801–856.
12. Steiner, "Recreation and Leisure Time Activities," 828–829.
13. Willey and Rice, "The Agencies of Communication," 200–201.
14. Ibid., 215–216.
15. Lynd, with the assistance of Alice Hanson, "The People As Consumers," 857.
16. Frederick, *Selling Mrs. Consumer*, 391–392.
17. Ewen, *Captains of Consciousness: Advertising and the Social Roots of the Consumer Culture*, 180.
18. Haiken, *Venus Envy: A History of Cosmetic Surgery*, 111–123.
19. Lynd, with the assistance of Alice Hanson, "The People As Consumers," 867–868.
20. Ibid., 871.
21. Ibid., 878.
22. Riordan, *Inventing Beauty: A History of the Innovations that Have Made Us Beautiful*, 15.
23. Peiss, *Hope in a Jar: The Making of America's Beauty Culture*, 101.
24. Scranton, ed., *Beauty and Business: Commerce, Gender and Culture in Modern America*, 15–16.
25. Peiss, *Hope in a Jar*, 205.
26. Haiken, *Venus Envy: A History of Cosmetic Surgery*, 104–105.
27. Ibid., 96.

28. Lavater, *Essays on Physiognomy One Hundred Physiognomical Rules, and A Memoir of the Author*, trans. Thomas Holcroft, 84.
29. Ewen, *Captains of Consciousness: Advertising and the Social Roots of the Consumer Culture*, 15.
30. Ewen and Ewen, *Channels of Desire: Mass Images and the Shaping of American Consciousness*, 177.

CHAPTER 30: RECENT SOCIAL TRENDS

1. Roosevelt, "Address of the President on Works Relief."
2. Roosevelt, "Second Inaugural Address."
3. Roosevelt, "Democratic nomination speech."
4. Ellison, "Writers' Project Interviews," http://memory.loc.gov/ammem/wpaintro/intro12.html.
5. Nelson, "Soldiers Without Swords."
6. Deane, "Amos 'n' Andy Show."
7. Downing, "Racism, Ethnicity and Television."
8. Ginsberg, *America and Other Poems*, 39-43.
9. Becker, "U.N. Study Finds Global Trade Benefits Are Uneven," *New York Times*, February 24, 2004.
10. Jackson, "The Westmoreland Mindset," *Boston Globe*, July 20, 2005.
11. Le Bon, *The Crowd: A Study of the Popular Mind*, 62.
12. "Falwell Apologizes to Gays, Feminists, Lesbians," *CNN.com/us*, September 14, 2001.
13. Pait to Landrith, August 31, 1998. Available online at *The Multiracial Activist*, http://www.multiracial.com/letters/bobjonesuniversity.html.
14. "Bob Jones University Ends Ban on Interracial Dating," *CNN.com*, March 4, 2000.

BIBLIOGRAPHY

Allport, Gordon. *The Nature of Prejudice*. Reading, Massachusetts: Addison-Wesley, 1954.

Altick, Richard D. *The Shows of London*. Cambridge: Harvard University/Belknap, 1978.

Aristotle. *The History of Animals and Treatise on Physiognomy: Vol. VIII of The Works of Aristotle*. Translated by Thomas Taylor. Dorset: The Prometheus Trust, 2004.

———. "Physiognomica." In *Aristotle: Minor Works*. Cambridge: Harvard University Press, 1963.

———. *Prior Analytics*. Translated by A. J. Jenkinson. The University of Adelaide Library Electronic Texts Collection, 2004. http://etext.library.adelaide.edu.au/a/aristotle/a8pra.

Armelages, George J., David S. Carlson, and Dennis P. Van Geren. "The Theoretical Foundations of Skeletal Biology." In *A History of American Physical Anthropology, 1930–1980*. New York: Academic Press, 1982.

Artlex Art Dictionary's official Web site, s.v. "Silhouette," http://www.artlex.com/ArtLex/s/silhouette.html.

Bajac, Quentin, and Dominique Planchon-de Font-Réaulx. *Le daguerréotype français. Un object photographique*. Paris: musée d'Orsay, 2003.

———. *The Dawn of Photography: French Daguerreotypes, 1839–1855*. An Exhibition Catalogue on CD-ROM. New York: Metropolitan Museum of Art and Yale University Press, 2003.

Balázs, Béla. *Theory of the Film: Character and Growth of a New Art*. New York: Dover, 1970.

Balkin, Harry H. *The New Science of Analyzing Character*. Harry H. Balkin Publishers: Boston, 1919.

Bank, Andrew. "Of 'Native Skulls' and 'Noble Caucasians': Phrenology in Colonial South Africa." *The Journal of Southern African Studies* 22, (1996): 387–403.

Barnes, James. *The Darkey Breach of Promise Case, A Nigger Mock Trial*. New York: Fitzgerald, 1898.

———. *The Darkey Phrenologist: A Nigger Absurdity*. New York: Dick's American Edition, Dick & Fitzgerald, n.d., ca. 1905.

Barnouw, Erik. *The Magician and the Cinema*. New York: Oxford, 1981.

BBC. "Historical Figures: Erasmus Darwin, 1731–1802." http://www.bbc.co.uk/history/historic_figures/darwin_erasmus.shtml.

Becker, Elizabeth. "U.N. Study Finds Global Trade Benefits Are Uneven." *New York Times*, February 24, 2004.

Benedict, Ruth. "Obituary, Franz Boas." *Science* 97 (January 15, 1943): 60.

Benedikt, Moriz. *Anatomical Studies Upon Brains of Criminals: A Contribution to Anthropology, Medicine, Jurisprudence, and Psychology*. Translated by E. P. Fowler. New York: Wm. Wood & Co., 1881.

Benjamin, Walter. "The Work of Art in the Age of Mechanical Reproduction," *Illuminations*. New York: Harcourt, Brace & World, 1968.

Berger, John. *Ways of Seeing*. London: Penguin, 1972.

Bernal, Martin. *Black Athena: The Afroasiatic Roots of Classical Civilization*, Vol. 1, *The Fabrication of Ancient Greece*. New Brunswick: Rutgers University Press, 1987.

Bertillon, Alphonse. *Instructions for Taking Descriptions for the Identification of Criminals and Others By Means of Anthropometric Indications*. Translated by Gallus Muller. Chicago: American Bertillon Prison Bureau, 1889.

———. *Legal Photography*. Translated by Paul Brown. New York, 1897.

———. *Les Races Sauvage*. Paris: Bibliotheque Nature, Ethnographie Moderne, 1882.

———. *Signaletic Instructions Including the Theory and Practice of Anthropometrical Identification*. Translated from the "Latest French Edition." Edited under the supervision of Major R. W. McClaughry. Chicago: Detective Publishing Company, 1896.

Bible: Designed to be Read as Living Literature, The Old and the New Testaments in the King James Version, The. New York: Simon & Schuster, 1936.

520

Binet, Alfred. "New Methods for the Diagnosis of the Intellectual Level of Subnormals." *L'Année Psychologique* 12 (1905): 191–244. Translated by Elizabeth S. Kite in *The Development of Intelligence in Children*. Vineland, NJ: Publications of the Training School at Vineland, 1916.

Black, Edwin. *War Against The Weak: Eugenics and America's Campaign to Create a Master Race.* New York: Four Walls Eight Windows, 2003.

Blacker, C. P. *Eugenics: Galton and After.* London: Gerald Duckworth & Co., 1952.

Blume, Mary. "A Rogues' Gallery in the Home of the Mug Shot." *International Herald Tribune*, February 26, 2000.

Blumenbach, Johann Friedrich. *The Anthropological Treatises.* London: Longman, Green, Longman, Roberts, & Green, 1865.

———. *The Elements of Physiology.* London: Longman, Rees, Orme, Brown, and Green, 1928. Translated from the Latin of the 4th and Last Edition, and supplied with copious notes, by John Elliotson. Note that Many of Elliotson's notes carry Blumenbach to places that he, himself, rejected, vis a vis inferiority of Ethiopian race, etc.

Boas, Franz. "Changes in Bodily Form of Descendants of Immigrants." United States Immigration Commission. Washington, DC: Government Printing Office, 1910.

———. *Mind of Primitive Man.* New York: MacMillan, 1911.

———. "Remarks on the Theory of Anthropometry." *Journal of American Statistical Association*, 1893.

"Bob Jones University Ends Ban on Interracial Dating." *CNN.com*, March 4, 2000. Available online at http://archives.cnn.com/2000/US/03/04/bob.jones.

Bogdan, Robert. *Freak Show: Presenting Human Oddities for Amusement and Profit.* Chicago: University of Chicago, 1988.

Boles, John. "Let the Screen Stars Teach You How to Make Love." *Serenade—The Illustrated Love Magazine*, June 1934.

Boyden, Dean. *Your Face is Your Fortune.* New York: George Sully and Company, 1928.

Brace, C. Loring et al. "Clines and Clusters versus 'Race.' A test in Ancient Egypt and the Case of a Death on the Nile." In *Black Athena Revisited.* Chapel Hill: University of North Carolina Press, 1996.

Brace, C. Loring. *The Dangerous Classes of New York, and Twenty Years' Work Among Them.* New York: Wynkoop & Hallenbeck, 1872.

———. "The Roots of Race in American Physical Anthropology." In *A History of American Physical Anthropology, 1930–1980.* New York: Academic Press, 1982.

Bradford, Phillips Verner, and Harvey Blume. *Ota Benga, the Pygmy in the Zoo: One Man's Degradation in Turn-Of-The-Century America.* New York: St. Martins Press, 1992.

Braudel, Fernand. *The Structures of Everyday Life: The Limits of the Possible*, Vol. 1, *Civilization & Capitalism 15th–18th Century.* New York: Harper and Row, 1981.

Brent, Linda [Harriet Jacobs]. *Incidents in the Life of a Slave Girl. Written by Herself.* Boston: self-published, 1861.

Brigham, C. C. *A Study of American Intelligence.* Princeton: Princeton University Press, 1923.

Broca, Paul. *On The Phenomena of Hybridity in the Genus Homo.* London: Longman, Green, Longman & Roberts, 1864.

Brontë, Charlotte. *Jane Eyre.* New York: Scholastic, 1969.

Brown, Dee. *Bury My Heart At Wounded Knee.* New York: Henry Holt, 1970, 2000.

Brown, Richard D. *Modernization: The Transformation of American Life, 1600–1865.* New York: Hill & Wang, 1976.

Bryan, William Jennings. *Bryan's Undelivered Speech, A Call to Christianity: The Great Commoner's Last Evolution Argument.* Kansas City: W. J. Smith, 1925.

Buck v. Bell, U.S. 292 (1926). Opinion of the Court delivered by Mr. Justice Holmes, May 2, 1927.

Burckhardt, Jacob. *The Civilization of the Renaissance in Italy.* London: Penguin, 1990.

Butler, Nicholas Murray. *The American As He Is.* New York: Macmillan, 1908.

Calloway, Thomas Julius. Thomas Julius Calloway to Booker T. Washington. In *The Booker T. Washington Papers*, edited by Louis R. Harlan, Raymond W. Smock, and Barbara S. Kraft. Urbana: University of Illinois Press, 1976.

Calverton, V. F., and S.D. Schmalhausen. *Sex in Civilization*. New York: Macaulay, 1929.

Camper, Petrus. *The Works of the Late Professor Camper, on the Connexion Between The Science of Anatomy and The Arts of Drawing, Painting, Statuary, &c. &c. in Two Books. Containing A Treatise on the Natural Difference of Features in Persons of Different Countries and Periods of Life; and on Beauty, as Exhibited in Ancient Sculpture; With a New Method of Sketching Heads, National Features, and Portraits of Individuals with Accuracy, &c. &c.* London: J. Hearne, 1821.

Carlson, Elof Axel. *The Unfit: A History of a Bad Idea*. Cold Spring Harbor, NY: Coldspring Harbor Laboratory Press, 2001.

Carpenter, Douglas. "Silhouette Art History," http://www.artist-doug-carpenter.i12.com.

Carpenter, Edward. *Intermediate Sex: A Study of Some Transitional Types of Men and Women*. London: George Allen, 1912.

———. *Love's Coming-Of-Age: A Series of Papers on The Relations of the Sexes*. 5th ed., enlarged. London: Swan Sonnenschein, 1906.

Carraro, Laura Favero. The Literary Encyclopedia, s.v. "Learned Ladies: 1650–1750." Available online at http://www.litencyc.com.

Carter, Walter. *The Coon and the Chink: A Vaudeville Sketch*. New York: Dick & Fitzgerald, 1912.

Chandler, Tertius, and Gerald Fox. *3000 Years of Urban Growth*. New York: Academic Press, 1974.

Chappell, Warren. *A Short History of the Printed Word*. Boston: NonPareil Books, 1970.

Chauncey, George. *Gay New York: Gender, Urban Culture and the Making of the Gay Male World, 1890–1940*. New York: Basic Books, 1994.

Christy, E. P. *Old Folks at Home, Ethiopian Melody*. As Sung by Christy's Minstrels. New York: Firth, Pond & Co., 1851. Actually written by Stephen Foster.

Colbert, Charles. *A Measure of Perfection: Phrenology and the Fine Arts in America*. South Carolina: Chapel Hill Press, 1997.

Columbia Encyclopedia, 6th ed., s.v. "Richard Louis Dugdale." New York: Columbia University Press, 2001.

Combe, George. *The Constitution of Man Considered in Relation To External Objects*. Hartford: S. Andrus and Son, 1845.

———. *Notes on the United States of America During a Phrenological Visit in 1838-9-40*, Vol. 1. Philadelphia: Carey and Hart, 1841.

———. *Notes on the United States of America During a Phrenological Visit in 1838-9-40*, Vol. 2. Philadelphia: Carey and Hart, 1841.

———. *A System of Phrenology*. 5th ed. William Colyer: New York 1843.

Comer, Jim. "Every Time I Turn Around: Rite, Reversal and the End of Blackface Minstrelsy." http://www.angelfire.com/oh/hydriotaphia/crow.html.

Congressional Record, 56th Cong., 1st sess., 704–711. As quoted in *Social Darwinism in American Thought* by Richard Hofstadter. Boston: Beacon, 1944, 1992.

Cook, David A. *A History of Narrative Film*. New York: Norton, 1981.

Coolidge, Calvin. "Whose Country Is This?" *Good Housekeeping*, February 1921, 13–14, 106–109.

Cuvier, Georges. *Discourse on the Revolutionary Upheavals on the Surface of the Earth*. Paris, 1825. Translated by Ian Johnston, Liberal Studies Department, Malaspina University College, Nanaimo, British Columbia, May 1998. Available online at http://www.mala.bc.ca/%7Ejohnstoi/cuvier/cuvier-e.htm.

Darrow, Clarence. "The Eugenics Cult." *The American Mercury*, 1926, 8:129–137.

Darwin, Charles. *The Descent of Man*. Amherst, New York: Prometheus, 1998.

———. *The Origin of Species*. New York: Oxford, 1998.

———. *The Origin of Species*, Signet Classic. London: Penguin.

Davies, John A. *Phrenology: Fad and Science, A 19th Century Crusade*. New Haven: Yale University Press, 1955.

Davis, Lee. *Scandals and Follies: The Rise and Fall of the Great Broadway Reviews*. New York: Limelight Editions, 2000.

de Fleury, Maurice. *The Criminal Mind*. London: Downey & Co., 1901.

de Guistino, David. *Conquest of Mind:Phrenology and Victorian Social Thought*. London: Croomheld Press, 1975.

Deane, Pam. The Museum of Broadcast Communications' official Web site. "Amos 'n' Andy Show," http://www.museum.tv/archives/etv/A/htmlA/amosnandy/amosnandy.htm.

"Death of Spurzheim," obituary from *Boston Medical and Surgical Journal*, November 14, 1832.

Debord, Guy. *Society of the Spectacle*. London: Zone, 1995.

Defoe, Daniel. "The Education of Women." *The Sophia Project*, 1719. Available online at http://www.molloy.edu/academic/philosophy/sophia/topics/phiedu/defoe.htm.

Delaumosne, Abb'e. *The Art of Oratory, Systems of Delsarte*. Translated by Francis A. Shaw. Albany: Edward S. Werner, 1882.

———. *Delsarte System of Oratory*. N.p., 1893. Note that Delaumosne was a student of Delsarte.

Delaumosne, L'Abbé et al. *The Delsarte System of Oratory*. 4th ed. New York: Edgar S. Werner, 1893. Also available online at http://www.fullbooks.com/Delsarte-System-of-Oratory1.html.

DeMille, Cecil B. *The Autobiography of Cecil B. DeMille*. Edited by Donald Hayne. New Jersey: Prentice Hall, 1959.

Dirks, Tim. "The Jazz Singer (1927)." *Greatest Films*, http://www.greatestfilms.org.

———. "King Kong (1933)." *Greatest Films*, http://www.greatestfilms.org.

Douglass, Frederick. *My Bondage and My Freedom*. New York: Miller, Orton and Mulligan, 1855. Reprint, Urbana: Univ. of Illinois Press, 1987. Citations are to the Univ. of Illinois Press edition.

———. *Narrative of the Life of Frederick Douglass, An American Slave*. Boston: Anti-Slavery Office, 1845.

Downing, John D. H. The Museum of Broadcast Communications' official Web site. "Racism, Ethnicity and Television," http://www.museum.tv/archives/etv/R/htmlR/racismethni/racismethni.htm.

Dugdale, R. L. *'The Jukes' A Study in Crime, Pauperism, Disease and Heredity, Also Further Studies of Criminals*. New York: G. P. Putnam's Sons, 1877.

Earle, Edward W., ed. *Points of View: The Stereograph in America—A Cultural History*. Rochester: Visual Studies Workshop Press, 1979.

Edwards, Elizabeth, ed. *Anthropology and Photography: 1860–1920*. New Haven: Yale, 1992.

Ehle, John. *Trail of Tears: The Rise and Fall of the Cherokee Nation*. New York: Anchor, 1988.

Ellis, Havelock. *The Criminal*. 1st ed. London: Walter Scott, 1900.

———. *The Criminal*. 2nd ed. London: Walter Scott, Ltd., 1895.

———. *The Criminal*. 4th ed. London, New York: Walter Scott Publishing, 1910.

———. *The Criminal*. 5th ed, rev. and enlarged. London: Walter Scott, 1914.

———. *Studies in the Psychology of Sex*, Vol. 1. 1898. Reprint, New York: Random House, 1936.

———. *Studies in the Psychology of Sex*, Vol. 11. 1898. Reprint, New York: Random House, 1936.

———. *The Task of Social Hygiene*. Boston: Houghton Mifflin, 1912.

Ellison, Ralph. "Writers' Project Interviews," http://memory.loc.gov/ammem/wpaintro/intro12.html.

Emblen, D. L. *Peter Mark Roget: The Word and the Man*. New York: Thomas Y. Crowell, 1970.

Emmett, Dan. "Dixie," circa 1859. http://ingeb.org/index.html.

Encyclopedia Britannica, 15th ed.

Engels, Frederick. *The Origin of the Family, Private Property and the State: In the Light of the Researches of Lewis H. Morgan*. New York: International Publishers, 1975.

"Erasmus Darwin: 1731–1802." A biography. http://www.ucmp.berkeley.edu/history/Edarwin.html.

Erb, Cynthia. *Tracking King Kong: A Hollywood Icon in World Culture*. Detriot: Wayne State University Press, 1998.

Ewen, Stuart, and Elizabeth Ewen. *Channels of Desire: Mass Images and the Shaping of American Consciousness.* New York: McGraw-Hill, 1982.

Ewen, Stuart. *Captains of Consciousness: Advertising and the Social Roots of the Consumer Culture.* New York: McGraw-Hill, 1976.

"Falwell Apologizes to Gays, Feminists, Lesbians." CNN.com/us, September 14, 2001.

Farber, Paul Lawrence. *Finding Order in Nature: The Naturalist Tradition from Linnaeus to E. O. Wilson.* Baltimore: Johns Hopkins, 2000.

Fausto-Sterling, Anne. *Sexing the Body: Gender Politics and the Construction of Sexuality.* New York: Basic Books, 2000.

Fee, Elizabeth. "The Sexual Politics of Victorian Social Anthropology." In *Clio's Consciousness Raised: New Perspectives on the History of Women.* Edited by Mary S. Hartman, Lois Banner. New York: Harper & Row,1974.

Fenton, Frances. *The Influence of Newspaper Presentations Upon the Growth of Crime and other Antisocial Activity.* Chicago: University of Chicago Press, 1911.

Fergus, Charles. "Bones, Boas and Race." *Online Research Penn State* 24, no. 2, (May 2003).

Ferrero, Gina Lombroso. *Criminal Man: According to the Classification of Cesare Lombroso.* New York: G. P. Putnam's Sons, 1911.

Ferri, Enrico. *Criminal Sociology.* Boston: Little Brown, 1917.

Fields, Jill. "Fighting 'The Corsetless Evil': Shaping Corsets and Culture, 1900–1930." *Journal of Social History* 33, no. 2 (1999): 355.

Fink, Arthur E. *Causes of Crime: Biological Theories in the United States, 1800–1915.* Philadelphia: University of Pennsylvania, 1938.

Firth, Henry. *How to Read Character.* London, New York: Ward, Lock and Bowdon, 1891.

"Fitter Family Contests." Eugenics Archive, Dolan DNA Learning Center, Cold Spring Harbor Laboratory. Also available online at http://www.eugenicsarchive.org/eugenics.

Fogarty, Lori. "Forward and Acknowledgments." In *Police Pictures: The Photograph as Evidence.* San Francisco: San Francisco Museum of Modern Art/Chronicle Books, 1997.

Fosbroke, Gerald Elton. *Character Reading through Analysis of the Features.* New York: G.P. Putman's Sons, 1914.

Foucault, Michel. *Discipline and Punish: The Birth of the Prison.* New York: Pantheon, 1977.

———. *The History of Sexuality, Vol. I: An Introduction.* New York: Vintage, 1990.

Founding Statement of the Eugenics Record Office, October 1, 1910. As quoted by Elof Axel Carlson in *The Unfit: A History of a Bad Idea.*

Fowler, L. N. *Familiar Lessons on Physiology Designed for the Use of Children and Youth*, Vol. 1 *and* 2. New York: Fowler and Wells, 1848.

Fowler, O. S. *Phrenology, Proved, Illustrated and Applied.* New York: Fowler and Wells, 1855.

Fowler, O. S., and L.N. Fowler. *The Illustrated Self-Instructor in Phrenology and Physiology with One Hundred Engravings and a Chart of the Character*, New York: Fowlers and Wells, 1855.

———. *New Illustrated Self-Instructor in Phrenology and Physiology.* New York: Samuel R. Wells, 1868.

———. *Phrenology: A Practical Guide To Your Head*, introd. to reprint by Andrew E. Norman. New York: Chelsea House, 1969.

———. *Practical Phrenology.* New York: Fowlers and Wells, 1856.

Fox-Genovese, Elizabeth and Eugene D. Genovese. *Fruits of Merchant Capital: Slavery and Bourgeois Property in the Rise and Expansion of Capitalism.* New York: Oxford, 1983.

"Francis Galton," http://galton.org/index.html.

Frederick, Christine McGaffey. *Selling Mrs. Consumer.* New York: The Business Bourse, 1929.

Fredrickson, George M. *The Black Image in the American Mind: The Debate on Afro-American Character and Destiny, 1817–1914.* New York: Harper and Row, 1971.

Freud, Sigmund. *An Autobiographical Study*, New York: Norton, 1935, 1952.

———. *Civilization and Its Discontents.* New York: Norton, 1961, 1930.

———. *Civilization and Its Discontents.* Translated by James Strachey. New York: Norton, 1961.

———. *Three Essays on the Theory of Sexuality.* New York: Basic Books, 1905, 2000.

Frisken, Amanda. *Victoria Woodhull, Sexual Revolutionary: Political Theater and the Popular Press in Nineteenth-Century America*. Philadelphia: University of Pennsylvania, 2004.

Fryer, Lorine Pruette. *Women and Leisure*. New York, 1924.

Gall to Joseph von Retzer, "On the functions of the brain, in man and animals," 1 October 1798 as quoted in "Biography: Franz Joseph Gall," http://www.whonamedit.com.

Galton, Francis. "Africa for the Chinese." Letter to the editor, *Times* (London), June 5, 1873. Also available online at http://www.galton.org.

———. "Composite Portraiture." *The Photographic News*, July 8, 1881–July 15, 1881.

———. "Eugenics. Its definition, scope and aims." *American Journal of Sociology* X, no. 1 (July, 1904). Also available online at http://www.galton.org.

———. *Hereditary Genius: An Inquiry Into Its Laws and Consequences*. London: MacMillan, 1869.

———. *Hereditary Genius: An Inquiry into Its Laws and Consequences*. Honolulu: University Press of the Pacific, 2001. Reprint of 1892 edition.

———. "Hereditary Talent and Character." *Macmillan's Magazine*, 1865.

———. *Inquiries into Human Faculty and Its Development*. London: MacMillan, 1883.

———. *Memories of My Life*. London: Methuen, 1908.

———. "On the Anthropometric Laboratory at the late International Health Exhibition." *Journal of the Anthropological Institute* 14 (1884): 205–218.

———. "Photographic Composites." *The Photographic News*, April 17, 1885.

———. "Record of Family Faculties." *Journal of the Royal Statistical Society* 47 (March 1884): 166. Also available online at http://www.galton.org.

———. "Retrospective of Work Done at My Anthropometric Laboratory at South Kensington." *Journal of the Anthropological Institute* 21 (1891): 32–35.

Garden, Mary. "Why I Bobbed My Hair." *Pictorial Review*, April 1927.

Gatto, John Taylor. "Racial Suicide." The Odysseus Group, http://www.johntaylorgatto.com/chapters/11d.htm.

Gay, Peter. *Freud: A Life for Our Time*. New York: Norton, 1988.

Gibson, Mary. *Born To Crime: Cesare Lombroso and the Origins of Biological Criminology*. Westport, CT: Praeger, 2002.

Gillham, Nicholas Wright. *A Life of Sir Francis Galton: From African Exploration to the Birth of Eugenics*. New York: Oxford University Press, 2001.

Gilman, Charlotte Perkins. *Women and Economics: A Study of the Economic Relation Between Men and Women as a Factor in Social Evolution*. New York: Harper & Row, 1966, 1898.

Gilman, Sander. *Differences and Pathology: Stereotypes of Sexuality, Race and Madness*. Ithaca: Cornell University Press, 1985.

Ginsberg, Allen. *America and Other Poems*. San Francisco: City Lights, 1956, 1996.

Goddard, Henry Herbert. *Psychology of the Normal and Subnormal*. New York: Dodd, Mead and Co., 1919.

———. *The Kallikak Family*. New York: Macmillan, 1912.

Gordon, Linda. *Woman's Body, Woman's Right: Birth Control in America*. New York: Penguin, 1976.

Gordon, Rosemary. *Stereotypy of Imagery and Belief as an Ego Defence*. Cambridge: Cambridge University Press, 1962. Part of a series published by Cambridge University Press in The British Journal of Psychology Monograph Supplements, XXXIV.

Gould, Stephen Jay. *The Flamingo's Smile: Reflections in Natural History*. New York: Norton, 1985.

———. *The Mismeasure of Man*. New York: Norton, 1996, 1981.

———. *The Panda's Thumb: More Reflections on Natural History*. New York: Norton, 1980, 1992.

Graham, John. *Lavater's Essays on Physiognomy: A Study in the History of Ideas*. Bern: European University Studies/Peter Lang, 1979.

Grant, Madison. *The Passing of a Great Race or The Racial Basis of European History*, 4th ed. New York: Scribner's Sons, 1923. First published 1916.

Graves, Robert, and Raphael Patai. *Hebrew Myths: The Book of Genesis*. New York: Doubleday, 1964.

"Great Theosophists," *Theosophy* 26, no. 2. December 1937, 50–56. Also available online at http://www.wisdomworld.org/setting/rogerbacon.html.

Grupp, Stanley E., ed. *The Positive School of Criminology: Three Lectures By Enrico Ferri*. Pittsburgh: University of Pittsburgh, 1968.

Haggard, H. Rider. *King Solomon's Mines*. New York: Oxford University Press, Oxford World's Classics, 1998.

Haggard, H. Rider. *She: A History of Adventure*. New York: Modern Library, 2002.

Haiken, Elizabeth. *Venus Envy: A History of Cosmetic Surgery*. Baltimore: Johns Hopkins, 1997.

Haining, P. ed., "Sir Henry Rider Haggard (1856–1925)," http://www.kirjasto.sci.fi/haggard.htm.

Hamilton, David L., ed. *Cognitive Processes in Stereotyping and Intergroup Behavior*. Hillsdale, NJ: Laurence Earlbaum Associates, 1981.

Haraway, Donna. *Primate Visions: Gender, Race and Nature in the World of Natural Science*. New York: Routledge, 1999.

Harper, Kenn. *Give Me My Father's Body: The Life of Minik, the New York Eskimo*. Vermont: Steerforth Press, 2000.

Harris, Louis. *The Story of Crime*. Boston: Stratford, 1929.

Hartnett, Stephen John. *Democratic Dissent and Cultural Fictions of Antebellum America*. Urbana-Champaign: University of Illinois, 2002.

Harvard University. "Lawrence H. Summers," http://www.president.harvard.edu/biography. Official biography of Harvard Univ.'s 27th president.

Hauser, Arnold. *The Social History of Art*, Vol. 2, *Renaissance, Mannerism, Baroque*. New York: Vintage, 1951.

———. *The Social History of Art*, Vol. 3, *Rococo, Classicism, Romanticism*. New York: Vintage, 1951.

Hecker, John. *The Scientific Basis of Education, Demonstrated by an Analysis of the Temperaments and of Phrenological Facts, in Connection with Mental Phenomena and the Office of the Holy Spirit in the Processes of the Mind: In a Series of Letters, to the Department of Public Instruction in the City of New York*. New York: A. S. Barnes & Co., 1868.

Higashi, Sumiko. *Cecil B. DeMille and American Culture: The Silent Era*. Berkeley: California, 1994.

Hill, Christopher. *The World Turned Upside Down: Radical Ideas During the English Revolution*. London: Penguin, 1975.

Hinkle, Beatrice M. "New Morals for Old: Women and the New Morality." *The Nation*, November 19, 1924.

Hockney, David. *Secret Knowledge: Rediscovering the Lost Techniques of the Old Masters*. New York: Viking Studio, 2001.

Hofstadter, Richard. *Social Darwinism in American Thought*. Boston: Beacon, 1944, 1992. Quoted in Hofstadter, *Social Darwinism In American Thought*, from the Congressional Record (56 Congress., 1st Session), Vol. XXXIII, 711.

Holy Bible: From the Ancient Eastern Text. Translated by George M. Lamsa from the Aramaic of the Pashitta. San Francisco: Harper, 1933, 1968.

Holy Scriptures, The. Philadelphia: The Jewish Publication Society of America, 1917, 1955.

Howard, Angela, and Sasha Ranaé Adams Tarrant, eds. *Antifeminism in America: A Collection of Readings from the Literature of the Opponents to U. S. Feminism, 1848 to the Present*. New York: Garland, 2000.

Hughes, Langston. "The Negro Artist and the Racial Mountain." *The Nation*. June 23, 1926.

Hunter, George William. *New Civic Biology—Presented in Problems*. New York: American Book Company, 1914.

Jackson, Derrick Z. "The Westmoreland Mindset." *Boston Globe*, July 20, 2005.

Jacobs, Joseph. "The Jewish Type and Galton's Composite Photographs." *The Photographic News*, April 24, 1885.

———. *Jewish Encyclopedia*, s. v. "Anthropology," 1901. Also available online at http://www.jewishencyclopedia.com.

Jacobson, Matthew Frye. *Whiteness of a Different Color: European Immigrants and the Alchemy of Race*. Cambridge: Harvard University Press, 1998.

Jefferson, Thomas. *The Life and Selected Writings of Thomas Jefferson*. New York: Random House, 1944.

————. "Notes on Virginia." In *The Life and Writings of Thomas Jefferson*. Edited by Adrienne Koch and William Peden. New York: Modern Library, 1944.

Jehel, Pierre-Jérôme. "Photographie et anthropologie en France au XIXe siècle." PhD diss., University of Paris VIII, St. Denis, 1994–1995.

Jensen, Joan M. "All Pink Sisters: The War Department and the Feminist Movement in the 1920s." In *Decades of Discontent: The Women's Movement, 1920–1940*. Edited by Klois Scharf and Joan M. Jensen. Westport, CT: Greenwood, 1983. Also available online at http://www.jofreeman.com./polhistory/spiderman.htm.

Johnson, Michael. *American Indians of the Southeast*. Oxford, UK: Osprey, 1995.

Jones, Ernest. *The Life and Work of Sigmund Freud*, Vol. 1. New York: Basic Books, 1951.

Jones, Leroi. *Blues People: Negro Music in White America*. New York, William Morrow, 1963.

Kansas Bureau of Child Research. "Fitter Families for Future Firesides: A Report of the Eugenics Department of the Kansas Free Fair, 1920–1924." Eugenics Committee of the United States of America, 1924. Eugenics Archive, Dolan DNA Learning Center, Cold Spring Harbor Laboratory. Also available online at http://www.eugenicsarchive.org/eugenics.

Kasson, John. *Amusing the Millions: Coney Island at The Turn of the Century*. New York: Hill & Wang, 1978.

Kellor, Frances A. *Experimental Sociology. Descriptive and Analytical Delinquents*. New York: Macmillan, 1901.

Kenrick, John. "That Shufflin' Throng." *A History of the Musical Minstrel Shows*, Parts 1 and 2. 1996, 2003. Also available online at http://www.musicals101.com/minstrel.htm#Throng.

King's College London. "Sir Charles Wheatstone and the Wheatstone Collection." Host Project Partners, Host Collection, 1801–1914. Available online at http://www.kcl.ac.uk/depsta/iss/library/speccoll/host/wheatstone.html.

Kinsey, Alfred C., Wardell B. Pomeroy, and Clyde E. Martin. *Sexual Behavior in the Human Male*. Philadelphia: W. B. Saunders, 1948.

Kinsey, Alfred C., Wardell B. Pomeroy, Clyde E. Martin, and Paul H. Gebhard. *Sexual Behavior in the Human Female*. Philadelphia: W. B. Saunders, 1953.

Kipling, Rudyard. "The White Man's Burden: The United States and the Philippine Islands (1899)." *McClure's Magazine*, February 1899. Reprinted in Rudyard Kipling's Verse: Definitive Edition. Garden City: Doubleday, 1929. Also available online at http://historymatters.gmu.edu/d/5478.

Kismaric, Susan. *American Politicians: Photographs from 1843 to 1993*. New York: Abrams, 1994.

Kline, Wendy. *Building a Better Race: Gender, Sexuality, and Eugenics from the Turn of the Century to the Baby Boom*. Berkeley: University of California, 2001.

Knight, Arthur. *The Liveliest Art: A Panoramic History of the Movies*. New York: New American Library, 1959.

Kraditor, Aileen S. *Up From the Pedestal: Selected Writings in the History of American Feminism*. Chicago: Quadrangle, 1968.

La Piere, Richard T., and Paul R. Farnsworth. *Social Psychology*. New York: McGraw-Hill, 1936.

Laqueur, Thomas W. *Making Sex: Body and Gender From the Greeks to Freud*. Cambridge: Harvard, 1990.

————. *Solitary Sex: A Cultural History of Masturbation*. New York: Zone Books, 2003.

Lavater, John Caspar. *Essays in Physiognomy, Designed to Promote the Knowledge and the Love of Mankind*. Translated by Henry Hunter. Executed by, or under the inspection of, Thomas Holloway. London: John Stockdale, 1810.

————. *Essays on Physiognomy One Hundred Physiognomical Rules, and A Memoir of the Author*, 17th ed. Translated by Thomas Holcroft. New York: R. Worthington, n.d. From 1804 Holcroft translation.

Lawrence, William. "Physiology, Zoology, and the Natural History of Man." Lecture delivered at the Royal College of Surgeons, London, 1821.

Le Bon, Gustave. *The Crowd: A Study of the Popular Mind*. London: Ernest Bernn, 1896.

Leavitt, Andrew J. and H. W. Eagan. *Black Ole Bull, An Original Ethiopian Sketch*. New York: Samuel French & Son/Ethiopian Drama New Series, No. 14, 1868.

Lefkowitz, Mary, and Guy McLean Rogers, eds. *Black Athena Revisited*. Chapel Hill: University of North Carolina Press, 1996.

Leloup, Jean-Yves. *The Gospel of Mary Magdalene*. Vermont: Inner Traditions, 2002.

Lewis, Lloyd. "The Deluxe Picture Palace." *The New Republic*, March 27, 1929.

Library of Congress. With essays by David Levering Lewis and Deborah Willis. *A Small Nation of People: W. E. B. DuBois and African American Portraits of Progress*. New York: Amistad/Harper Collins, 2003.

Lieberman, David E. "Upending the Expectations of Science." *New York Times*, July 14, 2002.

Limerick, Patricia Nelson. "Why Am I an Experiment?" *New York Times Book Review*, June 25, 2000.

Linder, Douglas O. "The Trials of Oscar Wilde: An Account." http://www.law.umkc.edu/faculty/projects/ftrials/wilde/wilde.htm.

Linneaus, Caroli. *Systema Naturæ Per Regna Tria Naturæ, Tomus I*. Upsala: Holmiæ, Impansis Direc. Salurentii Salvii, 1758.

Lippmann, Walter. *Public Opinion*. New York: Free Press, 1922.

Little, Michael A. "The Development of Ideas on Human Ecology and Adaptation." In *A History of American Physical Anthropology, 1930–1980*. New York: Academic Press, 1982.

Lomax, Leila. *Physiognomy: How to Read Character in the Face and Determine the Capacity for Love, Business or Crime*. Philadelphia: Penn Publishing Company, 1905.

Lombardo, Paul. "Eugenic Sterilization Laws." Image Archive on the American Eugenics Movement, Dolan DNA Learning Center, Cold Spring Harbor Laboratory. http://www.eugenicsarchive.org.

Lombroso, Cesare, and William Ferrero. *The Female Offender*. New York: The Philosophical Library, 1898, 1958.

Lombroso, Cesare. Introd. to *Criminal Man: According to the Classification of Cesare Lombroso*, by Gina Lombroso Ferrero. New York: G. P. Putnam's Sons, 1911.

Lombroso, Cesare. *The Man of Genius*. London: Walter Scott, 1891.

Long, Walter S. *Dat Famous Chicken Debate: The University of Africa (Aff.) vs. Bookertea College (neg.)*. Franklin, Ohio: Black Face Plays/ Eldridge Entertainment House, 1915.

———. *Ghoses Er Not Ghoses. A Negro Debate*. Franklin Ohio: Eldridge Entertainment, 1916.

Loos, Adolf. "Ornament and Crime," 1908. Reprinted in *Programs and Manifestoes of Twentieth Century Architecture*. Edited by Ulrich Conrads. Cambridge: MIT, 1964.

Lydston, G. Frank. *The Diseases of Society*. Philadelphia: J. B. Lippincott Co., 1904.

Lynd, Robert. With the assistance of Alice Hanson. "The People As Consumers." Chapter XVII in *Recent Social Trends in the United States: Report of the President's Research Committee on Social Trends Vol. II*. New York: McGraw-Hill, 1933.

MacDonald, Arthur. *Abnormal Man, Being Essays on Education and Crime and Related Subjects, with Digests of Literature and a Bibliography. Bureau of Education. Circular of Information No. 4, 1893*. Washington: Government Printing Office, 1893.

———. *Criminology*. With an introduction by Dr. Cesare Lombroso. New York: Funk & Wagnalls, 1893.

Macrae, C. Neil, Charles Stanger, and Miles Hewstone. *Stereotypes and Stereotyping*. New York: Guilford Press, 1996.

Man, John. *Gutenberg: How One Man Remade the World with Words*. New York: Wiley, 2002.

Marx, Karl to Danielson, 10 April 1879. As quoted in *The Age of Capital, 1848–1875* by Hobsbawm, E. J. New York: New American Library, 1975.

Marx, Karl, and Frederick Engels. *Selected Works, Vol. I*. Moscow: Foreign Languages Publishing House, 1962.

———. *Selected Works, Vol. II*. Moscow: Foreign Languages Publishing House, 1962.

Marzio, Peter. *The Democratic Art: Pictures for a 19th-century America: Chromolithography, 1840–1900*. Boston : D. R. Godine, 1979.

Maudsley, Henry. *The Physiology of Mind*. New York: D. Appleton, 1889.

Mauries, Patrick. *Cabinets of Curiosities*. London: Thames & Hudson, 2002.

528 Mayhew, Henry. *London Labor and The London Poor, Vol. I, The London Street-Folk*. New York: Dover, 1968. Originally published as articles in *The Morning Chronicle*, 1849–1850.

McDaniel, George. "Madison Grant and the Racialist Movement: The Distinguished Origins of Racial Activism." *American Renaissance*, December 1997, 56.

McDougall, William. *National Welfare and National Decay*. London: Methuen, 1921.

McKenzie, R. D. "The Rise of Metropolitan Communities," Chapter IX in *Recent Social Trends in the United States: Report of the President's Research Committee on Social Trends Vol. I*. New York: McGraw-Hill, 1933.

McLuhan, Marshall. *The Mechanical Bride: Folklore of Industrial Man*. Boston: Beacon, 1951.

McMahon, John R. "Unspeakable Jazz Must Go." *Ladies Home Journal*, December 1921. As quoted by Carolyn Johnston in *Sexual Power: Feminism and the Family in America*. Tuscaloosa: University of Alabama, 1992.

Mehler, Barry. "A Brief History of European and American Eugenics Movements." Excerpted from "A History of the American Eugenics Movement," Ph.D. Thesis, University of Illinois, 1988. Also available online at the Institute for the Study of Academic Racism's official Web site, www.ferris.edu/isar/arcade/eugenics/movement.htm.

Meijer, Miriam Claude. *Race and Aesthetics in the Anthropology of Petrus Camper, 1722–1789*. Amsterdam: Editions Rodopi, 1999.

Meyer, Marvin W. *The Secret Teachings of Jesus: Four Gnostic Gospels*. New York: Vintage, 1986.

Morton, Samuel George. *Crania Aegyptiaca, or Observations on Egyptian Ethnography, Derived from Anatomy, History, and the Monument*. Philadelphia: John Penington, 1844.

———. *Crania Americana or A Comparative View of the Skulls of Various Aboriginal Nations to which is prefixed An Essay on the Varieties of the Human Species*. Philadelphia: J. Dobson, Chestnut Street, 1839.

Moses, L. G. *Wild West Shows and the Images of American Indians, 1883–1933*. Albuquerque: University of New Mexico, 1996.

Mosse, George L. *The Image of Man: The Creation of Modern Masculinity*. New York: Oxford, 1996.

———. *Toward the Final Solution: A History of European Racism*. New York: Howard Fertig, 1978, 1985.

Mowry, George E. *The Twenties: Fords, Flappers & Fanatics*. New Jersey: Prentice-Hall, 1963.

Münsterberg, Hugo. *The Americans*. New York: McClure, Phillips & Co., 1904.

———. *On the Witness Stand: Essays in Psychology and Crime*. Garden City, NY: Doubleday, 1908.

———. *The Photoplay: A Psychological Study*. New York, 1916. Republished as *The Film, A Psychological Study, The Silent Photoplay* in 1916. New York: Dover, 1971.

Nelson, Stanley. "Soldiers Without Swords." Public Broadcasting System, 1999.

New York Times. "An Unexpected Face," July 12, 2002.

Newhall, Beaumont, ed. *Photography: Essays & Images, Illustrated Readings in the History of Photography*. New York: Museum of Modern Art, 1980.

Nielsen, Kim E. *Un-American Womanhood: Anti-Radicalism, Anti-Feminism and the First Red Scare*. Columbus, OH: State University Press, 2001.

Nordau, Max. *Degeneration*. New York: D. Appleton, 1895.

Nott, Josiah Clark, and George Gliddon. *Types of Mankind: or, Ethnological Researches, Based upon the Ancient Monuments, Paintings, Sculptures, and Crania of Races, and upon Their Natural, Geographical, Philological and Biblical History*. Philadelphia: Lippincott, Grambo, 1854, 1855.

Oakes, Penelope J., S. Alexander Haslam, and John C. Turner. *Stereotyping and Social Reality*. Oxford: Blackwell, 1994.

Ogburn, William F. *Social Change With Respect to Culture and Original Nature*. 1922. Reprint, New York: Viking, 1938.

Oppenheim, Annie P. *The Face and How to Read It—Physiognomy Made Easy, Phreno-Physiognomy*. London: T. Fisher Unwin, 1907.

Owens, Lance S. "An Introduction to Gnosticism and The Nag Hammadi Library," The Gnostic Society Library, http://gnosis.org.

Pagels, Elaine. *Beyond Belief: The Secret Gospel of Thomas*. New York: Random House, 2005.

———. *The Gnostic Gospels*. New York: Vintage, 1979.

Pait, Jonathan to James Landrith. August 31, 1998. Available online at The Multiracial Activist, http://www.multiracial.com/letters/bobjonesuniversity.html.

Palter, Robert. "The Historiography of Black Athena." In *Black Athena Revisited*. Chapel Hill: University of North Carolina Press, 1996.

Paskman, Dailey. "Gentlemen, Be Seated!" New York: Clarkson N. Potter, 1928, 1976.

Patai, Raphael. *The Hebrew Goddess*. Detroit: Wayne State University Press, 1978.

Pearson, Karl. *The Life, Letters and Labour of Francis Galton*, Vol. 3a. Cambridge: Cambridge Univ. Press, 1930.

Peiss, Kathy. *Hope in a Jar: The Making of America's Beauty Culture*. New York: Metropolitan Books, 1998.

Phillips, Sandra S. "Identifying the Criminal." In *Police Pictures: The Photograph as Evidence*. San Francisco: San Francisco Museum of Modern Art/Chronicle Books, 1997.

Phillips, Sandra S., Mark Haworth-Booth, and Carol Squiers, eds. *Police Pictures: The Photograph as Evidence*. San Francisco: San Francisco Museum of Modern Art/Chronicle Books, 1997.

Photographic News. "Notes," April 17, 1885.

Phrenology Miscellany or the Annals of Phrenology and Physiognomy: From 1865 to 1873, The. New York: Fowler and Wells, 1882.

Pichard, Max. *The Human Face*. Translated by Guy Endore. New York: Farrar and Rinehardt Inc., 1930.

Pick, Daniel. *Faces of Degeneration: A European Disorder, c. 1848–c. 1918*. Cambridge, UK: Cambridge University Press, 1989.

Pickford, Mary. "Why I Have Not Bobbed Mine." *Pictorial Review*, April 1927.

Pierpont, Claudia Roth. "The Measure of America: How a Rebel Anthropologist Waged War on Racism." *New Yorker*, March 8, 2004, 48–63.

Pilgrim, David, and Phillip Middleton. Jim Crow Museum of Racist Memorabilia's official Web site. "Niggers and Caricatures," http://www.ferris.edu/news/jim crow.

Potts, Alex. *Flesh and the Ideal: Winckelmann and the Origins of Art History*. New Haven: Yale, 1994.

Pratt, Samuel Jackson. "The Fair Circassian: A Tragedy." London: R. Baldwin, 1781.

President's Research Committee on Social Trends. Recent Social Trends in the United States: *Report of the President's Research Committee on Social Trends* Vol. I. New York: McGraw-Hill, 1933.

———. Vol. II. New York: McGraw-Hill, 1933.

Prichard, J. C. *The Natural History of Man comprising inquiries into the Modifying Influence of Physical and Moral Agencies on the Different Tribes of the Human Family*. London: H. Bailliere, 1843.

———. *Researches into the Physical History of Mankind*, 3rd ed. Vol. I. London: Sherwood, Gilbert and Piper, 1836.

Rado, Sander. "A Critical Examination of the Concept of Bisexuality." *Psychosomatic Medicine* 2 (October 1940): 459–467.

Rafter, Nicole Hahn. *Creating Born Criminals*. Urbana and Chicago: Illinois, 1997.

Redfield, James W. *Comparative Physiognomy or the Resemblences between Men and Animals*.

———. *The Twelve Qualities of Mind or Outlines of a New System of Physiognomy*. New York: J.S. Redfield, 1852.

Animals. New York: Redfield Publishing Company, 1852.

Reese, Bill. "Thumbnail History of the Banjo." http://bluegrassbanjo.org/banhist.html.

Reilly, Phillip R. *The Surgical Solution: A History of Involuntary Sterilization in the United States*. Baltimore: Johns Hopkins, 1991.

Rhodes, Henry T. F. *Alphonse Bertillon: Father of Scientific Detection*. London: George G. Harrap & Co., 1956.

———. *Genius & Criminal: A Study in Rebellion*. London: John Murray, 1932.

Richardson, Ruth. *Death, Dissection and the Destitute*. Chicago: University of Chicago,1987, 2000.

Richter, I. A., ed. *Selections from the Notebooks of Leonardo da Vinci*. Oxford: Oxford University Press, 1977.

530

Rimer, Sara, and Patrick D. Healy. "Furor Lingers as Harvard Chief Gives Details of Talk on Women." *New York Times*, February 18, 2005.

Riordan, Teresa. *Inventing Beauty: A History of the Innovations that Have Made Us Beautiful.* New York: Broadway Books, 2004.

Ripley, William Z. *The Races of Europe.* New York: D. Appleton, 1899.

Rivers, Christopher. *Face Value: Physiognomical Thought in the Legible Body in Marivaux, Lavater, Balzac, Gautier and Zola.* Madison: University of Wisconsin Press, 1994.

Robb, Graham. *Strangers: Homosexual Love in the Nineteenth Century.* New York: Norton, 2004.

Roberts, Mary Louise. *Civilization Without Sexes: Reconstructing Gender in Postwar France, 1917–1927.* Chicago: University of Chicago, 1994.

Robinson, David. *Hollywood in the Twenties.* New York: A. S. Barnes and Company, 1968.

Robinson, James M., ed. *The Nag Hammadi Library: The Definitive Translation of the Gnostic Scriptures.* San Francisco: Harper, 1978.

Roget, Peter Mark. *Roget's International Thesaurus.* New York: Thomas Y. Crowell, 1946.

———. *Thesaurus of English Words and Phrases Classified and Arranged so as To Facilitate the Expression of Ideas And Assist In Literary Composition.* London: Longman, Green, and Co., 1871.

Roget's Thesaurus of English Words and Phrases Classified and Arranged So as to Facilitate the Expression of Ideas and Assist in Literary Composition. Edited by C. O. Sylvester Mawson. New York: Thomas Y. Crowell Company, 1911.

Rogin, Michael. *Blackface, White Noise: Jewish Immigrants in the Hollywood Melting Pot.* Berkeley: University of California, 1998.

Roosevelt, Franklin Delano. "Address of the President on Works Relief," April 28, 1935. Available online at http://www.multied.com/documents/FDRsseventhfireside.html.

———. "Democratic nomination speech," Madison Square Garden, NY, 1936. Available online at http://history.sandiego.edu/gen/text/us/fdr1936.html.

———. "Second Inaugural Address," January 20, 1937. Available online at http://www.yale.edu/lawweb/avalon/presiden/inaug/froos2.htm.

Rosen, David N. "King Kong: Race, Sex and Rebellion. "*Jump Cut* no. 6 (1975): 7–10.

Rosenblum, Naomi. *A World History of Photography.* New York: Abbebille, 1984.

Ross, E. A. "The Causes of Race Superiority." *Annals of the American Academy of Political and Social Science* 18 (1901): 88.

———. "The Suppression of Important News." *Atlantic Monthly*, March 10, 1910.

Rousseau, Jean Jacques. *Discourse on Inequality.* Translated by Maurice Cranston. London: Penguin, 1985. Originally published in 1754.

Rousseau, Jean Jacques. *Emile.* London: Everyman, 1911, 1993.

Rowbotham, Sheila. *Hidden From History: Three Hundred Years of Women's Oppression and Fight Against It.* London: Pluto, 1973.

———. *Women, Resistance and Revolution: A History of Women and Revolution in the Modern World.* New York: Pantheon, 1972.

Rudé, George. *The Crowd in History: A Study of Popular Disturbances in France and England, 1730–1848.* New York: Wiley, 1964.

Ruyter, Nancy Lee Chalfa. *The Cultivation of Body and Mind in Nineteenth-Century American Delsartism.* Westport: Greenwood Press, 1999.

Sabbatini, Renato M. E. "Phrenology: The History of Brain Localization." Center for Biomedical Informatics, State University of Campinas, Brazil. http://www.epub.org.br/cm/n01-frenlog/frenlogia.htm.

Sanger, Margaret. "Is Race Suicide Probable?" *Collier's: The National Weekly*, August 15, 1925, 25.

———. *The Pivot of Civilization.* New York: Brentano's, 1922. Imprint, Elmsford, NY: Maxwell Reprint Co., 1969. Citations are to the Maxwell Reprint Co. edition.

Schaack, Michael J. *Anarchy and Anarchists: A History of The Red Terror and the Social Revolution in America and Europe.* Chicago: F. J. Schulte & Co., 1889.

Schaaf, Larry J. *The Photographic Art of William Henry Fox Talbot.* Princeton: Princeton Univ., 2000.

Schickel, Richard. *D. W. Griffith: An American Life.* New York: Simon and Schuster, 1984.

Schiebinger, Londa. *Nature's Body: Gender in the Making of Modern Science*. Boston: Beacon Press, 1993.

Schiller, Francis. *Paul Broca: Founder of French Anthropology, Explorer of the Brain*. Oxford: Oxford University Press, 1992.

"School Principal and Family Take Fair Top Honors." *The Savannah Press*, November 6, 1924. Eugenics Archive, Dolan DNA Learning Center, Cold Spring Harbor Laboratory. Also available online at http://www.eugenicsarchive.org/eugenics.

Schuyler, George A. "The Negro-Art Hokum." *The Nation*, June 16, 1926.

Scranton, Philip, ed. *Beauty and Business: Commerce, Gender and Culture in Modern America*. New York: Routledge, 2001.

Selden, Steve. "Eugenics Popularization." Eugenics Archive, Dolan DNA Learning Center, Cold Spring Harbor Laboratory. Also available online at http://www.eugenicsarchive.org/eugenics.

———. *Inheriting Shame: The Story of Eugenics and Racism in America*. New York: Teachers College Press: 1999.

Sengoopta, Chandak. *Otto Weininger: Sex, Science and Self in Imperial Vienna*. Chicago: University of Chicago, 2000.

Shenton, James P. *History of the United States to 1865*. New York: Doubleday, 1963.

Simms, J. *A New Physiognomical Chart of Character*. Glasgow: Dunn & Wright, 1873.

Sinfield, Alan. *The Wilde Century: Effeminacy, Oscar Wilde and the Queer Moment*. New York: Columbia, 1994.

Sizer, Nelson, and H.S. Drayton. *Heads and Faces and How to Study Them: a Manual of Phrenology and Physiognomy for the People*. New York: Fowler and Wells, 1885.

Sklar, Robert. *Movie-Made America: A Cultural History of American Movies*. New York: Vintage, 1976.

Slide, Anthony, and Edward Wagenknecht. *Fifty Great American Silent Films, 1912–1920: A Pictorial Survey*. New York: Dover, 1980.

Smith, Page. "The Nation Comes of Age." Vol. 4 of *A People's History of the Ante-Bellum Years*. New York: McGraw-Hill, 1981.

Smithsonian Institute. National Portrait Gallery's official Web site, "Mathew Brady's World." http://www.npg.si.edu/exh/brady.

Snowden, Frank M. "Bernal's 'Blacks' and the Afrocentrists." In *Black Athena Revisited*. Chapel Hill: University of North Carolina Press, 1996.

Sontag, Susan. *On Photography*. New York: Ferrar, Straus and Giroux, 1973.

Spencer, Frank, ed. *A History of American Physical Anthropology, 1930–1980*. New York: Academic Press, 1982.

Spurzheim, J. G. *Phrenology in Connexion With The Study of Physiognomy*. Boston: Marsch, Capen & Lyon, 1833. Citations are to the first American edition.

Squiers, Carol. "Perfecting Mankind: Eugenics and Photography." New York: ICP, 2001.

Staehlin, Jakob. *Original Anecdotes of Peter the Great*. New York: Arno Press, 1970.

Stanton, Jeffrey. "Coney Island Freaks," http://naid.spprsr.ucla.edu/coneyisland/histart.htm.

State of Virginia. Acts of Assembly. *Ch. 394—An ACT to provide for the sexual sterilization of inmates of State institutions in certain cases*. Approved March 29, 1924.

Steadman, Philip. *Vermeer's Camera: Uncovering the Truth Behind the Masterpieces*. Oxford: Oxford University Press, 2001.

Stearns, Frank Preston. "Doctor Holmes." In *Cambridge Sketches*. Authorama Public Domain Books, 1985.

Steiner, J. F. "Recreation and Leisure Time Activities," Chapter XVIII in *Recent Social Trends in the United States: Report of the President's Research Committee on Social Trends* Vol. II. New York: McGraw-Hill, 1933.

Stenn, David. *Clara Bow: Runnin' Wild*. New York: Cooper Square Press, 2000.

Stern, Madeleine B. "Mathew B. Brady and the Rationale of Crime: A Discovery in Daguerreotypes." *The Quarterly Journal of the Library of Congress* 31, no. 3 (July 1974): 127–135.

Stern, Madeleine B. *Heads and Headlines: The Phrenological Fowlers*. Norman, Oklahoma: The University of Oklahoma Press, 1971.

———, comp. *A Phenological Dictionary of 19th Century Americans*. Connecticut: Greenwood Press, 1982.

Sterns, Frank Preston. *Cambridge Sketches*. Digital edition, Whitefish, MT: Kessinger, 2004. First published 1905.

Stoddard, Lothrop. *The Rising Tide of Color Against White World-Supremacy*. New York: Charles Scribner's Sons, 1920.

———*The Revolt Against Civilization: The Menace of the Underman*. New York: Scribner, 1922.

———*A Gallery of Jewish Types*: portrait drawings by Lionel Reiss; explanatory text by Lothrop Stoddard. Imprint Metairie, La. Sons of Liberty, 1980

Extract from *The Forum*, vol. 75, no. 3, March 1926, "The pedigree of Judah."

———*Into the Darkness: An Uncensored Report from Inside the Third Reich at War*. Newport Beach California: The Noontide Press, 2000

Stoyan-Rosenzweig, Nina. "Perfect Babies and Fitter Families: Popularizing Eugenics," University of Florida College of Medicine, http://medinfo.ufl.edu/other/histmed/stoyan/index.html.

Sutherland, Edwin H. *Criminology*. Philadelphia: Lippincott, 1924.

Swarns, Rachel L. "Bones in Museum Cases May Get Decent Burial." *New York Times*, November 4, 2000.

———. "Gaborone Journal: Africa Rejoices as a Wandering Soul Finds Rest." *New York Times*, October 6, 2000.

Swoboda, H. *Otto Weiningers Tod*. In *Chandak Sengoopta, Sex, Science, and Self in Imperial Vienna*. Ph.D. diss., John Hopkins, 1996. *See also* "Precious Pieces about Weininger," available online at http://www.theabsolute.net/ottow/ottoinfo.html.

Talbot, W. H. Fox. *The Pencil of Nature*. With introd. by Beaumont Newhall. London: Longman, Brown, Green and Longmans, 1844. Reprint, New York: Da Capo, 1968. Citations are to the Da Capo edition.

Tawney, R. H. *Religion and the Rise of Capitalism*. New York: NAL, 1954.

Thornber, Craig. "Peter Mark Roget, 1779–1869." In *Men of Ideas and Action*. http://www.home.clara.net/craigthornber/Cheshire/ideasmen/roget.html.

"To Our Patrons," *Freedom's Journal* 1, no. 1 (March 16, 1827): 1. Wisconsin Historical Society, Library-Archive of African-American Newspapers and Periodicals.

Toll, Robert C. *Blacking Up: The Minstrel Show in Nineteenth-Century America*. New York: Oxford, 1974.

Trachtenberg, Alan, ed. *Classic Essays on Photography*. New Haven: Leete's Island Books, 1980.

Travis, Milers Everett. "Mixed Messages: Thomas Calloway and 'The American Negro Exhibit.'" Master's Thesis, Montana State University, Bozeman, April 2004.

Turnley, Joseph. *The Language of the Eye*. London: Partridge Co., 1856.

University of Indiana. "Human Intelligence," http://www.indiana.edu/~intell/kallikak.shtml.

University of Virginia. Department of American Studies official Web site, "Eugenics and the Race Betterment Movement," http://xroads.virginia.edu/~MA03/holmgren/ppie/eug.html.

Van Wyhe, John. "George Combe (1788–1858) The Most Prolific British Phrenologist of the Nineteenth Century." The History of Phrenology on the Web, http://pages.britishlibrary.net/phrenology.

———. "Johann Gaspar Spurzheim (1776–1832), Gall's disciple and the man most responsible for popularizing phrenology." The History of Phrenology on the Web, http://pages.british library.net/phrenology.

———. "Ridiculing Phrenology: 'this persecuted science,'" http://pages.britishlibrary.net/phrenology.

Vaz, Mark Cotta. *Living Dangerously: The Adventures of Merian C. Cooper, Creator of King Kong*. New York: Villard, 2005.

Vukin, Matthew C. "Phrenology in America." http://clearinghouse.mwsc.edu/manuscripts/83.asp.

Wachman, Gay. *Lesbian Empire: Radical Crosswriting in the Twenties*. New Brunswick: Rutgers, 2001.

Wajda, Shirley Teresa, "'This Museum of the Human Race': Fowler and Wells' Phrenological Cabinet and American National Character," http://www.personal.kent.edu/~swajda-phrenology.htm. 533

Wakeman, John, ed. *World Film Directors*, Vol. 1: *1890–1945*. New York: H. H. Wilson, 1987.

Wallace, Heather E. "Sophie: Woman's Education According to Rousseau and Wollstonecraft," http://www.georgetown.edu/faculty/irvinem/english016/franken/sophie.txt.

Wallas, quoted in *PR!: A Social History of Spin*, by Stuart Ewen. New York: Basic Books, 1996.

Wallerstein, Immanuel. *The Modern World-System: Capitalist Agriculture and the Origins of the European World-Economy in the Sixteenth Century*. New York: Academic Press, 1974.

Weber, Max. *The Protestant Ethic and the Spirit of Capitalism*. New York: Charles Scribner's Sons, 1958.

Weikart, Richard. *From Darwin to Hitler: Evolutionary Ethics, Eugenics and Racism in Germany*. New York: Palgrave MacMillan, 2004.

Weininger, Otto. *Sex and Character*. London: William Heinemann, 1906.

Wells, Samuel Robert. *How To Read Character: A New Illustrated Handbook of Phrenology and Physiognomy for Students and Examiners*. New York: Fowler and Wells, 1869.

Wells, Samuel Robert. *The New Physiognomy or Signs of Character*. New York: Samuel R. Wells, 1868.

White, Charles. *Uncle Eph's Dream: An Original Negro Sketch, In Two Scenes and Two Tableaux*. New York: Robert M. Dewittt, 1874.

———. *Wake Up! A Negro Sketch Known as Psychological Experiments, Psychology, Bumps and Lumps, Bumpology, etc*. New York: Dewitt Publishing House, 1874.

Whitman, Walt. *Leaves of Grass*. Garden City: Peter Pauper, 1928.

Wilford, John Noble. "A Fossil Unearthed in Africa Pushes Back Human Origins." *New York Times*, July 11, 2002.

Willis Deborah and Williams Carla, *The Black Negro Body: A Photographic History*. Philadelphia: Temple University Press, 2002.

Willey, Malcolm M., and Stuart A. Rice. "The Agencies of Communication." Chapter IV in *Recent Social Trends in the United States: Report of the President's Research Committee on Social Trends Vol. I*. New York: McGraw-Hill, 1933.

Williams, Eric. *Capitalism & Slavery*. New York: Capricorn, 1966.

Williams, Frederick, Robert La Rose, and Frederica Frost. *Television and Sex-Role Stereotyping*. New York: Praeger, 1981.

Winckelmann, John. *The History of Ancient Art, Vol. II*. Translated by G. Henry Lodge. Boston: James Munroe and Company, 1849.

Wing, Paul. *Stereoscopes: The First One Hundred Years*. Nashua, NH: Transition, 1996.

Wojcik, Pamela Robertson. "Typecasting." *Criticism* 45, no. 2 (Spring 2003).

Wollstonecraft, Mary. *Vindication of the Rights of Women*. London: Joseph Johnson, 1792. Reprint, Mineola, NY: Dover.

Wolman, Leo, and Gustave Peck. "Labor Groups in the Social Structure." Chapter XVI in *Recent Social Trends in the United States: Report of the President's Research Committee on Social Trends Vol. II*. New York: McGraw-Hill, 1933.

Wood, John. *America and the Daguerreotype*. Iowa City: University of Iowa, 1991.

Woodhull, Victoria. *Claflin's Weekly*. August 12, 1871.

Woofter Jr., T. J. "The Status of Racial and Ethnic Groups." Chapter XI in *Recent Social Trends in the United States: Report of the President's Research Committee on Social Trends Vol. I*. New York: McGraw-Hill, 1933.

Worden, Gretchen. *Mütter Museum of the College of Physicians of Philadelphia*. New York: Blast Books, 2002.

Yurco, Frank. "Black Athena, An Egyptological Review." In *Black Athena Revisited*. Chapel Hill: University of North Carolina Press, 1996.

INDEX

ABOUT THE AUTHORS

Ewen & Ewen is an authorial sobriquet assumed by Stuart Ewen and Elizabeth Ewen in no particular order. Elizabeth Ewen is Distinguished Teaching Professor in the Department of American Studies at SUNY College at Old Westbury. Stuart Ewen is CUNY Distinguished Professor of Film & Media Studies at Hunter College and in Ph.D. programs in history and sociology at the CUNY Graduate Center.

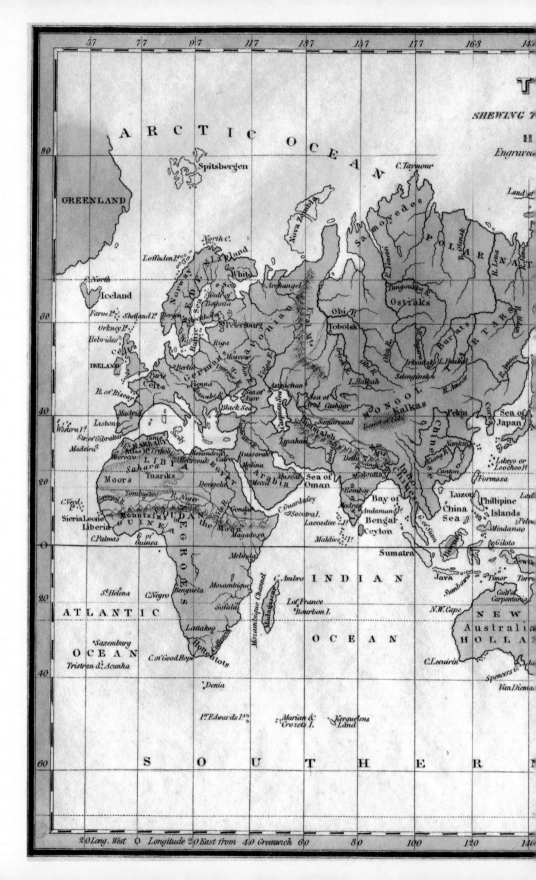